THE PHOTOGRAPHY OF

GAME OF THRONES™

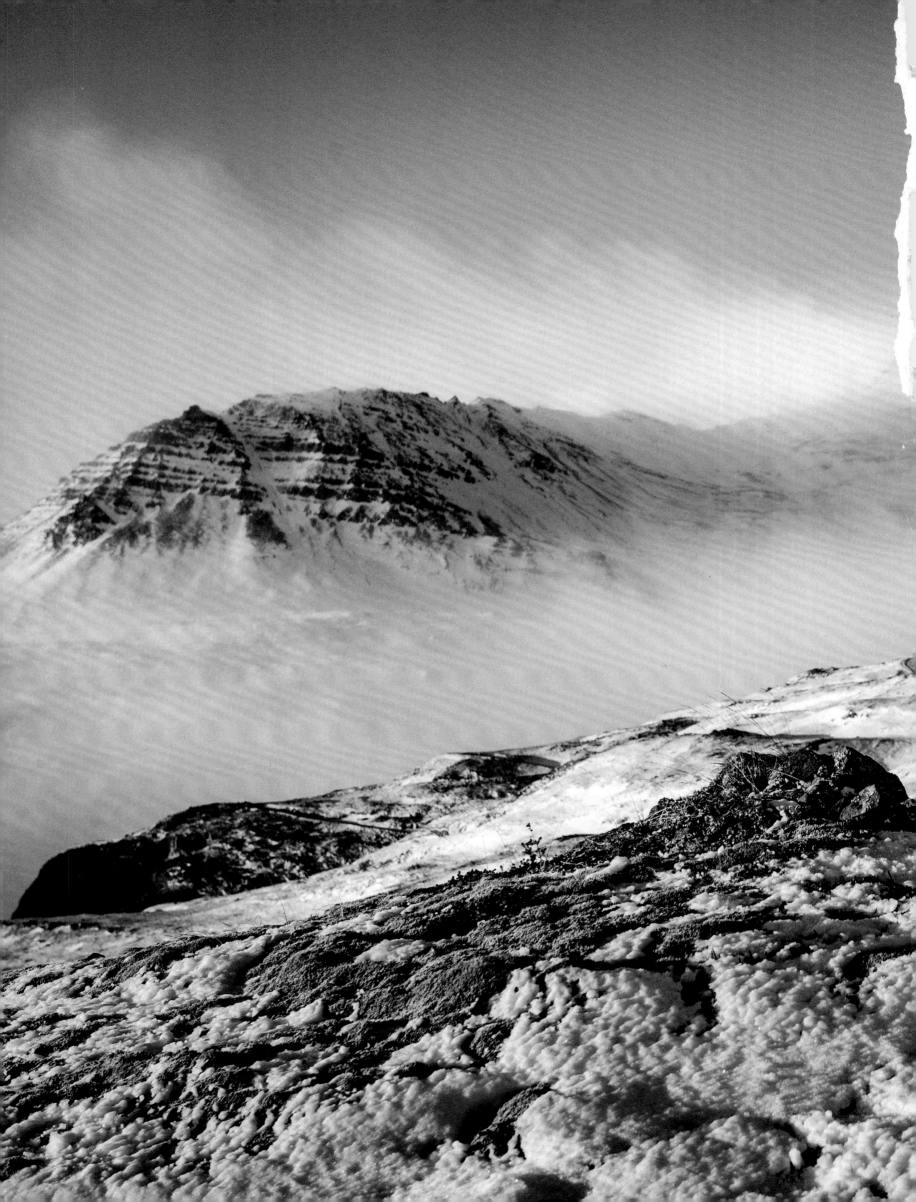

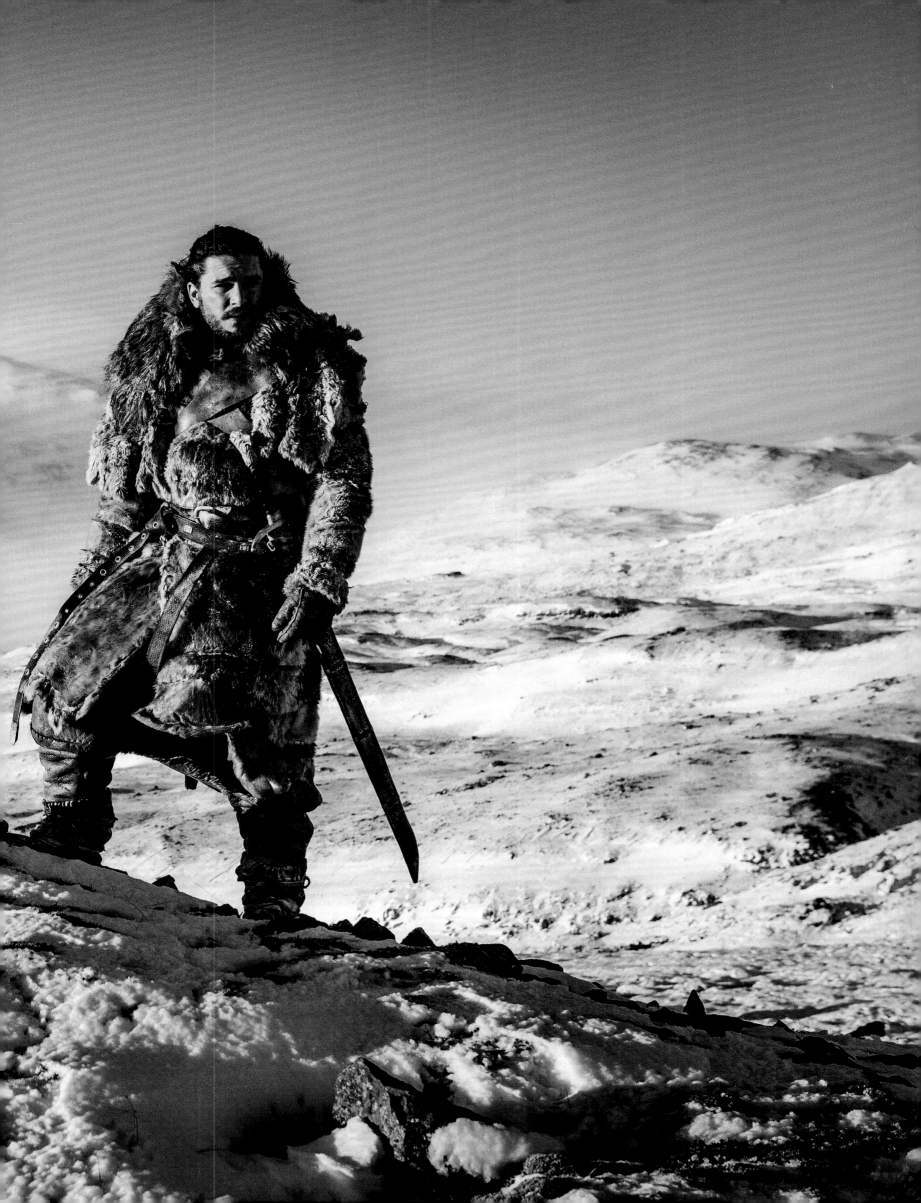

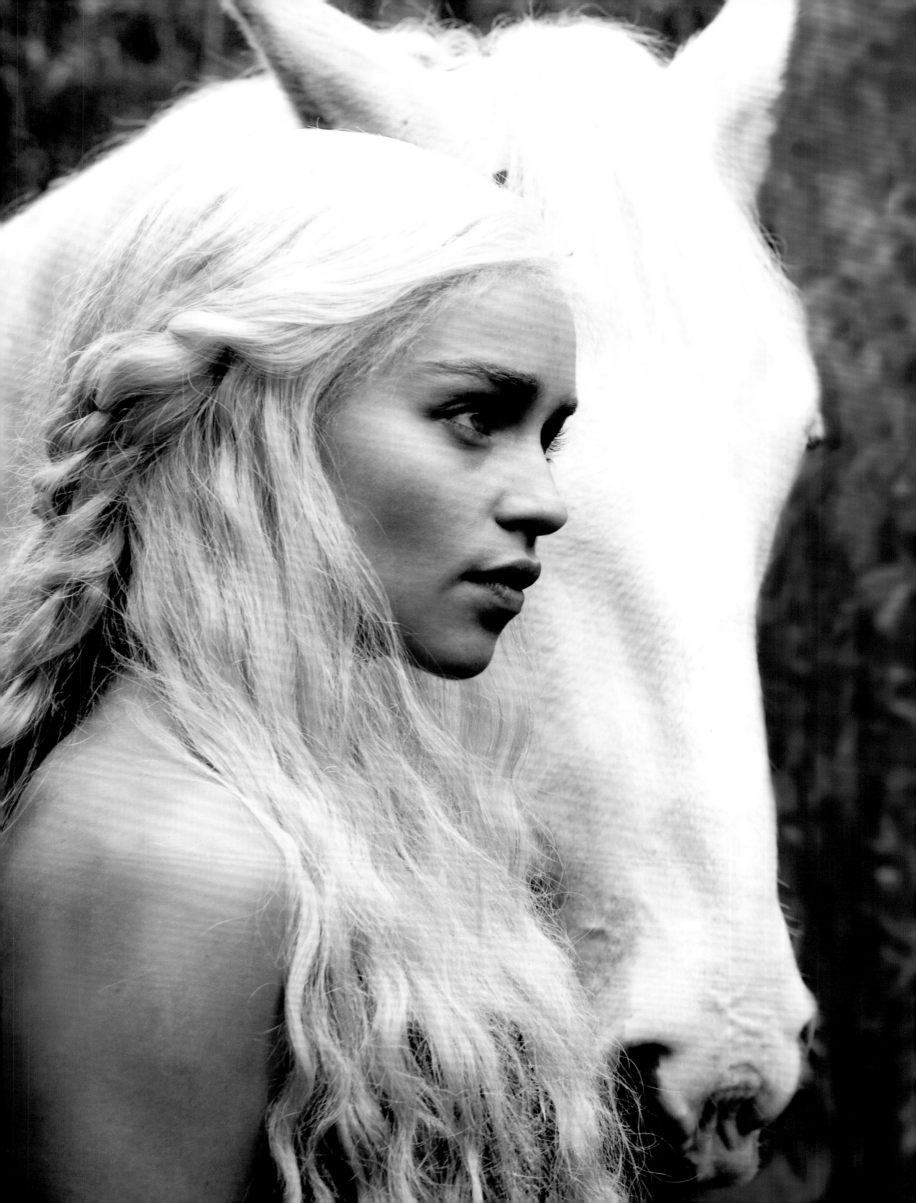

THE PHOTOGRAPHY OF
GAME OF THRONES™

BY HELEN SLOAN

WITH MICHAEL KOGGE

FOREWORD BY

DAVID BENIOFF AND D. B. WEISS

INSIGHT EDITIONS

San Rafael · Los Angeles · London

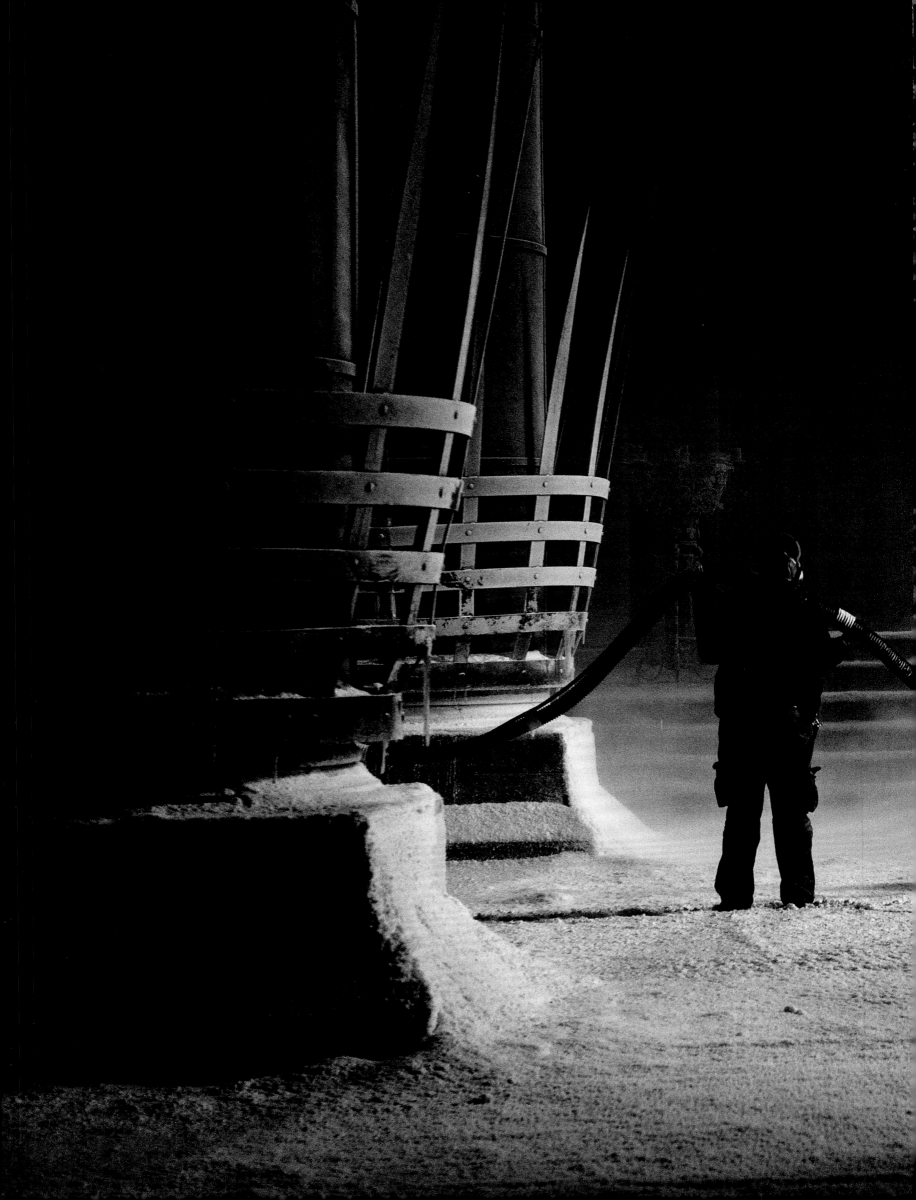

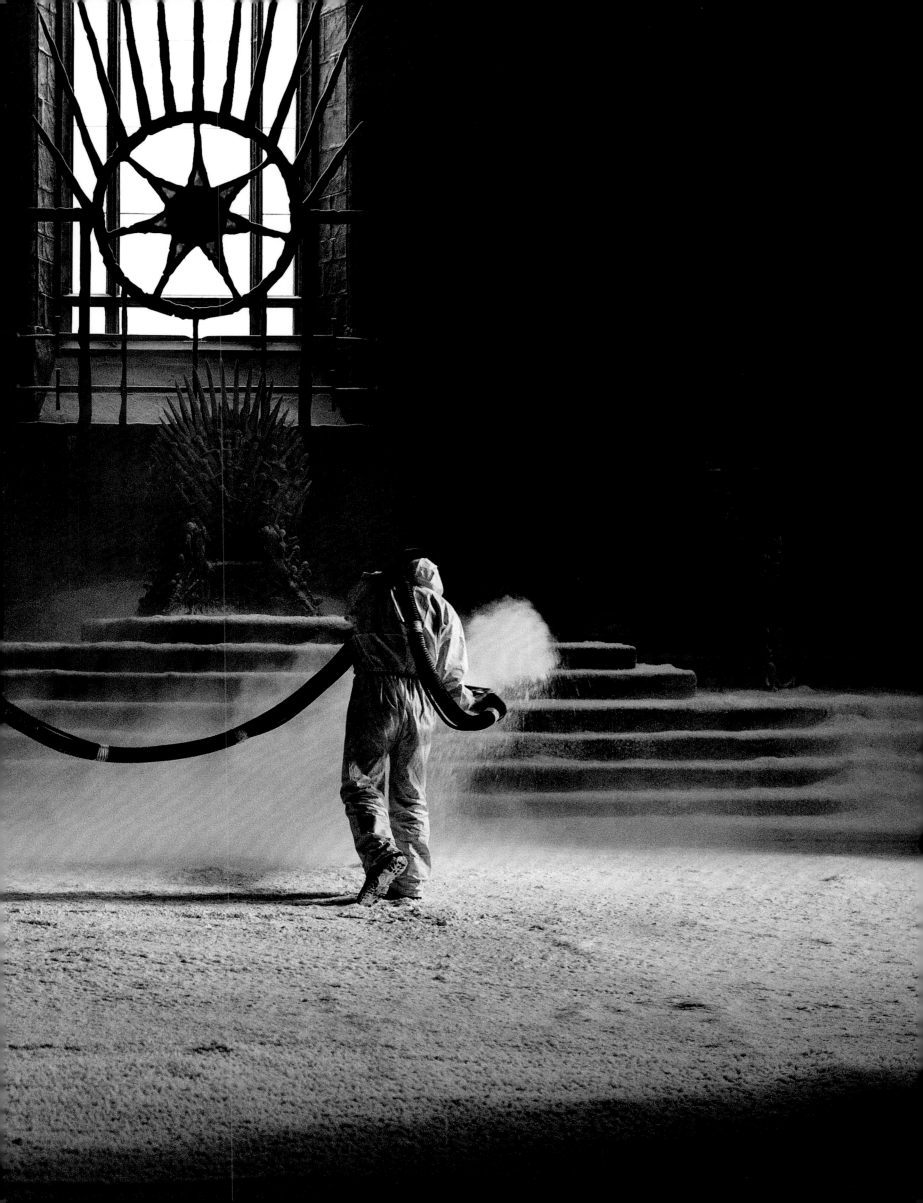

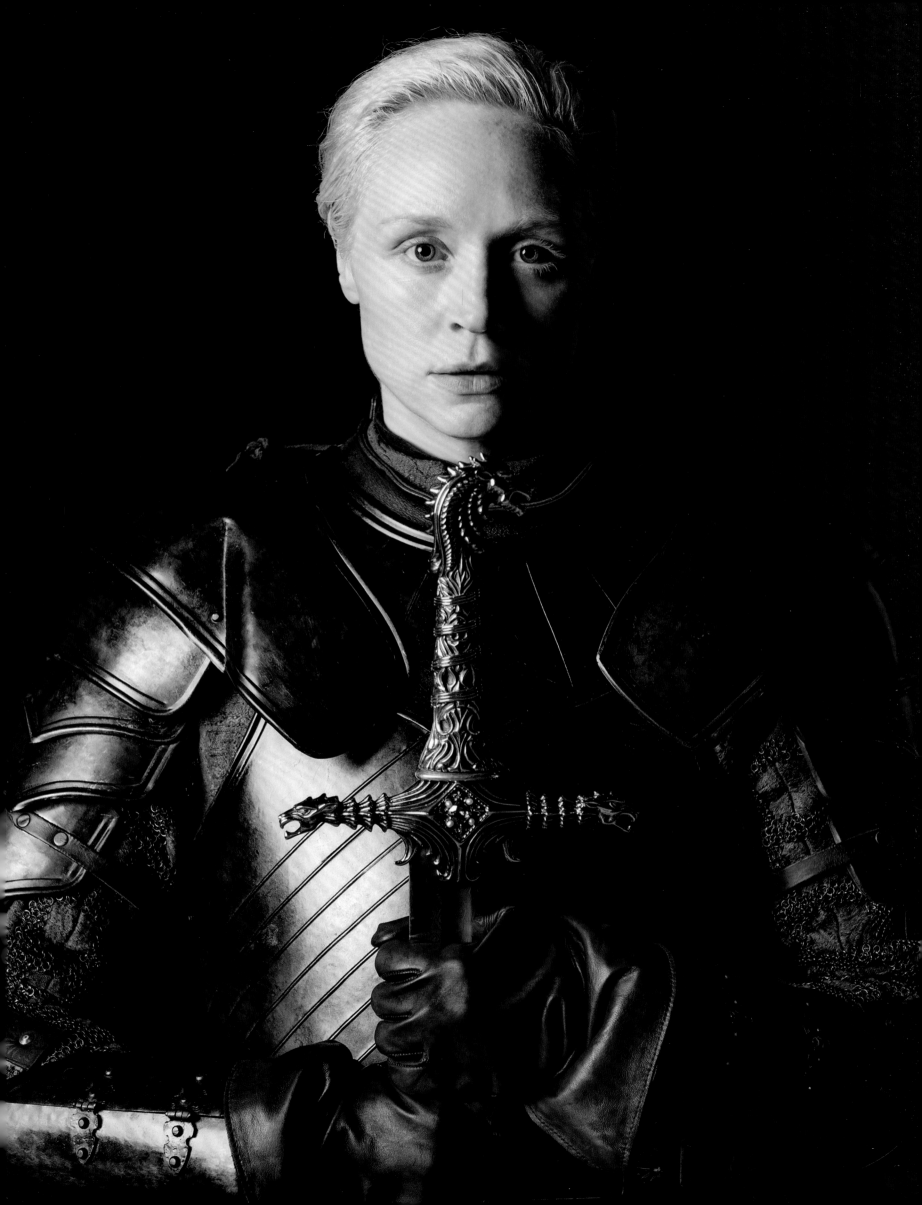

CONTENTS

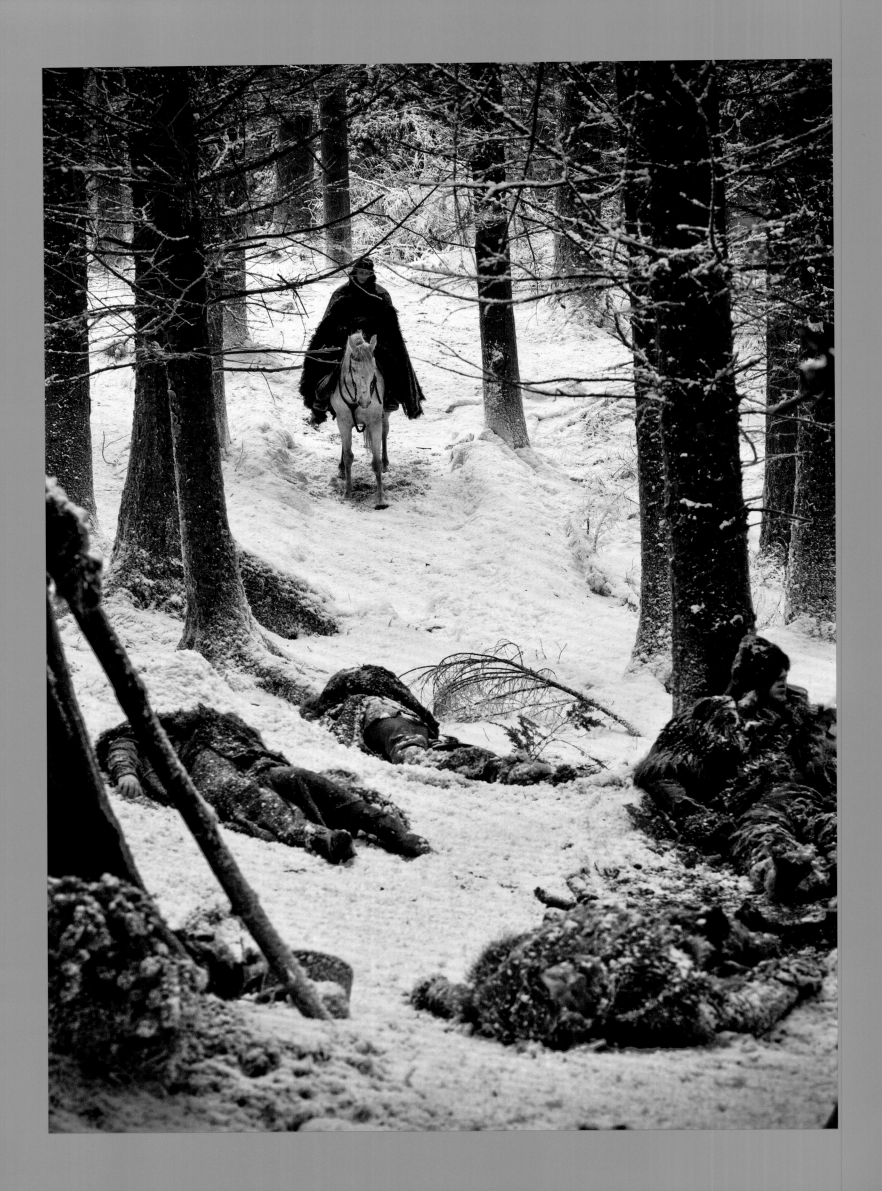

FOREWORD

BY DAVID BENIOFF AND D. B. WEISS

When folks ask us what we miss most about *Game of Thrones*, we always answer, "The people." In our decade of production, we were lucky to work with hundreds of dedicated actors, producers, directors, costume designers, VFX coordinators, stunties, scripties, sparks, and grips. But no one represents the show in our eyes more than Helen Sloan, our genius set photographer. She has a commanding role in our memories and the memories of everyone who worked on set. Helen was always there, a beloved presence from the first days in the Moroccan heat to the Magheramorne rain, the Larrybane winds, the Toome mud, the frigid Paint Hall sets, and the glaciers of Iceland. She seemed to have a few hundred close friends, from third assistant directors to mister first on the call sheet, Peter Dinklage. Between takes, she'd chat with anyone nearby. "What's the craic?"

Once the cameras started rolling, Helen got to work. She had an uncanny ability to station herself in the spot with the best view of the action, where she'd snap quiet shots, her Nikon encased in a bulky sound blimp. Those shots soon became famous throughout the world. The iconic images of Daenerys standing in front of her white horse, of a muddied, bloodied Jon Snow at the Battle of the Bastards, of Joffrey smirking, and of Brienne holding Oathkeeper—all the work of our very own Sloan Ranger.

Just as it's impossible for us to think about the show now without thinking of Ramin Djawadi's score and Michele Clapton's costumes, our memories of the key *Game of Thrones* moments tend to be Helen-curated slideshows. That crew was a true family, and Helen was the beloved sister. Hell, she was so integral to the series that when we needed a baby to play the doomed son of Daenerys Targaryen and Khal Drogo, we chose Helen's beautiful daughter.

These photographs memorialize the work of hundreds of brilliant people who worked their butts off making the costumes, the sets, the weaponry, and the prosthetics. But most of all, they showcase the work of our very own Helen Sloan, the best in the business, whom we have loved from our first days working together and will love until our last days.

OPPOSITE: A trail of victims in the tundra beyond the Wall. This was the first official image of *Game of Thrones* released to the public.

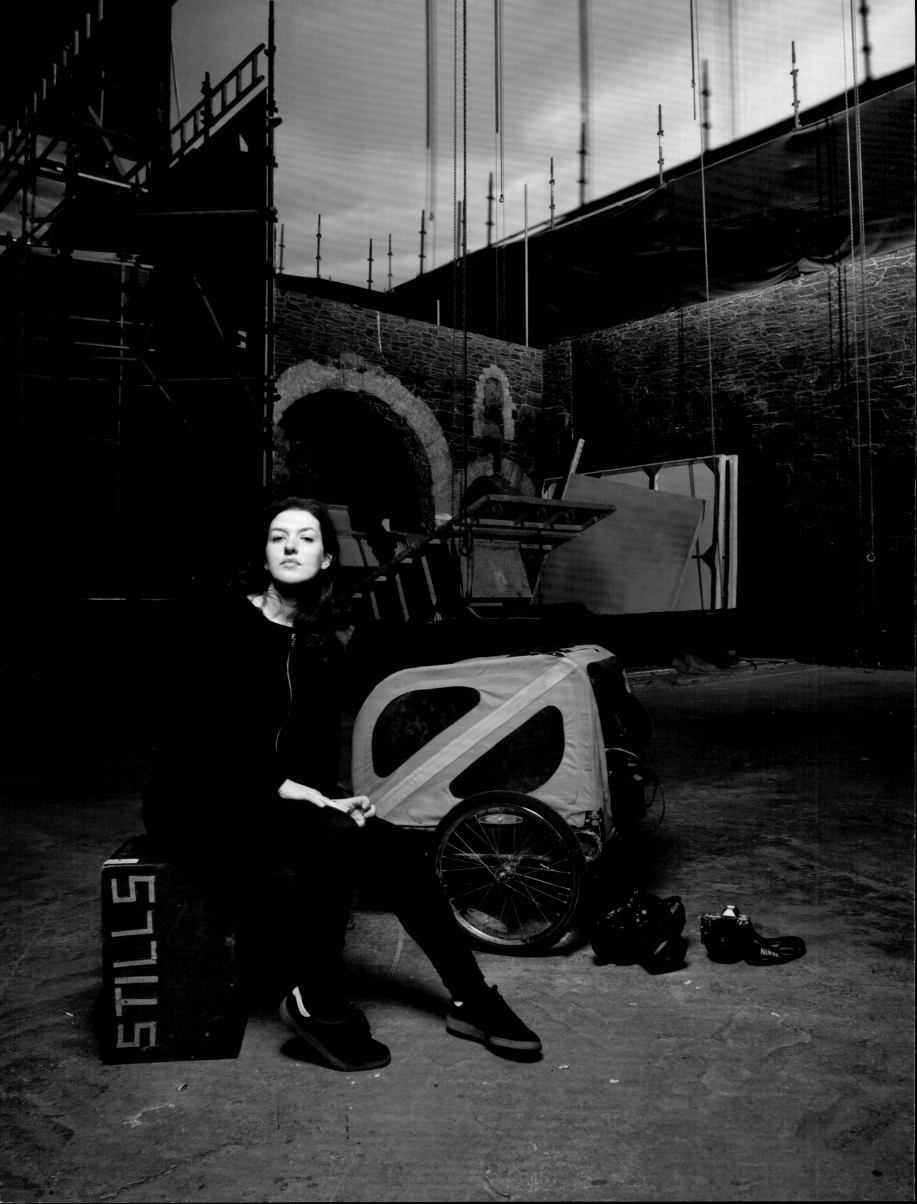

INTRODUCTION

BY HELEN SLOAN

I didn't think I could ever be a movie photographer growing up; it didn't seem like a real job that a girl from small-town rural Ireland could pursue. I collected lobby cards as a kid and had pictures cut out of TV magazines stuck to the wall—but in my mind, those were all shot by "some guy from America." I thought I might be an illustrator or a cartoonist instead—weaker skills for me—but my dream of photography seemed unachievable at that time, especially in a recovering Northern Ireland where big dreams weren't quite on the menu just yet. After being removed from art class at school because I was a headstrong kid when it came to my creativity, I went to a night class instead to pursue illustration. My amazing tutor Niall said, "Are you crazy? You're clearly a photographer. That's your stand-out skill, and you should do it." It galvanized me completely. At that point, my ever-supportive parents spoke to their friend Hugo, a local newspaper photographer, about letting me come in for some work experience. Armed with the trusty Nikon my dad gave me, I entered a smoky room, cluttered with prints and journalists' notes pinned to the walls and the distinctive smell of darkroom chemicals in the air . . . and my love affair with making images began.

I moved to Belfast at seventeen and immediately sought out a photo community. Luckily I came across Belfast Exposed (BX), a group of photographers who, over the last few decades, have recorded various aspects of Northern Ireland—the Troubles, the people, and the communities—to create an amazing archive of socially and politically engaged work. In exchange for making cups of tea and cleaning the dark room, Mervyn Smyth taught me how to print and let me look through their impressive back catalogue of negative folders. Many afternoons were spent listening to their tales of being documentary photographers in the fluctuating landscape of Northern Irish life. I heard wonderful stories about the varied people who inhabit this small island, and what makes them tick. I learned how they dealt with various situations and managed to get such incredible shots. I was taught how to look—particularly in places where others aren't looking. My time at BX undeniably helped me develop the ability to negotiate with people on film sets. With so many different personalities in one place, it's like a strange dance with a lot of different steps to learn.

Cut to: How did I get into movie stills? Clowns. Obviously! One day in a bar behind BX, we got chatting with a group of circus performers who asked if I wanted to have a go at photographing them for some publicity material. We produced some weird and wonderful shots in a forest. Word of mouth spread, and more people in the Belfast circus community came forward needing photography. Soon I was having an amazing time, traveling to different parts of Europe with circus performers from all over the world, shooting their promotional material, live shows, and cabarets. Without a doubt, that experience informs my practice as a stills photographer and taught me the rules: You have to stand back, respect the performers, learn the moves to catch the moments, be quiet, and stay out of the way of the audience. Essentially, you're a fly on the wall, following people around to document their art and how they live.

That summer, a couple of close friends of mine made a short film about a goldfish. They needed stills, and my friend Anna asked if I'd like to be involved. A few shots later, I was starting to get a feel for film sets, and I thought maybe my dream wasn't too far away. Lo and behold, a phone call came from the production office of a big movie filming down in the Paint Hall—a huge imposing old building on the shore in Belfast where ships were once painted—and the voice on the other end of the line said: "We saw some of your circus work—perhaps you'd like to come and shoot some portraits for us. They'll be turned into prop paintings by our artist Will Simpson." I said "yes!" so quickly I almost swallowed the phone. A big movie? With Will Simpson, the *2000 AD* guy, whose pictures were cellotaped to my brother's teenage bedroom wall? And I knew then there would be a real-life stills photographer there. This was my chance.

Sure enough, they had one of the world's greatest photographers on board: Keith Hamshere. He was so lovely: encouraging without being unrealistic. He laid out the responsibilities and realities of succeeding in the role at a high level. Eagerly and seriously I said I could handle that someday—he laughed at my ironclad confidence and said, "I think that might be the case!" He graciously took the time to look over my portfolio, give me advice, and ask if I'd like to come help him with some "boring computer stuff" for a few weeks.

Delighted, I did my best to play it cool, but I'm fairly sure I absolutely did not. During my stint with Keith, the VFX producers Eric Durst and Kim Jorgensen Adams were seeking out a helper for the VFX department. They needed someone who could handle computers and take some texture photography. This was my chance to spend time on a big film set and see how things really worked. I spent a lot of the time watching how everyone worked together in this big machine, what the roles were, and how the stills photographer would fit into that. Unfortunately I didn't get to see Keith at work on set much, as we seemed to be there at opposite times—but I know this was his way of helping me get my foot in the door, and I am forever grateful for my time on *City of Ember*.

The texture photography happened when the crew left, which was fine, as it gave me this incredible opportunity to wander around a giant film set on my own and truly inhabit a fantasy world. To this day, one of my favorite pastimes is wandering around sets alone—it's a total escape from the real world. A well-designed, well-dressed, and beautifully lit set is truly a thing to behold and creates a powerful sensation that you've been dropped into an alternate universe. The little girl with the big imagination in me enjoys every minute.

My introduction to *Game of Thrones* came while I was in line for a cup of coffee. At the time I was working in VFX on another film, and a colleague said to me, "There's this big HBO pilot coming in, and it's got witches and magic—all that stuff you like. You should put your name in." Strangely enough, the producer, Mark, who was bringing the show to Ireland, came to talk to me later that day on set about the stills position. He warned me it was a big production, but it was still worth a try, and he helped me throw my hat in the ring. A call came from Vicky, the photo editor on the production, who said, "We love your style and think it's very much in keeping with the story of this show. Would you like to join us?" And, of course, Vicky would become my partner in crime for all eight seasons.

What is a stills photographer? On set, I have the privilege of documenting the entire ballet of filmmaking, from what's happening in front of the cameras to what's going on behind the scenes. I have free roam around the studios, offices, and workshops and get to interact with everyone and see such varied talents up close, from the secret world of the artisans who create this magical world and everything in it to the shooting crew working to bring it all to life. It's 360 degrees of art on an industrial scale.

To capture *Game of Thrones*, my kit was entirely Nikon; D3s to begin with, then D5s, DFs, and D850s. For the studio work and campaigns, everything was shot on my Nikon D850 or D800. My favorite lenses, which I had with me all the time, were the 24–70mm f/2.8, 70–200mm f/2.8, and the older version of the 85mm 1.4 prime.

People often ask, "What settings, lens, and camera do you use?" The combination of camera and lens depends on what's in front of me, what the scene is, and what the scene requires. Often I employ the flexibility of a zoom lens, because I'll be looking in many directions: wide shots of the crew, then a portrait of the cast, then back to a mid of the checks happening. *Game of Thrones* was often quite dark, so I tended to push the ISO up a bit—but that crunchy look suits my aesthetic, and the Nikons can handle it. Mirrorless cameras are a newcomer to the photo world, so all of my shots on *Game of Thrones* were done with my cameras enclosed inside large Jacobson and AquaTech sound blimps to stop anyone from hearing the "click." The blimps are essential for shooting during takes! While it feels a bit like doing embroidery wearing gardening gloves, they were necessary and turned out to be a great friend to me on set, saving my lens from rogue plastic swords, mud, blood, desert sand, and most commonly, *rain*!

From the very beginning during the pilot, HBO, David, and Dan generously let me try out my own color grade, and I went for a hard "contrasty" fantasy look. Thank goodness they thought it was a good fit, and they let me keep going with it over the seasons. It's a real treat for any photographer to be allowed this much control over the look of the imagery. I've always loved to see background detail, like in the photographs in my father's *National Geographic* magazines, which my brother and I pored over as children. They hold so much information and dimension. On our *Game of Thrones* sets, the background is absolutely as important as the foreground, because the sets are so expansive and richly detailed, and they make the world that the characters inhabit believable.

There was no such thing as a typical day on *Game of Thrones*. One day we were in a lush forest watching a horse-riding team head out into the Irish vista, then the next day we were on top of a glacier experiencing some horrendous windchill, then we were in the desert with an entirely different cast, or we were back in the studio setting fire to someone and pushing them off the side of a fake boat—a stunt performer, obviously! There were also days when something big was going to happen, something dangerous, and there was a lot of pressure. The horse charge during the Battle of the Bastards was my most terrifying moment, and a series of tiny heart attacks ensued as they ran toward us. My heart was saying "Run!" while my brain was chiming in with "It's safe! The Devil's Horsemen are the best in the world. These are stunts! It's OK." But looking down a tube at the action, it all seems pretty real.

The only thing that is consistent on a film set is that you have to get it done right. Every time. You have to make friends with many kinds of people very quickly, because you're thrown in the deep end with a hundred different personalities all working together, because no one's job is more important than anyone else's in the grand scheme of things. We shoot all day—nothing ever *really* stops on a film set, as there is always someone working on something. From the outside it can seem like complete chaos and clatter, but it's a system: a giant organism. The only metaphor that really works in my mind is that if the film or show is a jar of delicious honey on the shelf in a store, then a film set is like a beehive. It's closed off to the world; nobody on the outside gets to look in and see how it really happens. But in there the swarm is working like crazy, with a constant hum of noise and energy. There's an urgency on sets, but also a family atmosphere of fun and creativity. This job was so physically and mentally demanding, for every hour of every day for months on end. Even outside normal shooting hours, there are teams with eye-watering precalls and superlate finishes—hair, prosthetics and makeup, costumes, locations, the extras teams, the after-hours teams, producers, writers, drivers, facilities moving the trucks to the next location, editors,

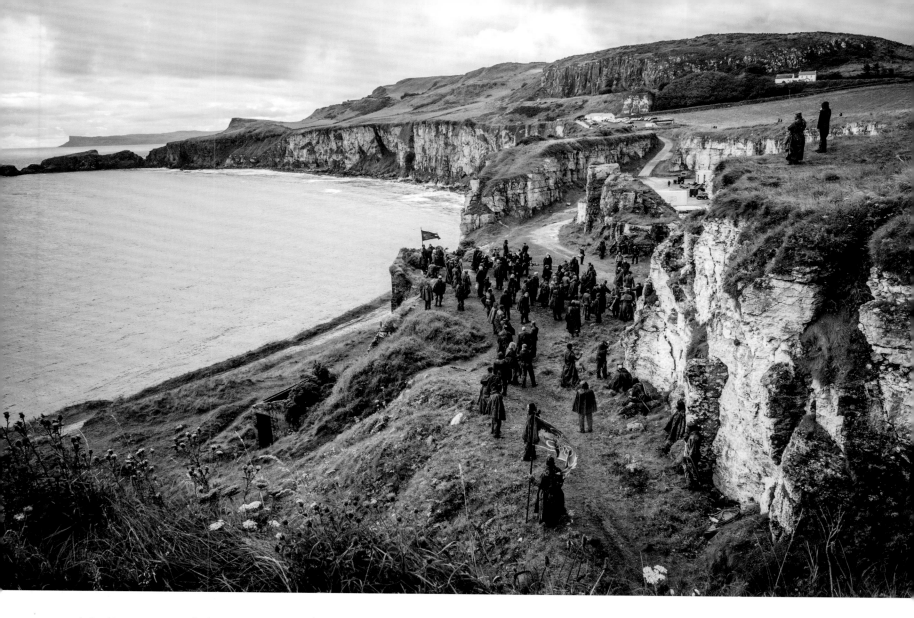

and the list goes on, including myself meta tagging and Photoshopping out rogue background bum cracks in crew photos into the night—all the glamour! Unless you find mud glamorous—in which case, you're in luck! We had plenty of that.

To be a stills photographer, you have to be flexible creatively. You have to be good at landscape, portrait, documentary, and studio photography, and also have the ability to switch between those trades at a moment's notice. There was rarely any sitting down and planning on set; it was just "go go go." I read the scripts, schedule, and every call sheet, all while asking questions obsessively and watching the rehearsals to know all the right spots and exactly what the choreography was so I could get the moment.

The sit-down planning happens when we do our end-of-season prop and costume shoots or studio portraits for advertising campaigns. I'd sit down with HBO and with my teammates Damien and Trevor and plan it all out meticulously with the various departments. The rest of the time, it was all happening around me on set, and I was navigating various dilemmas and challenges in my head as I was shooting. Sometimes when I got back to the computer, I wouldn't remember what was shot that day until I looked at the images. It is surprising how the brain works in those situations—the adrenaline rush was crazy.

When I look at the world, I'm always seeing still moments, fragments of time that prompt my finger to click the shutter. After a while, a photographer will stop thinking about composition and exposure so intently. It all becomes second nature, and you're totally free to creatively make images. The last count of my photo database for *Game of Thrones* totaled over a million frames. Along with the material from the other fantastic set photographers, we curated material for each season and kept narrowing down the focus. For this book, I've done the same, narrowing down the photographs to present the the most iconic images. *Game of Thrones* was such an enormous and overwhelming project, it had to be categorized in some way. We knew there was no way this book could be linear because of the complexity of the series. Instead, it has been divided to reflect the seven aspects of the Faith of the Seven, one of the most important concepts in the show. Each of these aspects—the Father, the Mother, the Maiden, the Crone, the Warrior, the Smith, and the Stranger—reflects a different facet of life, and those aspects are what connect the characters and the storylines to each other. The concept of the Smith is shown throughout the book with images that reveal the work that went on behind the scenes and the incredible amount of labor that went into creating *Game of Thrones*.

There are thousands of photographs I love of cast, crew, and locations that are just never going to see the light of day—it's impossible—but this selection absolutely represents some of my favorite images and most memorable scenes from my time on this phenomenal show.

ABOVE: Larrybane Quarry in Northern Ireland, where the Kingsmoot was filmed.

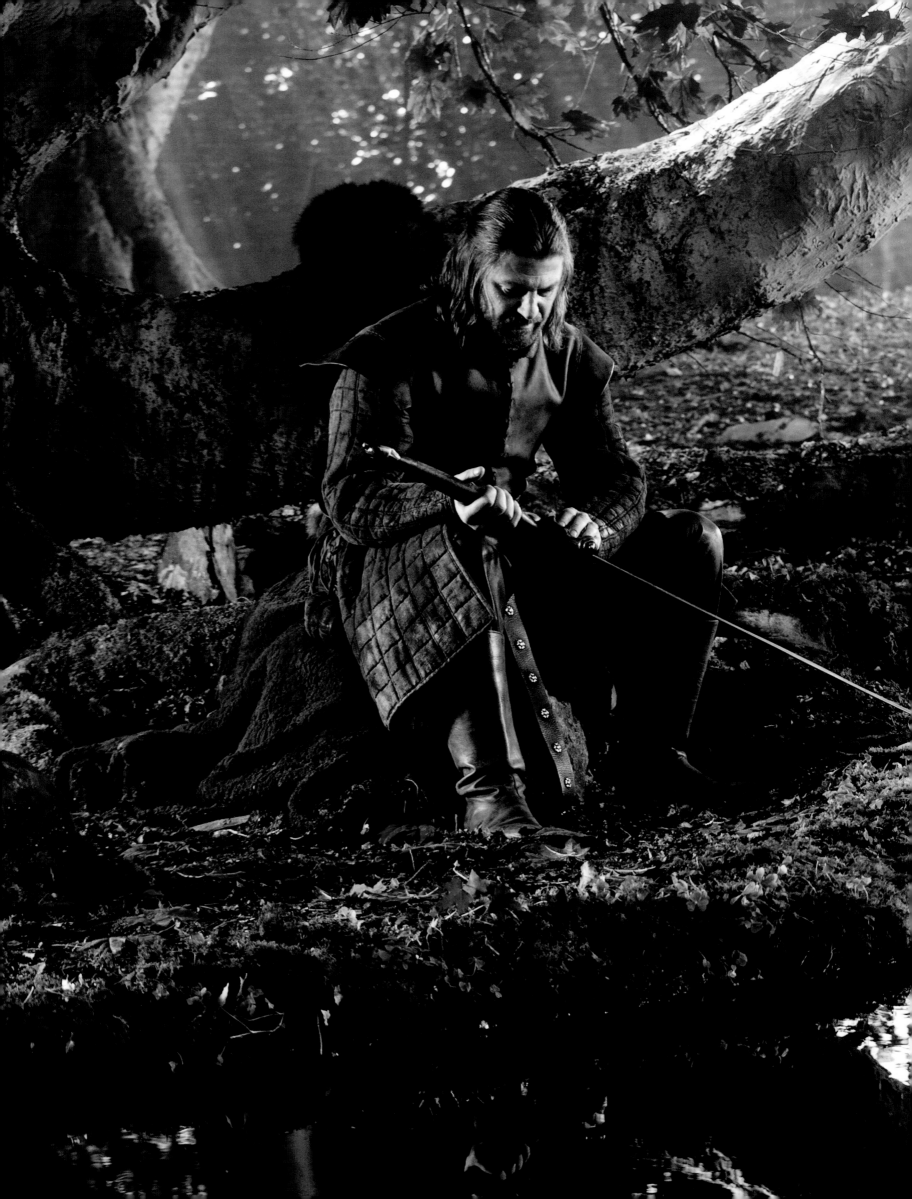

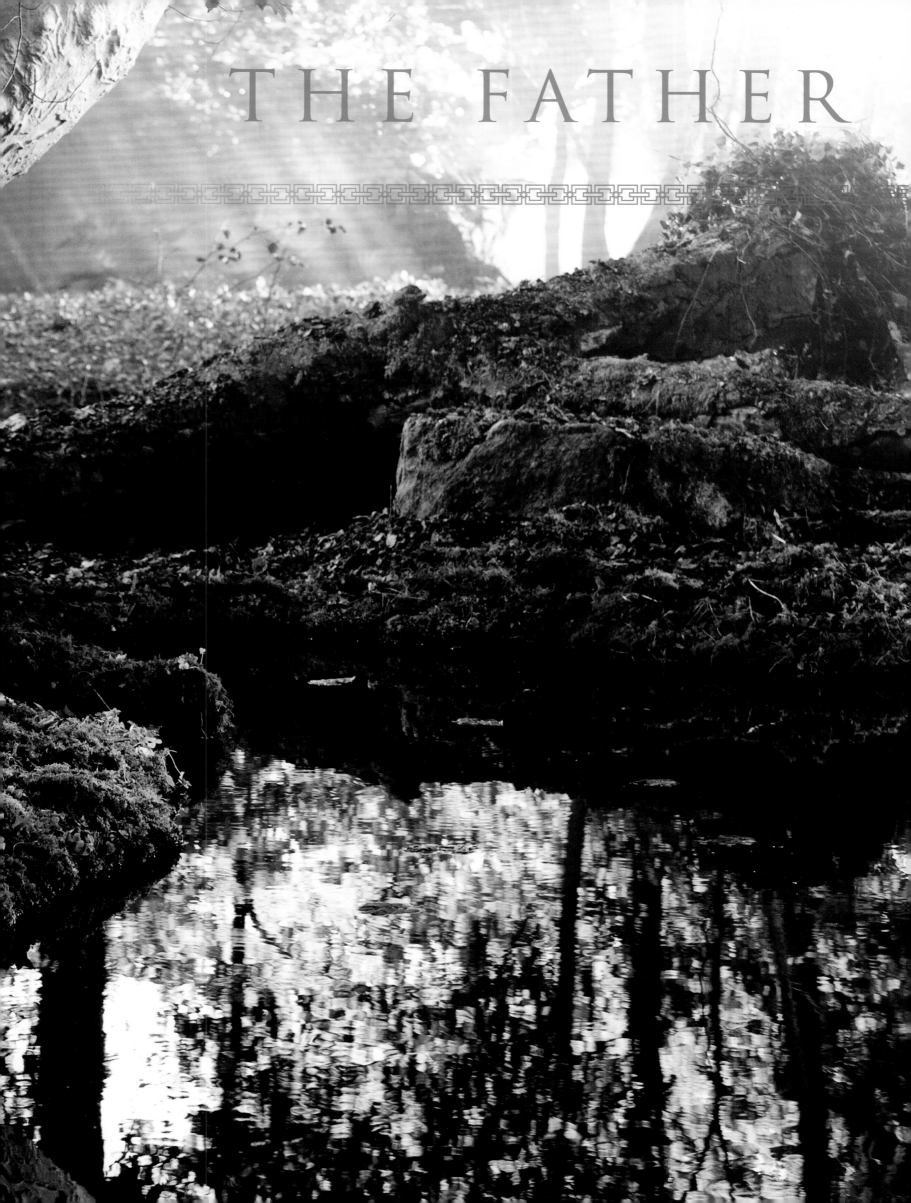

THE FATHER

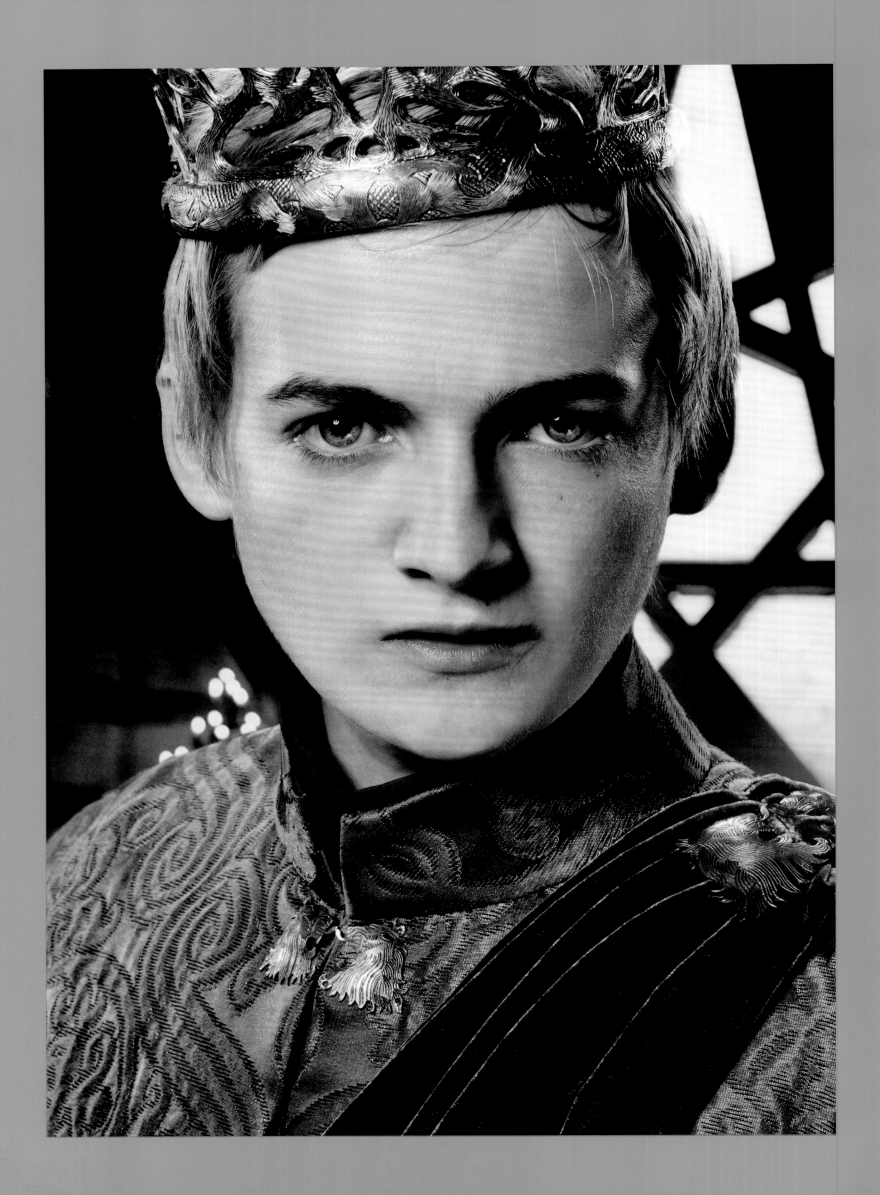

The Father represents justice and presides over the souls of the dead.

As the first of the seven aspects of the Faith of the Seven, the Father represents divine justice. *Game of Thrones* is about the struggle for supremacy—or more simply, the pursuit of power. The characters that battle for the throne do so in order to gain the power to rule the Seven Kingdoms, to determine what is right and mete out judgments—cruel or benevolent—upon the populace.

This pursuit propels the narrative on both macro and micro levels as it pits great armies against each other in pitched battle and foments rivalries within families. It promotes the lowliest of wretches to players in the game and demotes would-be rulers to pawns. Power is the great enabler, both a creative and destructive force.

Those who pursue power at its highest levels are often consumed by the pursuit. After King Robert Baratheon dies following a wild boar hunt, his eldest supposed son and heir, Joffrey Baratheon, wields his power with a maniacal fervor that quickly becomes his undoing. When Joffrey's younger brother, Tommen Baratheon, ascends the throne, he is nothing more than a pawn being controlled by the more powerful.

Meanwhile, Robert's brothers, Stannis and Renly, wage war against each other for the Iron Throne. Neither achieves his goal: Stannis is so consumed by his conviction that he assassinates Renly with dark magic and eliminates his own daughter; his pursuit of the throne ends when he is taken down by House Bolton forces.

Far from King's Landing, Robb Stark, the King in the North, leads an army to avenge his father's murder, but the Lannisters' treachery cuts short his bid for the throne. Much later, his siblings Sansa Stark and Jon Snow revive the Starks' claim to rule in the North.

Across the narrow sea, Viserys Targaryen, the exiled son of the Targaryen line, stops at nothing in his quest to be restored to the throne of Westeros, even if that means selling off his young sister Daenerys to a Dothraki leader. But he meets his end when that leader, Khal Drogo, proves himself a capable ally to Daenerys. Viserys's death elevates Daenerys to become the last known Targaryen heir with a claim to the throne.

Of everyone who strives for control of Westeros, Cersei Lannister is most unyielding as she works to keep her children safe and in power. She uses any tool available to her benefit, whether it be ruthless politicking or indiscriminate killing, in order to maintain first Joffrey's and then Tommen's position on the throne. When she loses Tommen to suicide, she seizes the throne for herself and is crowned as Queen of the Seven Kingdoms. As queen, Cersei puts all her energy into expanding her power and ensuring the survival of her family line. When Jon Snow warns her that the Night King's Army of the Dead is coming to devastate the peoples of the Seven Kingdoms, Cersei sees the approaching battle as an opportunity to destroy her enemies and solidify her power, though she loses her throne and her family when Daenerys razes the city.

The terrifying specter of the Night King looms as he bides his time, amassing his army and waiting for the right time to strike and seize the whole of the Seven Kingdoms from the living. Ultimately, he is defeated by Arya Stark, who was destined to shut many eyes: brown eyes, green eyes, and blue eyes.

But not everyone pursues power or holds on to it for the purpose of ruling the Seven Kingdoms. Some merely use it to maintain their status or their superiority. For warriors like the Hound and the Mountain, power comes from their brute strength as they batter their opponents into submission. Assassins like Jaqen H'ghar, on the other hand, find their power in striking from the shadows. Others like Jorah Mormont grow to truly respect their ruler and do everything in their power to maintain their place at their ruler's side. Then there are fanatics like the High Sparrow, who exploit age-old suspicions among god-fearing people in order to exert control over the masses. The Sparrow's willingness to reject the ordinary trappings of wealth camouflages his takeover as the moral authority in King's Landing.

Lastly, there are the kingmakers and queenmakers. Tyrion Lannister, Olenna Tyrell, Petyr Baelish, Varys, and Melisandre (to name just a few) seek not thrones but influence. They silently spin webs and plot schemes around the rulers they serve, doling out counsel that best suits themselves. Sometimes their ambitions can turn noble—as in Tyrion's case—and move them to champion a cause greater than themselves. Often, however, their aims are purely selfish, and they are content beside the throne, exerting a soft power that allows them to get what they desire.

"Power is probably the most relatable theme in *Game of Thrones* because we all need to have some sort of power in life to get things done," says Helen Sloan. "In a world like Westeros, power in its many forms is what's going to keep you alive. Power need not be obvious; it can also be quiet power, such as the power that Baelish and Varys wield. Power can also shift quickly in *Game of Thrones*—one minute you think you know who has the power, and then the next minute they're gone because someone silently snuck up on them. On a film set, one might think that a producer or an actor always has the power, but for me it can be my colleagues in the crew. For instance, the boom swinger may have a better position or angle than I do on a scene, so in a moment we have to negotiate and barter to find a way that suits us both. Even the biggest sets turn into an exercise in human origami once the crew is crammed in the corner! We make it work somehow—but it's cozy!"

PAGES 16—17: Ned Stark cleaning his ancestral sword, Ice, by the weirwood tree in the godswood of Winterfell. Helen Sloan says, "What made this shot so special is that for the first few seasons, I shared office space with the greens department. They created the tree and everything around it. I saw how hard they worked to make that look so beautiful. Mike Gibson, the head greensman on the series, has this picture hanging in his living room, so I know the godswood has a special place in his heart, too."

OPPOSITE: Jack Gleeson as King Joffrey I Baratheon.

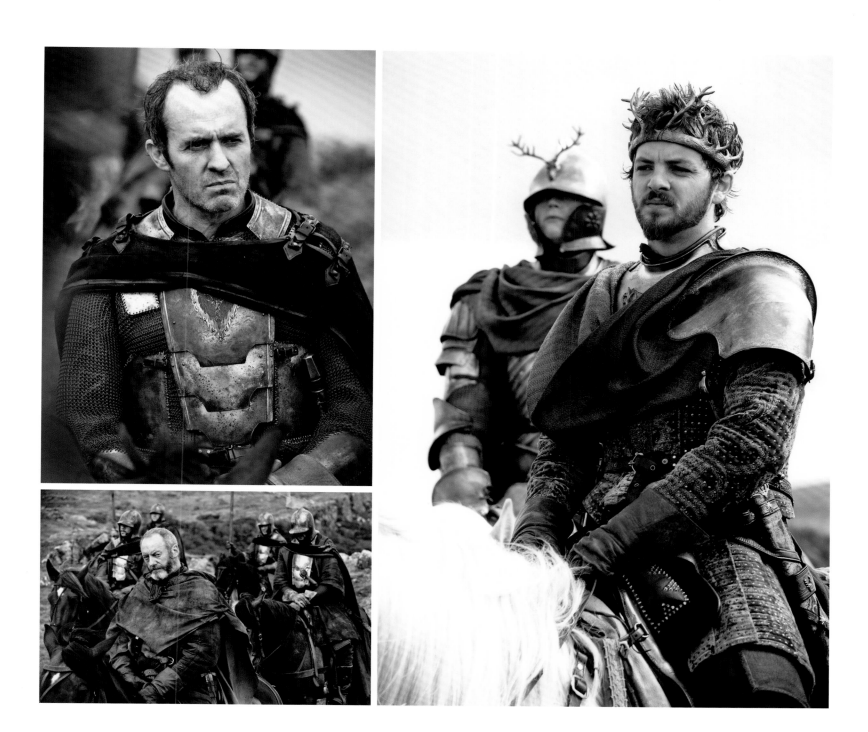

OPPOSITE: Mark Addy as Robert Baratheon.
TOP LEFT: Stephen Dillane as Stannis Baratheon.
RIGHT: Gethin Anthony as Renly Baratheon.
BOTTOM LEFT: Liam Cunningham as Ser Davos Seaworth.

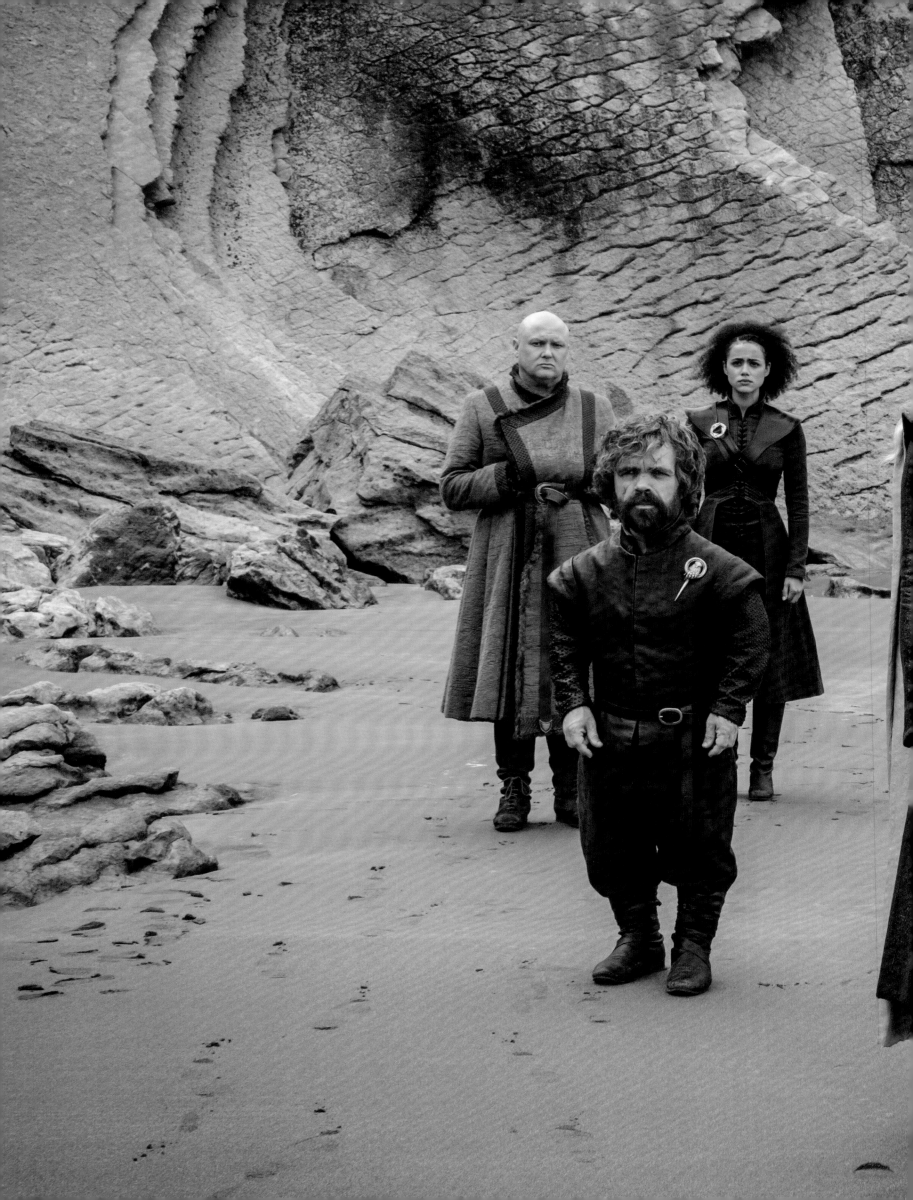

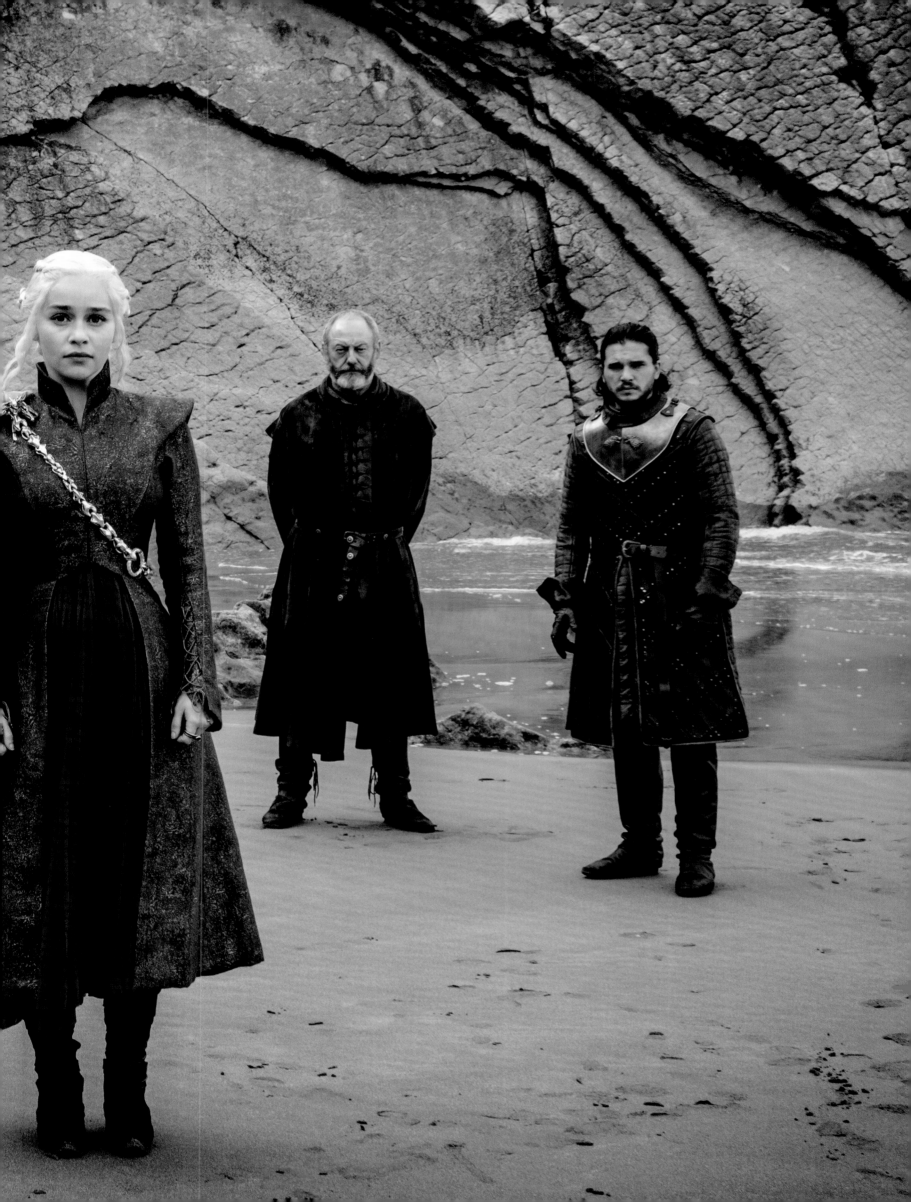

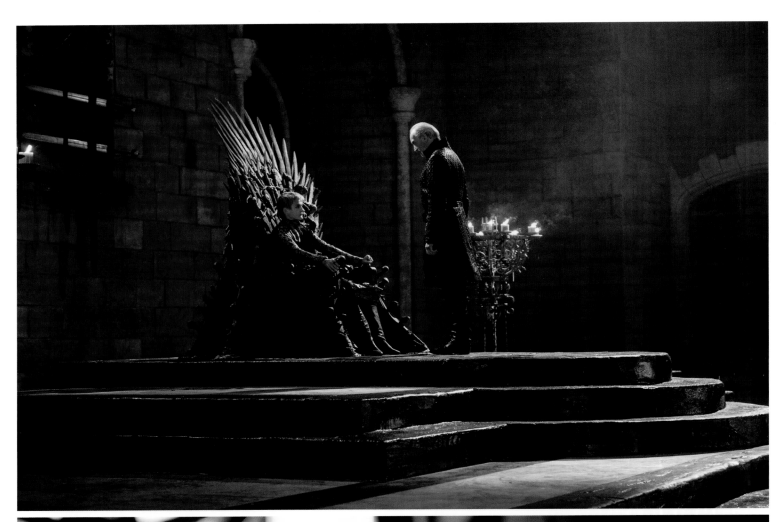

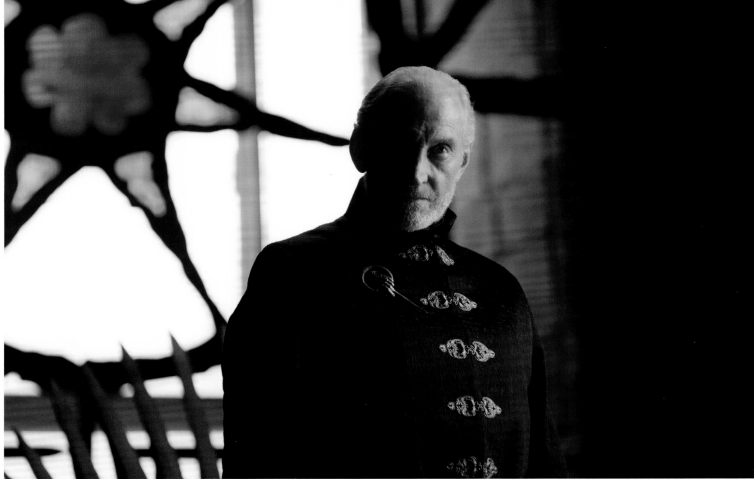

PAGES 22–23: Daenerys Targaryen and her advisors on the island of Dragonstone in Blackwater Bay.
ABOVE: Tywin Lannister, played by Charles Dance, counsels King Joffrey on matters of the Seven Kingdoms.
OPPOSITE: Jason Momoa as Khal Drogo and the Dothraki encampment.

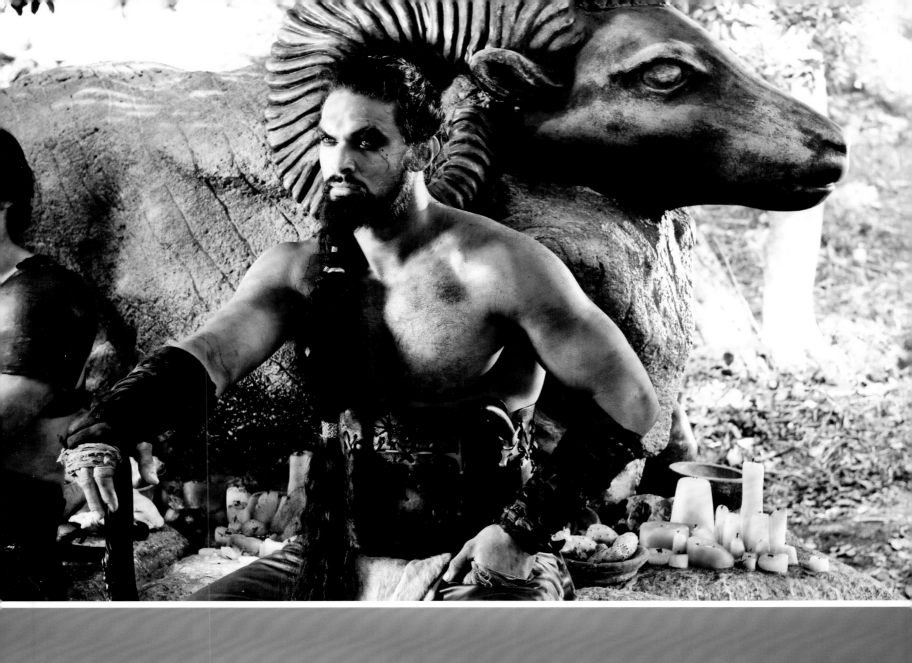
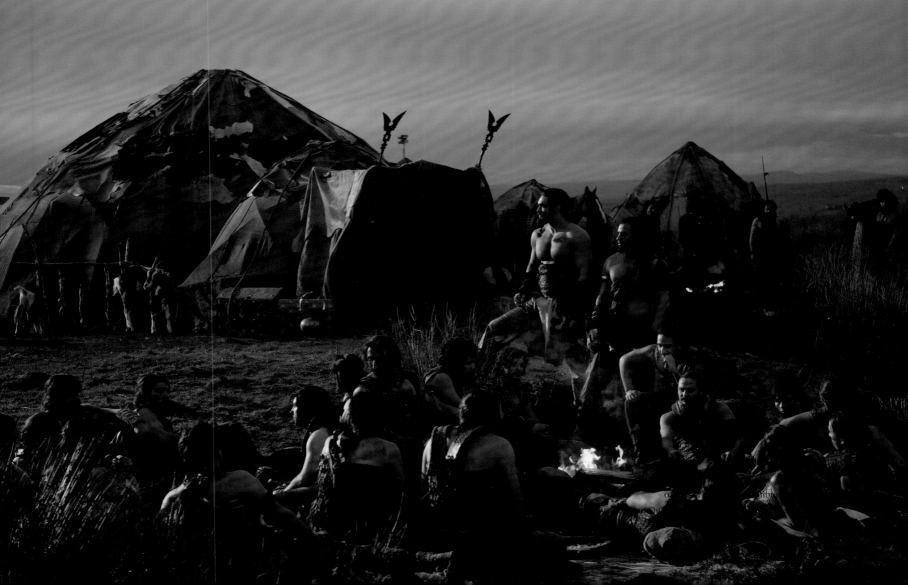

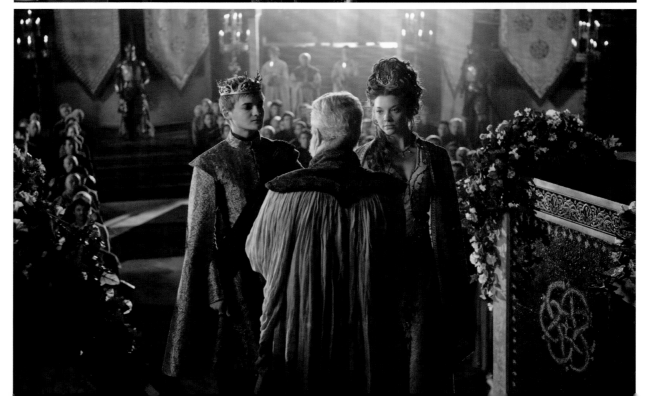

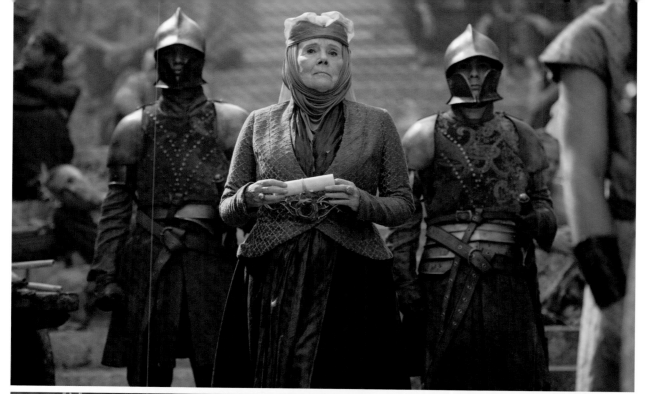

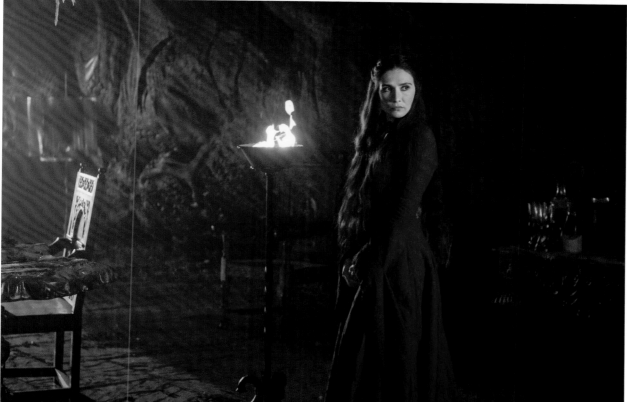

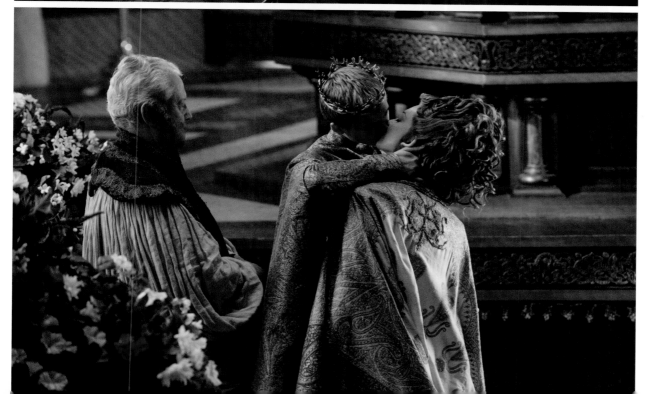

THESE PAGES: House Tyrell (*top*) and House Lannister united against Stannis Baratheon and the Lady Melisandre (*center*) through the wedding of Joffrey and Margaery (*bottom*).

27

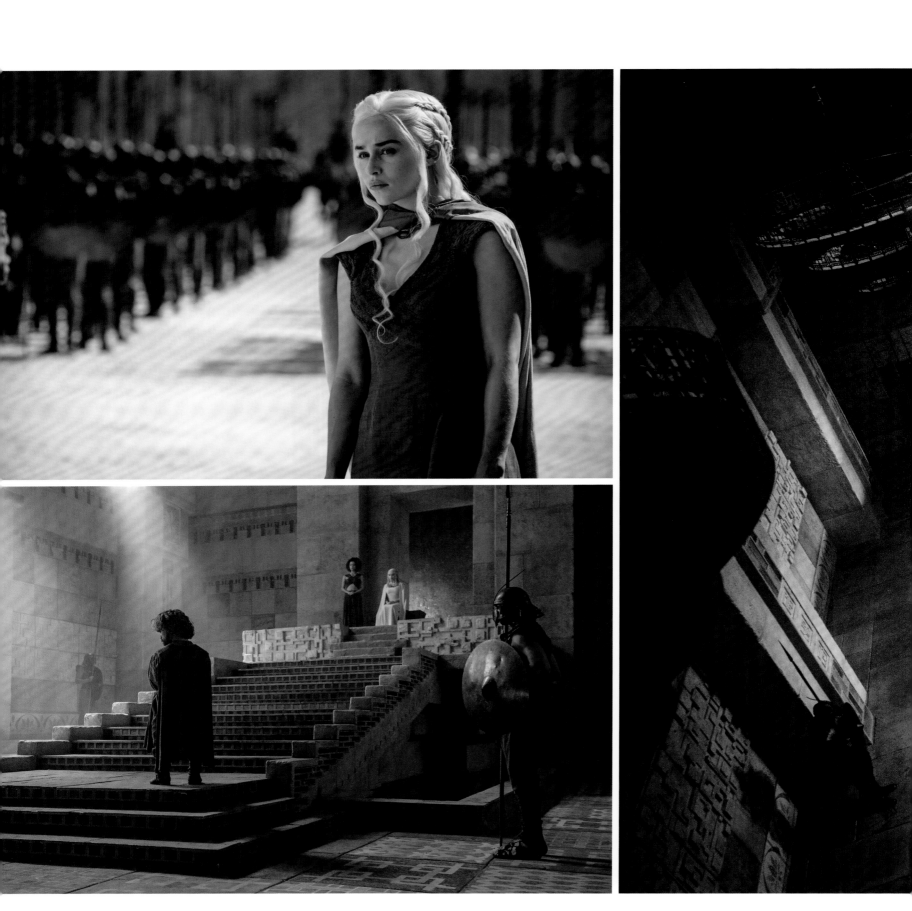

ABOVE AND RIGHT: Daenerys sits in the audience chamber of Meereen after conquering the city. Sloan notes, "The Meereen audience chamber set was such a commanding location. That platform at the top of the stairs offered an imposing view, and the water below makes the light twinkle on the walls. The heat from the flaming chandeliers . . . was unbelievable. I went up top to take some photos a few times, and it felt really immersive. It felt like I was part of the work crew in Daenerys's temple, eavesdropping."

TOP: Daenerys at the gates of Meereen with the Unsullied.

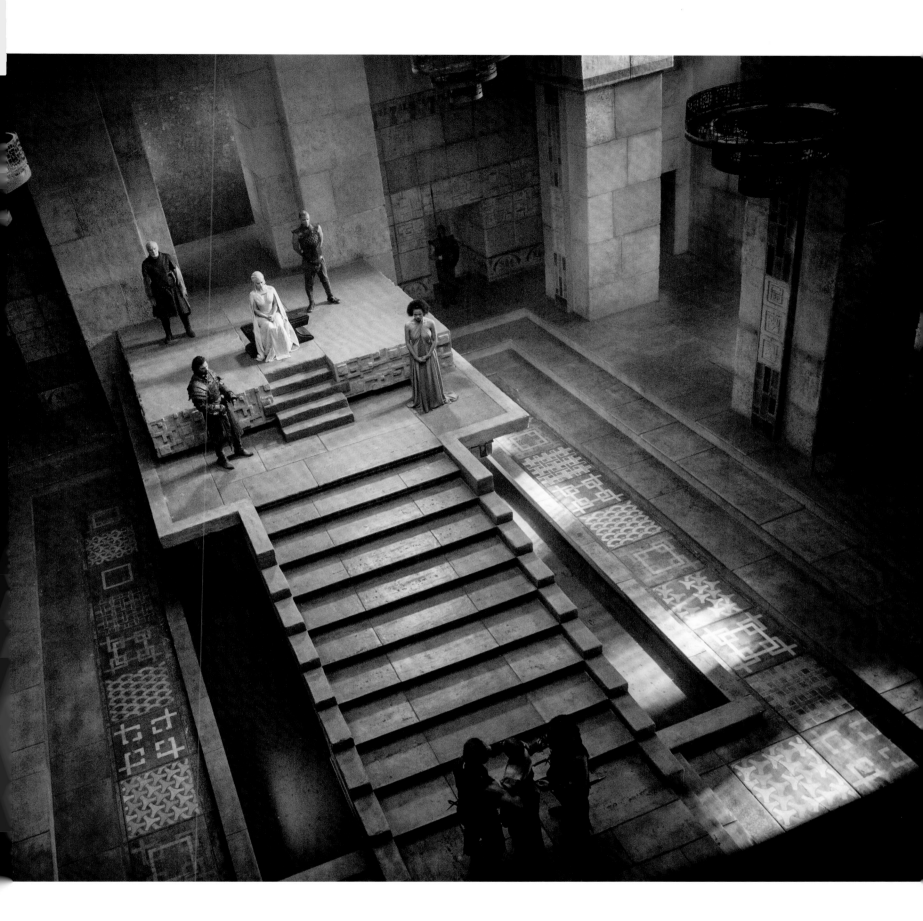

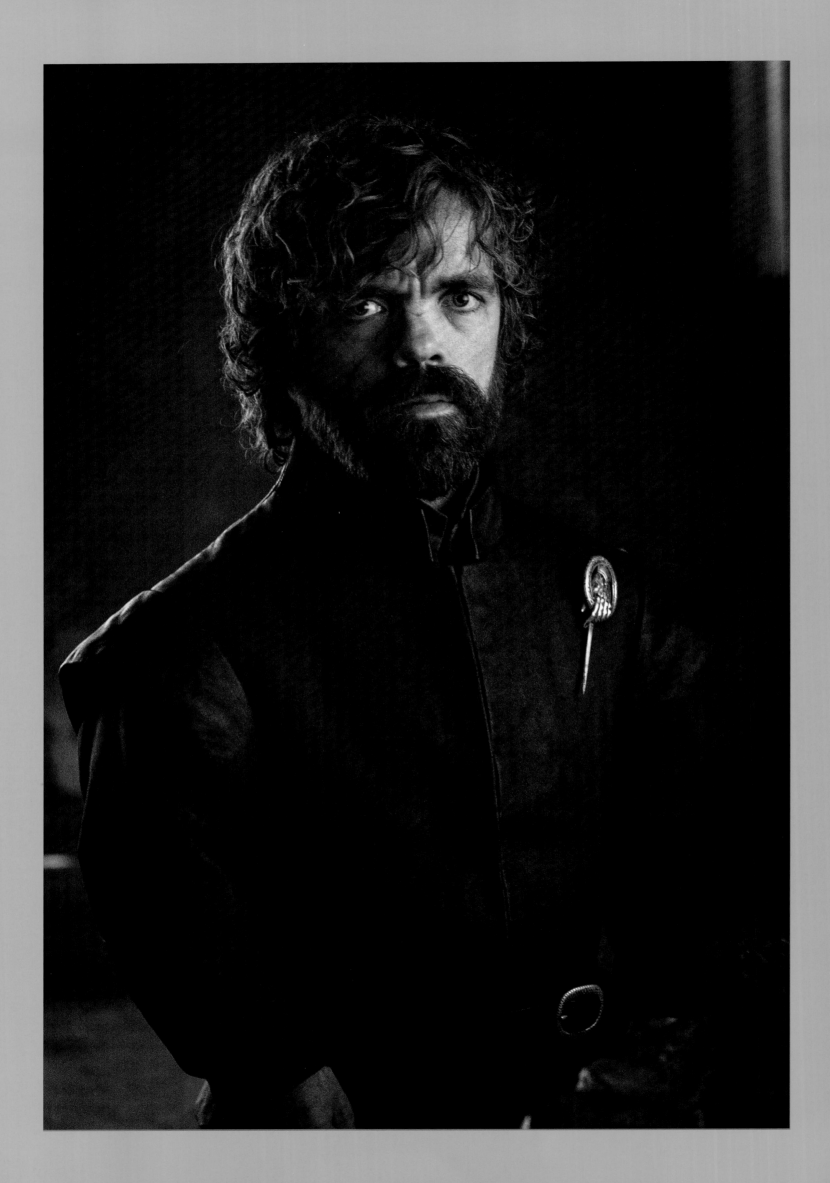

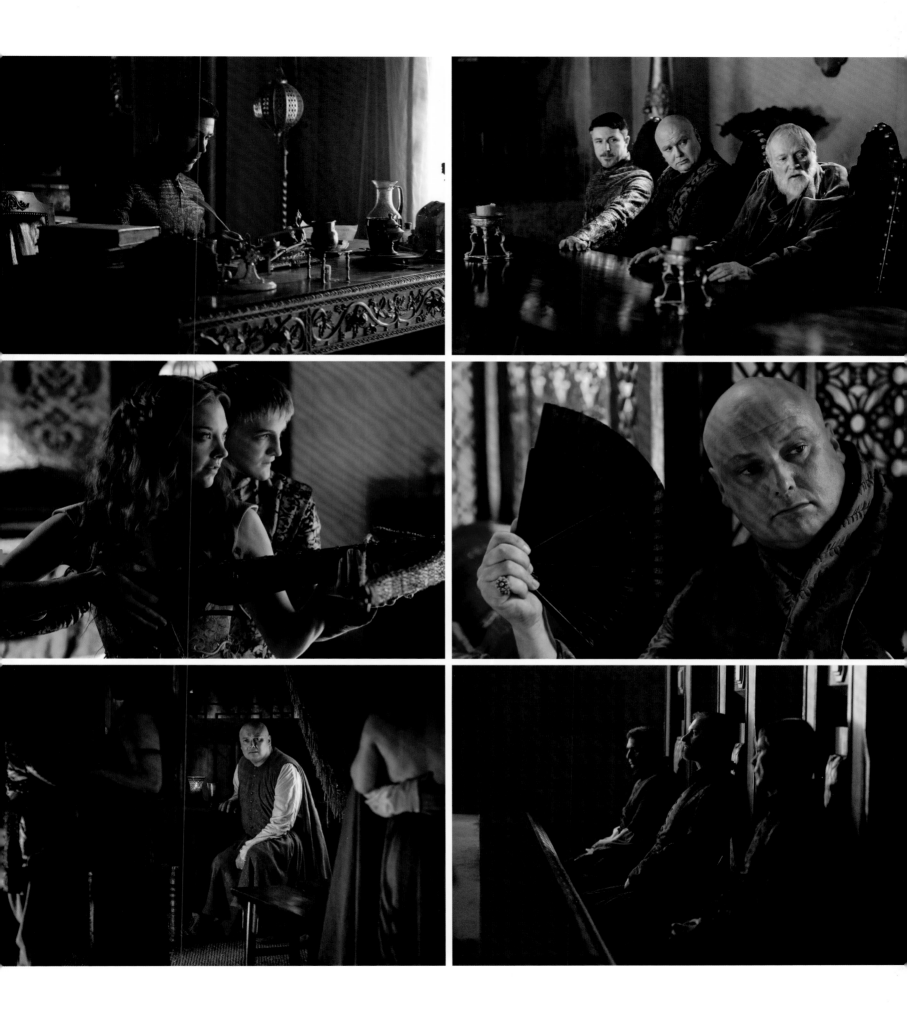

OPPOSITE: Peter Dinklage as Tyrion Lannister. TOP LEFT: Master of Coin, Petyr Baelish.
TOP RIGHT: King Joffrey's small council includes Baelish, Varys, and Grand Maester Pycelle.
CENTER LEFT: Joffrey and Margaery. CENTER RIGHT AND BOTTOM LEFT: Varys, the
Master of Whisperers. BOTTOM RIGHT: The Iron Bank of Braavos hears Stannis's request.

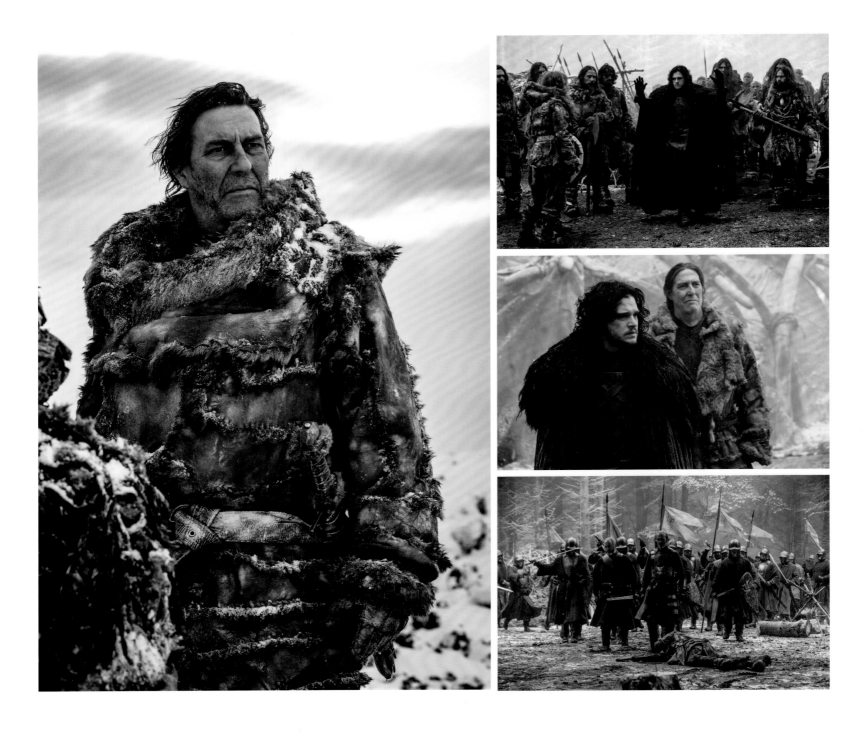

ABOVE: The leader of the Free Folk and King-Beyond-the-Wall, Mance Rayder.

TOP RIGHT AND CENTER RIGHT: Jon Snow meets with Mance Rayder.

BOTTOM RIGHT: Stannis leads his army beyond the Wall.

OPPOSITE: Lord Tywin Lannister, head of House Lannister. "When I'm shooting on set, I'm very conscious and cautious about getting in an actor's eyeline," says Helen Sloan. "But at some point when you're stepping between three cameras, it's going to happen. Before I set up to take a great shot of Charles Dance, I talked to him about it and asked if he needed me to move so as not to distract him. He said to me, 'Darling, darling, darling, I'm an actor. When we are in the theater, it's our job to make hundreds of people disappear. You won't bother me. Just please do your job. That's what we're all here to do.'"

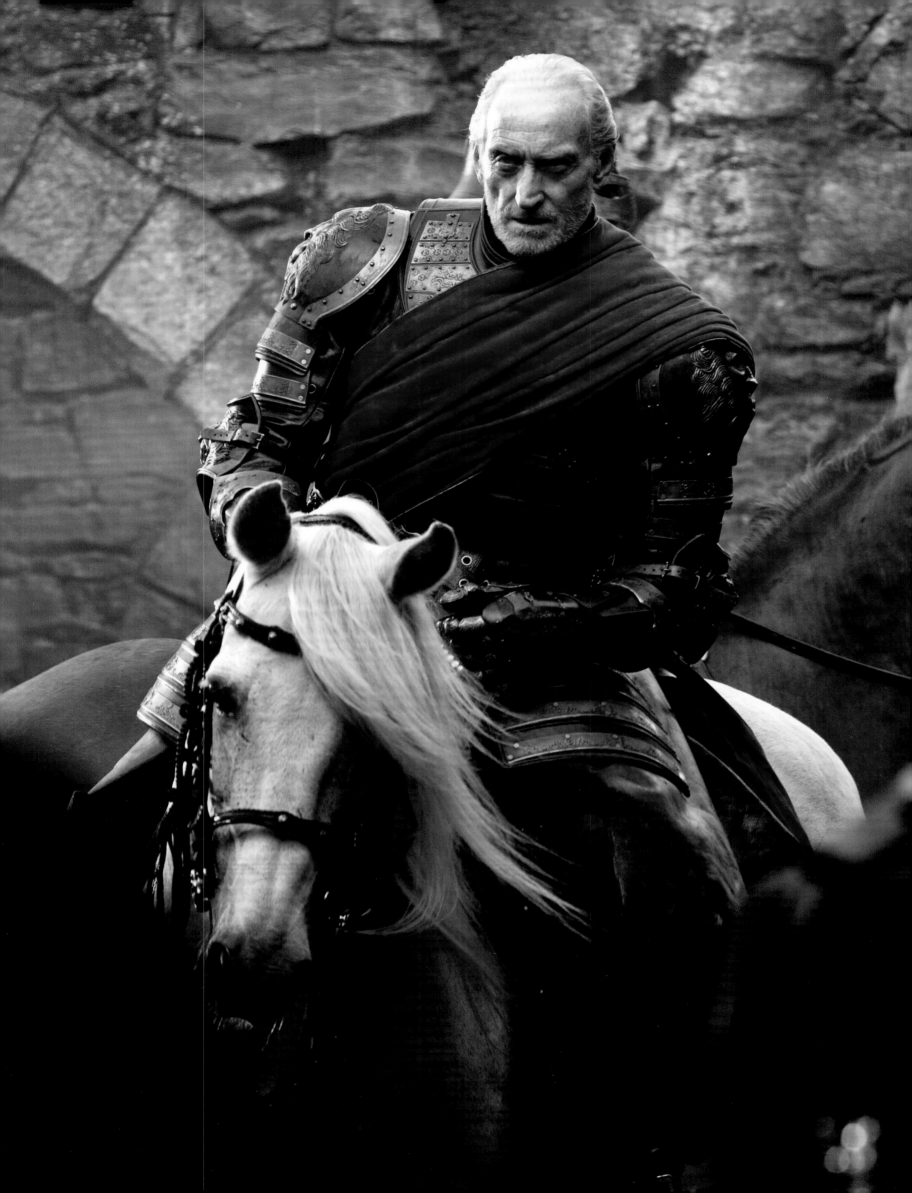

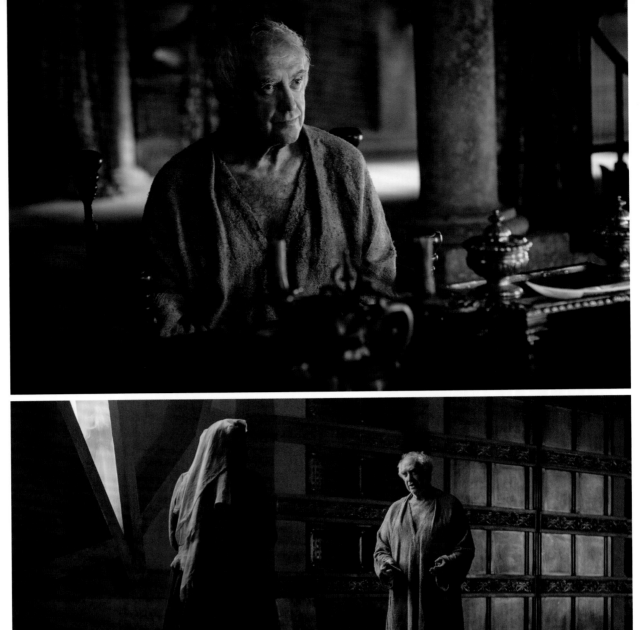

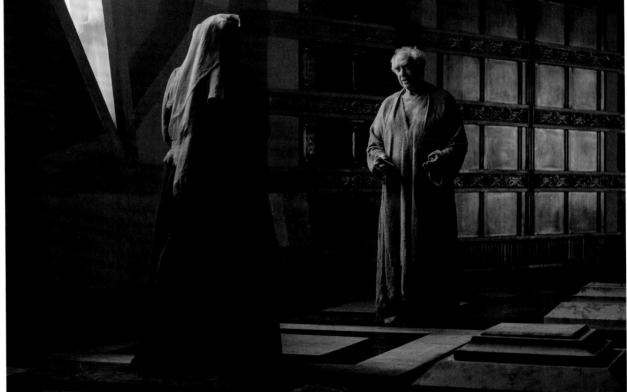

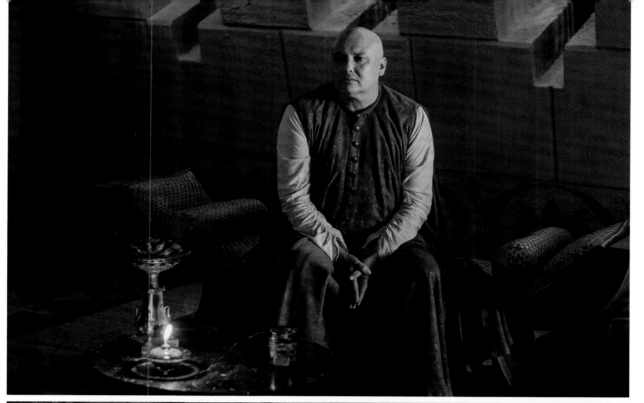

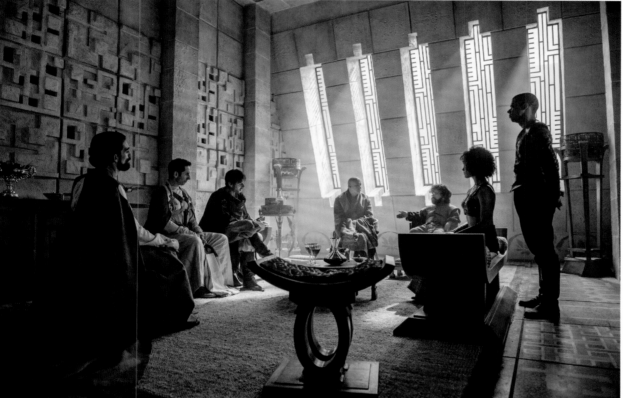

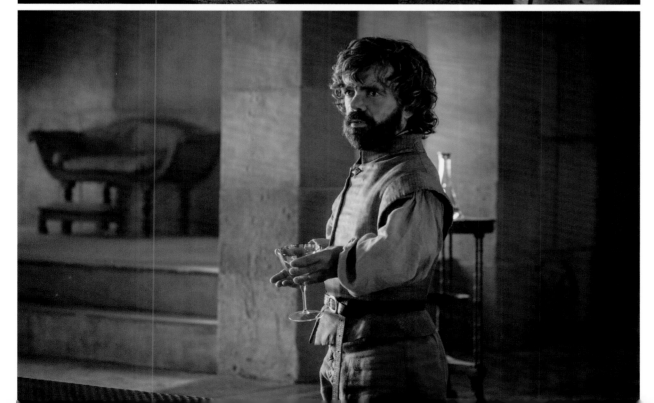

OPPOSITE: The High Sparrow meets with House Tyrell's Lady Olenna.

THIS PAGE: Varys and Tyrion negotiate with the rulers of Slaver's Bay.

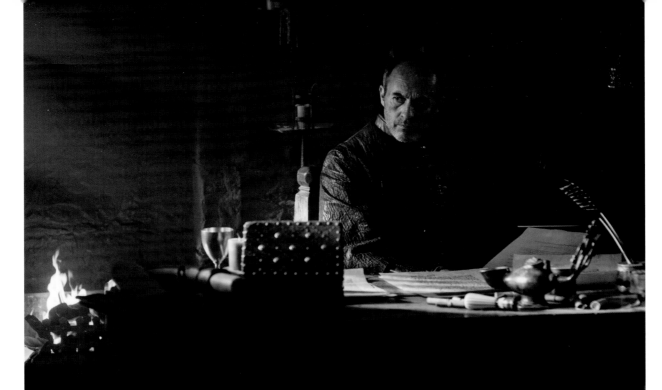

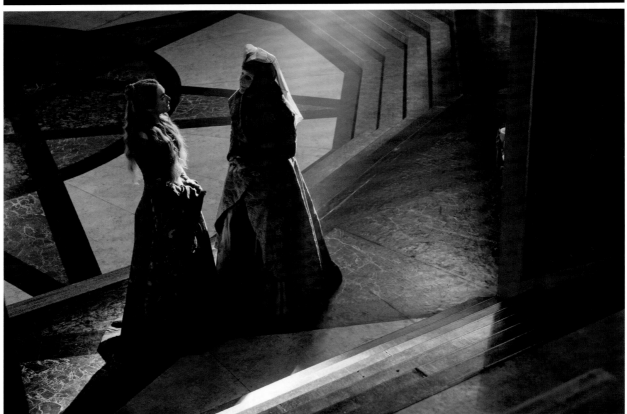

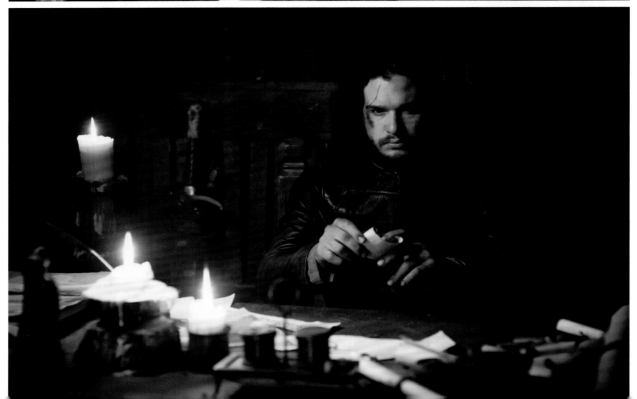

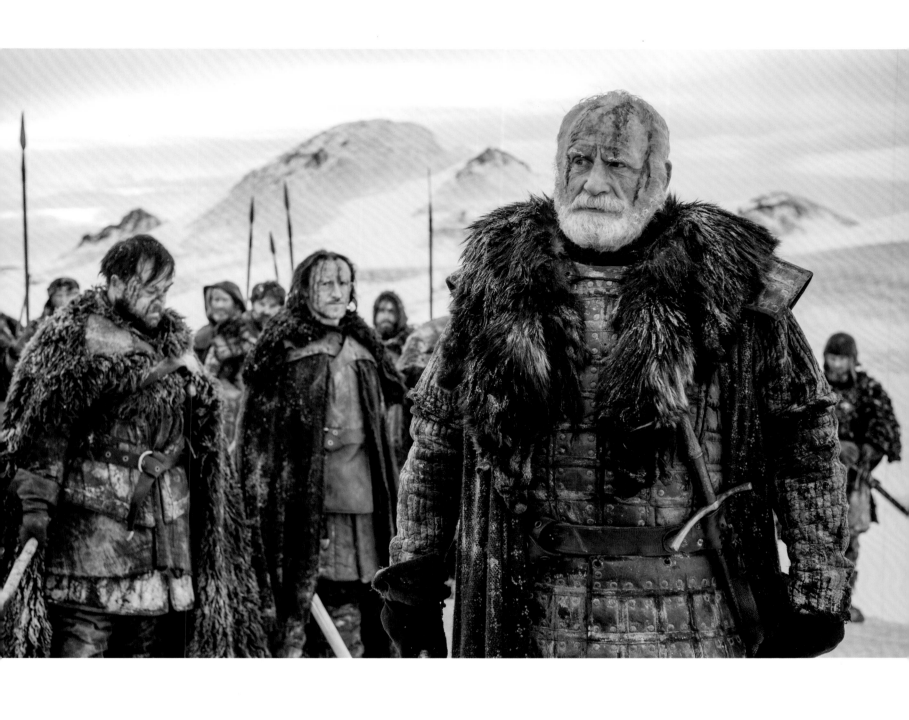

OPPOSITE: Stannis Baratheon (*top*), Cersei Lannister and Olenna Tyrell (*center*), and Jon Snow (*bottom*) plot the path to victory in the Seven Kingdoms.
ABOVE: Lord Commander Jeor Mormont of the Night's Watch.

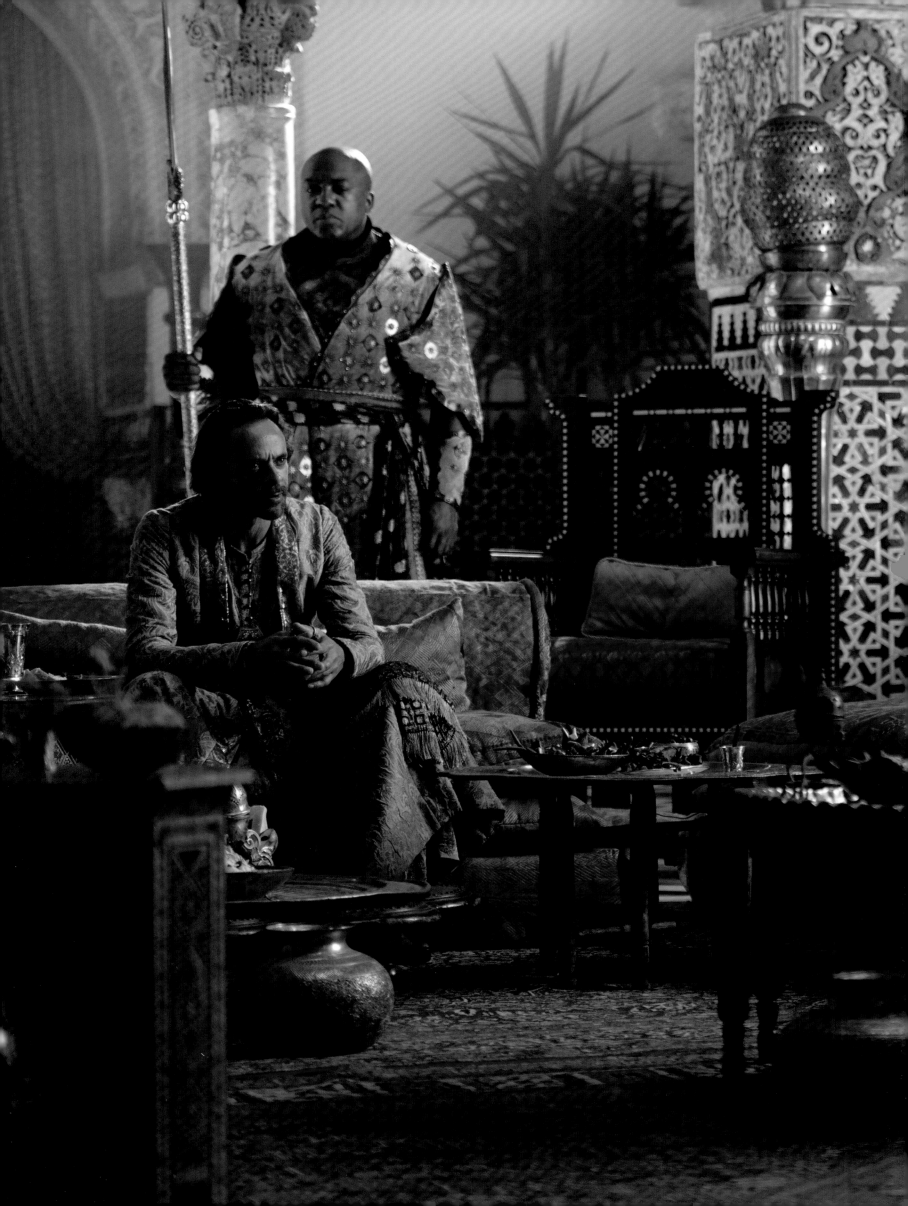

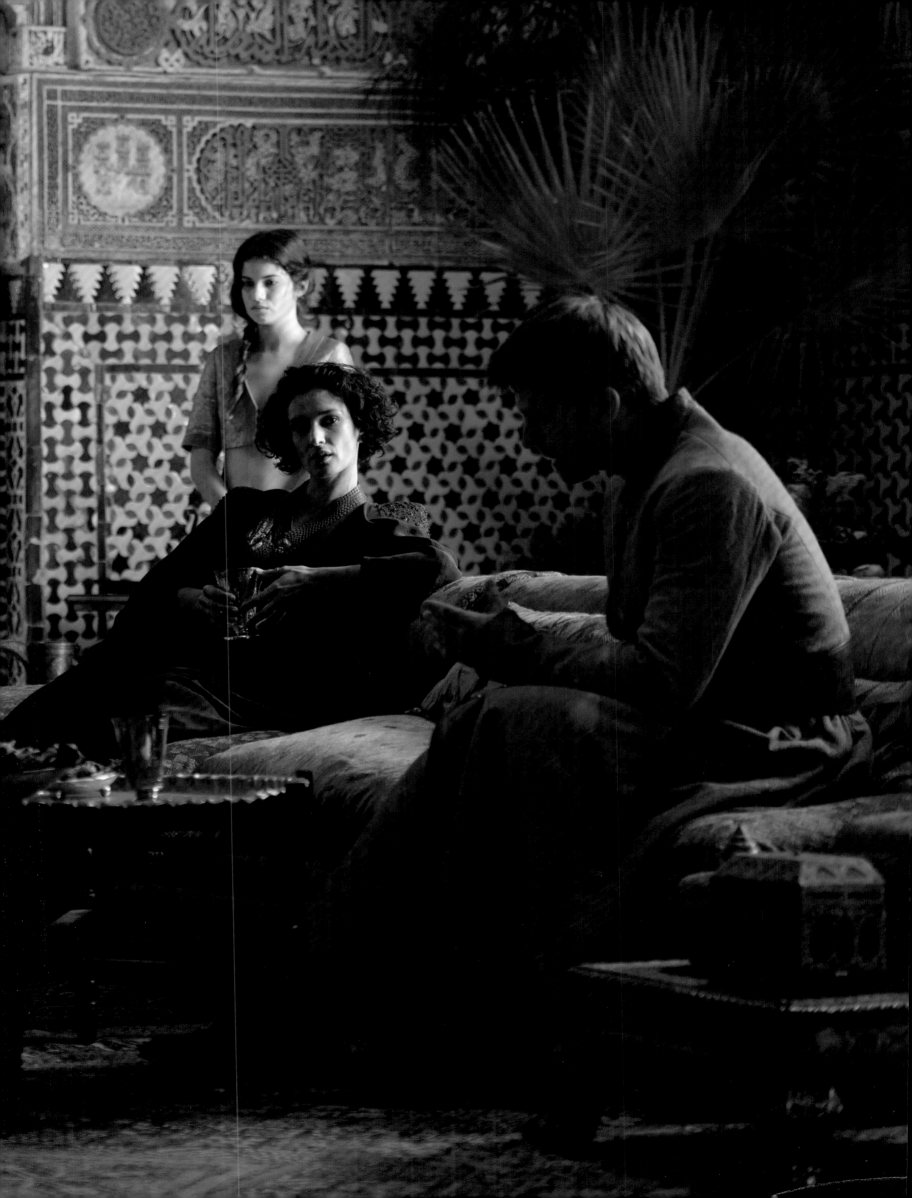

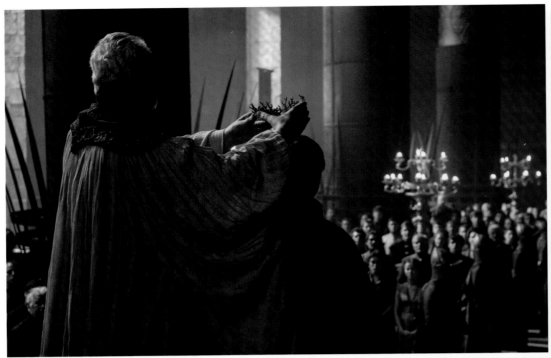

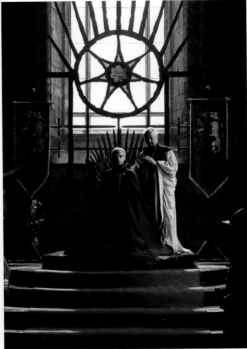

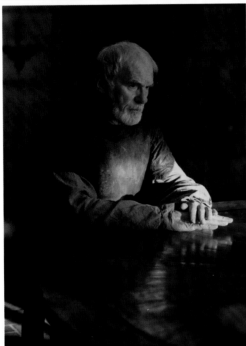

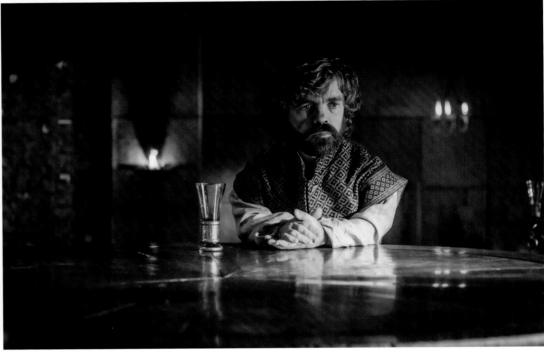

PAGES 38—39: Ser Jaime Lannister meets with the ruling Prince of Dorne, Doran Martell.

TOP LEFT AND RIGHT: The coronation of King Tommen Baratheon.

BOTTOM LEFT: Ser Barristan ponders Daenerys's next move.

BOTTOM RIGHT: Tyrion lost in his thoughts in Meereen.

OPPOSITE: Dame Diana Rigg as Lady Olenna Tyrell.

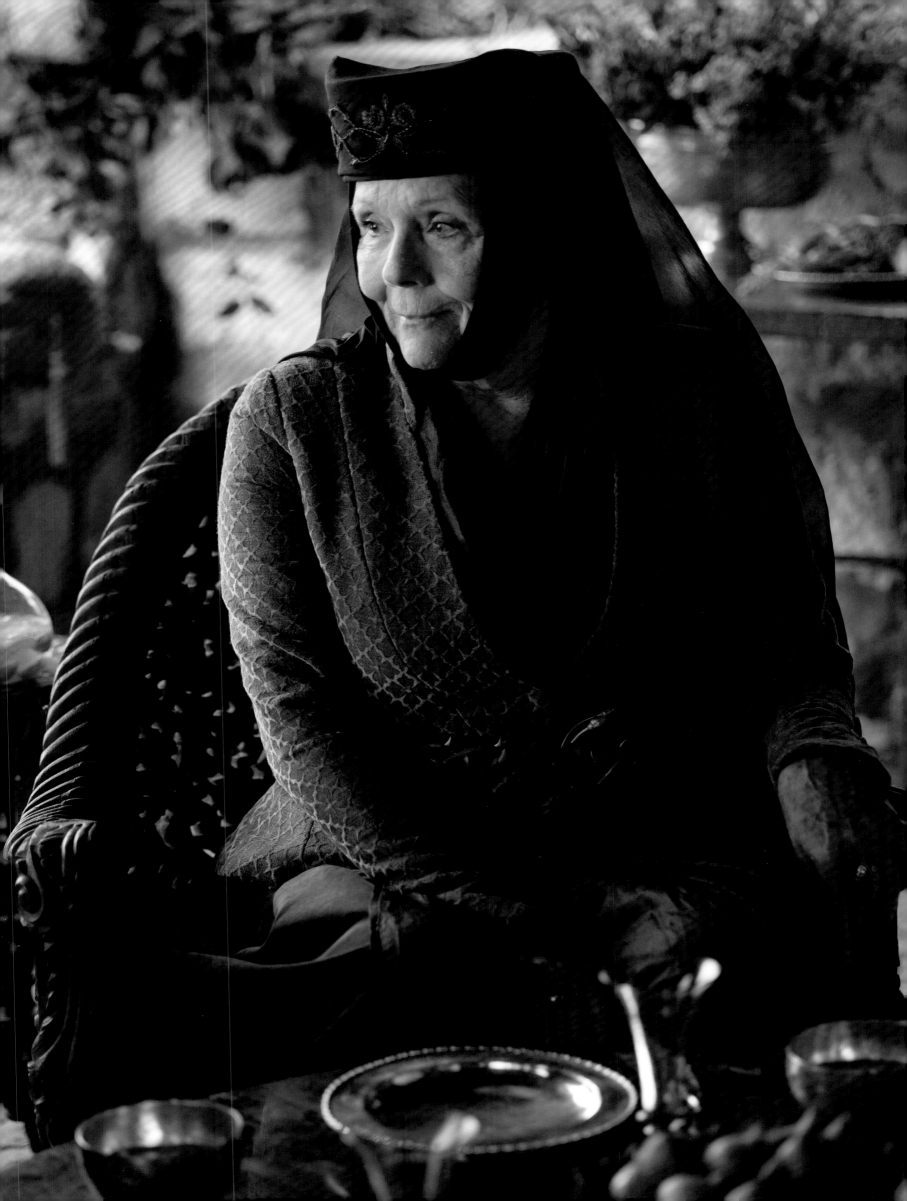

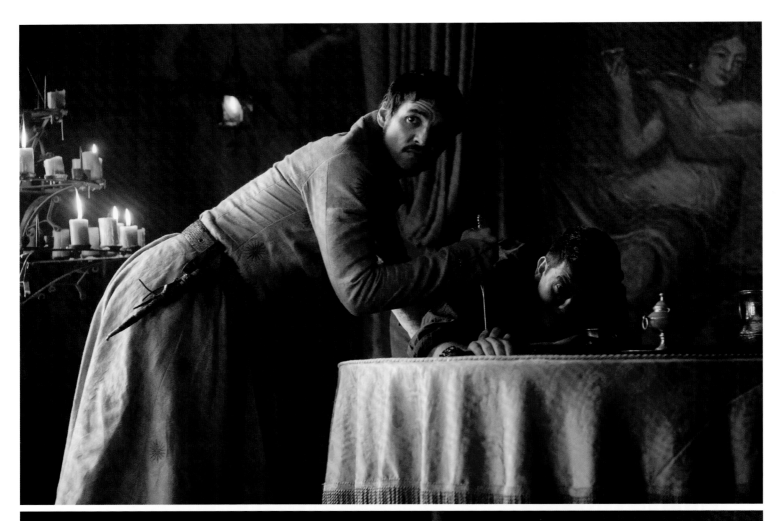

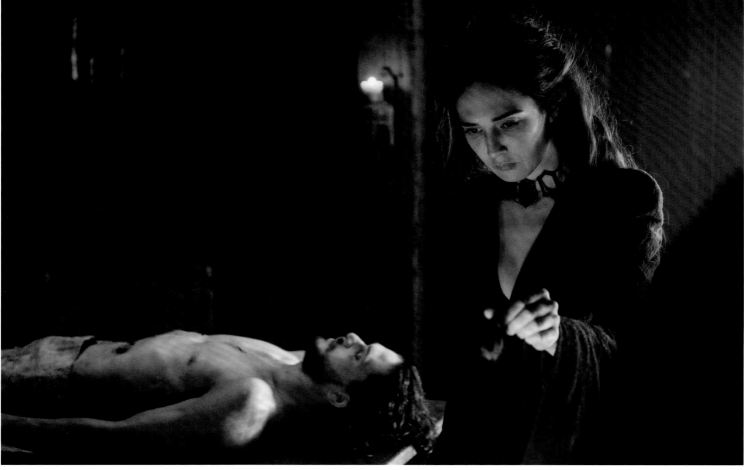

TOP: Prince Oberyn Martell of Dorne.
ABOVE: Melisandre resurrects Jon Snow.
OPPOSITE TOP: Yara Greyjoy sits on the Salt Throne.
OPPOSITE BOTTOM: The Greyjoy siblings, Theon and Yara.

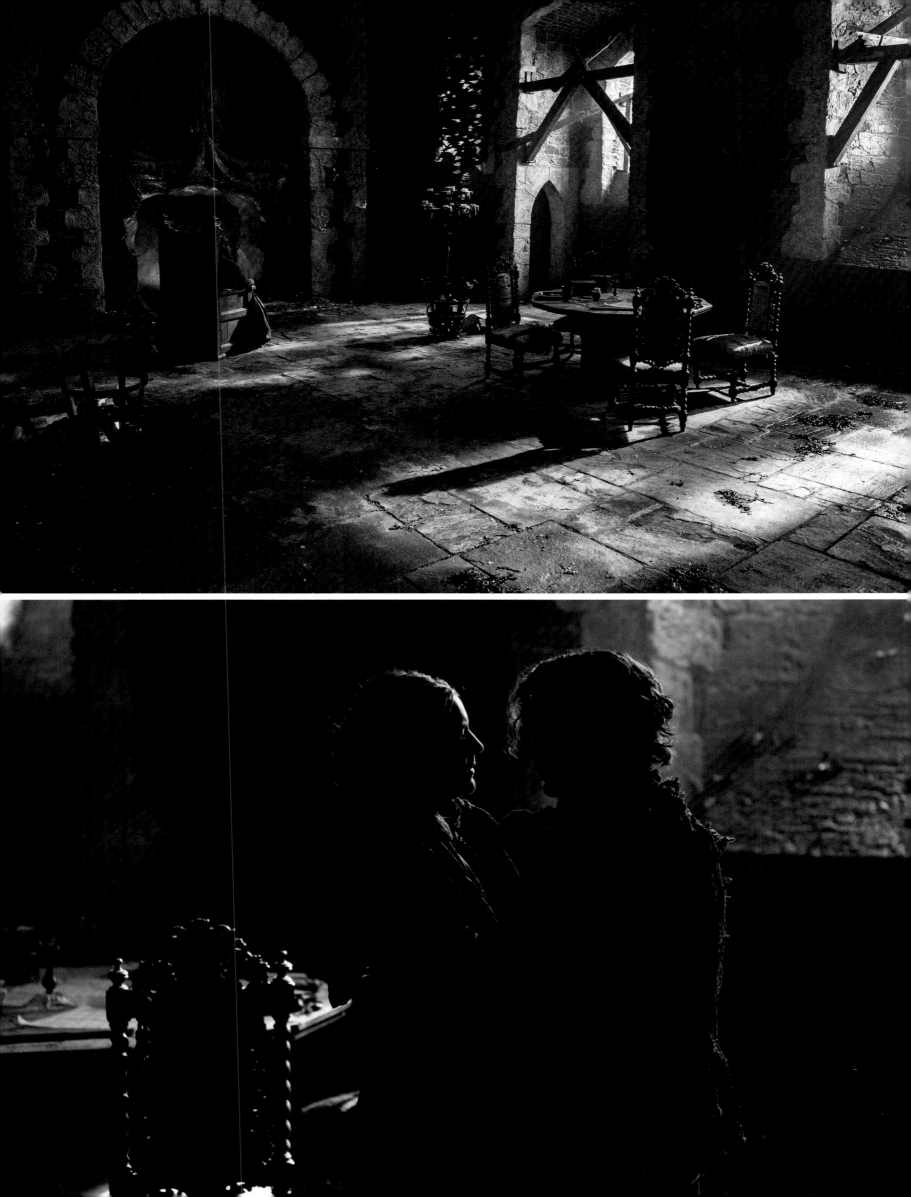

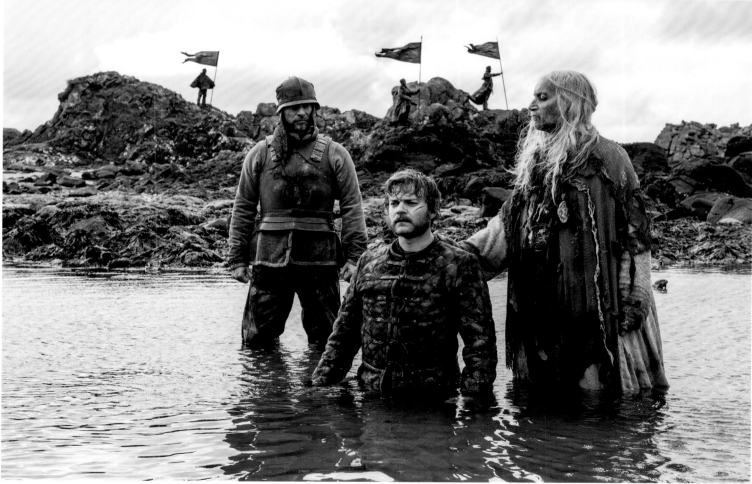

THIS PAGE: Euron is crowned King of the Iron Islands before the Drowned God. All of the Pyke castle scenes were shot in and around a place called Ballintoy Harbor in Northern Ireland, which is near where Sloan grew up. "What's funny is that there is now a photo I took of Alfie Allen in the harbor," Sloan remarks. "My grandad would be so proud to know a photo of mine from the biggest TV show in the world is in the little harbor we all used to visit."

THIS PAGE: Lord Petyr Baelish's
attempts at manipulation
anger Jon Snow.
OPPOSITE: Sophie Turner as
Sansa Stark, Lady of Winterfell.

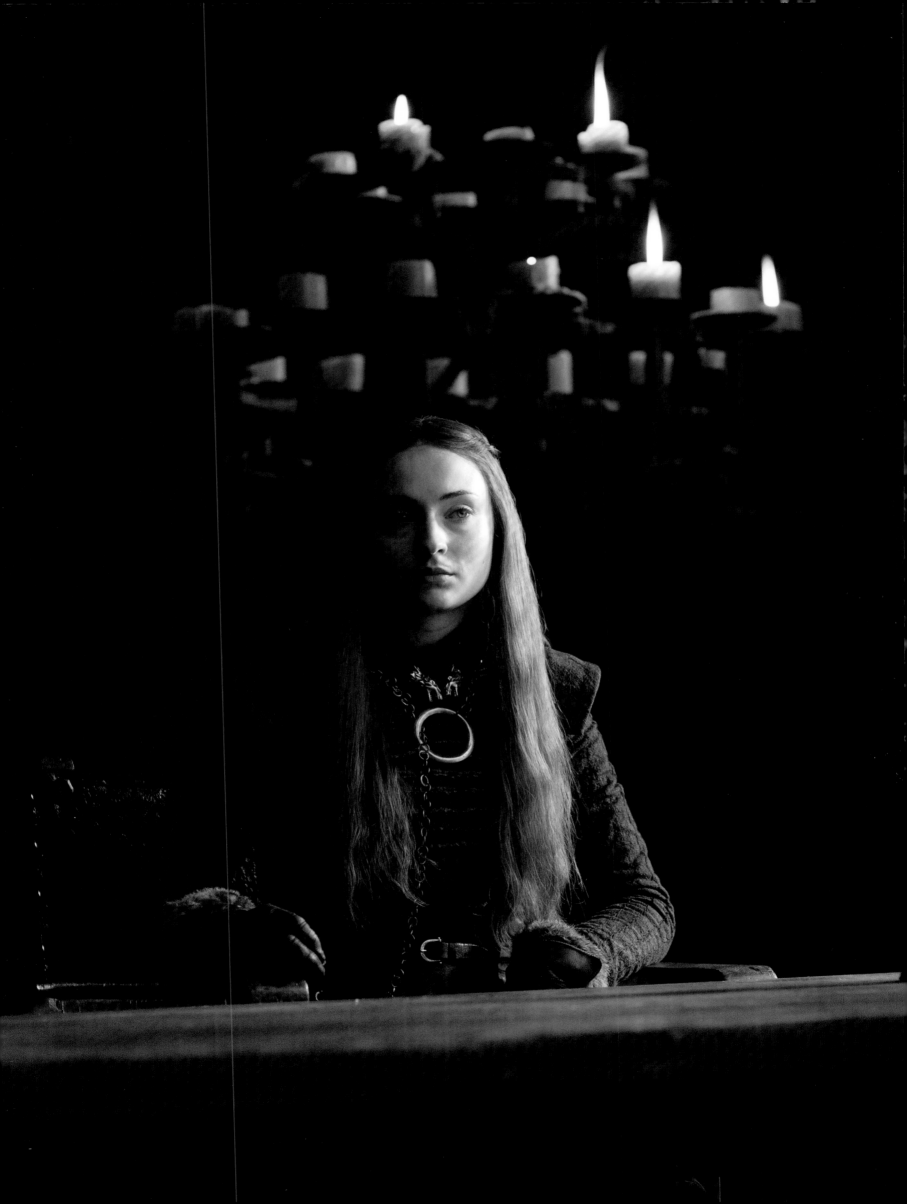

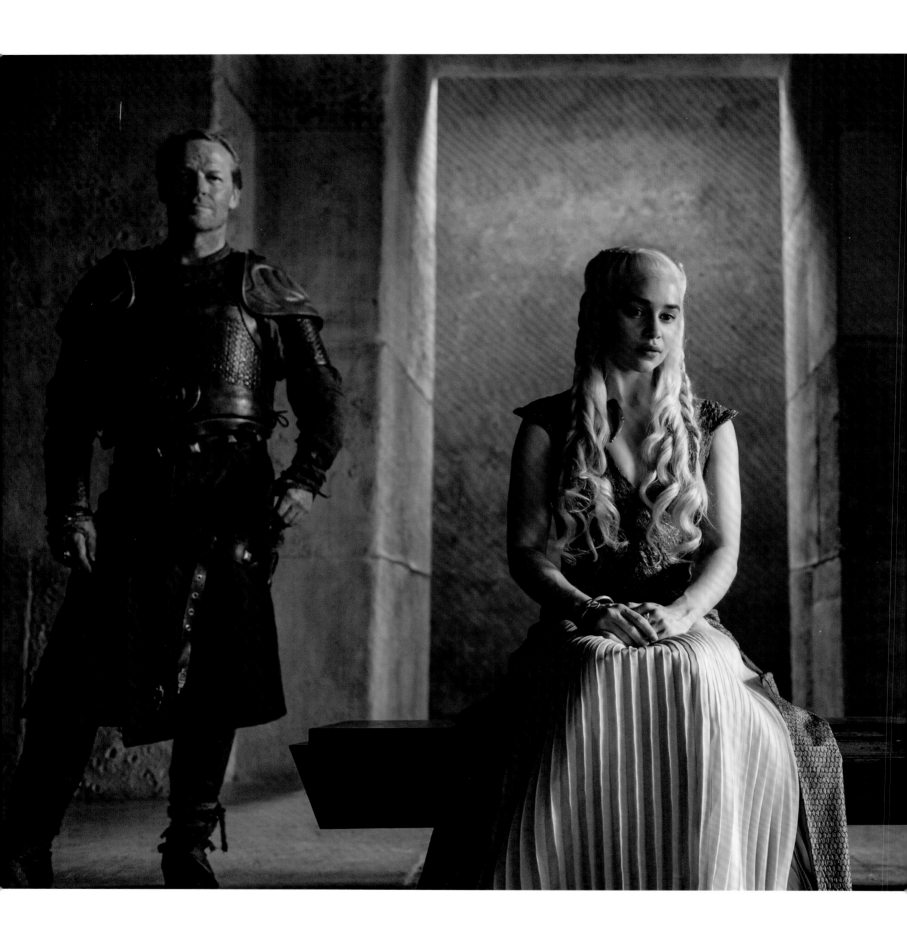

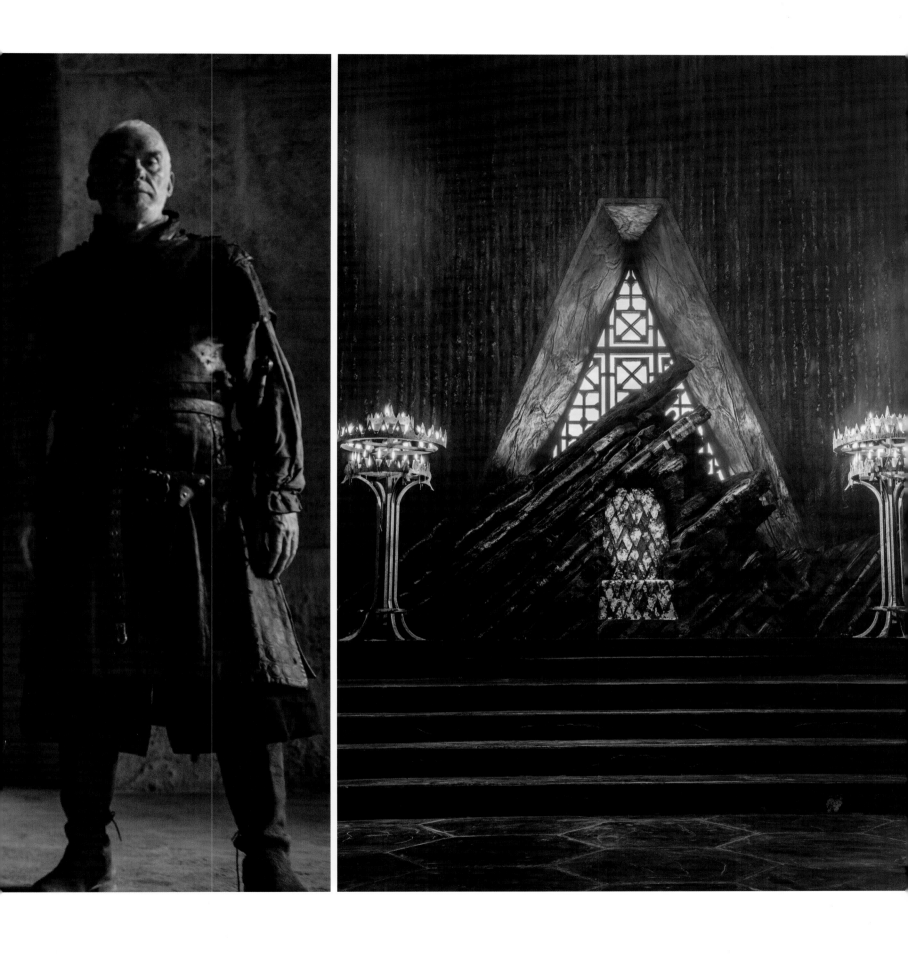

LEFT: Ser Jorah Mormont and Ser Barristan Selmy stand guard beside their queen, Daenerys Targaryen.
ABOVE: The audience chamber at Dragonstone, the ancestral home of the Targaryens.

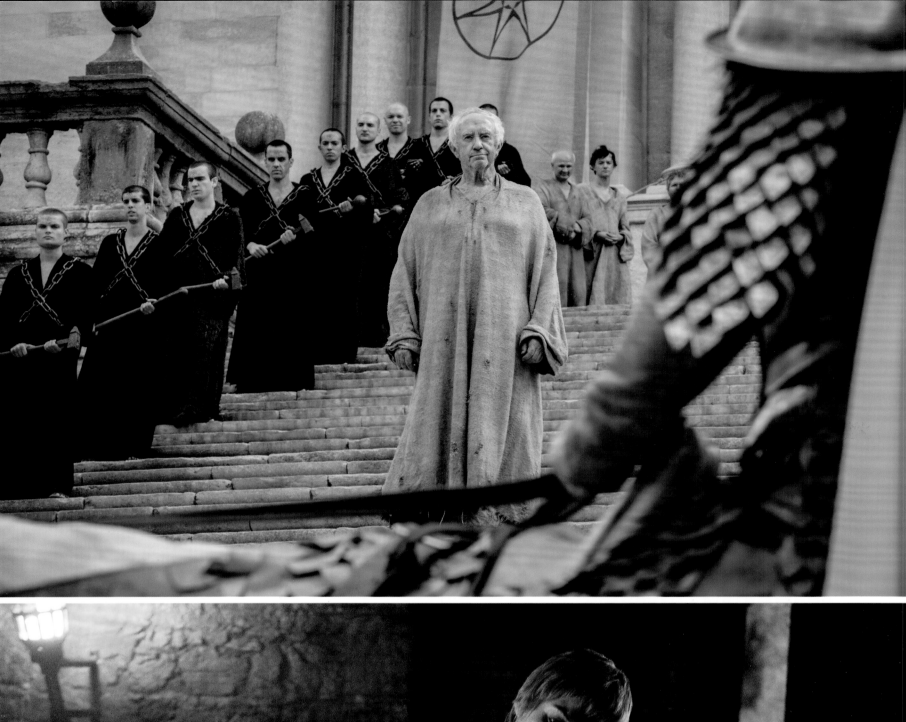

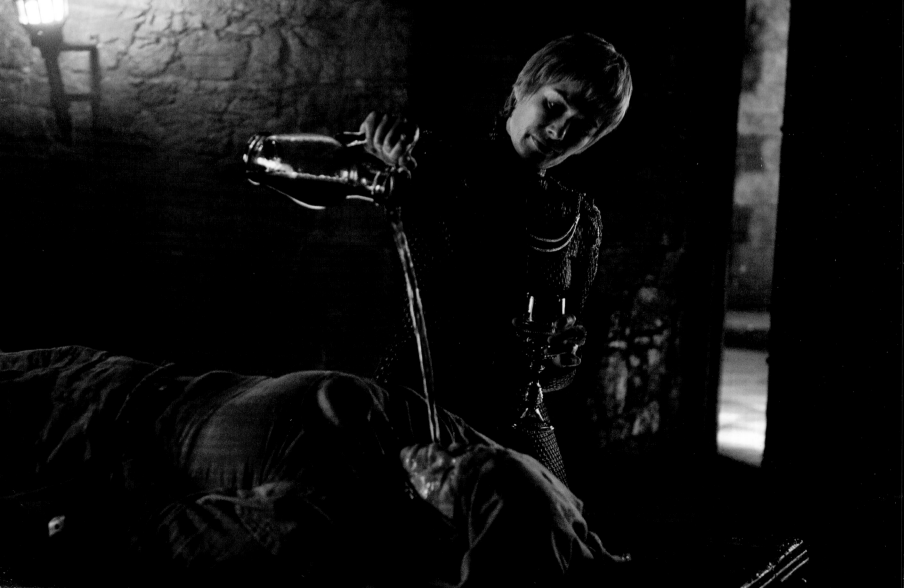

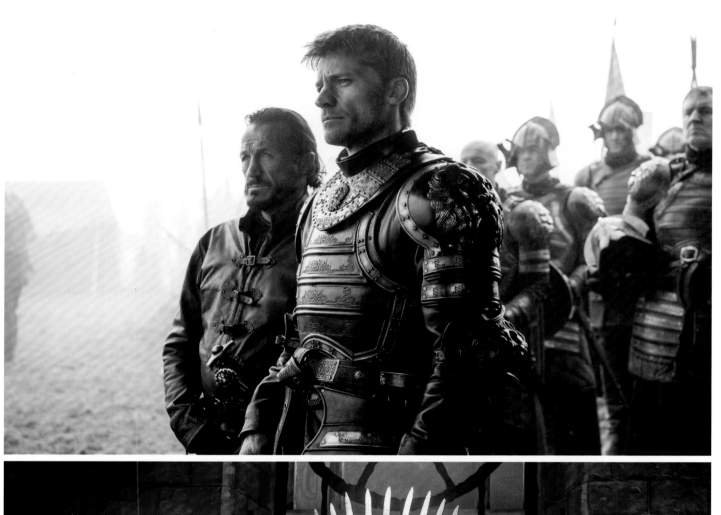

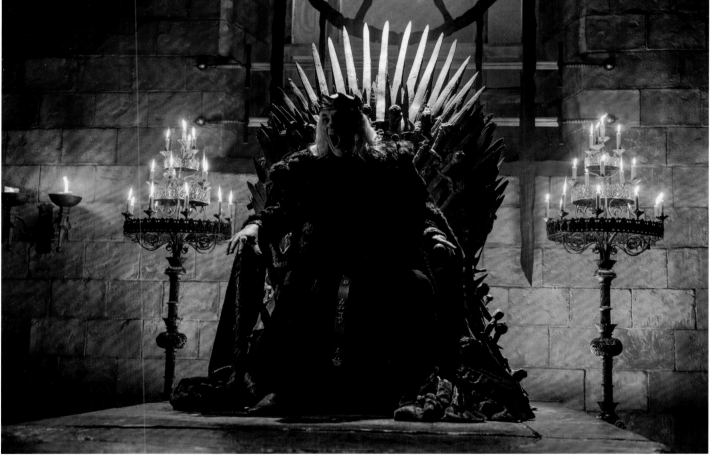

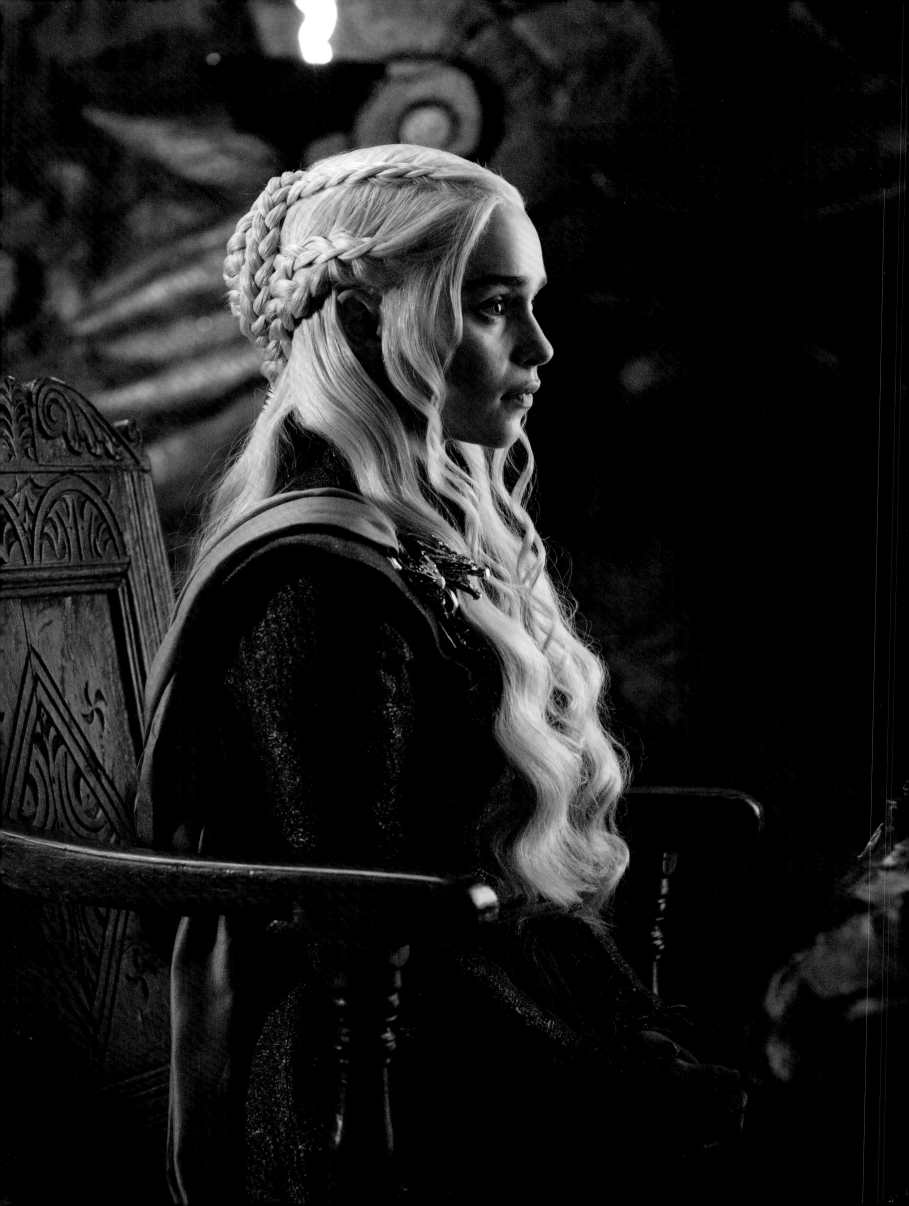

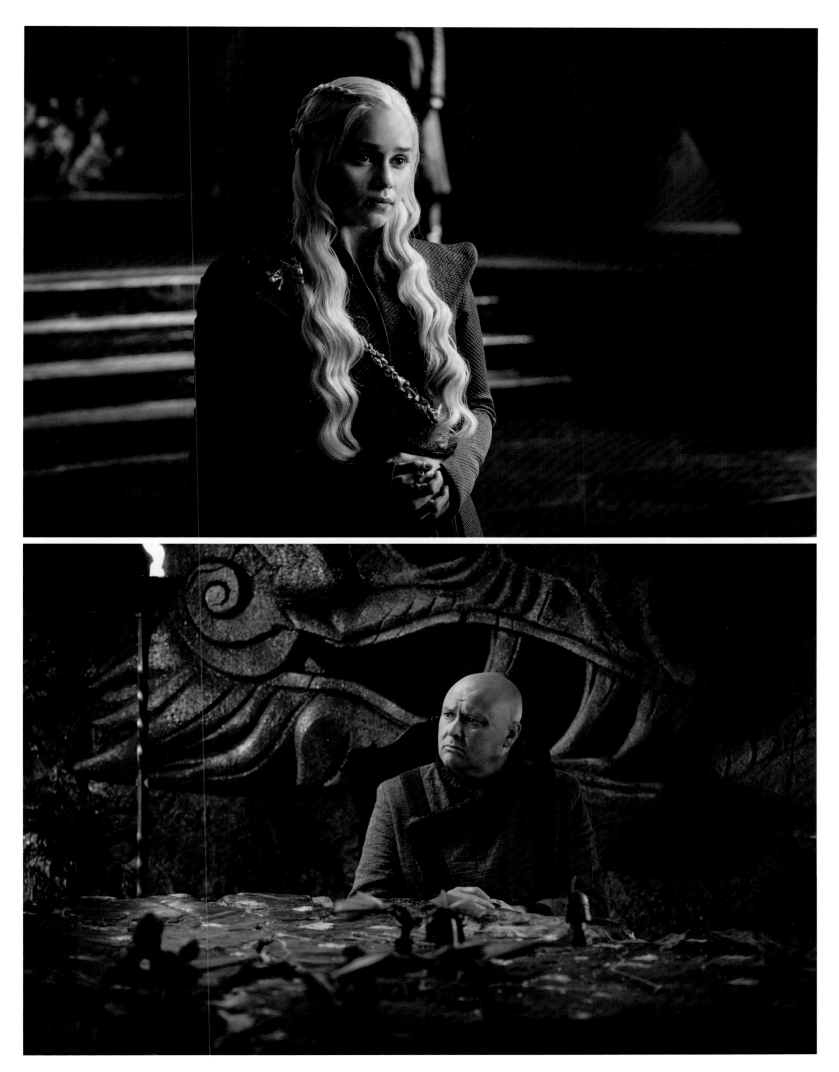

THESE PAGES: Daenerys and her advisor Varys at Dragonstone.

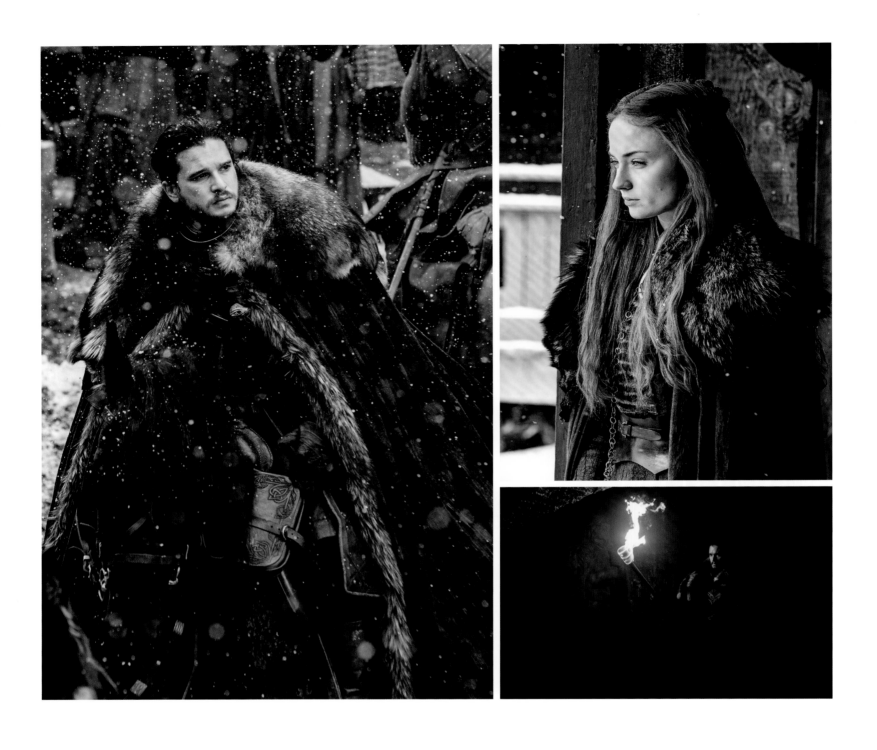

THESE PAGES: House Stark at Winterfell: (*above and bottom right*) Jon Snow, (*top right*) Sansa Stark, (*opposite*) Bran Stark, the Three-Eyed Raven.

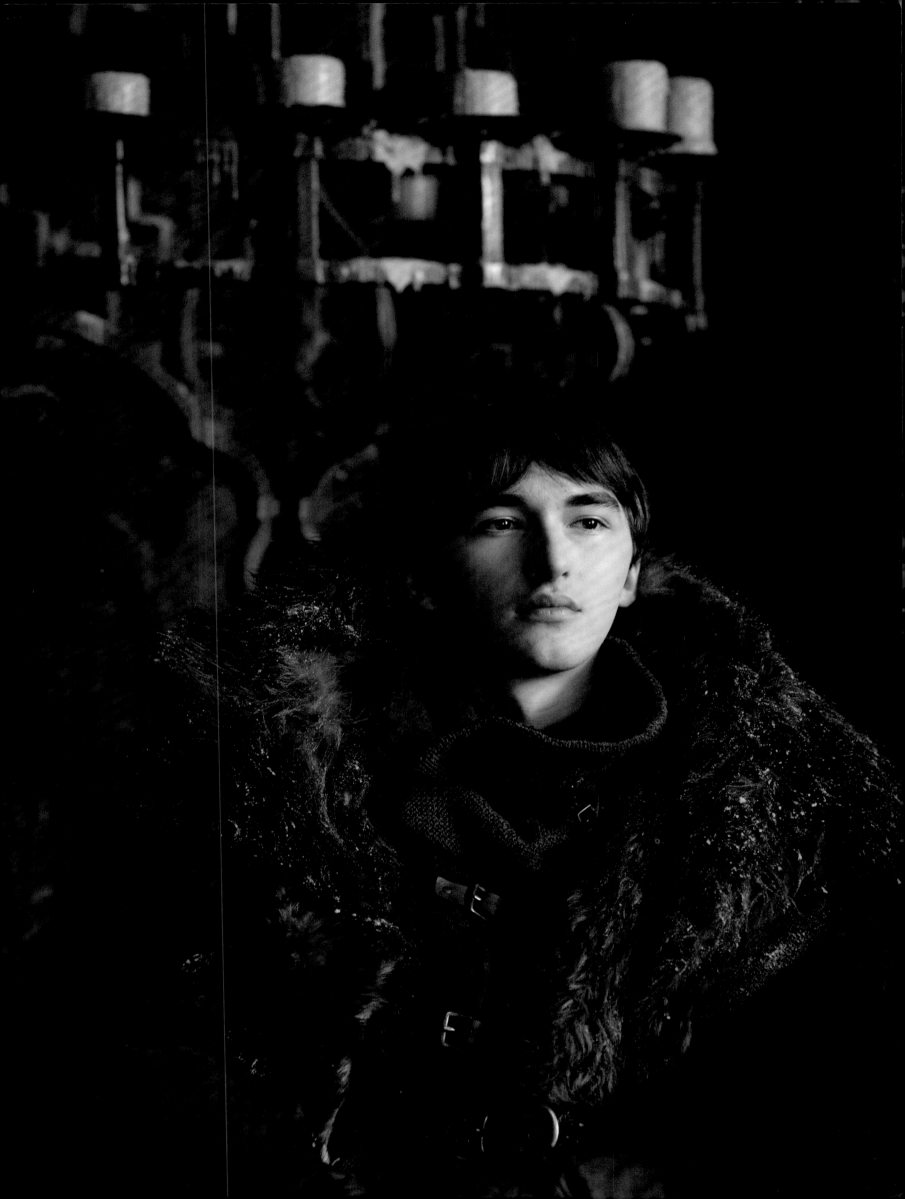

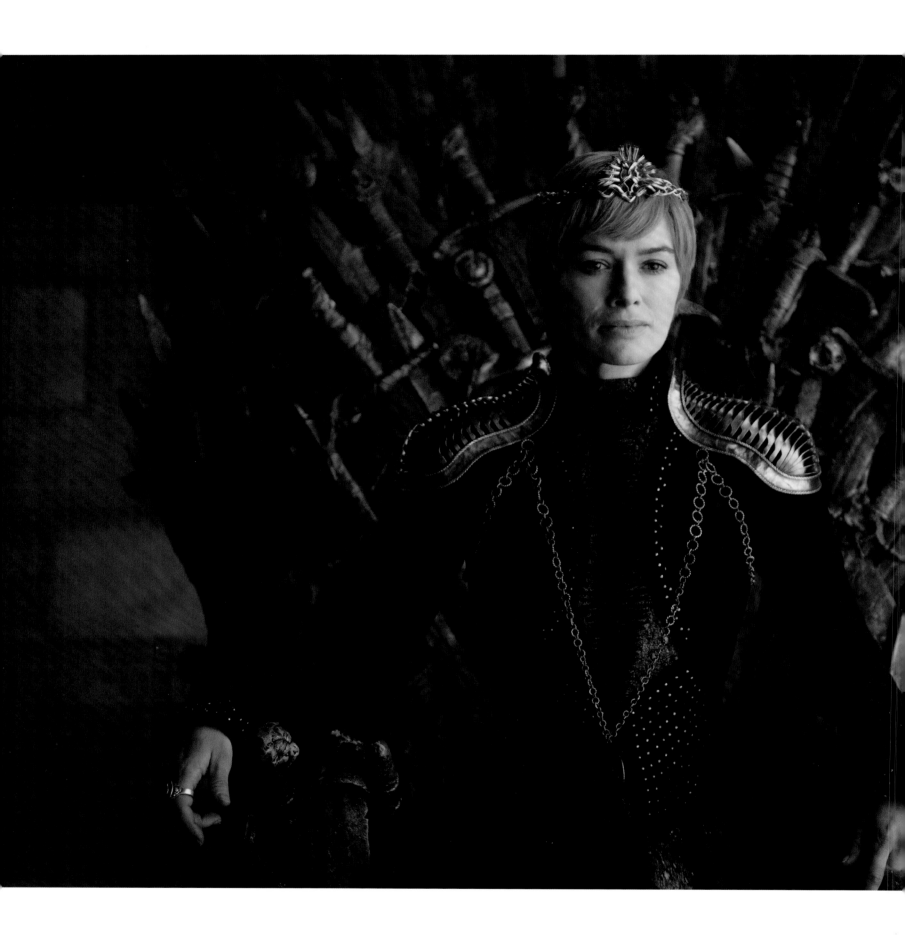

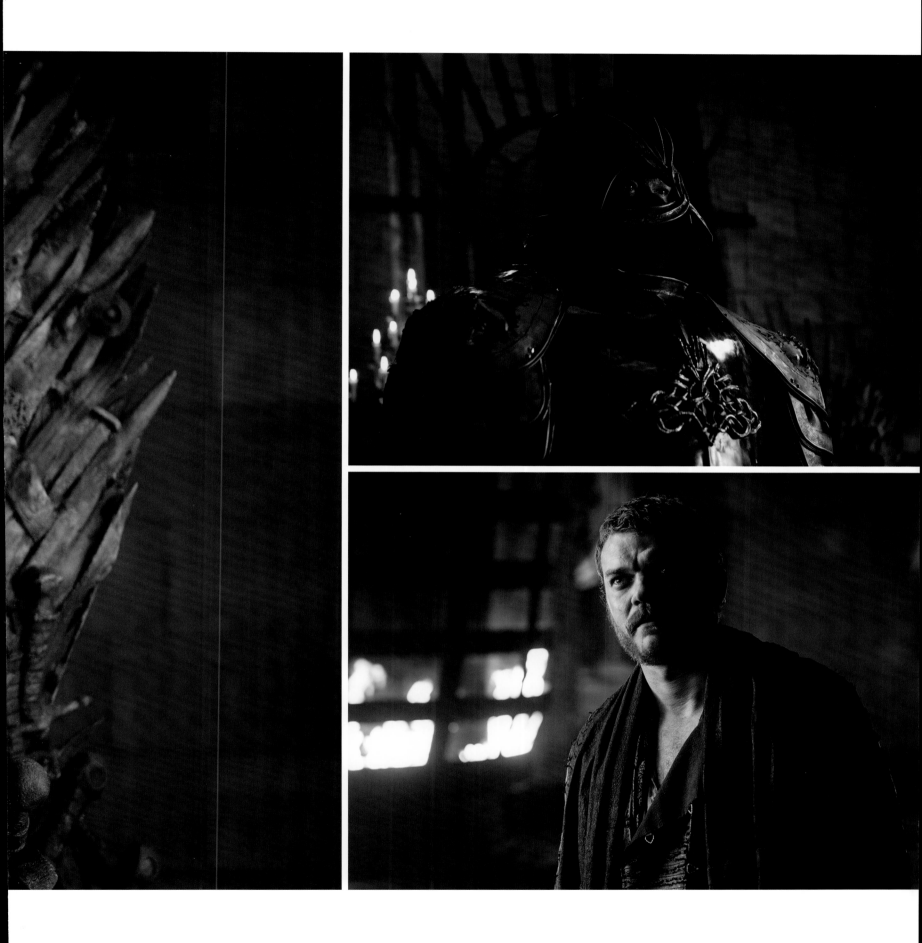

THESE PAGES: Euron Greyjoy makes a proposal to Queen Cersei while the Mountain keeps watch.

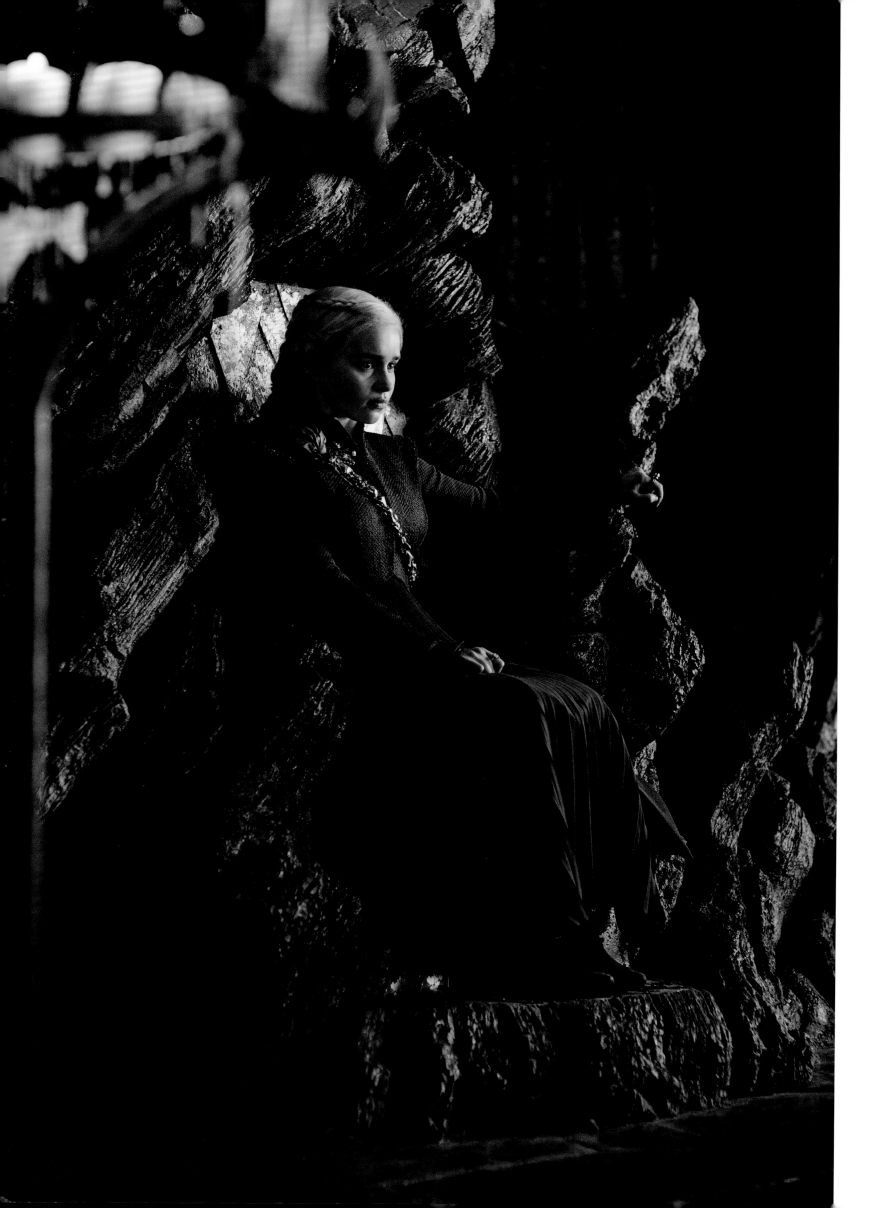

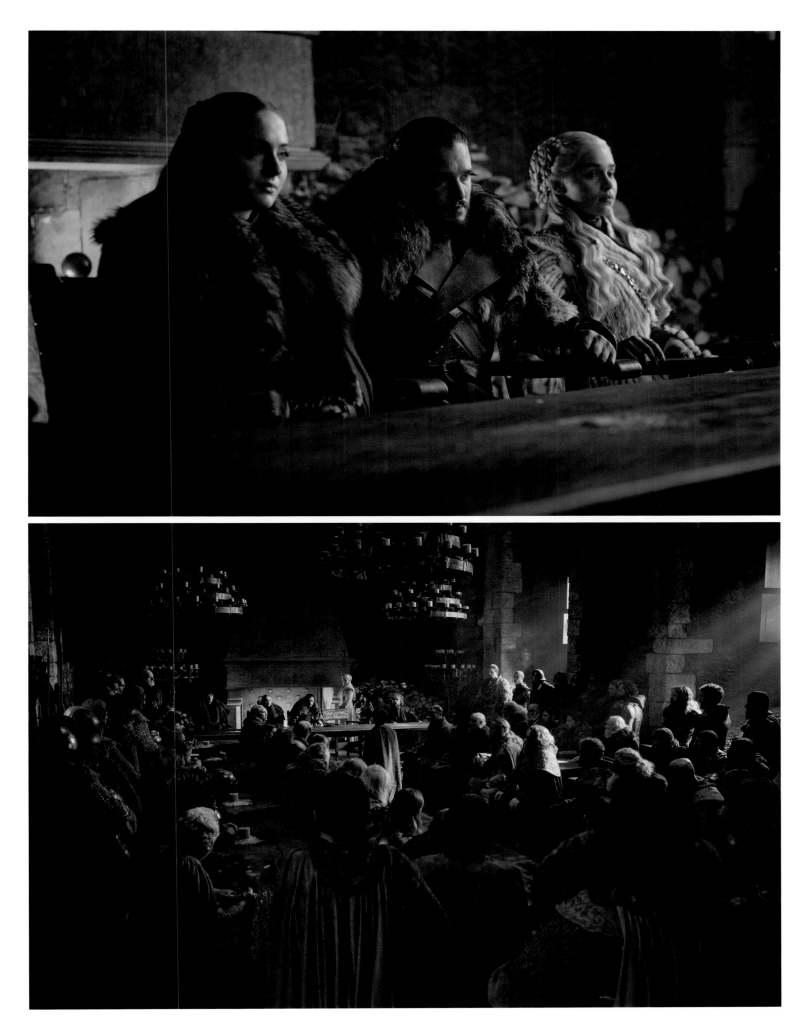

OPPOSITE: Daenerys in the audience chamber at Dragonstone.
ABOVE: Ned Umber addresses Sansa Stark, Jon Snow, and Daenerys Targaryen at Winterfell.
PAGES 60–61: Daenerys of the House Targaryen, the First of Her Name. Helen Sloan notes that the set was eerily quiet when this scene of Daenerys in front of the Iron Throne was filmed. The cast and crew were very reflective, because it wasn't just the end for the character but the end of the whole series.

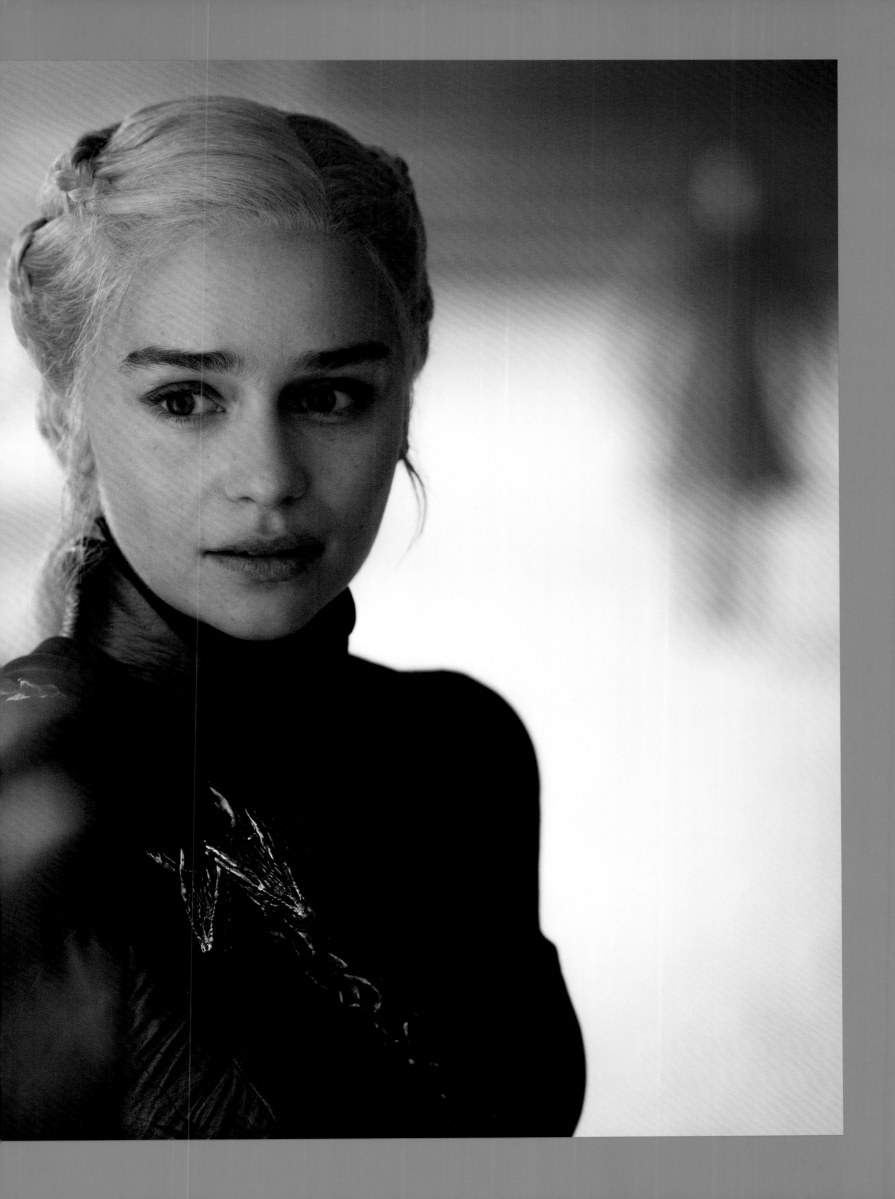

THE SMITH:
BEHIND THE SCENES

The Smith represents the creator and presides over craftspeople and farmers.

Game of Thrones is a global phenomenon with a communal journey shared by its characters, creators, and viewers. The show is a culmination of the extraordinary work of each member of the cast and crew—and with the other members of the photography team, Helen Sloan was there to document the action, not just in front of the camera but also behind the scenes in workshops and armories, of fabricators and other craftspeople.

Sloan says, "While I might not have experienced the themes of murder and revenge, I can certainly relate to the themes of power, love, and relationships, because they are part of life on a film set. You have these intense personal relationships with people with whom you spend [so much] time.

"This job has changed me—as well as many or all of us on the production, I'm sure. We've encountered the biggest challenges of our careers and overcome them. The job has given me an enormous amount of confidence, the belief that any challenge can be met head-on. To think that when I was growing up, this career seemed like a fantasy. To be honest, some days I still have to pinch myself. Now that the show's over and I'm looking back at the experience, it's absolutely mind-blowing that something on the scale of Game of Thrones ever happened here in Northern Ireland. But it did—and why not—it's an amazing, special place—and this job changed our lives."

Here in these pages, Helen shares a special look at the inner workings of Game of Thrones, which she was privy to across eight action-packed seasons.

OPPOSITE TOP: The Eyrie, seat of House Arryn. Sloan particularly loved the Eyrie's design, which had incredible colors and details like the mosaic. The wooden throne was another highlight.
OPPOSITE BOTTOM: The Twins, seat of House Frey.

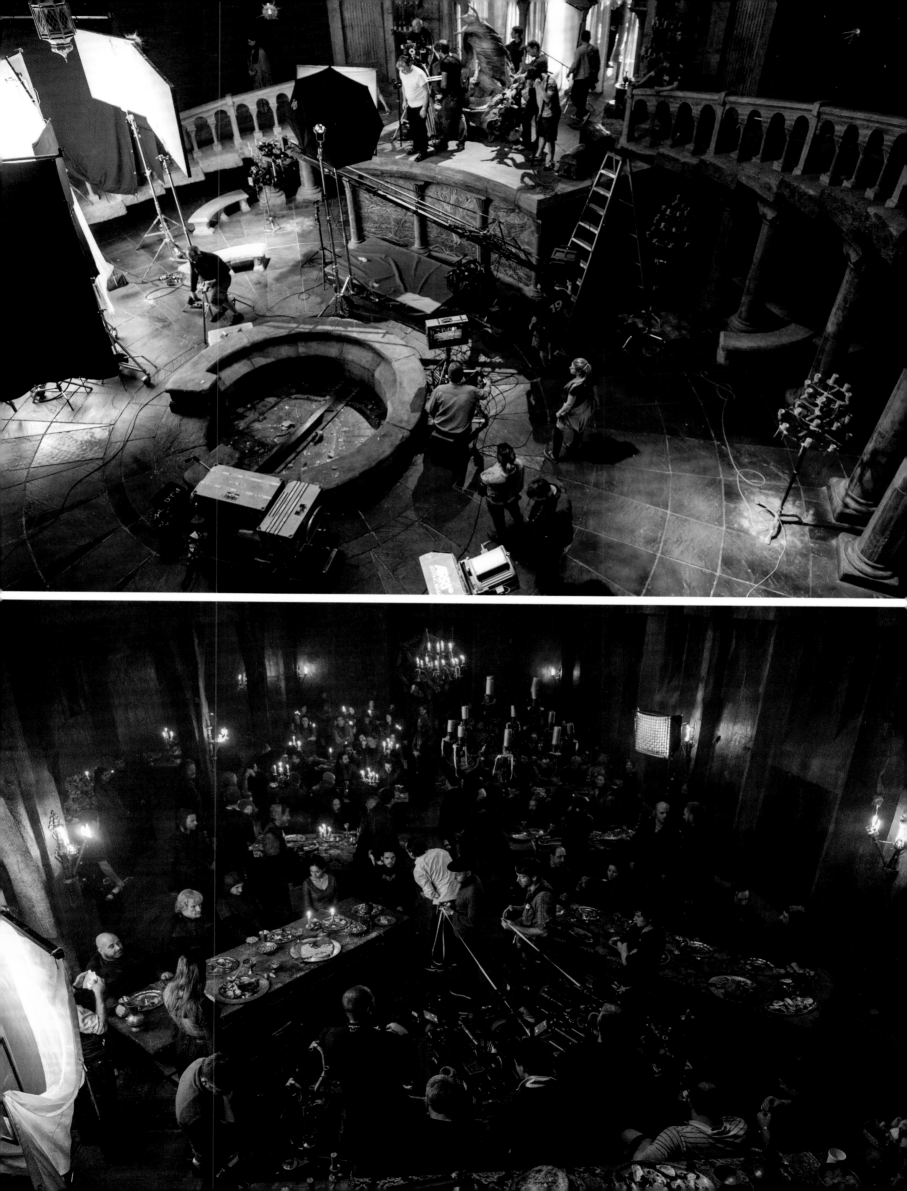

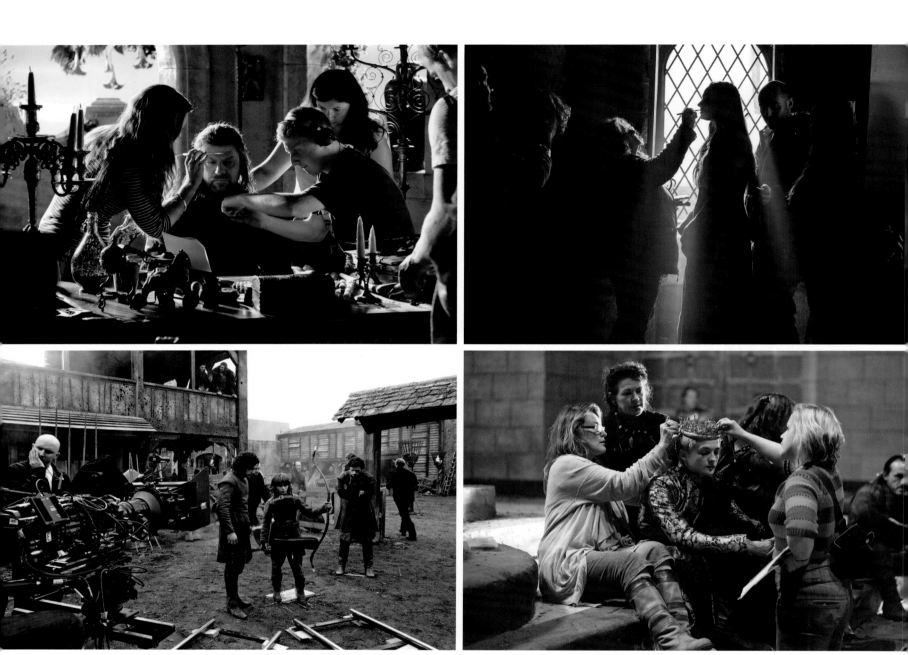

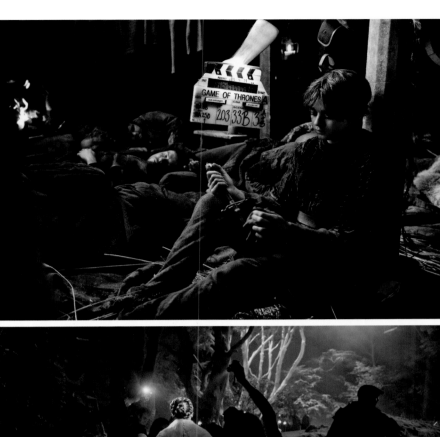

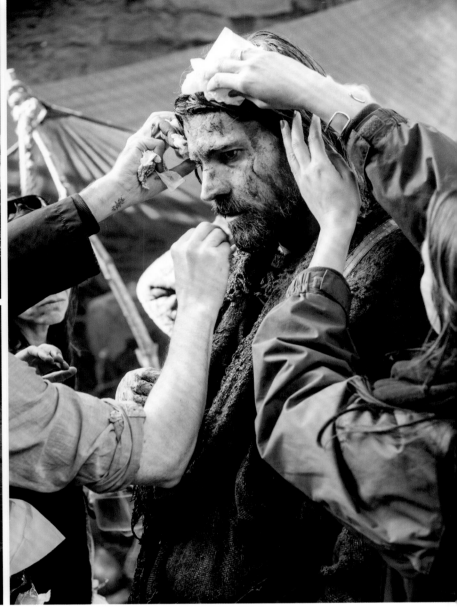

THESE PAGES: Various actors receiving "checks" between filming.

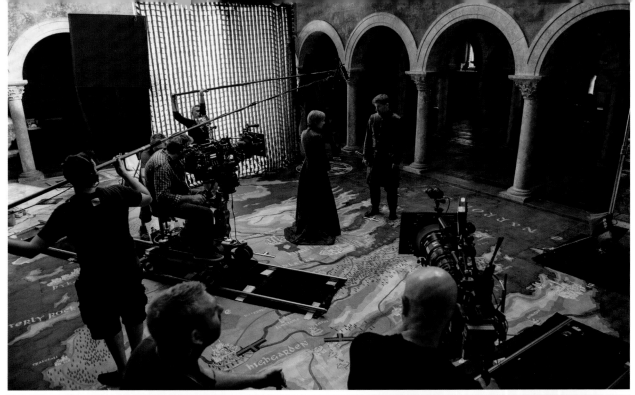

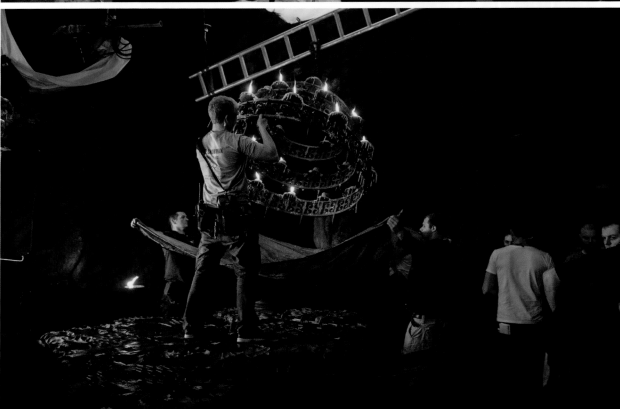

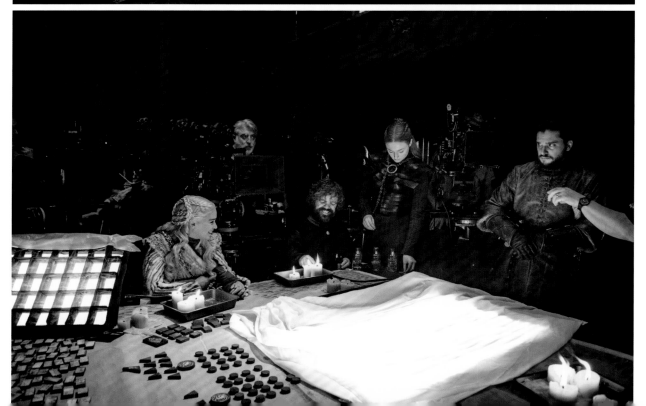

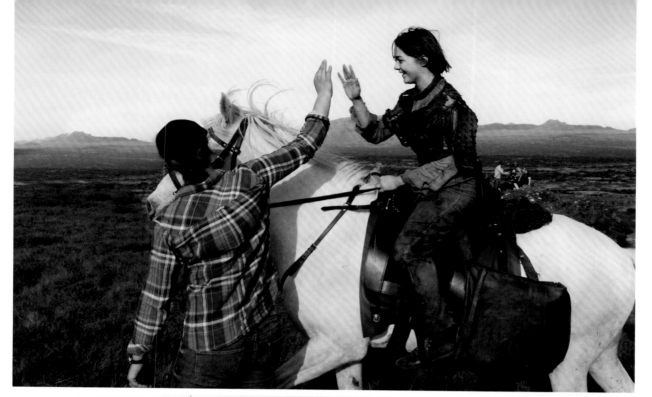

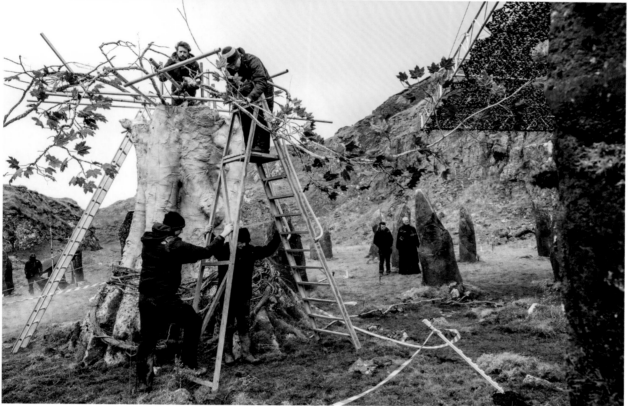

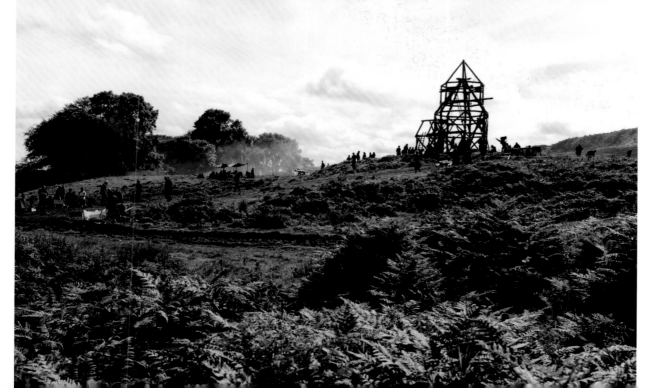

OPPOSITE: Filming in Cersei's map room (*top*); the Chamber of the Painted Table in Dragonstone (*center*); Emilia Clarke, Peter Dinklage, Sophie Turner, and Kit Harington between takes in Winterfell.

TOP: Maisie Williams and horse mistress Camilla Naprous on location in Iceland.

CENTER: A weirwood tree being constructed.

BOTTOM: A wide view of the crew setting up a scene.

PAGES 68–69: The Fair Head cliffs in Northern Ireland were a key shooting location for Dragonstone.

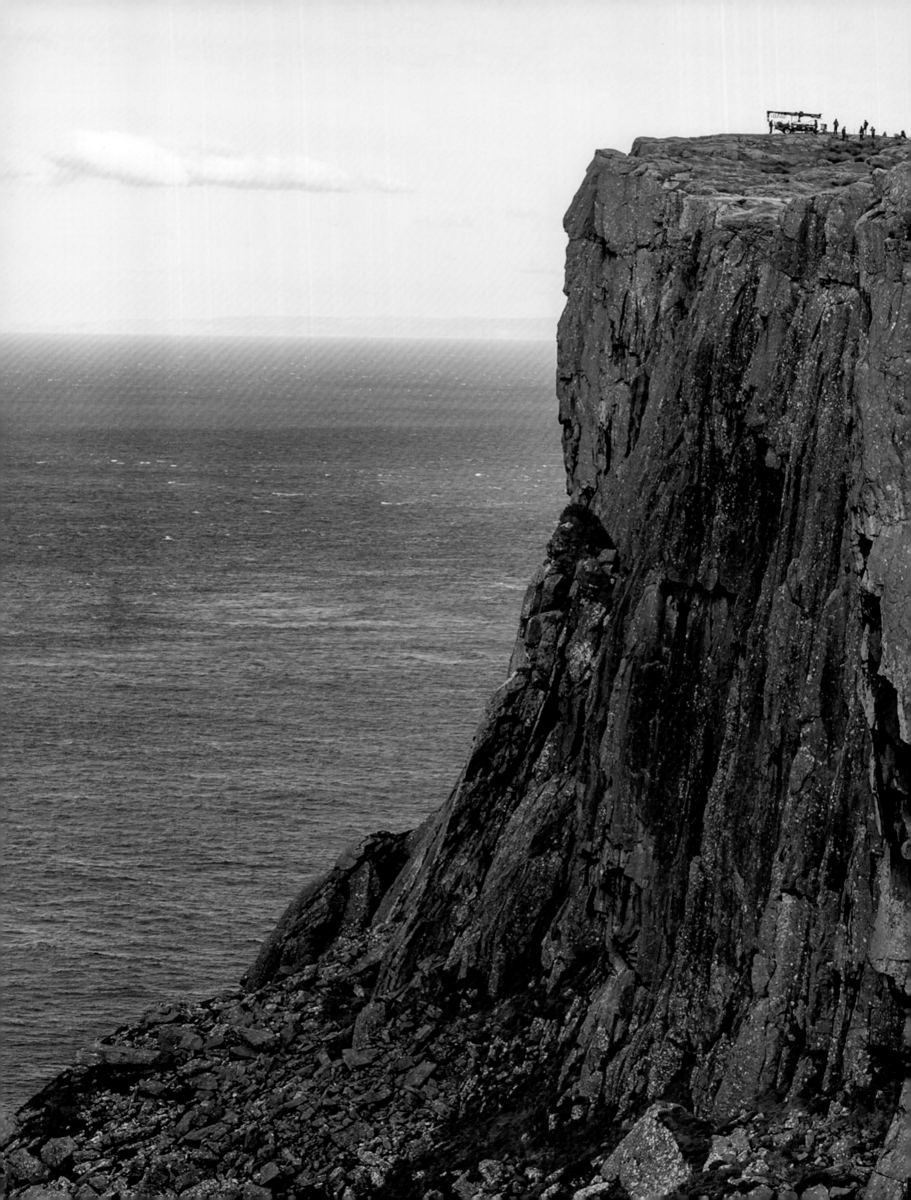

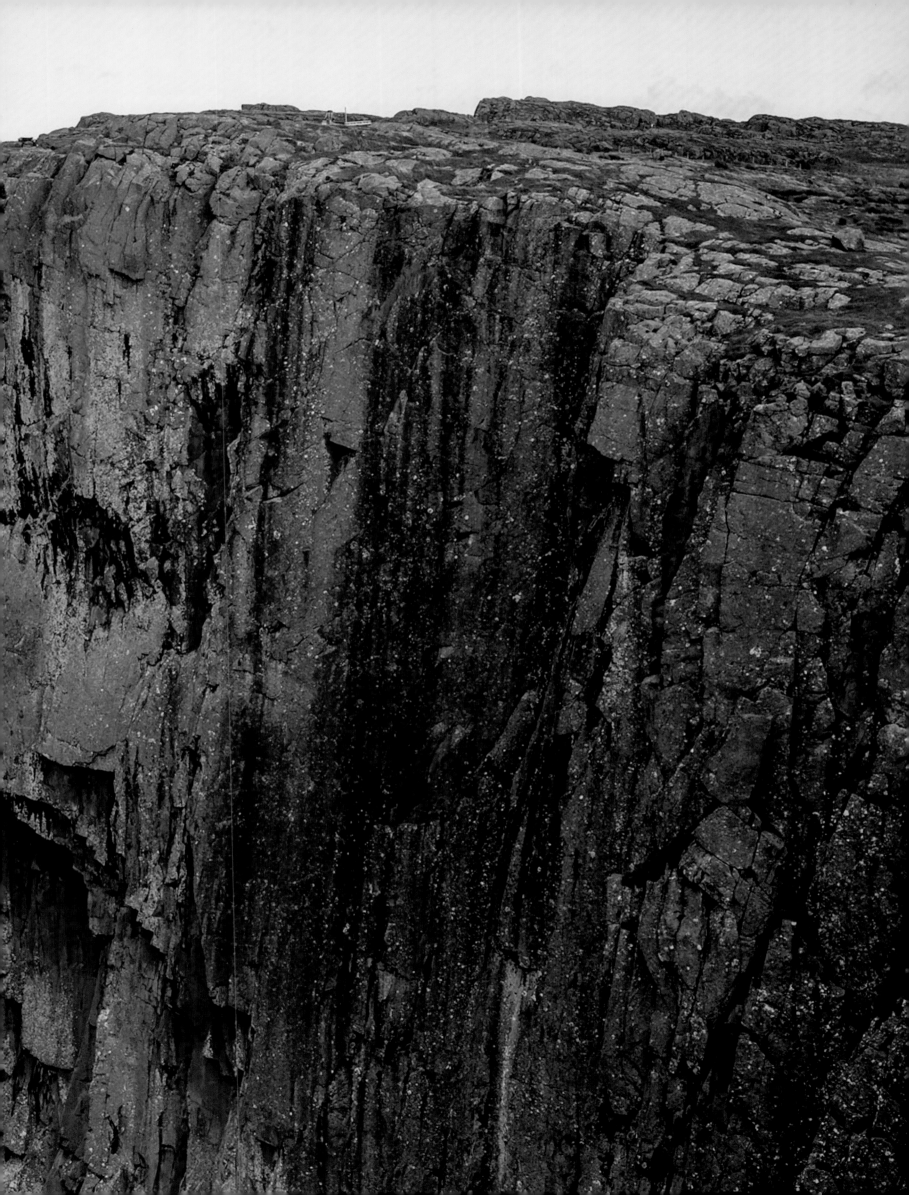

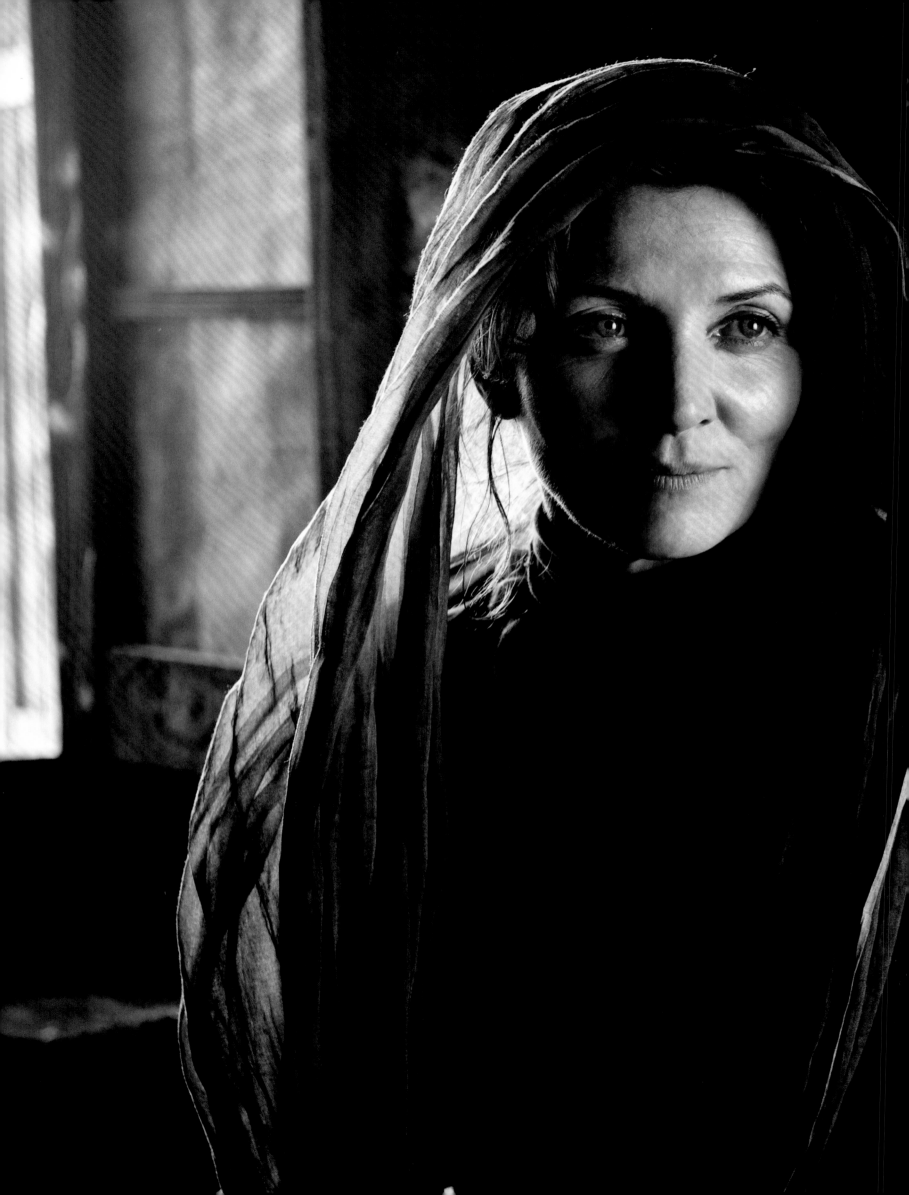

THE MOTHER

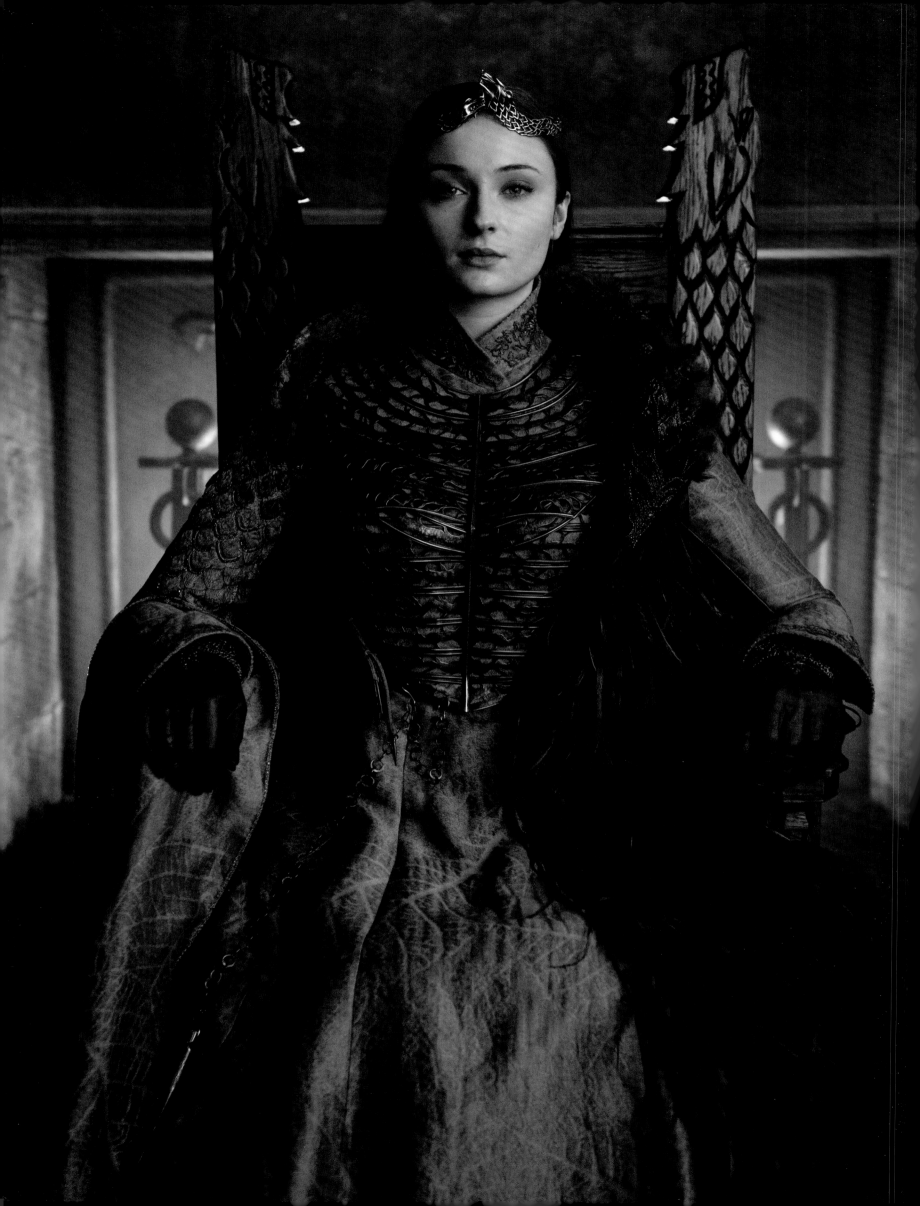

The Mother represents peace, mercy, fertility, and childbirth.

The Mother represents key aspects of the family, and no bond is more sacred in Westeros than that of the family; it defines an individual's place in the world and determines how they are perceived. Many embrace this bond and the shared history, political roles, and goals of the family that come with it. Some individuals, however, forsake this bond—or are forsaken by their families—and must forge new identities of their own.

Families are the vehicles that drive the never-ending pursuit of power, safety, and security in *Game of Thrones*. Power is concentrated in the Great Houses of the Seven Kingdoms.

The loyal members of these great families embody their house's traditions and long-sought ambitions. The fathers of these Great Houses are concerned with training their children to continue the family name and maintain the family holdings, but some—such as Ned Stark—can see that their children are meant for things other than what society has planned for them. The mothers must navigate a dangerous and treacherous world, work to keep their children safe, and prepare them for the role society has set for them. However, not all mothers follow the same mold: Ellaria Sand treats all the Sand Snakes, Oberyn Martell's illegitimate daughters, as her own children; Daenerys Targaryen, accepting that she may never birth a human child, loves her dragons as her children.

Where do one's loyalties lie? How deep do those loyalties go? What could compel someone to shift their loyalties? The characters of *Game of Thrones* are constantly being tested with these questions. Family is usually one's foremost allegiance, as its bonds fortify the dynastic aristocracy of the Seven Kingdoms. Oaths represent another kind of loyalty—an unwavering public allegiance to a person, persons, or code of honor. Yet the strongest allegiance often comes from the simplest of bonds: friendship. When all else fails, the trust and affection between two people can be worth more than all the sworn oaths and signed contracts in the world.

The most common form of allegiance is an alliance, made by treaty or handshake and sometimes in secret. Alliances can help maintain the status quo or radically alter the state of play. In the War of the Five Kings, Robb Stark, Stannis Baratheon, Renly Baratheon, Joffrey Baratheon, and Balon Greyjoy call on their alliances to bolster their bases of power, declare the sovereignty of their realms, and mobilize armies to move against each other for control of the Iron Throne. Cersei proves to be a master alliance-maker and alliance-breaker; she weds first Joffrey and then Tommen to Margaery Tyrell for the support of her house, and when Cersei deems Margaery a threat to her control over her son, she sends Margaery, Loras, and Mace Tyrell to their deaths by ordering the obliteration of the Great Sept of Baelor. As the Army of the Dead approaches, Jon Snow and Daenerys Targaryen persuade Cersei to enter a temporary alliance with them to fight off the invaders, but Cersei tells her brother Jaime that her only true allegiance is to herself.

Oaths are, in many ways, the opposite of alliances, as there is no bartering or deal-making involved; one who swears an oath is honor-bound to commit to it. Brienne of Tarth exemplifies the most serious of oath-takers, first vowing to avenge the lord who made her part of his Kingsguard, Renly Baratheon, then becoming the sworn sword of Catelyn Stark and later her daughters, Sansa and Arya. The members of the Night's Watch are similarly devoted to the oaths they swear in order to ensure that the Wall is manned and the northern border defended.

When asked about the theme of family and relationships, Sloan's thoughts turn toward the crew. "The way the crew enjoys the show is completely different from how an outside viewer watches it. We're watching live theater, though all the scenes are out of sequence since we don't shoot chronologically.

"Every day when we watched scenes play out in front of us, there were also so many other scenes happening from our real lives. In a way, the crew's relationships reflected what occurred on the show—obviously we're not getting into sword fights, but as a unit we've had a ten-year journey during which people have gotten married, gotten divorced, had babies, lost children, and lost parents.

"When you watch the show, you reflect upon what you've seen and relate it to your own life. I watch the show in a twofold way and remember things that happened to my crew family that day—people's life events, or laughing so hard you think you'll faint, or someone bringing you a surprise chocolate bar and a coffee because it's pouring with miserable rain—the simple beautiful memories of ten years spent with a new family.

"I remember where we shot that photograph of the wildlings in a row in Iceland. It was the same spot where, when back living in Iceland and not having a great time personally, I went out for a hike on top of this snowy mountain and thought, 'What am I going to do with this life?' And then to be back on the same hill, back in the country I love with this amazing production, looking in the same direction, and thinking, 'Look what has happened with my life,' was just this lovely moment. That is what I see looking at that image. Part of me hopes that the rest of the crew also uses some of the images as a sort of little talisman for their own journeys and memories."

PAGES 70–71: Michelle Fairley as Lady Catelyn Stark. OPPOSITE: Sansa Stark, the Queen in the North.

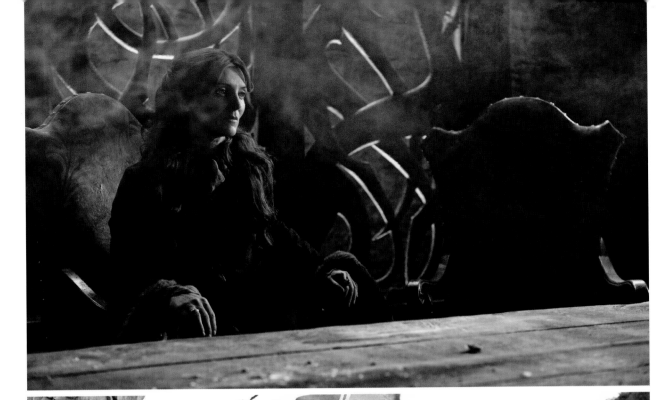

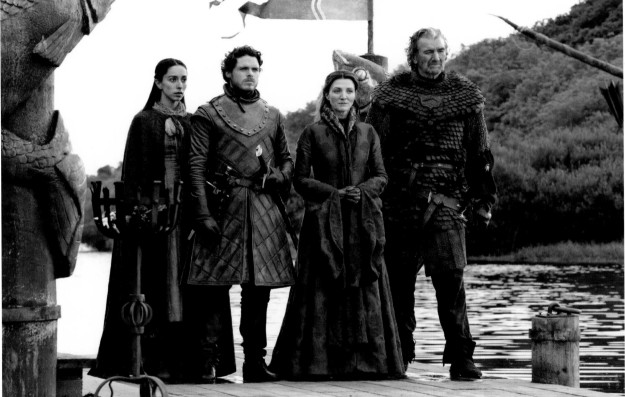

TOP AND CENTER: Catelyn Stark with her family.
BOTTOM: Lysa Arryn, Lady Regent of the Vale and Catelyn's sister.
OPPOSITE: Lady Stark shares a tender moment with her son Bran.

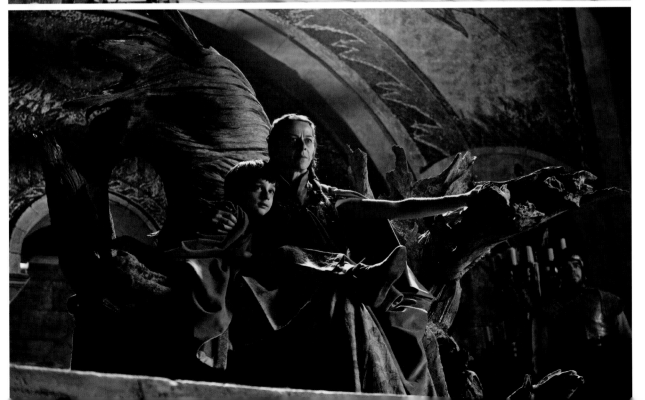

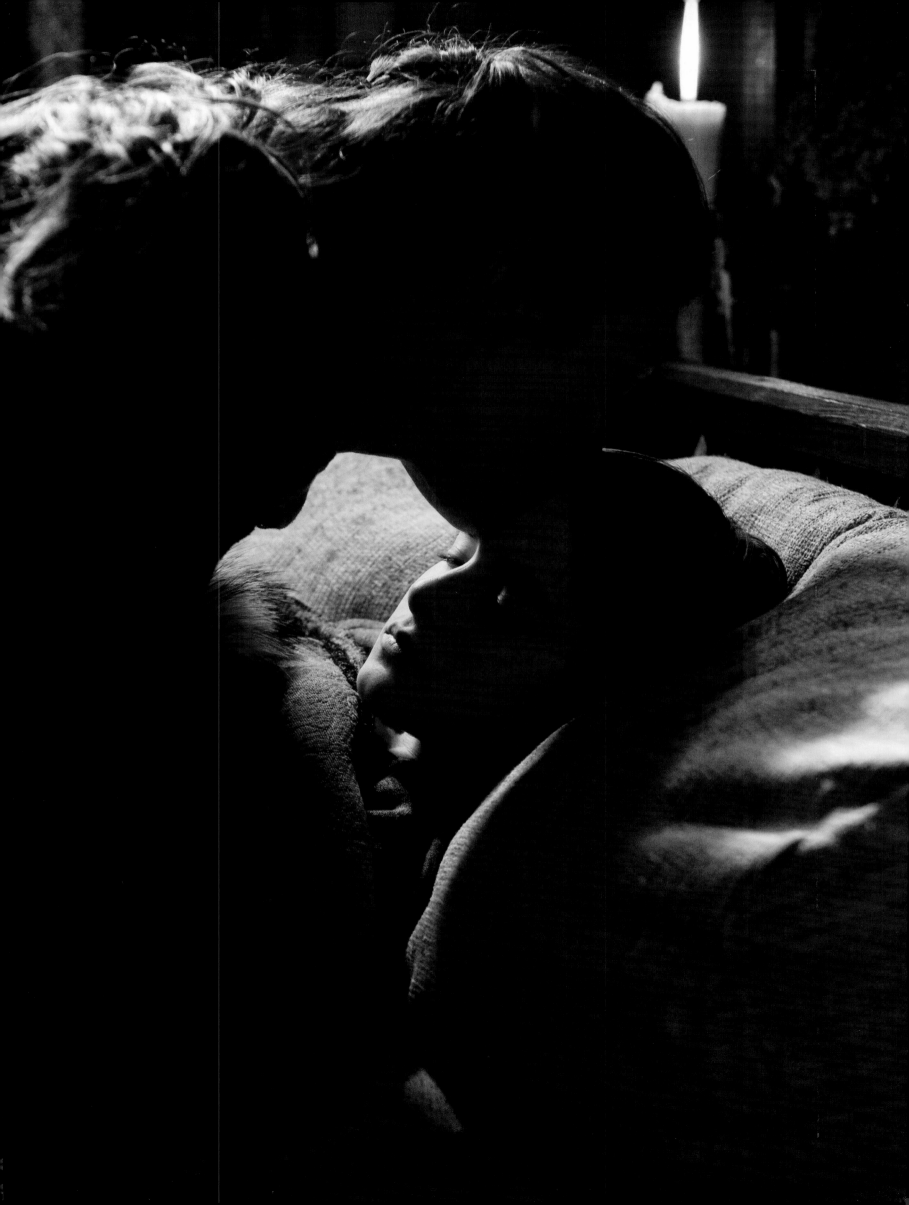

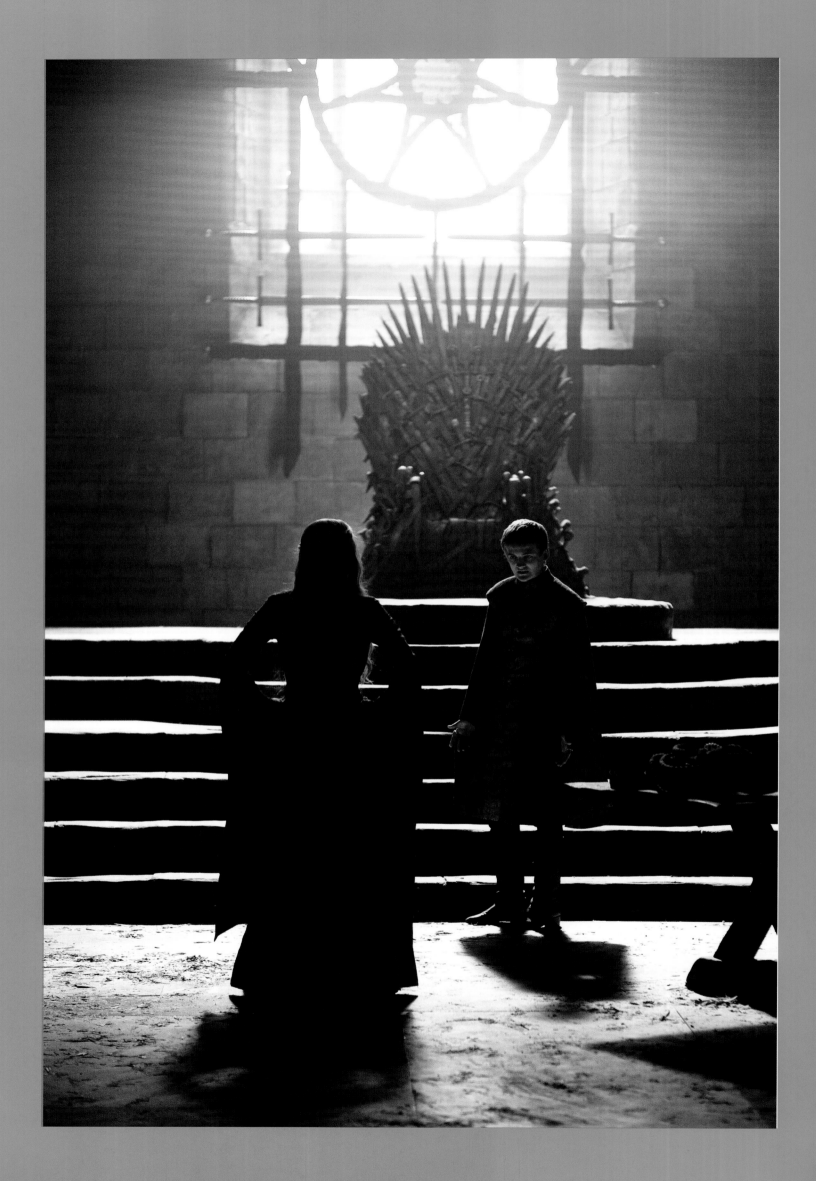

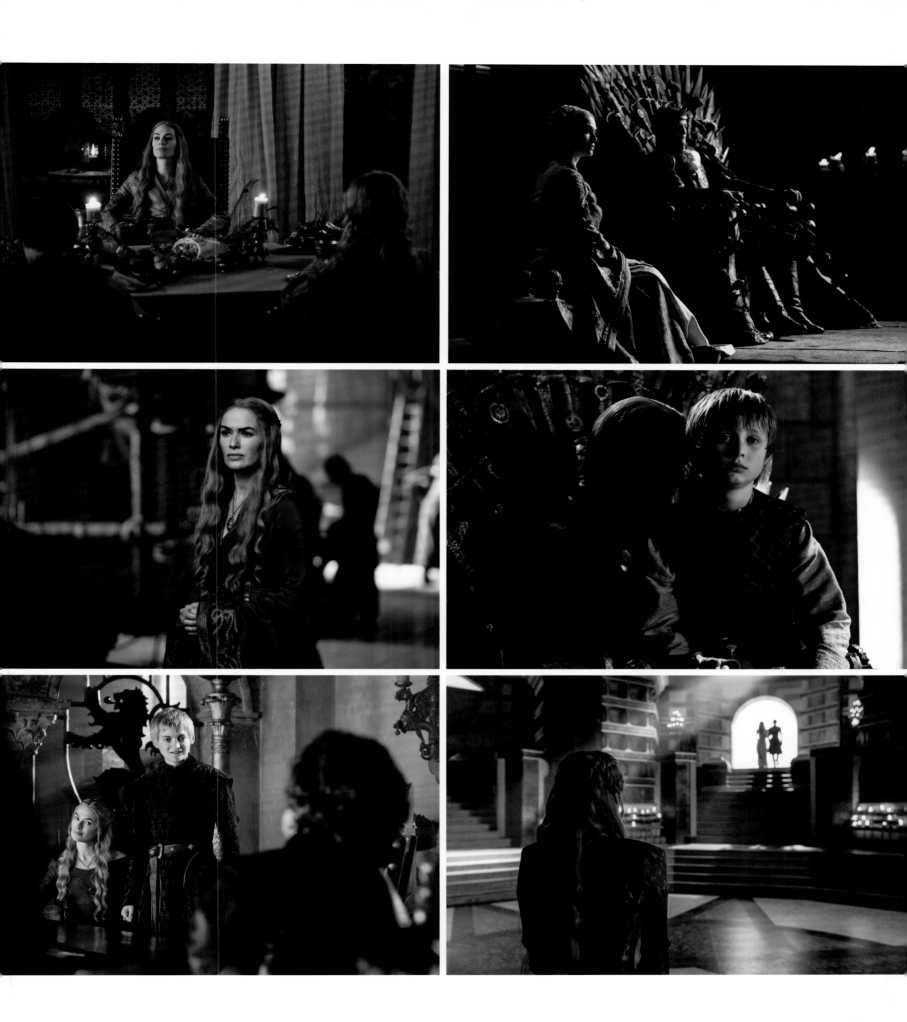

THESE PAGES: Cersei Lannister and her children.

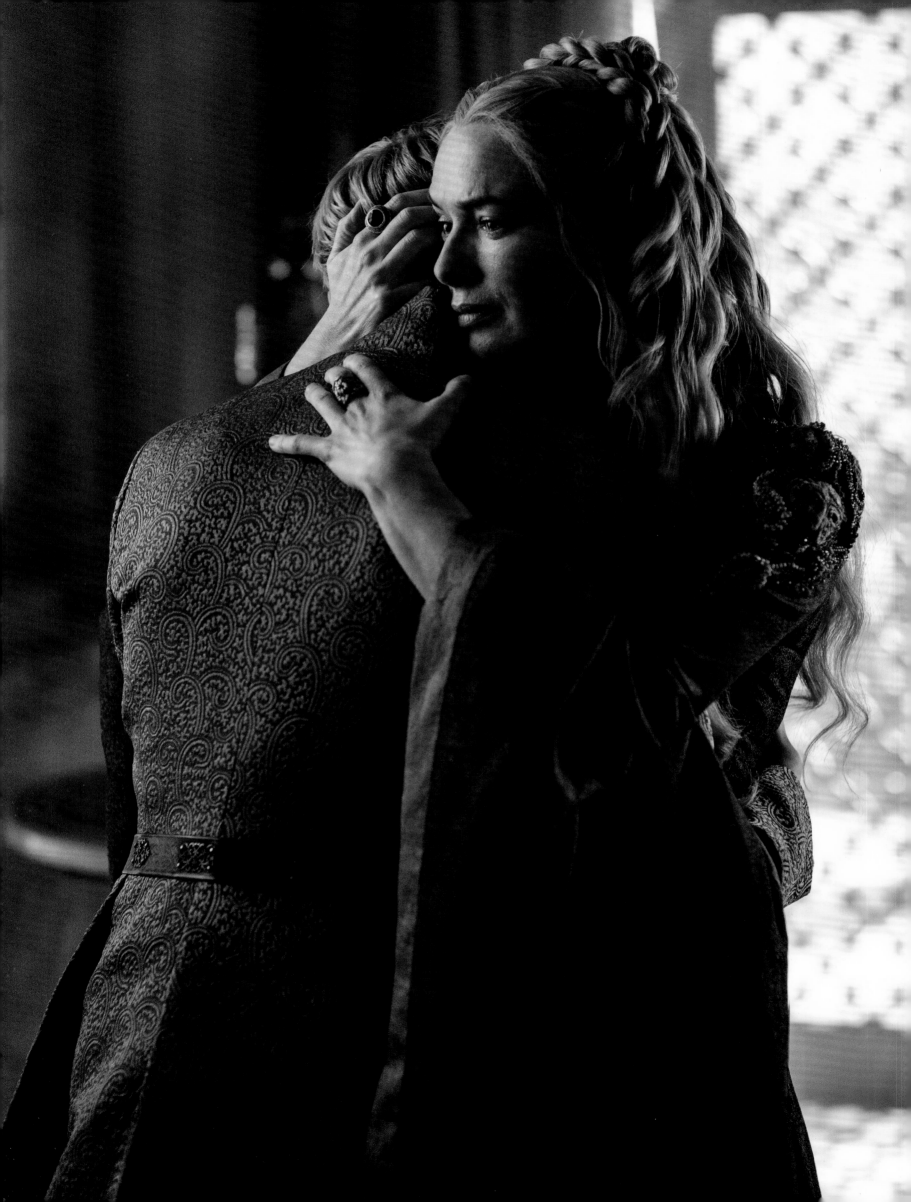

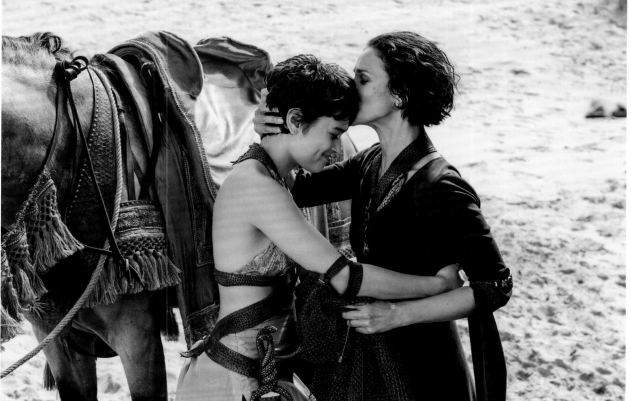

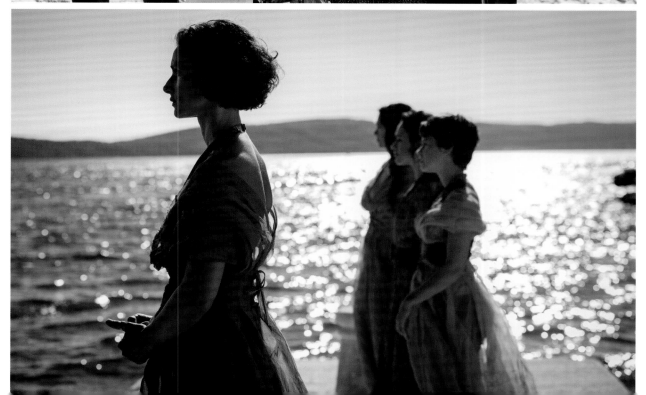

OPPOSITE: Cersei and her son King Tommen.

TOP: Margaery and Olenna Tyrell in conversation.

CENTER AND BOTTOM: Ellaria Sand and the Sand Snakes, including her daughter Tyene Sand.

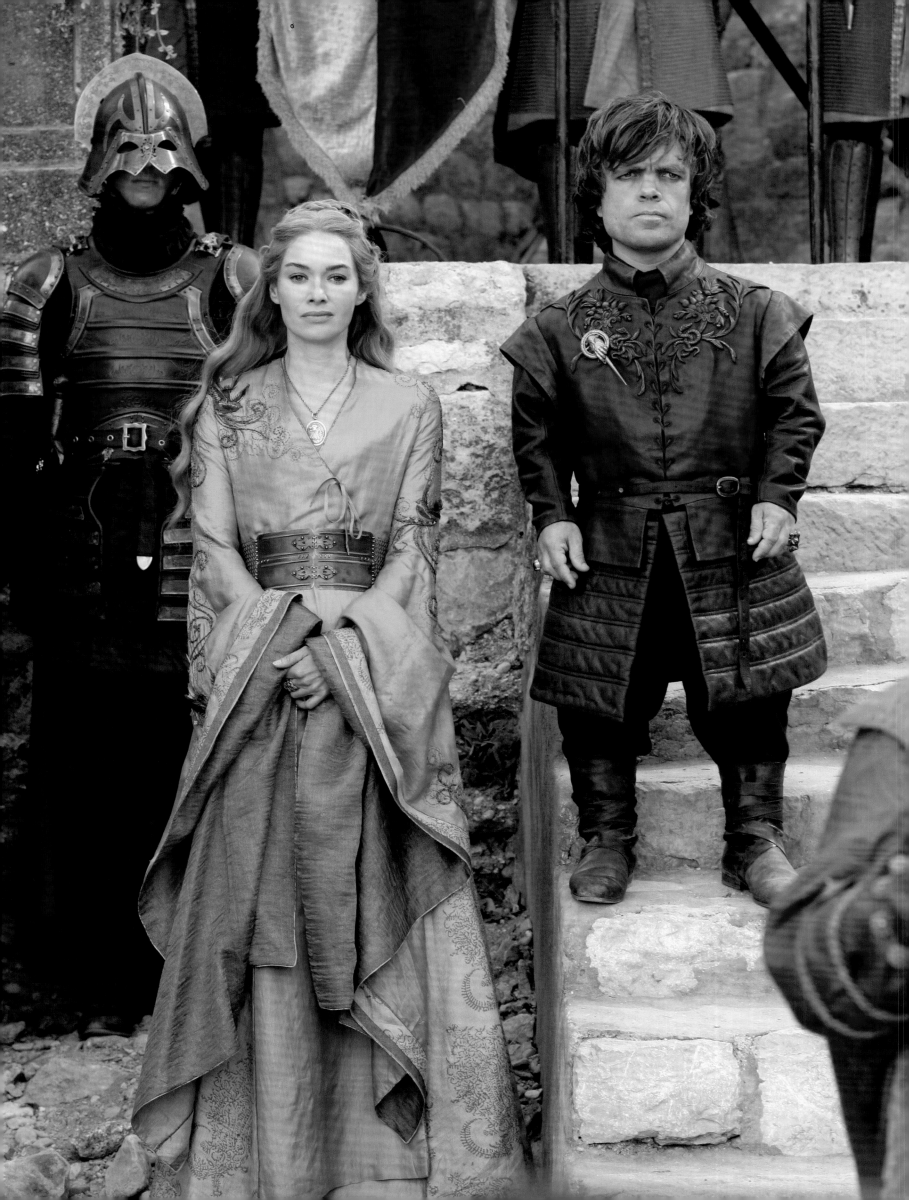

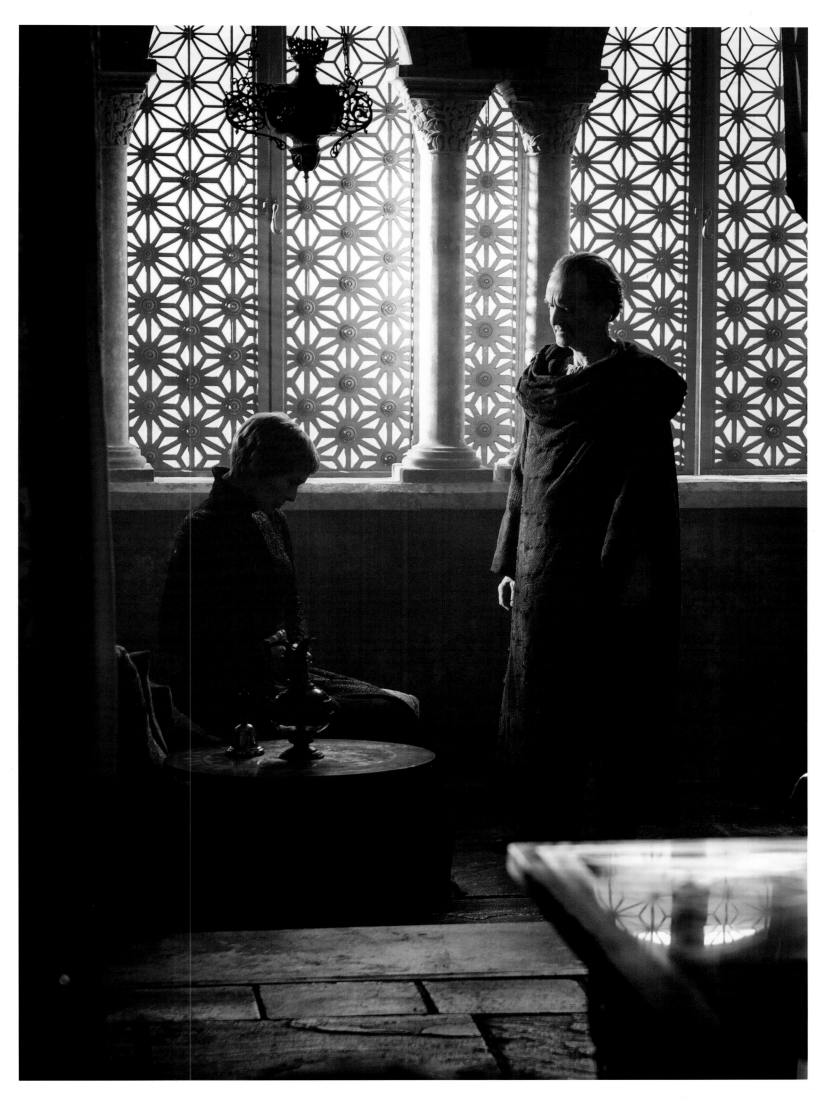

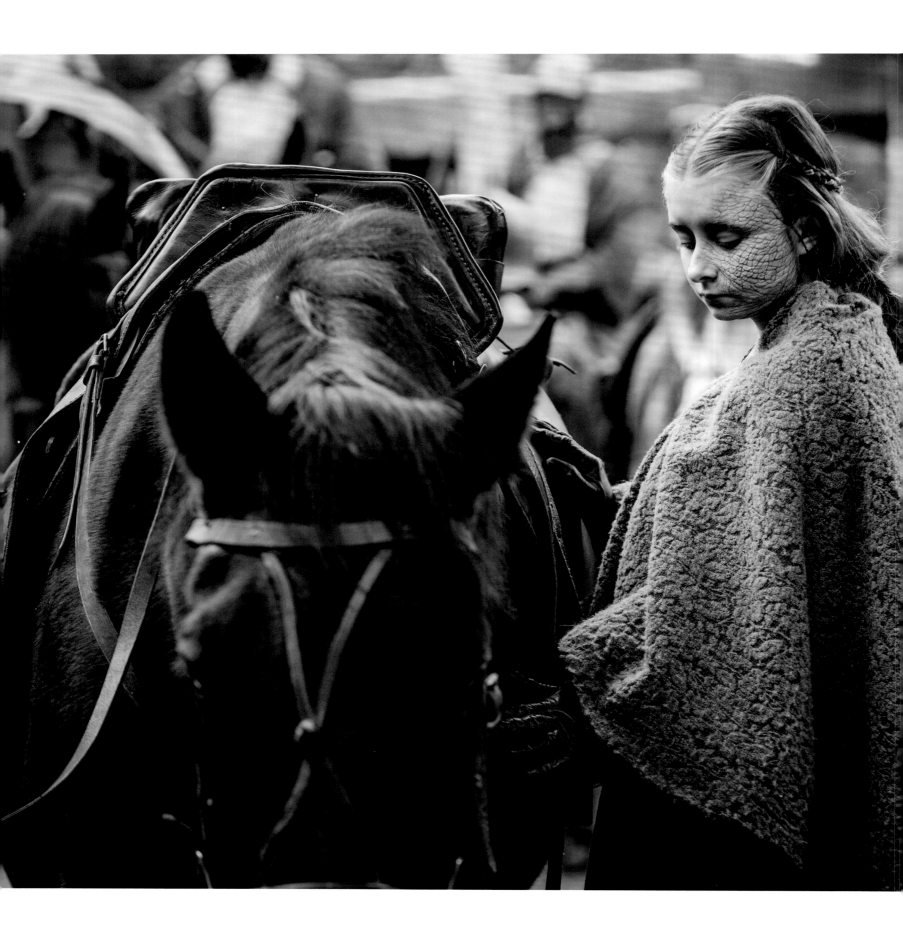

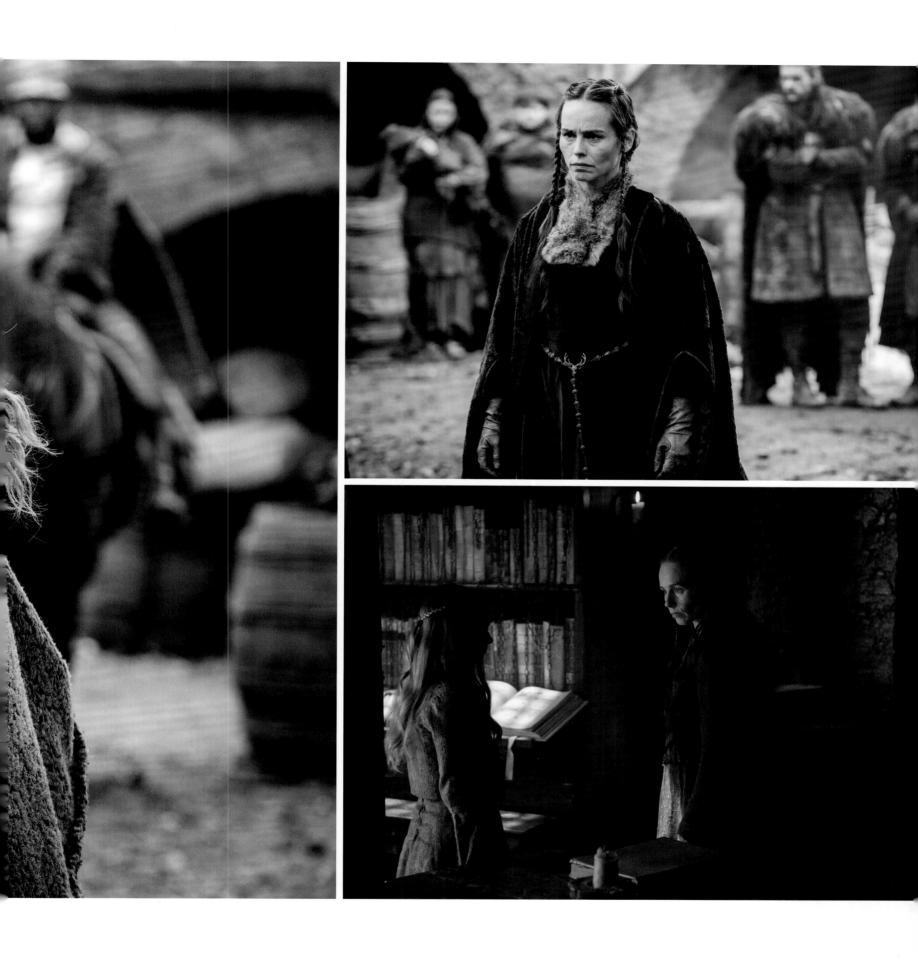

LEFT: Kerry Ingram as Shireen Baratheon.
ABOVE: Tara Fitzgerald as Selyse Baratheon, Shireen's mother.

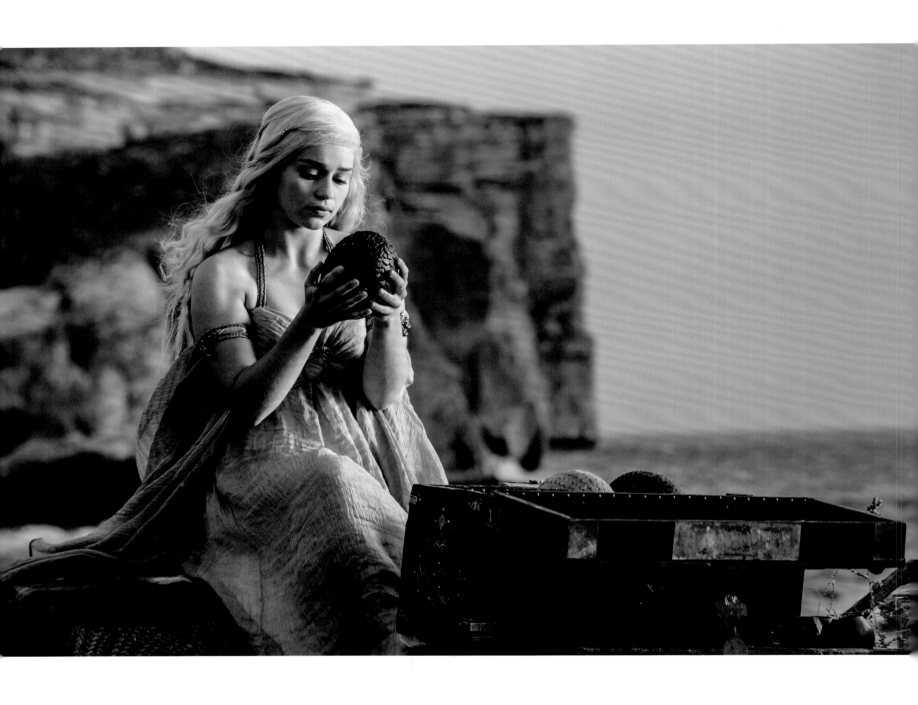

"*Dragon's eggs, Daenerys. From the Shadow Lands beyond Asshai. The ages have turned them to stone, but they will always be beautiful.*" —Illyrio Mopatis

ABOVE: Daenerys with her three dragon eggs.
OPPOSITE TOP: Young Eddard Stark with his sister Lyanna and her baby, Aegon Targaryen.
OPPOSITE CENTER AND BOTTOM: Gilly with her son, Sam.

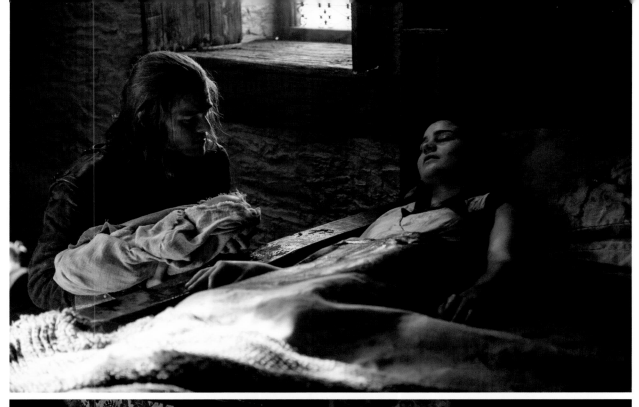

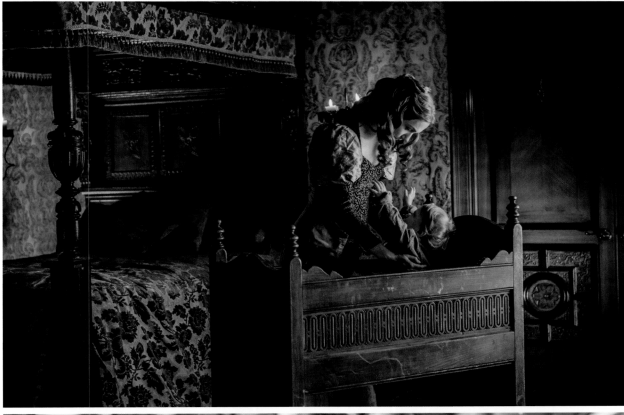

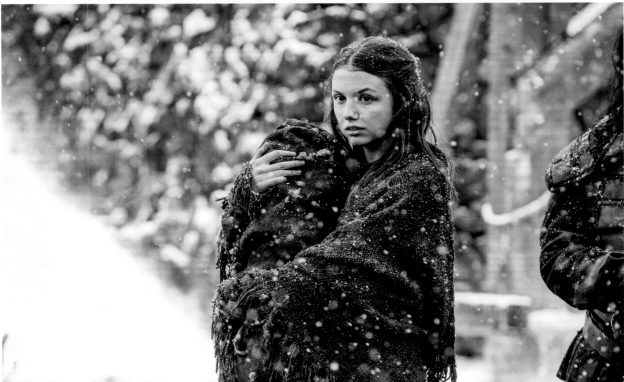

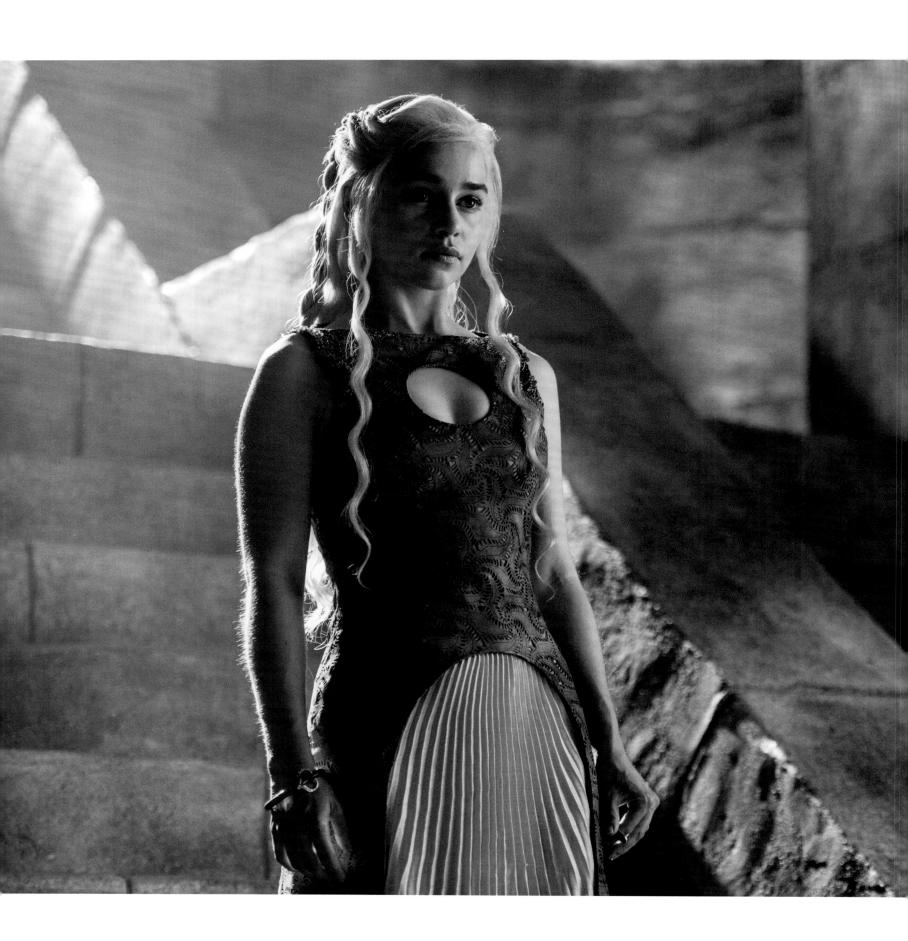

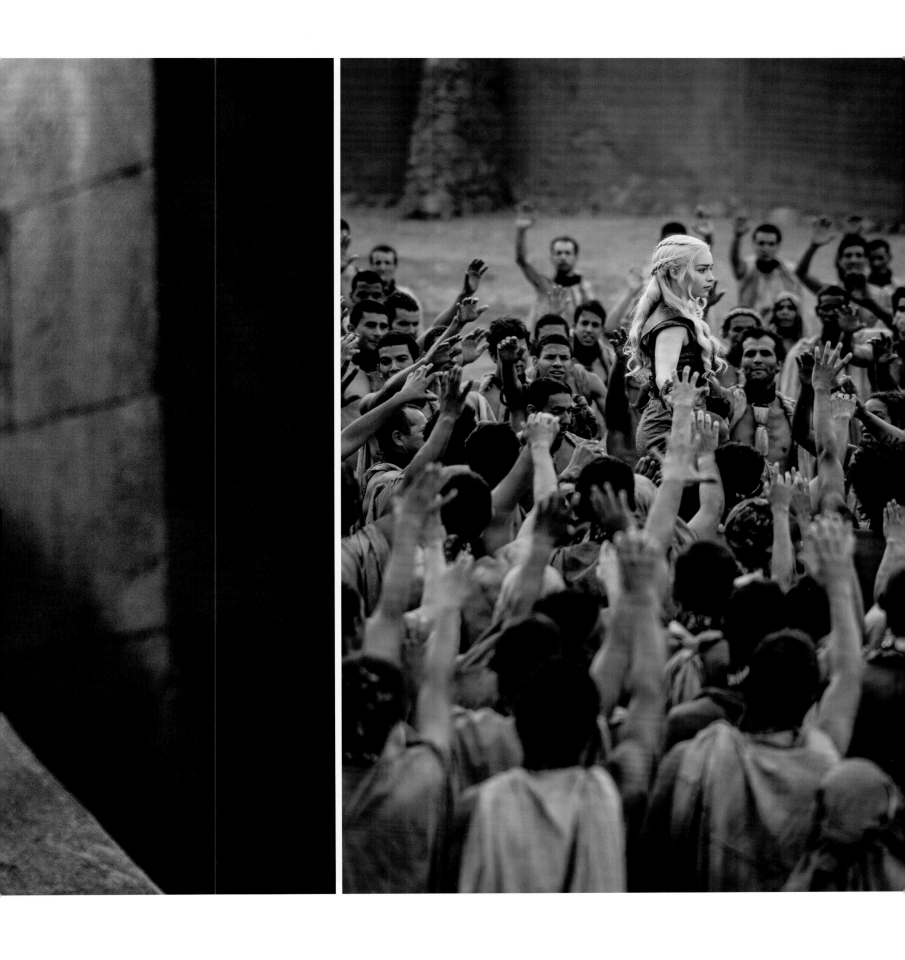

LEFT: Daenerys Stormborn, the Breaker of Chains.
ABOVE: The freed slaves of Yunkai celebrate their *mhysa*.

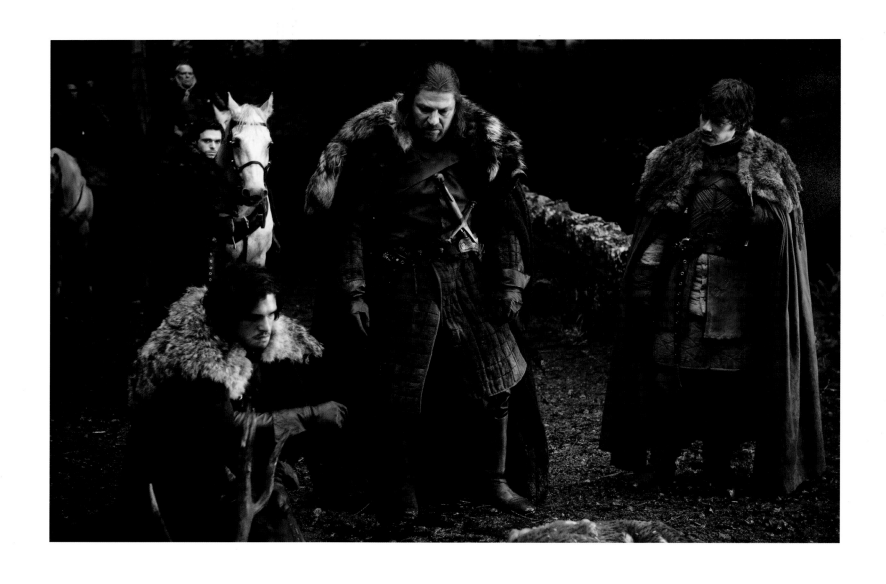

ABOVE: Ned Stark with Robb, Jon, and Theon.
OPPOSITE: Ned with his daughter Arya.

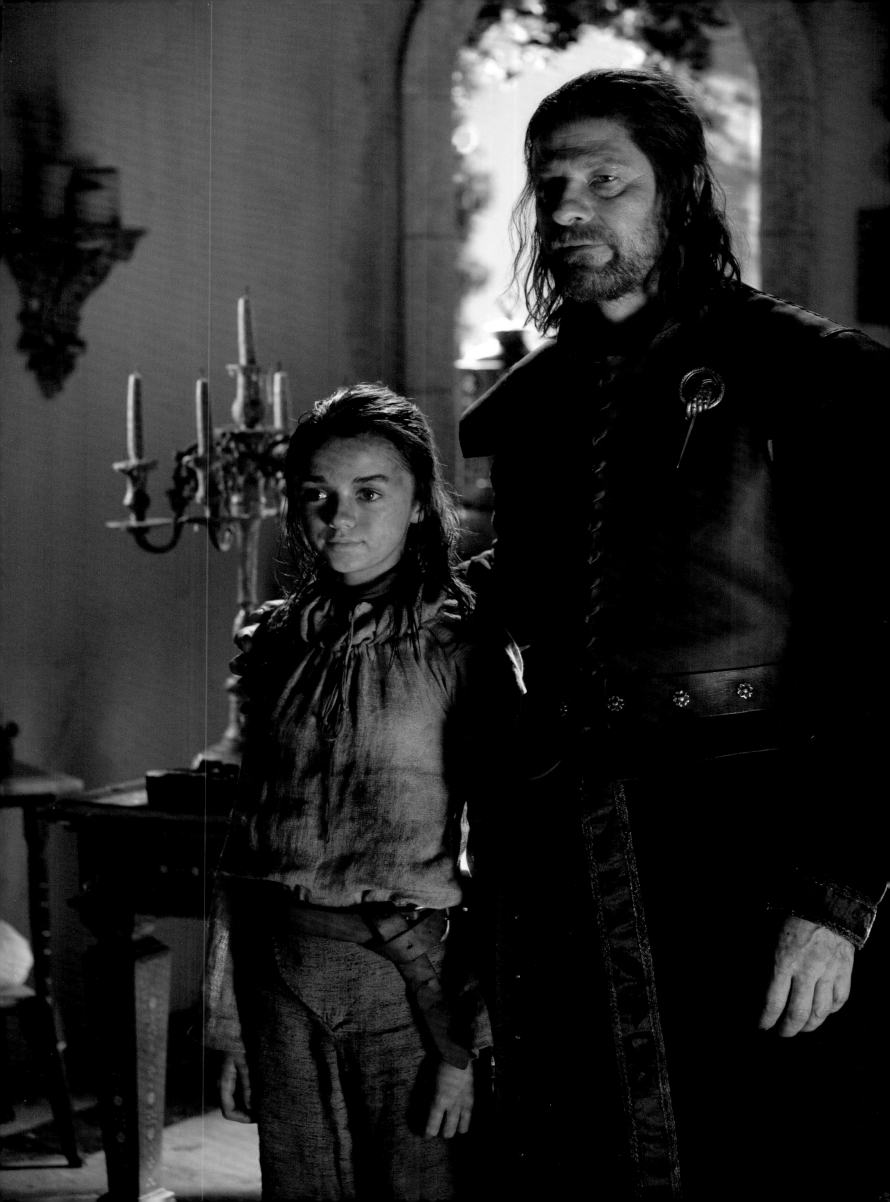

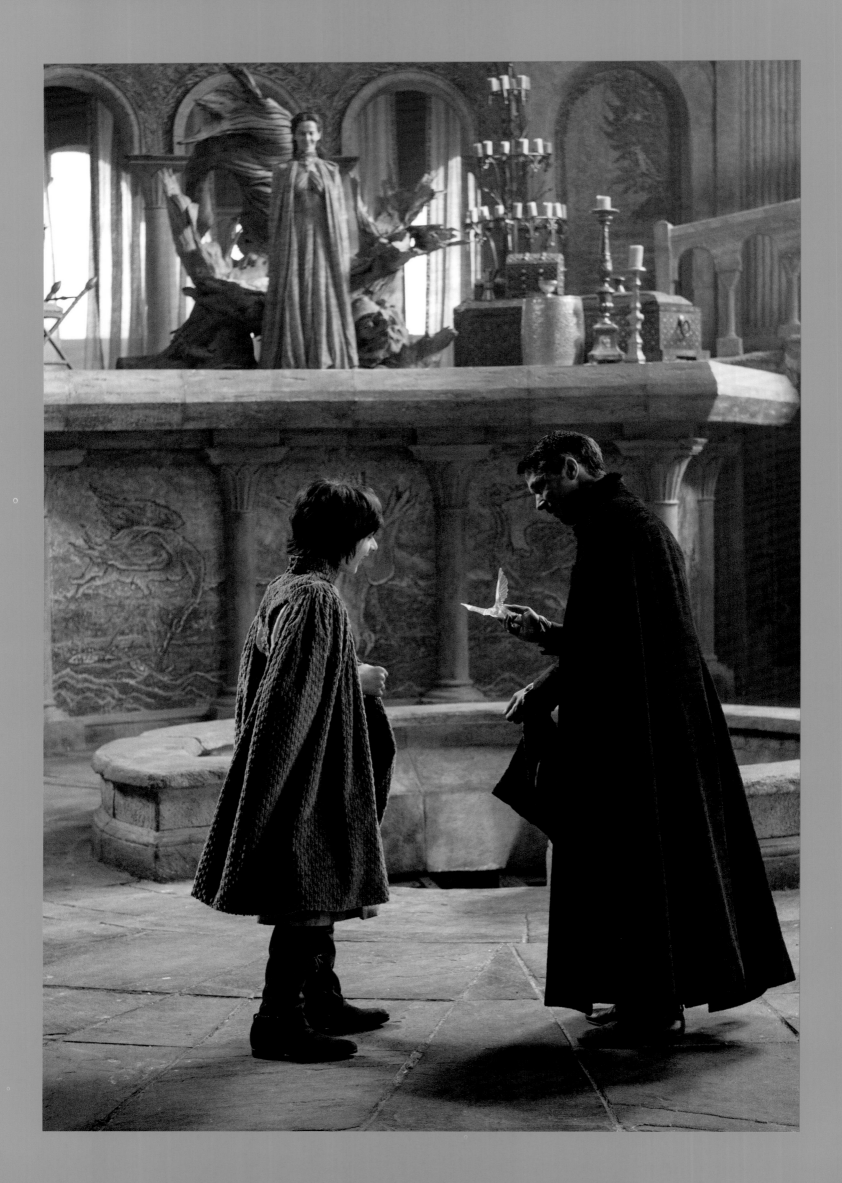

OPPOSITE: Littlefinger schemes at the Vale, presenting young Robin Arryn with a gift.
THIS PAGE: Stannis Baratheon and his daughter Shireen.

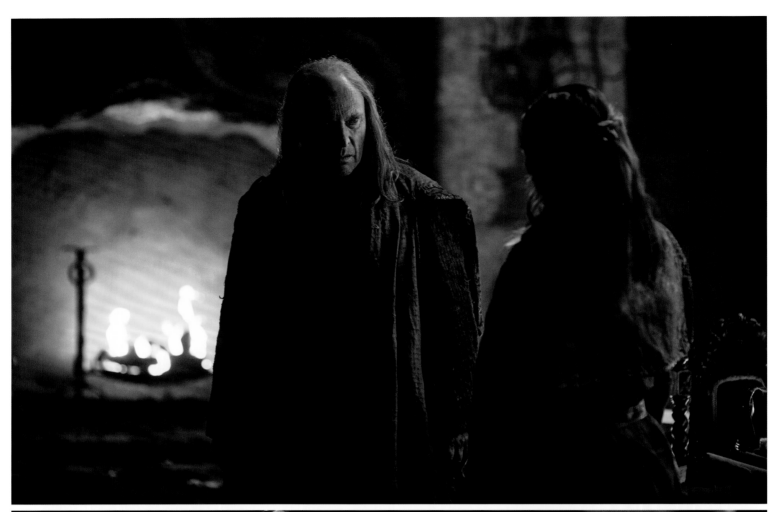

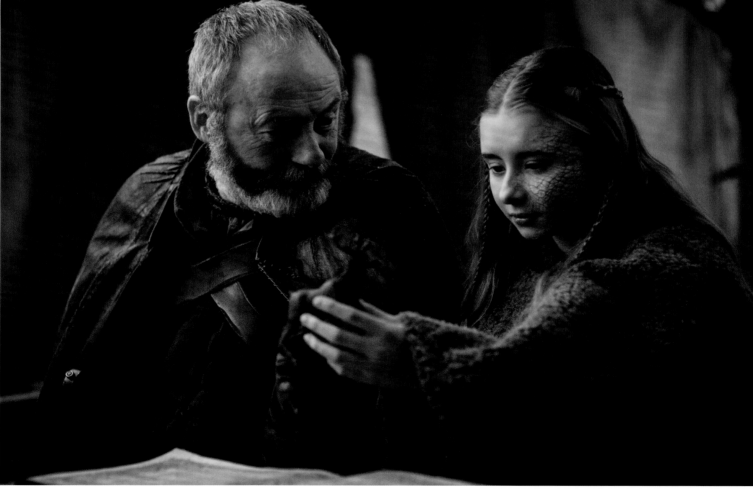

TOP: Balon and Yara Greyjoy.

BOTTOM: Ser Davos and Shireen Baratheon. "A few people have asked why I included Ser Davos in this section of photos about fathers," Sloan says. "I think if you were paying attention, it's fairly obvious that he was the father Shireen never had."

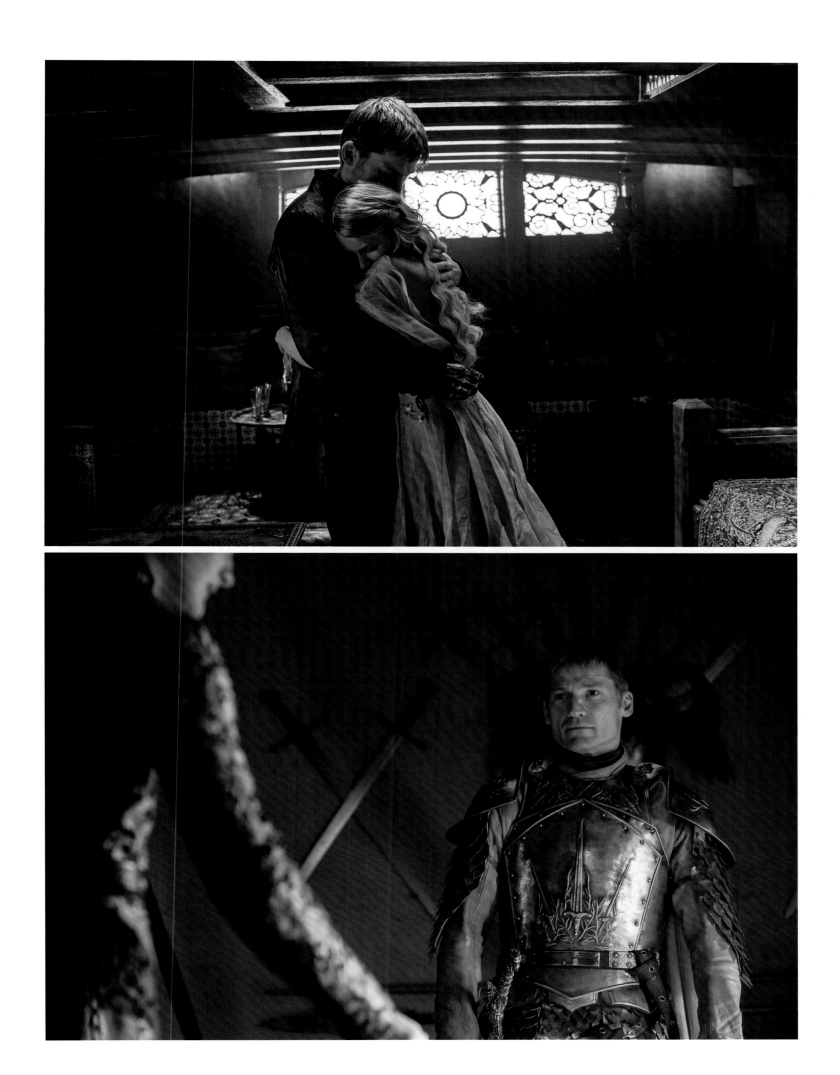

TOP: Ser Jaime and Myrcella.
BOTTOM: Joffrey and Jaime.

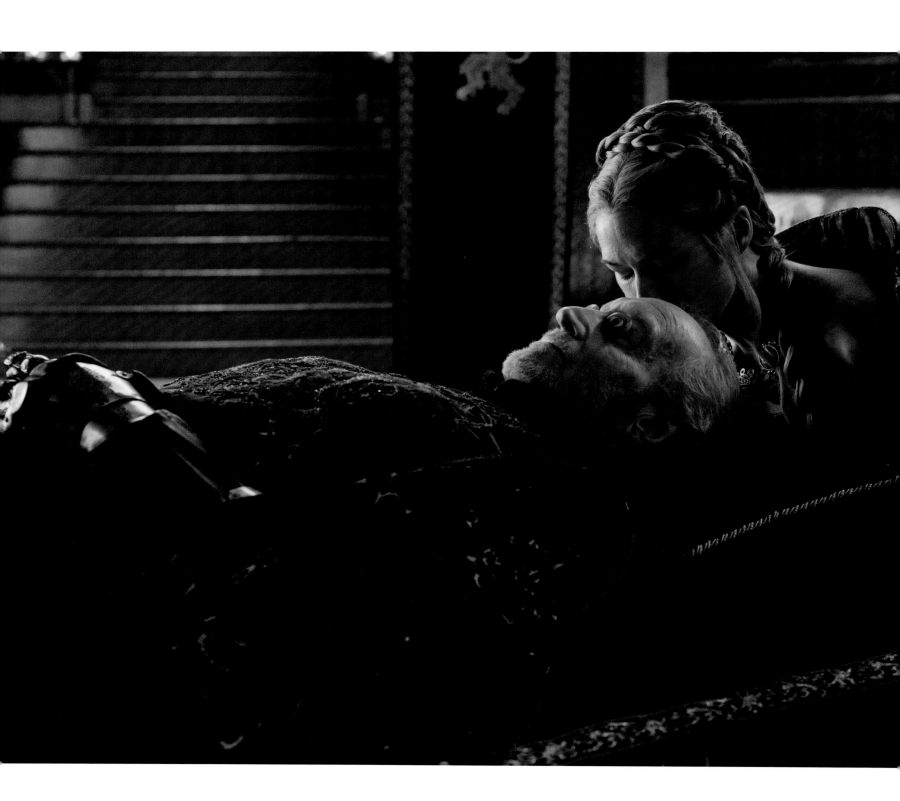

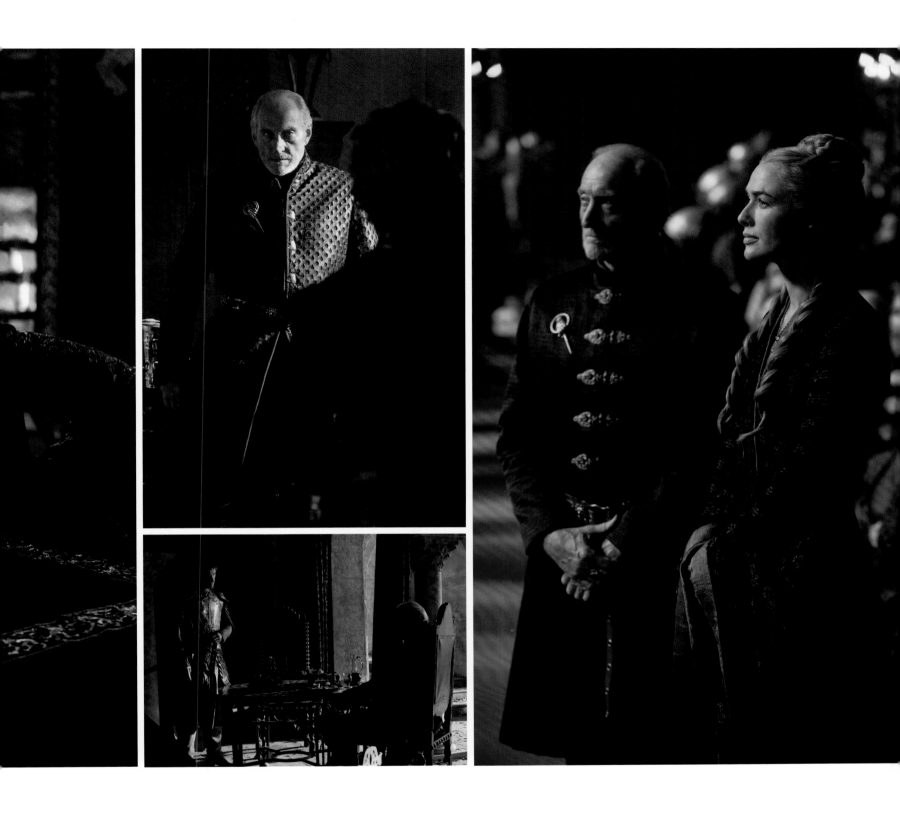

OPPOSITE: Cersei says goodbye to her father, Tywin Lannister, at the Great Sept of Baelor.
THIS PAGE: The Lord of Casterly Rock, Tywin Lannister, with his children: Tyrion, Cersei, and Jaime.

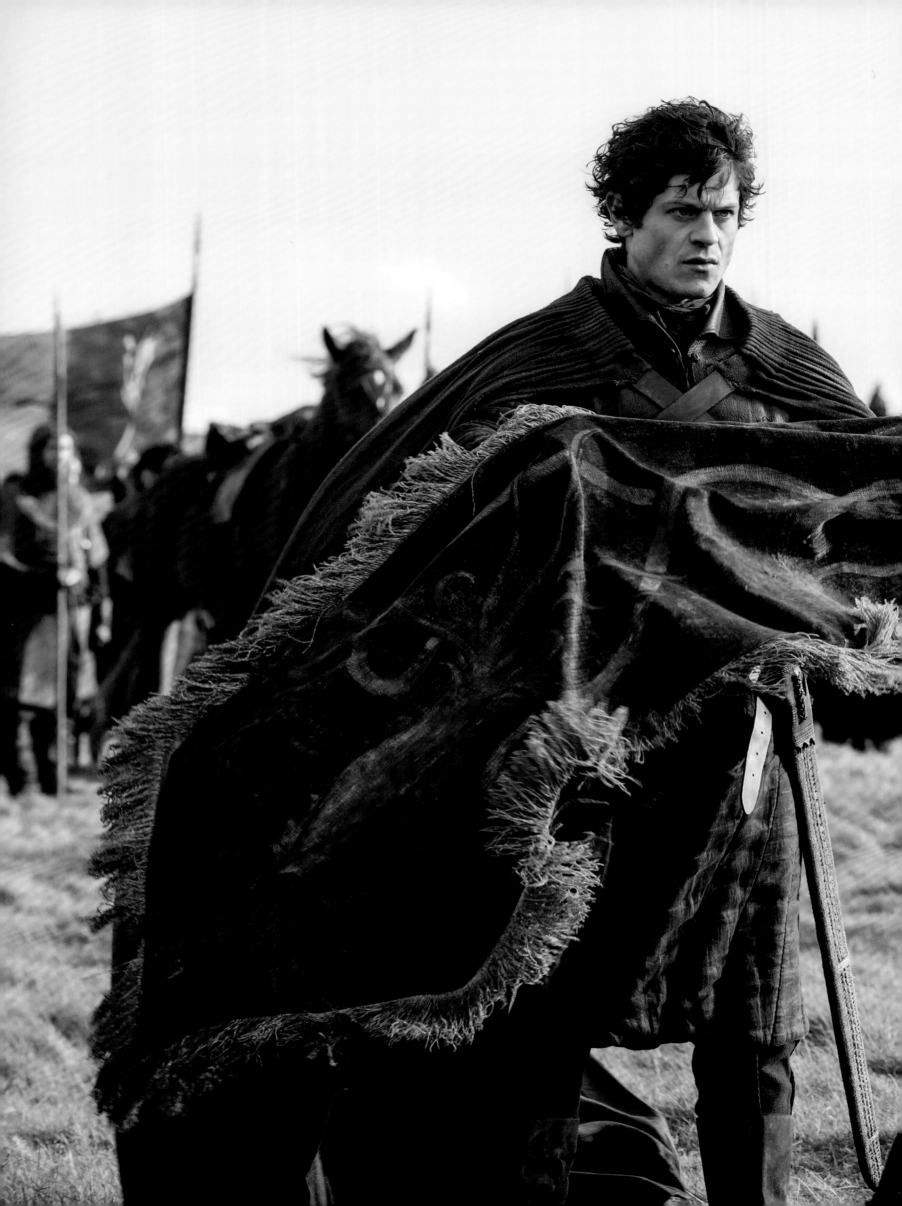

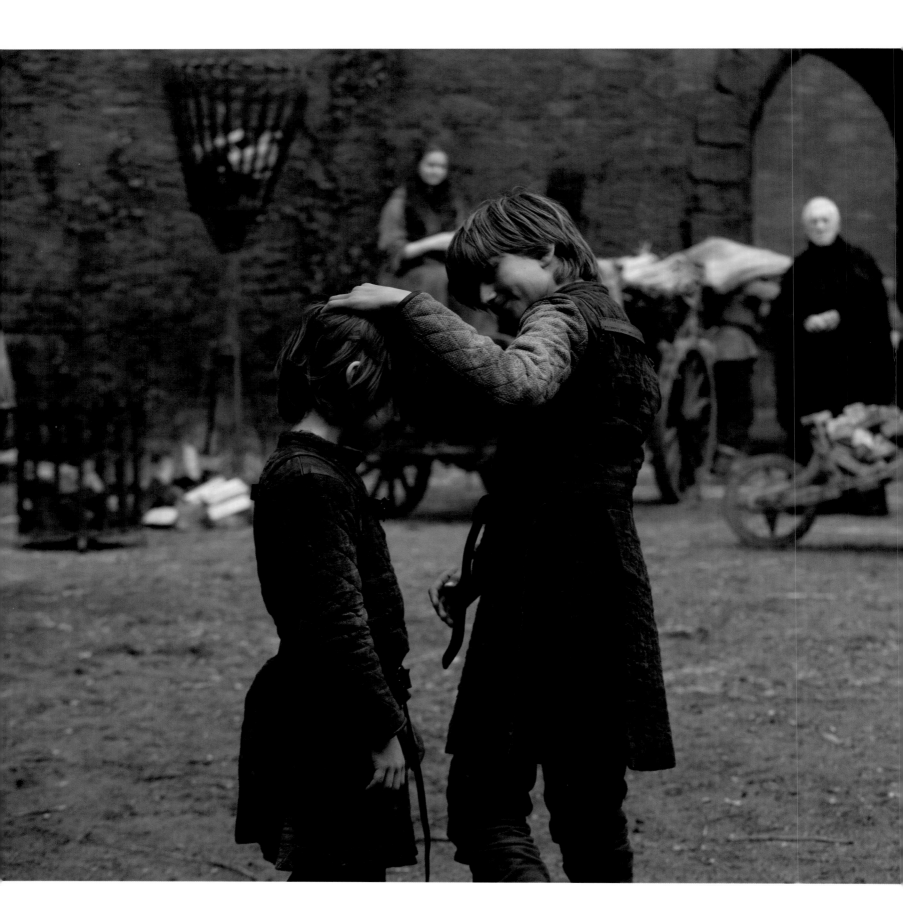

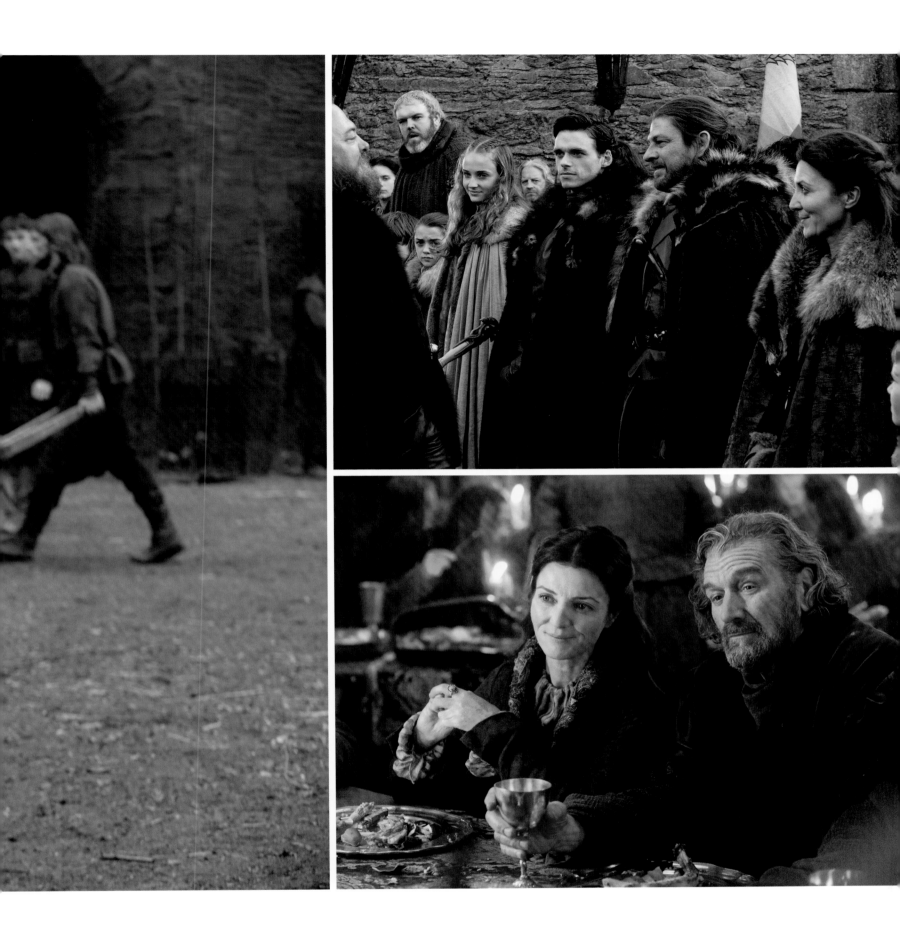

PAGES 96—97: Ramsay Snow brings the banner of the ironborn to his father, Roose Bolton, after his victory at Moat Cailin.
LEFT: Young Ned and Benjen Stark at Winterfell as Bran Stark has a vision of the past with the Three-Eyed Raven.
TOP: The Starks greet King Robert Baratheon upon his arrival at Winterfell.
BOTTOM: Catelyn Stark with her uncle Brynden Tully, "the Blackfish."

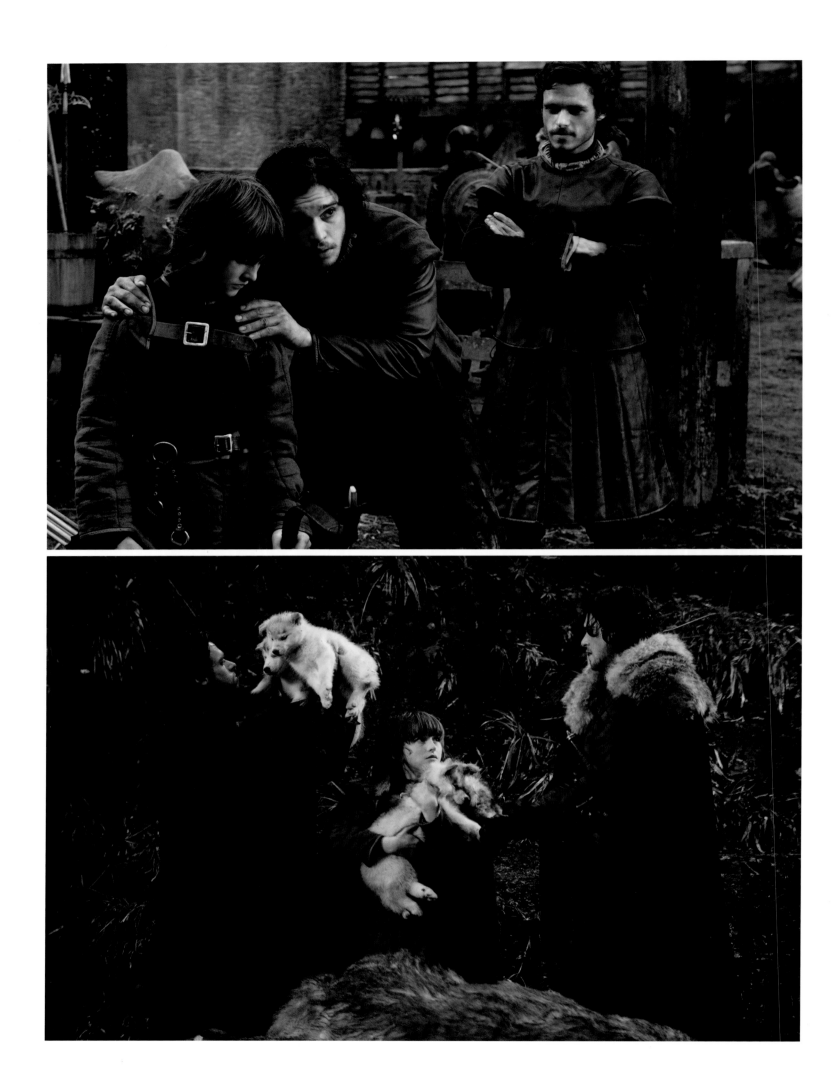

THESE PAGES: The Stark family, including Robb, Sansa, Arya, Bran, and Jon Snow.

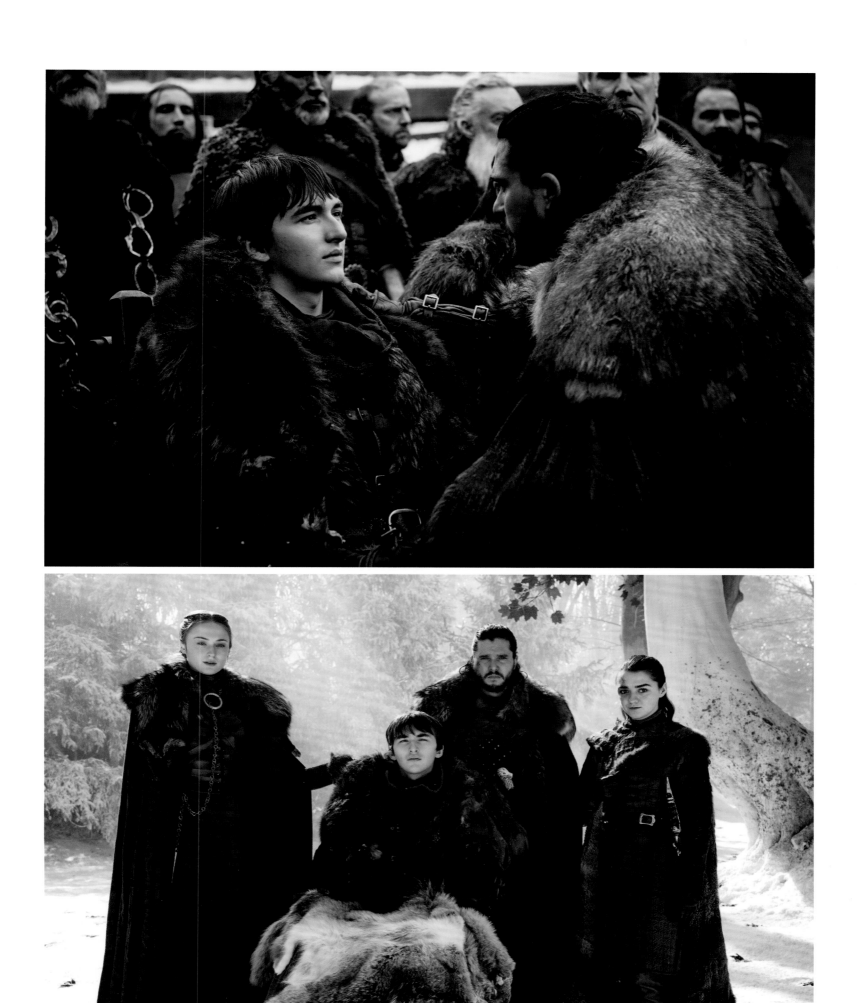

THESE PAGES: The last of the Stark children—Sansa, Jon, Arya, and Bran—reunite at Winterfell.

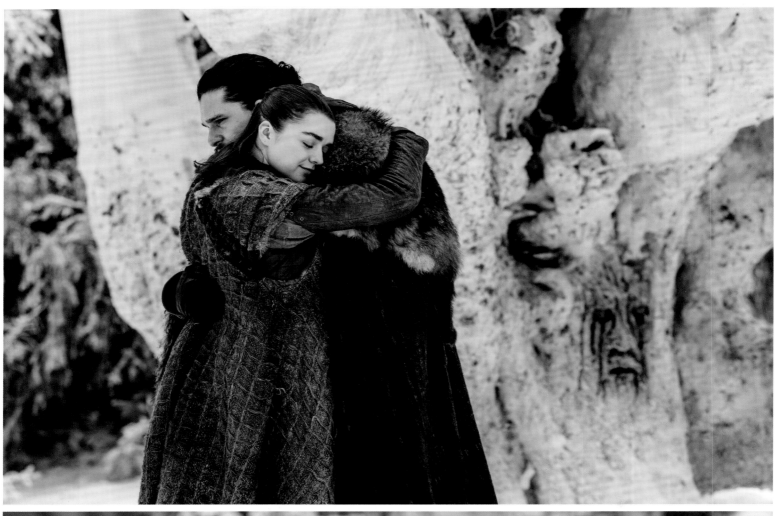

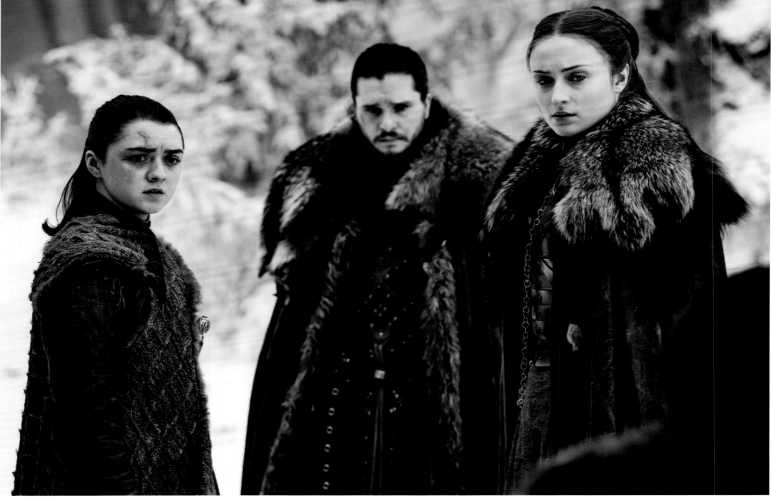

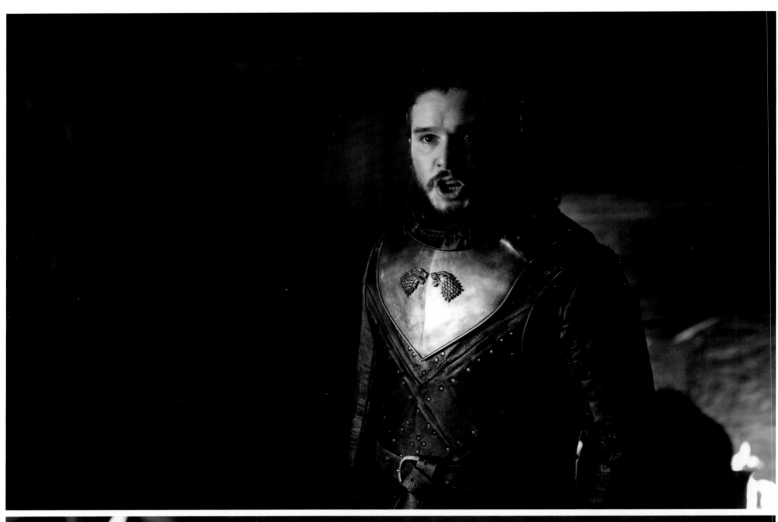

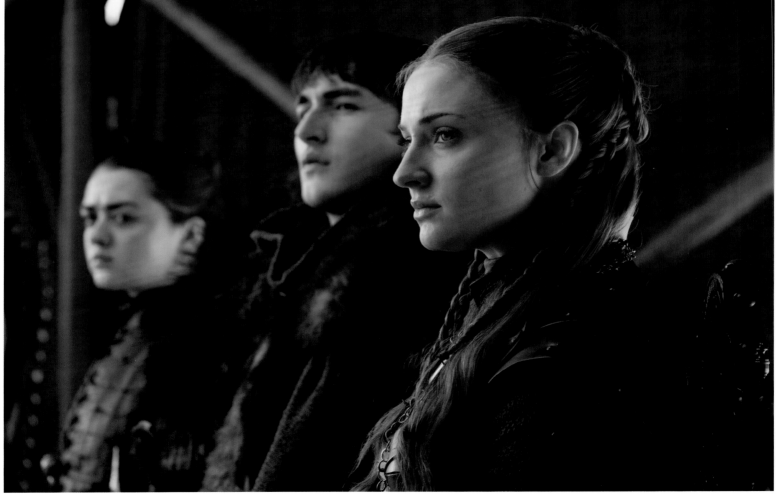

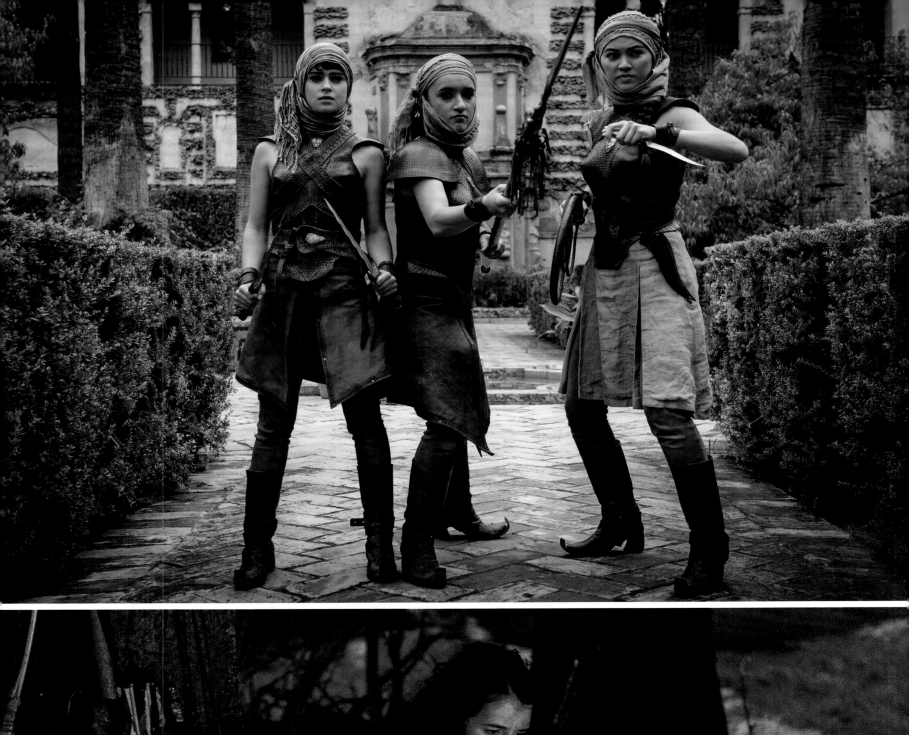
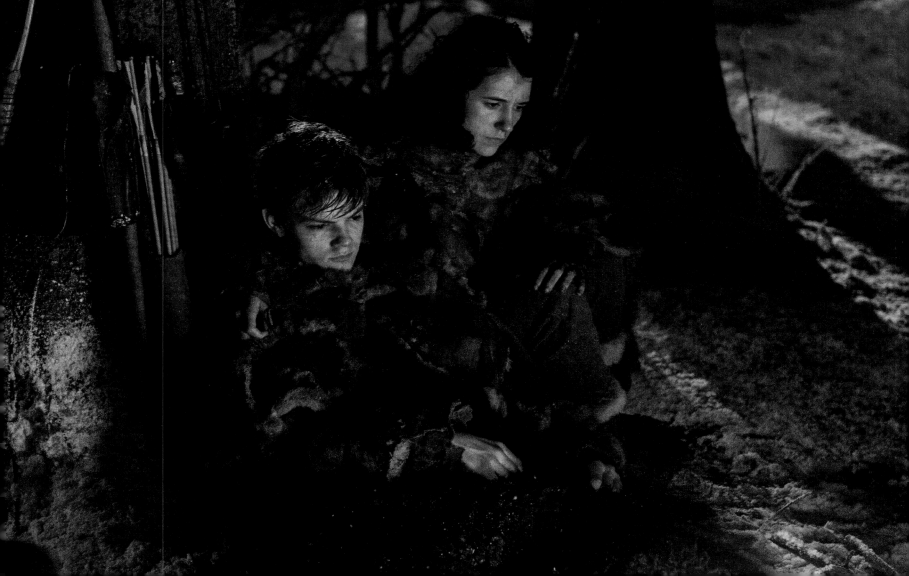

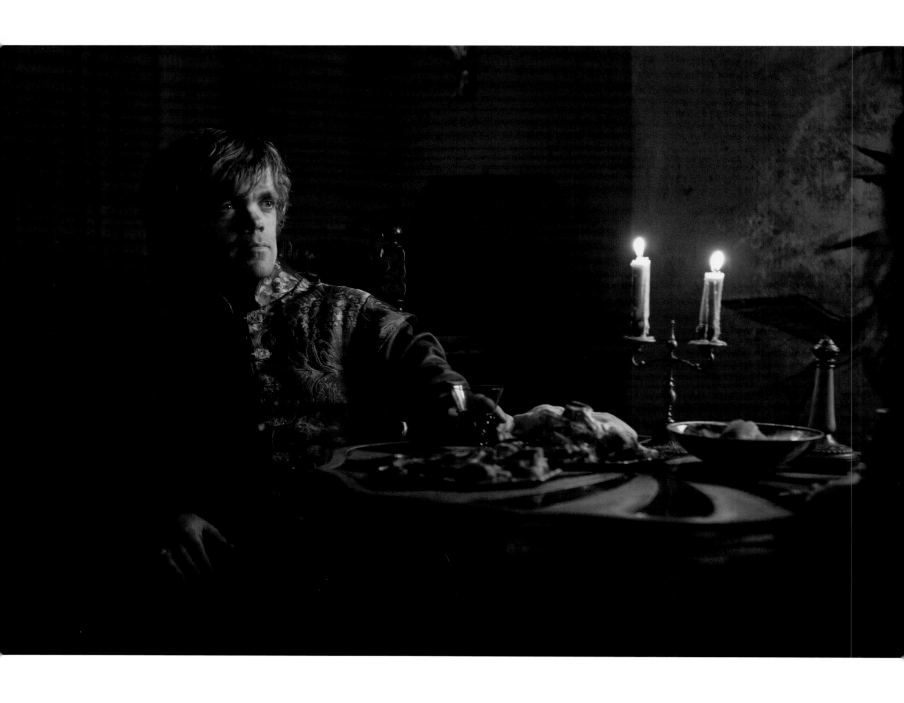

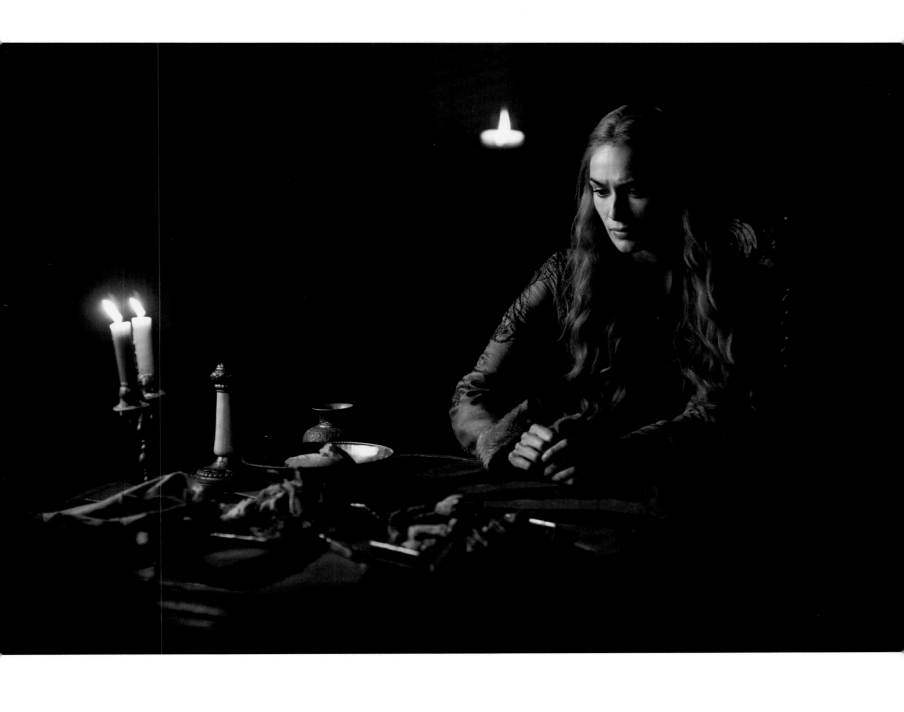

THESE PAGES: A conversation between siblings and bitter rivals: Tyrion and Cersei.
PAGES 112—113: Cersei and Jaime Lannister.

111

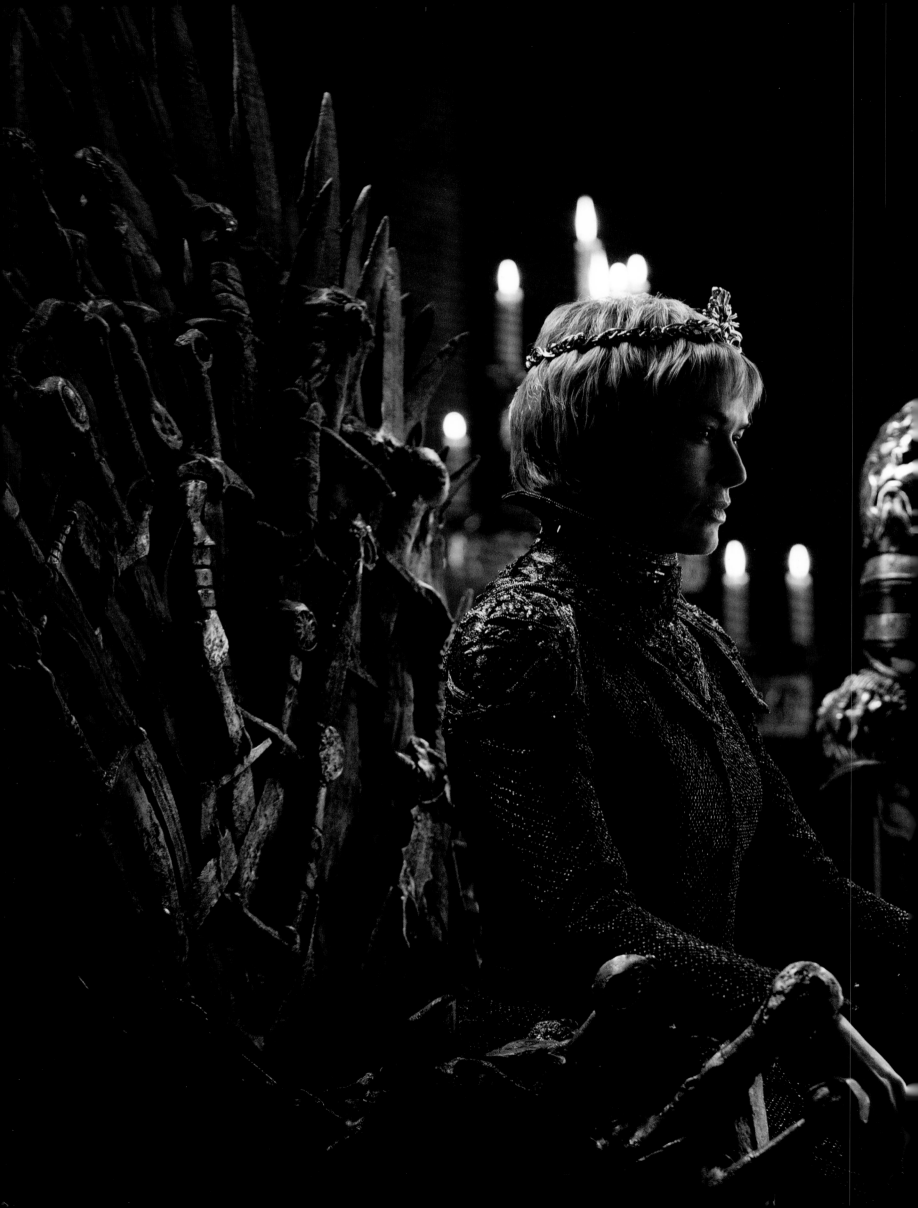

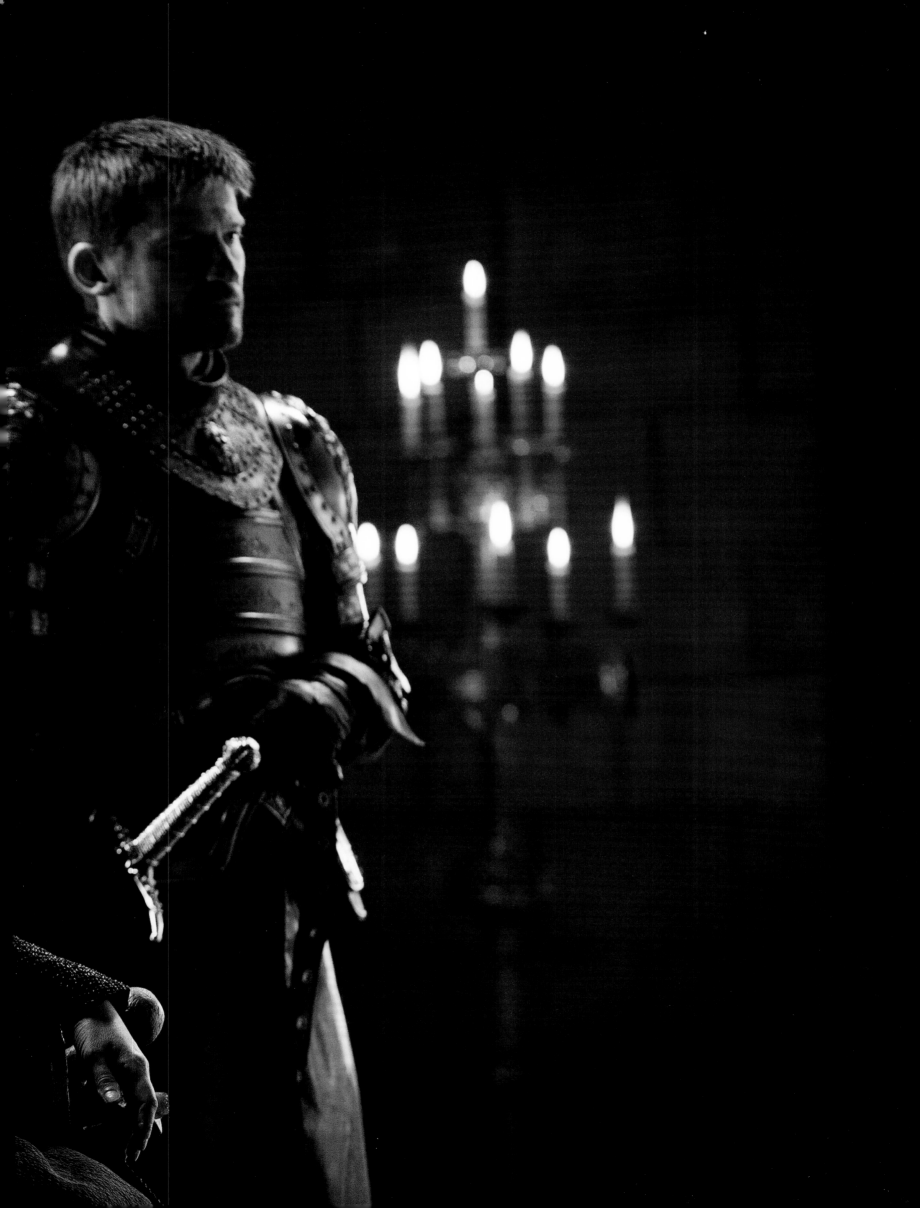

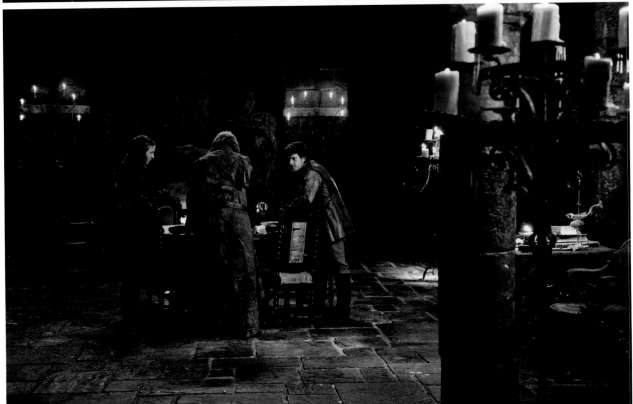

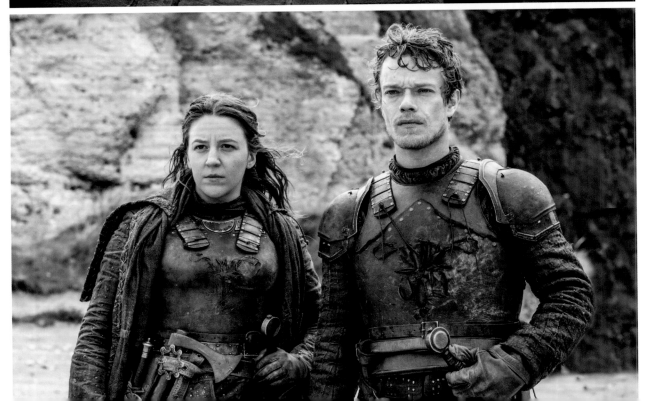

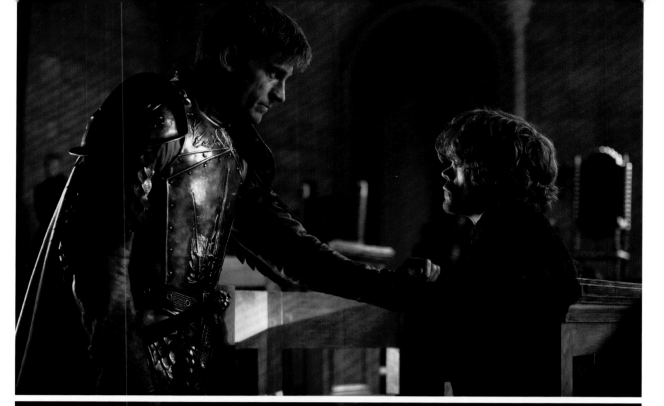

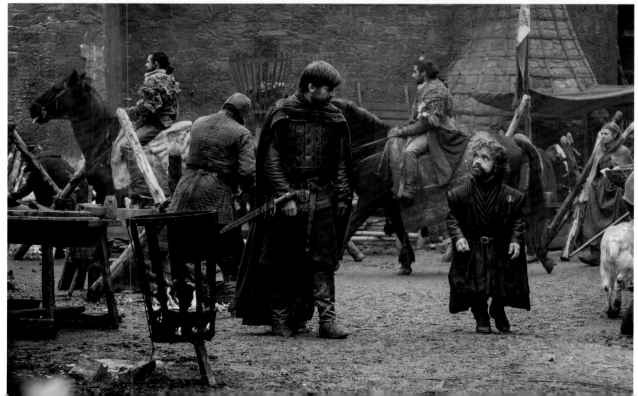

OPPOSITE: The Greyjoy siblings, Yara and Theon.
THIS PAGE: The Lannister brothers, Jaime and Tyrion.

115

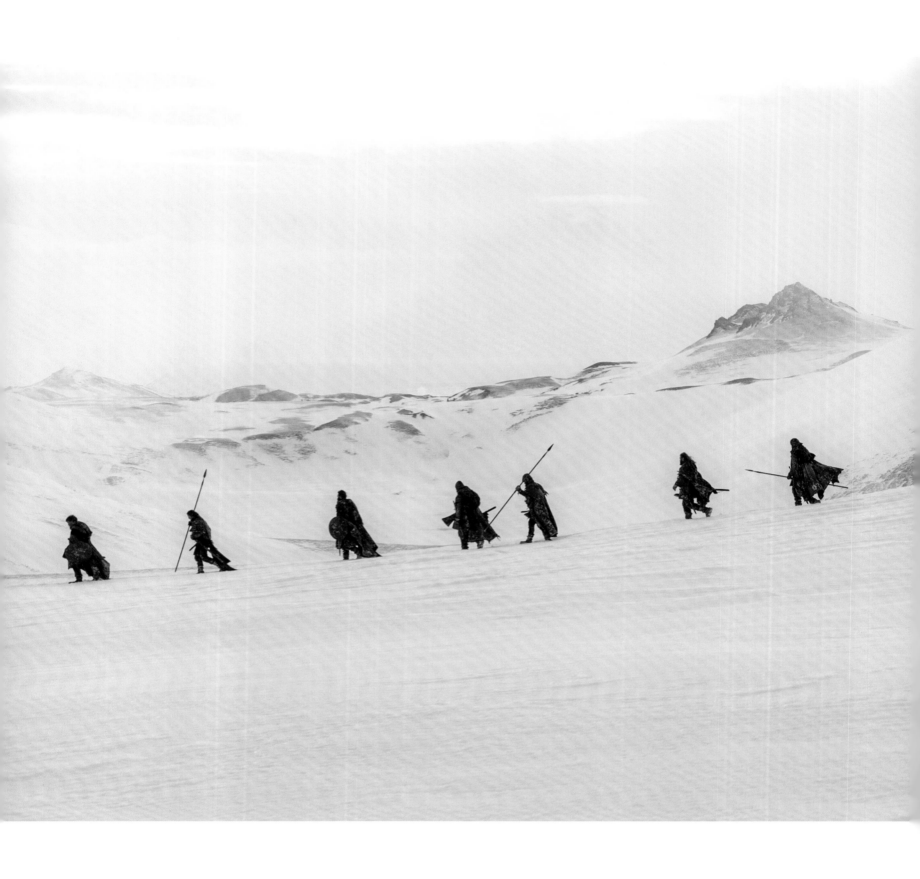

THESE PAGES: The Night's Watch journeys beyond the Wall.

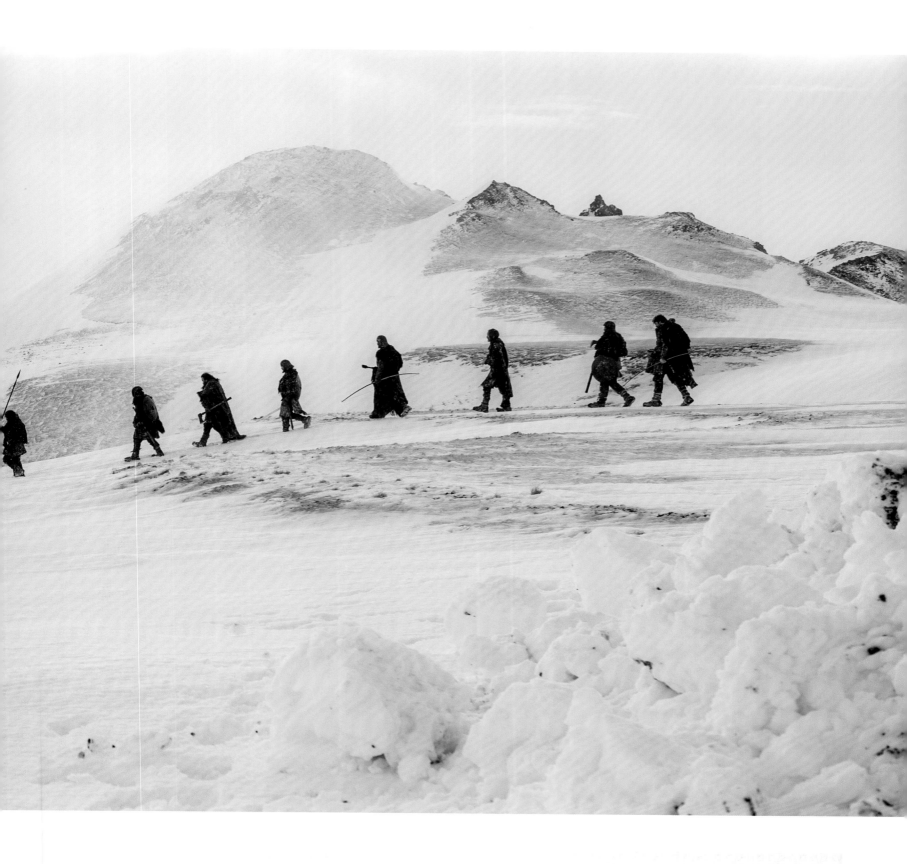

"Night gathers, and now my watch begins. It shall not end until my death. I shall take no wife, hold no lands, father no children. I shall wear no crowns and win no glory. I shall live and die at my post. I am the sword in the darkness. I am the watcher on the walls. I am the shield that guards the realm of men. I pledge my life and honor to the Night's Watch, for this night and all the nights to come." —The Night's Watch Oath

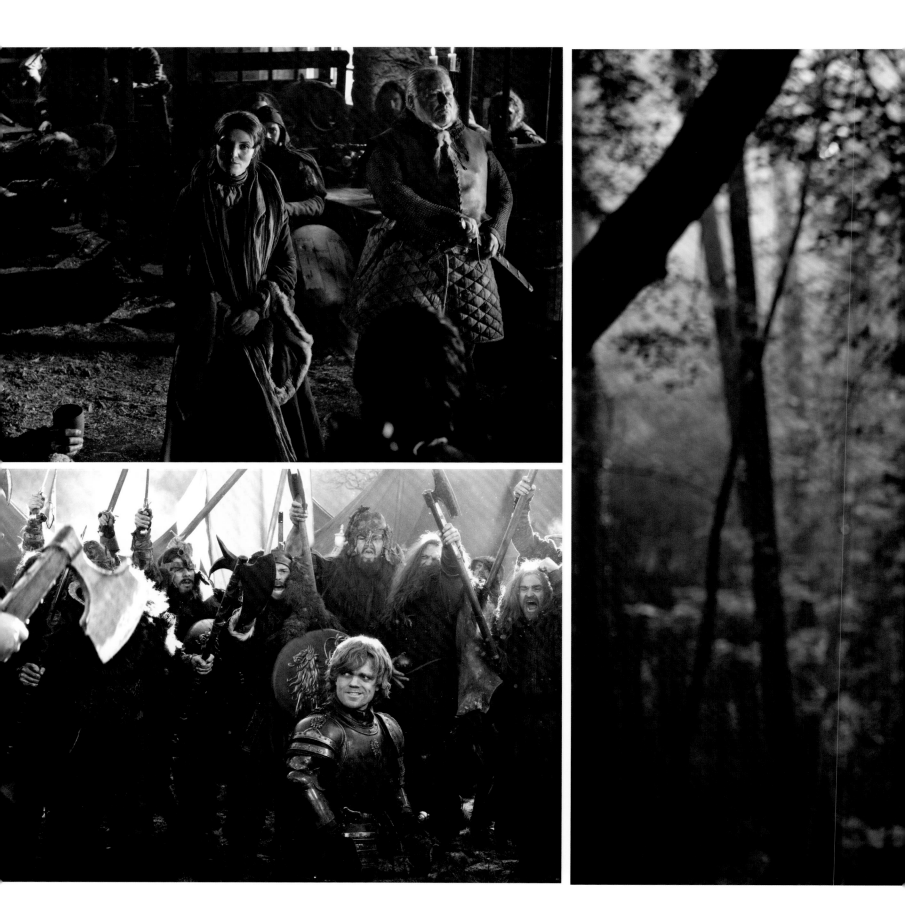

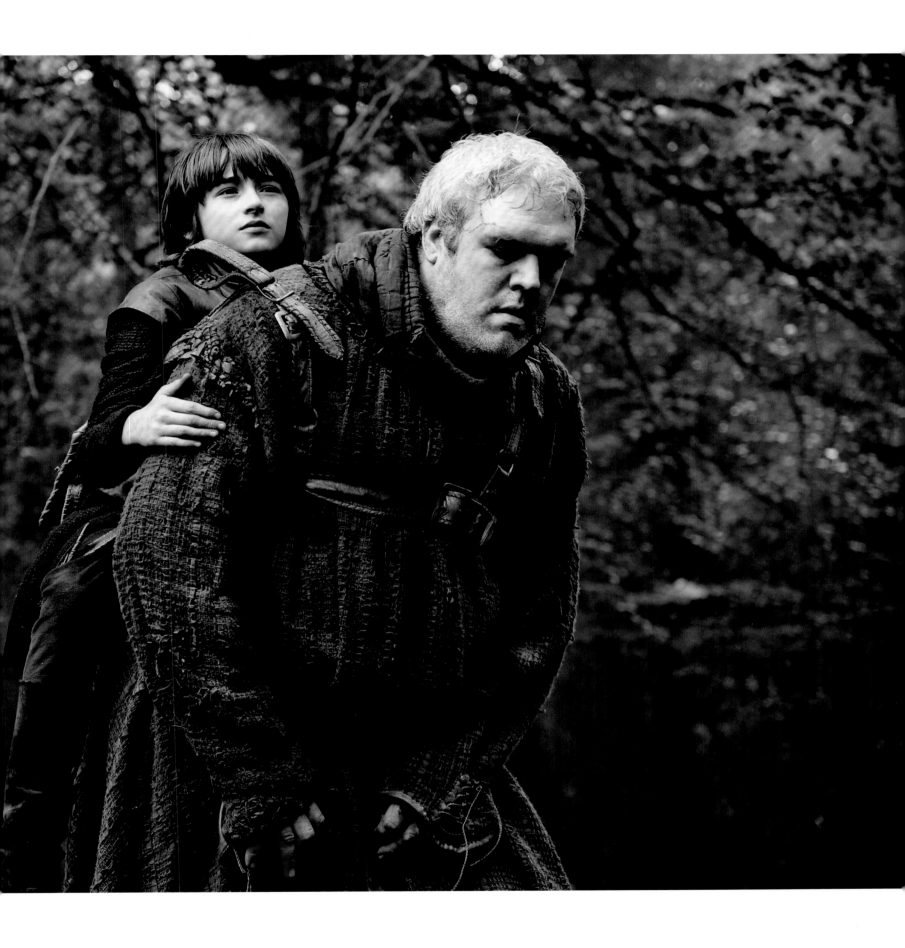

OPPOSITE TOP: Lady Stark.
OPPOSITE BOTTOM: Tyrion rallies the troops.
ABOVE: Bran and Hodor.

119

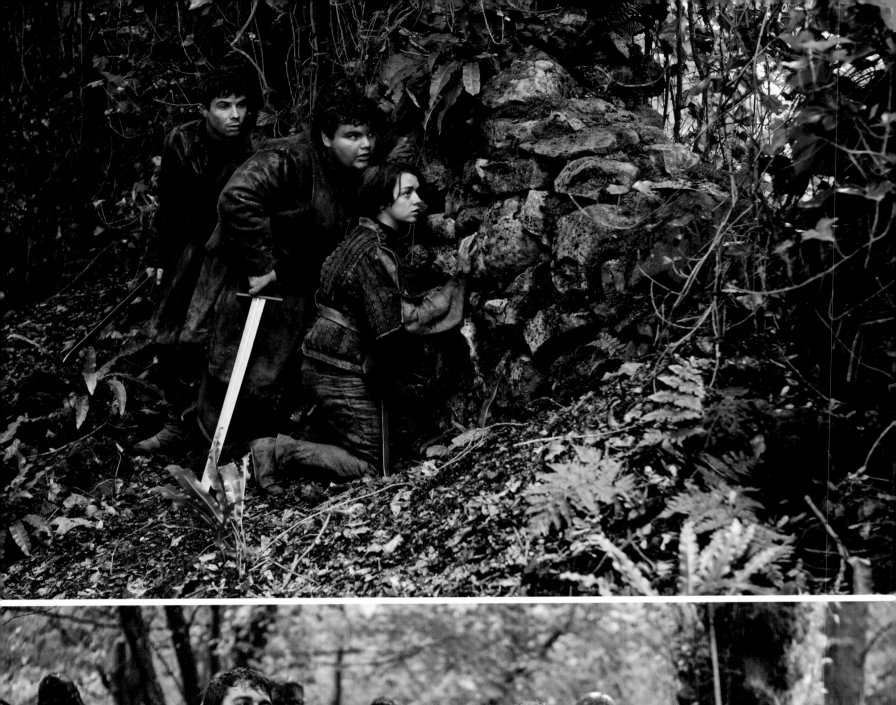
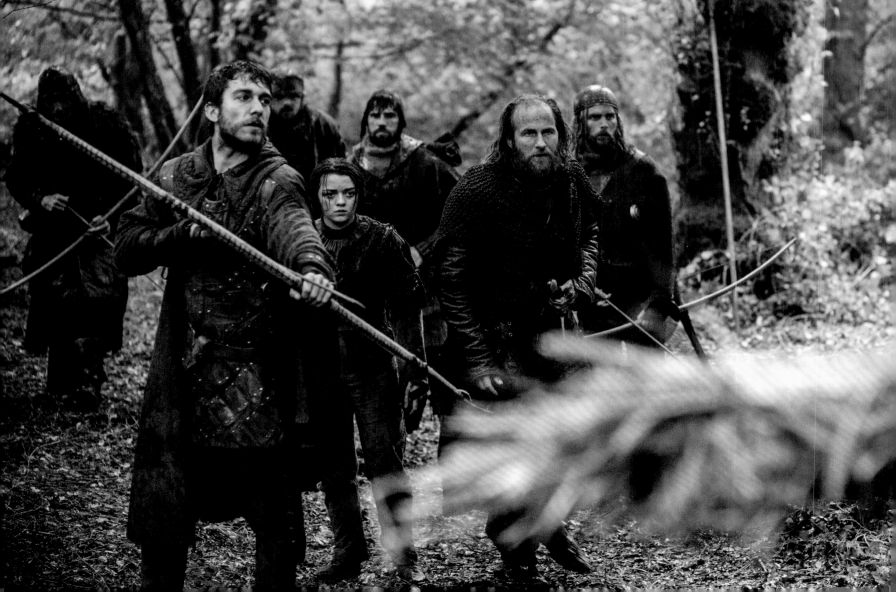

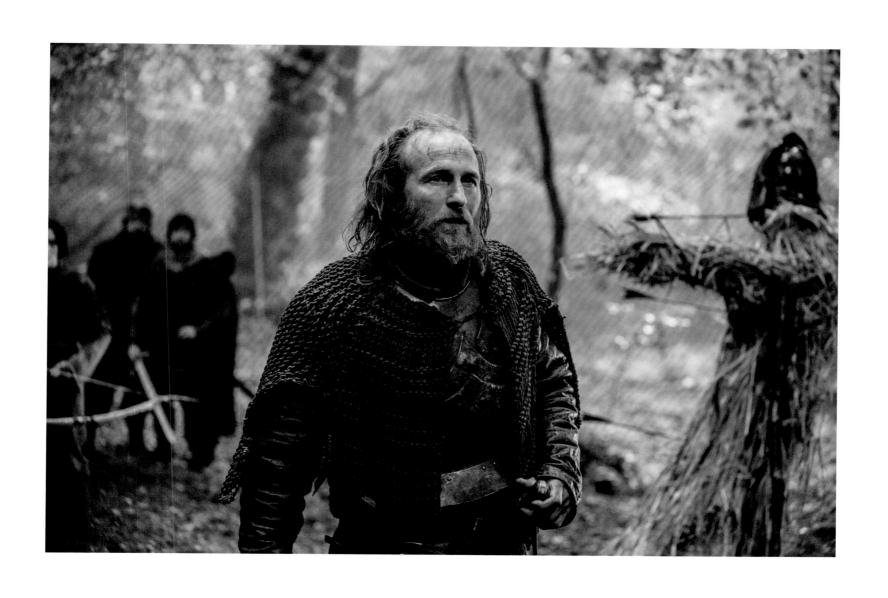

OPPOSITE: Arya Stark on the Kingsroad.
THIS PAGE: The Red Priest, Thoros of Myr.

121

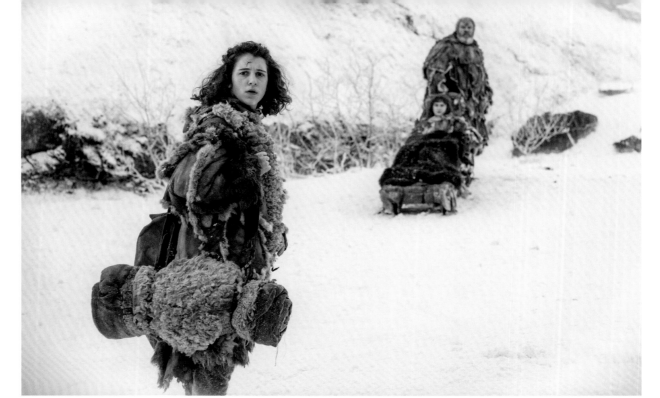

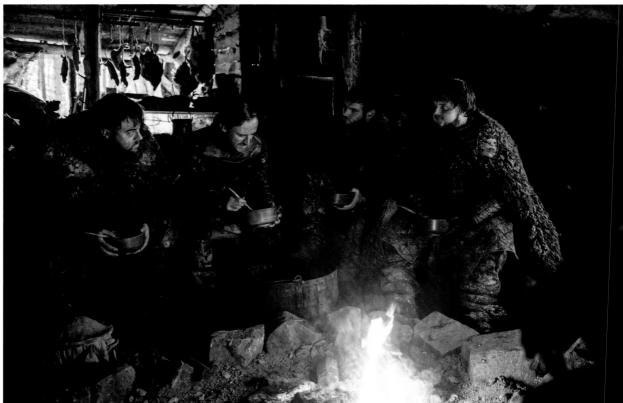

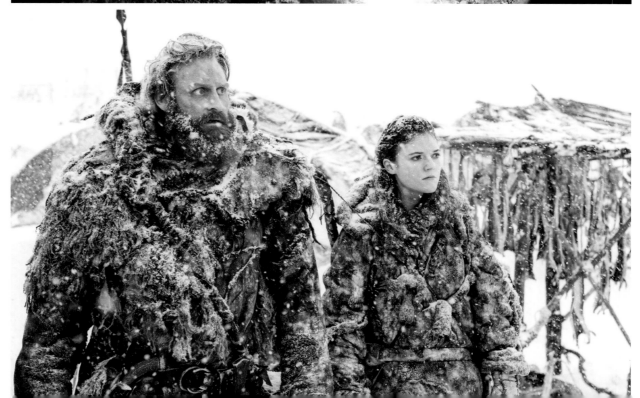

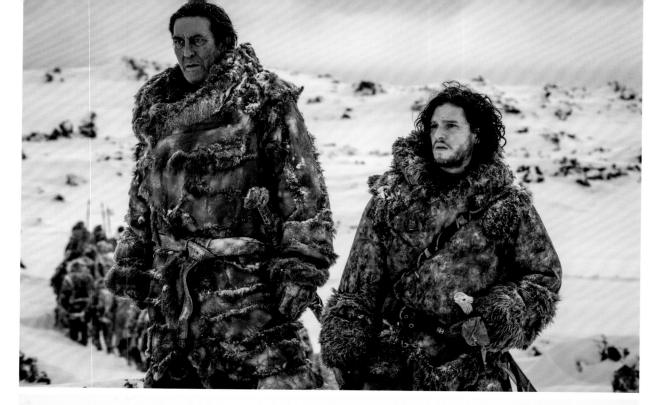

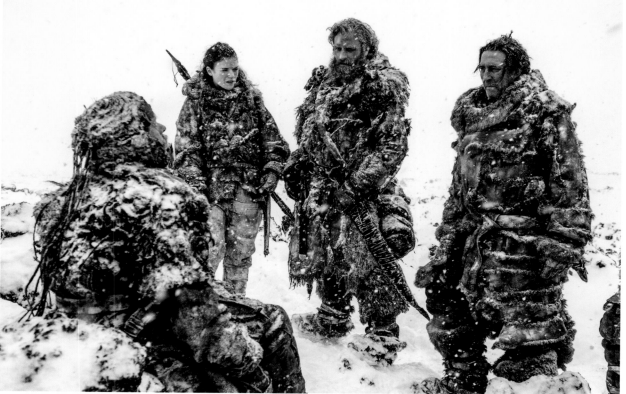

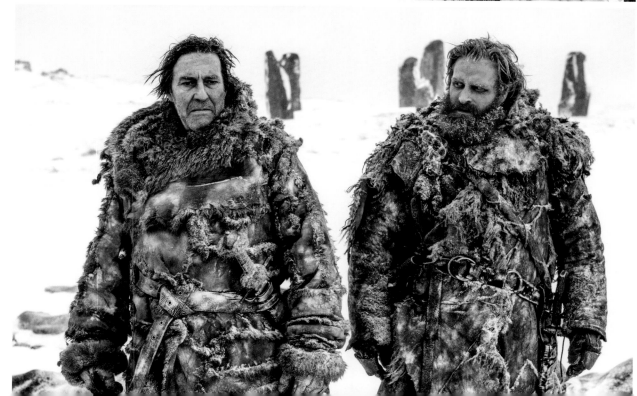

OPPOSITE TOP: Meera, Bran, and Hodor.

OPPOSITE CENTER: The Night's Watch.

OPPOSITE BOTTOM: Tormund Giantsbane and Ygritte of the Free Folk.

THIS PAGE: Jon Snow travels with Mance Rayder and the Free Folk. "I did love the rough textures of the wildlings," says Sloan. "Aesthetically speaking, I preferred shooting the colors, tones, and textures of the scenes beyond the Wall. If I had to wear a costume, it would be something like what the wildlings wore."

123

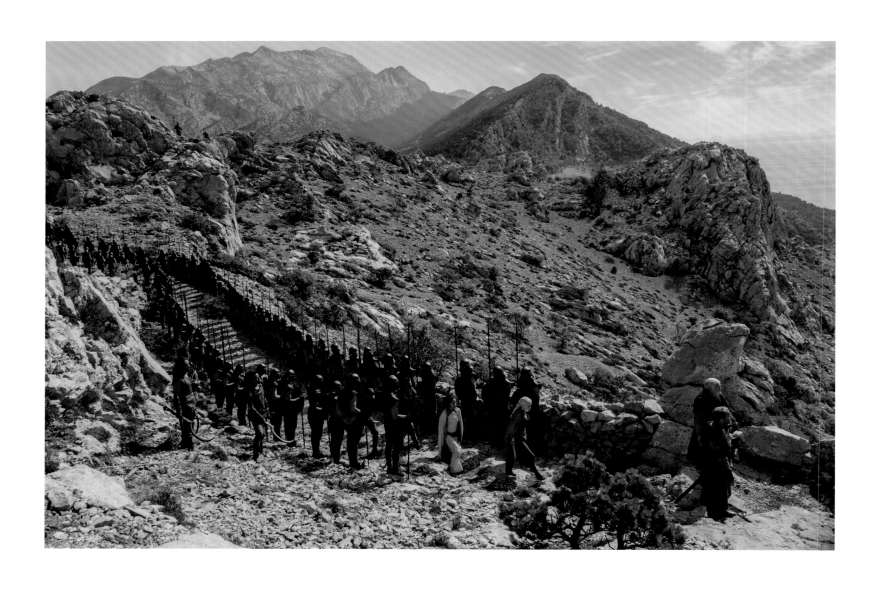

ABOVE: Daenerys and the Unsullied on the march to Meereen.
OPPOSITE: Nikolaj Coster-Waldau as Ser Jaime Lannister.

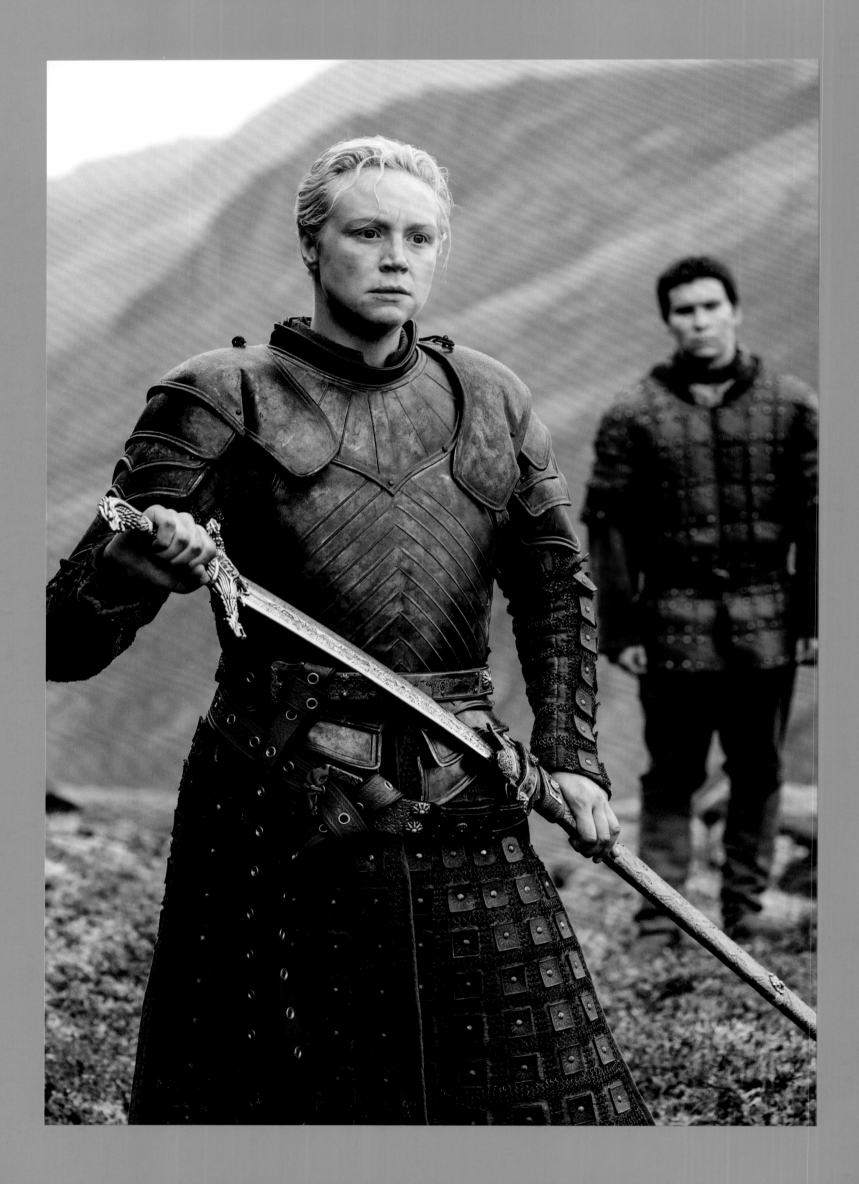

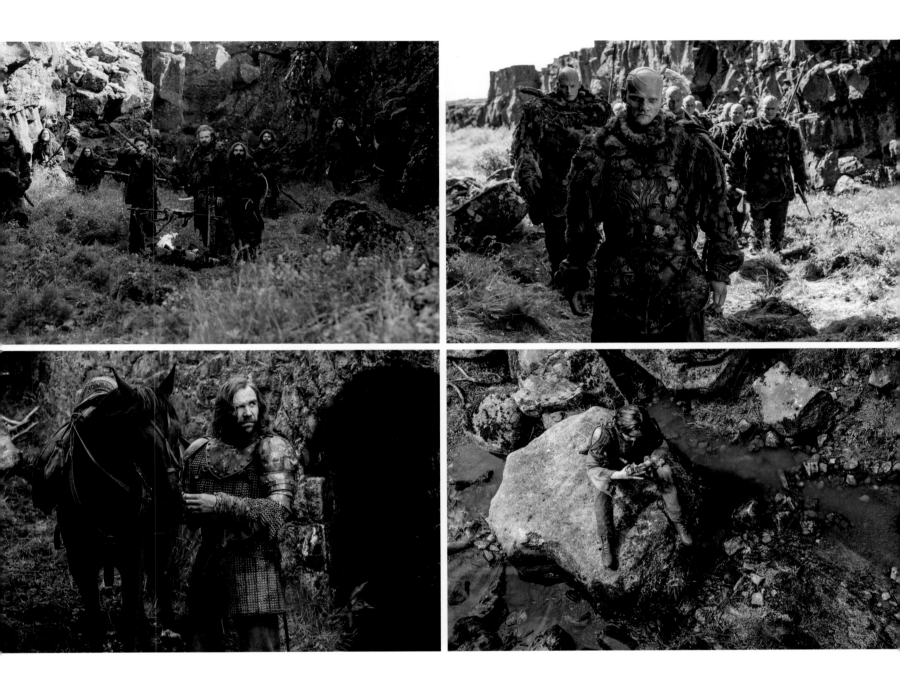

OPPOSITE: Brienne of Tarth and her squire, Podrick.
TOP ROW: A band of Free Folk led by Tormund meet with a band of Thenns sent by Mance Rayder.
BOTTOM ROW: The Hound and Arya.

127

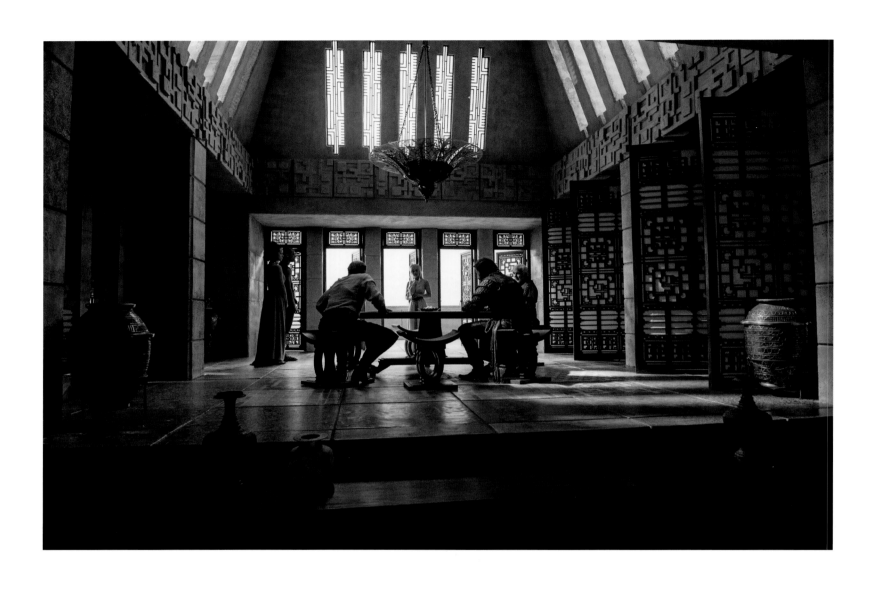

ABOVE: Daenerys and her council.
OPPOSITE: Ser Davos advises Stannis.

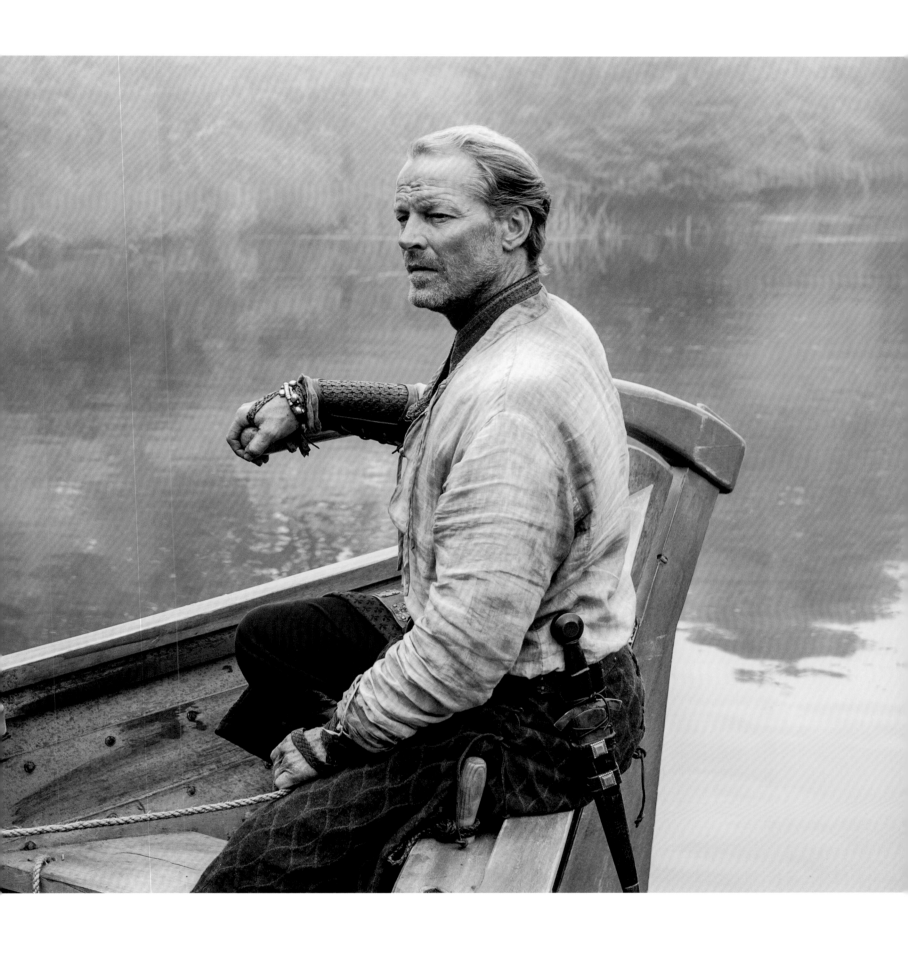

THESE PAGES: Iain Glen as Ser Jorah Mormont.

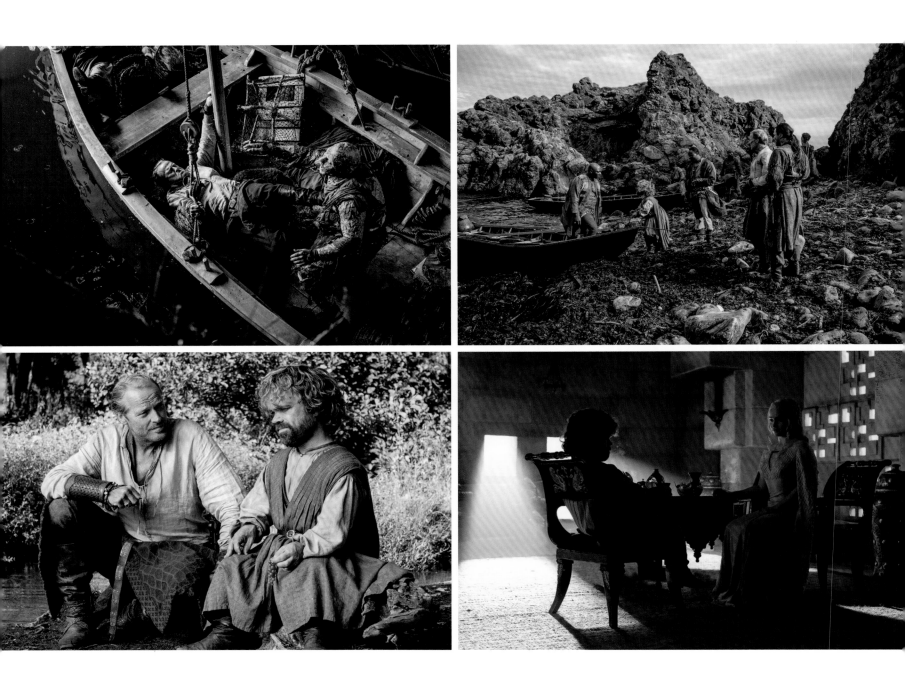

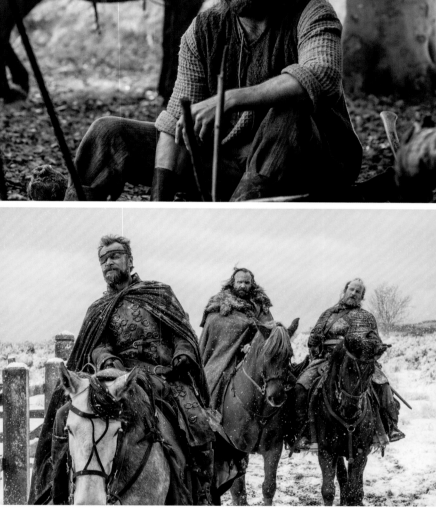

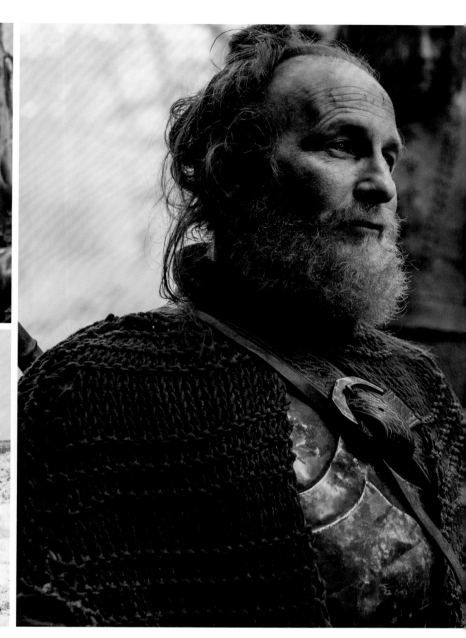

OPPOSITE: Ser Jorah and Tyrion's dangerous journey to meet with Daenerys Targaryen.
THIS PAGE: Sandor Clegane and the Brotherhood Without Banners.

133

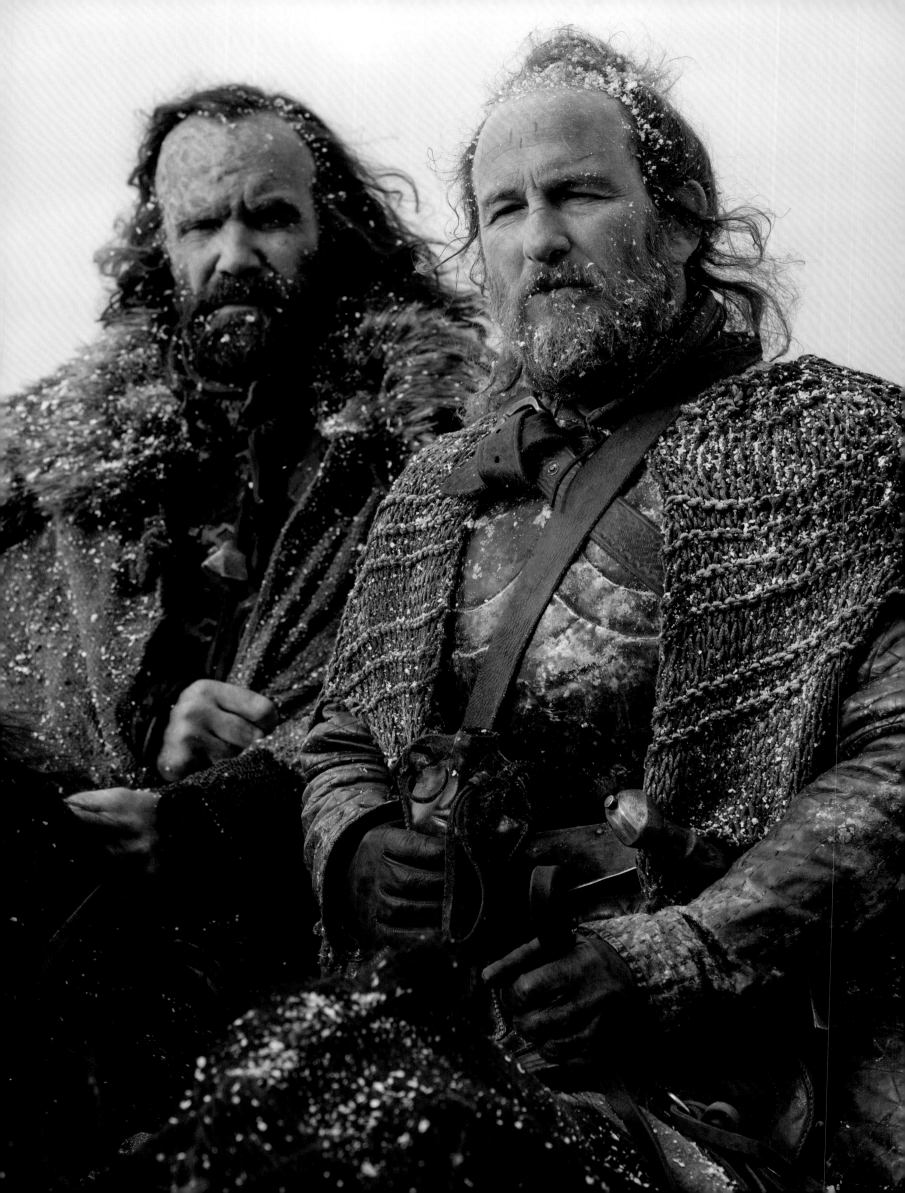

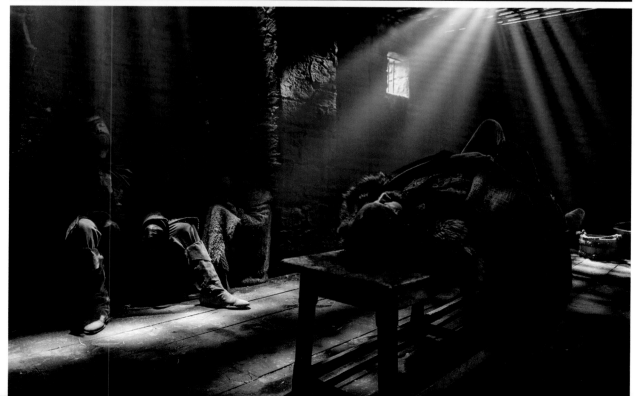

THESE PAGES: The Hound, Thoros of Myr, Beric Dondarrion, Tormund Giantsbane, Ser Davos Seaworth, and Ser Jorah Mormont at Eastwatch-by-the-Sea before embarking on the wight hunt.

135

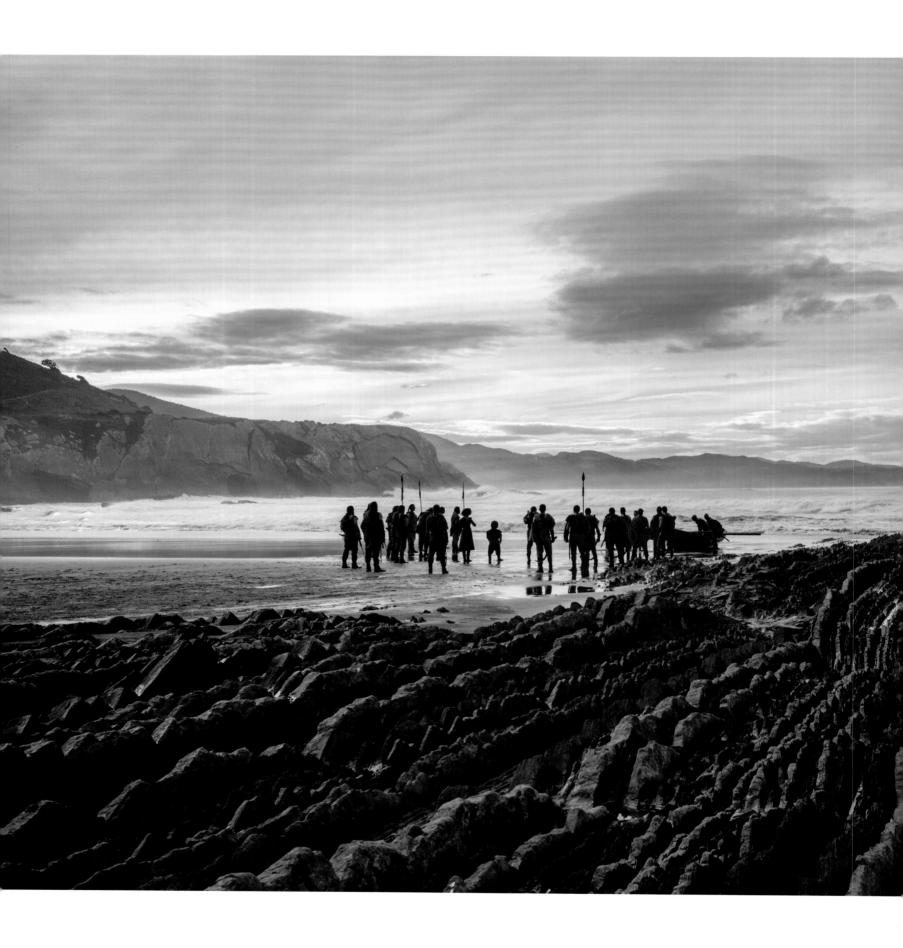

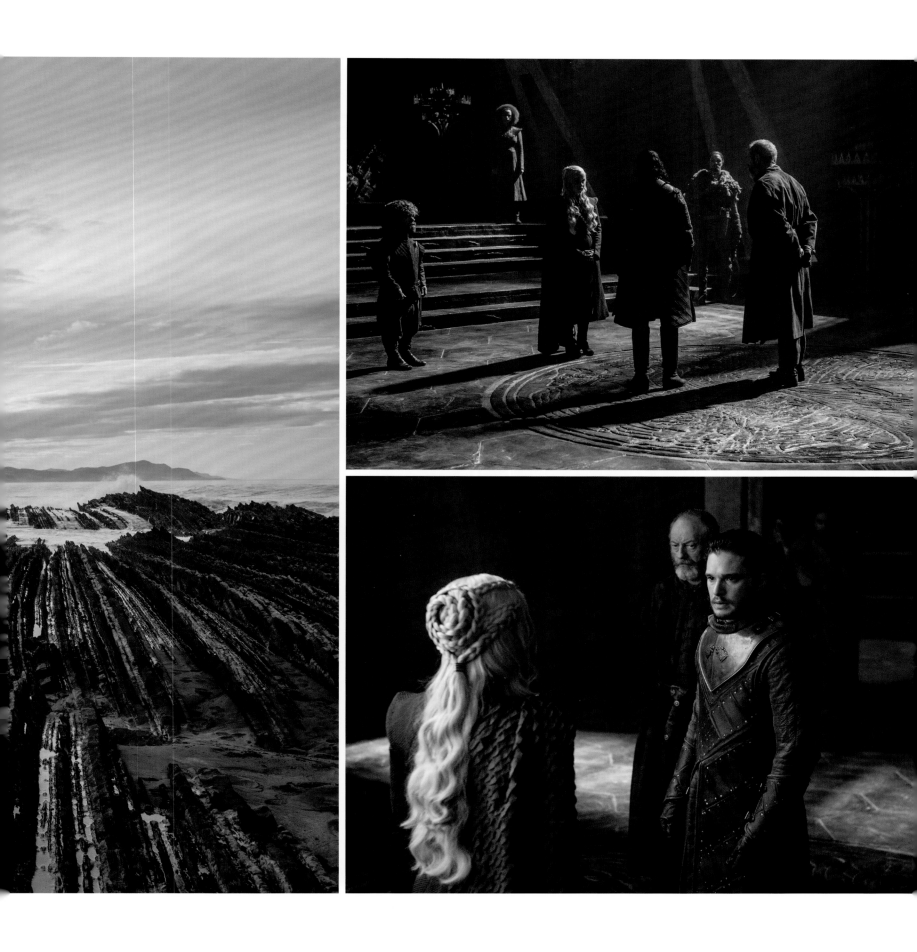

LEFT: Jon Snow arrives at Dragonstone.
ABOVE: Daenerys meets with Jon Snow and commands him to bend the knee to her.

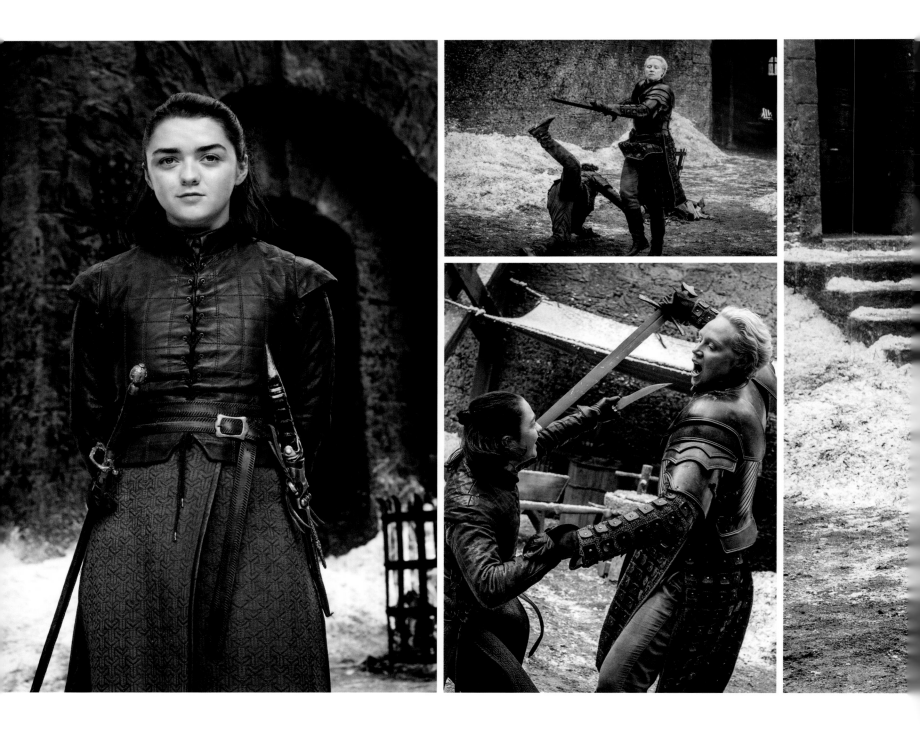

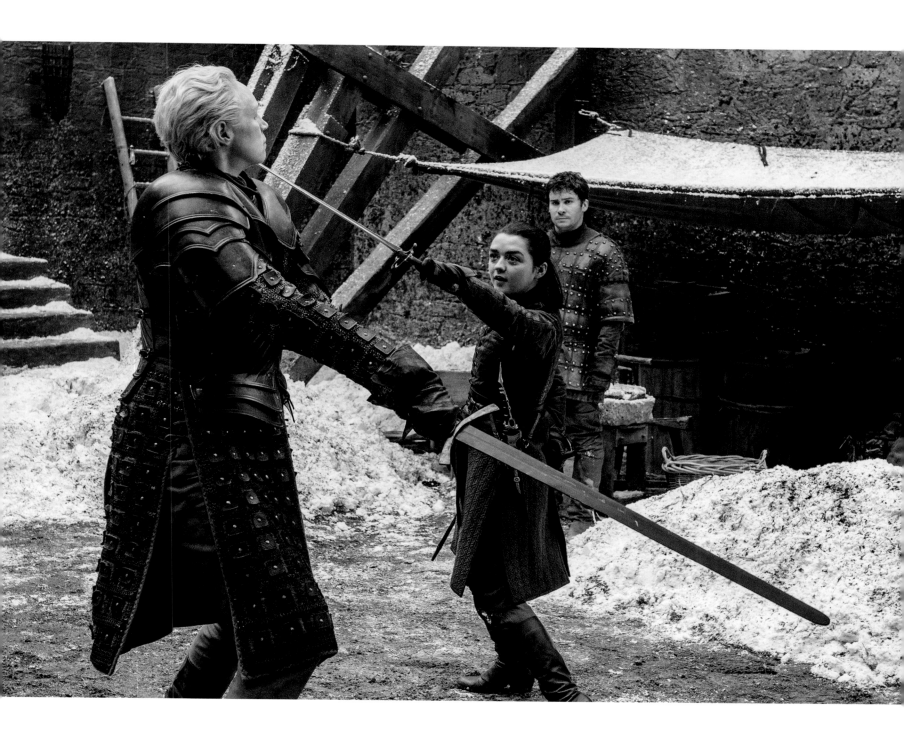

THESE PAGE: Arya Stark returns to Winterfell a vastly different person, displaying her new skills as she spars with Brienne of Tarth. "It's often more difficult to shoot in close quarters like this because you have less room to get the close-ups you want," Helen Sloan says of shooting more intimate one-on-one skirmishes. "I have to work with the camera department to make sure I don't interfere with their shot."

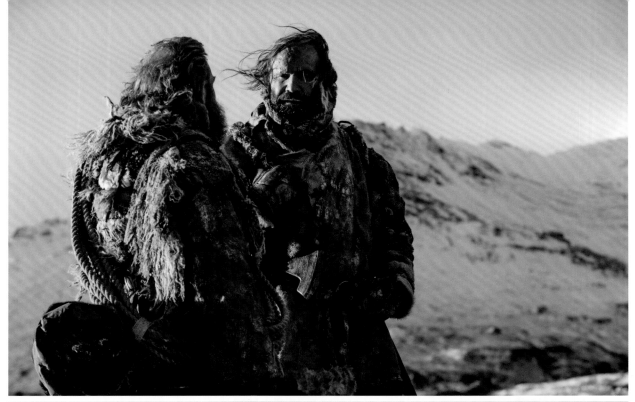

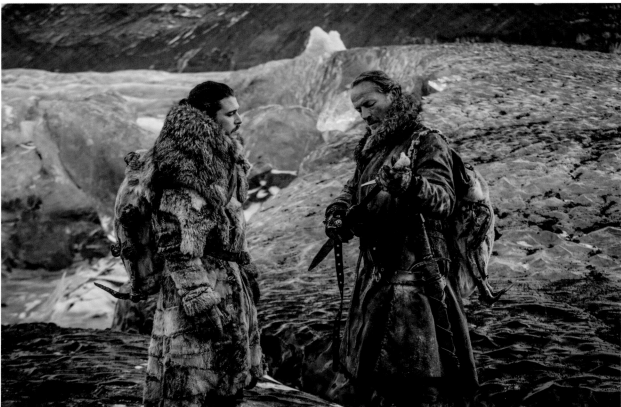

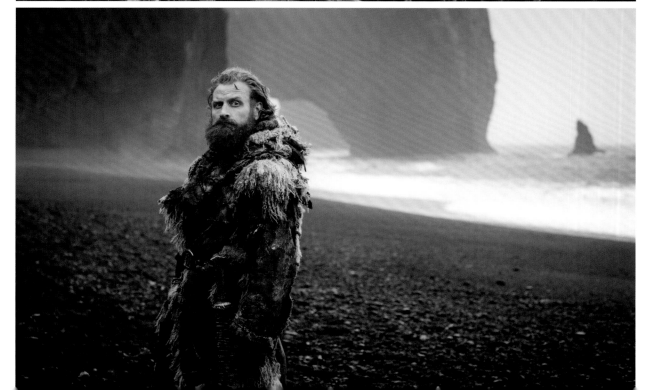

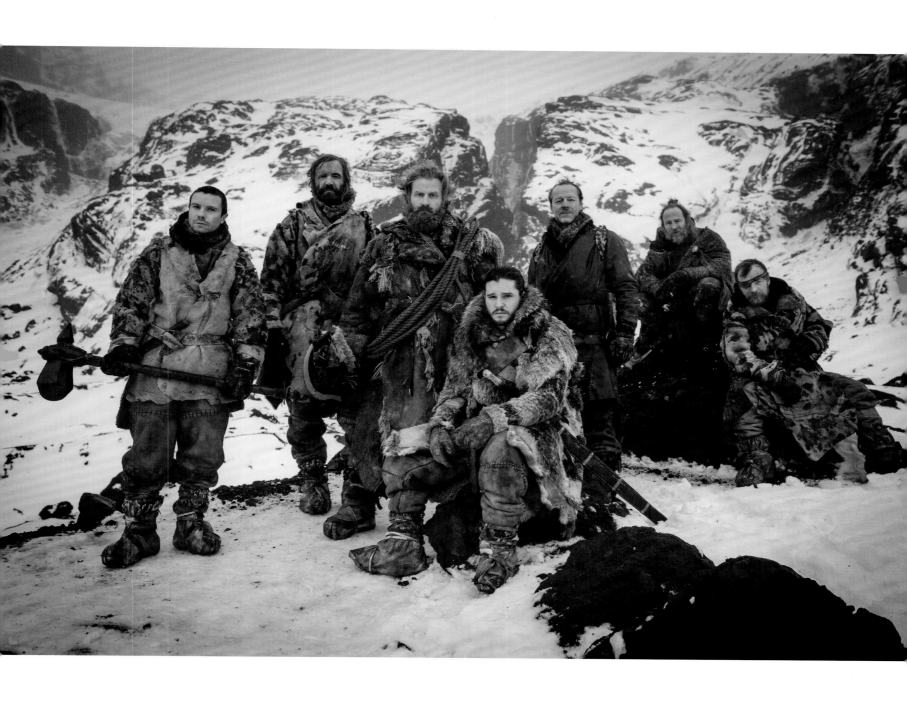

OPPOSITE: The members of the wight hunt travel beyond the Wall.
ABOVE: Jon Snow leads his expedition to find a wight and bring it back to the Seven Kingdoms.

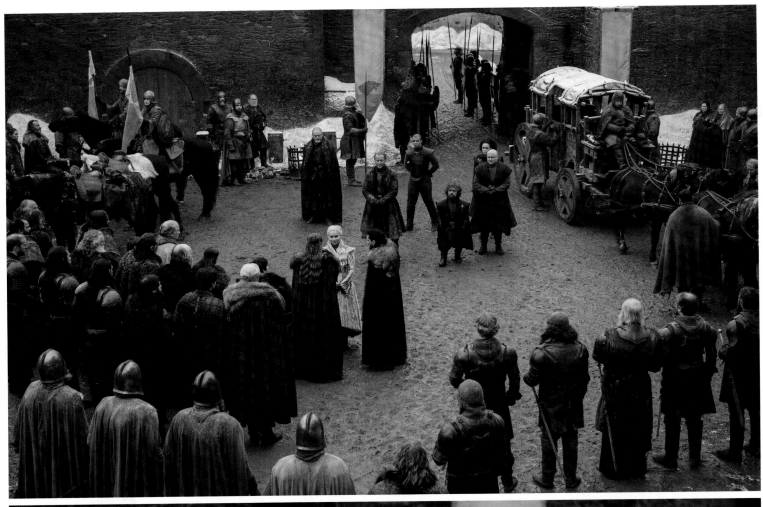

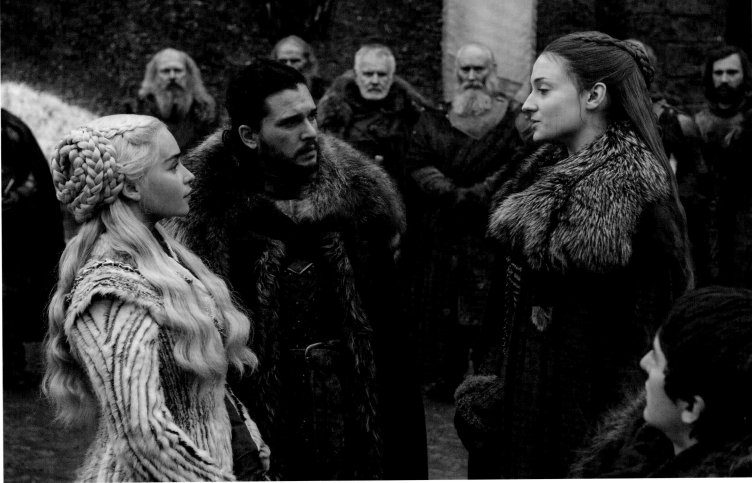

THIS PAGE: Daenerys arrives at Winterfell, accompanied by Jon Snow, and meets Sansa Stark.
OPPOSITE: Tyrion Lannister, the new Hand of King Bran, convenes the small council.

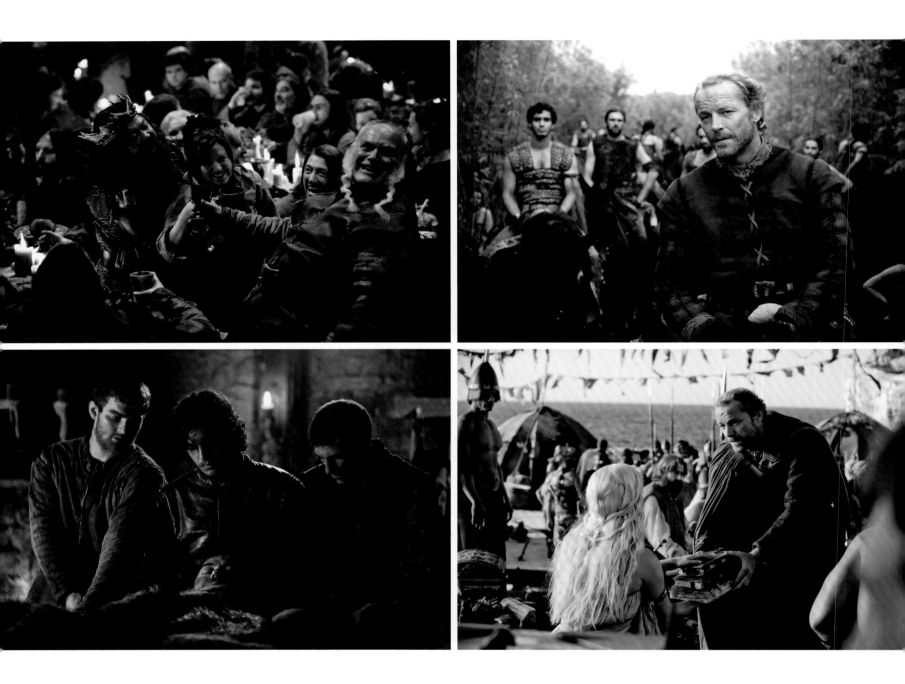

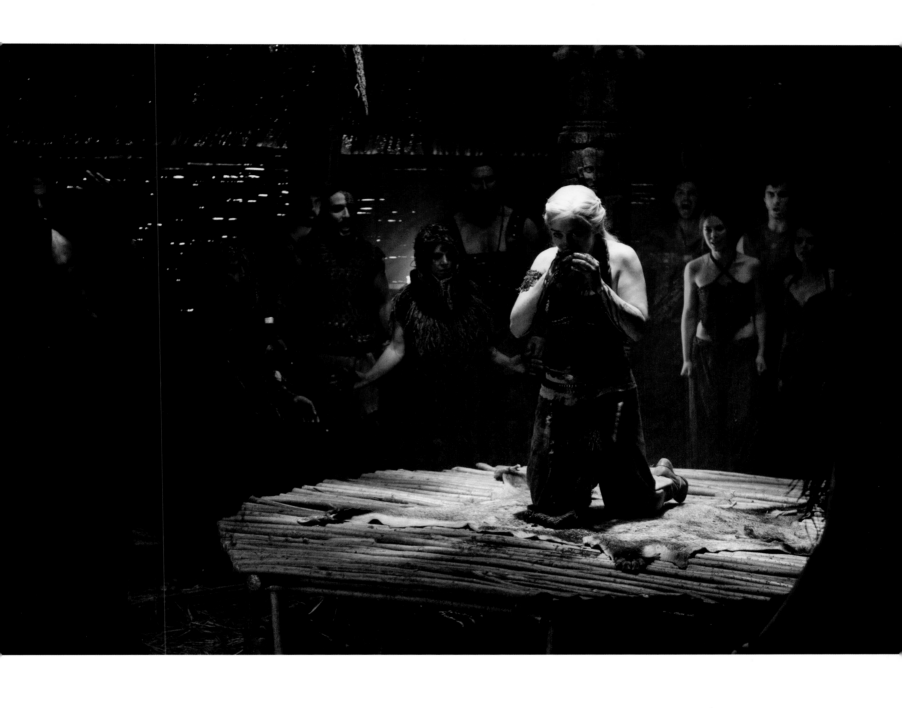

OPPOSITE TOP LEFT: King Robert celebrates at Winterfell.
OPPOSITE BOTTOM LEFT: Jon Snow and the Night's Watch confront Rast.
OPPOSITE TOP RIGHT AND OPPOSITE BOTTOM RIGHT: Ser Jorah meets Daenerys beyond the Narrow Sea in Essos.
ABOVE: Daenerys eats a stallion's heart to prove her mettle.

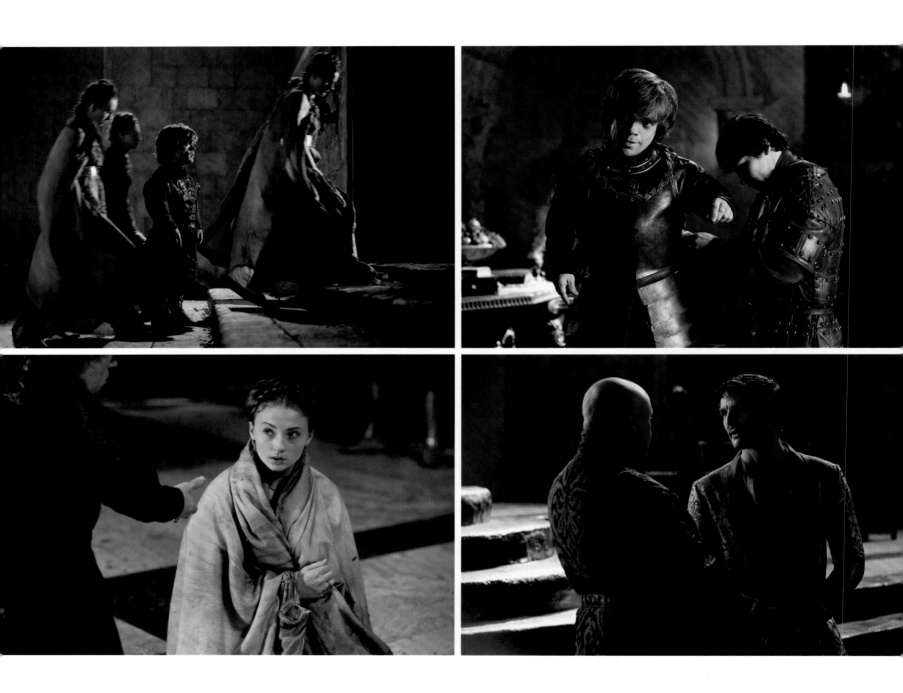

TOP LEFT AND BOTTOM LEFT: Tyrion leads Sansa to safety after Joffrey's cruelty.
TOP RIGHT: Tyrion's loyal squire, Podrick, helps him with his armor before combat.
BOTTOM RIGHT: The Spider and the Red Viper in discussion.
OPPOSITE TOP: Stannis and Melisandre.
OPPOSITE CENTER AND OPPOSITE BOTTOM: Jon Snow is taken into Castle Black after being injured by Ygritte.

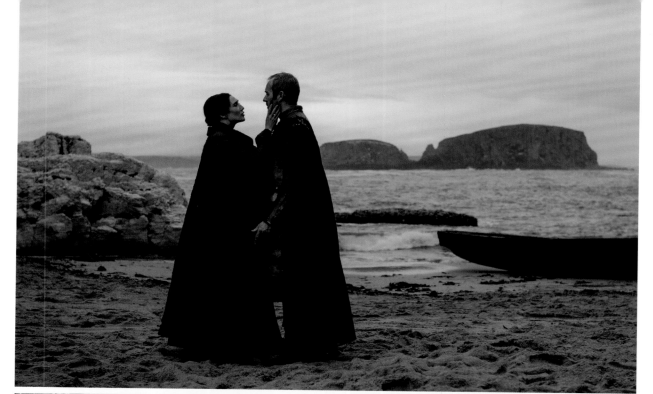

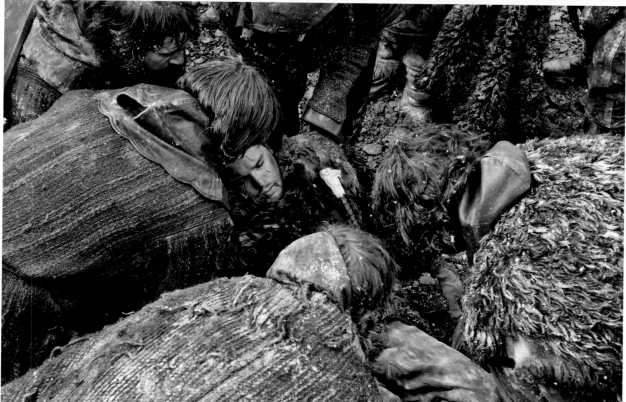

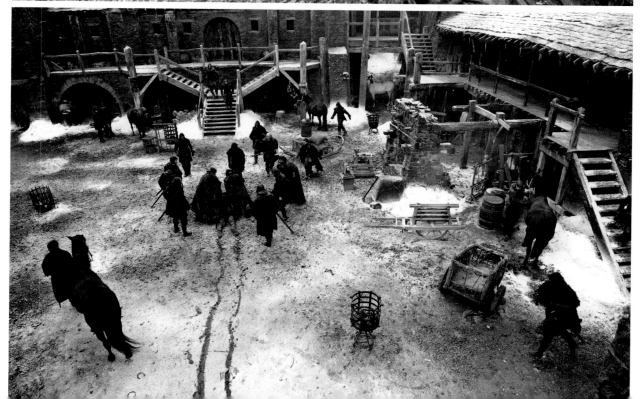

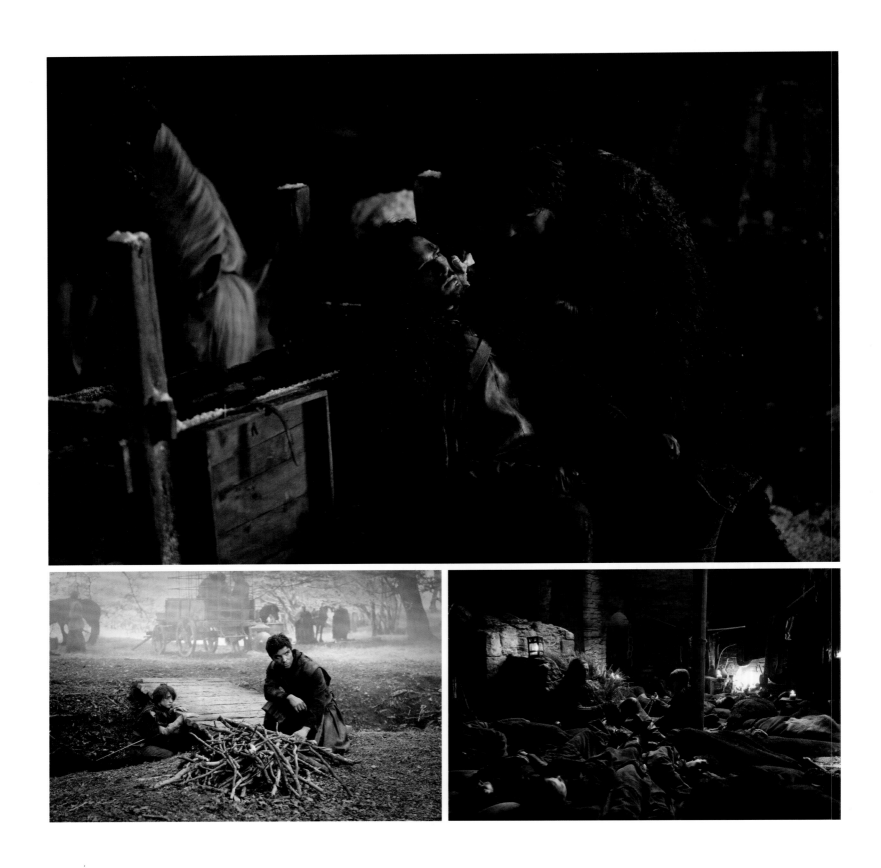

TOP: Sam tends to Jon's injuries.
ABOVE LEFT: Gendry and Arya.
ABOVE RIGHT: Arya and Yoren speak late at night. Arya is disguised as a boy and a recruit for the Night's Watch.
OPPOSITE TOP: Jon Snow faces judgment at Castle Black for killing a fellow member of the Watch.
OPPOSITE BOTTOM: Maester Aemon.

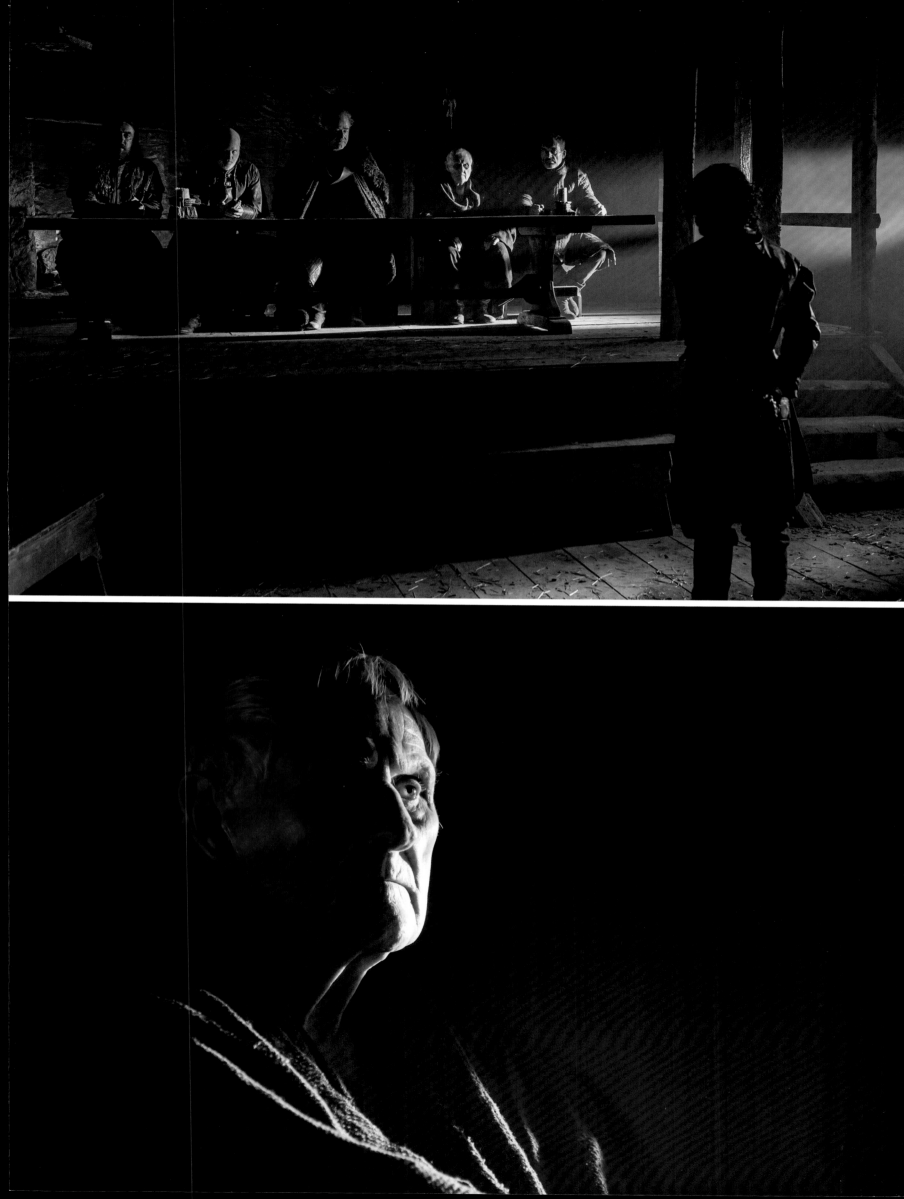

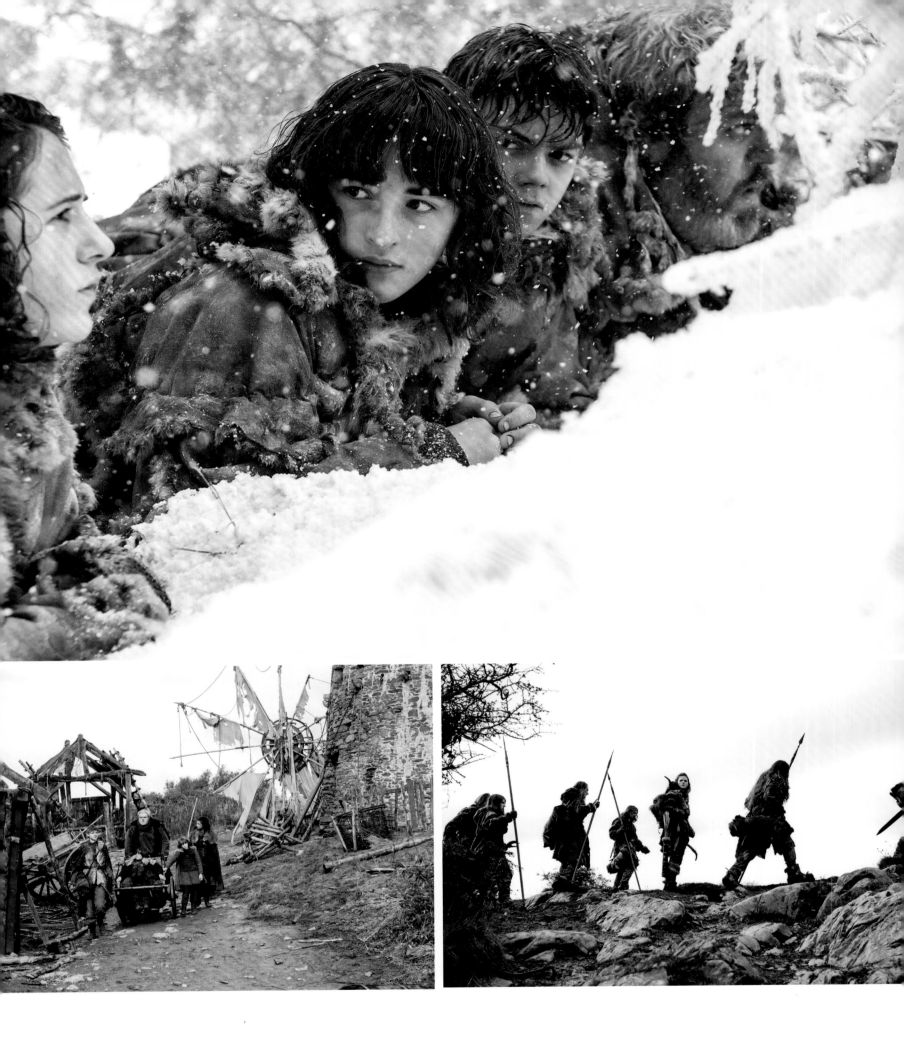

TOP AND BOTTOM LEFT: Bran, the Reed siblings, and Hodor on their journey.
BOTTOM RIGHT: Ygritte and the Free Folk.
OPPOSITE: Jon, Grenn, Dolorous Edd, and other men of the Night's Watch.

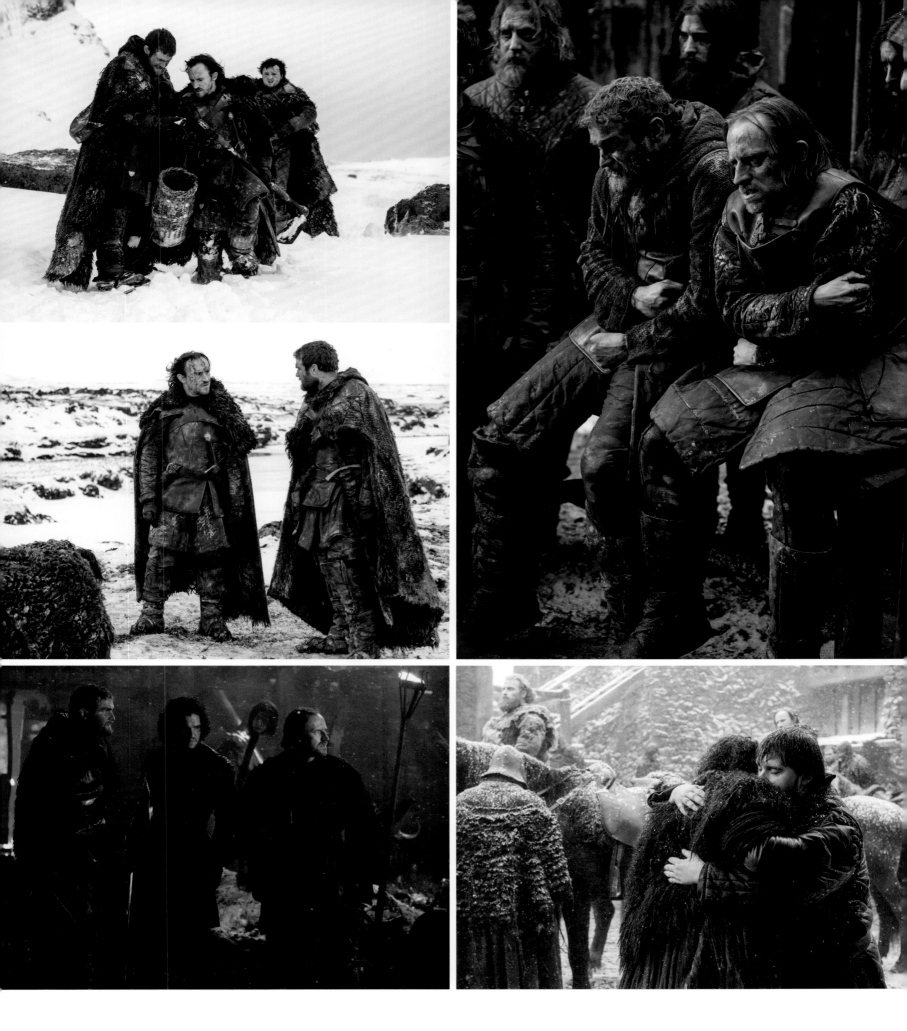

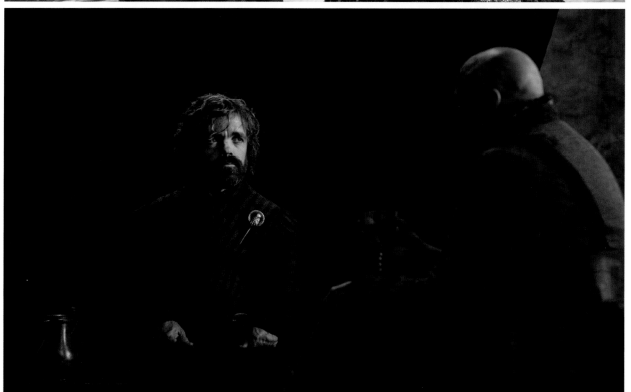

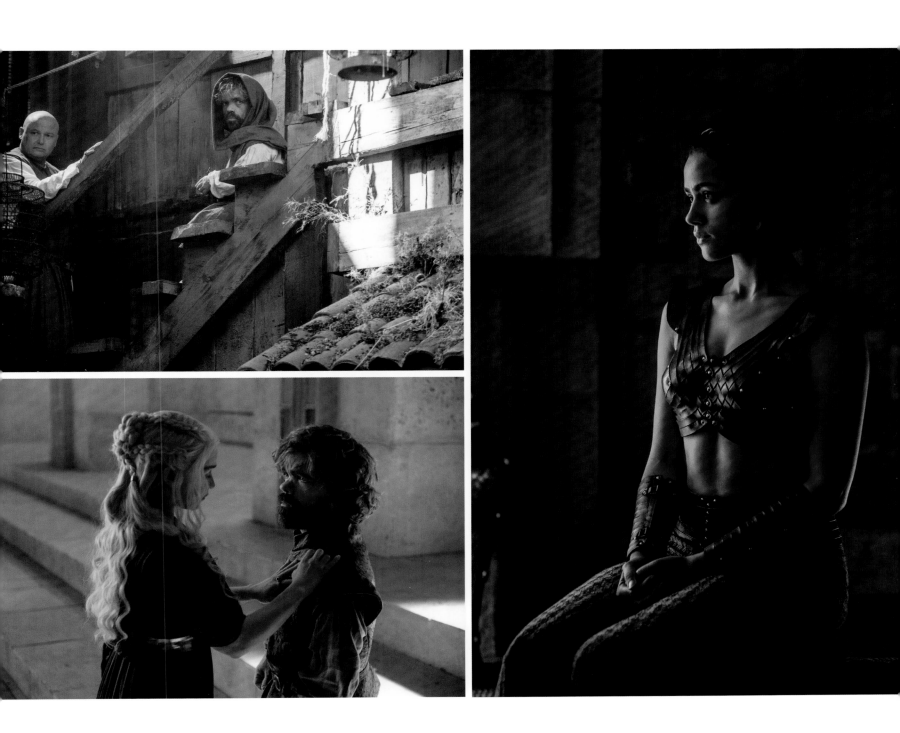

OPPOSITE TOP AND OPPOSITE CENTER: Sansa and Theon make their escape from Ramsay Bolton.
OPPOSITE BOTTOM AND TOP LEFT: Varys and Tyrion ponder the future of Westeros.
BOTTOM LEFT: Daenerys names Tyrion her Hand.
ABOVE: Missandei, Daenerys's closest friend and confidante.

153

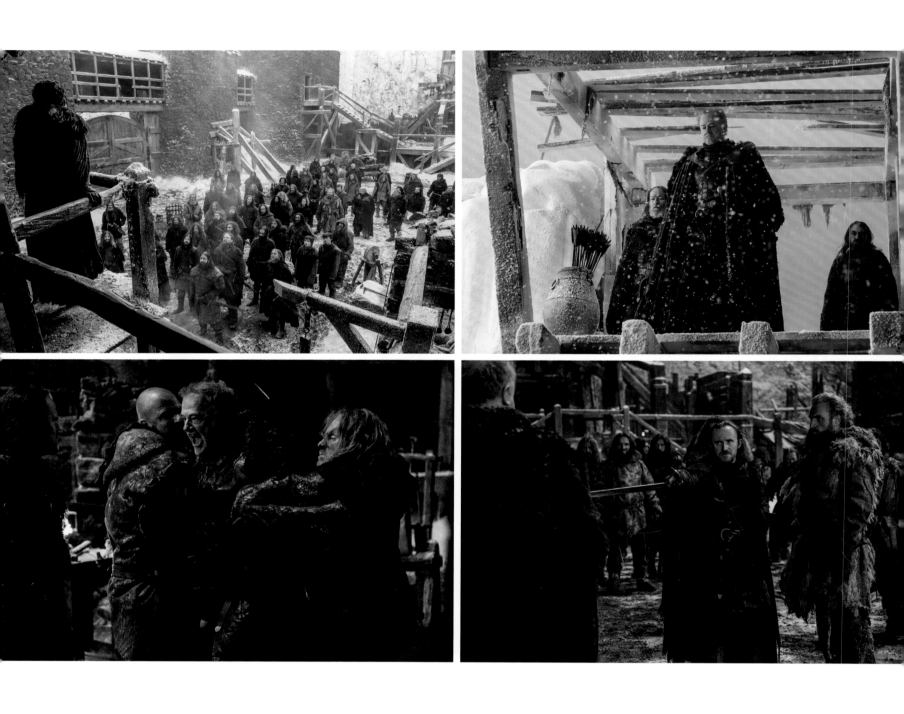

THIS PAGE: First Ranger Alliser Thorne is hanged for betraying and killing Jon Snow.
OPPOSITE: Eddison Tollett meets Meera and Bran at the base of the Wall.

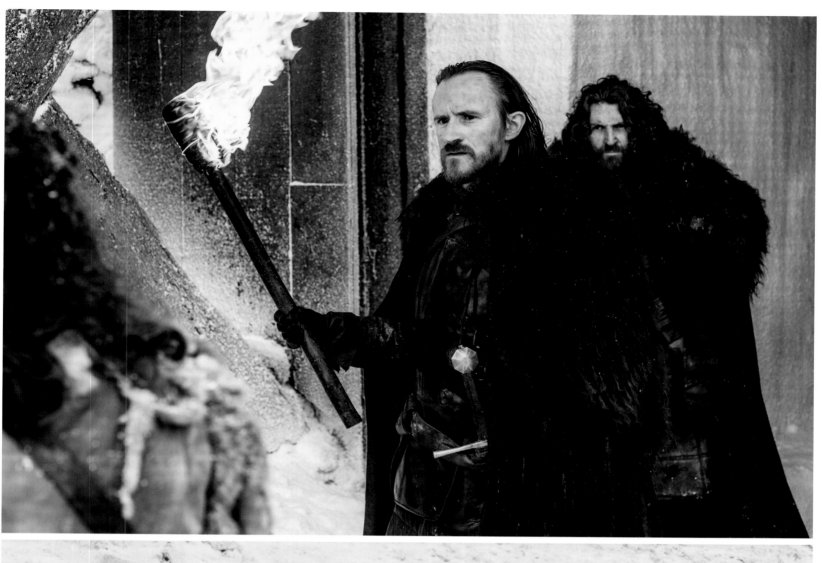

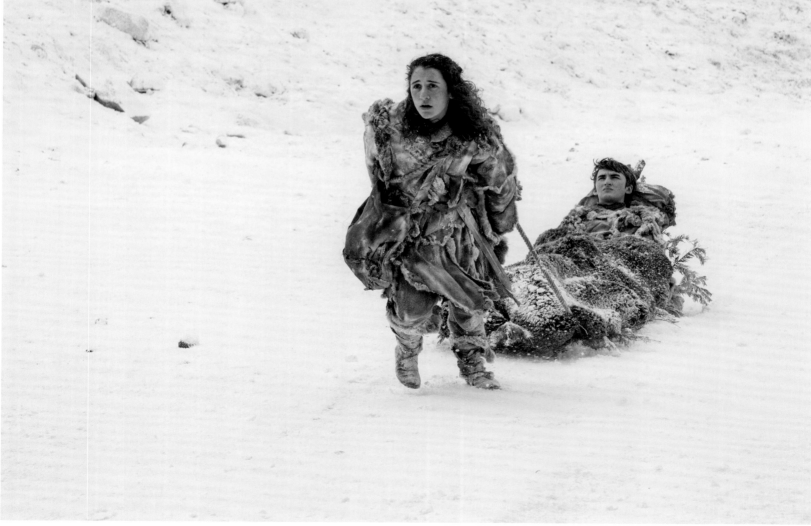

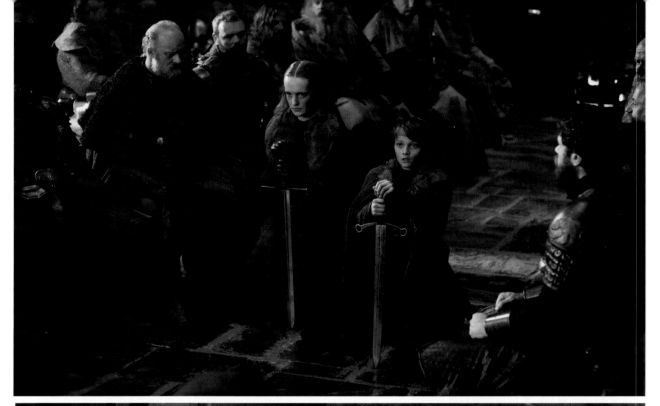

THIS PAGE: The children of the Northern houses, including Umber, Karstark, and Mormont, pledge loyalty to the King in the North.

OPPOSITE: Jaime Lannister, the Kingslayer.

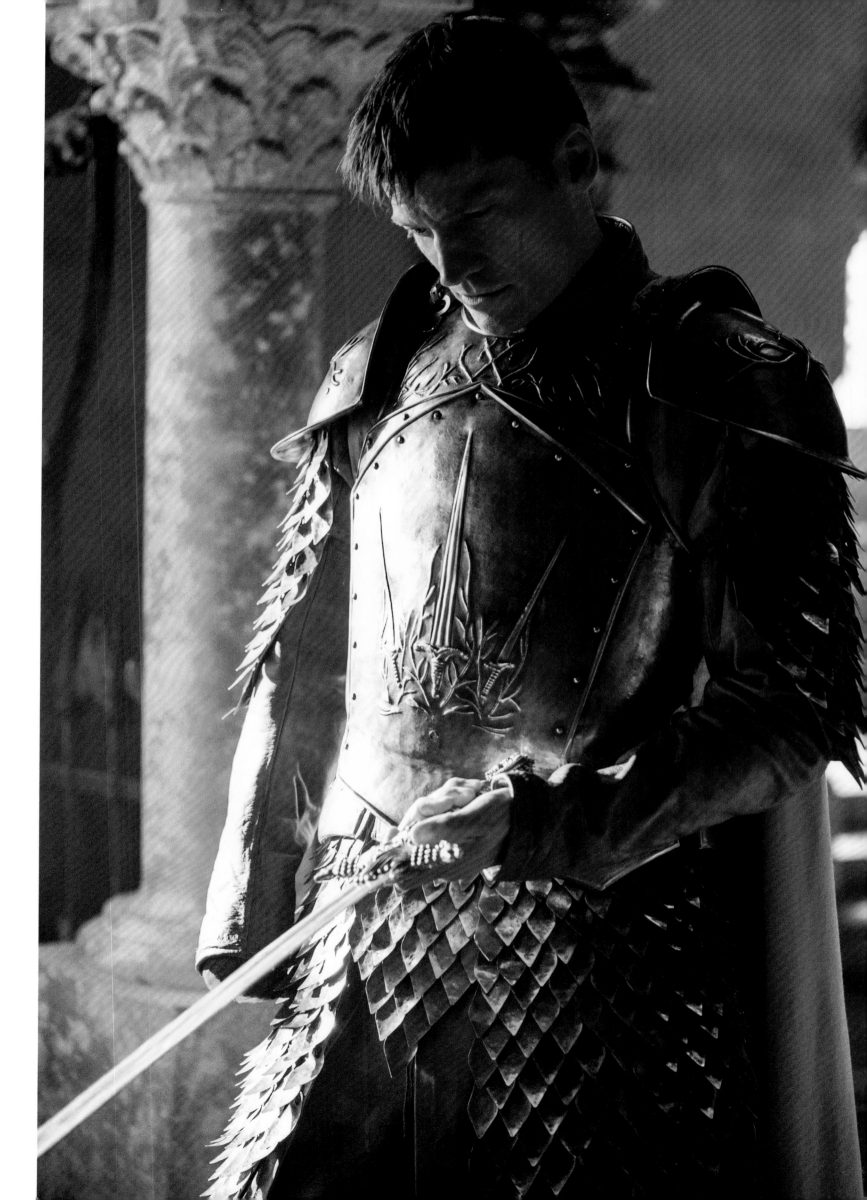

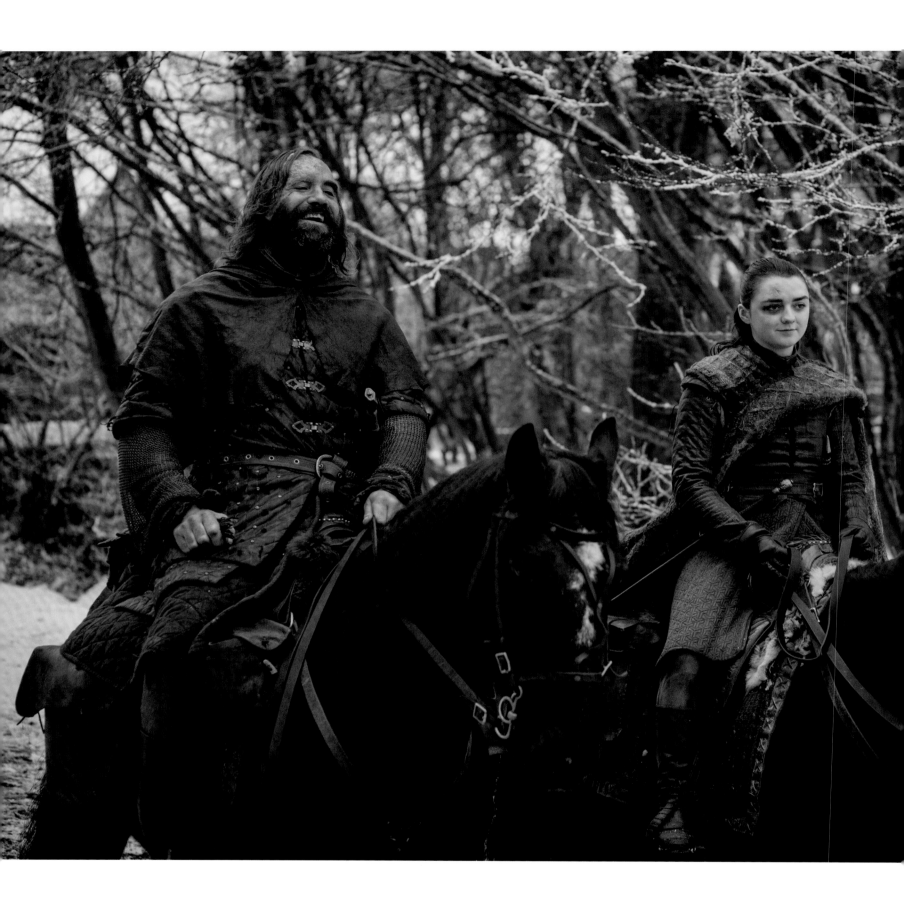

LEFT: The Hound and Arya reunited at Winterfell.
TOP: Jaime and Brienne.
ABOVE: Tormund Giantsbane and Beric Dondarrion.

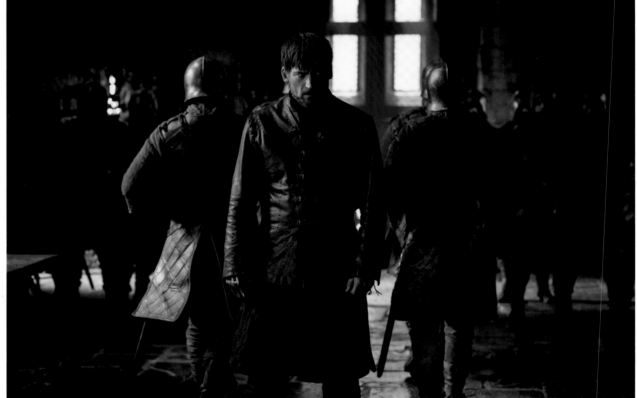

THIS PAGE: Ser Jaime is brought before Daenerys Targaryen.
OPPOSITE: Brienne defends and vouches for Jaime.

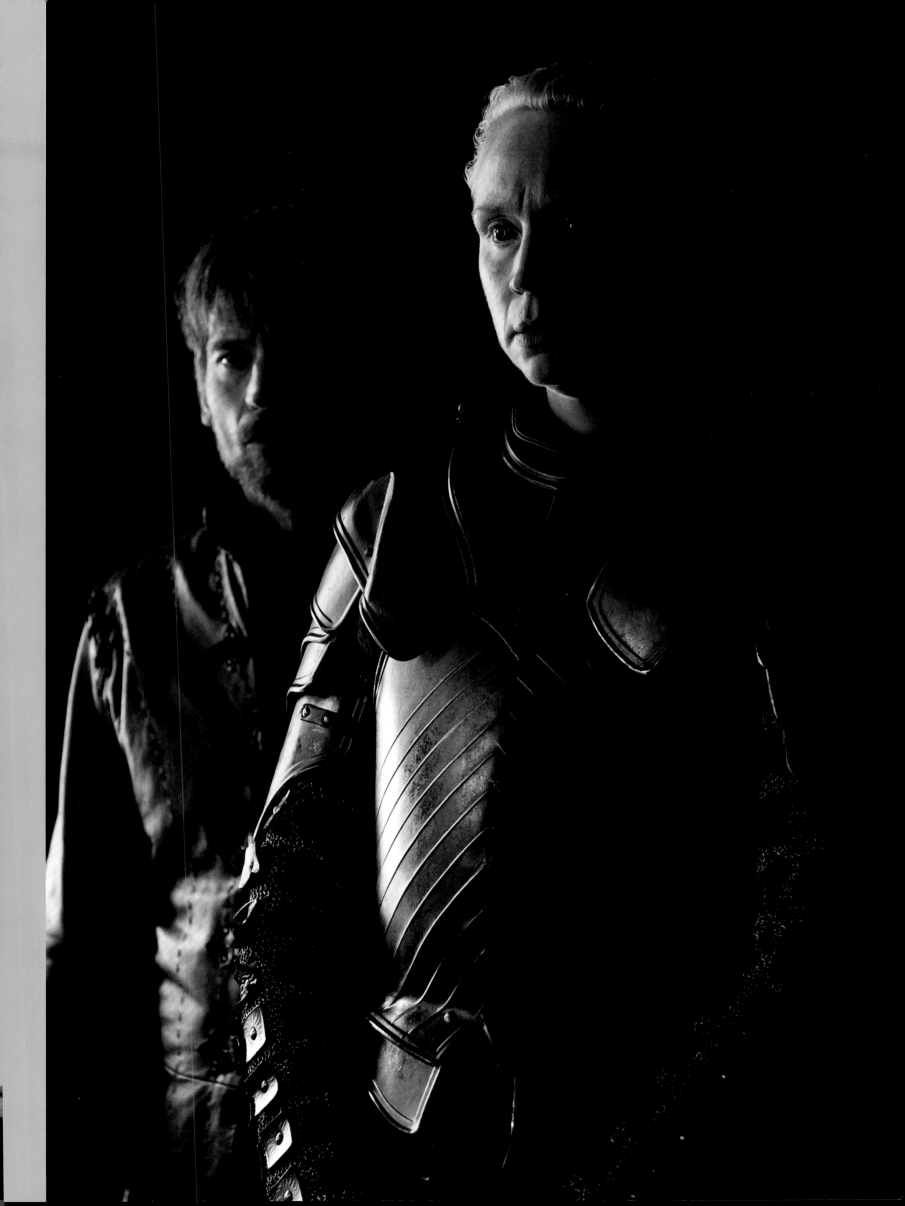

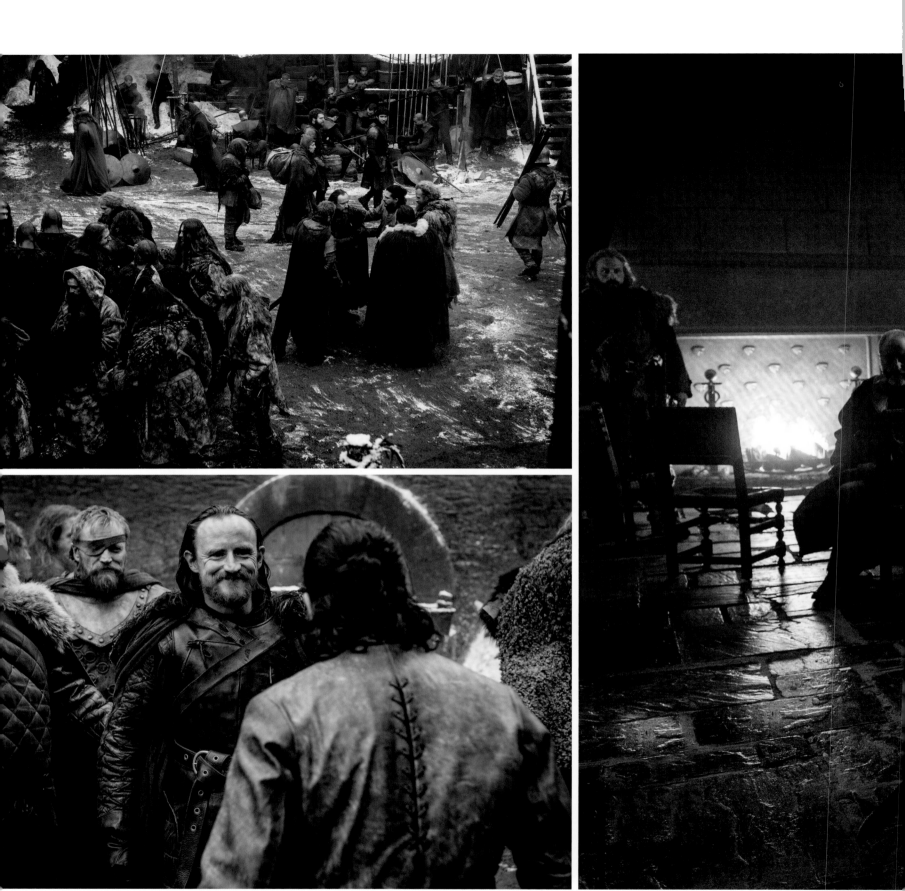

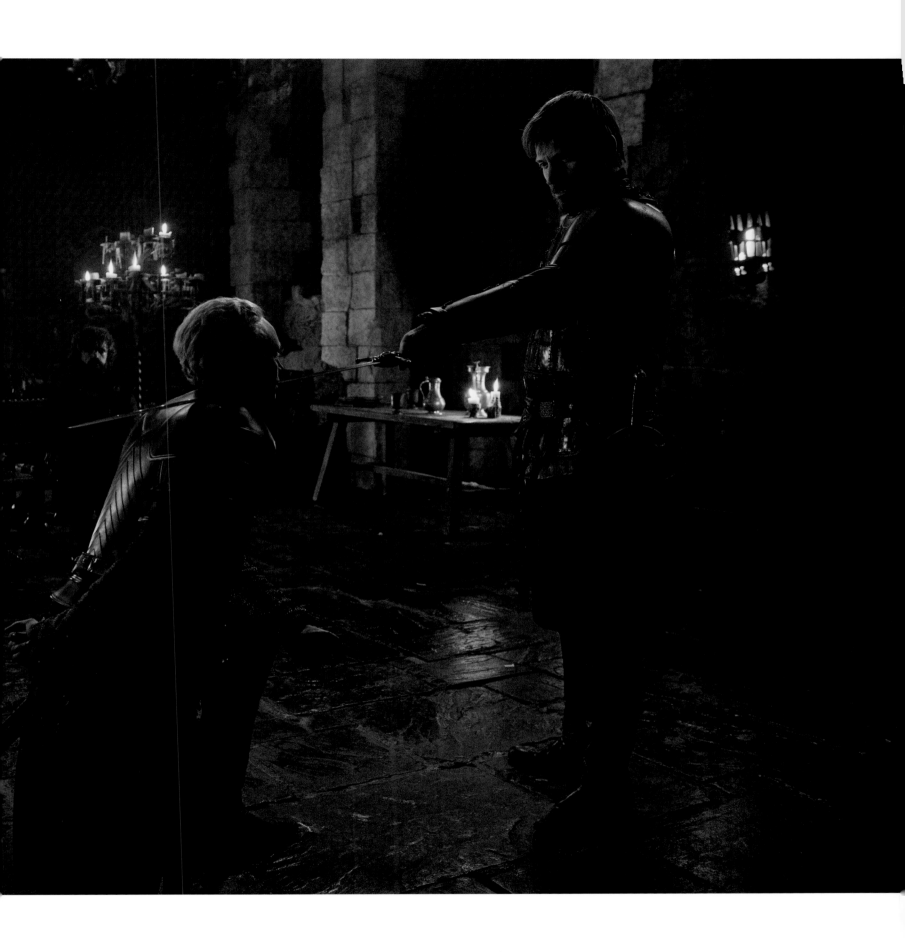

OPPOSITE: The Night's Watch reunite.
ABOVE: Brienne is knighted by Ser Jaime.

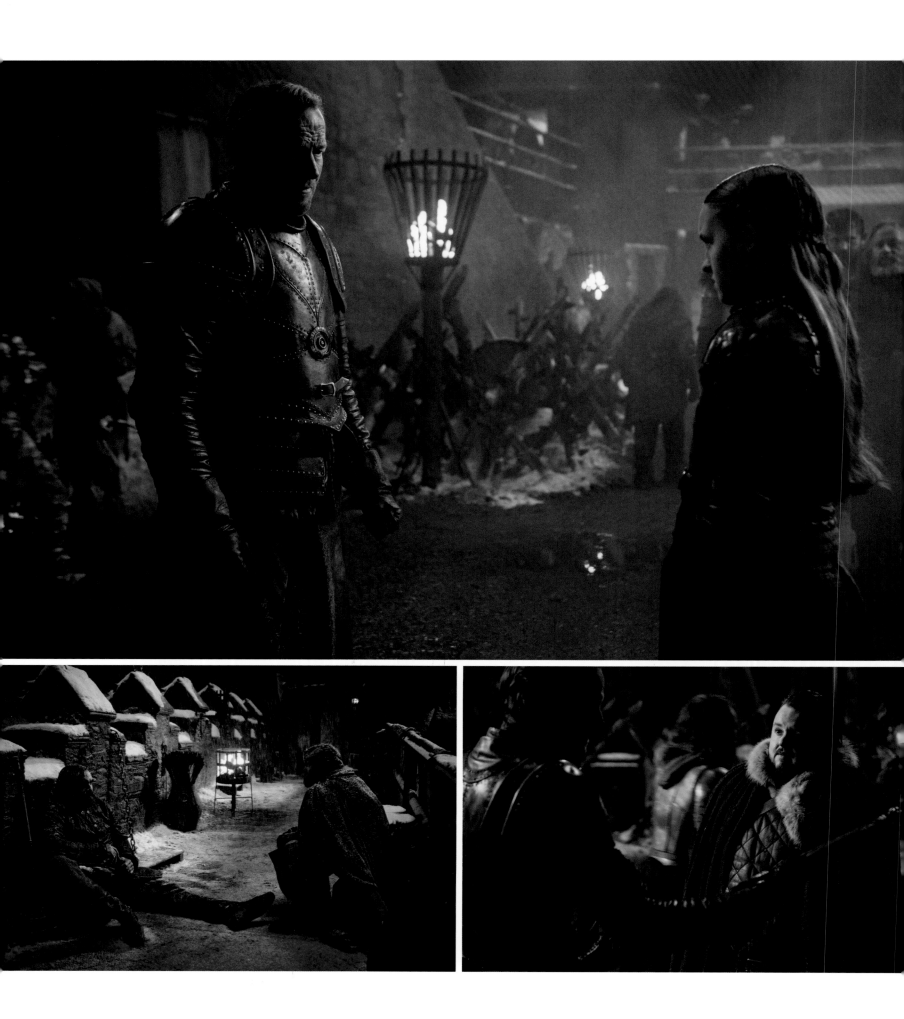

THIS PAGE: Family and friends, like Ser Jorah Mormont and his cousin Lyanna, commiserate before the Battle of Winterfell. Night shoots like the Battle of Winterfell are very technically challenging. "You have to be hyperaware of your focus and the actors' movements and how far away they are from you," says Helen Sloan. "It's very intense to shoot in such darkness, because it's such a shallow depth of field. The room for error is minimal. It really kept me on my toes."

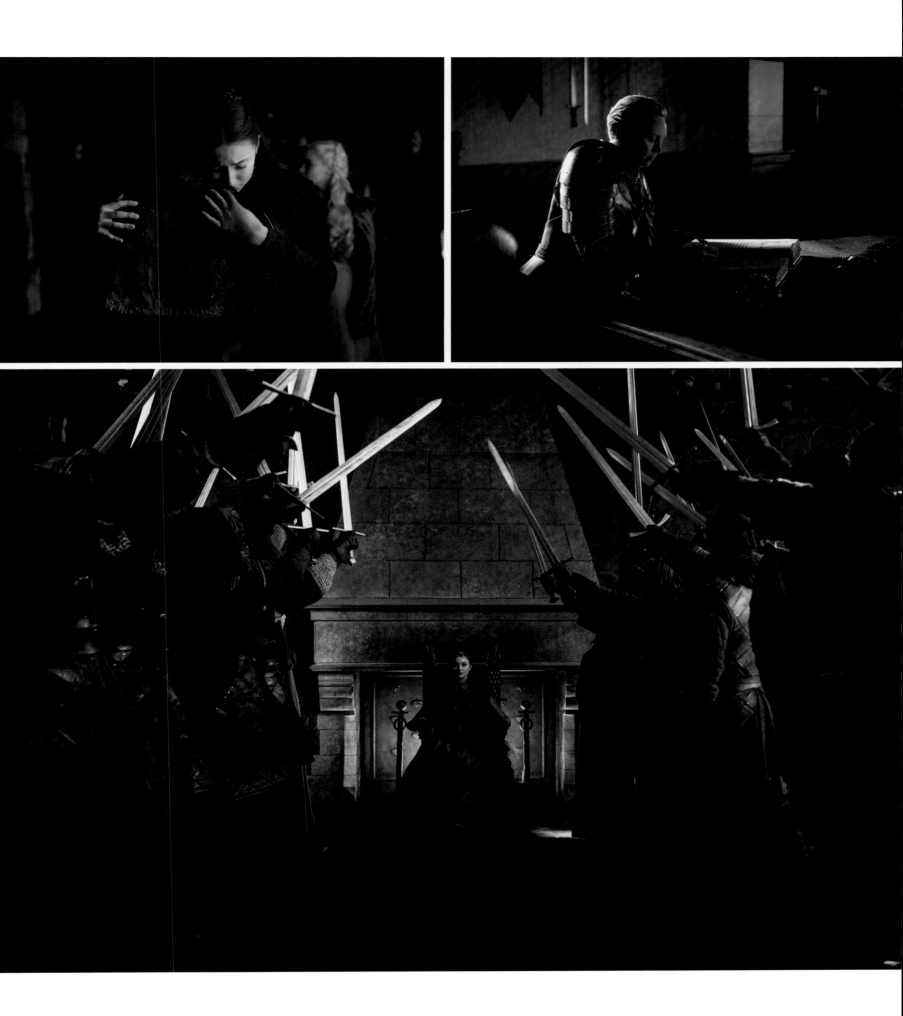

TOP LEFT: Sansa embraces Theon.
TOP RIGHT: Brienne writes Jaime into the history books.
ABOVE: Sansa is named Queen in the North.

BEHIND THE SCENES

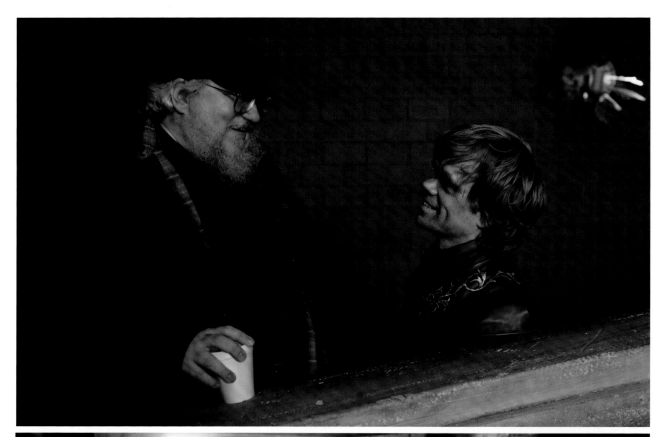

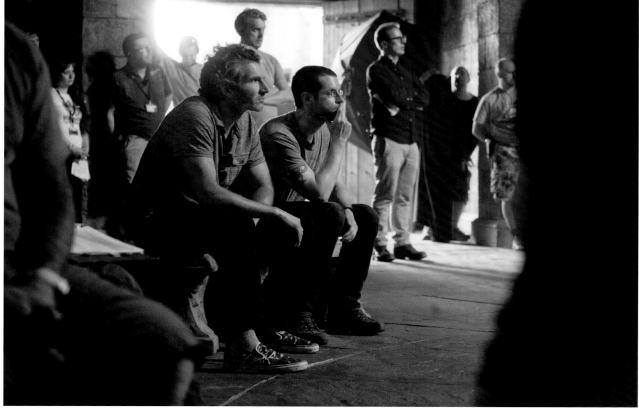

TOP: George R. R. Martin has a conversation with Peter Dinklage.
BOTTOM: Showrunners David Benioff and D. B. Weiss on set.
OPPOSITE: Emilia Clarke is checked between scenes.

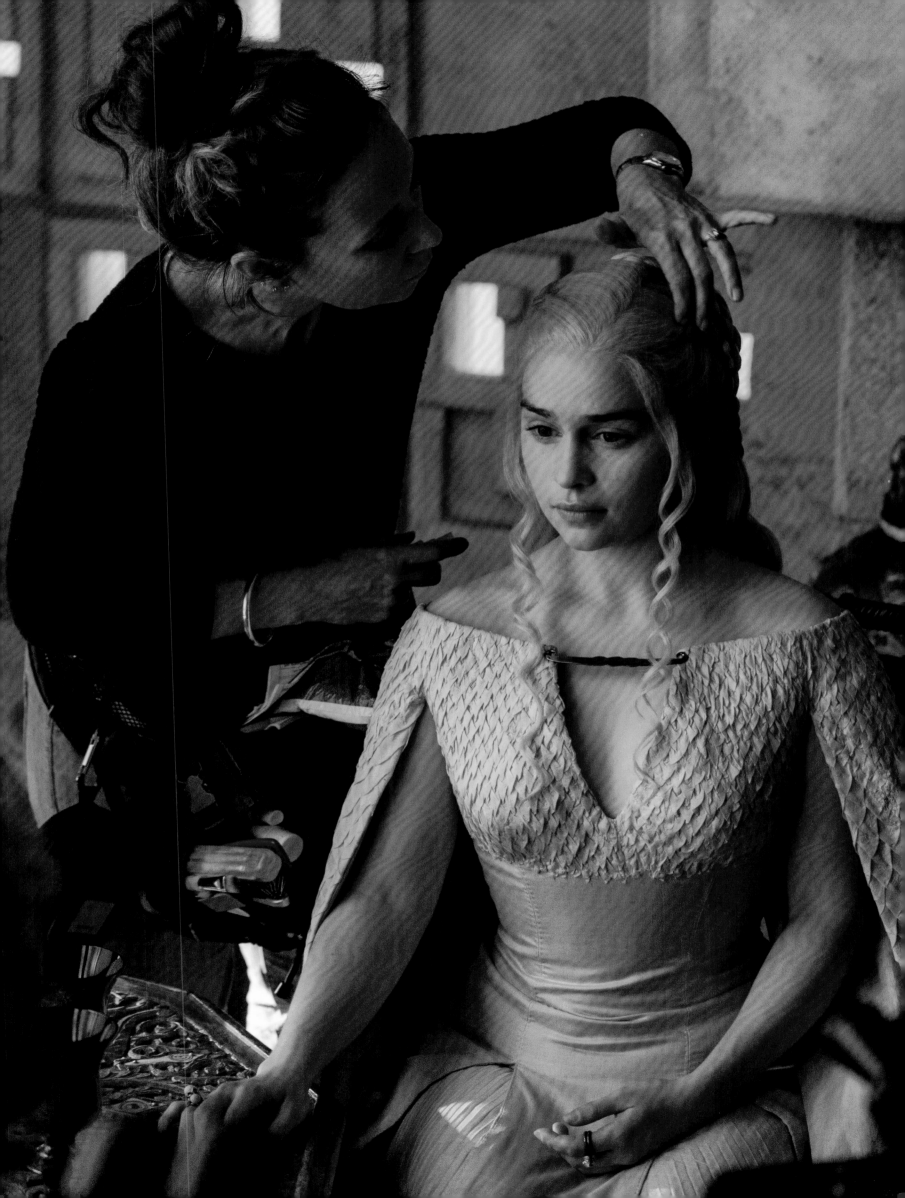

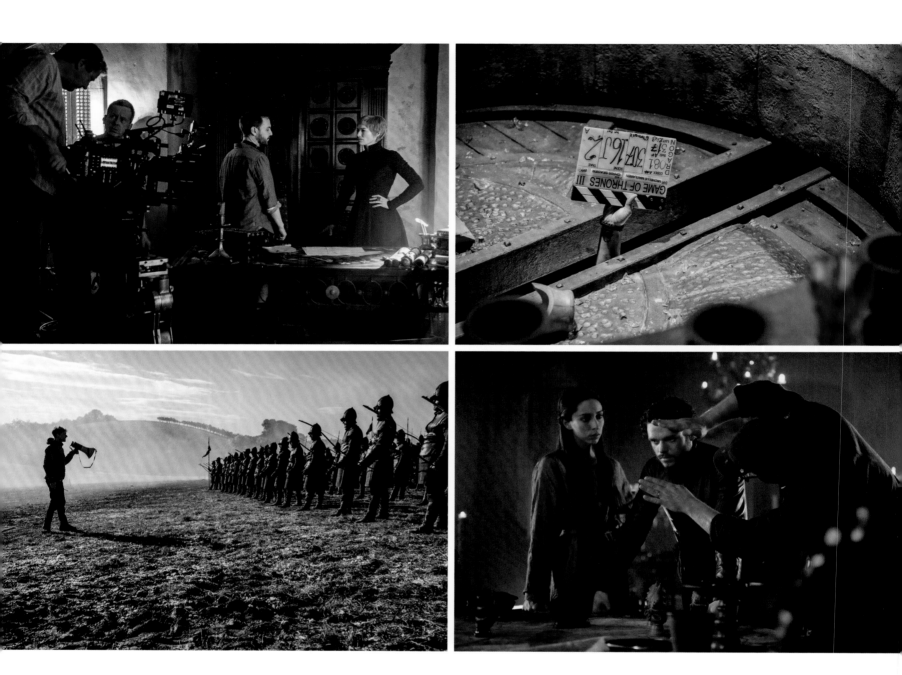

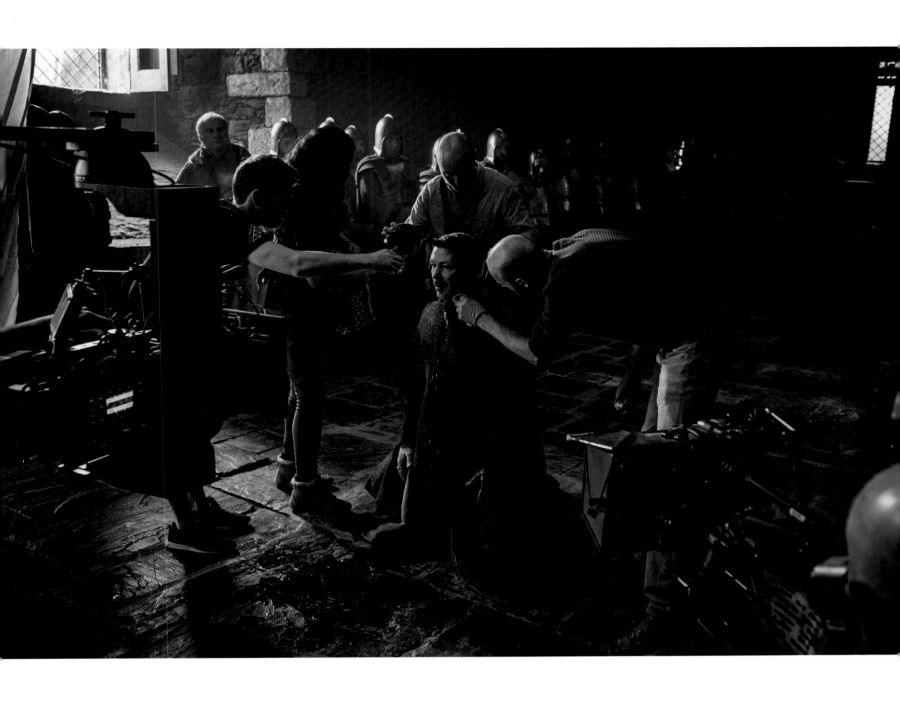

OPPOSITE: Cast and crew members prepare for their scenes.
THIS PAGE: Prosthetic artists checking Aidan Gillen's neck for his character's final scene.

169

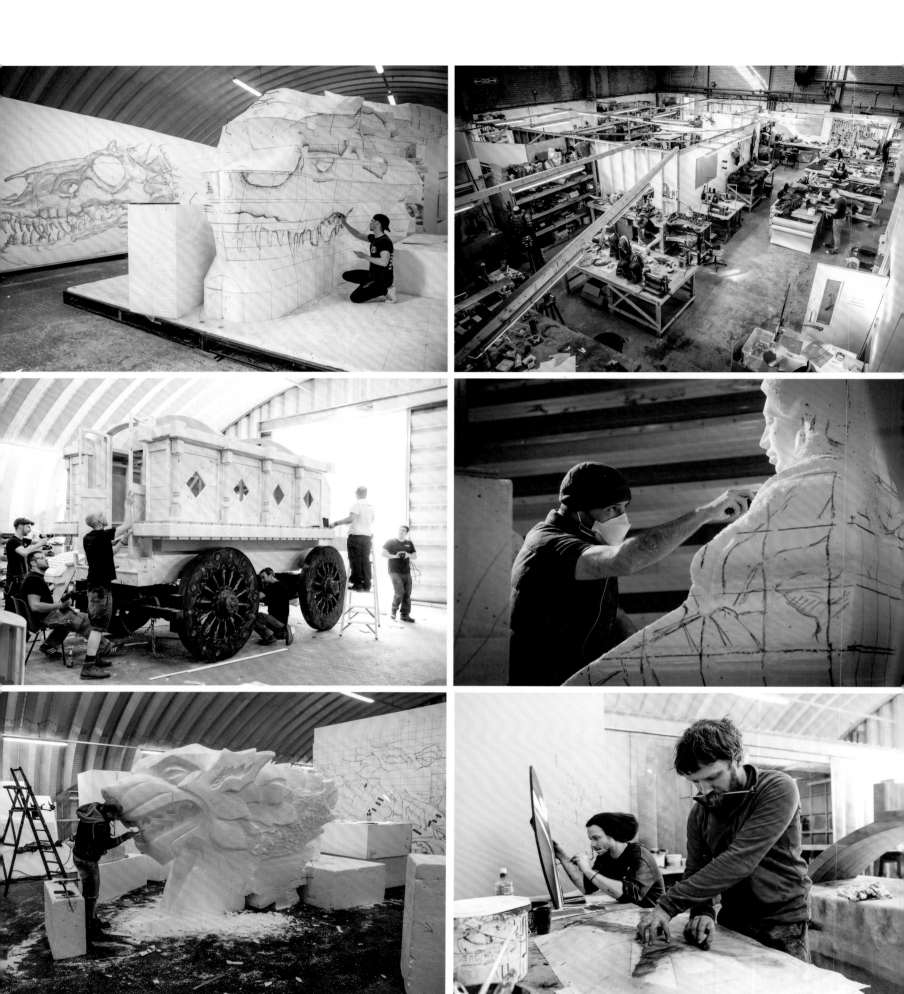

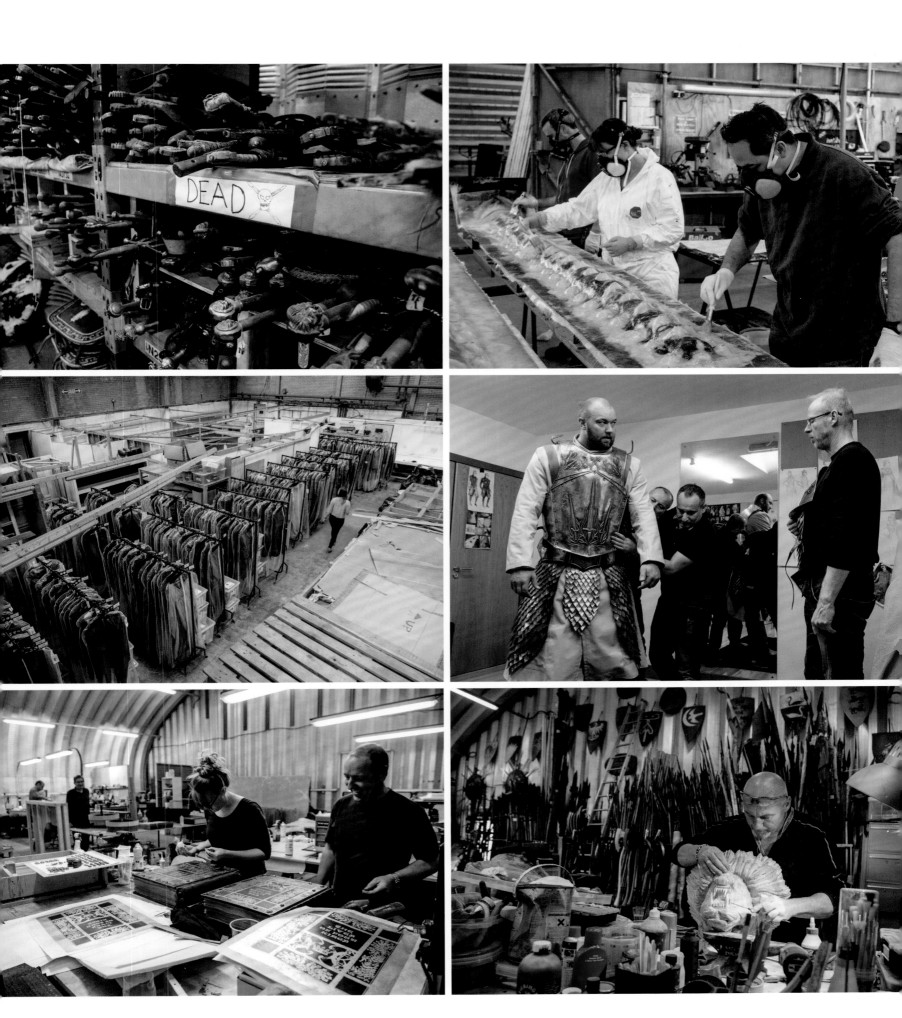

THESE PAGES: Numerous artisans worked together to create the thousands of props, costumes, and set decorations required for the show.

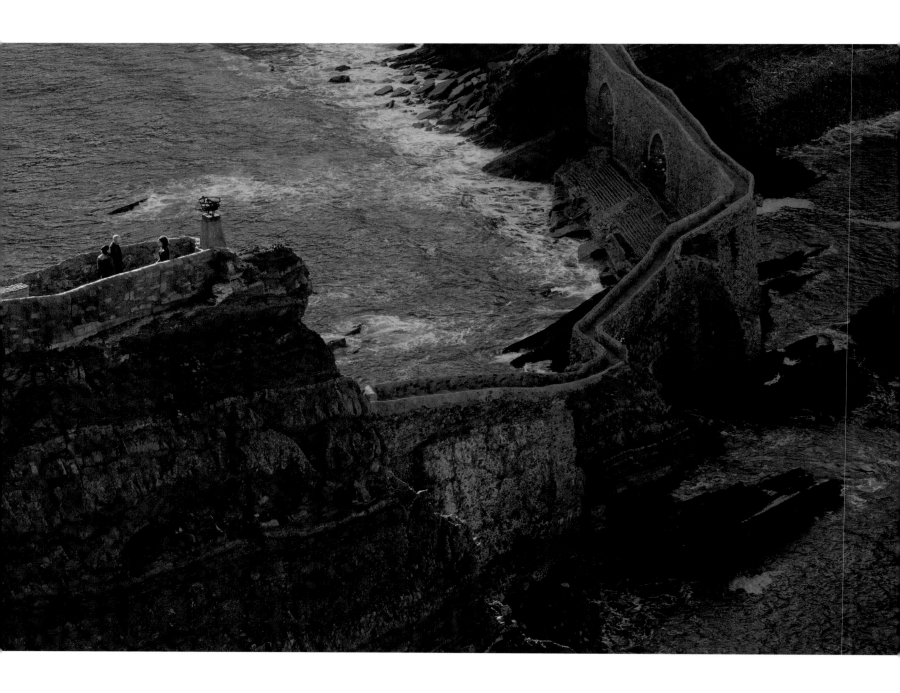

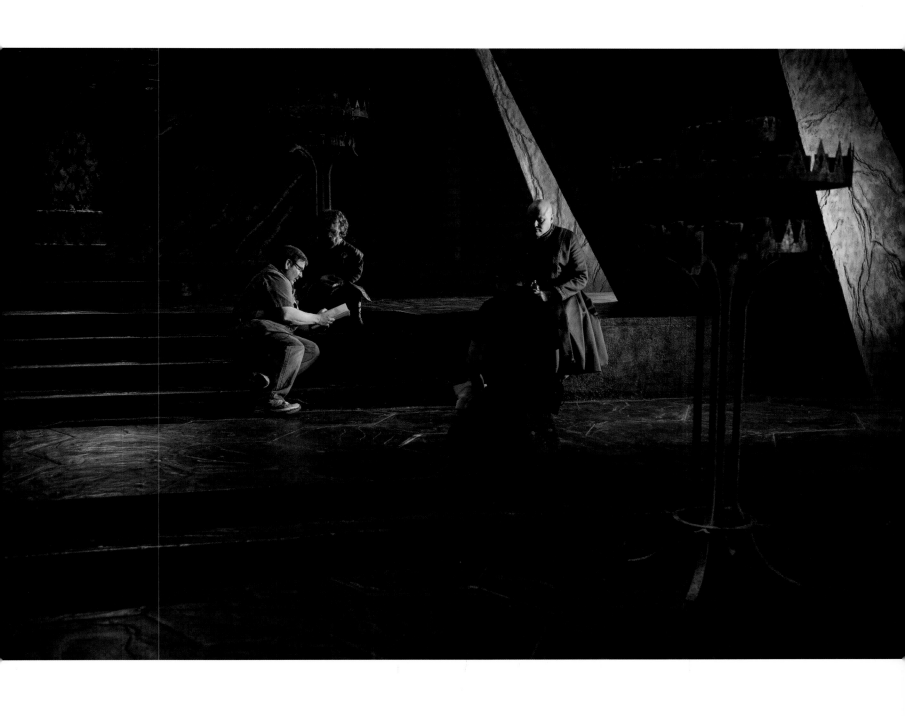

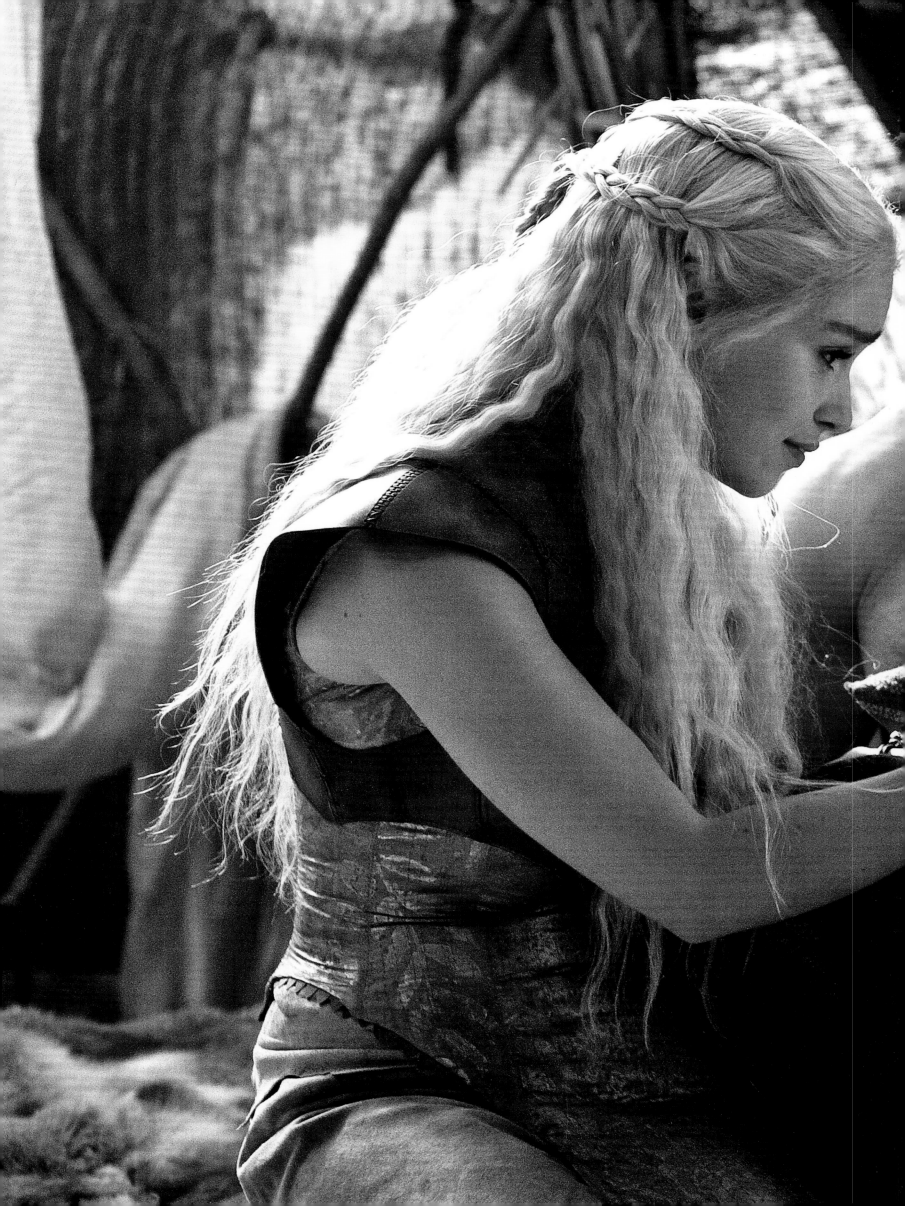

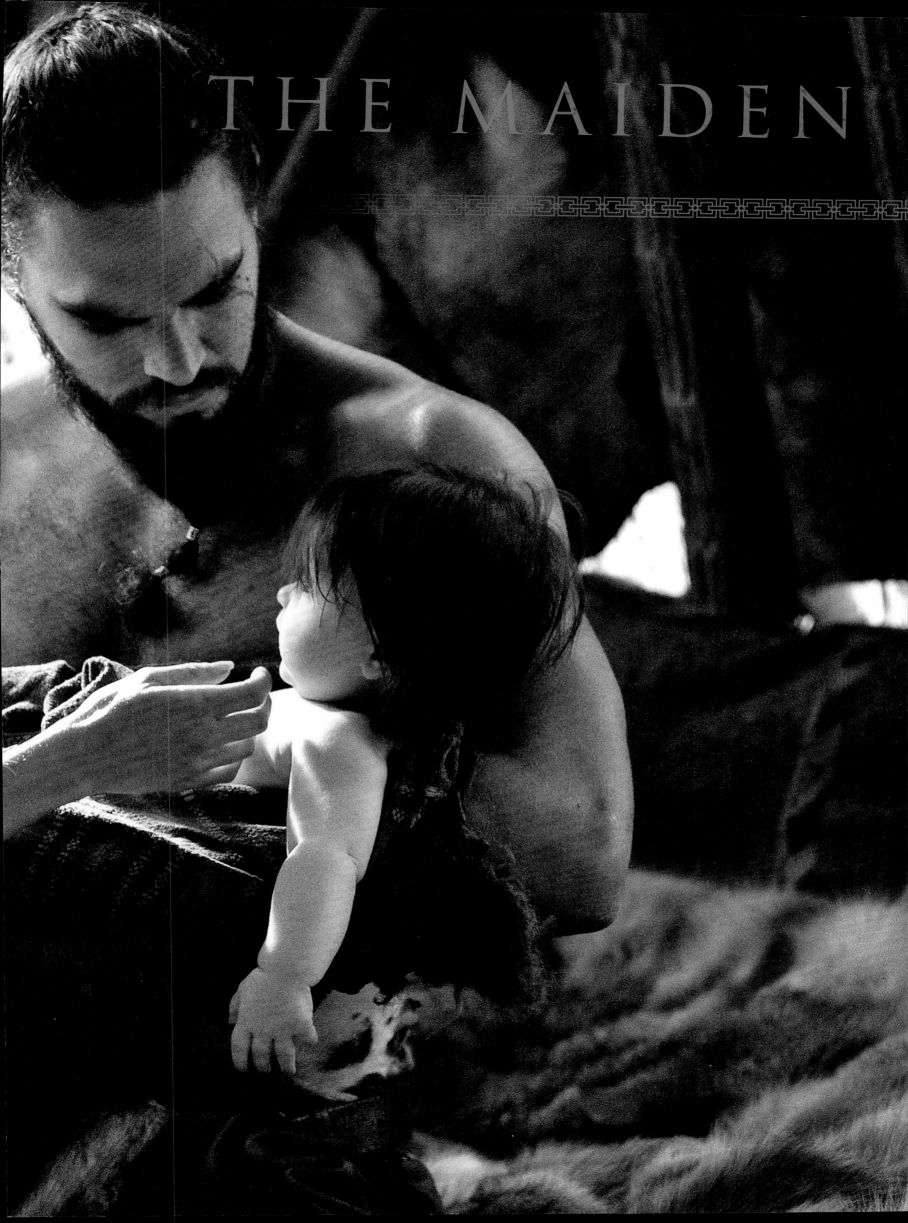

THE MAIDEN

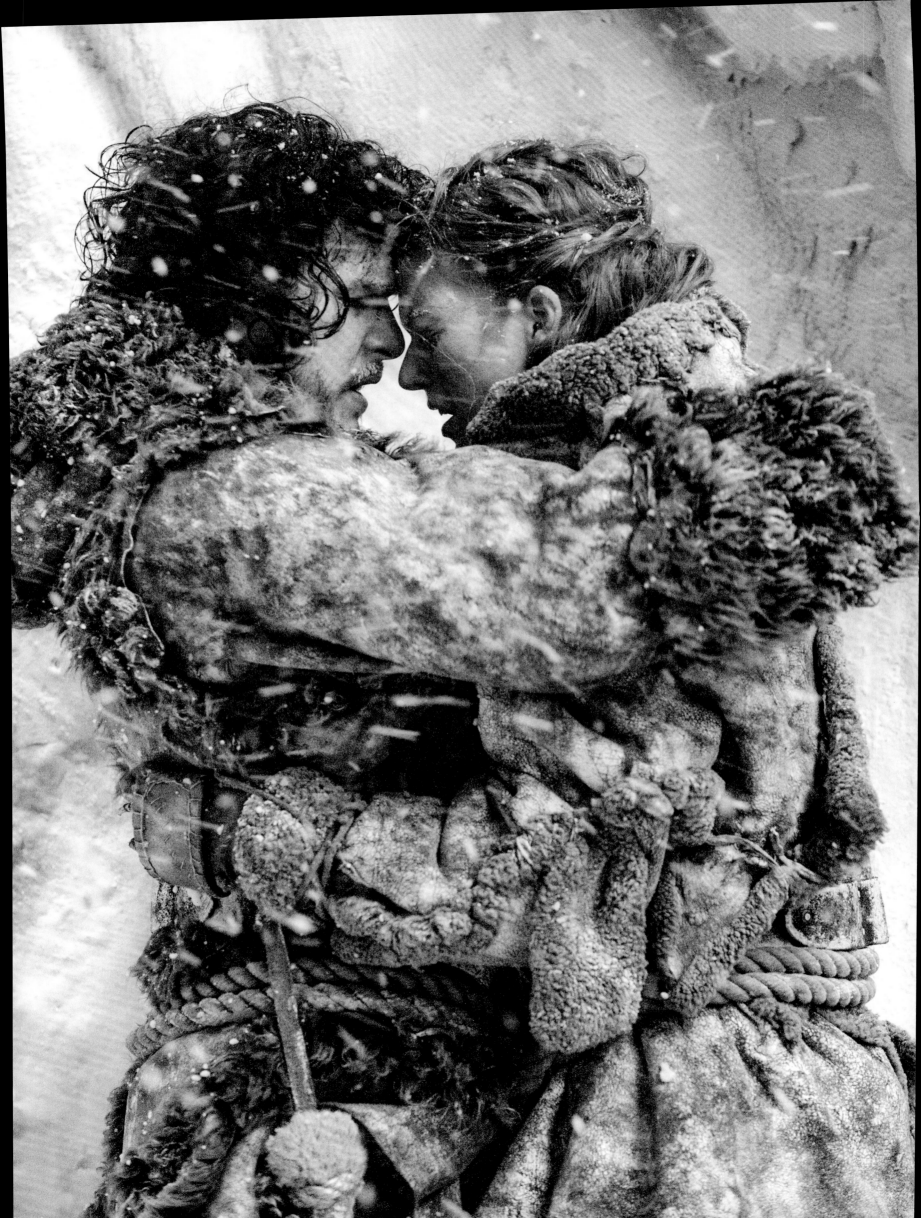

The Maiden represents innocence, love, and beauty.

Though the interminable war, habitual betrayals, and unremitting pursuit of power in *Game of Thrones* seem to condemn the populace of the Seven Kingdoms to a fraught existence, there is an antidote to this struggle: love. The Maiden represents some of the best elements in life, including love and beauty. Love bridges chasms between people, brings disparate parties together, establishes trust, and cements friendships. It can be romantic or intimate, and sometimes it is unrequited or refused. Under love's glow, power can become a worthless pursuit, betrayal an unimaginable act, and war an event to end and avoid.

Love can emerge from the unlikeliest of places. For Jon Snow, it arrives in the form of an enemy captive, a woman of the Free Folk named Ygritte, who puts his vow to the Night's Watch to the test. Ygritte's indefatigable spirit wins Jon over, and his noble earnestness intrigues her. Gradually neither can deny their feelings for the other, despite sworn vows and opposing backgrounds. Love works its magic on them, overcoming cultural and historical divides to draw together would-be enemies.

Jon's love for Ygritte enables him to see the wildlings not as inferiors but rather as equals. This is what leads him to do what no Lord Commander of the Night's Watch had ever considered before: lead the wildling tribes behind the Wall to save them from the White Walkers.

Love can also be born of passion, as it is with the Lannisters. In particular, Tyrion is so taken by the Lorathi courtesan Shae that he disobeys his father, Tywin, and takes her to live with him in secret in King's Landing. Unlike everyone else, Shae treats Tyrion not as an object of ridicule but as a full person, and she seems to have real feelings for him. But those affectionate feelings morph into jealousy when Tyrion is made to wed Sansa Stark. When he tries to send Shae away to protect her, it only heightens her jealousy.

Tragically, Shae tries to kill Tyrion when he discovers her affair with his father, impelling Tyrion to do the unthinkable: kill the woman he loves out of self-defense. Emotions shattered, he flees King's Landing and endures an arduous journey across Westeros and Essos, eventually talking his way into the court of Daenerys Targaryen, the bitter enemy of his family. Tyrion's passionate love for Shae leads to a broken heart, but it also gives him the confidence to become something more than the drunken fool that others perceive him to be. Eyes opened to how a leader like Daenerys could reshape the world and help all its people, he becomes a true champion of her claim to the throne.

In contrast, some relationships wear the guise of love, with repercussions that can be disastrous or even cataclysmic. In Cersei and Jaime Lannister's case, their relationship is an expression of selfish desire that leads to much pain and strife for their family. Love is recognizing something greater in others for which one will risk one's own life. It is what persuades Jon Snow to aid the wildlings and what awakens Tyrion's inner sense of duty. Without love, the Seven Kingdoms and its people would be no different than what is coming for them—an army of the dead.

The heightened emotions of *Game of Thrones* come through in Sloan's photography, but she has only a short window in which to capture those feelings. She comments, "Unless it's impossible, I absolutely avoid asking actors to hold for a shot after we've finished the take. I'm always shooting while they're filming a scene, because it seems deeply unfair to expect the cast to roll out the same amount of emotion again for a photograph. No one's got time for that on a film set, and stills photographers should be able to work within the take. And some moments can't be re-created. I can't ask, 'Oh Sam, you wouldn't mind blowing up that whole rig again just for a photo please, mate?' I don't think that would fly."

Sloan's job as a stills photographer has her working in a photo studio as well as on set. "If I need to set up a shot, or if I have an actor in the studio for character portraits, I won't start talking about the weather or something amusing that's going to snap them out of character, especially if we are trying to achieve a specific emotion. It's important to invite the character into the room as well as the cast member. I want to be true to the storyline and achieve the same intensity as on set. It's all about teamwork at every level," she says.

The mutual respect extended to the cast as well. Sloan notes, "Even in those really critical moments, when stress was high and the photographer might be first on the chopping block, I've been so lucky, because this cast respected what we were doing and they understood wholeheartedly that each crew member was there to do a job. They knew that the photography was an important part of the legacy and advertising on the show.

"We had around two hundred actors on the show, and each one of them wants to work in a different way. My responsibility is to learn how each cast member likes to work with a photographer. Certain actors want me or someone else to read a few lines of dialogue with them so that they can get into character, and some want to come in and have a bit of fun away from the intense pressure of the set. I keep this catalog of people and personalities always in my mind, and I'm always ready to adapt. "

PAGES 174—175: During her time in the House of the Undying, Daenerys imagines herself reunited with Drogo and their son, Rhaego.

OPPOSITE: Jon and Ygritte embrace after a near-death experience while climbing the Wall. "The sculptors built the Wall out of polystyrene, wax, and other materials. There were these giant cranes and cherry pickers used as well," Sloan says of filming the wildlings' climb up the Wall. "Getting the angles [was] crazy when we shot by the Wall, because we had the cameras sort of pointing down the Wall, so there was no way for me to hang off [it] to capture my shots. For this shot, I was on a platform with a really long lens, and they were on a ledge. It wasn't a fluke, but I was lucky to be able to get in proper position to capture what became an iconic shot. To capture moments like this, it's 50 percent luck and 50 percent the friends you've made on set that help you get to the right place at the right time."

177

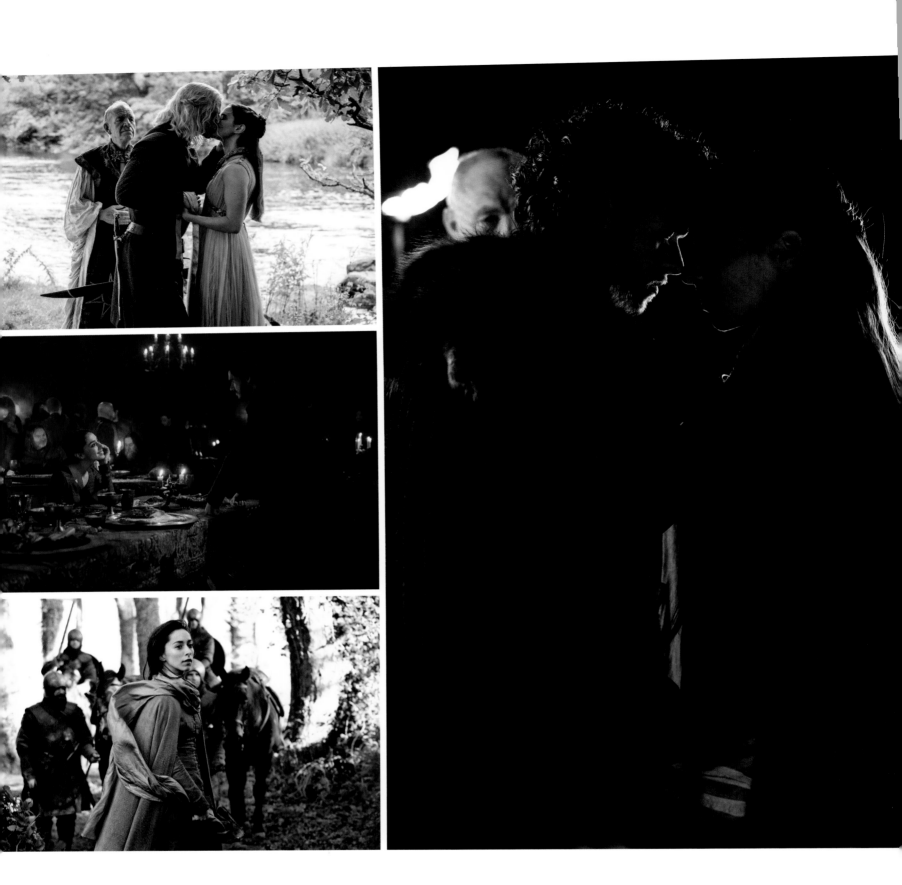

TOP LEFT: Rhaegar Targaryen and Lyanna Stark wed in a secret ceremony.
CENTER LEFT, BOTTOM LEFT, AND RIGHT: Robb and Talisa grow closer.
OPPOSITE TOP RIGHT: Ned and Catelyn share a moment together.
OPPOSITE LEFT, OPPOSITE CENTER RIGHT, AND OPPOSITE BOTTOM RIGHT:
Romance blossoms between Missandei and Grey Worm.

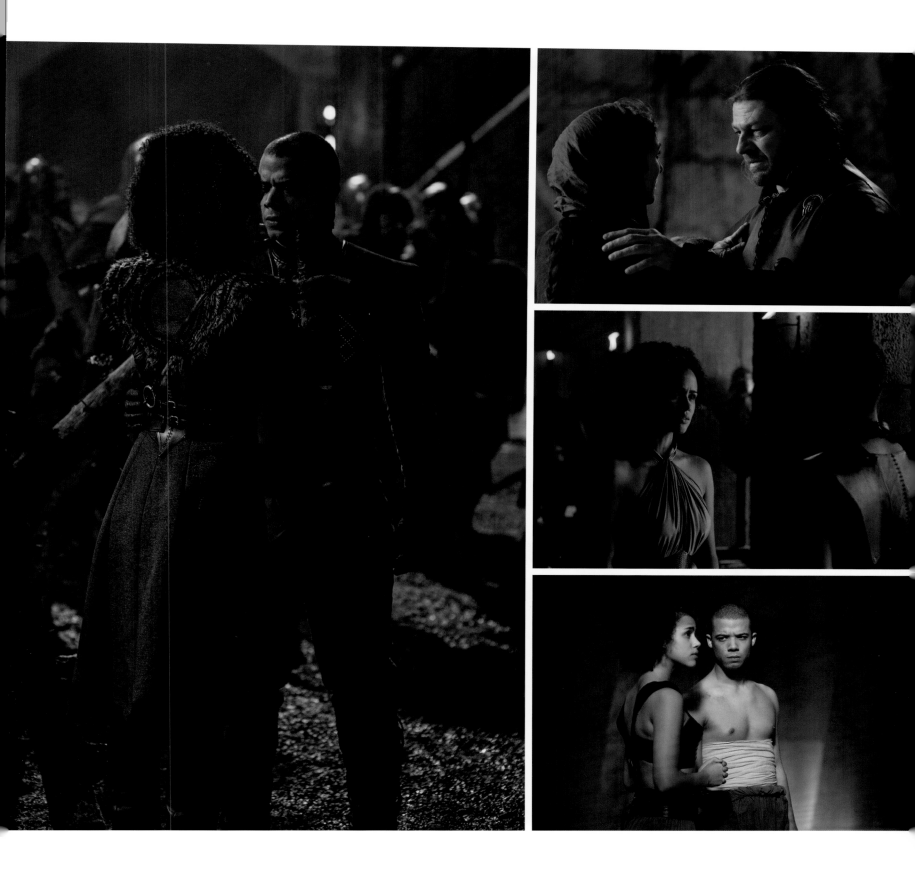

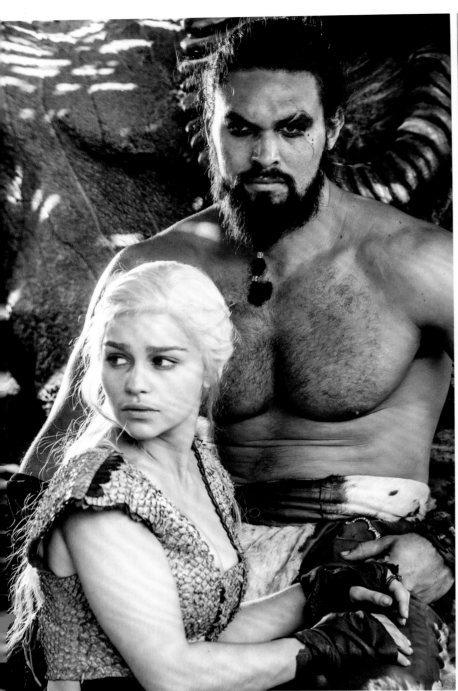

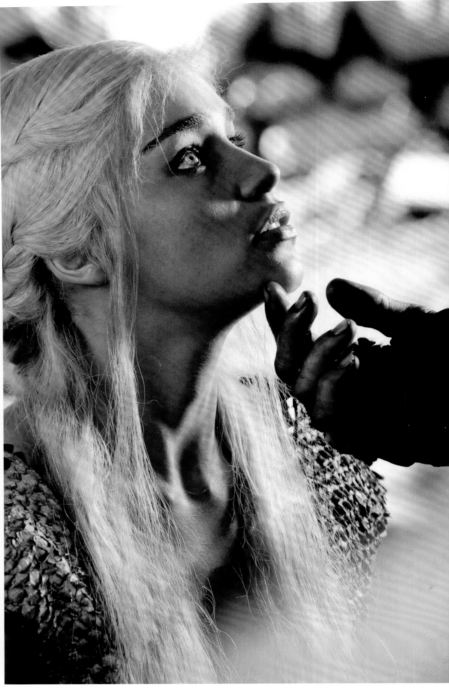

"Moon of my life." —Khal Drogo

THIS PAGE: Khal Drogo and his *Khaleesi*.

OPPOSITE LEFT: Drogo holding his son in Daenerys's vision. This memorable image from season two has great personal significance to Sloan, because it's her baby that Momoa and Clarke are holding. "David, Dan, and Alan Taylor were looking for a baby for this scene, and they decided they were going to use my daughter. I was slightly nervous about it, but then I realized it would be fun. She already knew Emilia and Jason, so that helped. I love the moment in the sequence where she reaches out for Emilia. She must have been wondering why Emilia had all this white hair out of nowhere. That day was a real testament to the actors' professionalism, because she was quite gassy all through the scene, but Jason is an experienced dad and didn't crack a smile once during takes! It's quite funny that she's Daenerys's dream baby. My daughter still calls Jason and Emilia her TV mommy and daddy!"

OPPOSITE RIGHT: Jon Snow and Daenerys.

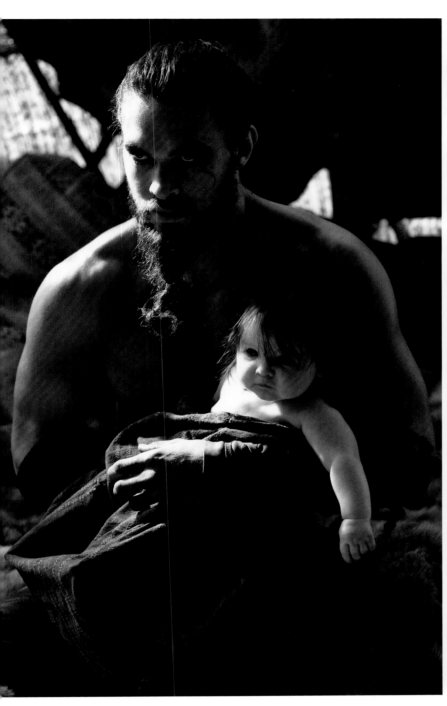

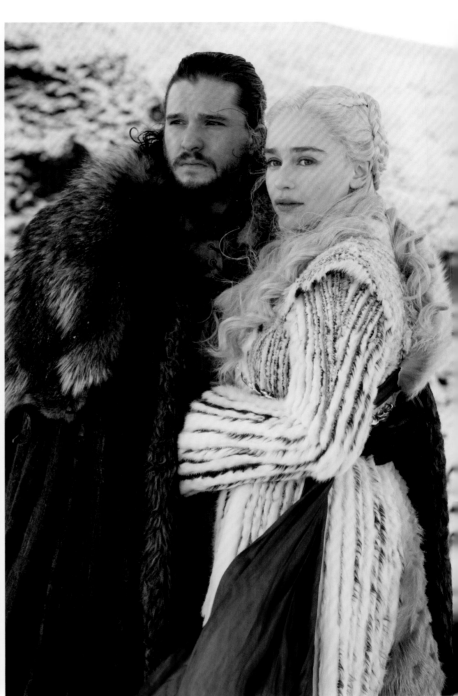

"My sun and stars." —Daenerys Targaryen

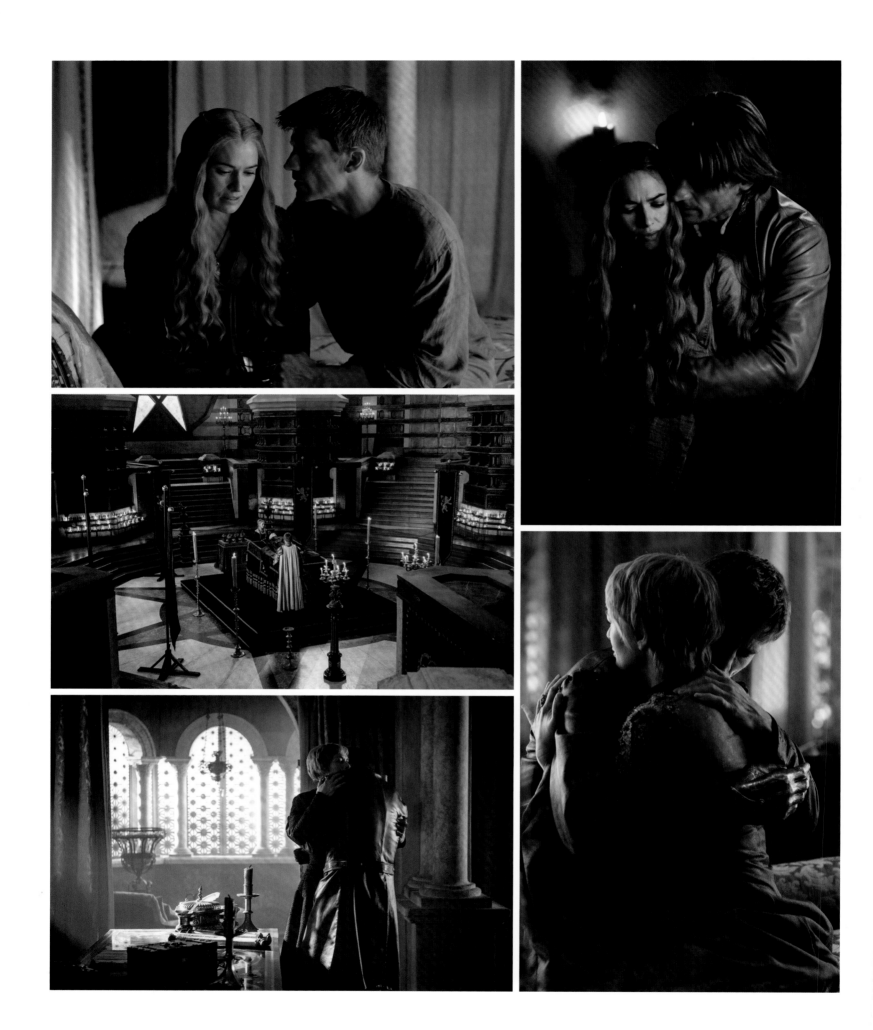

THIS PAGE: The relationship between Cersei and Jaime Lannister led to great sorrow and tragic consequences.
OPPOSITE: Jaime and Cersei meet their fate in the destruction of the Red Keep. Highly detailed, lifelike prosthetic dummies of Cersei and Jaime were used for this image of the Lannister siblings in the aftermath of Daenerys's attack on King's Landing.

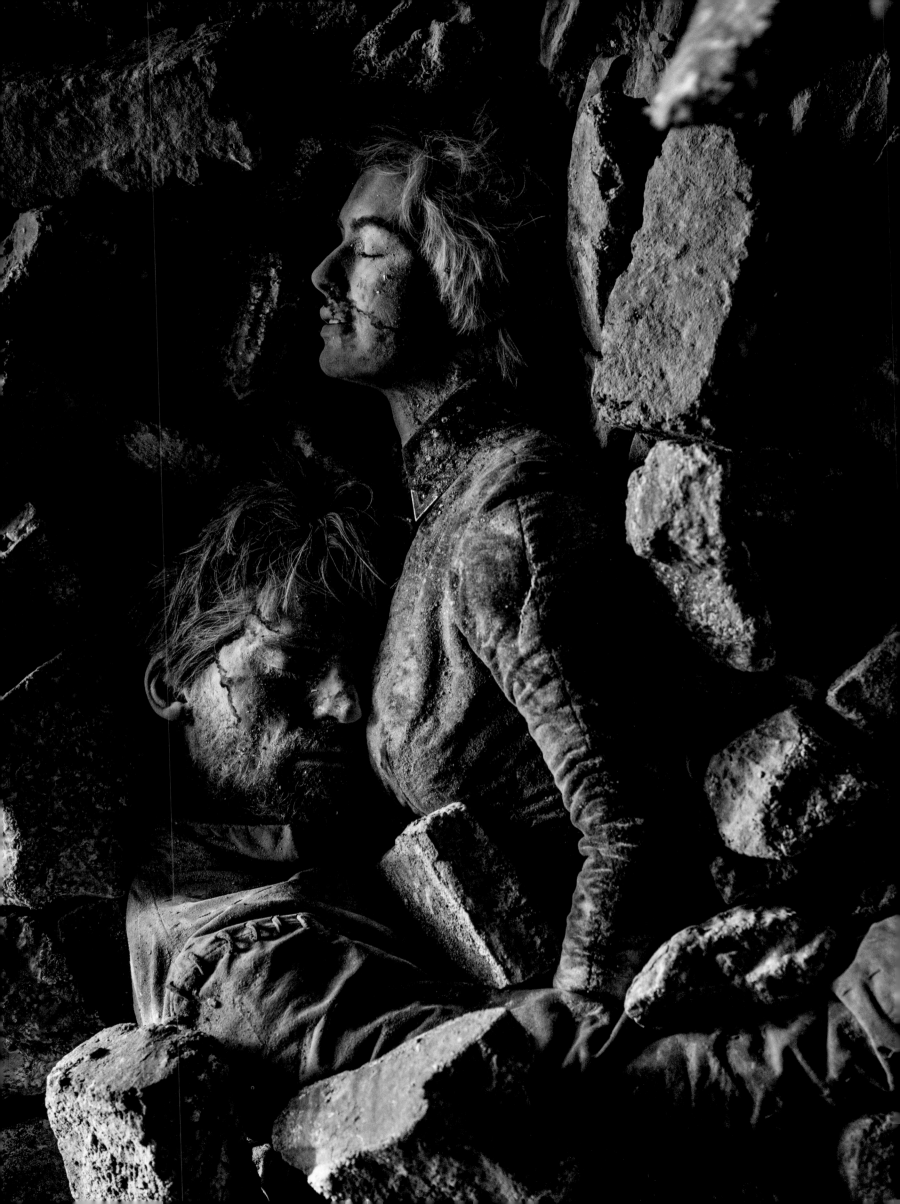

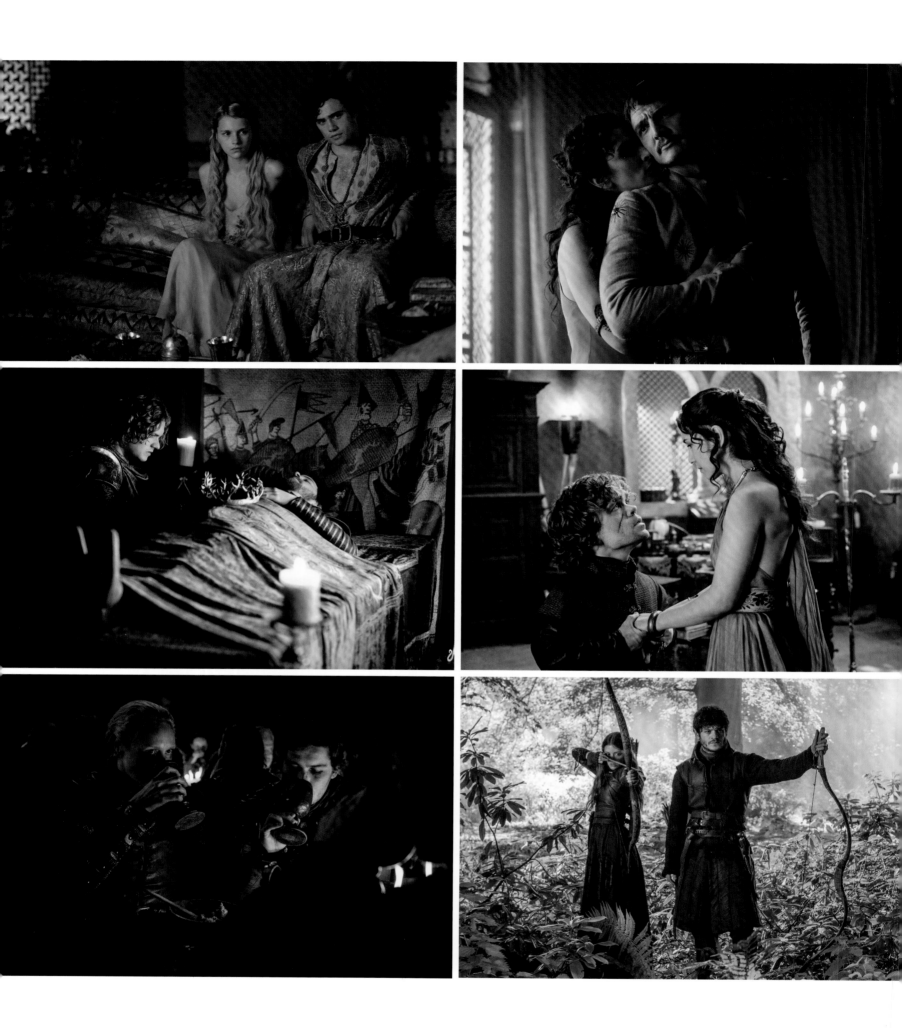

THIS PAGE: (*clockwise from top left*) Myrcella Baratheon and Prince Trystane Martell; Ellaria Sand and Oberyn Martell; Tyrion Lannister and Shae; Ramsay Snow and his mistress Myranda; Brienne, Podrick, and Jaime play a drinking game at Winterfell; Ser Loras Tyrell mourns his lover, Renly Baratheon.

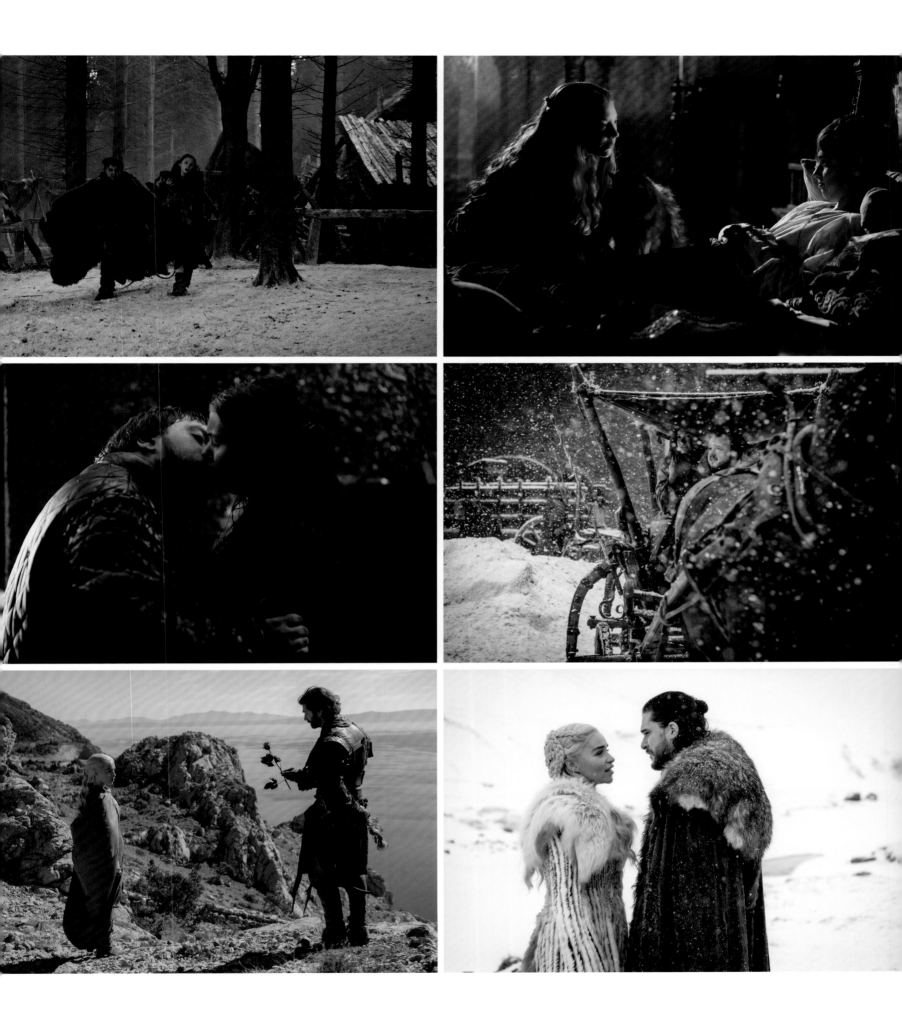

THIS PAGE: (*clockwise from top left*) Sam, Gilly, and baby Sam escape; Margaery seduces Tommen; Sam and Gilly arrive at Winterfell from the Citadel; Jon and Daenerys share a lighter moment before battle; Daario Naharis woos Daenerys; Sam and Gilly's romance blossoms.

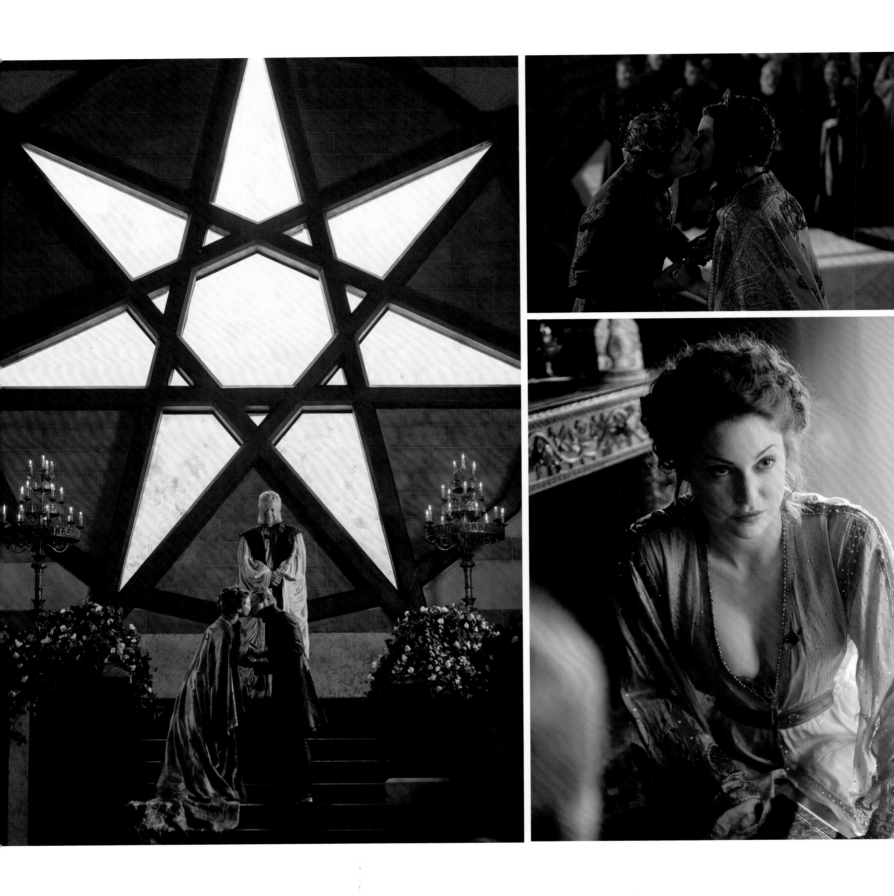

ABOVE AND TOP RIGHT: The wedding of King Tommen and Margaery in the Sept of Baelor. Helen Sloan found the Sept set particularly impressive and imposing to work in, because half of it was a practical, built-out set. She feels that the big beautiful window and all of the surrounding details made it special.

RIGHT: Esmé Bianco as Ros.

OPPOSITE TOP: Gendry and Arya kiss.

OPPOSITE CENTER AND OPPOSITE BOTTOM: Ser Jorah's undying love for Daenerys.

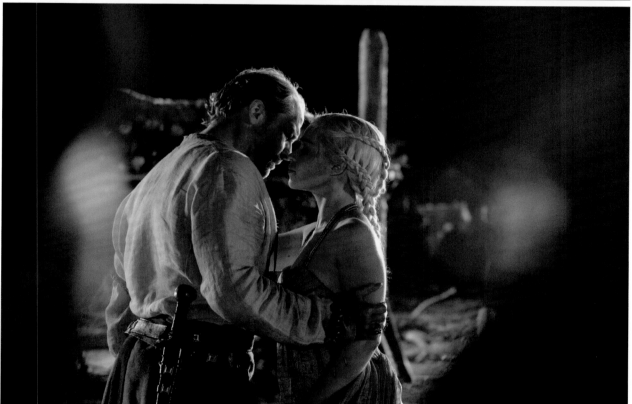

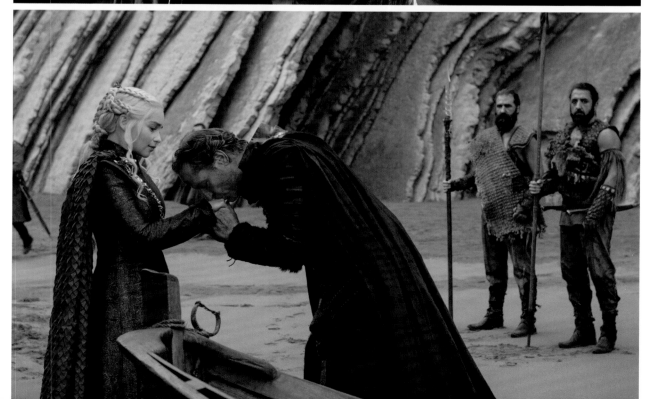

BEHIND THE SCENES

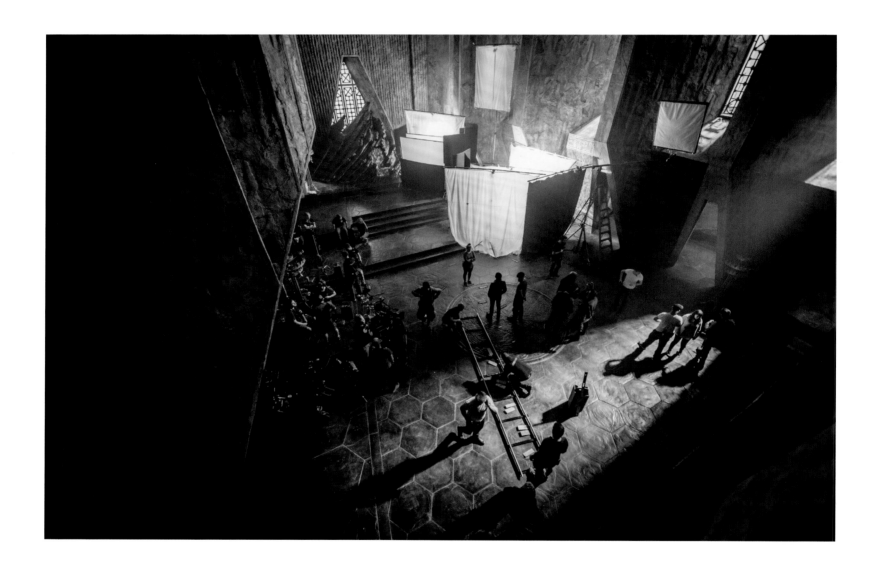

ABOVE: The audience chamber at Dragonstone. The Dragonstone set wasn't comprised of just a single room; it was enormous, with numerous passageways and a balcony that lent authenticity to the scenes shot there.

OPPOSITE TOP: Crew members prepare the windmill where Bran and Jon nearly meet for shooting.

OPPOSITE BOTTOM: The Castle Black set, like the Red Keep's throne room, became like a second home for the cast and crew, as they returned to it so often during the show's eight seasons.

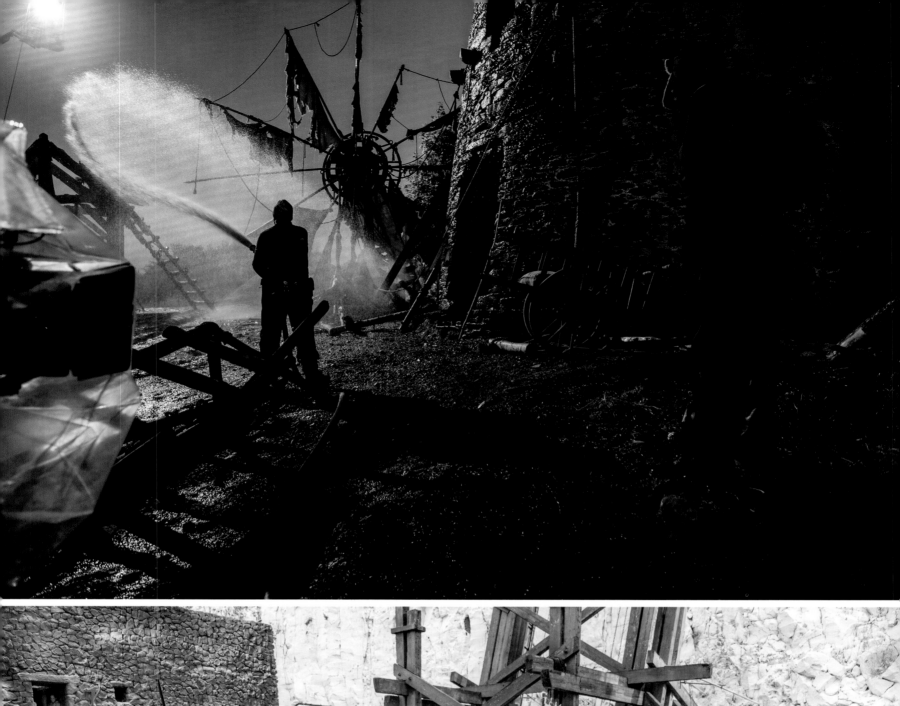
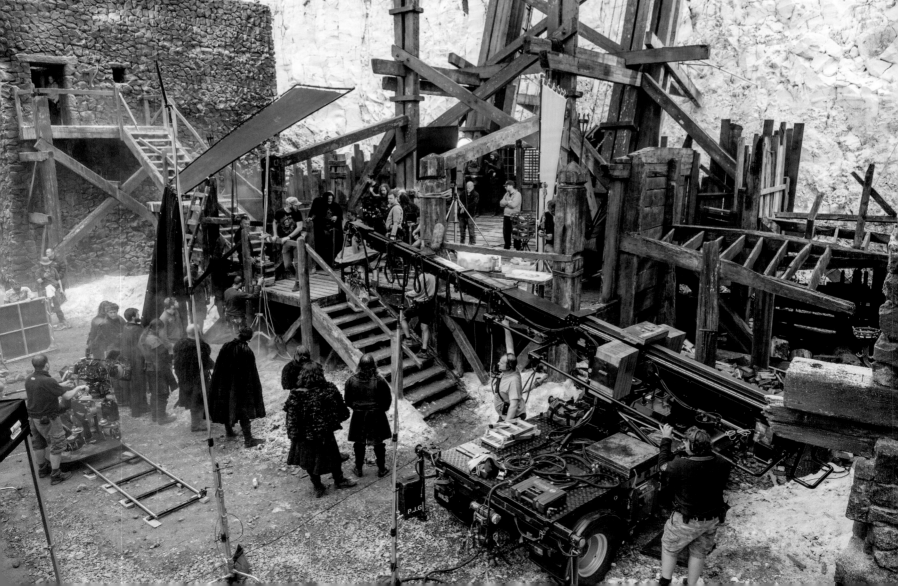

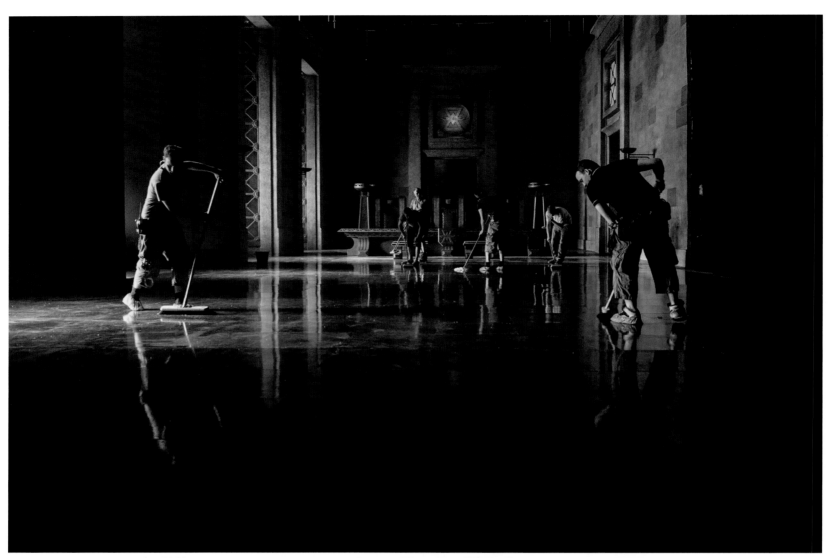

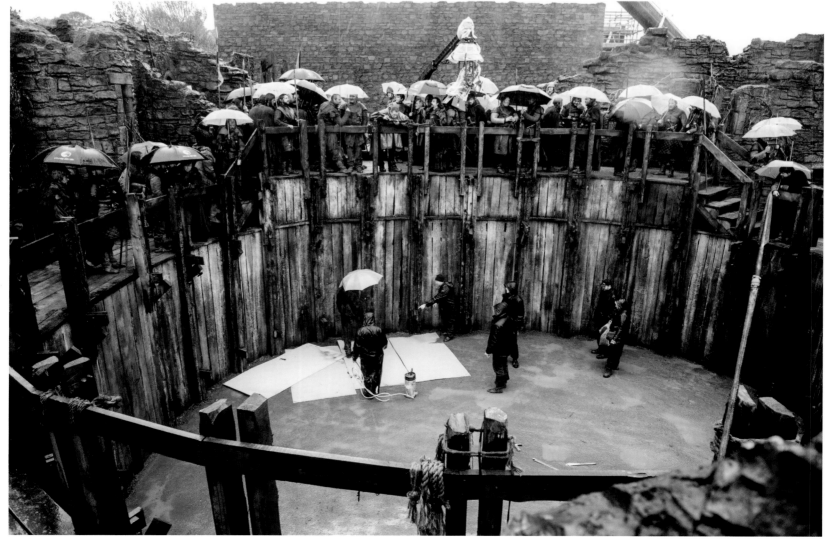

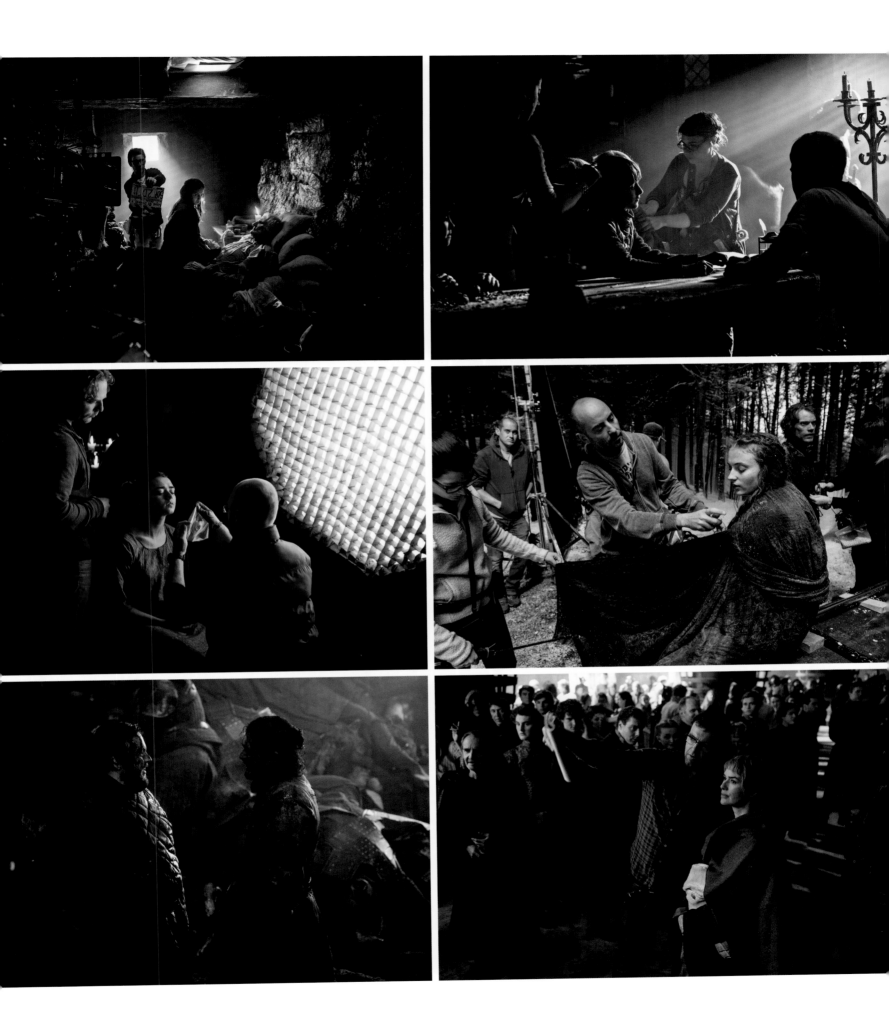

OPPOSITE TOP: The meticulously polished floors of the Iron Bank.
OPPOSITE BOTTOM: The bear pit at Harrenhal.
THIS PAGE: Actors preparing to film their next scene.

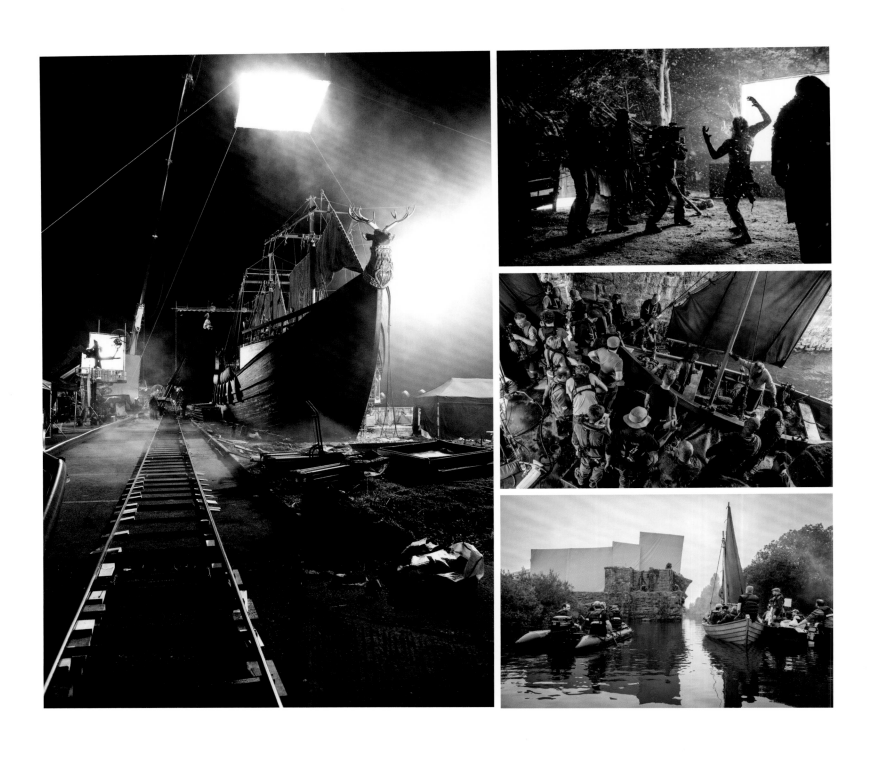

ABOVE: One of the ships that was regularly redressed for shooting numerous scenes.

TOP RIGHT: Filming a White Walker at night.

CENTER RIGHT AND BOTTOM RIGHT: The crew prepares to shoot the Stone Men's attack on Jorah and Tyrion.

OPPOSITE: Kate Dickie (as Lysa Arryn) performs a stunt wherein she falls through the Eyrie's Moon Door.

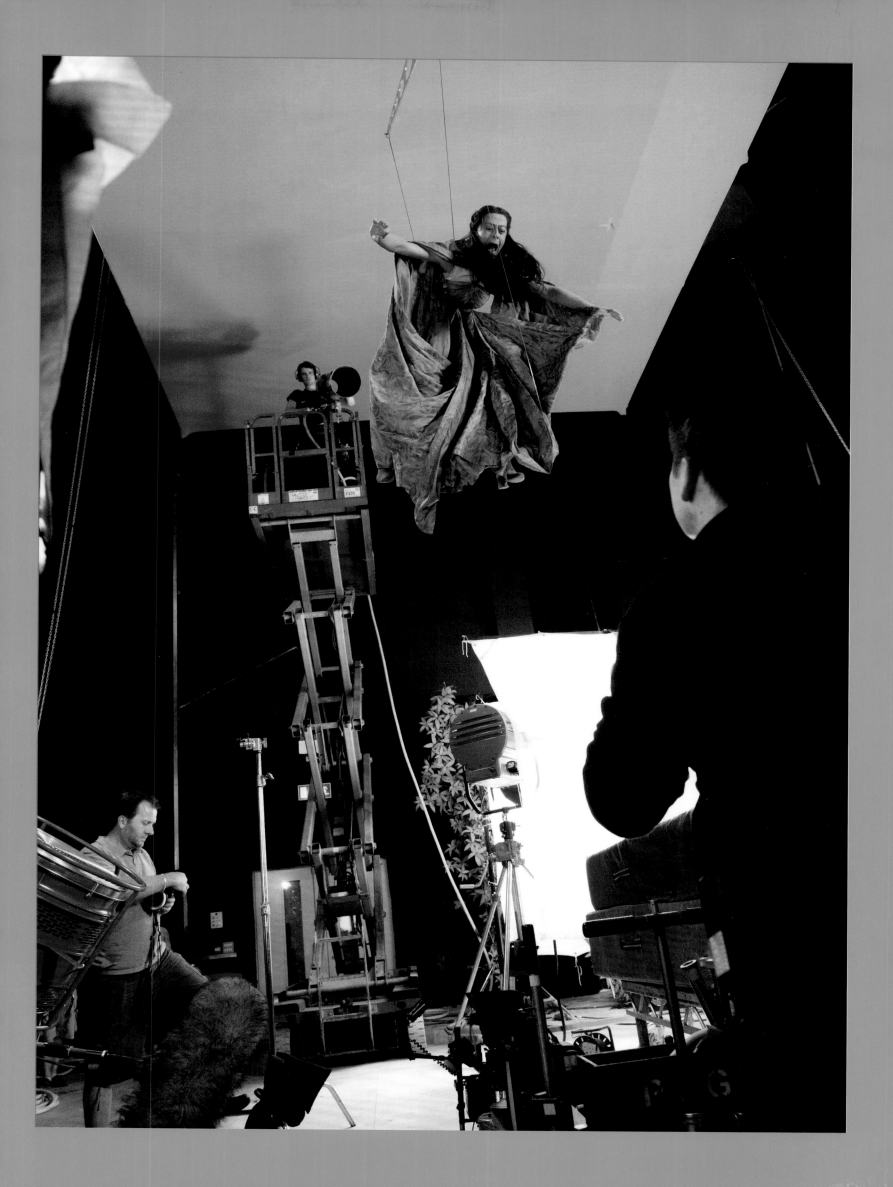

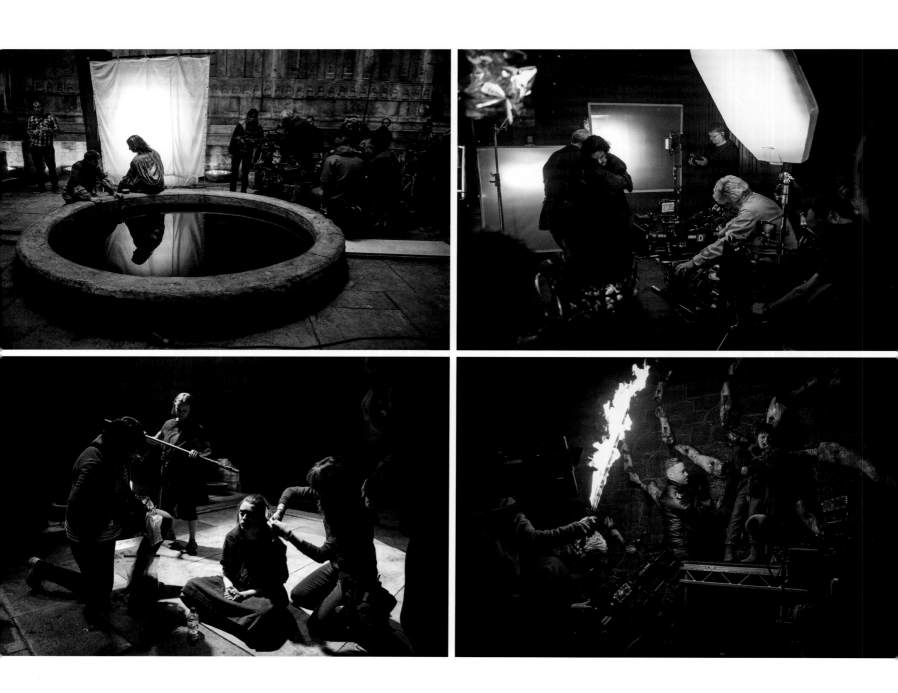

TOP LEFT AND BOTTOM LEFT: Filming in the House of Black and White.
TOP RIGHT: Kit Harington and Liam Cunningham filming a scene.
BOTTOM RIGHT: Harry Grasby mid-take as Lord Ned Umber reacting to Beric Dondarrion's flaming sword.
OPPOSITE: The crew films the death of Mance Rayder at Castle Black.

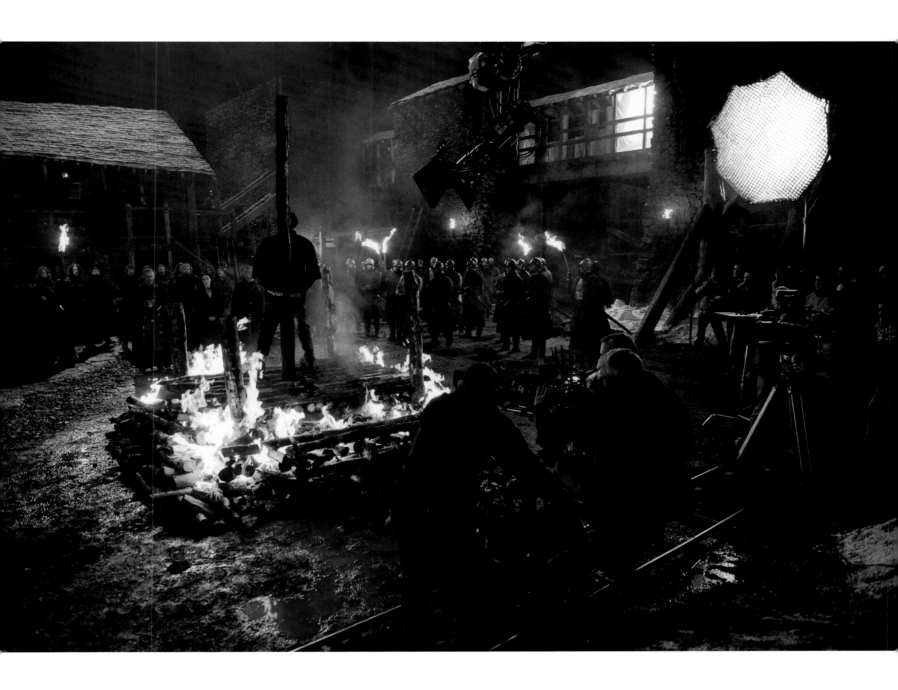

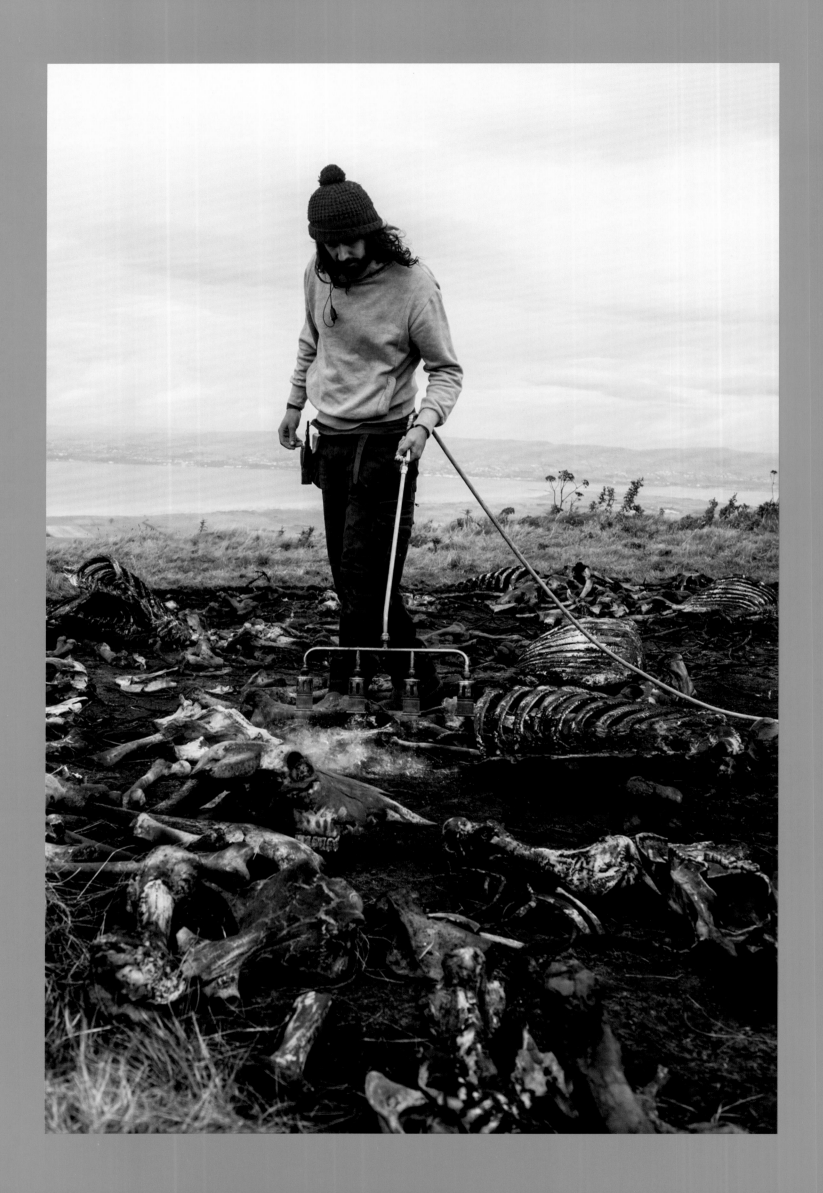

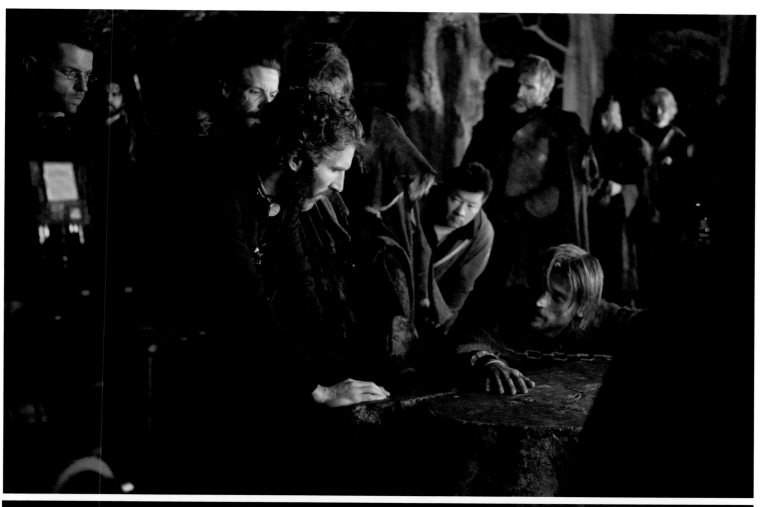

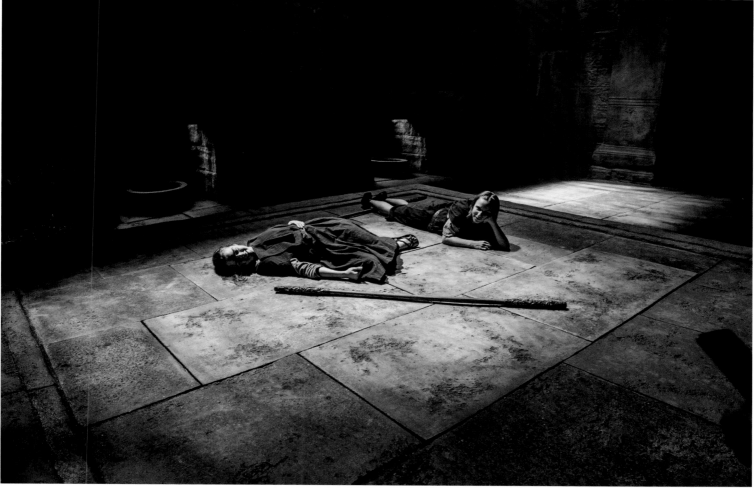

OPPOSITE: A crew member prepares the set where Drogon will be inserted digitally after his rescue of Daenerys from Daznak's pit.
TOP: David Benioff and D. B. Weiss directing Nikolaj Coster-Waldau before a pivotal scene.
BOTTOM: Maisie Williams and Faye Marsay taking a break from their stunt rehearsals.

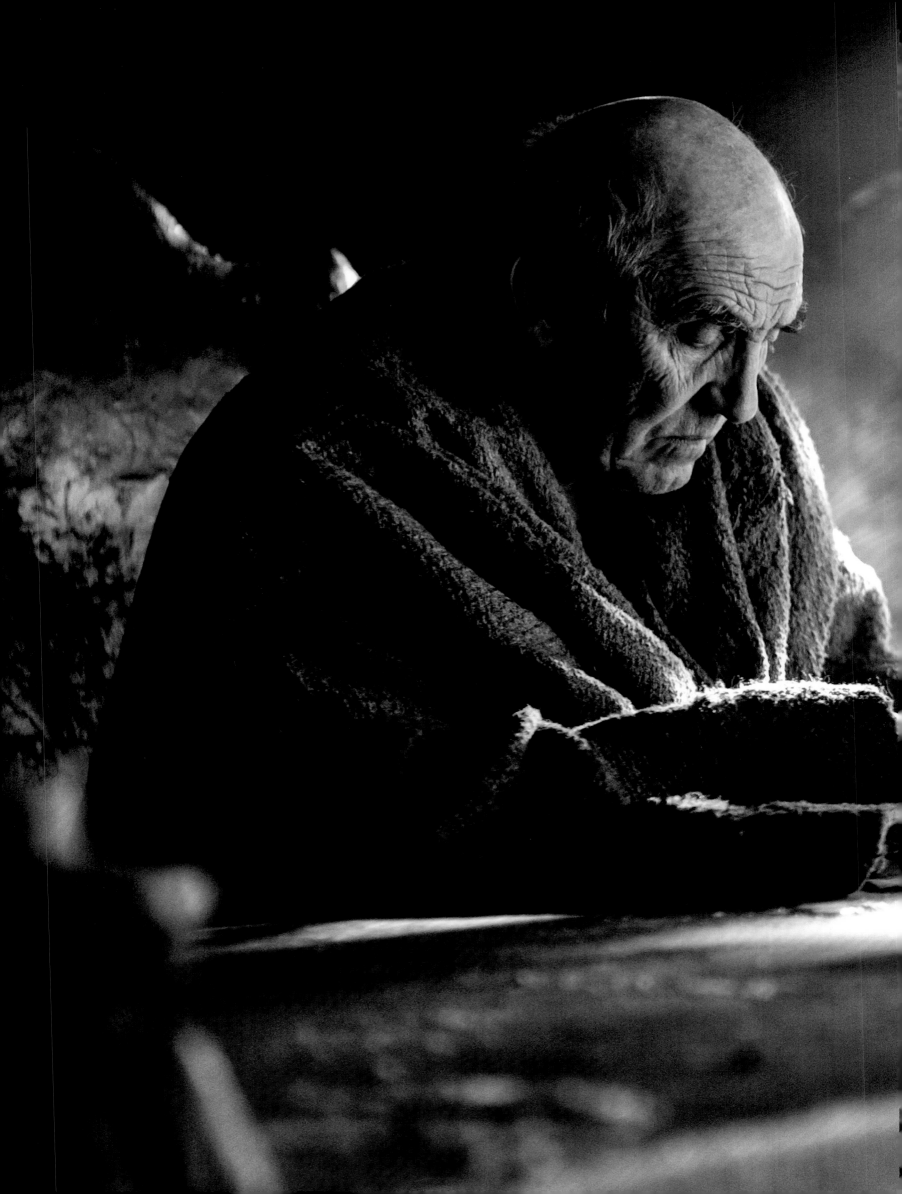

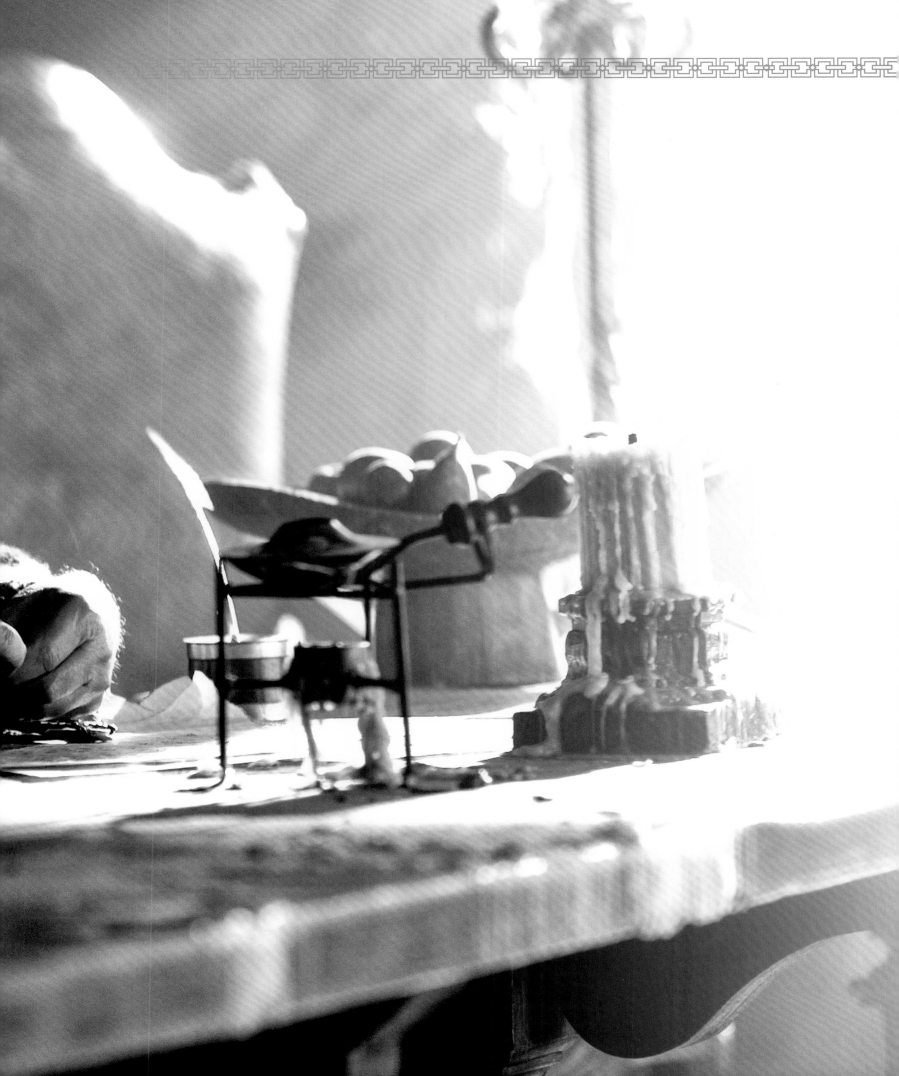

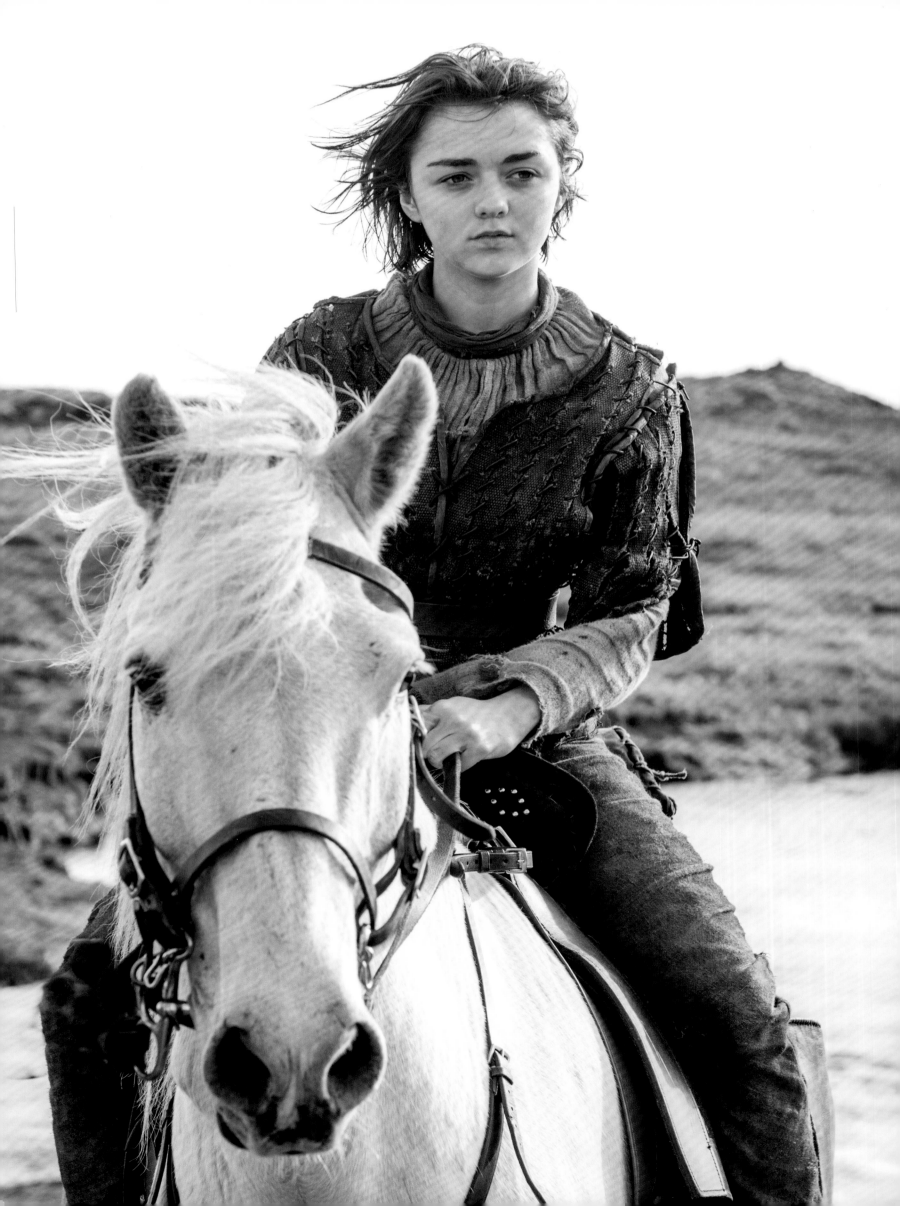

The Crone represents wisdom and is the knower of fates.

In *Game of Thrones*, the varied characters go on disparate journeys to every corner of Westeros and Essos over the course of eight seasons. The central question—Who will occupy the Iron Throne?—is the impetus for the journey, but the answer matters less than the steps taken to discover it. The concept of the crone tracks the fate of each character as they encounter unexpected beginnings, changes, and endings—all of which are what make *Game of Thrones* unique.

The thrilling journey that the show takes is bolstered by an expansive world and fascinating characters. From the start, the opening sequence depicts the gate in the Wall being drawn up and a trio of rangers riding out, demonstrating that the series transgresses boundaries and ventures into the unknown. The danger that those rangers discover within the woods—beings with ice-blue eyes known as White Walkers—serves as the overarching threat of the series. But many of the characters with the power to do something about the threat lack the wisdom needed to take action, and instead ignore or disregard rumors about the growing danger.

No character is pure of virtue and no character is wholeheartedly wicked, which is why *Game of Thrones* and the journeys it portrays are captivating. Characters do what they can—what they must—to get ahead, even if it means betraying an ally in the process. On these journeys, cunning and guile can boost one's standing, while honor and decency can be a death sentence. This is how Ned Stark meets his fate: He refuses to arrest Cersei Lannister and her illegitimate children as her husband, King Robert Baratheon, lies dying. Not one to waste an opportunity, Cersei outmaneuvers Ned, and soon after Robert's death, her son Joffrey is crowned king while Ned Stark is imprisoned and then executed. Other characters have their lives abruptly ended in similar fashion; the journeys taken in *Game of Thrones* are fraught with peril.

Characters can experience a shift in direction, an alteration of motivations, or even an outright transformation. Embarrassed by his son's disinterest in soldiering, Lord Tarly ships Samwell off to the Night's Watch. Even with his training, the unathletic Samwell makes a poor ranger. His friend Jon Snow recognizes Samwell's scholarly talents, and when Snow becomes Lord Commander of the Night's Watch, he approves Samwell's request to study at the Citadel to become a Maester for the Night's Watch. Samwell's transformation throughout the series brings a bright beam of optimism, as he changes from a bumbling recruit to a learned man and member of King Bran's small council.

The series depicts scores of other character journeys, some of which feature incremental changes, while others are monumental transformations. Brandon Stark undergoes a tremendous change, from a boy who loves climbing towers to a wheelchair-bound man who sees visions through space and time, and ultimately to the King of the Six Kingdoms. Despite the deterioration of Bran's physical body, the journey he takes is a physical, mental, and spiritual one to the extent that he can inhabit other living creatures and perceive the world through their senses. His sisters also experience transformations of their own. Arya loses much of her old identity so that she can assume the identities of others, although she never forgets that she's a Stark first and foremost. Sansa grows from a naive and wide-eyed adolescent into a woman of wisdom and courage, scarred yet still strong.

Across the Narrow Sea, Daenerys Targaryen experiences one of the most stunning transformations in the series as she changes from a terrified young woman who follows her brother's every move into a *Khaleesi* and mother of dragons—and a woman with the power to take the Iron Throne for herself.

There are many other cases of dramatic character development in the show, such as Theon Greyjoy's transformation into Reek and his painful struggle to regain his identity, and Jaime's glacial realization of his sister's all-consuming greed—both of which illustrate journeys on different scales. These journeys, large and small, are what make the characters in *Game of Thrones* so relatable and engaging.

Helen Sloan, the cast, and the crew have all gone on their own journeys spanning ten years of making *Game of Thrones*. "I know it's nerdy, but I really get into the story and want to be with the characters on their journeys," Sloan says. "I enjoy being in the scene with them. I feel that if I didn't care about it, I would just be taking a picture or a portrait of an actor, not capturing something special. That would be unfair to the writers, the cinematographers, and the actors who work so hard to make these moments so wonderful."

PAGES 198—199: Donald Sumpter as Luwin, the Maester of Winterfell and loyal servant to the Starks.

OPPOSITE: Arya atop the horse she took from the Lannister soldiers who killed her friend and stole her sword, Needle, in the Riverlands.

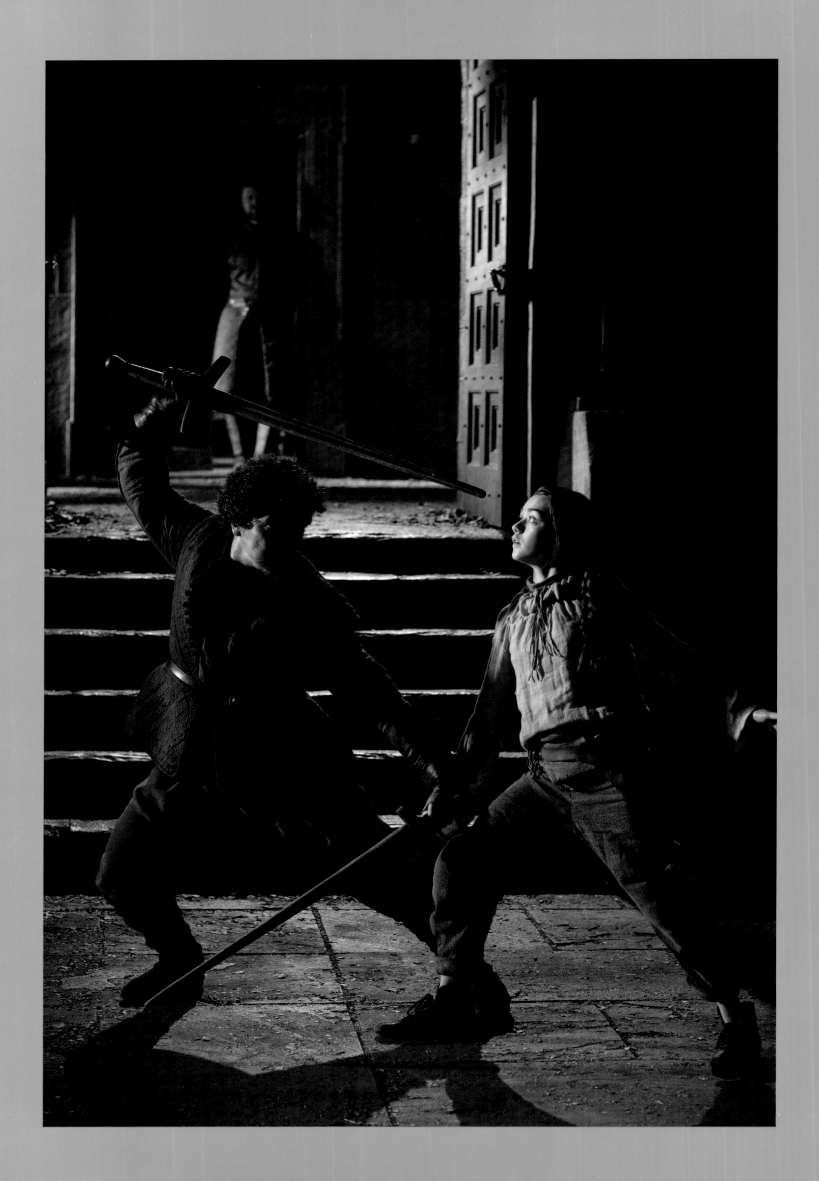

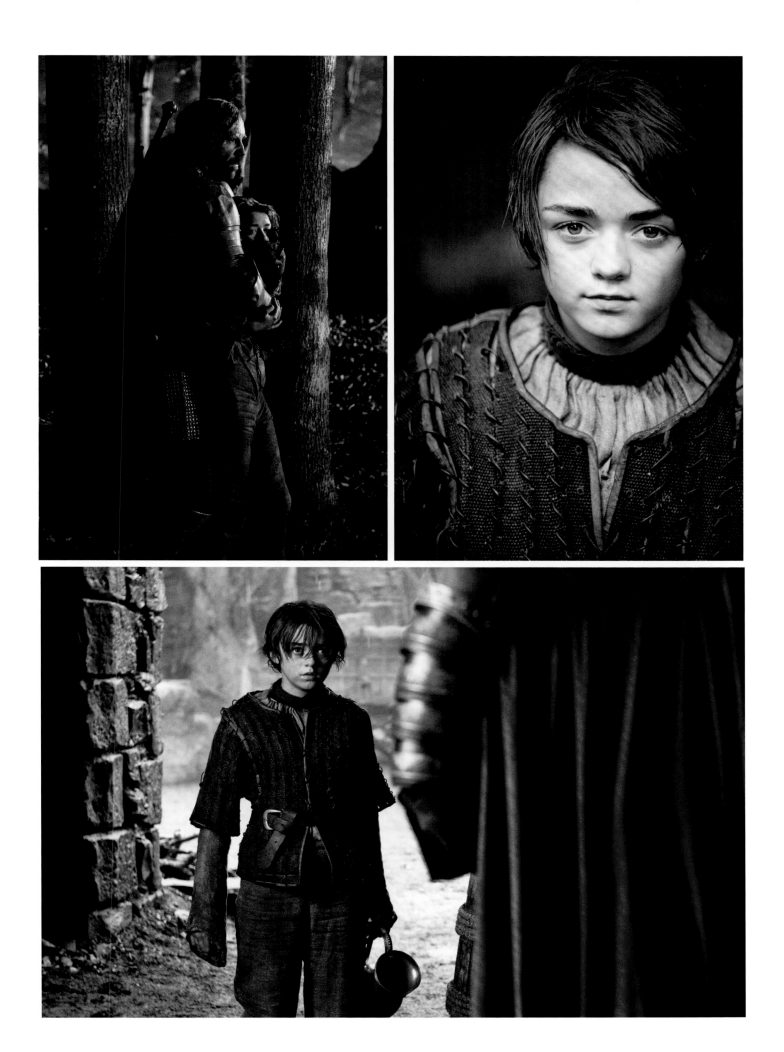

OPPOSITE: Master swordsman Syrio Forel trains young Arya Stark in the Braavosi style of sword fighting known as the Water Dance.
TOP LEFT: The Hound quiets Arya to avoid detection.
TOP RIGHT AND BOTTOM: After being taken prisoner at Harrenhal, Arya poses as a boy and becomes Tywin Lannister's cupbearer.

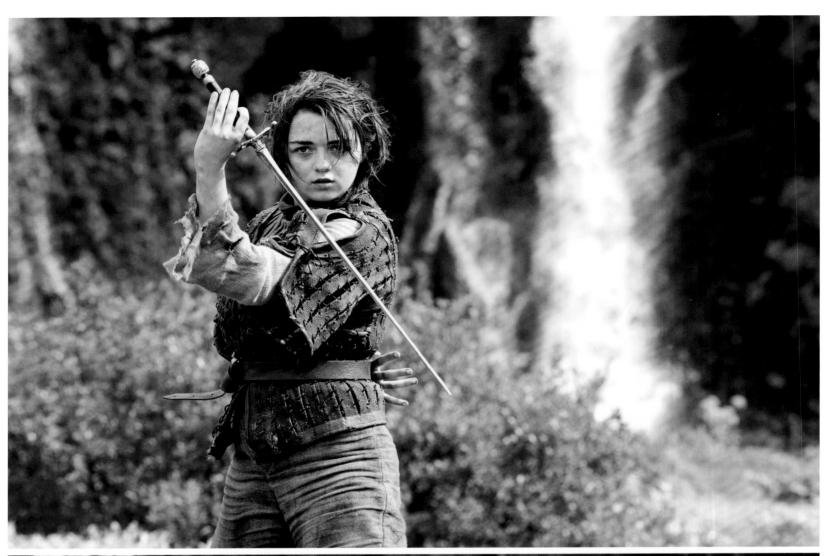

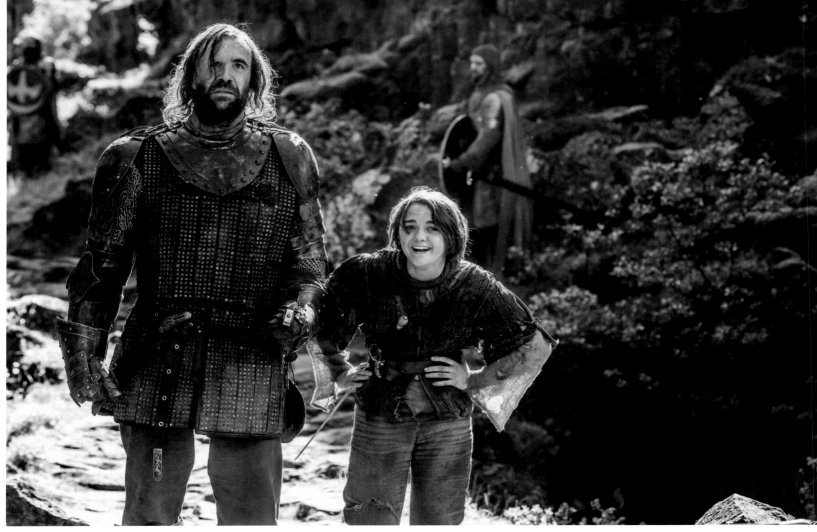

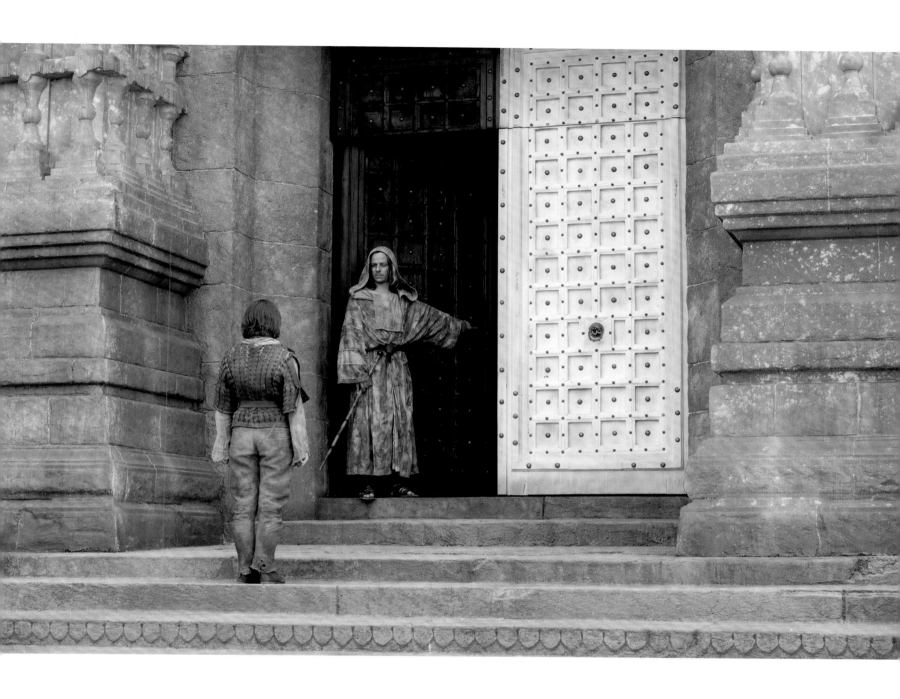

OPPOSITE TOP: Arya trains with her beloved sword, Needle.
OPPOSITE BOTTOM: Arya laughs upon finding out her aunt Lysa is dead and the Hound can no longer demand a ransom for Arya.
ABOVE: Arya arrives at the House of Black and White in Braavos to train with the assassins' guild known as the Faceless Men.

205

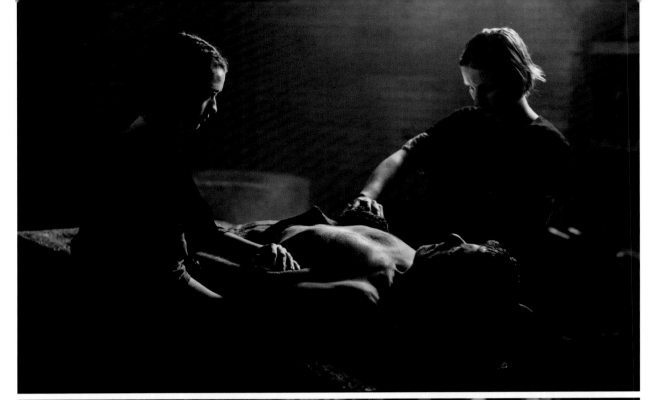

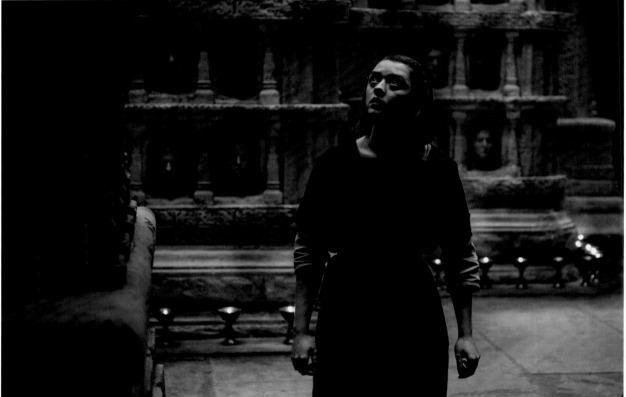

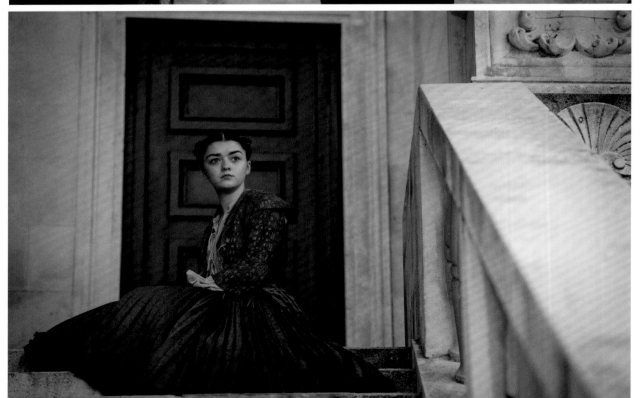

TOP: Arya cleans a body in the temple.

CENTER: Arya is fascinated by the Hall of Faces.

BOTTOM AND OPPOSITE: Arya poses as a shellfish merchant to study her first target as one of the Faceless Men.

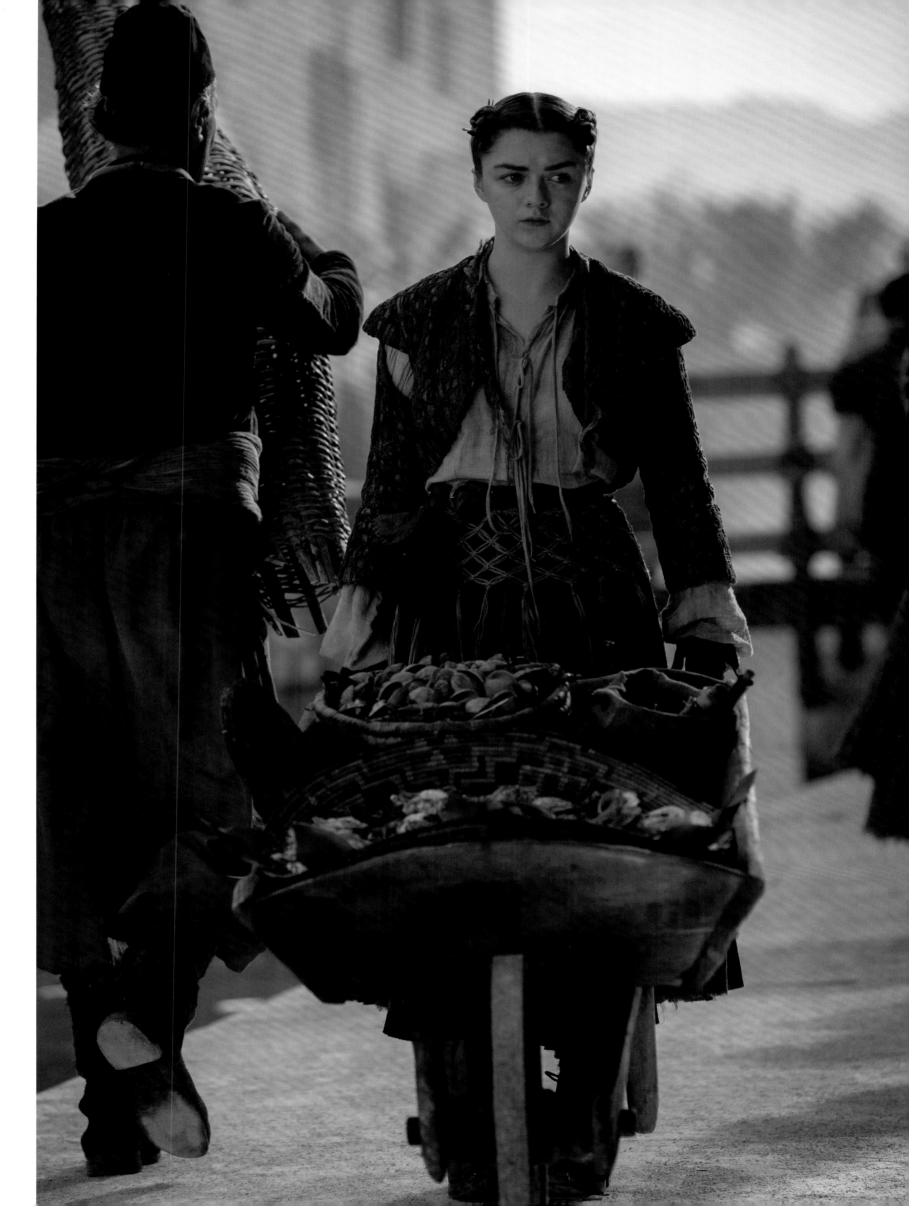

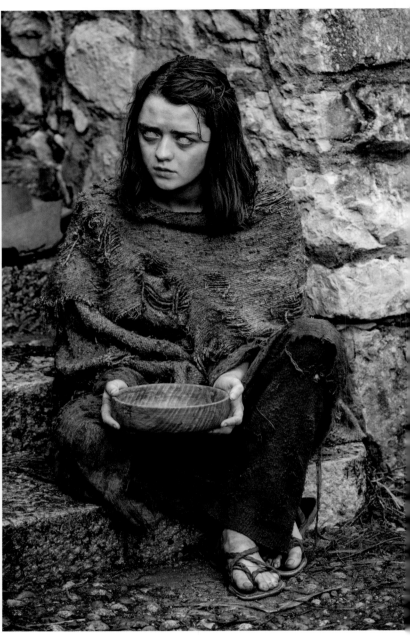

TOP AND ABOVE: Jaqen H'ghar discovers Arya's deception and imbibes a poison to teach her a lesson. According to Helen Sloan, there were a number of hidden cameos in the Hall of Faces inside of the House of Black and White, including various artisans' relatives, producers, and other crew members, as well as David Benioff and D. B. Weiss themselves. The faces were made out of prosthetic skin material, and the ones that would be featured in close-up were convincingly lifelike, with hair and meticulously detailed sculpting.

RIGHT: Arya is blinded by improperly using a "face."

OPPOSITE: A blind Arya resumes her training with Jaqen, using staves.

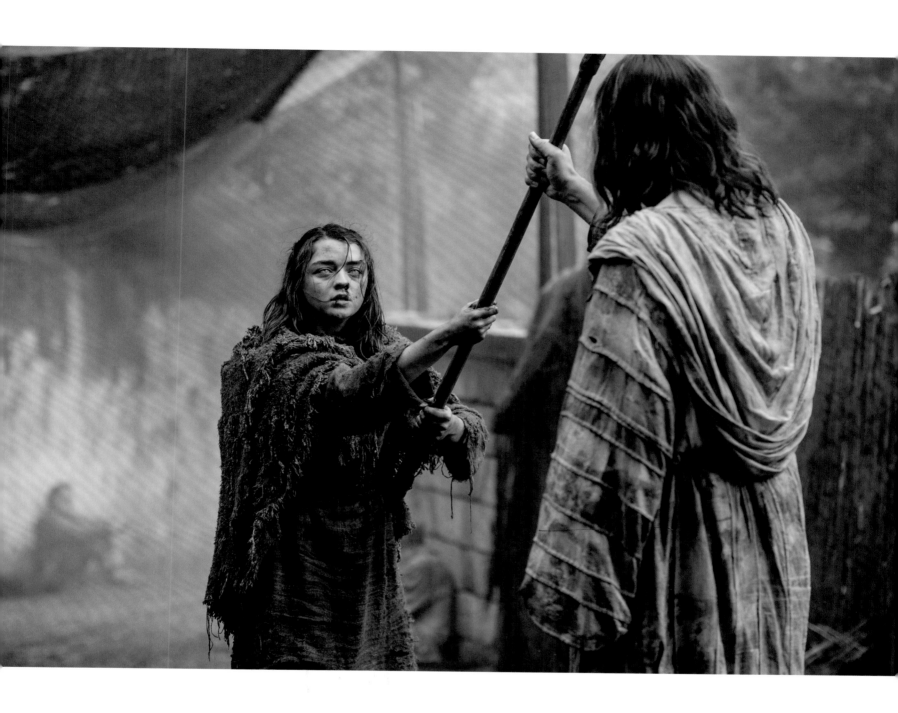

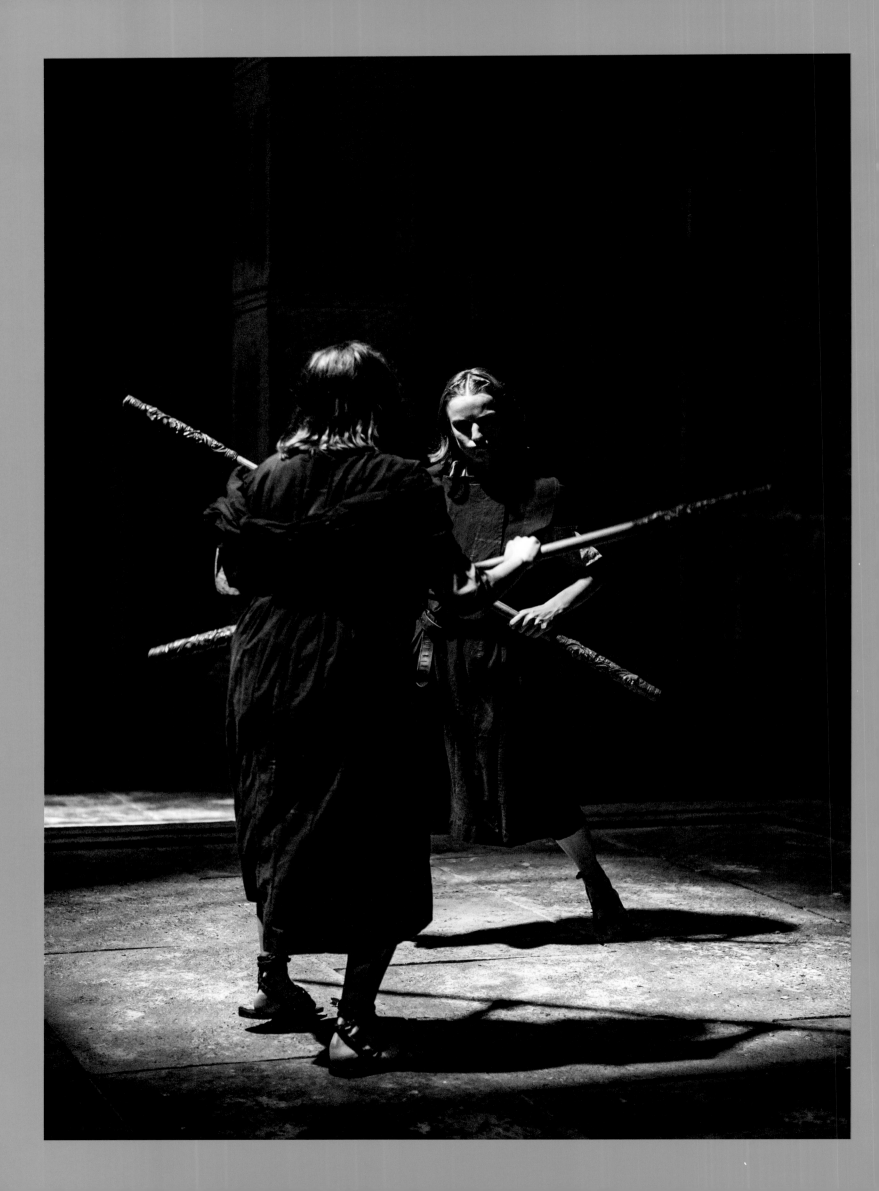

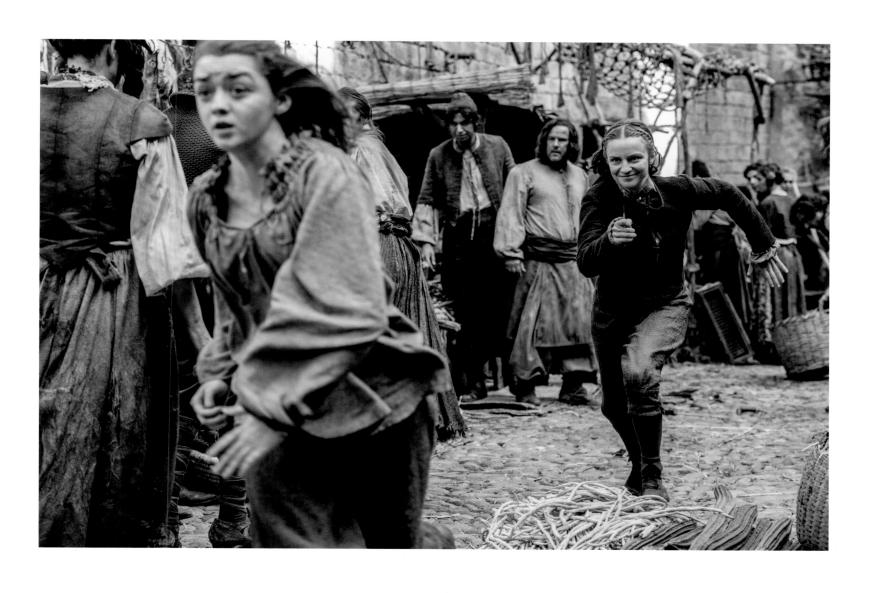

OPPOSITE: Arya spars with the Waif, an apprentice of the Faceless Men. Helen Sloan says, "It's a ways harder to shoot a fight sequence in the dark like this one between Arya and the Waif, because you're dealing with shallow focus. You have no room for error and you have to be in the right position. For certain stunts and fight scenes like this, I would learn the choreography the actors were going to do. That way I would know when they were going to slow down and when they would hit their marks. This moment where Arya and the Waif strike their sticks in this X formation wasn't a rest moment, but it was definitely a very brief pause. That's when I grabbed my shot."

ABOVE: The Waif chases Arya through the streets of Braavos, attempting to kill her.

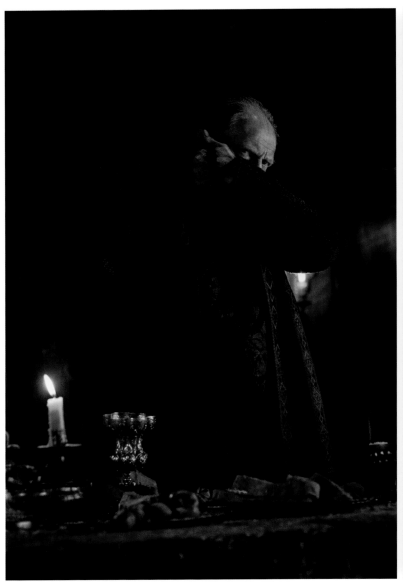
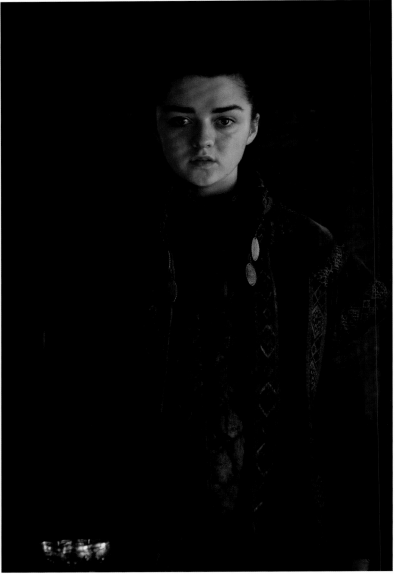

ABOVE: Arya uses her training from the Faceless Men to pose as Walder Frey and exact her revenge against House Frey after the Red Wedding.
OPPOSITE: Arya returns home to Winterfell and reunites with her brothers Bran and Jon.

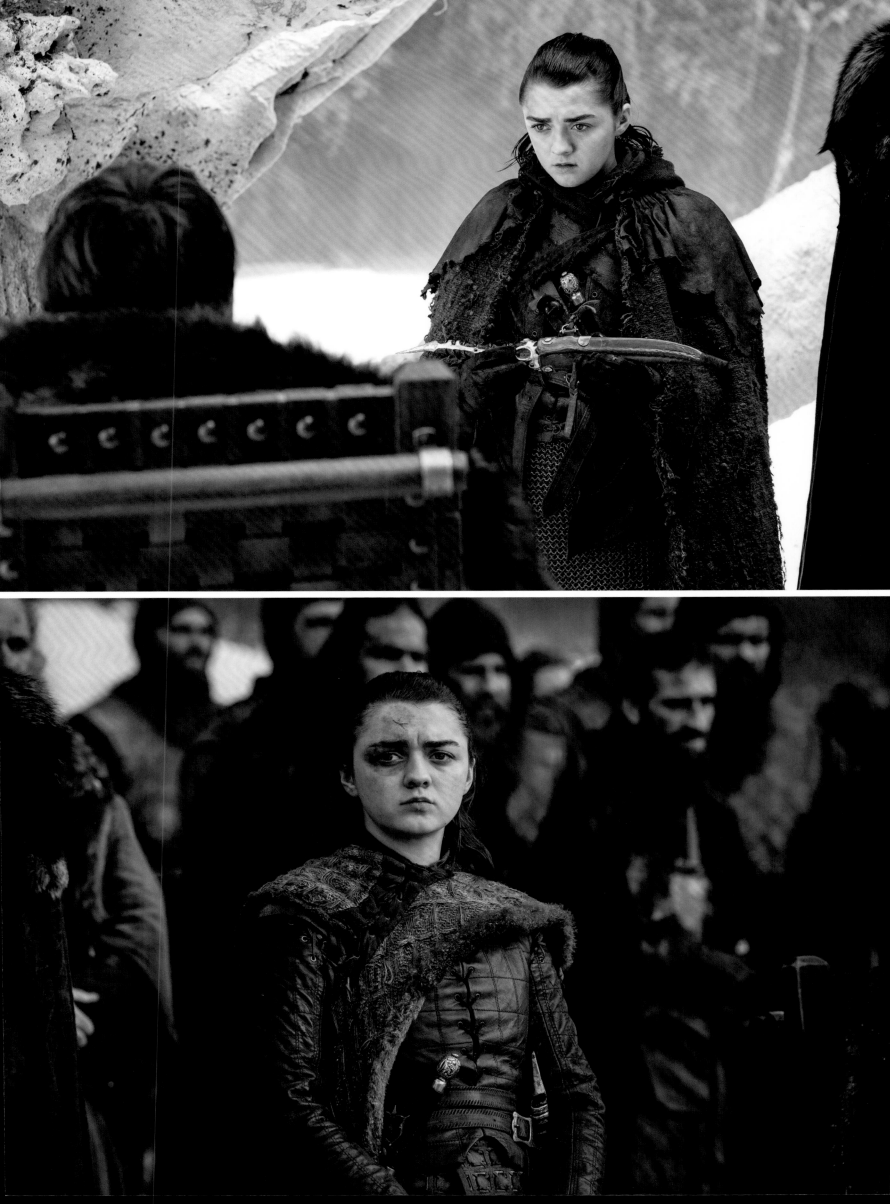

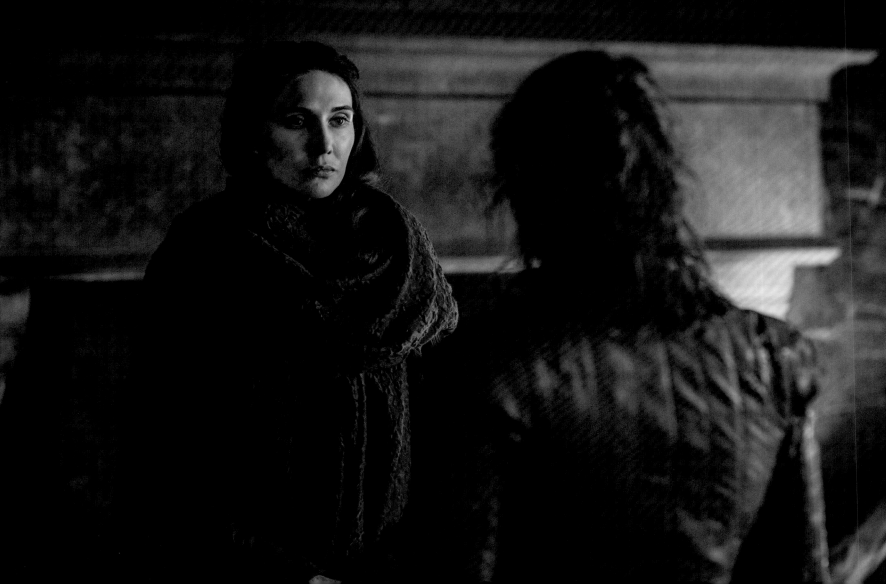

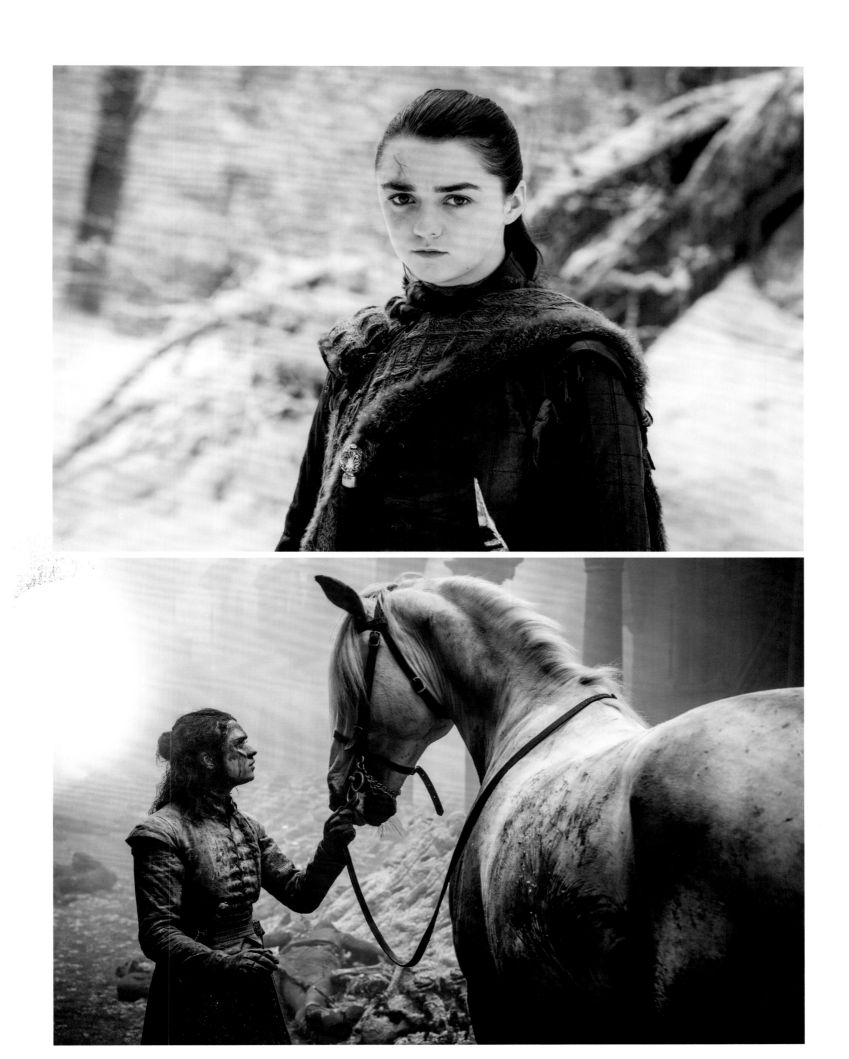

OPPOSITE TOP: The Hound and Arya's paths cross again on the eve of the Battle of Winterfell.
OPPOSITE BOTTOM: During the Battle of Winterfell, Melisandre asks Arya, "What do we say to the God of Death?"
TOP: Arya Stark in Winterfell's godswood.
BOTTOM: Arya Stark survives the destruction of King's Landing and rides a horse out of the rubble.

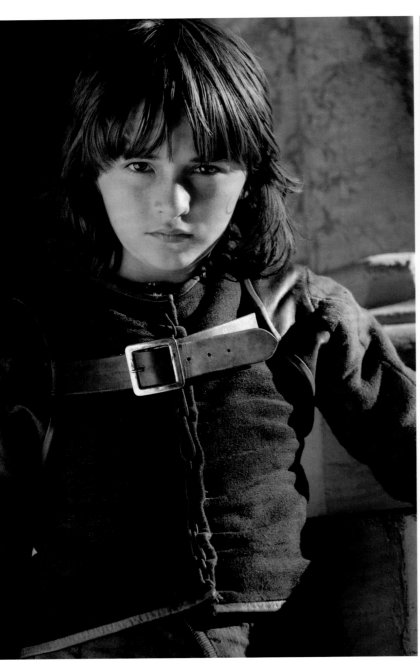

ABOVE AND RIGHT: Bran Stark, the future Three-Eyed Raven.
OPPOSITE: Leaf, one of the Children of the Forest who created the White Walkers to defend against the First Men.

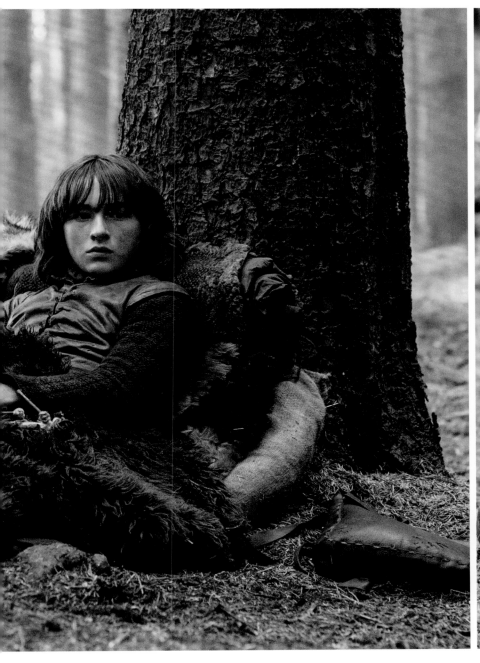
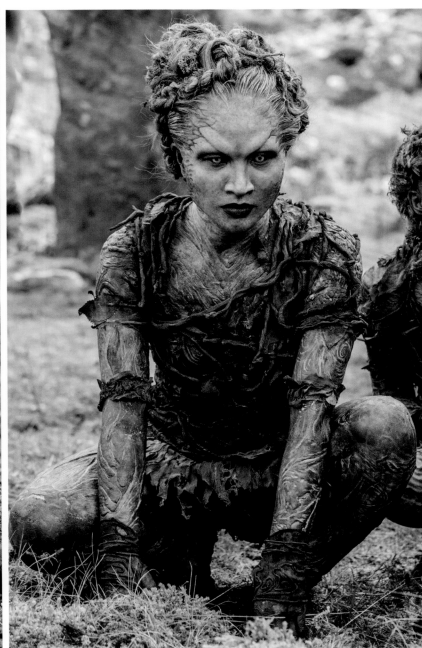

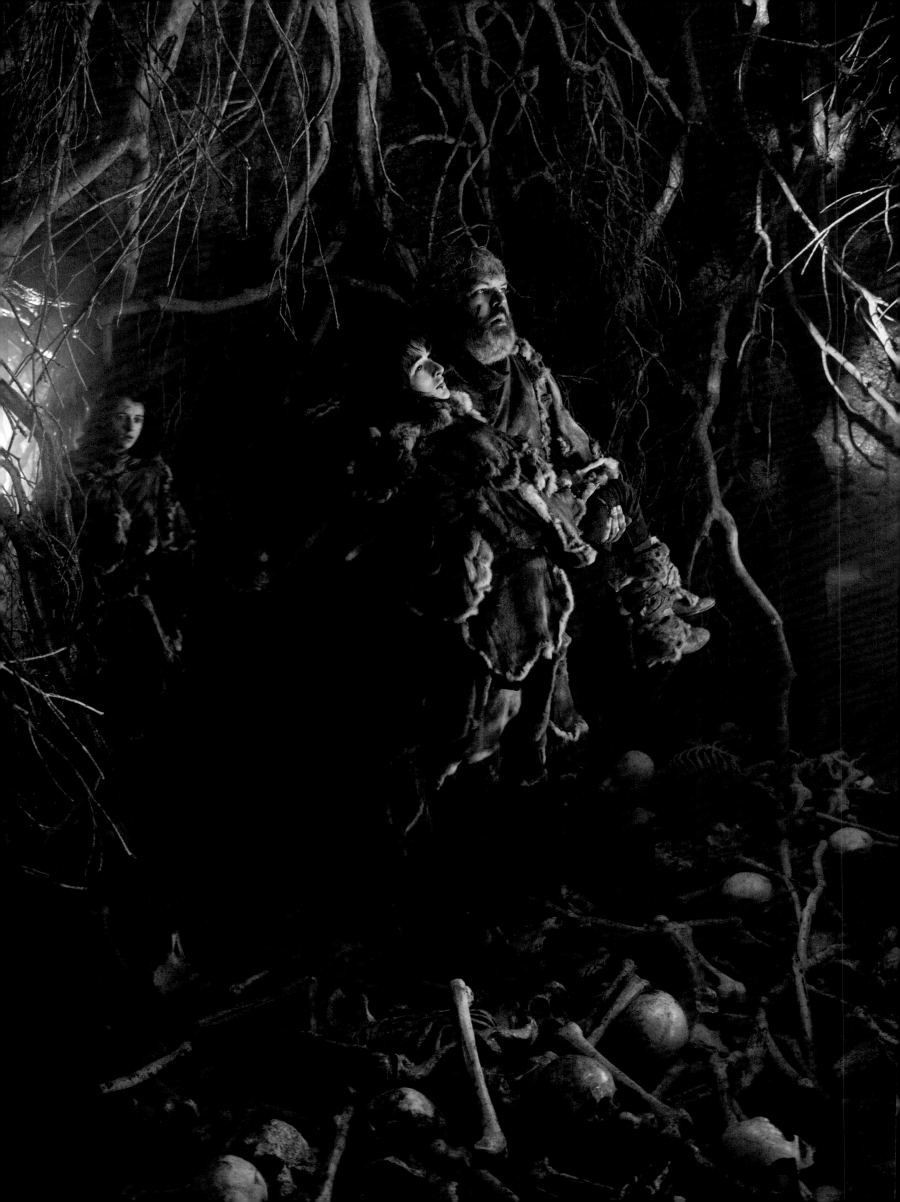

OPPOSITE: Hodor brings Bran into the cave of the Three-Eyed Raven, which lies beneath a giant weirwood tree.
THIS PAGE: The roots of the weirwood tree extend far into the cave. The Three-Eyed Raven's cave was an incredible challenge, because it was a dark, cramped, and delicate set. The branches and bones on the floor were fragile. When the fog machines started, it was almost impossible for the crew members to see where they were standing. Sloan says she struggled to navigate that set but that it was worth the extra effort to get the shot.

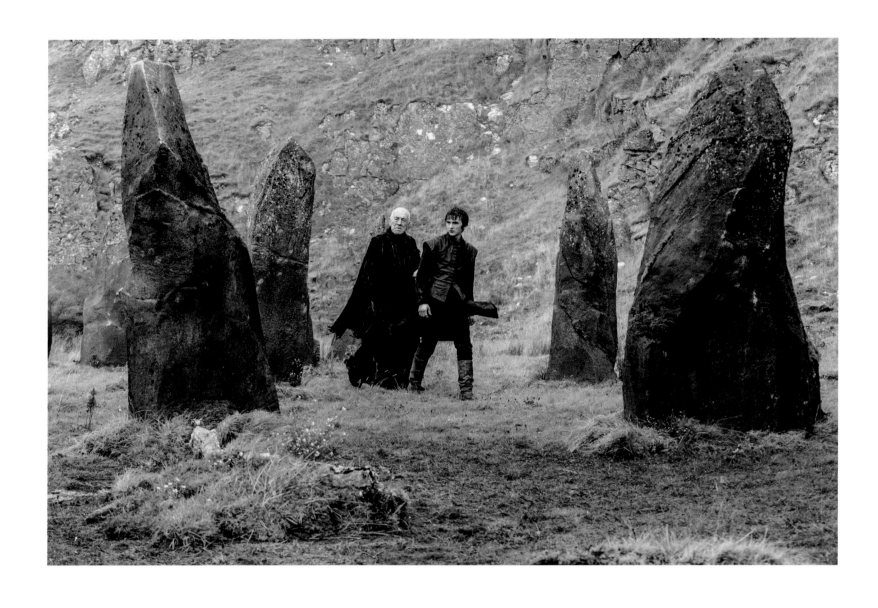

THESE PAGES: Bran begins to learn more about his abilities with the Sight. The Three-Eyed Raven, played by Max von Sydow (*opposite top right*), takes human form and guides Bran through past moments, such as the reasons behind Hodor's lack of communication. With the skills he learns, he is later able to see the marriage of Rhaegar Targaryen and Lyanna Stark, confirming Jon Snow's lineage.

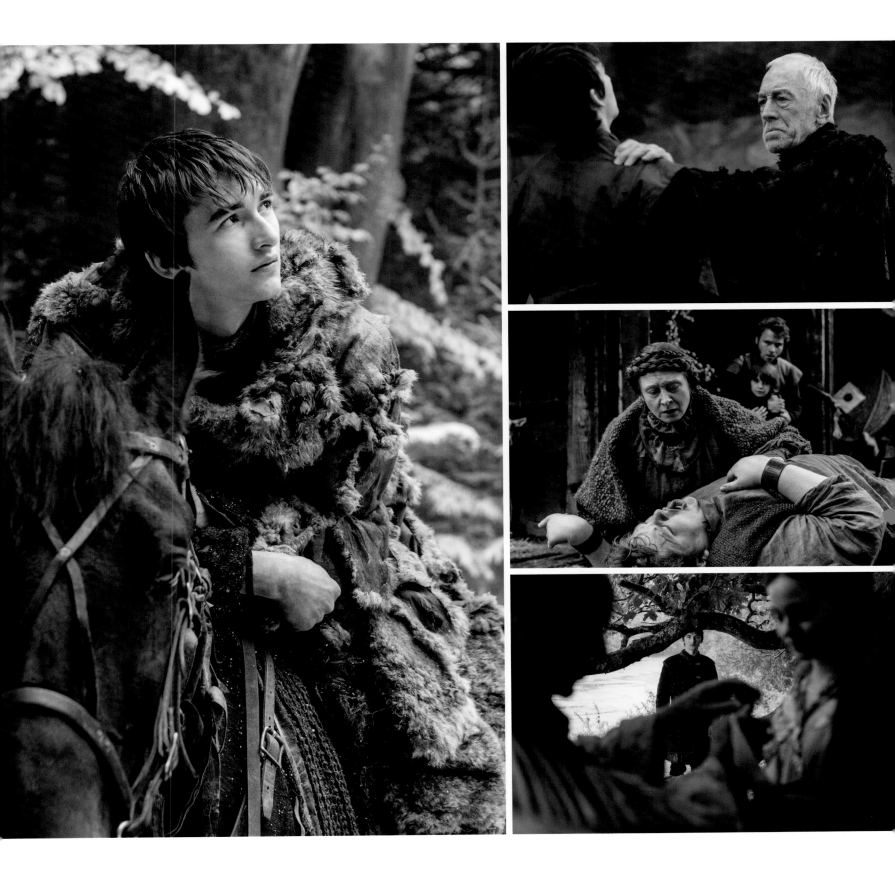

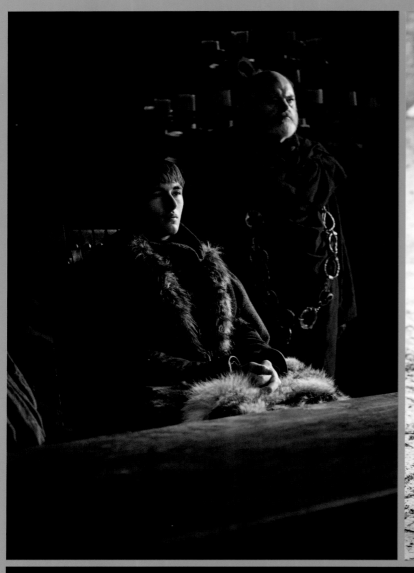

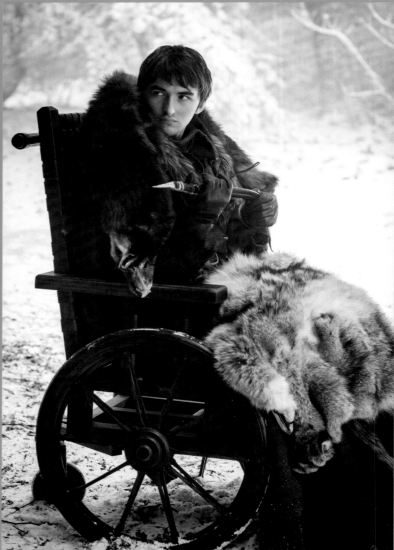

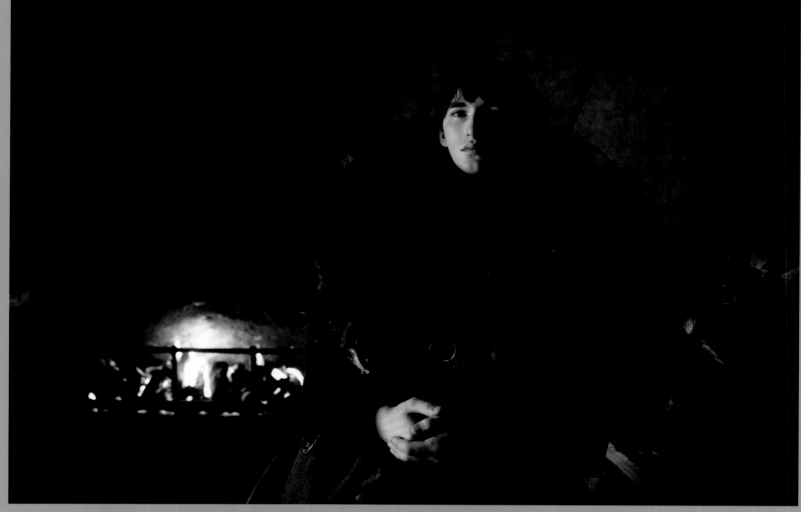

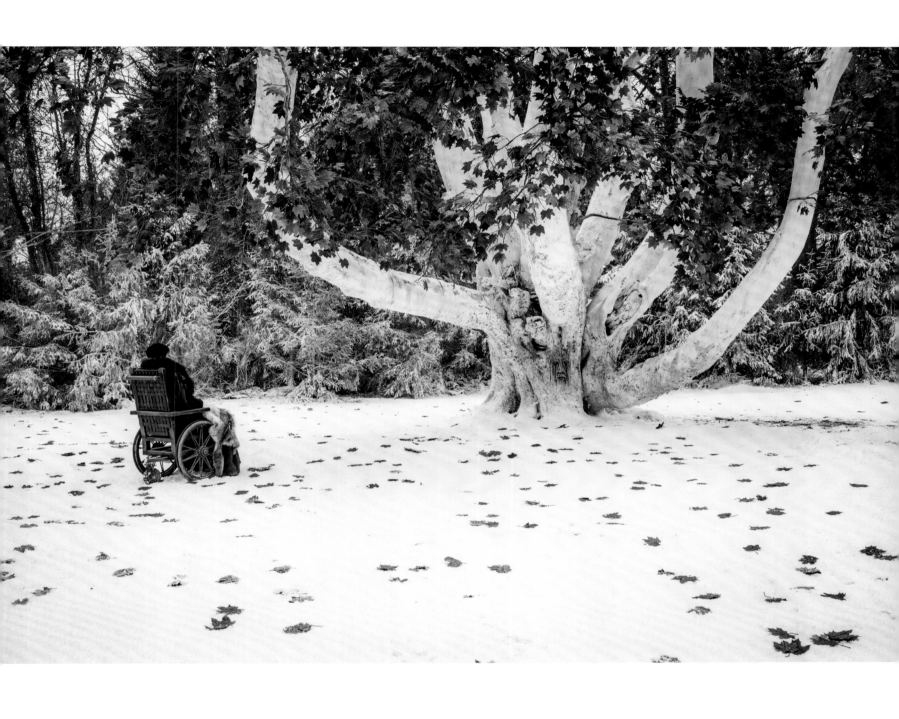

OPPOSITE TOP LEFT AND OPPOSITE BOTTOM: Bran returns to Winterfell a profoundly different person.
OPPOSITE TOP RIGHT: Bran holds the Valyrian steel catspaw dagger that was once used in an attempt to murder him.
THIS PAGE: Bran reflects at the base of the weirwood tree outside Winterfell.

223

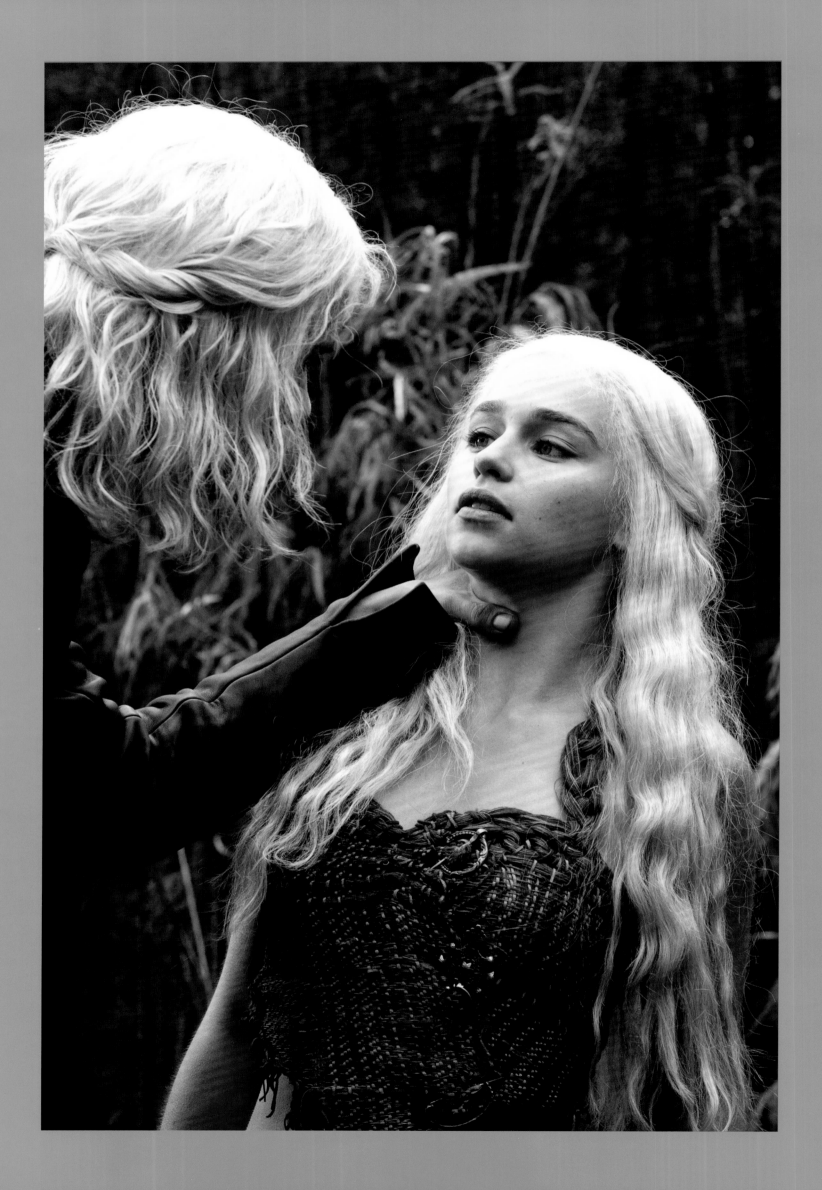

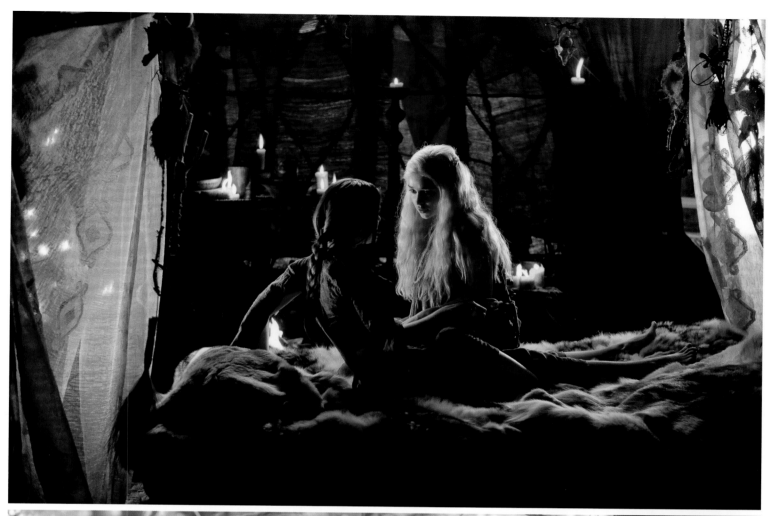

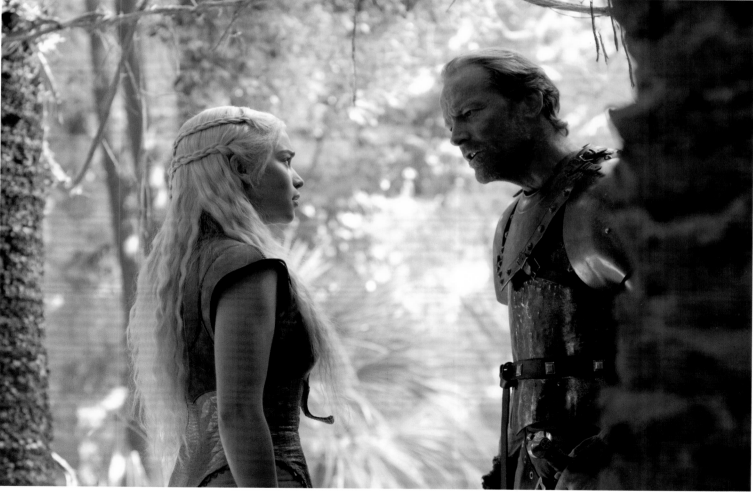

OPPOSITE: Viserys Targaryen menaces his sister, Daenerys.
TOP: Daenerys and her handmaiden, Doreah.
BOTTOM: Ser Jorah counsels Daenerys.

225

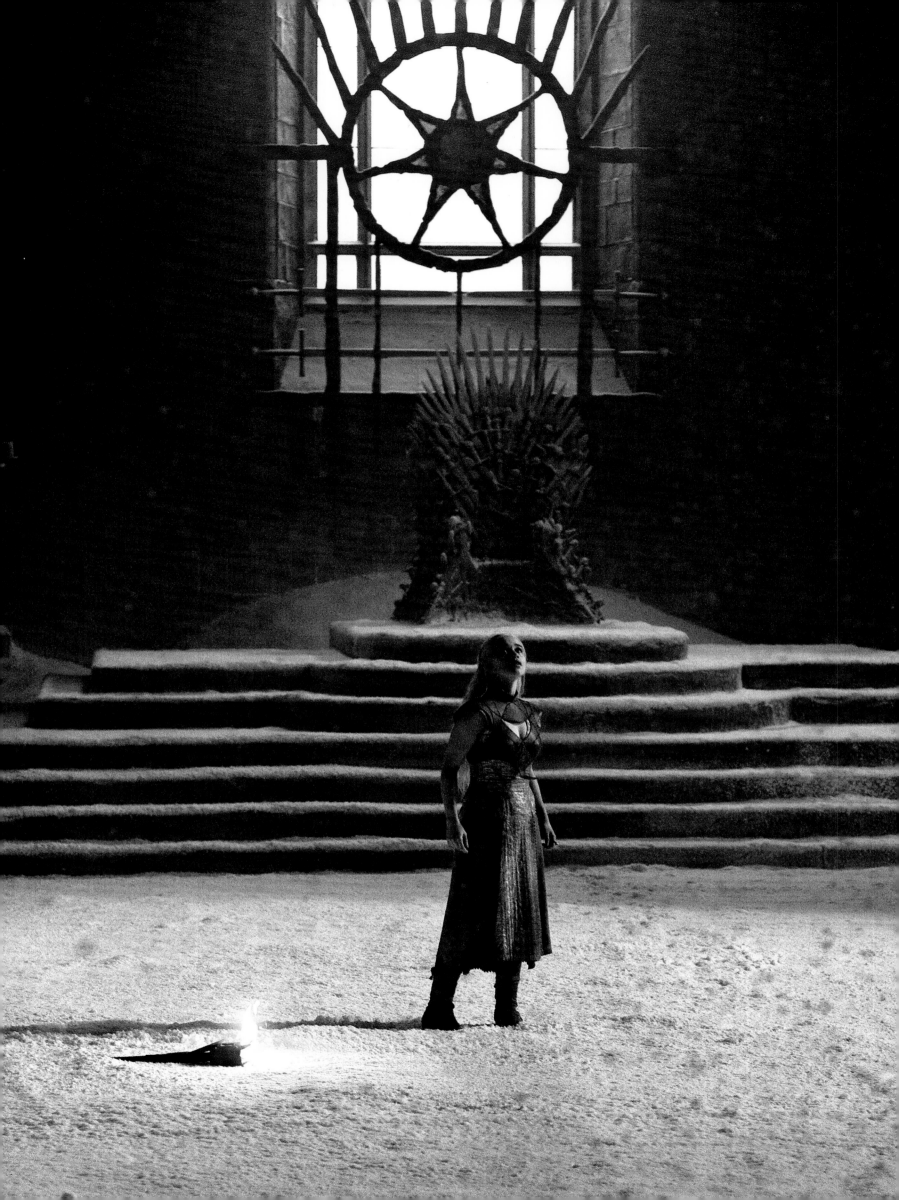

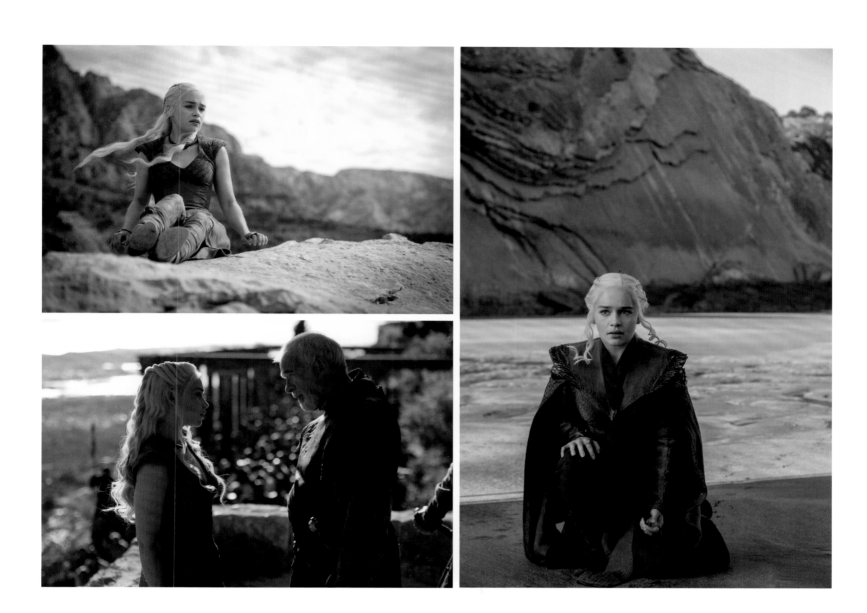

OPPOSITE: Daenerys steps inside the throne room within the Red Keep during her vision at the House of the Undying. She is ultimately killed by Jon Snow while standing in this same location, just steps away from the Iron Throne.

TOP LEFT: Daenerys sits and watches her dragons.

BOTTOM LEFT: Ser Barristan advises his queen in Meereen.

RIGHT: Daenerys kneeling on the shores of Dragonstone.

PAGES 228—229: Tyrion Lannister walks with his queen, Daenerys.

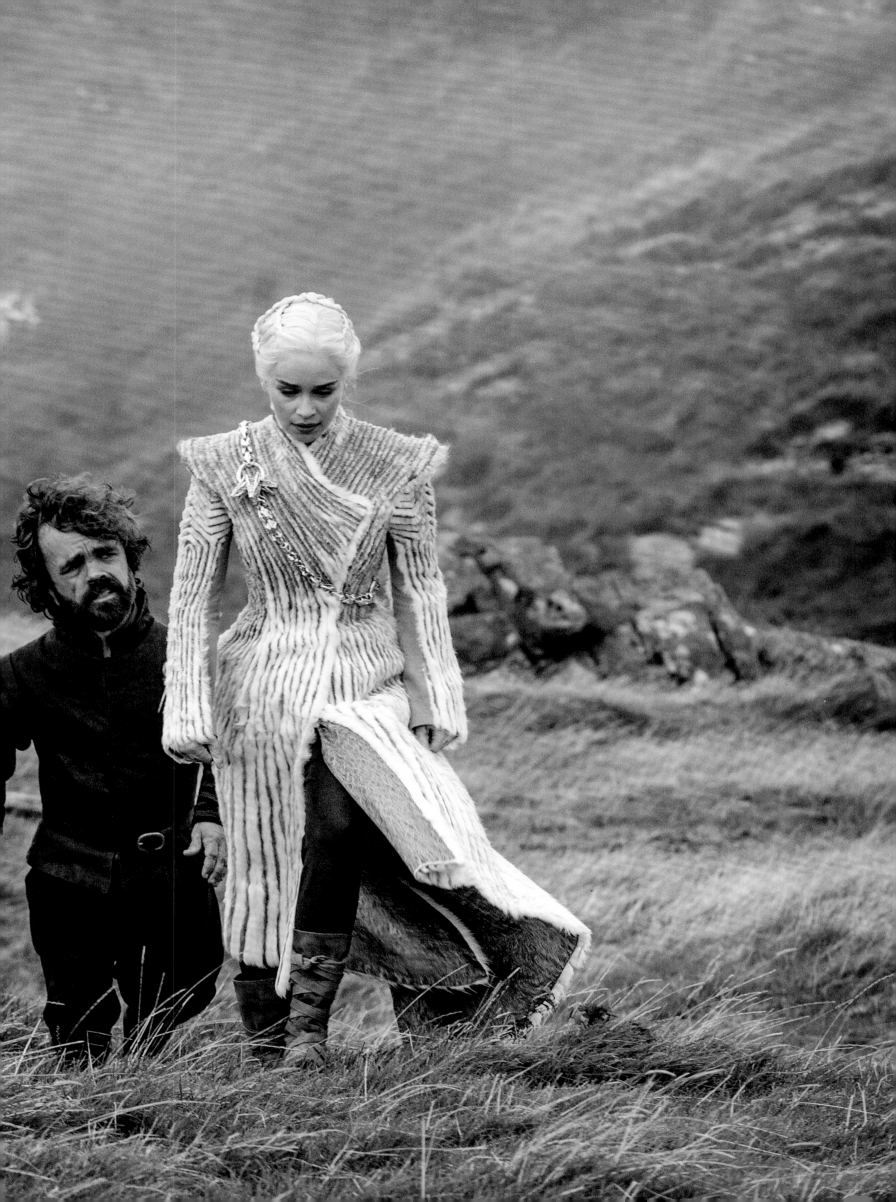

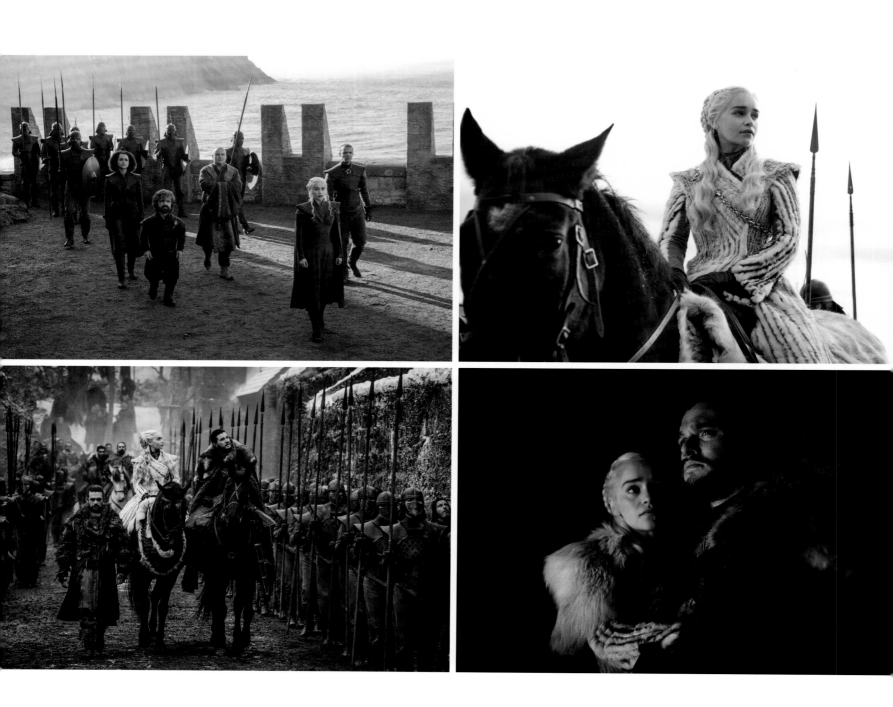

TOP LEFT: The queen returns to the place of her birth: Dragonstone.

TOP RIGHT AND BOTTOM ROW: The *Khaleesi* rides into Winterfell with the King in the North by her side.

OPPOSITE: Daenerys grieves after Ser Jorah gives his life to help keep her alive. Helen Sloan says of this moment, "There is quiet during filming, but sometimes there is silence on a set that almost feels like a vacuum. Emilia's performance in this scene with Iain was one of those moments; everyone was just so moved. It was just so powerful."

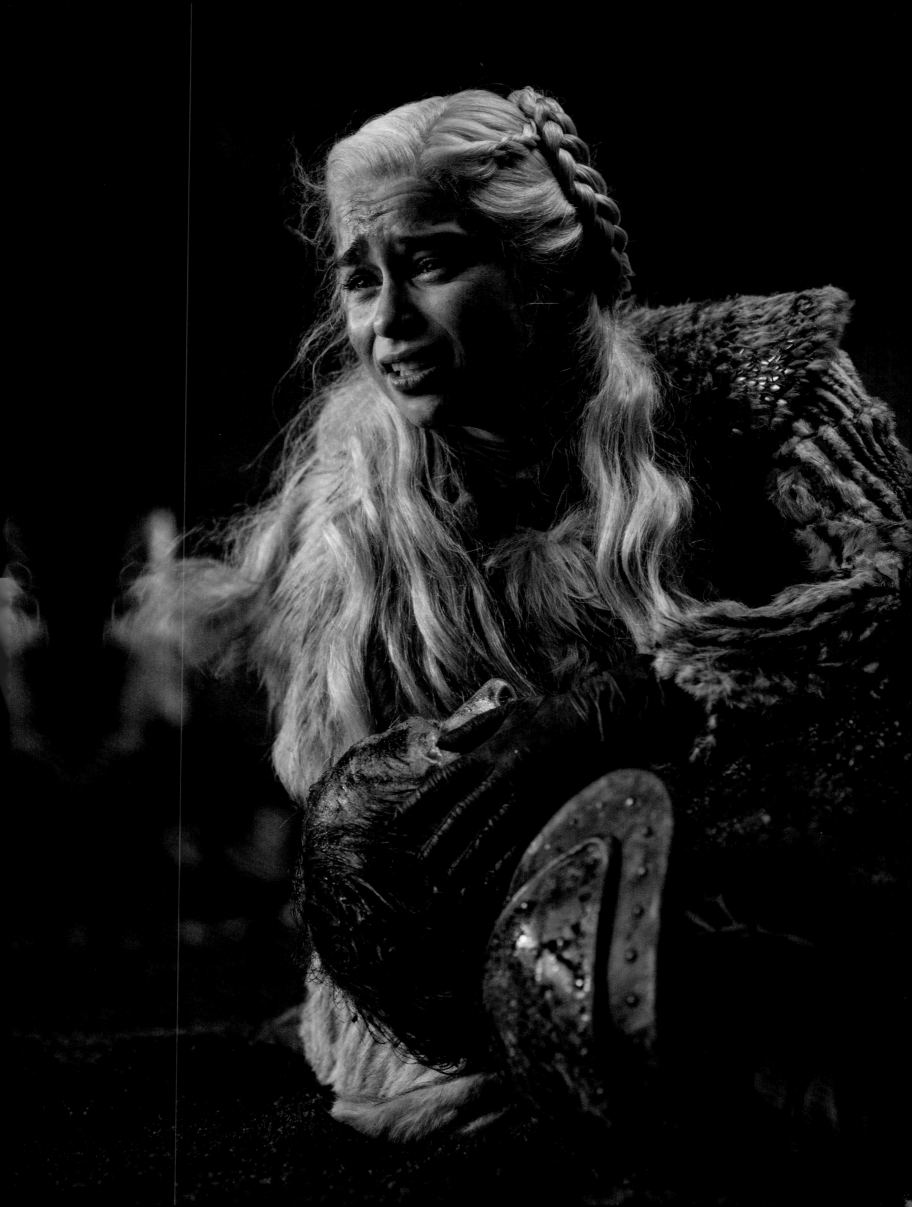

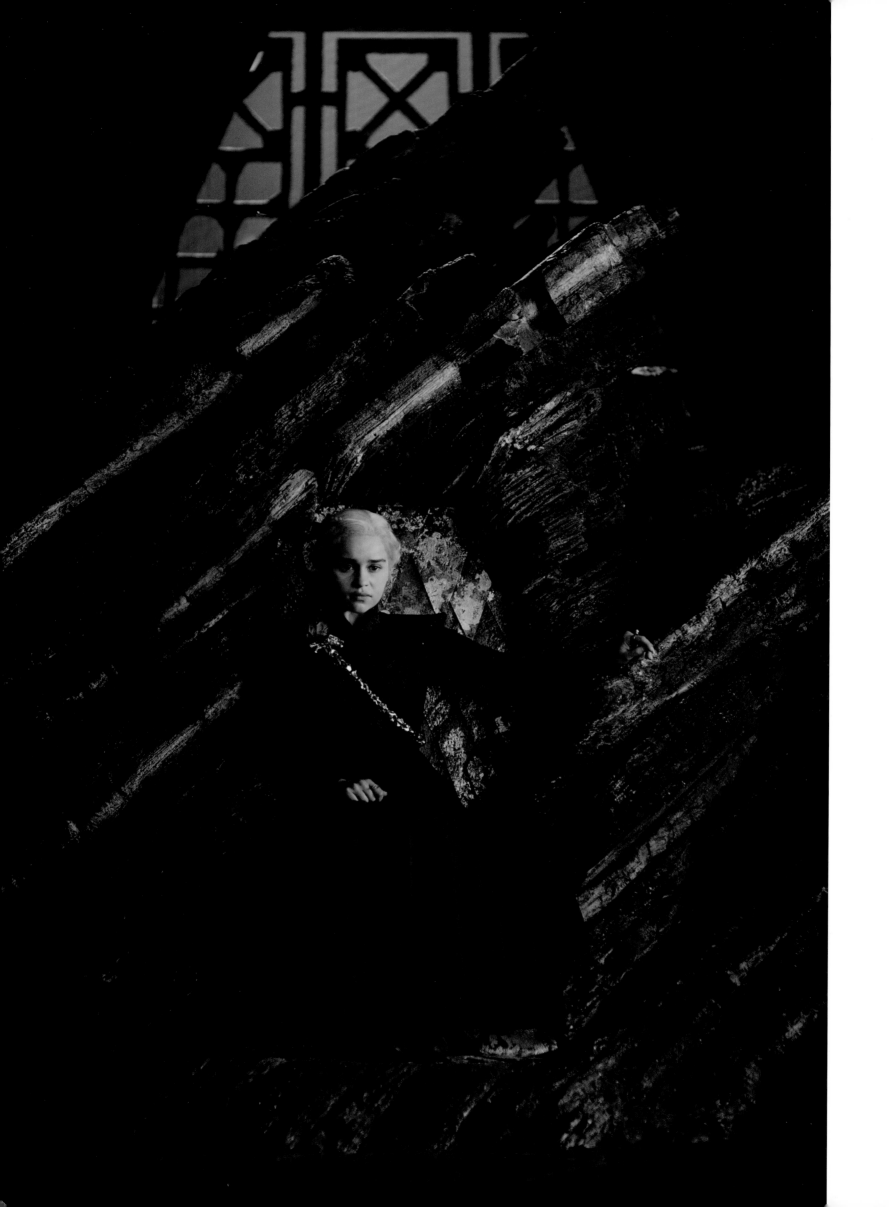

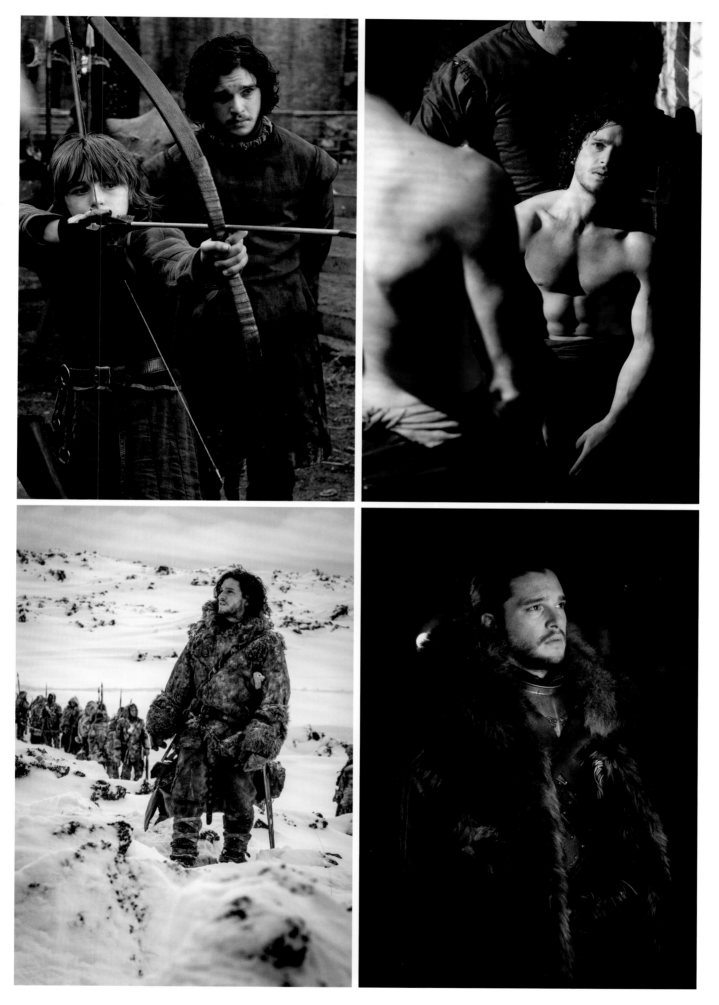

OPPOSITE: The queen is displeased.

TOP LEFT: Jon keeps a dutiful eye as young Bran sharpens his archery skills.

TOP RIGHT: Jon sits down for a shave.

BOTTOM ROW: Jon Snow's Valyrian steel sword, Longclaw, was given to him by Jeor Mormont and was his primary weapon. He is seen carrying it while traveling with the Free Folk and during his return to Winterfell.

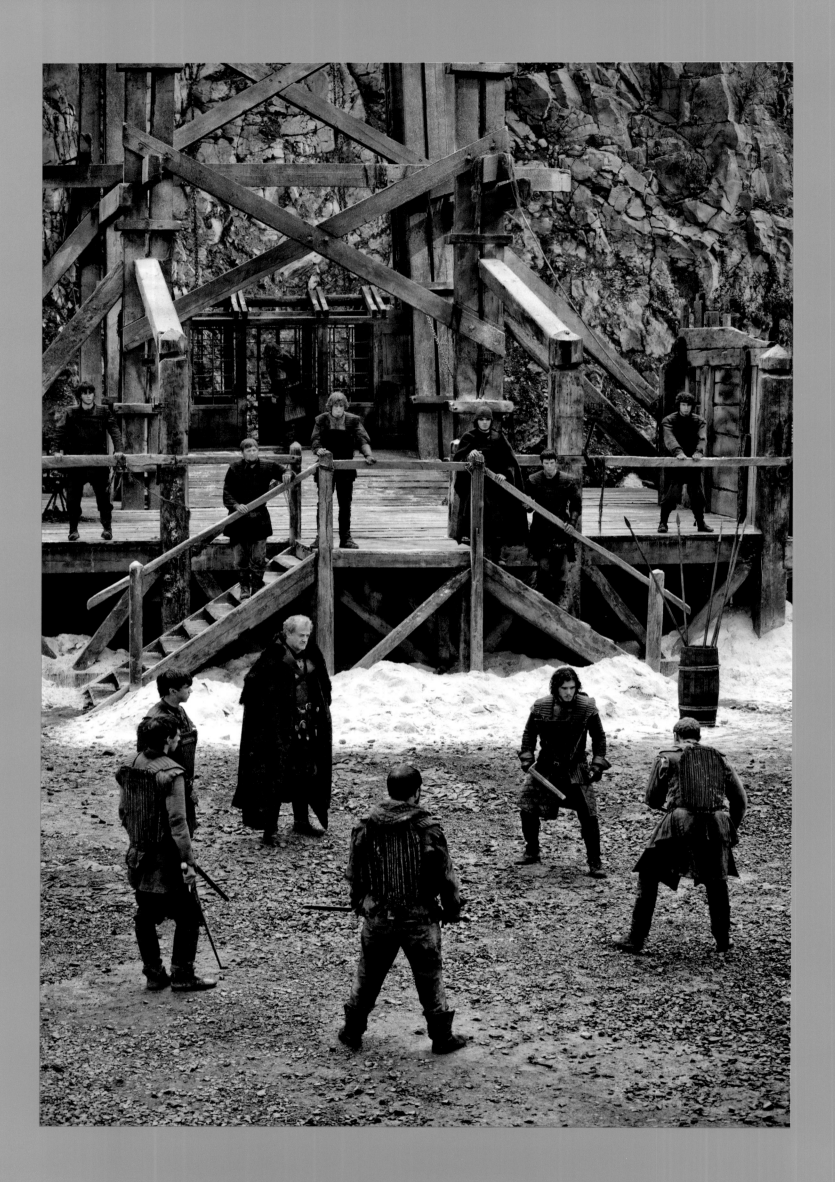

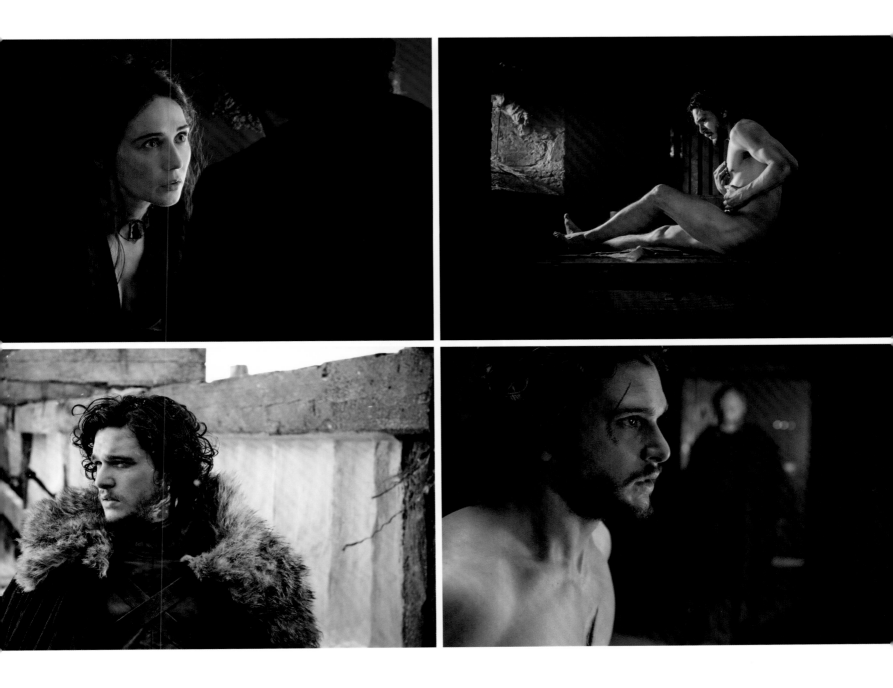

OPPOSITE: Jon hones his sword skills at Castle Black.
TOP LEFT, TOP RIGHT, AND ABOVE RIGHT: Melisandre brings Jon back to life after his fatal
stabbing at the hands of the traitors of the Night's Watch.
ABOVE LEFT: Jon on watch.

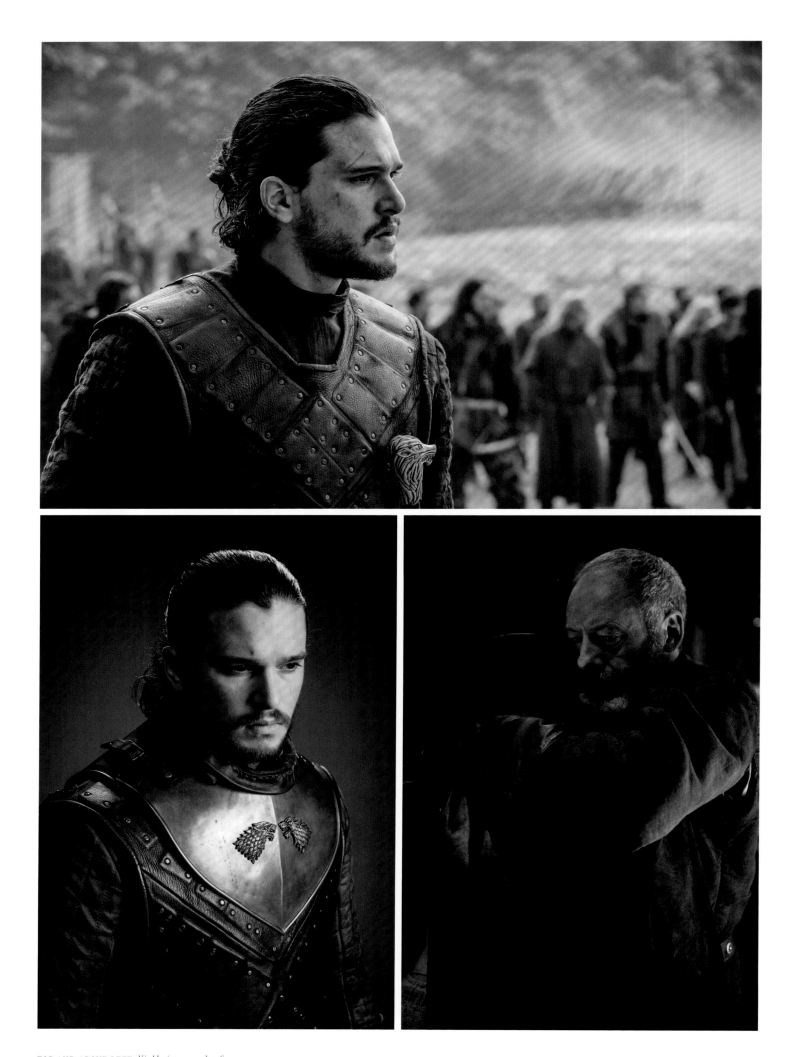

TOP AND ABOVE LEFT: Kit Harington as Jon Snow.
ABOVE RIGHT: Ser Davos Seaworth.
OPPOSITE: Jon Snow on the cliffs at Dragonstone. Helen Sloan notes that the beautiful, rugged Dragonstone cliffs might be mistaken for CGI, but this scene was filmed on the north coast of Ireland—one of the most beautiful coastlines in the world and just one of the island's many incredible, unspoiled landscapes.

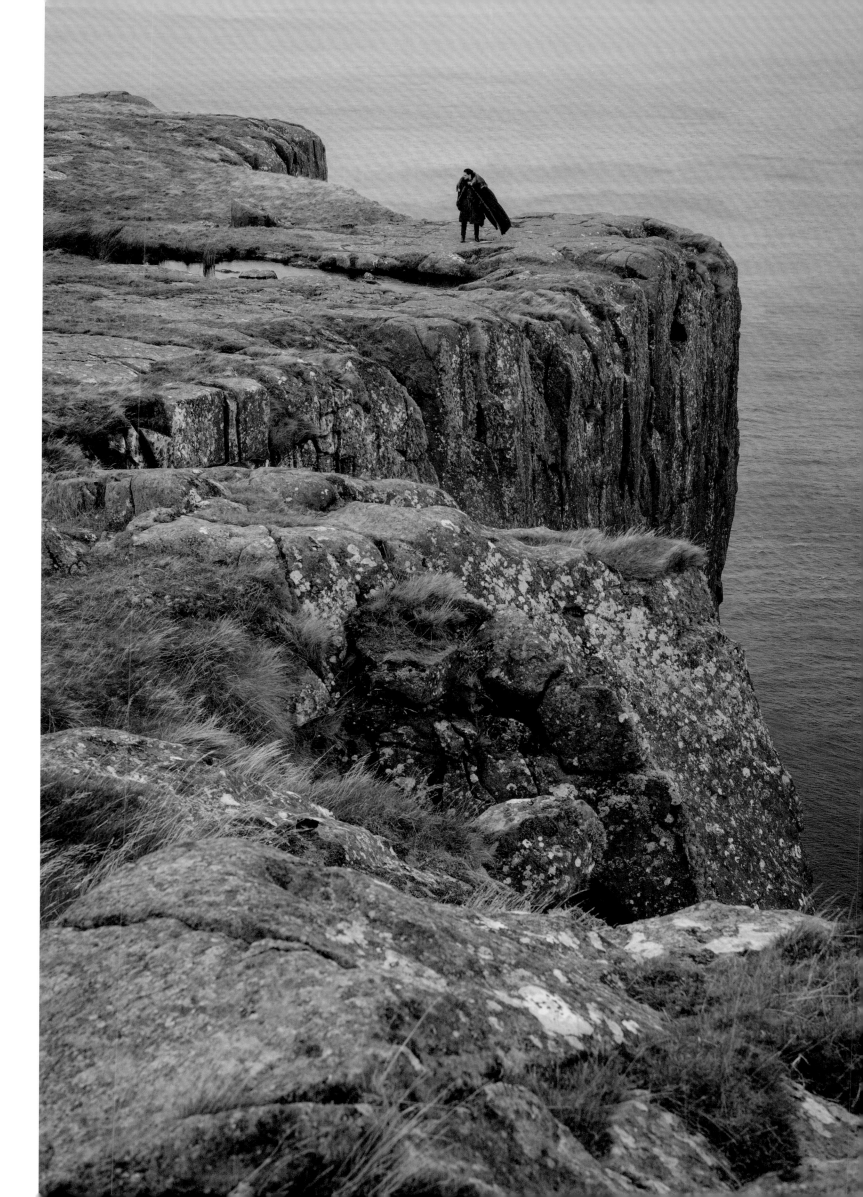

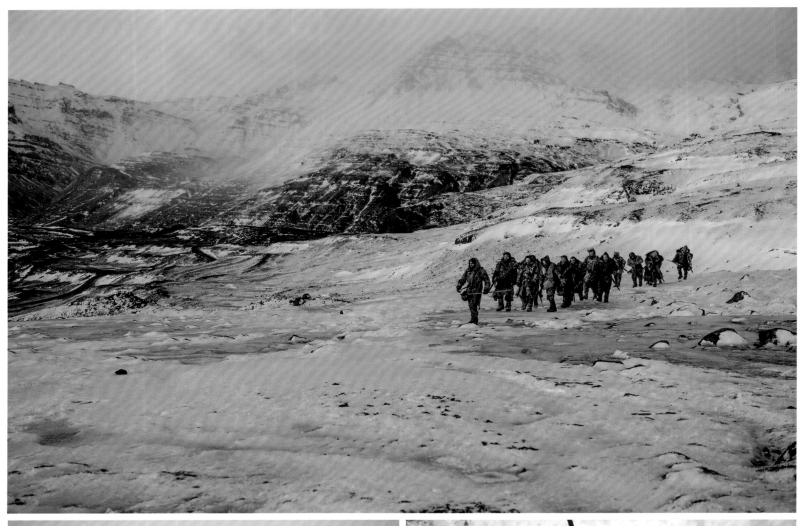

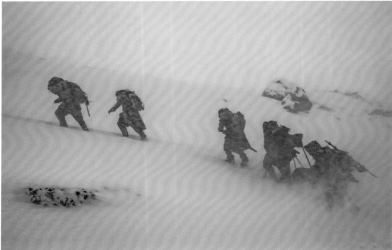

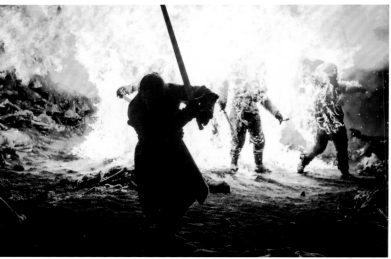

TOP AND ABOVE LEFT: Jon leads a team on a treacherous mission beyond the Wall to capture a wight.

ABOVE RIGHT: Jon moves to escape the flames from Daenerys's dragons after she arrives to save them.

OPPOSITE: Daenerys pleads with Jon to not reveal his true Targaryen identity.

PAGES 240–241: Jon Snow keeps watch at Castle Black.

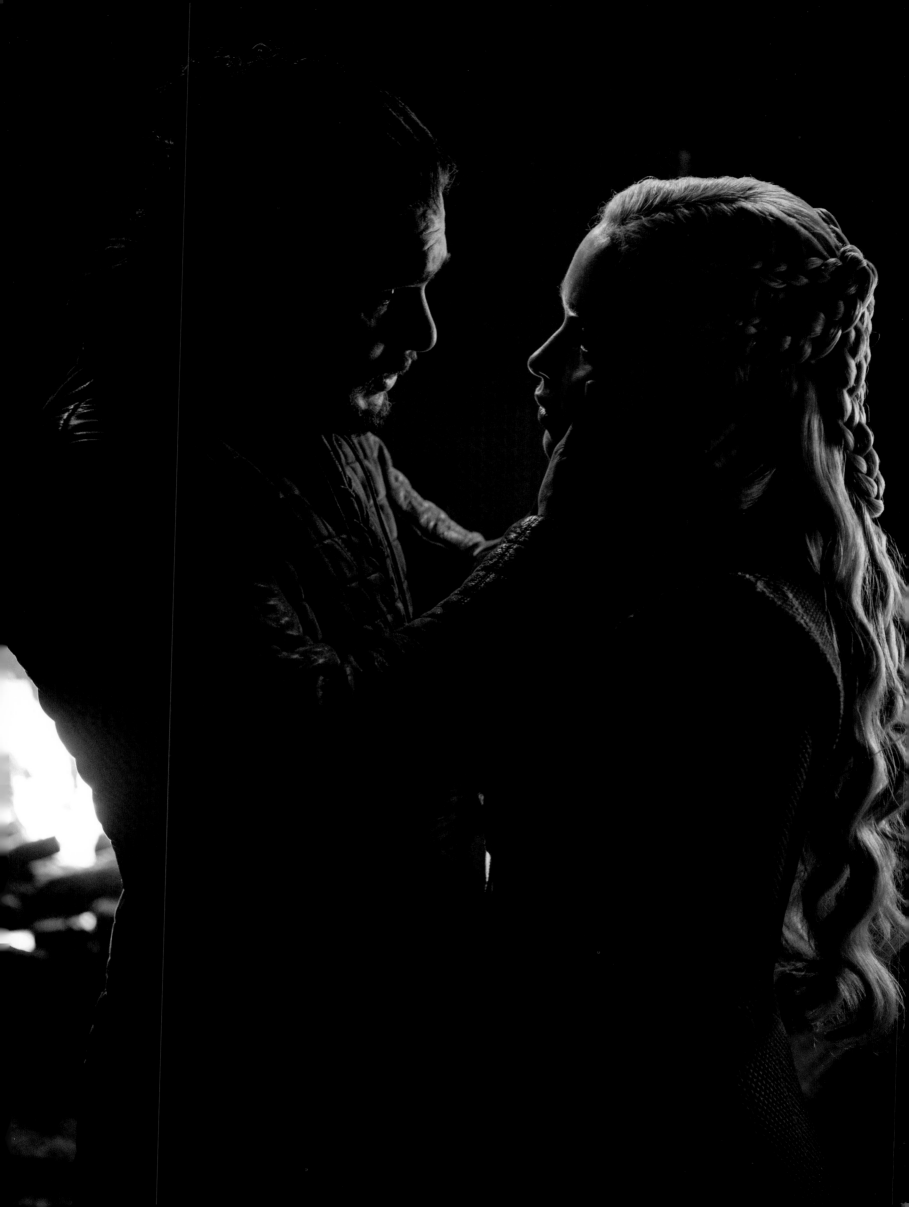

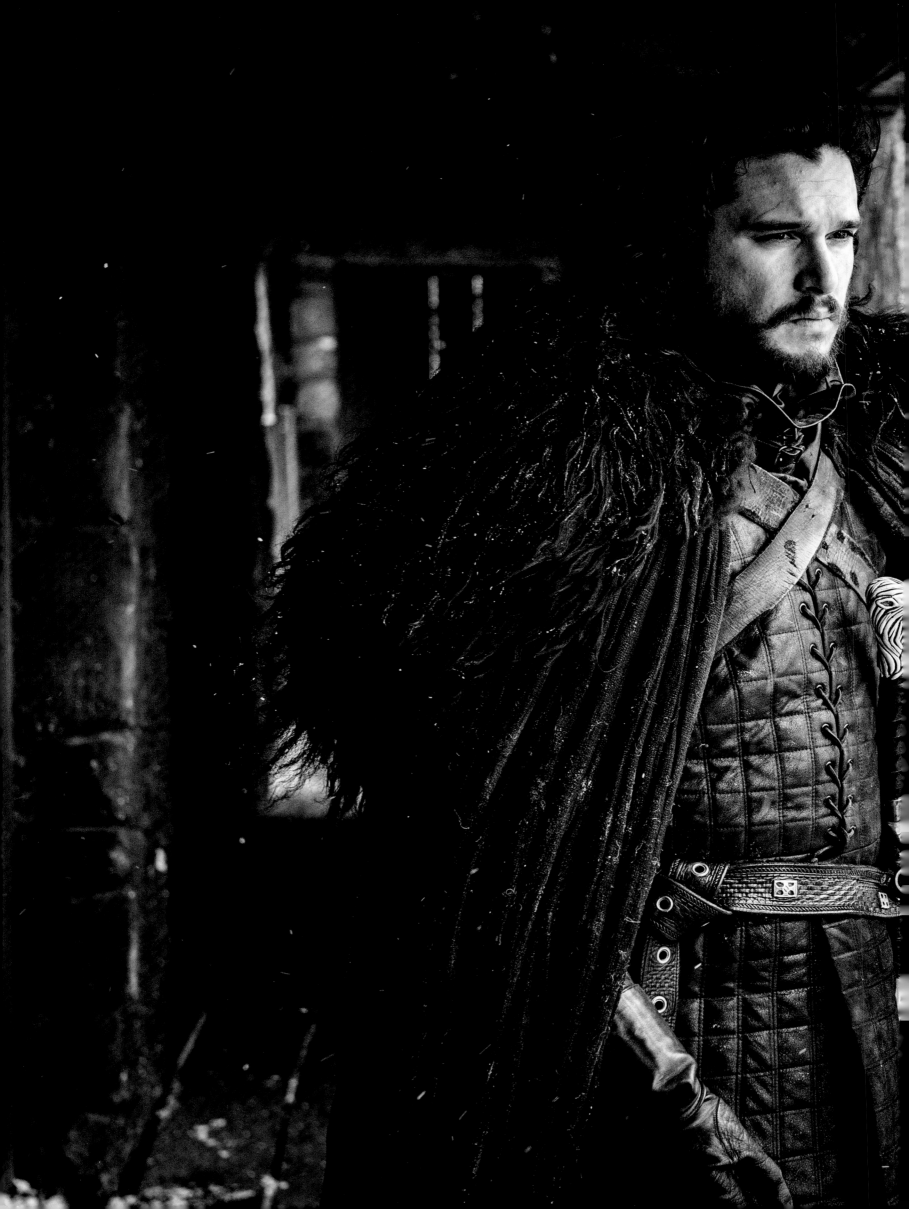

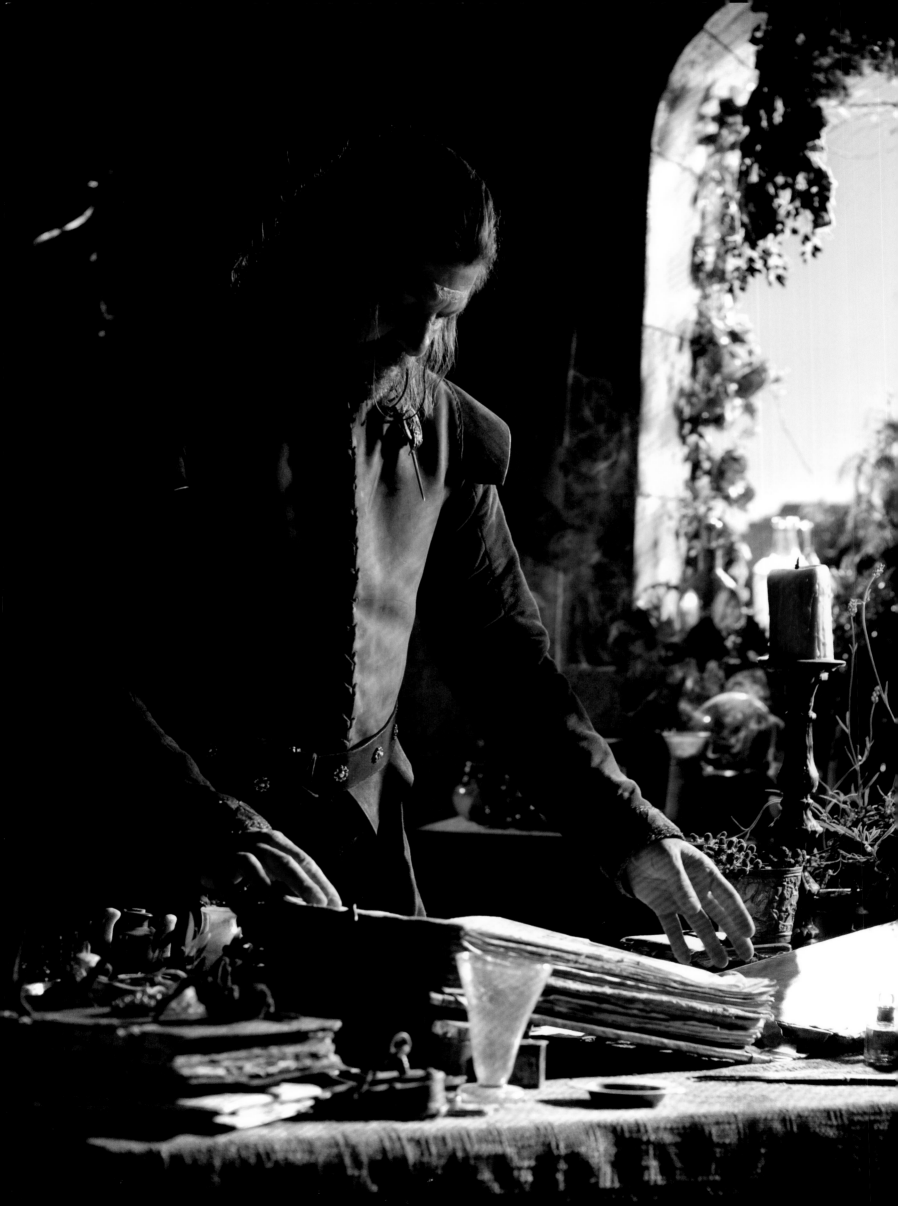

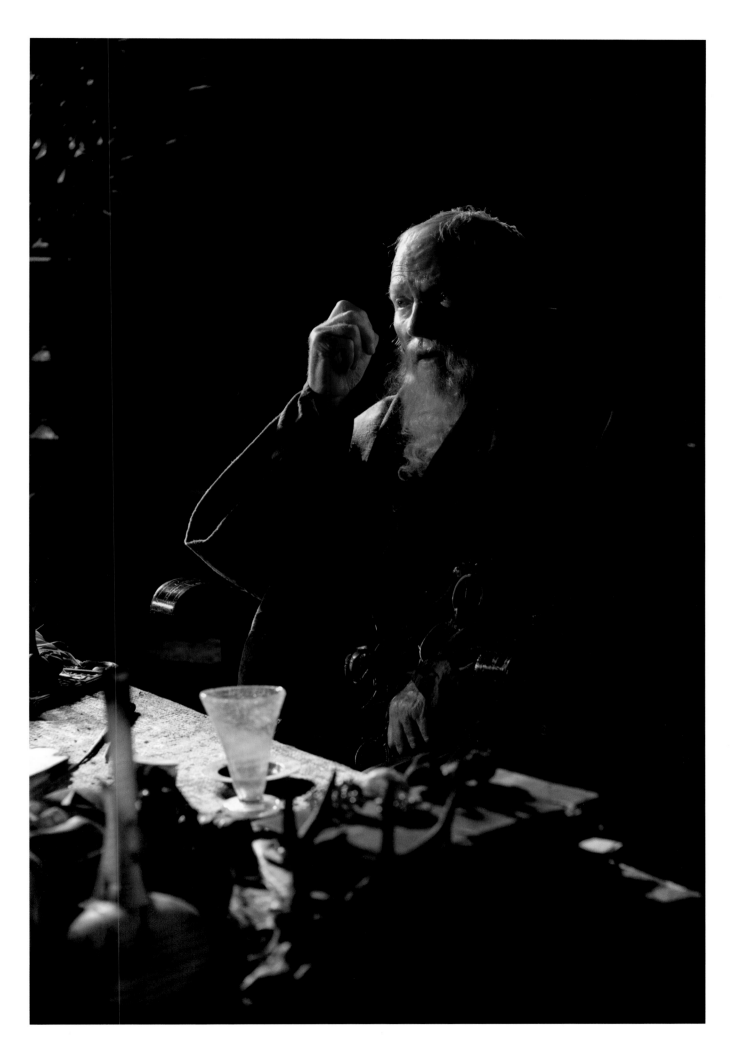

OPPOSITE: Sean Bean as Eddard "Ned" Stark examines the gene-
alogy book of the Seven Kingdoms in Maester Pycelle's quarters.
ABOVE: Maester Pycelle converses with Ned.

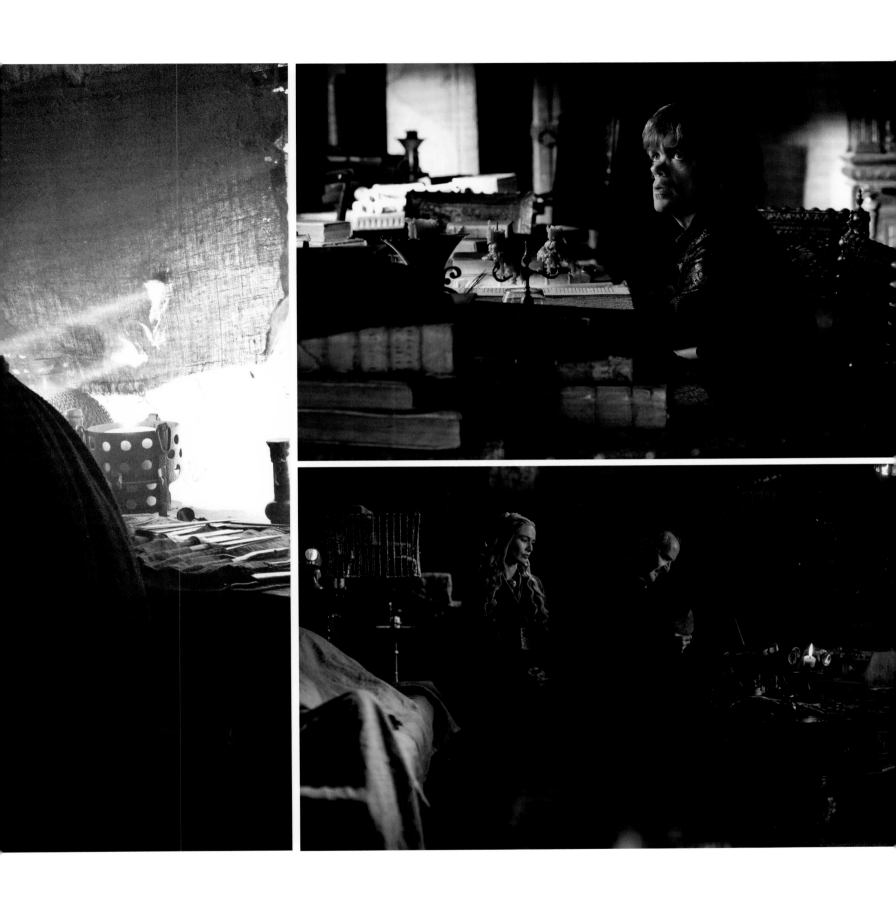

LEFT: Jaime Lannister's infected arm is examined after his hand has been cut off.
TOP: Tyrion studying during his first term as Hand of the King.
BOTTOM: Cersei visits with the new Master of Whisperers, the disgraced Maester Qyburn.

245

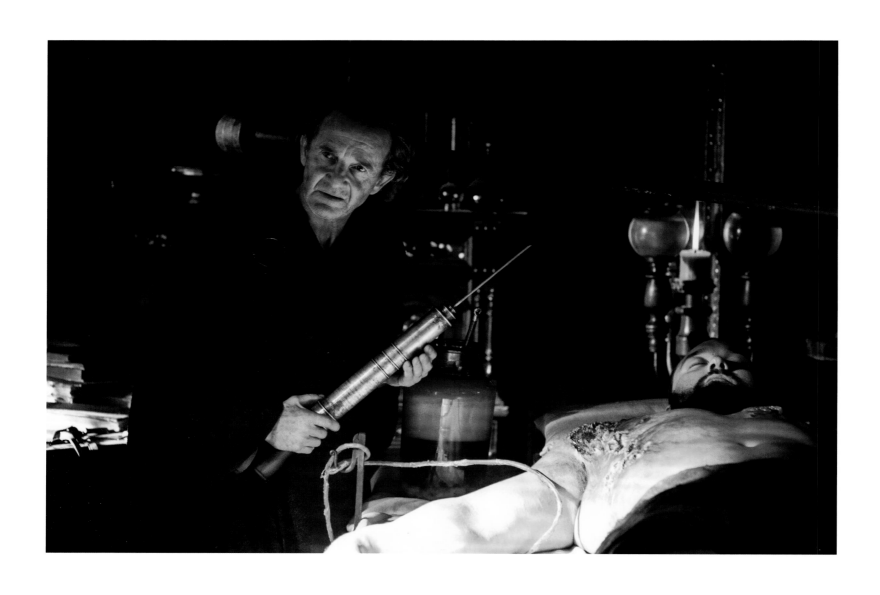

ABOVE AND OPPOSITE CENTER: Qyburn explains to Cersei his plans to "resurrect" the Mountain.

OPPOSITE TOP: Qyburn's table of surgical tools and potions. Sloan loved Qyburn's office and any sets involving the Maesters, because of their density and the interesting props on display. She says, "They were just full of interesting things and trinkets and bottles. They are like [an] old-fashioned science lab, and for me, the science lab at school was always the most interesting place visually, because it had so many weird pieces. Those sets are just so beautifully dressed, with so much attention to detail. It's a real treat for a photographer, because everywhere you look, there is a shot."

OPPOSITE BOTTOM: A Red Priestess in Volantis.

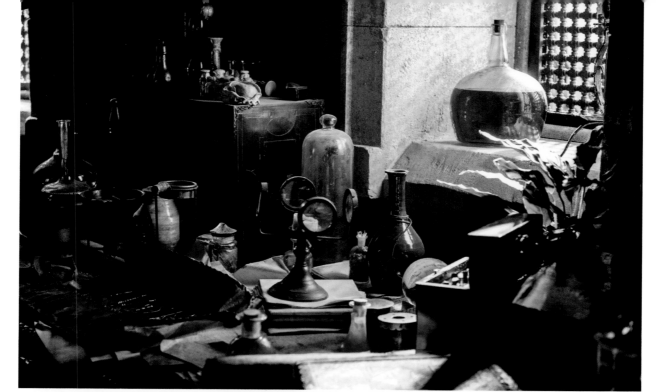

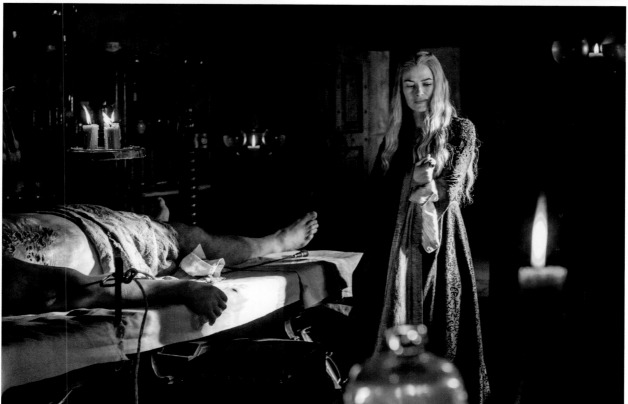

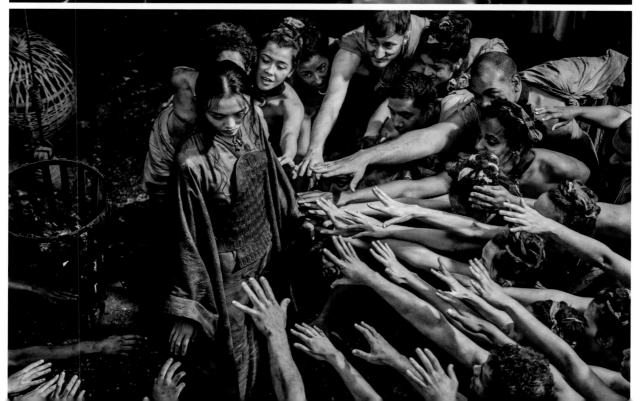

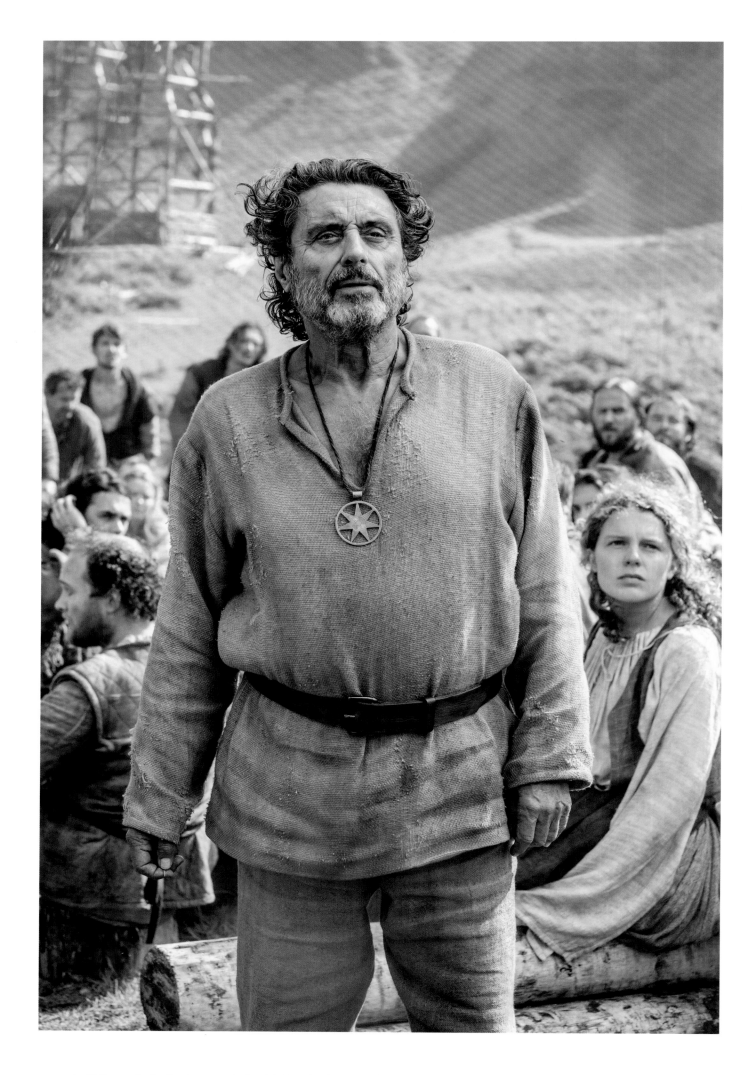

ABOVE: Ian McShane as Brother Ray, the septon who found the Hound and saved his life.
OPPOSITE: Kerry Ingram as Shireen Baratheon, who was afflicted by greyscale.

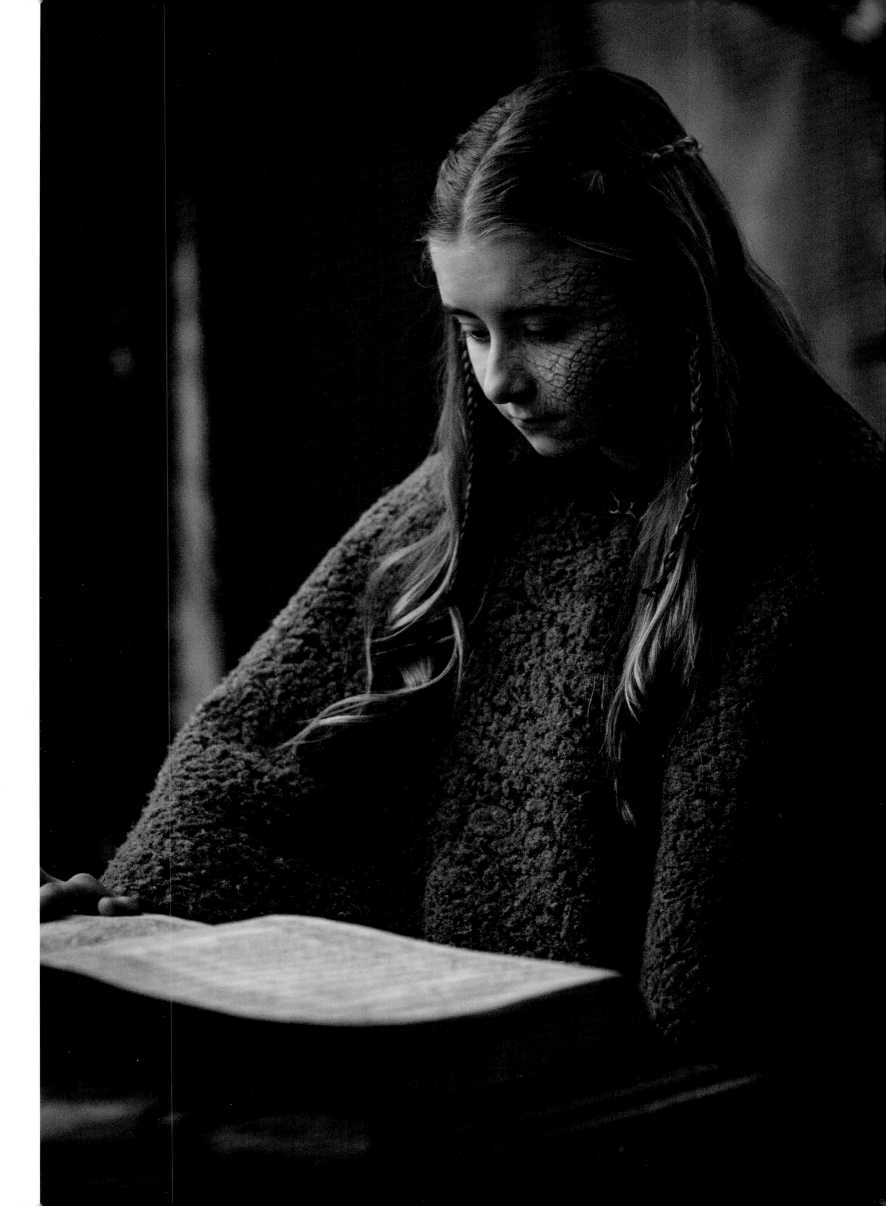

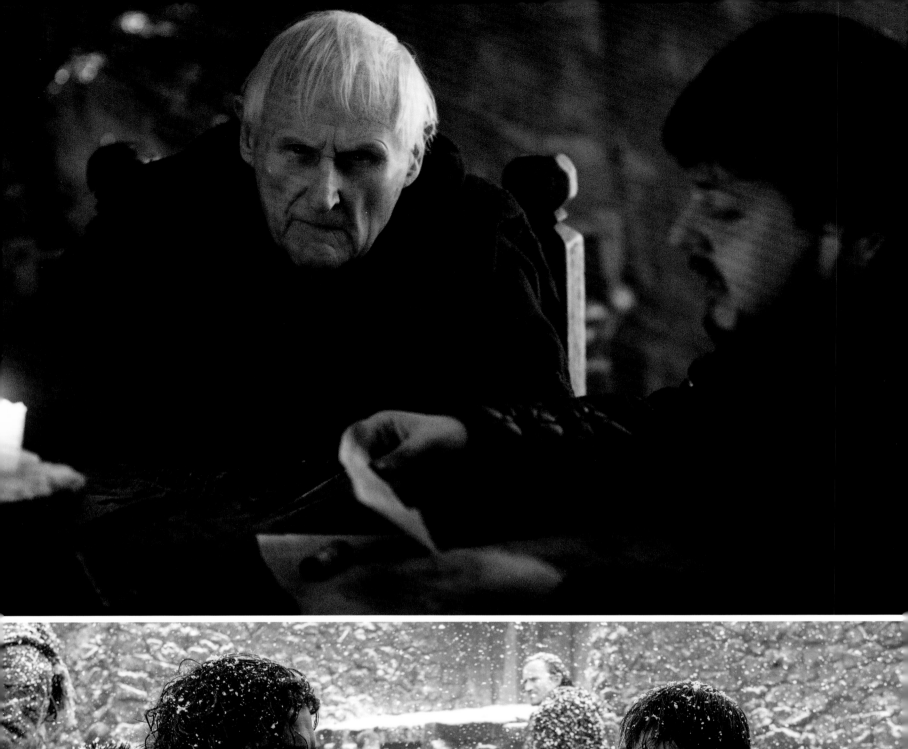
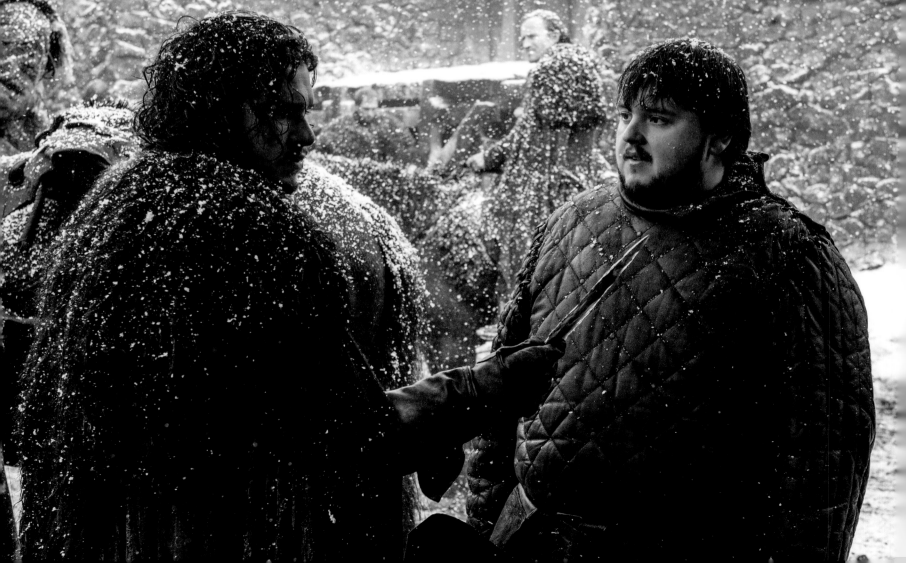

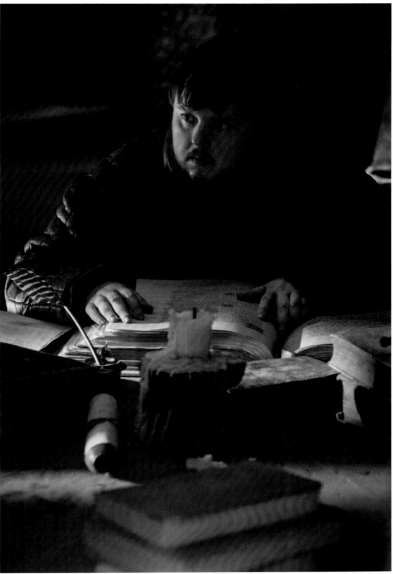

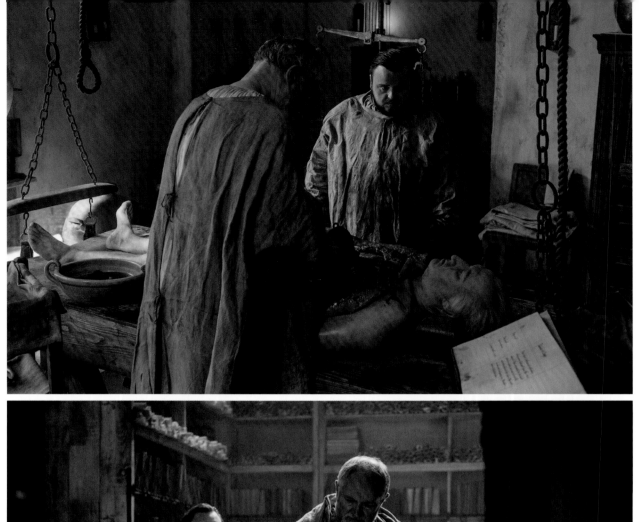

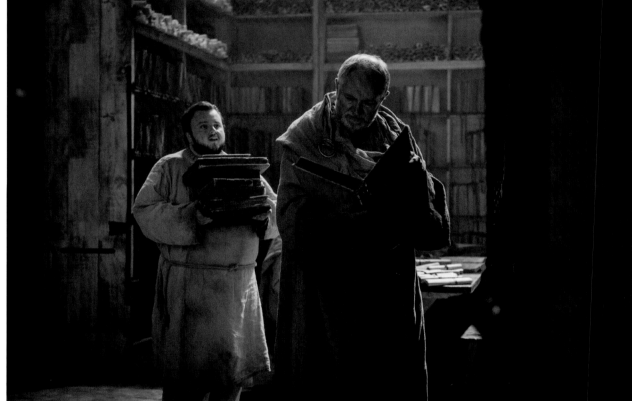

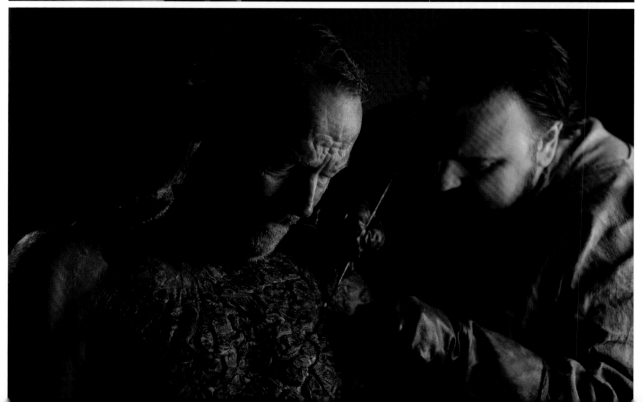

OPPOSITE TOP AND CENTER: Sam assists Archmaester Ebrose in the dissection of a corpse and does menial work in the library.

OPPOSITE BOTTOM: Sam treats Ser Jorah's greyscale against the orders of the Archmaester.

TOP AND CENTER: Sam and Gilly stumble upon the secret marriage of "Prince Ragger" while reading books he has "liberated" from the Citadel's library.

BOTTOM: Archmaester Ebrose is a stern mentor to Sam when he arrives at the Citadel.

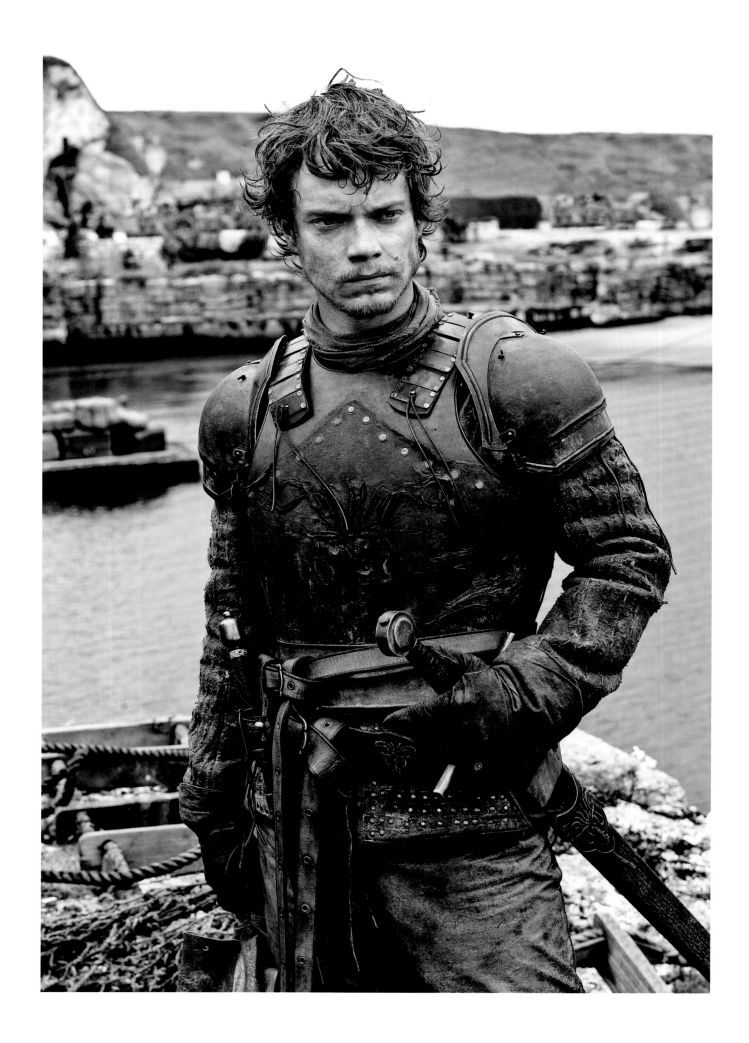

ABOVE: Theon Greyjoy, heir to the Iron Islands and ward of Ned and Catelyn Stark.

OPPOSITE: Theon's journey from traitor to victim of Ramsay Bolton to hero was completed where it began—at Winterfell.

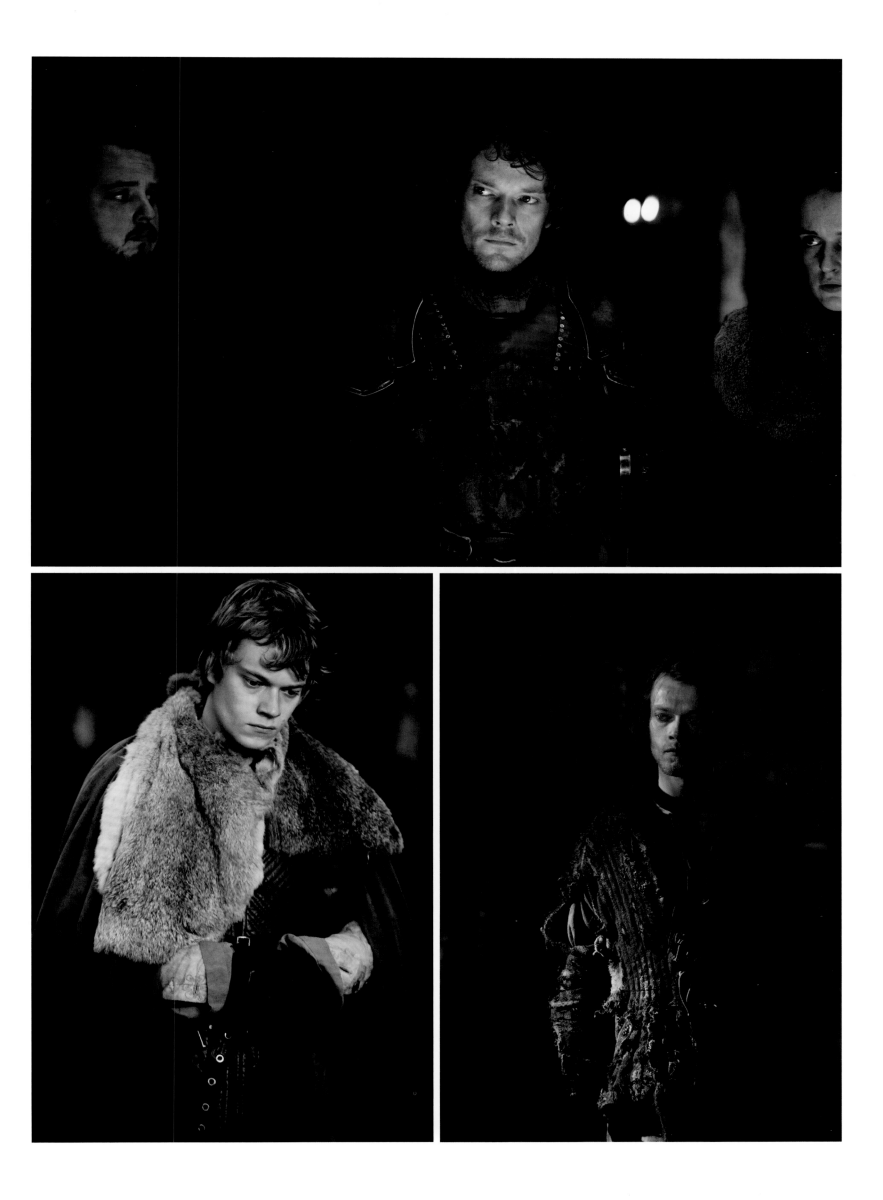

BEHIND THE SCENES

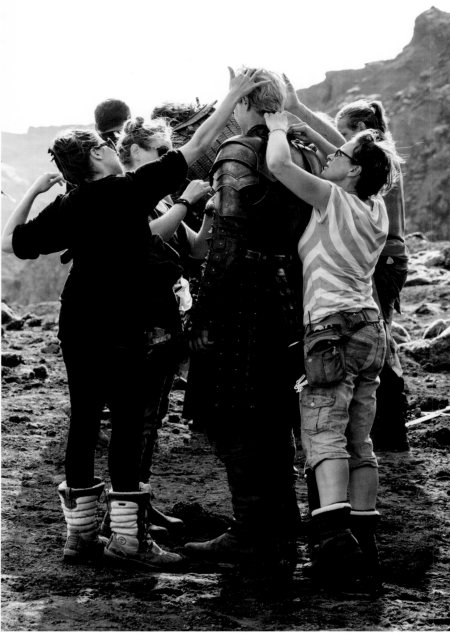

OPPOSITE: Jack Gleeson waits between takes on the set of the Great Sept in the Paint Hall studio.

ABOVE: It takes numerous people to make sure every element for every scene is precisely in place.

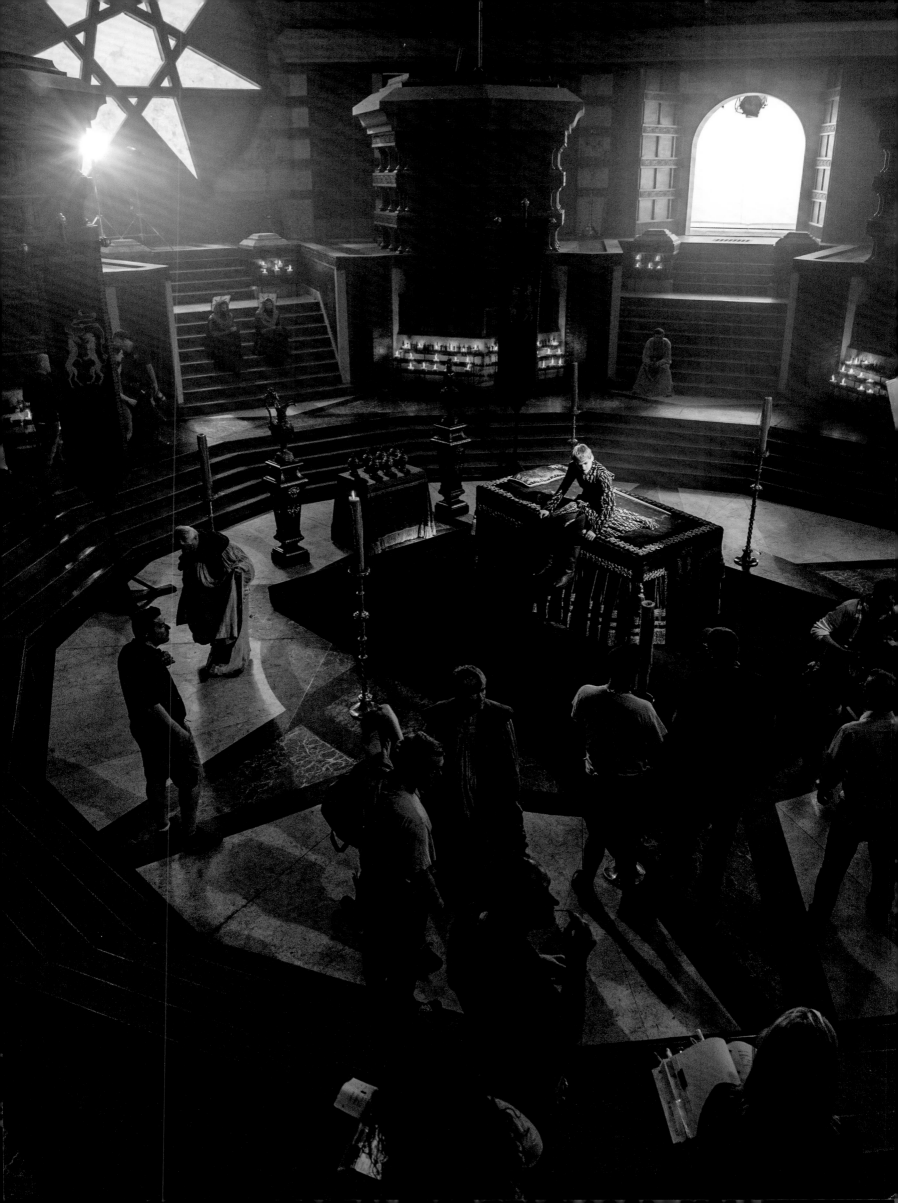

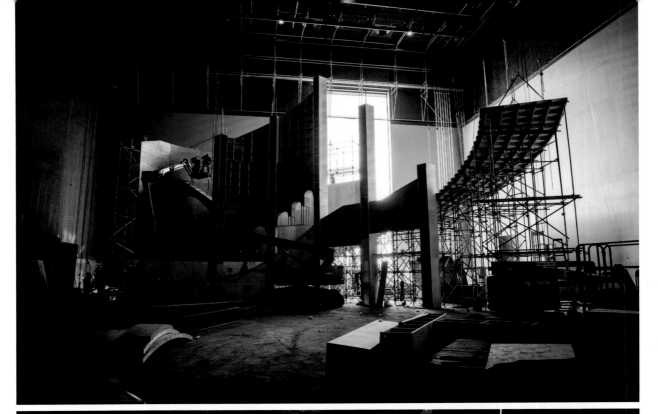

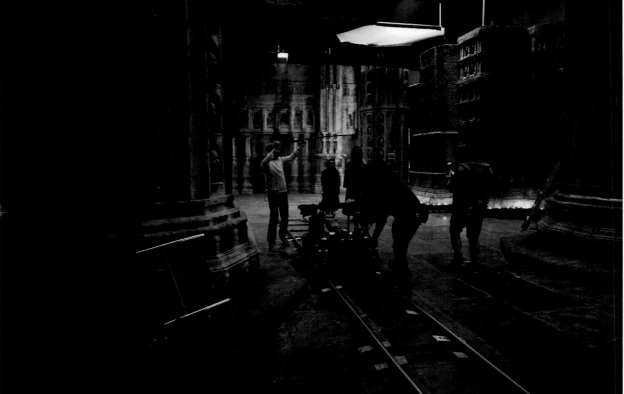

TOP: The stairway in the Red Keep that Cersei and Qyburn escape down while Daenerys lays siege to the castle is under construction.

CENTER: Filming in the House of Black and White.

BOTTOM: Emilia Clarke on a mechanical rig that simulates her dragon's movement for filming.

OPPOSITE TOP: A fully constructed scorpion crossbow.

OPPOSITE BOTTOM: The direwolves were often filmed using fake stuffed stand-ins.

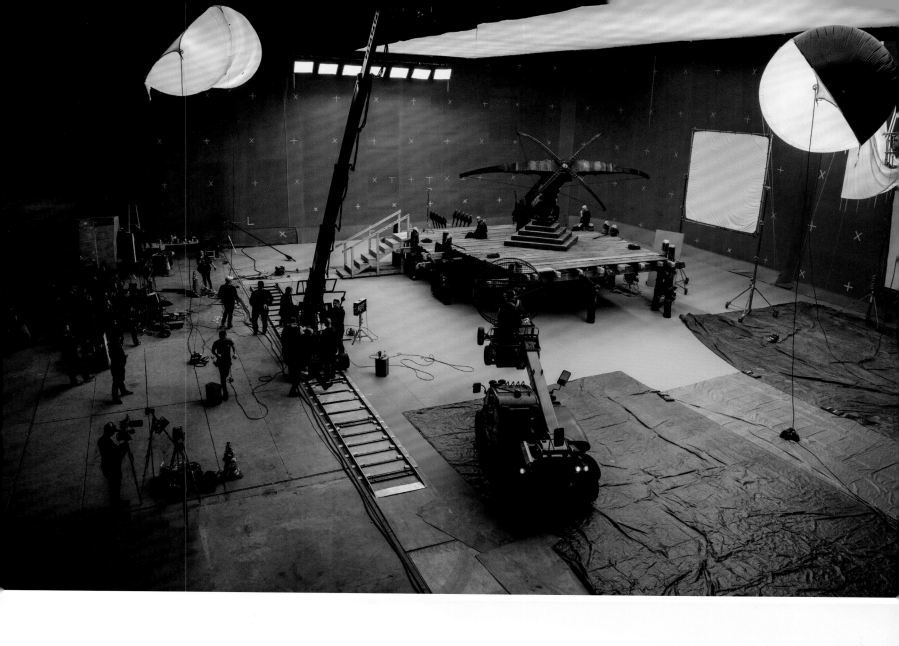
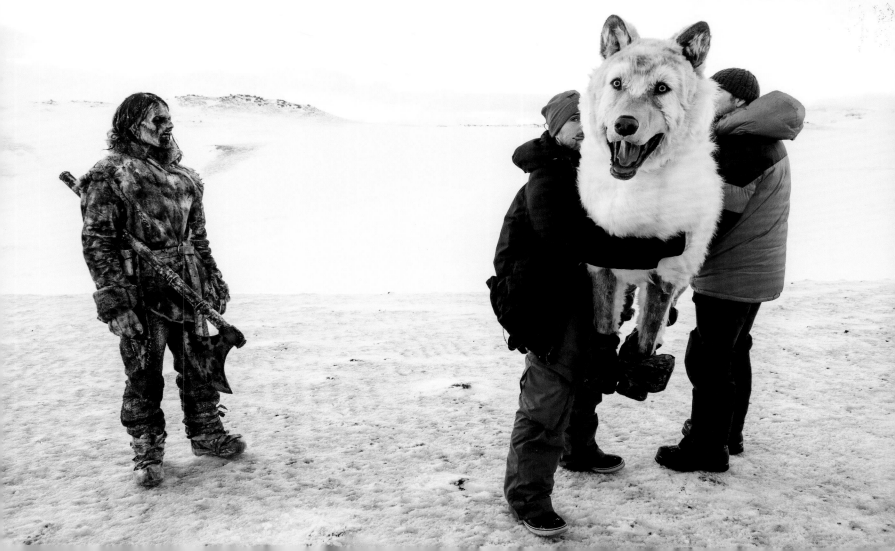

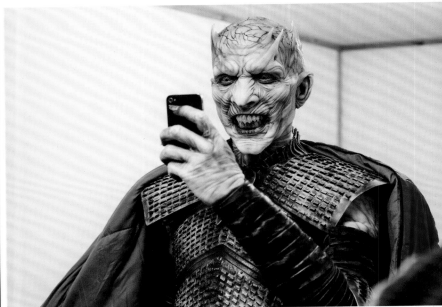
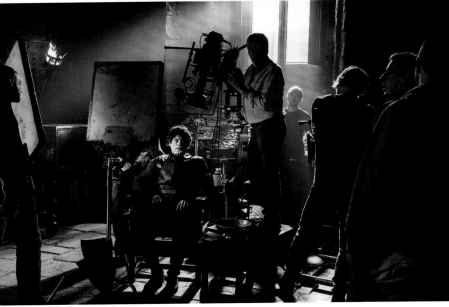
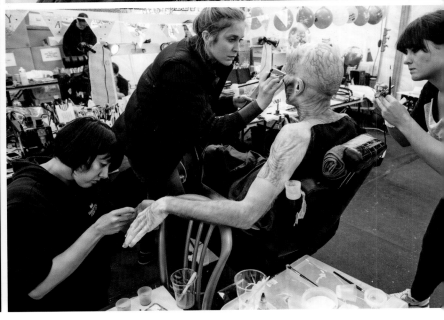

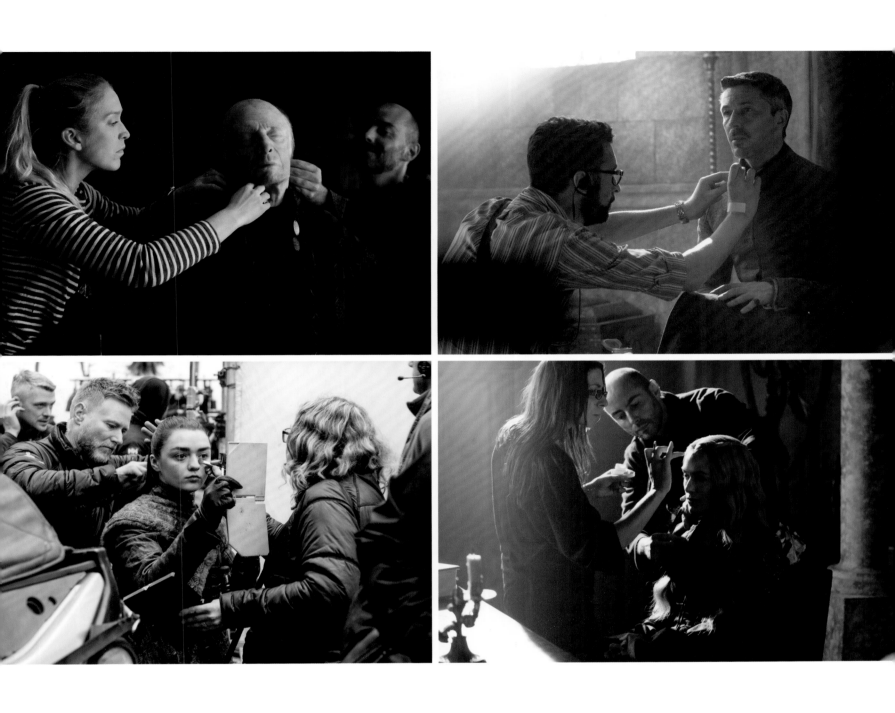

THESE PAGES: Hundreds of crew are involved in the creation of each scene.

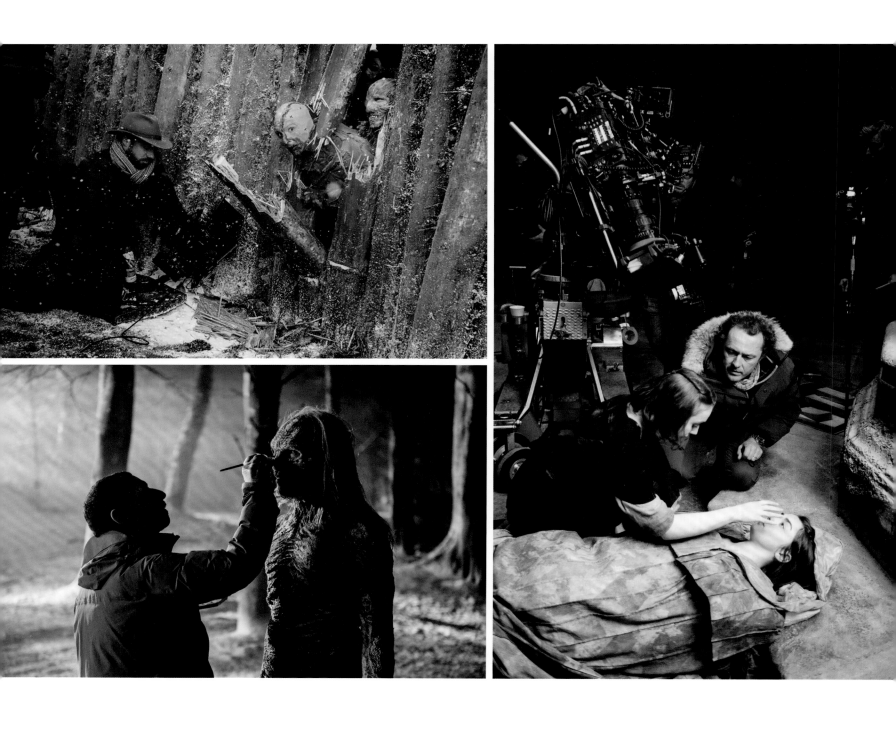

THESE PAGES: *Game of Thrones* filmed in a wide variety of locations around the world, on physical sets constructed in studios, and on green screen sets.

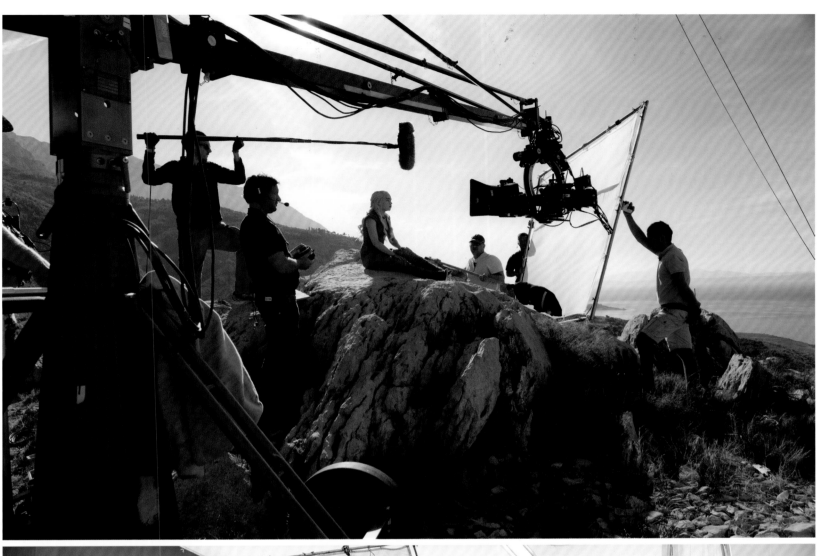

THE WARRIOR

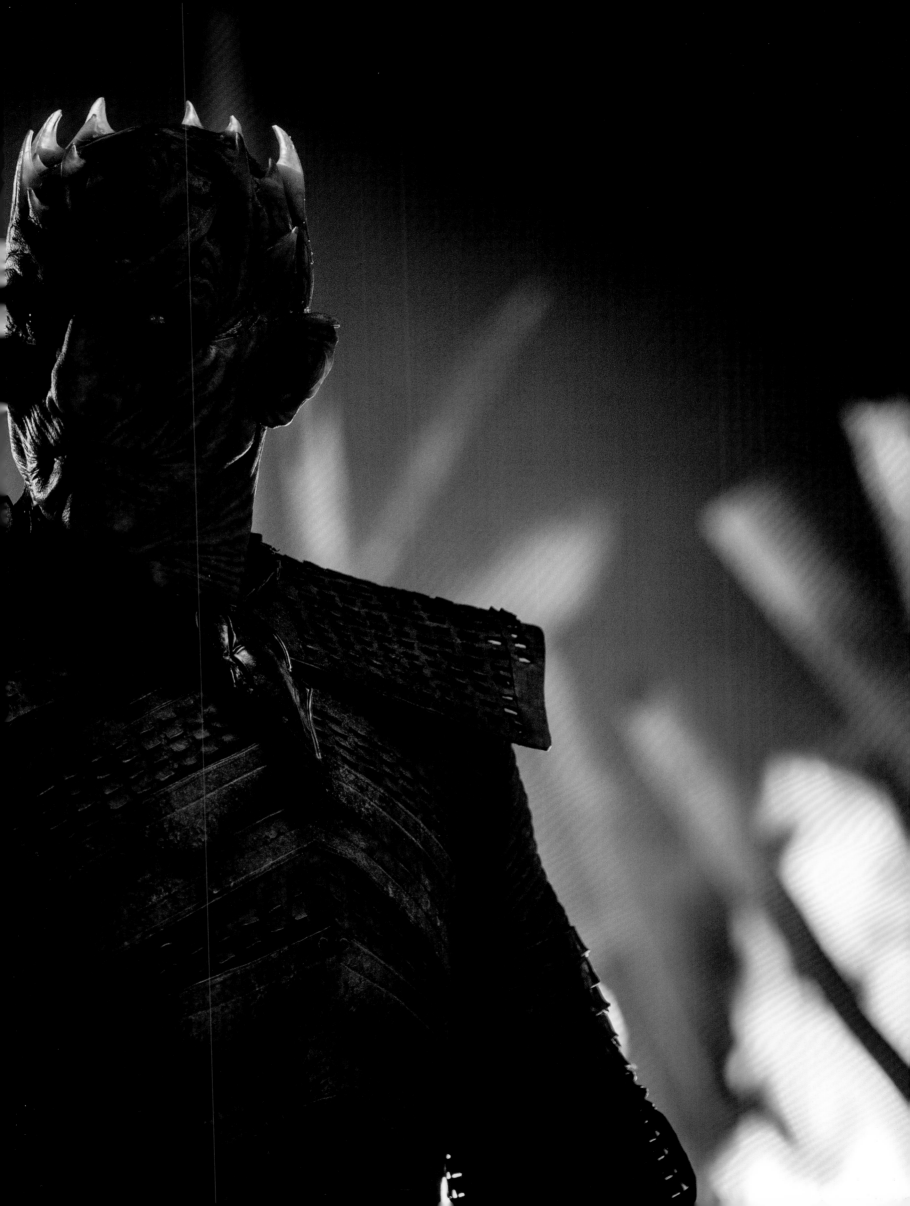

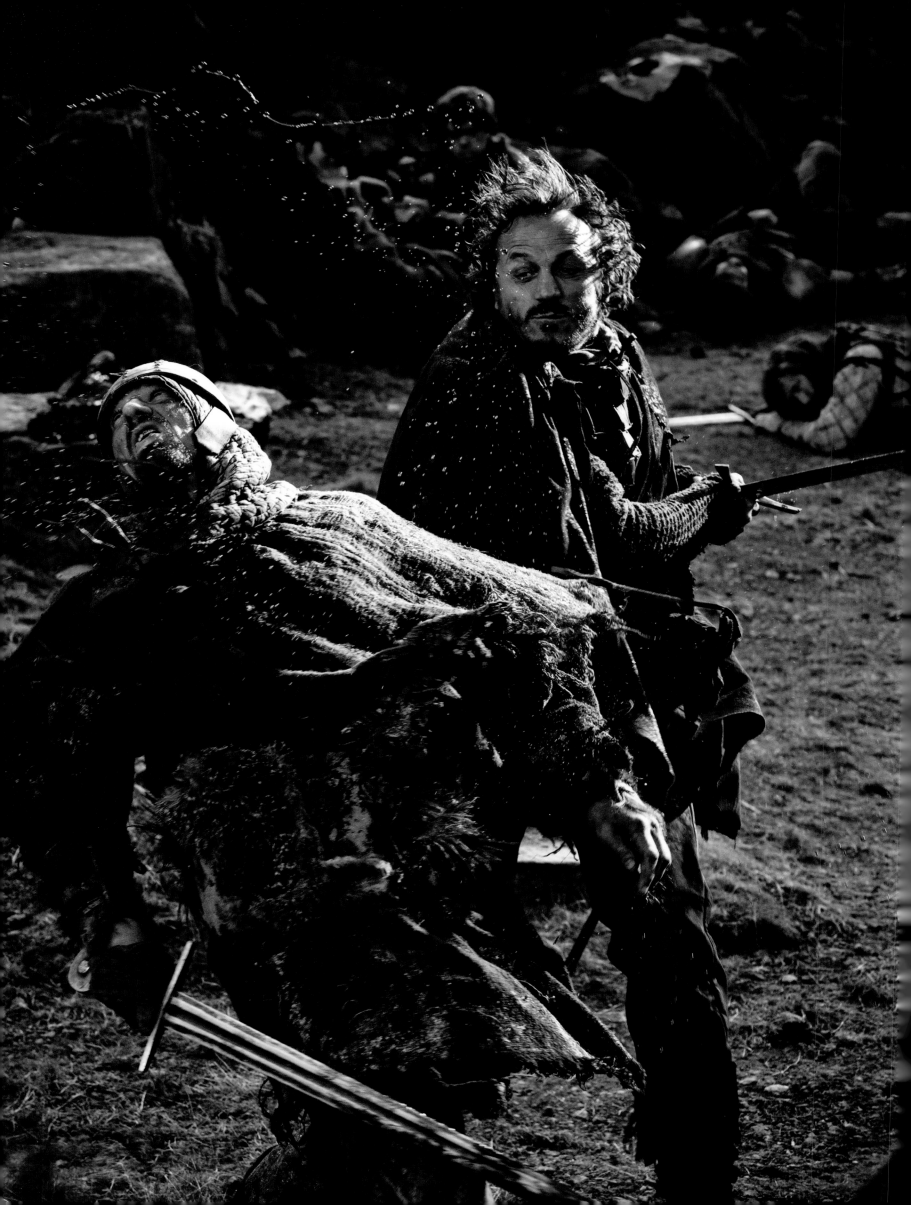

The Warrior represents courage and dominance in battle.

War is an immutable backdrop in *Game of Thrones*. In some places it pounds with the drumbeat of constant battle; in others its looming threat resides in anxious minds. Battles in Westeros aren't limited to soldiers and armies—they can also be deadly duels between two opponents, ambushes by mysterious adversaries, or even desperate missions into enemy territory. War is part of daily existence in the Seven Kingdoms, and one learns to live with it and within it. Even stretches of peace can suddenly swell into waves of brutality and crash down without mercy, drowning the innocent and villainous alike. In the ebb and flow of war, military battles are the milestones, marking major events and turning points, though victories can be short-lived and the toll exceedingly high. The Warrior is often prayed to in Westeros, as many need the strength to engage in the incredible pitched battles seen in the show.

During the War of the Five Kings, one of the most significant military events is the Battle of the Blackwater. It begins with an audacious seaborne attack by Stannis Baratheon, as he takes his fleet into Blackwater Bay to land his troops on the shore of King's Landing and wrench the Iron Throne from Joffrey. The size of Stannis's force should allow him to easily overwhelm the Red Keep, but Tyrion Lannister deploys wildfire, which consumes much of Stannis's navy. Tywin Lannister's reinforcements turn back the remainder of Stannis's soldiers, and Stannis is never able to fully recover and become the king he believes he is fated to be.

Another key struggle, the Battle of Castle Black, lays bare the hostilities in the North—the enduring conflict between the Night's Watch, who guard the Wall, and the wildlings who live beyond it. Fearful of the White Walkers advancing from farther north, Mance Rayder leads the tribes of the Free Folk in a siege attack on Castle Black, the Night's Watch's primary fortification in the Wall. Only the arrival of Stannis Baratheon's cavalry curbs the wildling invasion. Rayder's subsequent death opens the door for Jon Snow to provide safety for the wildlings, though not without substantial resistance from his own side.

The Battle of the Bastards is another historical turning point: Jon Snow and Ramsay Bolton face off against each other as Jon fights to retake Winterfell. Snow's motley army manages to defeat Bolton, aided by Sansa's call for the knights of the Vale. This victory cements Snow as the new King in the North.

Many leagues to the south, the Battle of the Goldroad is Daenerys Targaryen's first foray into the war for the Iron Throne. Riding Drogon, she incinerates much of the Lannister-Tarly army and shows Jaime Lannister—and the rest of Westeros—the apocalyptic might of her fire-breathing dragons, changing the balance of power in the war.

These pivotal battle sequences provided Sloan with many dynamic images as she regularly found herself in the midst of these intense sequences. "We've shot a lot of battles, but the Battle of the Bastards was really insane. It was weeks of madness and dozens of horses on the battlefield and hundreds of extras swinging swords. It was such a spectacle. There's a little scrum of us with a few camera operators, boom swingers, focus pullers, grips, and special effects people who are chucking a load of mud and blood and entrails into the air. It's sort of terrifying and exhilarating at the same time. You have to go on autopilot and do your craft without thinking about it, but at the same time you have to be hyperaware and try not to get mowed down by a horse or an overzealous fighter. We're all moving like a little organism and following Kit [Harrington]. It's just so impressive because he really is fighting a battle—without all the actual killing and maiming obviously.

"It's my responsibility to stay out of the camera operator's way as much as possible, but also be close enough to get the angles, especially in a battle situation. If the camera operators and focus pullers don't get their shot, the show is in much bigger trouble than if I don't get mine. That's important to remember during those ultra-frustrating moments where getting the iconic shot required seems a long way away. If I catch something in the corner of my frame that breaks the reality of the moment, it doesn't really cost anything to edit it out in Photoshop. But if the film cameras catch something in the corner of their frame, it's [much more difficult and requires visual effects] to fix it. The benefit is that I have the creative freedom to get away with more angles than they can. Good old Photoshop!

"My method of shooting a battle is 'freaky.' Normally, photographers close the eye that's not against the viewfinder. I keep both of my eyes open so I have some peripheral vision. Since the camera unit is moving as a single organism, the stunt horses aren't going to run right into us, they're going to slalom around us. But [if you aren't careful, you won't come out] completely unscathed! I've been hit by fake swords, splashed with mud and cupfuls of fake blood. If you're not feeling well that day or you're off balance, you just have to stay out of the way!"

PAGES 264–265: The Night King.

OPPOSITE: The noted sellsword, Ser Bronn of the Blackwater, in battle.

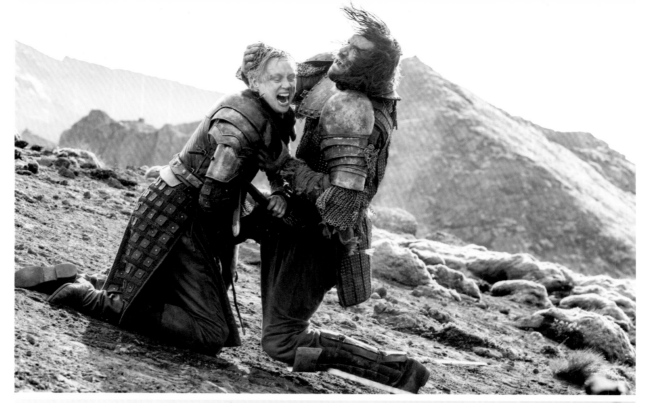

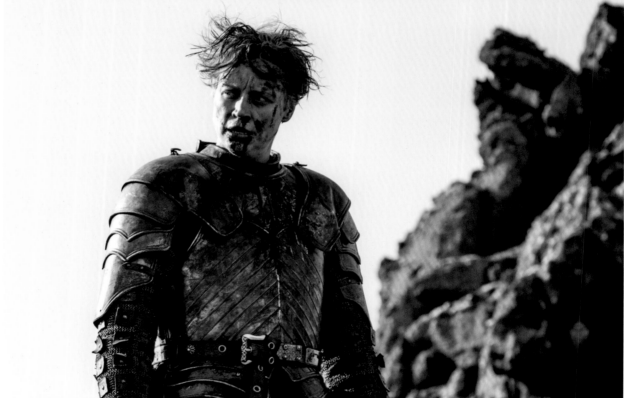

THIS PAGE: Brienne and the Hound in a vicious bout, in which Brienne emerges victorious.

OPPOSITE: (*clockwise from top left*) Participants in the Battle of the Blackwater, including Ser Davos's doomed son, Matthos Seaworth; Hallyne the Pyromancer, head of the Alchemists' Guild, which created the wildfire; acting Hand of the King, Tyrion Lannister, who led the successful defense of the city; Stannis Baratheon, whose forces were defeated.

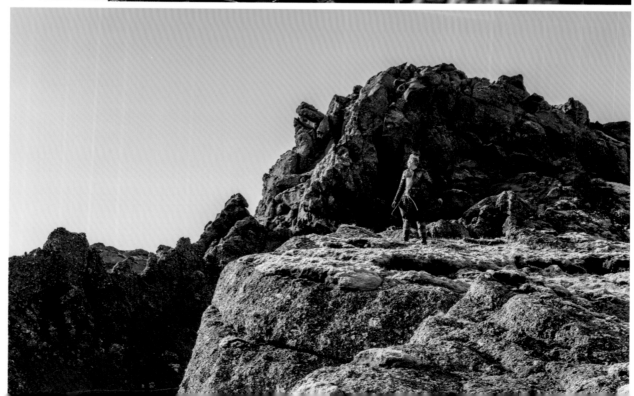

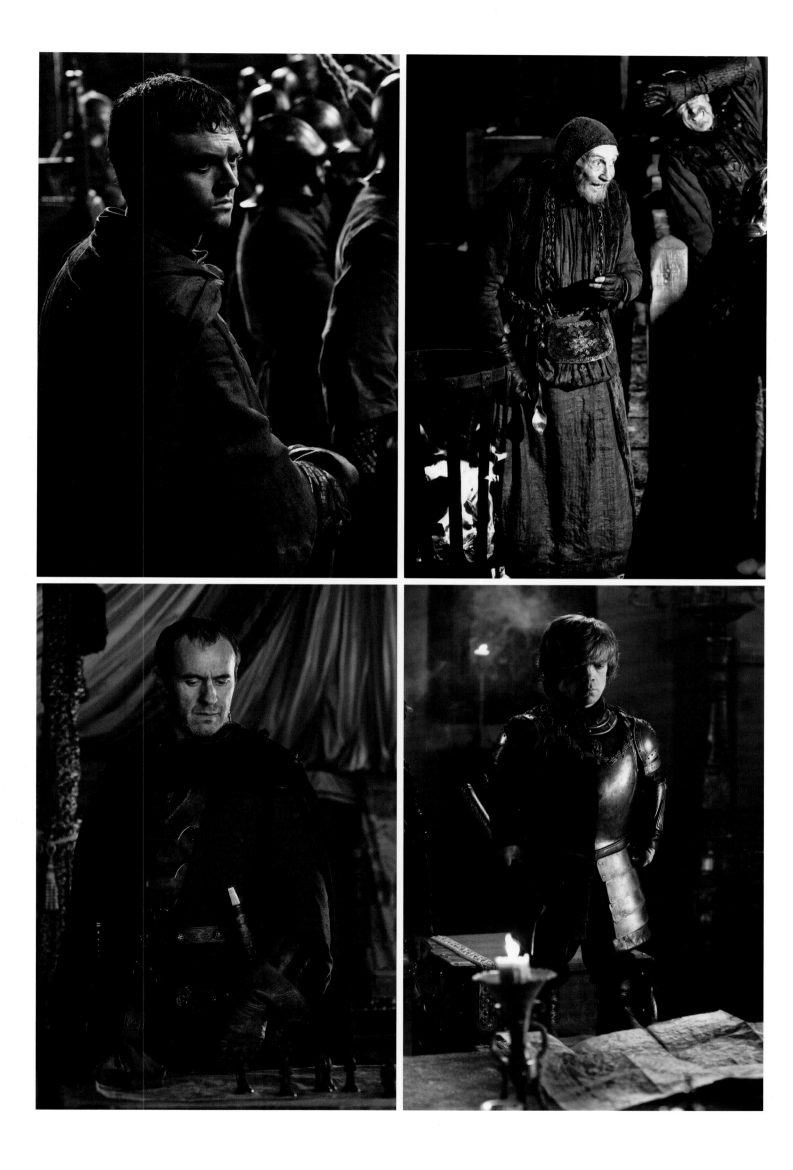

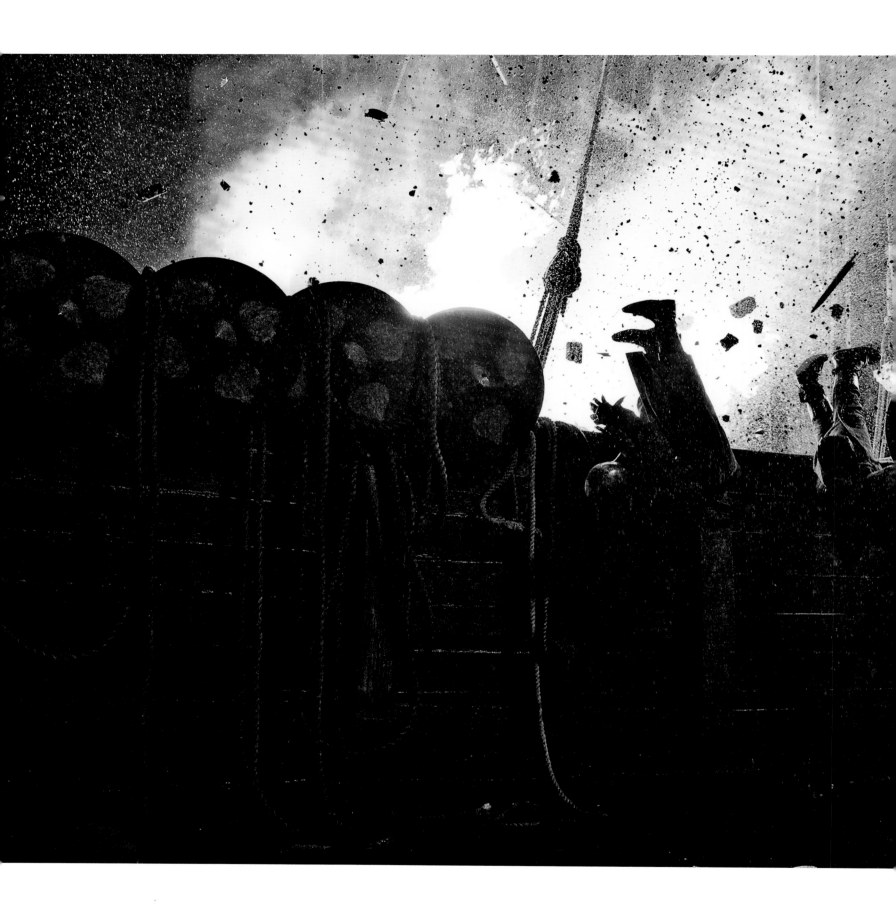

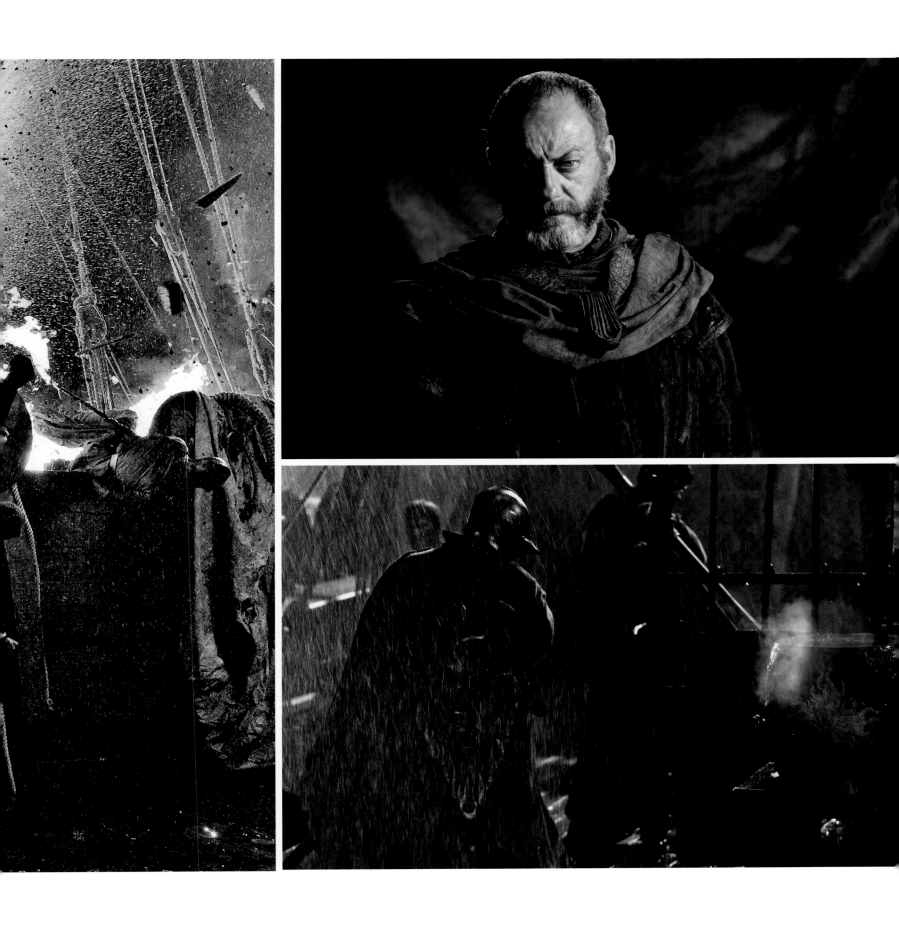

LEFT AND ABOVE: The wildfire devastates Stannis's fleet.
TOP: Ser Davos barely survives the assault.
PAGES 272—273: The squire Podrick cares for Tyrion after saving him from a deadly blow on the battlefield.

271

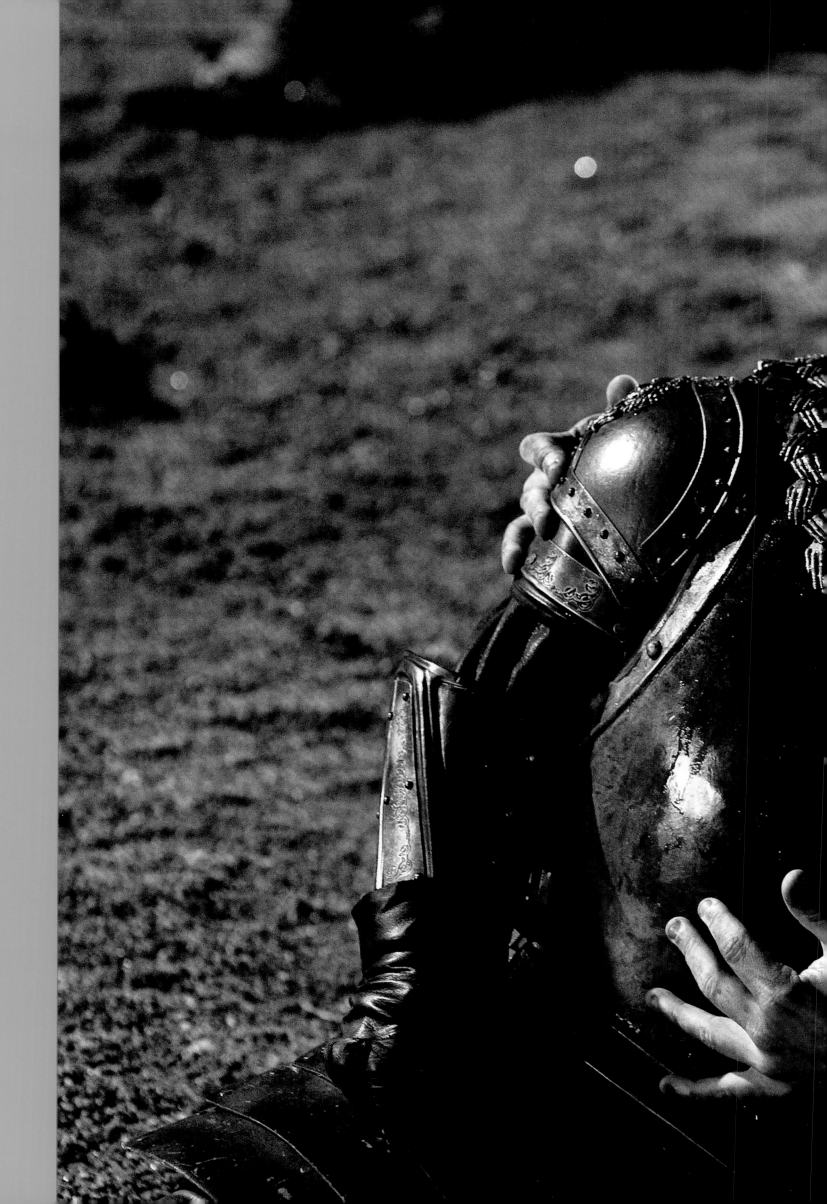

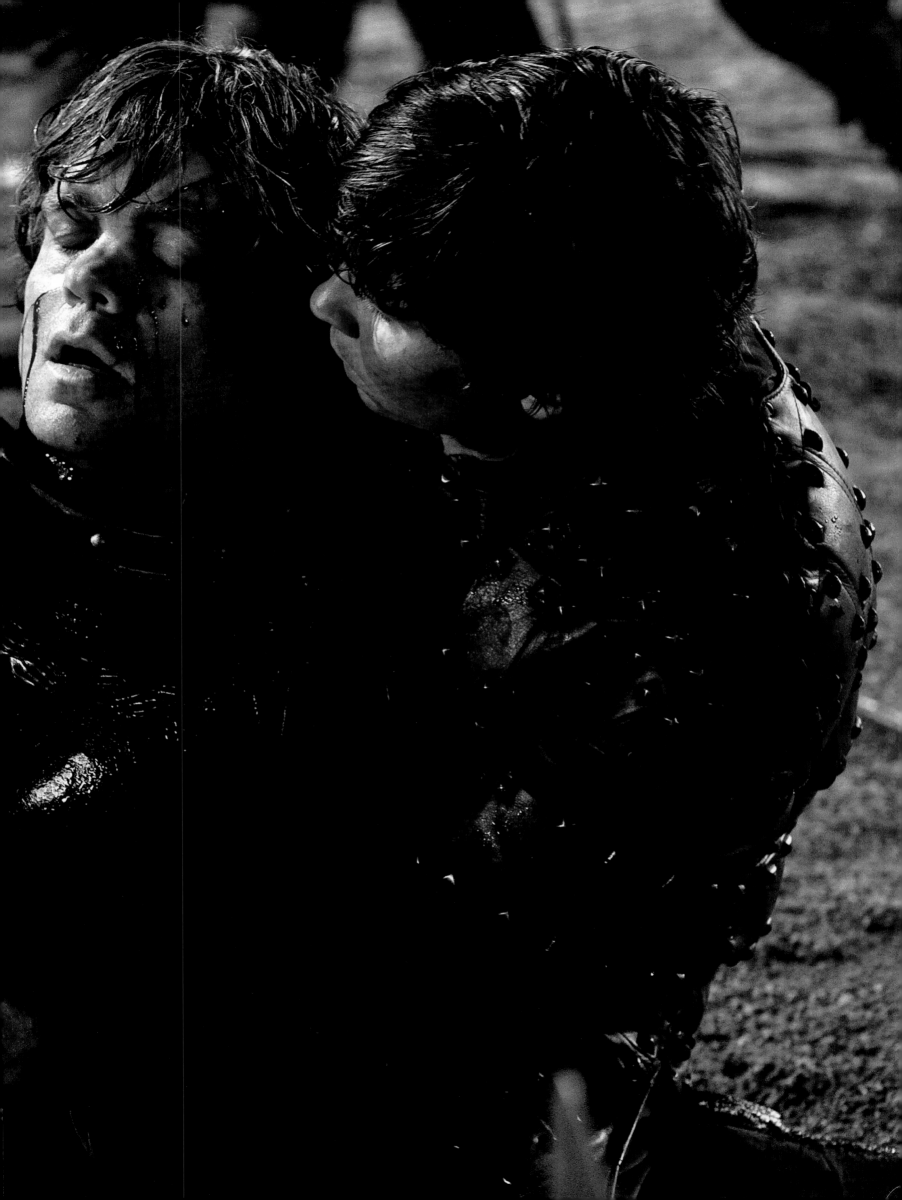

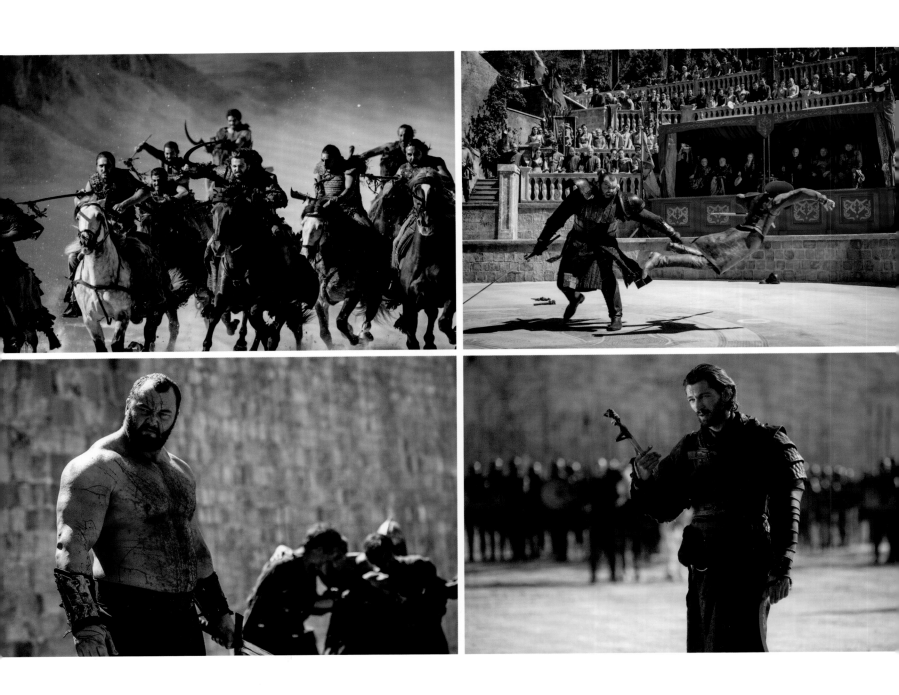

THIS PAGE: (*clockwise from top left*) The warriors of Westeros: Daario Naharis leads the Dothraki into Meereen to end the Great Masters' siege; the Mountain flings Prince Oberyn, the Red Viper of Dorne, during their colossal fight; Daario confidently readies himself to face the champion of Meereen; Hafþór Júlíus Björnsson as Ser Gregor Clegane.

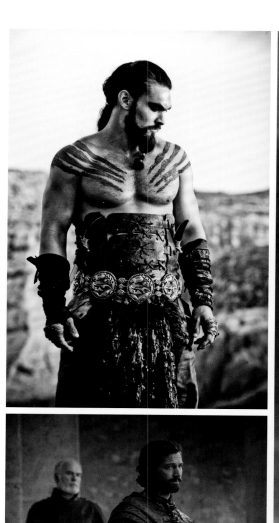

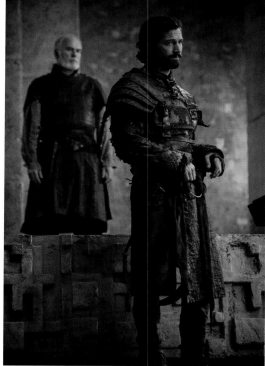

THIS PAGE: (*clockwise from top left*) Jason Momoa as Khal Drogo; Grey Worm, leader of the Unsullied; Ser Barristan Selmy and Daario.

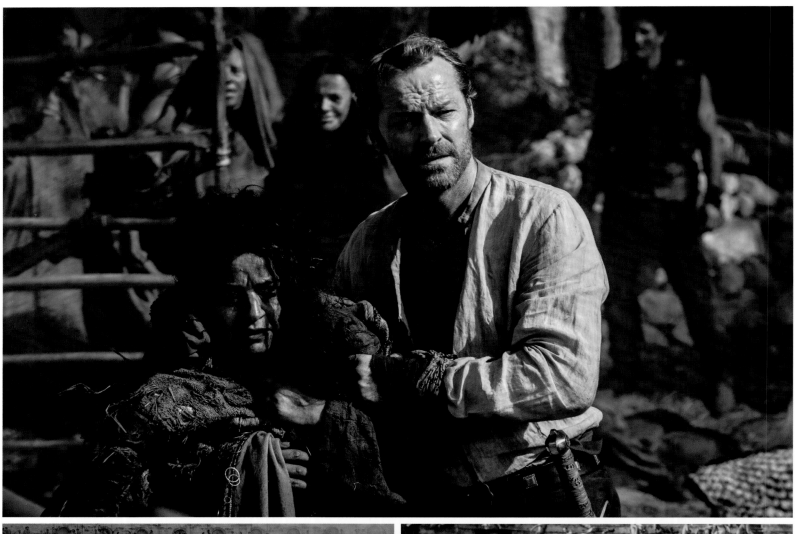

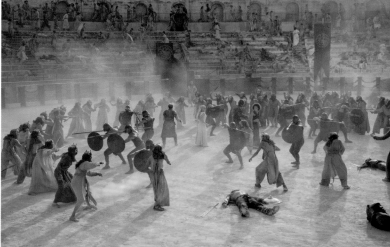

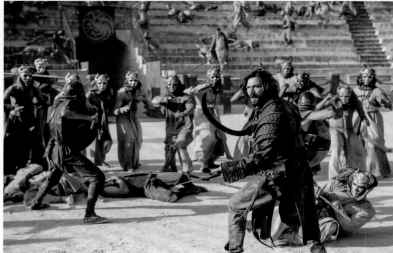

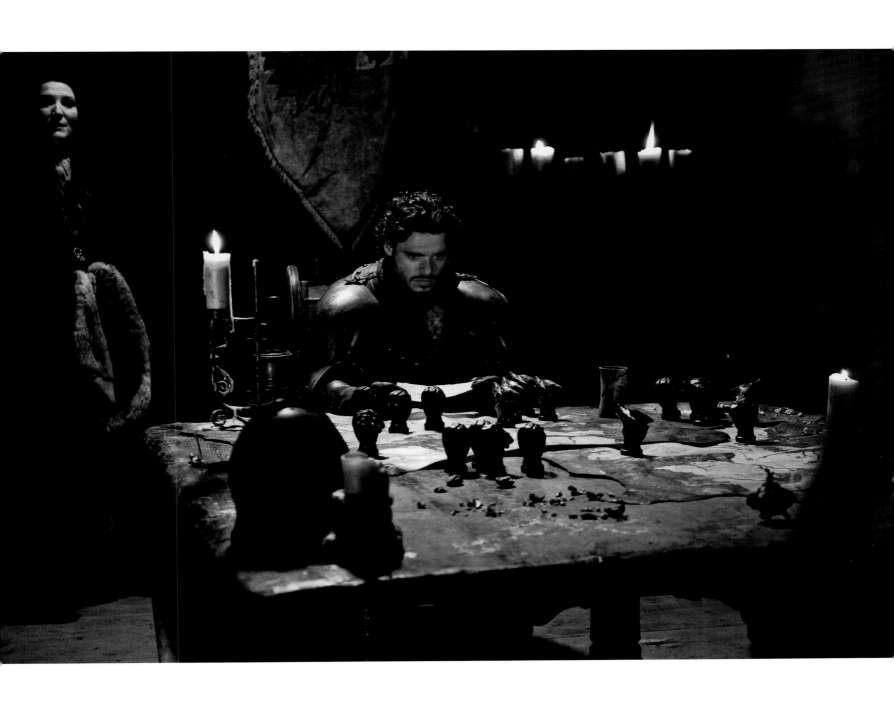

OPPOSITE TOP: Ser Jorah with the Lhazareen woman who poisoned Drogo and killed Daenerys's unborn child.
OPPOSITE BOTTOM ROW: Daario, Jorah, and the Unsullied defend Daenerys in Daznak's Pit.
ABOVE: Robb Stark, the King in the North, ponders his next move against the Lannisters.

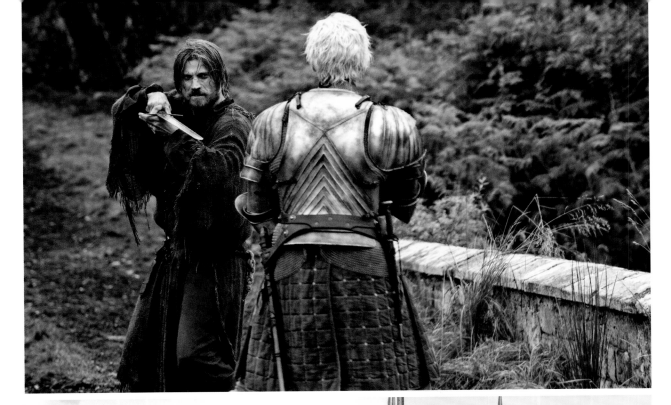

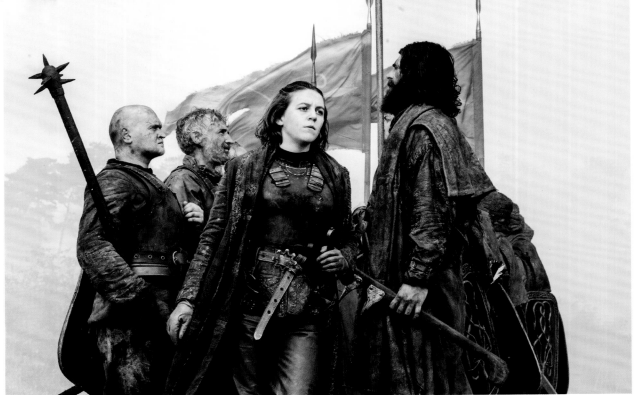

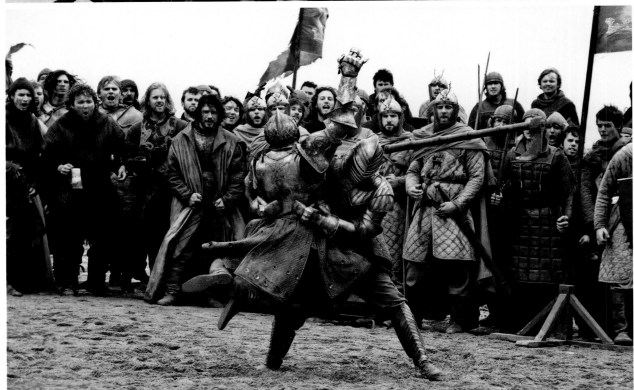

TOP: Jaime and Brienne face off against each other.
CENTER: Yara Greyjoy leading her men.
RIGHT: Brienne of Tarth battles Loras Tyrell hand to hand in Renly Baratheon's camp.
OPPOSITE: Richard Dormer as Beric Dondarrion, the Lightning Lord.

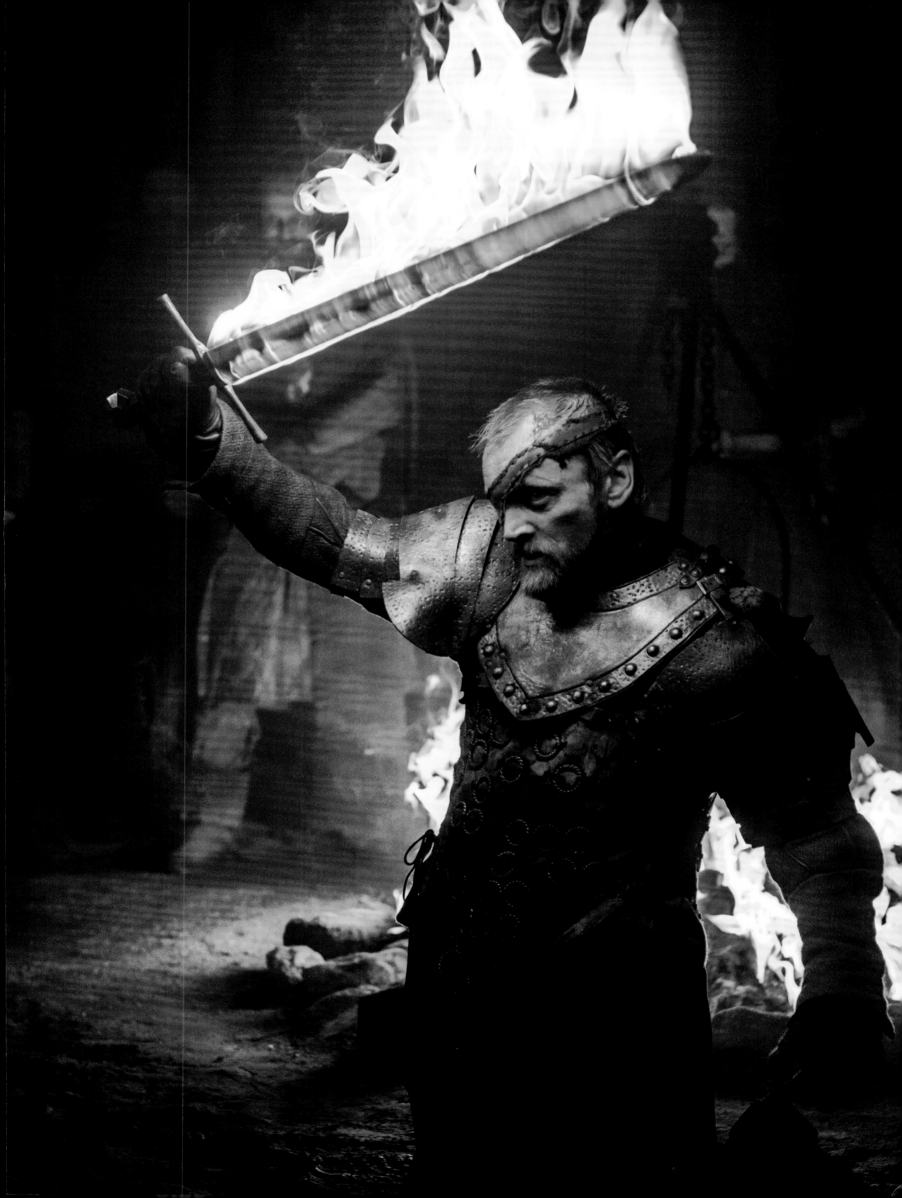

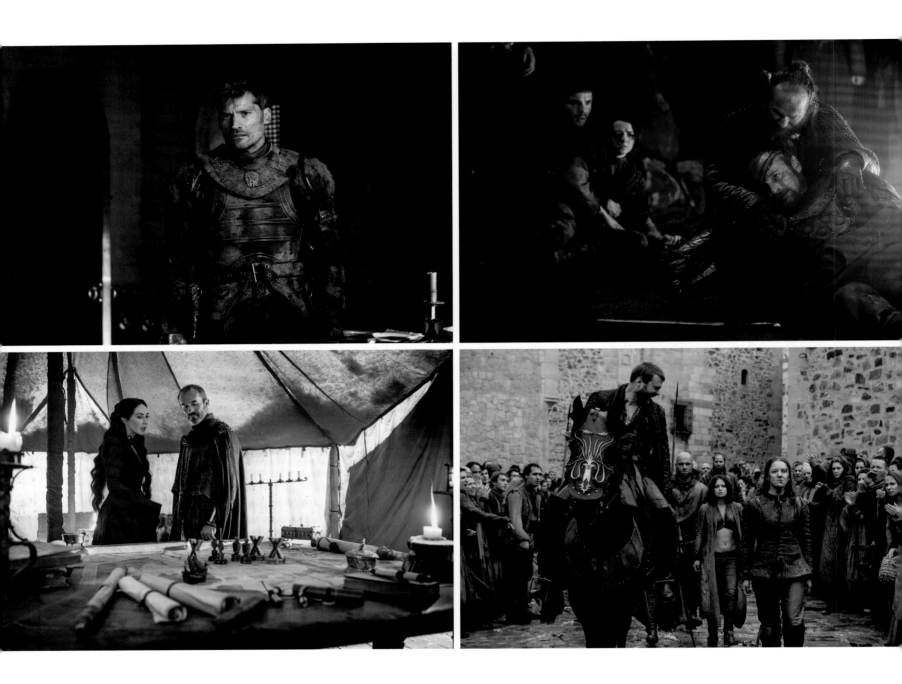

TOP ROW: (*from left*) Jaime after his forces are slaughtered by the Dothraki and Daenerys's dragons; Arya and Gendry gaze as Beric dies after his battle with the Hound; Euron impales Obara Sand.

BOTTOM ROW: (*from left*) Stannis and Melisandre discuss strategy; Euron humiliates a captured Yara and Tyene Sand; Benjen Stark.

OPPOSITE RIGHT: Tormund Giantsbane climbs the Wall.

PAGES 282—283: Cersei Lannister beside the enormous skull of the great dragon Balerion the Dread in the crypts beneath the Red Keep. Helen Sloan notes that the dragon skulls used on the show start off as polystyrene blocks glued together, and then the sculptors, painters, and set decorators turn them into works of art. This massive sculpt of Balerion the Dread is more than twice the height of actress Lena Headey.

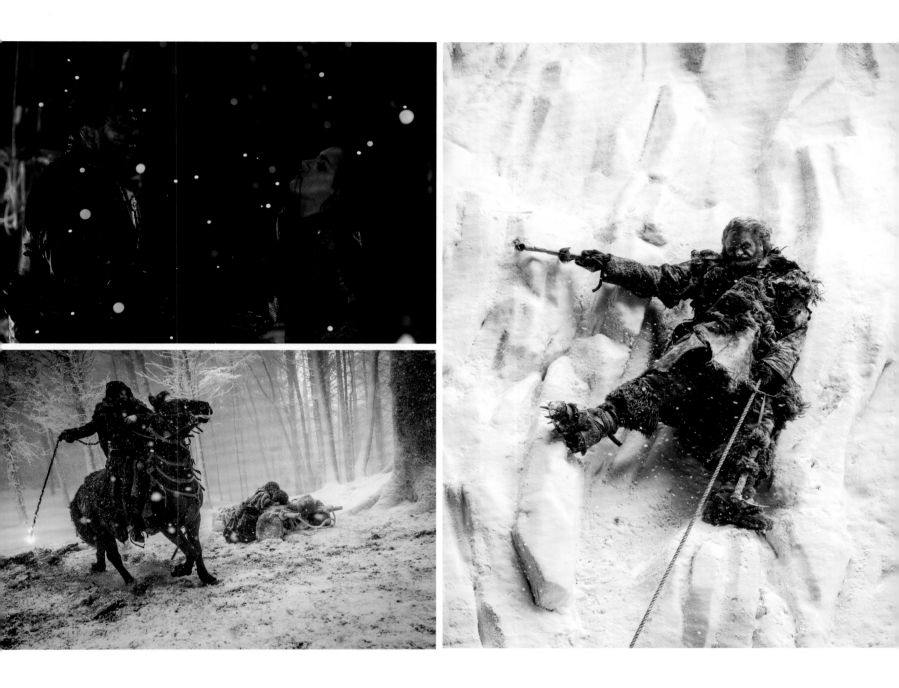

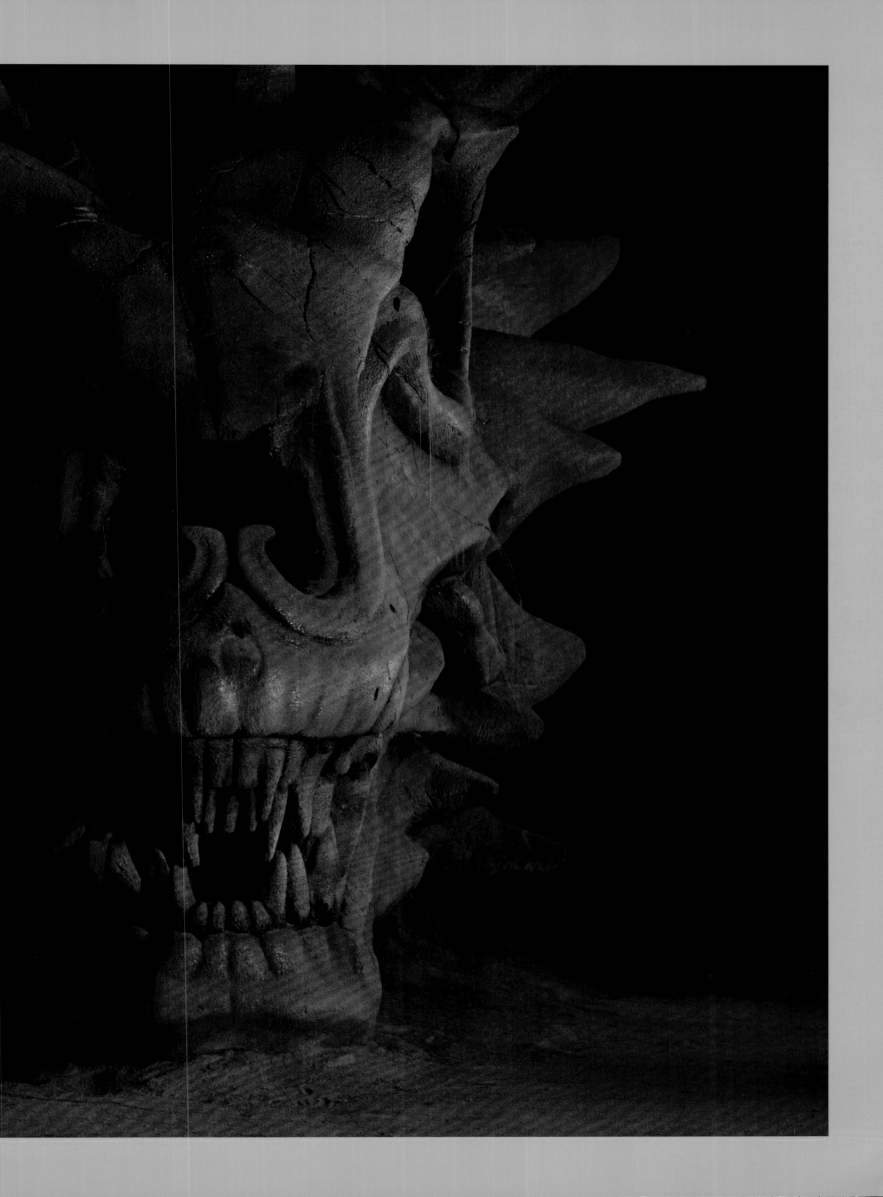

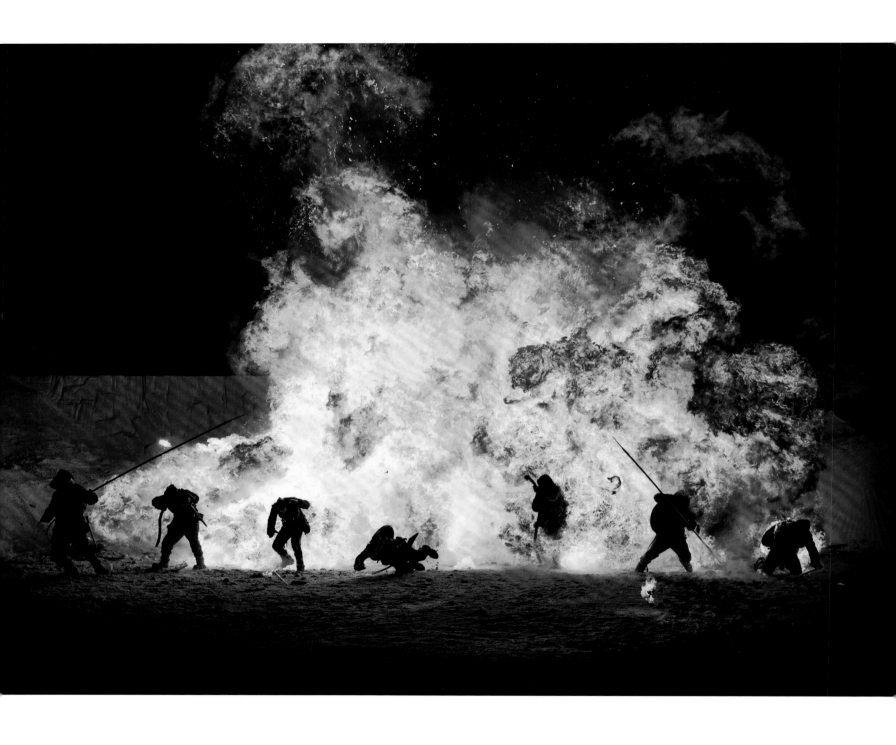

THIS PAGE: A massive explosion during the Battle of Castle Black that pits the Night's Watch against Mance Rayder's army. The action in an episode like "The Watchers on the Wall," in which this battle occurs, is tightly choreographed. Plus, the episode includes a 360-degree continuous camera shot. "A photographer has to pick the moments they think will make a good still frame, because stills and moving video are completely different," Helen Sloan says. "That 360-degree camera shot was so complicated for everyone involved, the best thing I could do was pick my moments, learn the dance, stay out of the way, and don't get it wrong."

OPPOSITE: (*clockwise from top left*) Ser Alliser Thorne rallies the Night's Watch at the Battle of Castle Black; Styr, the Magnar of the fierce Thenn wildling tribe; Jon Snow squares off against Styr; Ygritte takes aim.

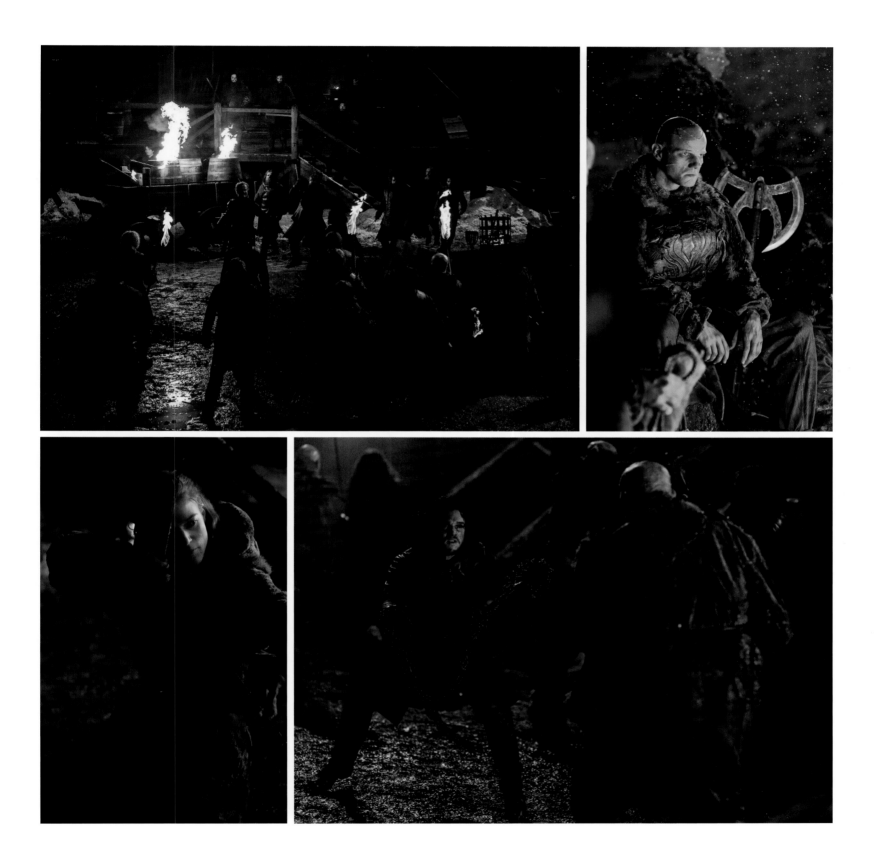

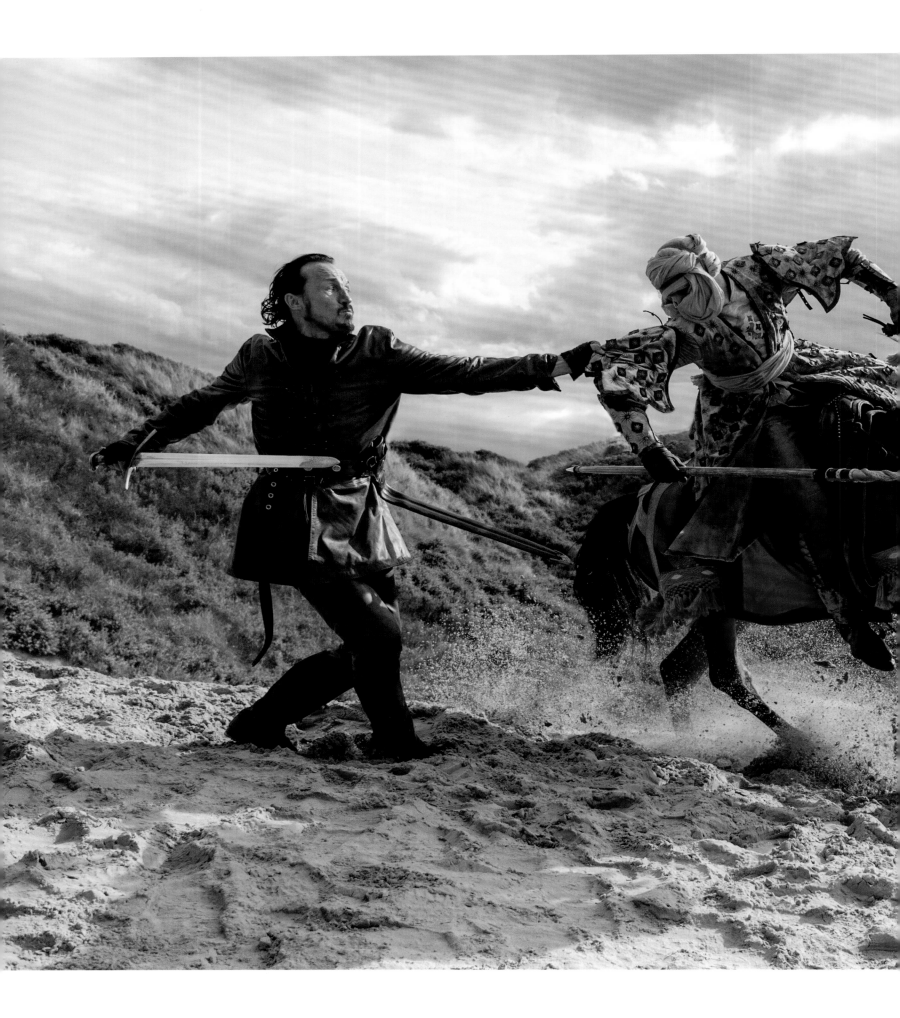

ABOVE: Bronn unhorses one of the men-at-arms from House Martell he encounters on the beaches of Dorne. "Any time there are horses running around, it scares me. They are enormous animals. I'm always very on edge capturing shots like this. I was pleased to get this photo because it's a nice angle, with the sun just right. The sand kicking up everywhere enhances the action element in the photograph. I'm really happy with this one," says Sloan.

OPPOSITE TOP: Jaime Lannister is captured at the Battle of the Whispering Wood.

OPPOSITE CENTER: Gendry, the blacksmith and son of Robert Baratheon.

OPPOSITE BOTTOM: Bronn just before he battles several hill tribesmen on the way to the Vale of Arryn.

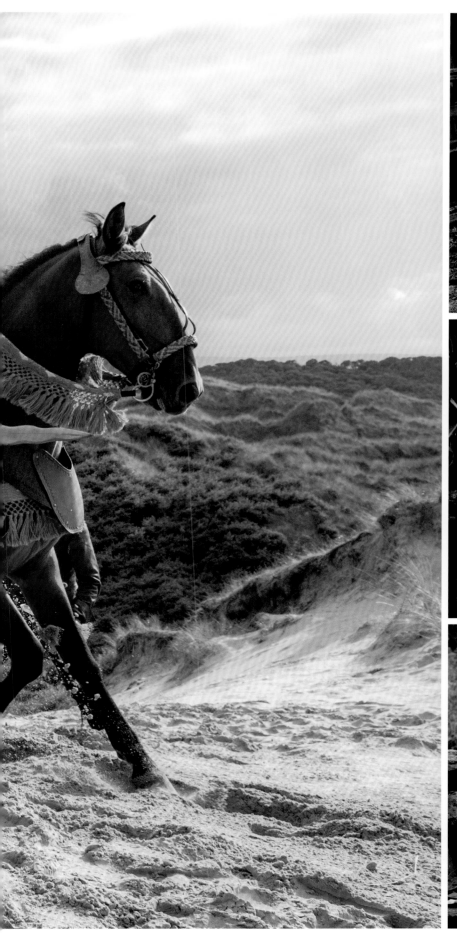

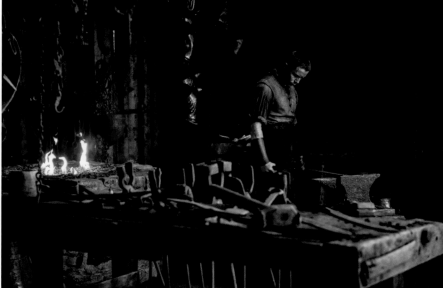
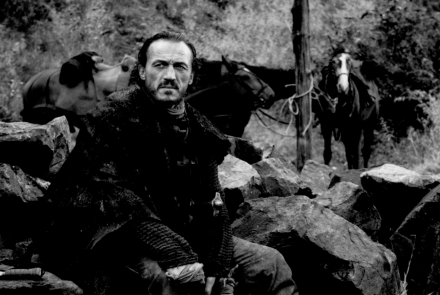

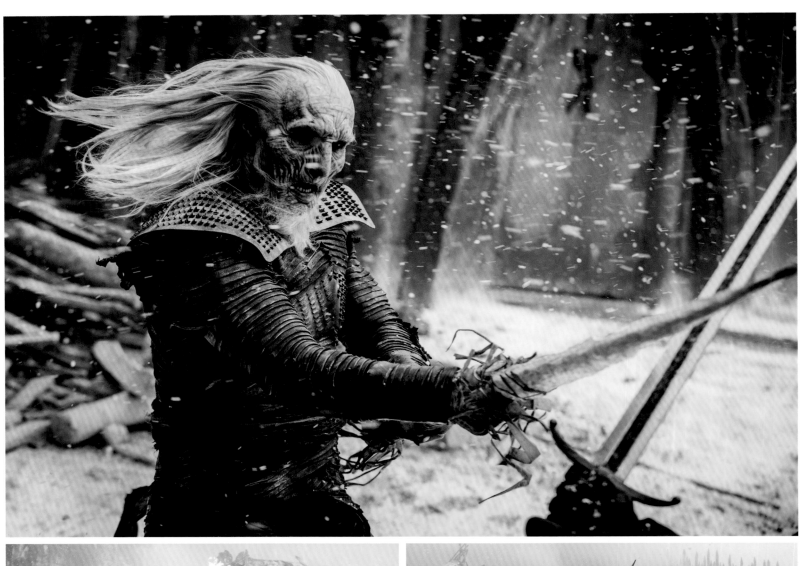

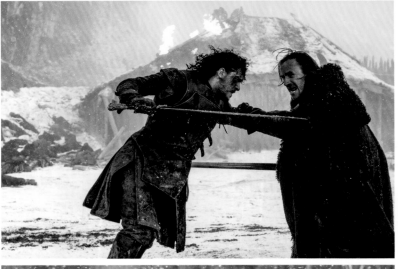

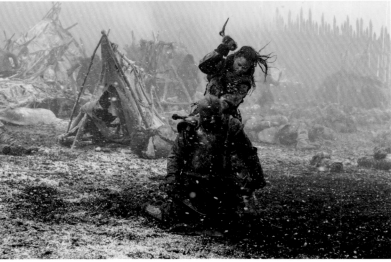

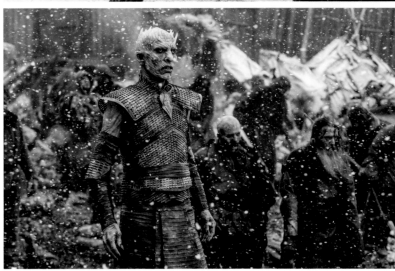

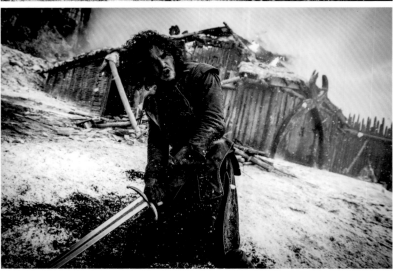

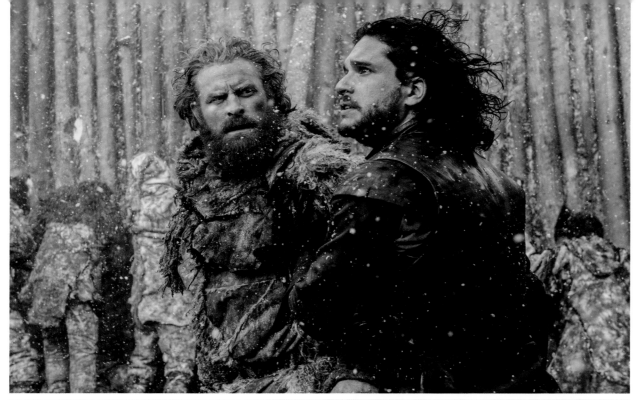

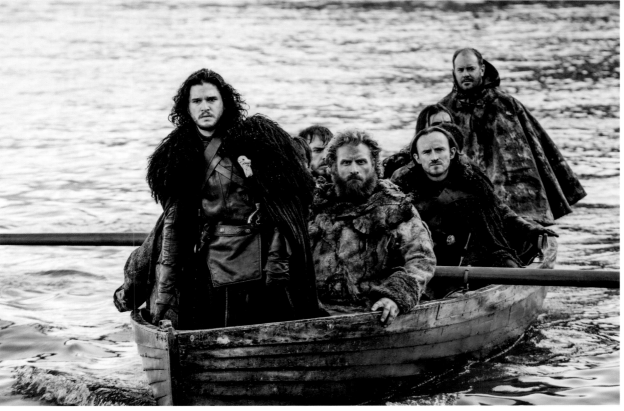

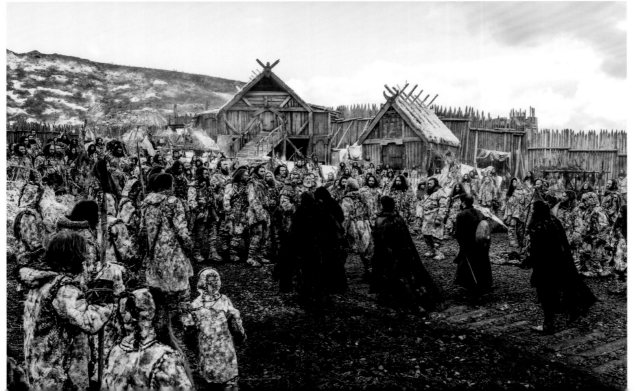

THESE PAGES: The Massacre at Hardhome results in countless Free Folk casualties but reveals the White Walkers' vulnerability to Valyrian steel, as Jon Snow's sword, Longclaw, is able to slay a White Walker. Jon Snow and the survivors escape and return to Castle Black. Some of the weather conditions on *Game of Thrones* are man-made. The snow, for example, is made of either soap bubbles or paper. The soap bubbles pose a special challenge for photographers because they can stick to the camera lens. It was times like those that Sloan was thankful for the protective blimp she had covering her camera. Sloan says, "Every time I saw the White Walkers, I thought, 'Oh great, more paper, more snow.' But the weather is just so convincing; everything you see in these pictures [is] fake snow."

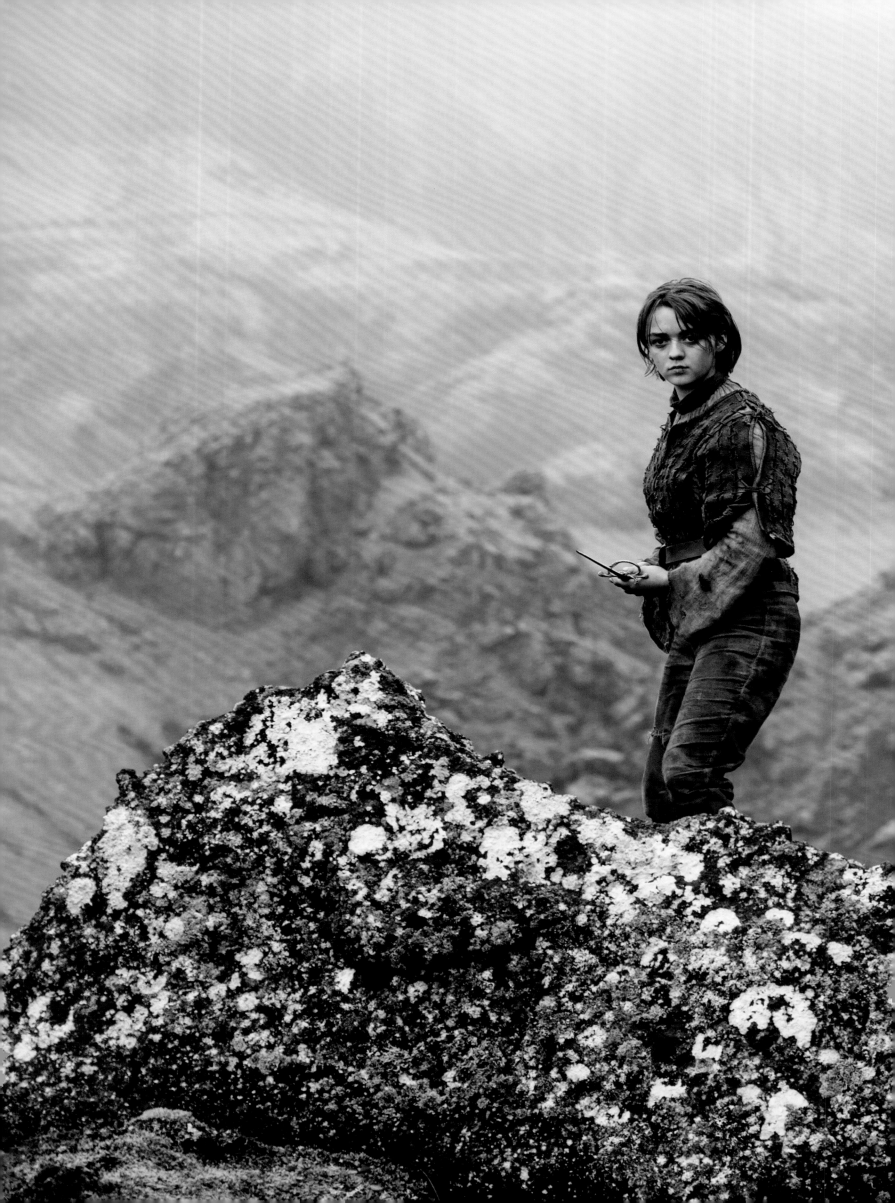

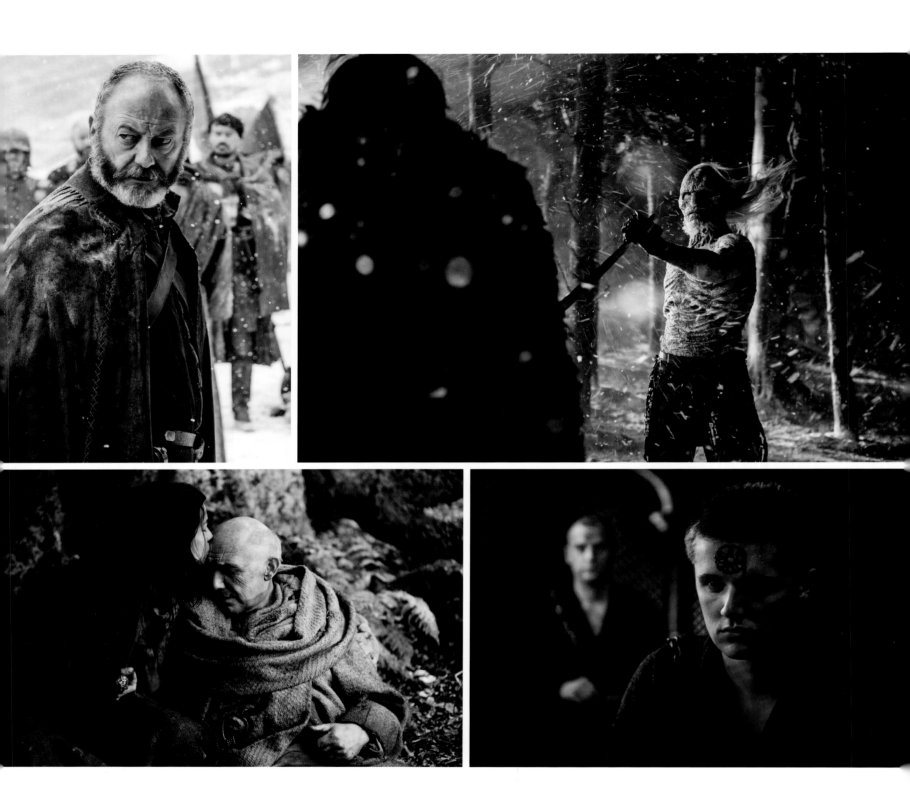

PAGES 290–291: Maisie Williams as Arya Stark.

THIS PAGE: (*clockwise from top left*) Ser Davos leaves Stannis's camp to return to the Wall for more supplies; one of the White Walkers; Lancel Lannister, former squire to King Robert Baratheon, has become Brother Lancel; Osha comforts Maester Luwin in his final moments, giving him the quick end he requests.

OPPOSITE TOP: Jon reads a challenge missive from Ramsay with Tormund by his side.

OPPOSITE CENTER AND OPPOSITE BOTTOM: Jon, Edd, and Ser Davos strategize about how to take back Winterfell.

PAGES 294–295: Ramsay Bolton sits confidently in command of his army before the Battle of the Bastards begins.

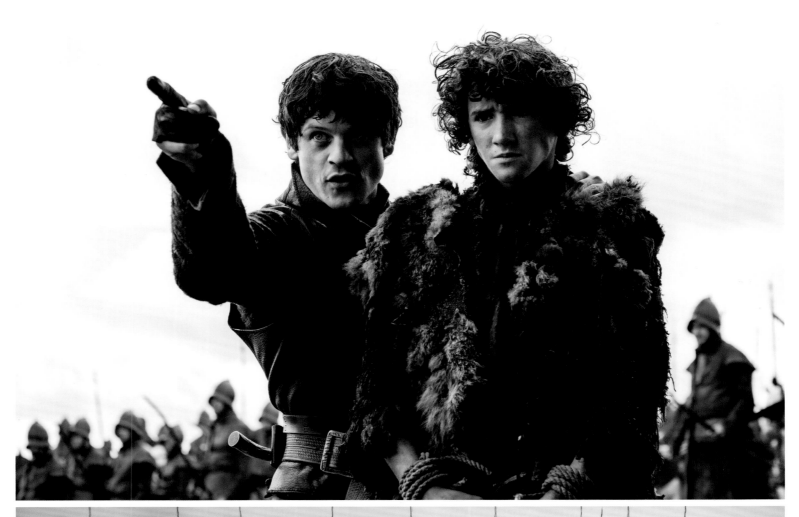

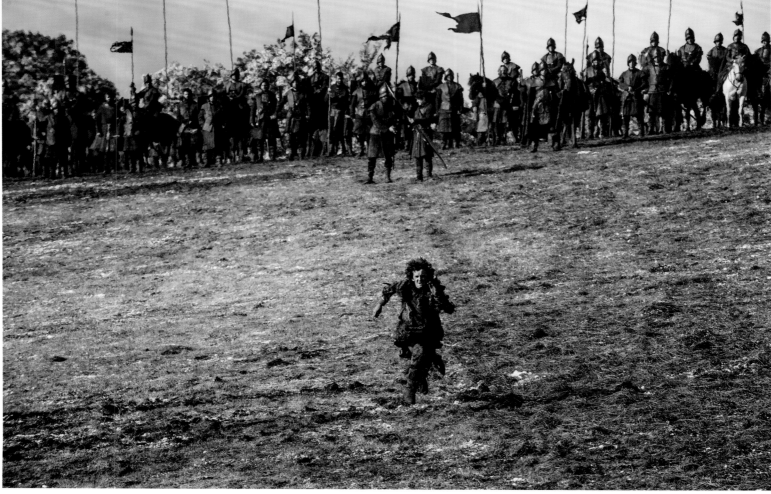

THIS PAGE: Ramsay sends Rickon off to his doom.

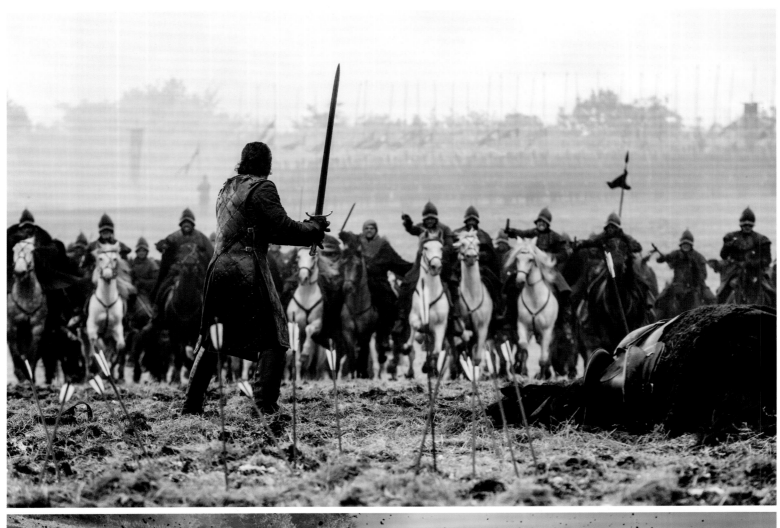

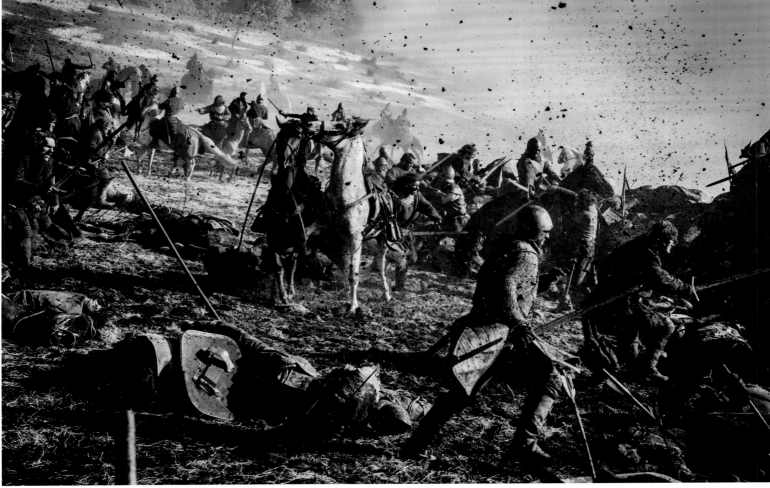

THESE PAGES: Jon Snow and his men face down House Bolton's cavalry charge, and the battle rages on.

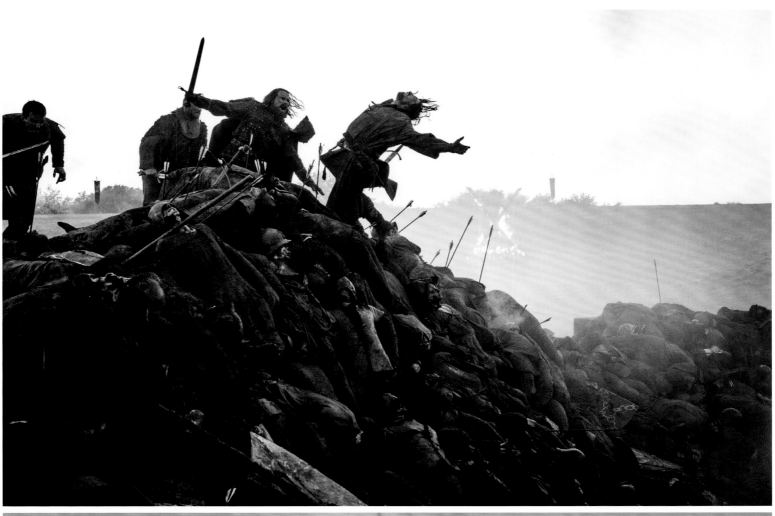

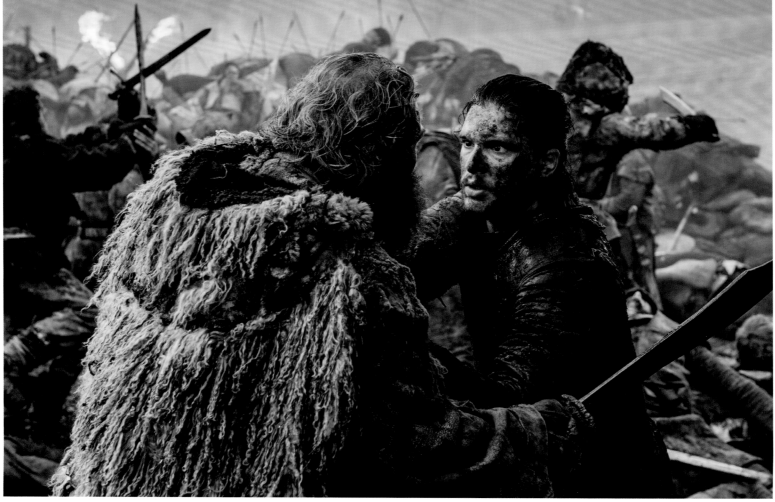

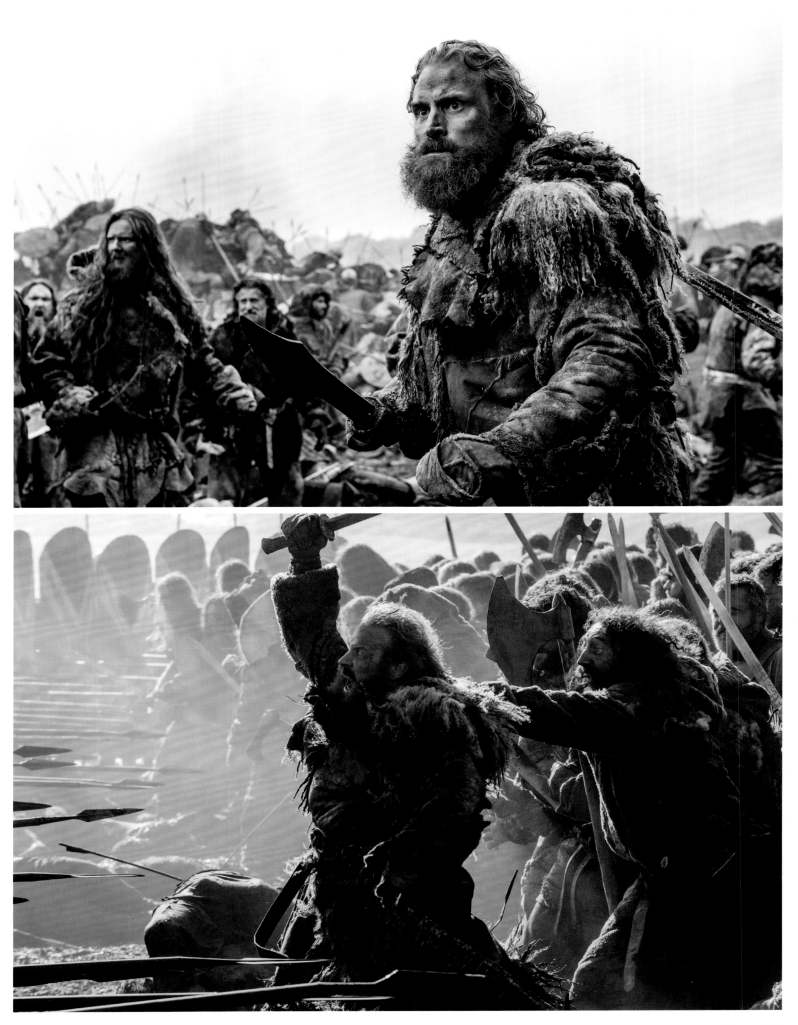

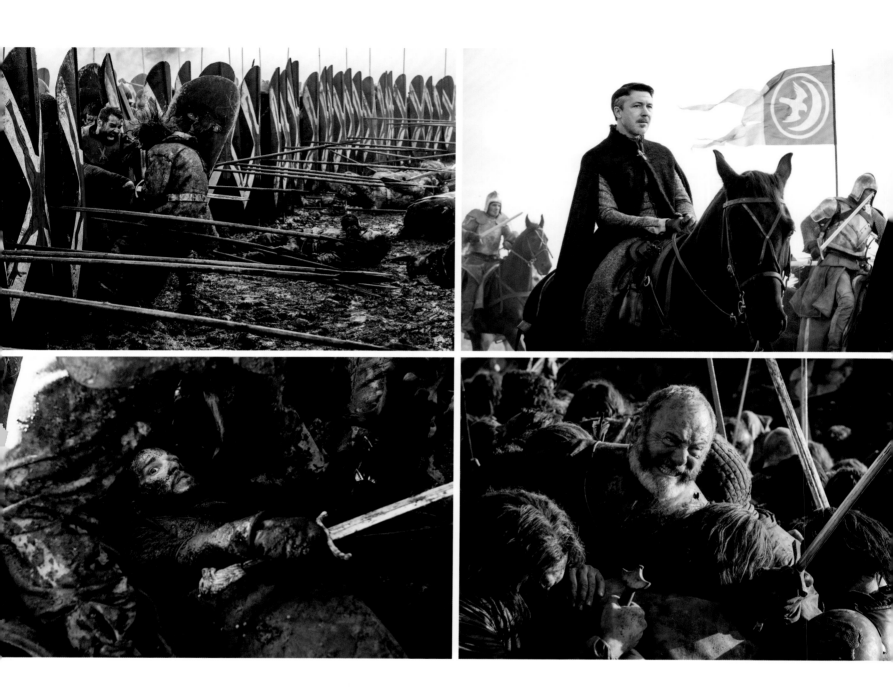

TOP LEFT: Armies clash. Helen Sloan sees "The Battle of the Bastards" as a daylight training run for the final season's "The Battle of Winterfell." Decent weather blessed the shoot, but as she remembers, "It was full of mud and so many [fake bodies], so much fake blood, so much muck, and so many horses! Everyone went home each night of that shoot full of mud and fake blood. . . . One day I accidently left my camera bag open while it was next to one of the mud cannons used for that scene. I remember half laughing and half crying and saying to my assistant Trevor, 'We left the flap open. It looks like a bag of roadkill.'"

TOP RIGHT: Littlefinger brings the Knights of the Vale to save the day.

BOTTOM LEFT: Jon fights for his life.

BOTTOM RIGHT: Ser Davos fights for his life.

OPPOSITE: Jon Snow, the grief-stricken victor.

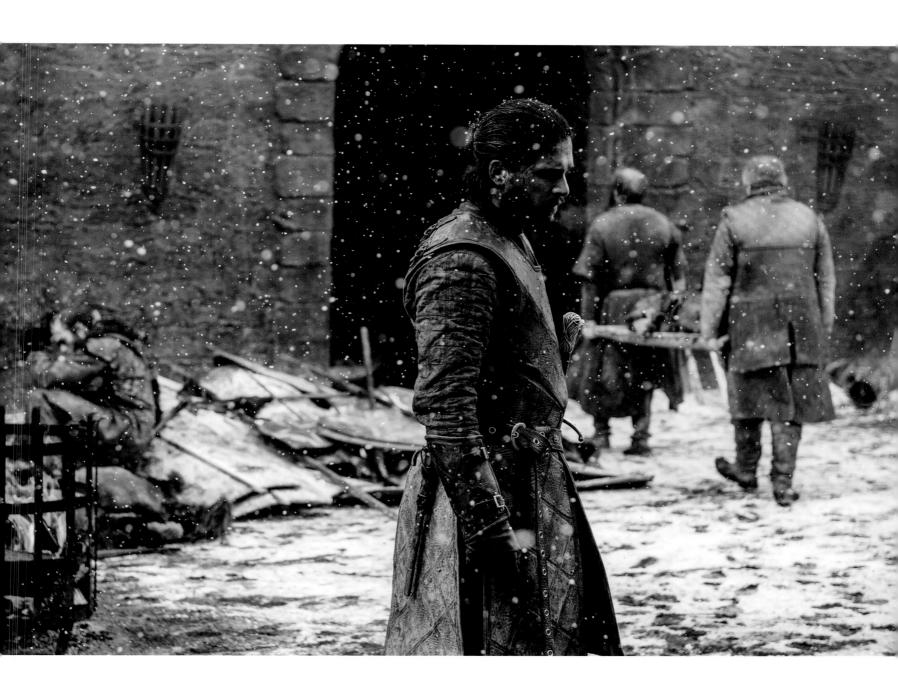

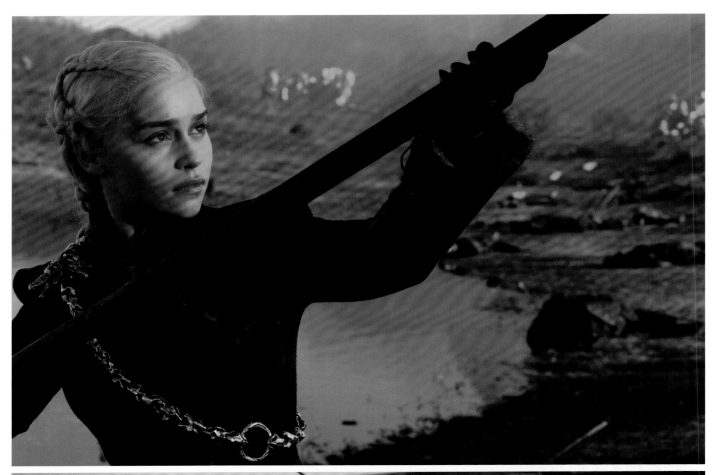

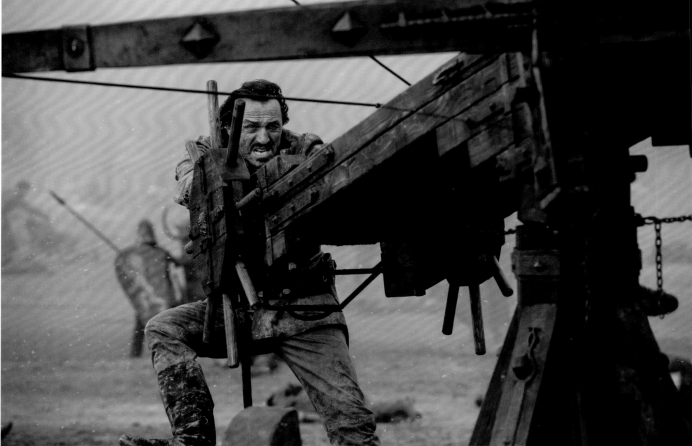

TOP: Daenerys removes a spear from her dragon.
BOTTOM: Bronn takes aim at Drogon.
OPPOSITE TOP: Jaime encounters a Dothraki rider.
OPPOSITE BOTTOM: Jaime sees an opportunity to take out Daenerys.

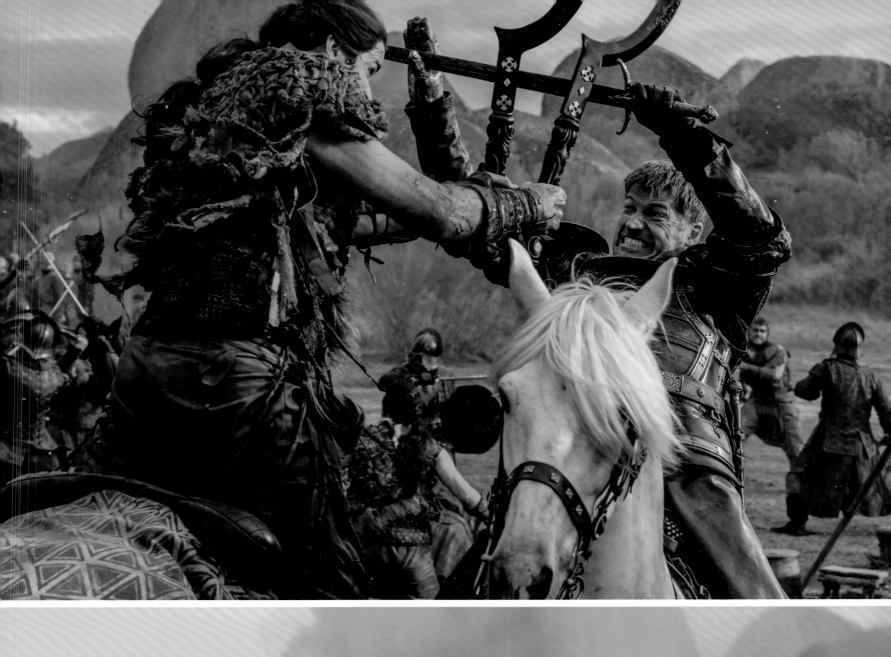
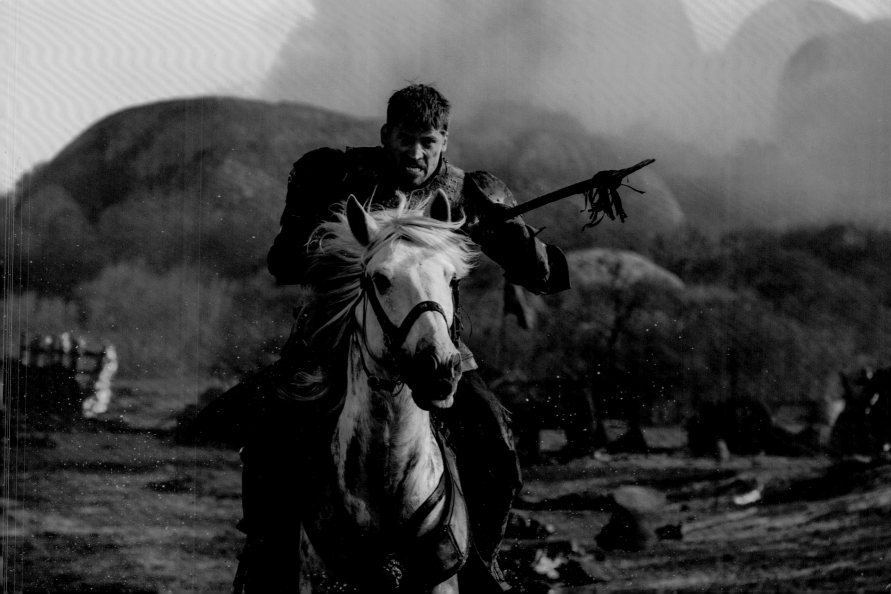

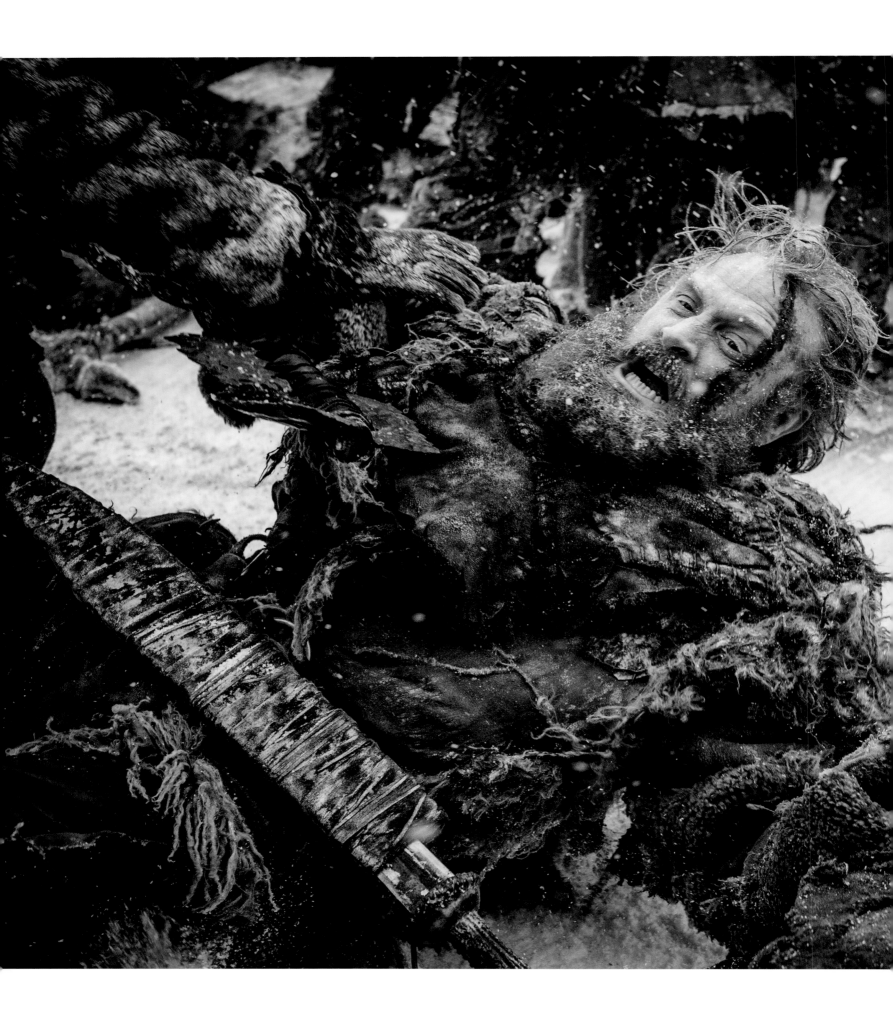

ABOVE: Tormund Giantsbane is overwhelmed by wights.

OPPOSITE TOP: The Night King stalks his prey.

OPPOSITE CENTER AND OPPOSITE BOTTOM: Beric Dondarrion and his cohorts attempt to escape. Sloan recalls that it was extremely cold in the quarry that doubled as the frozen lake during the wight hunt shoot. But the scene was surprisingly simpler in terms of capturing still photos, because the action happened in shorter bursts rather than the longer takes for other battles in the series.

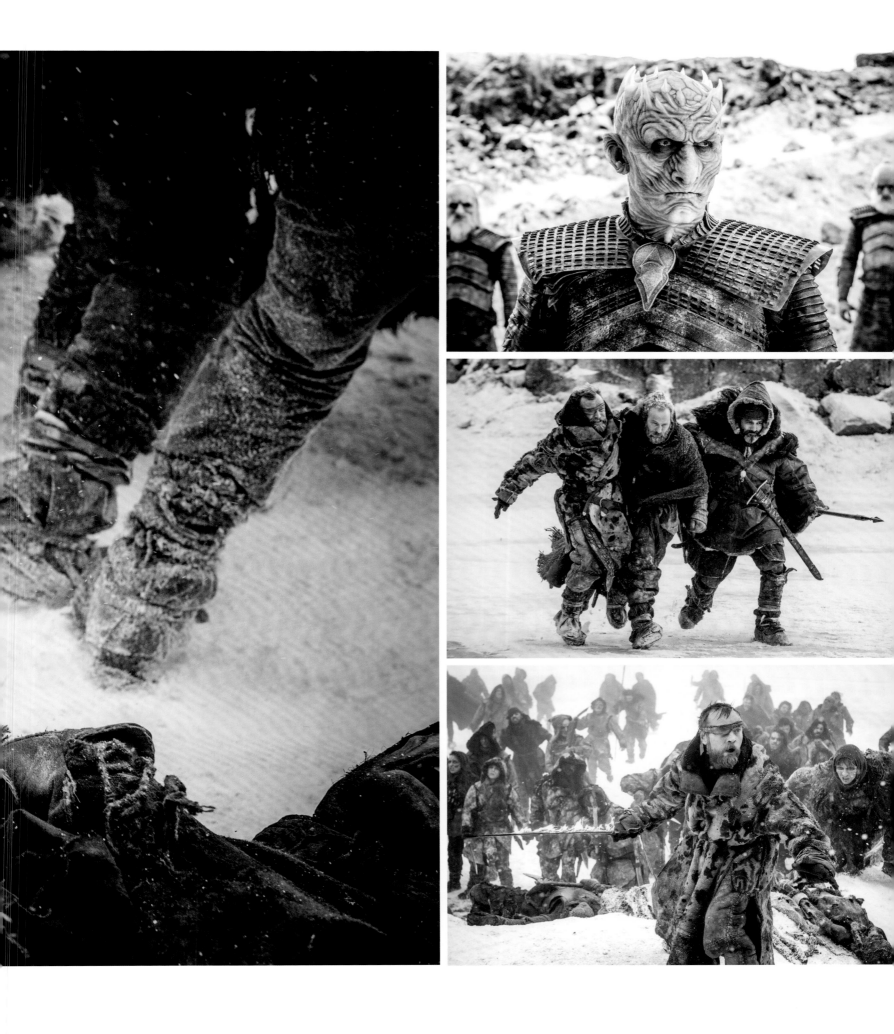

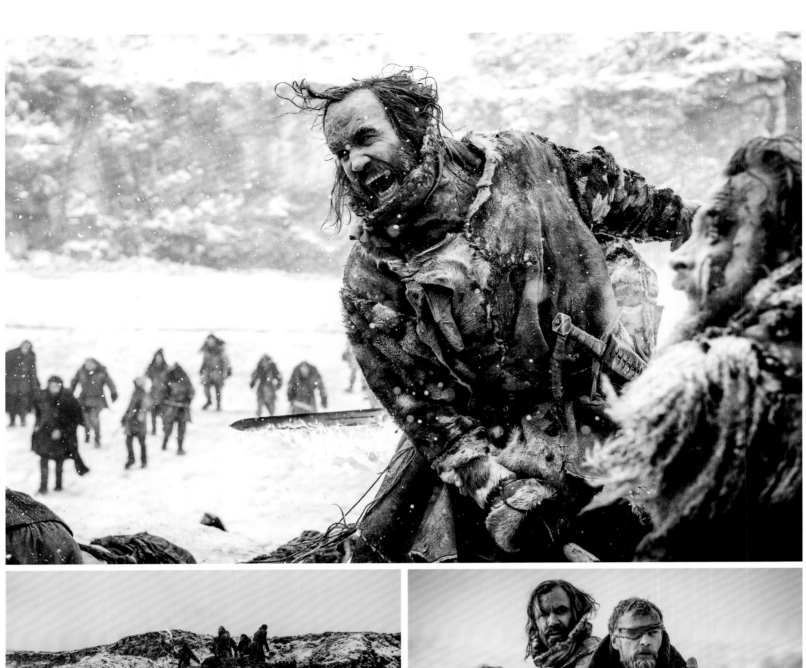

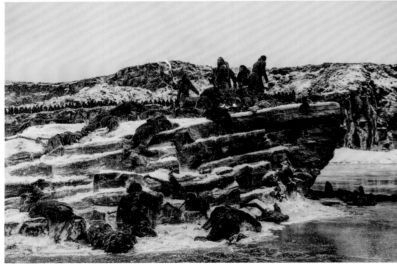

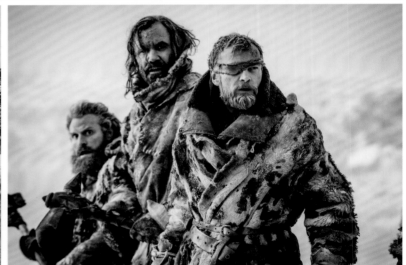

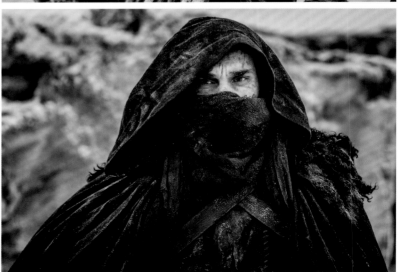

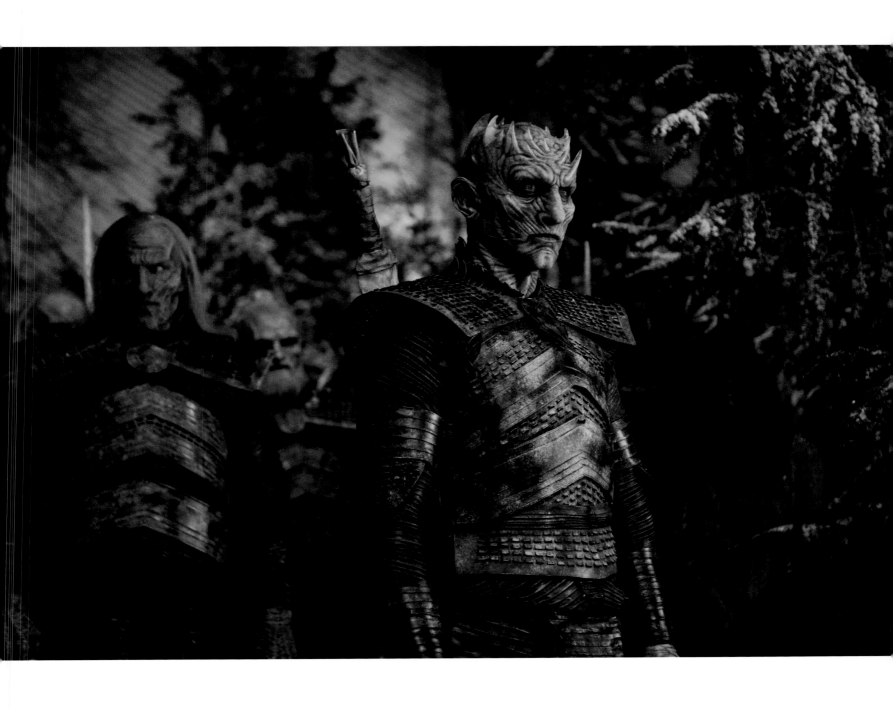

OPPOSITE: Jon's team fights desperately to hold off the Army of the Dead (*top and center row*);
Benjen Stark arrives to save Jon (*bottom row*).
ABOVE: The Night King and the White Walkers at his command at Winterfell.
PAGES 310–311: Queen Daenerys and the armies of the living devise their plan to take out the Night King.

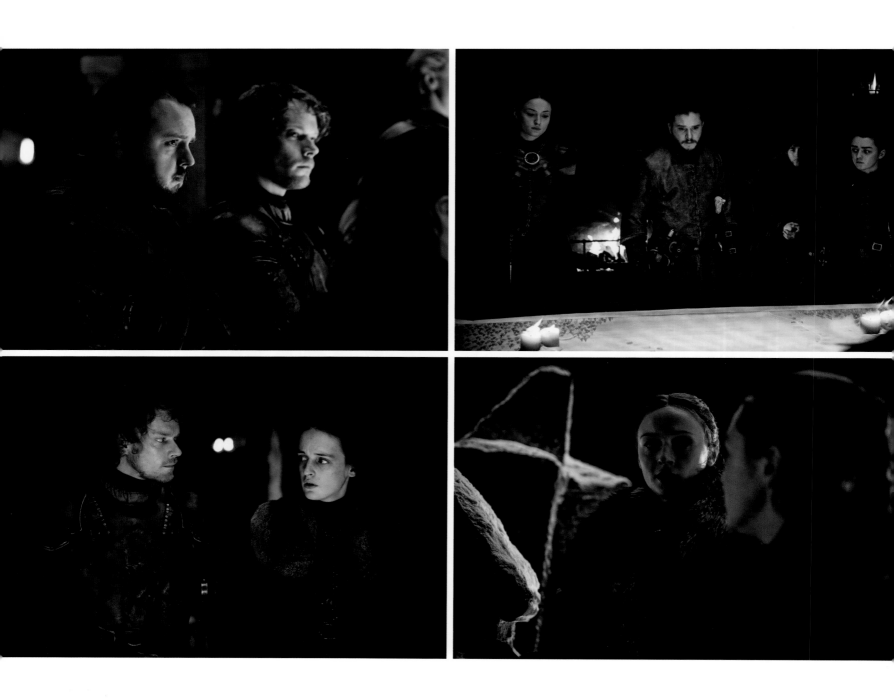

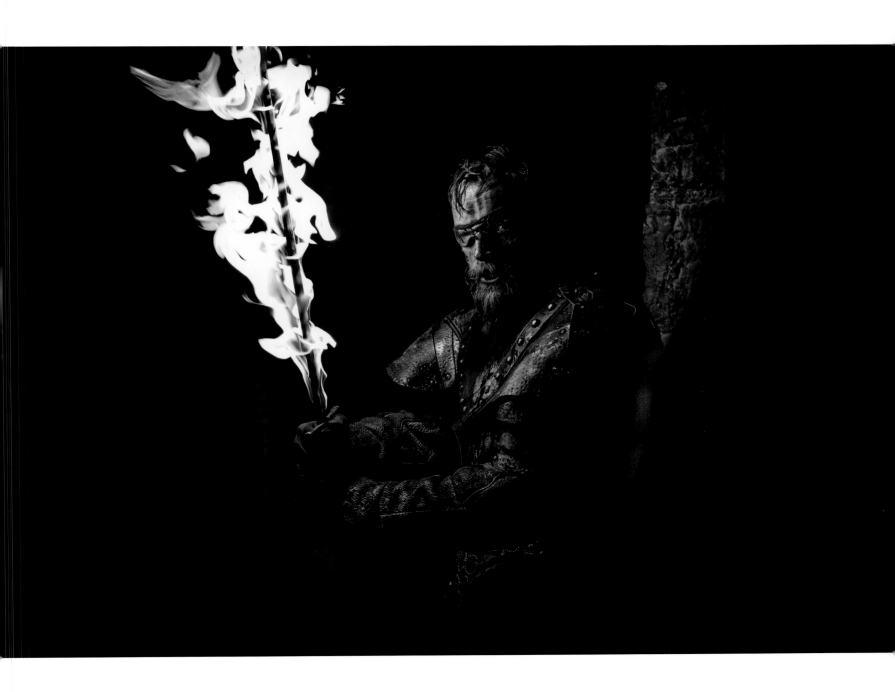

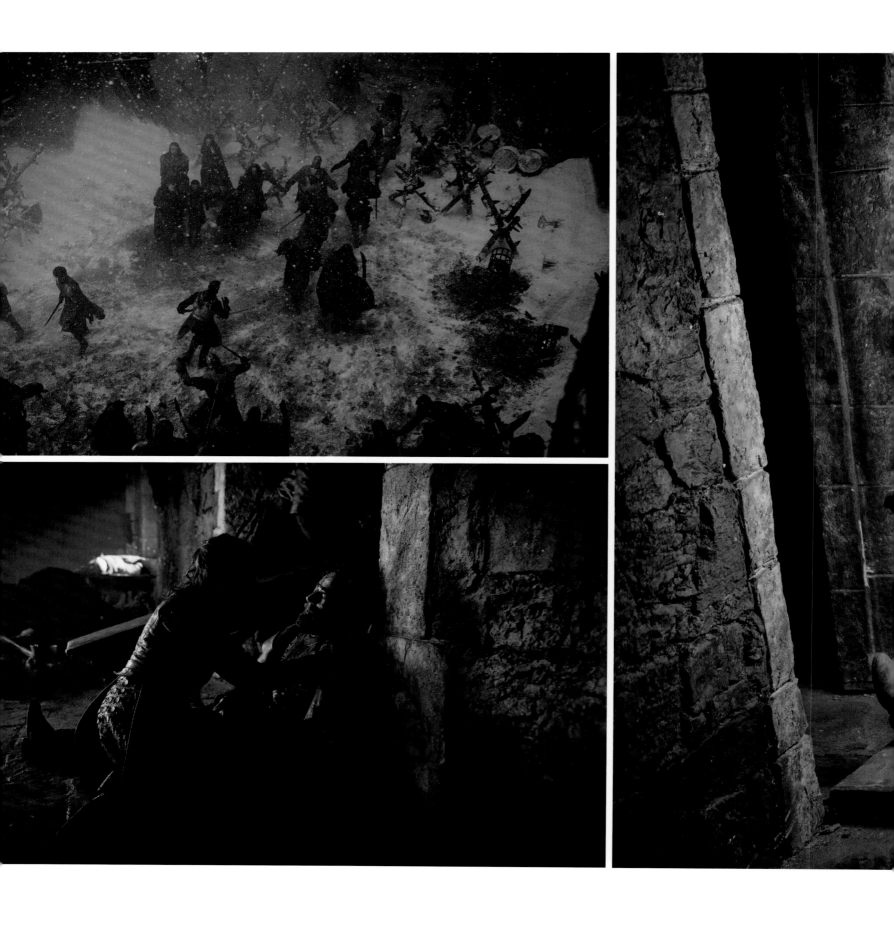

TOP: The Battle of Winterfell erupts.
BOTTOM AND RIGHT: Arya is saved from a wight by Beric Dondarrion, who makes his last stand fighting off the dead.

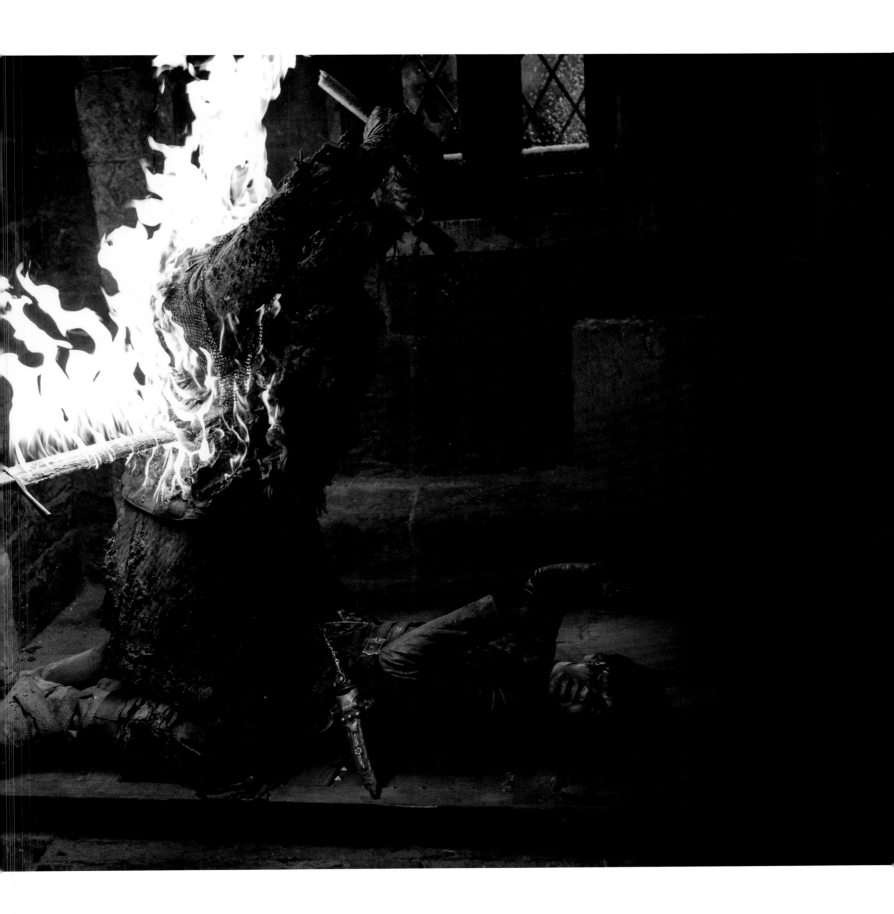

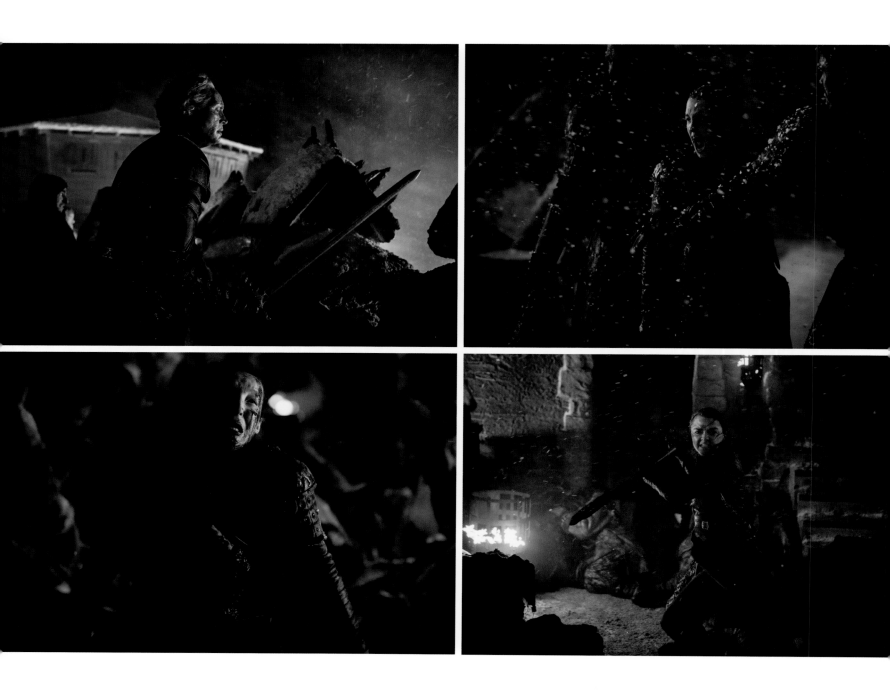

TOP LEFT: Ser Brienne of Tarth takes command.

TOP RIGHT AND BOTTOM LEFT: Lyanna Mormont, the Lady of Bear Island, dies on the Winter-
fell battlefield.

BOTTOM RIGHT: Arya goes on the attack.

OPPOSITE: Guarded by the Unsullied, Melisandre prays to the Lord of Light to set fire to the
trench as wights rush toward her.

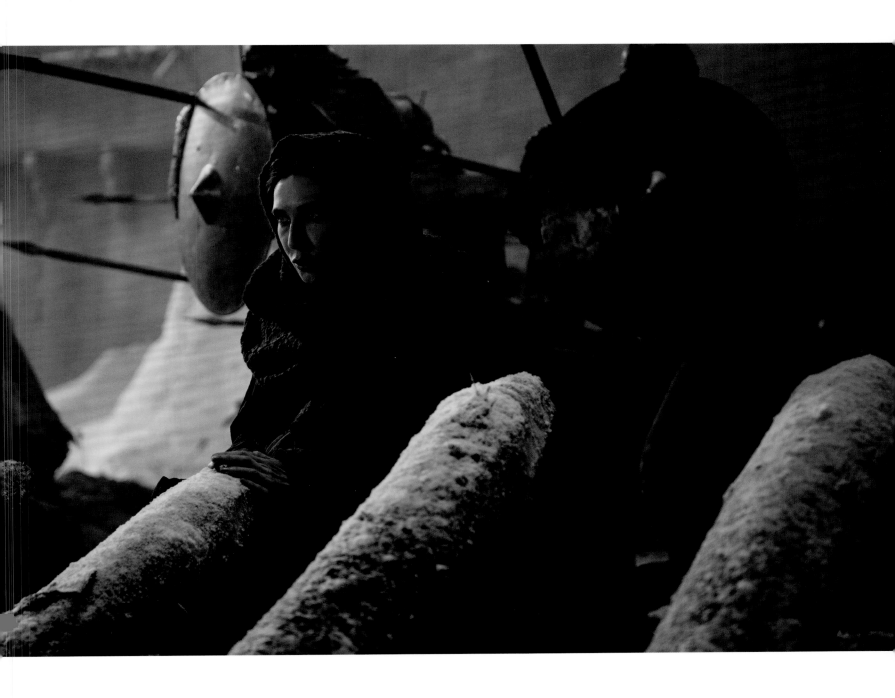

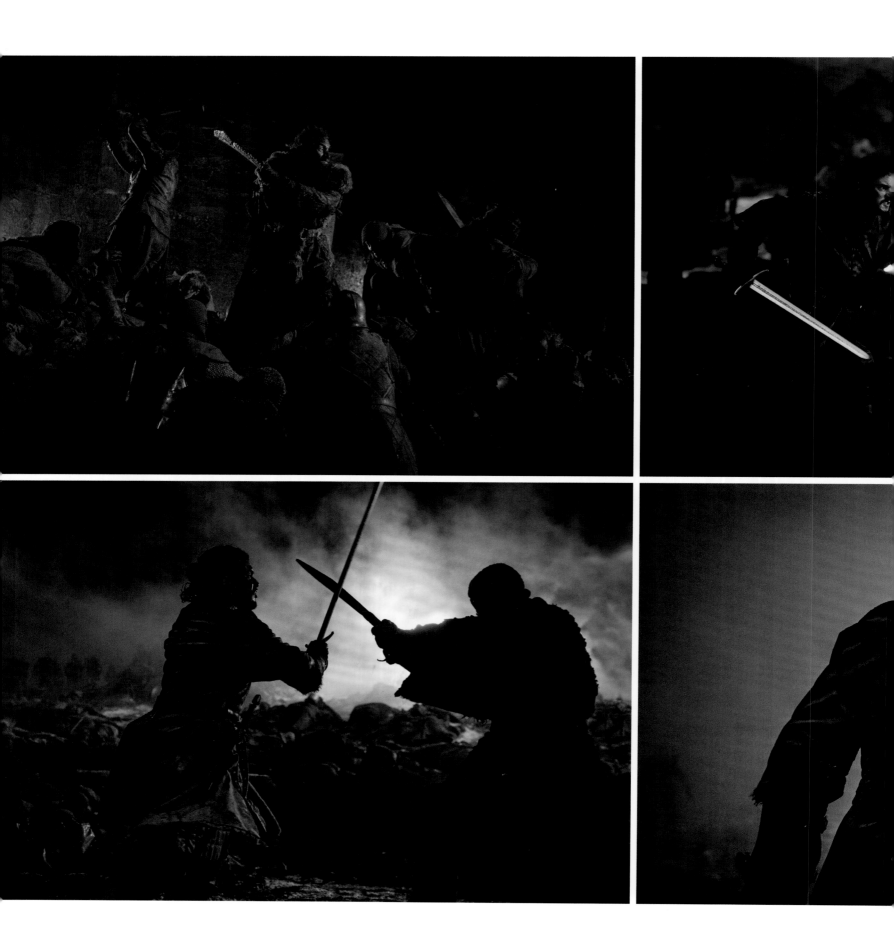

TOP LEFT: Gendry and Tormund desperately fight off the wights inside the walls of Winterfell.

TOP RIGHT, BOTTOM LEFT, BOTTOM RIGHT, AND OPPOSITE: Jon Snow (Kit Harington) races to try to confront the Night King. Sloan says, "Poor Kit Harington always seems to be in some sort of fight scene. Everything he's done throughout the series just looks like it hurts. And with Kit, he does most of it on his own. He's doing the sword fighting, he's running through that battlefield in that last season again and again, take after take . . . he's a machine. He just kept going, and there seemed to be no stopping him. It was exhausting just watching him!"

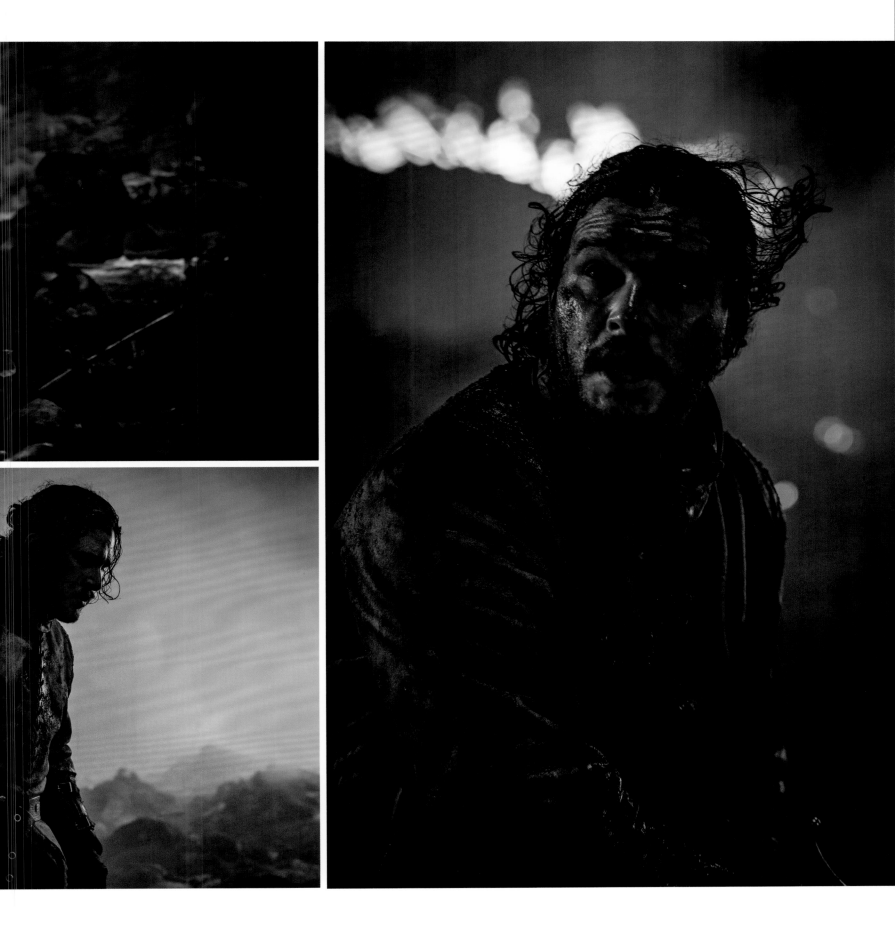

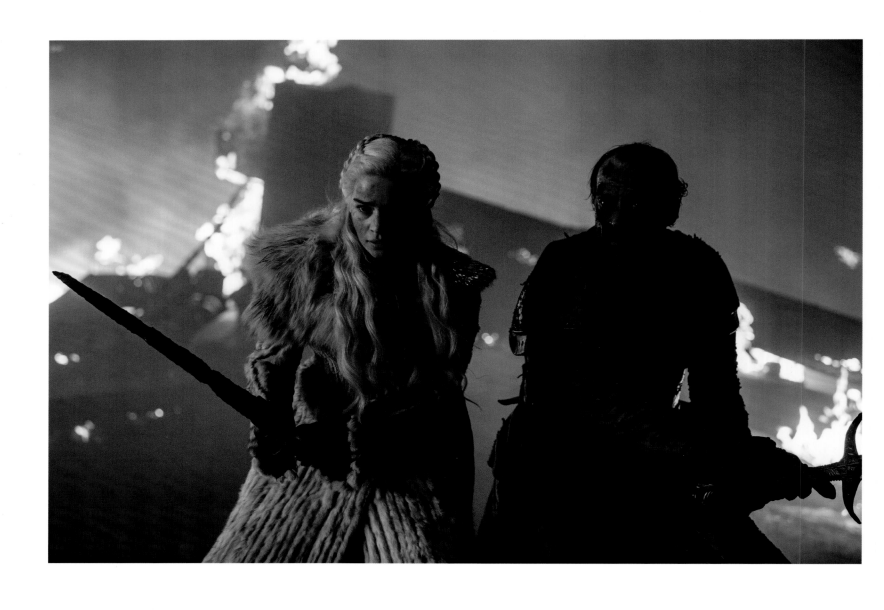

THIS PAGE: Daenerys and Ser Jorah make their stand against the dead together.
OPPOSITE: The end of the Great War exacts a heavy price, as Daenerys grieves over the loss of her most trusted advisor and friend.

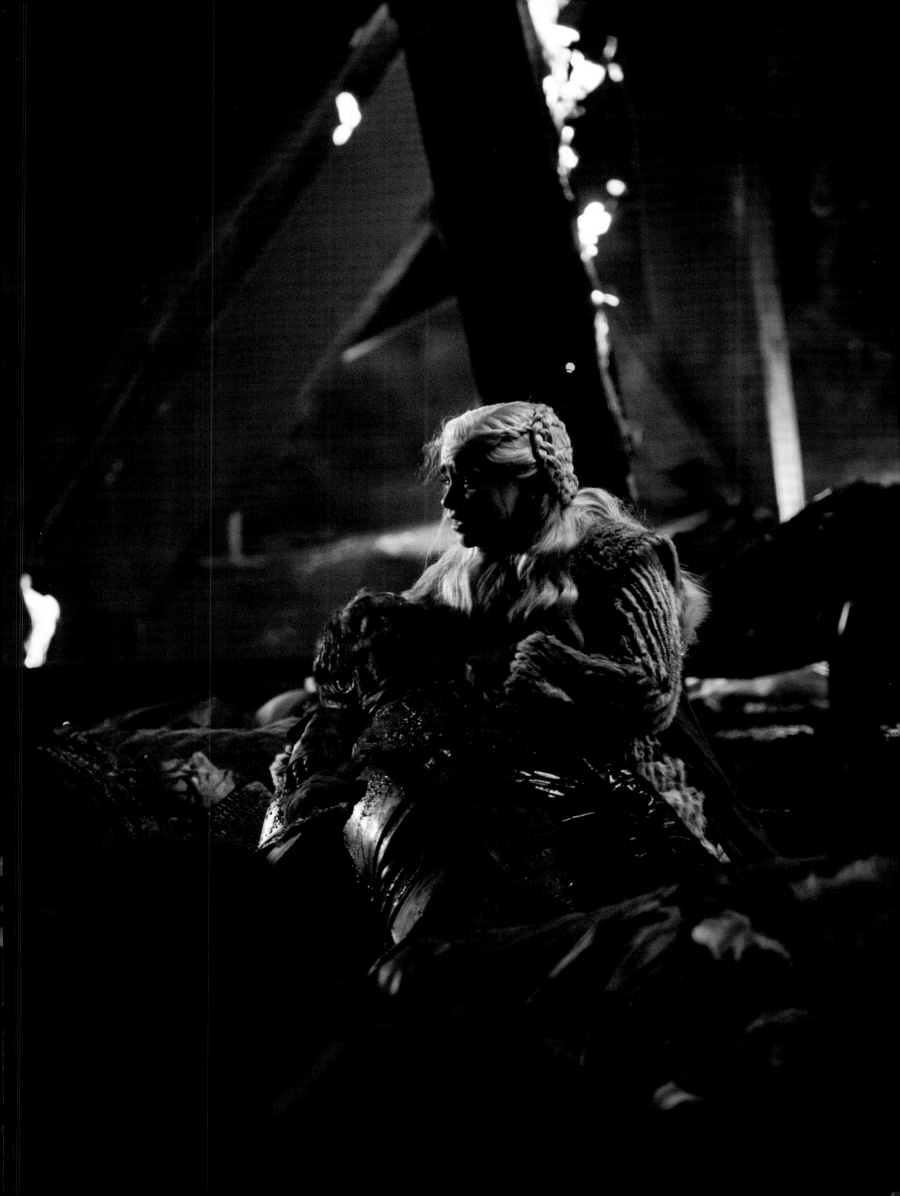

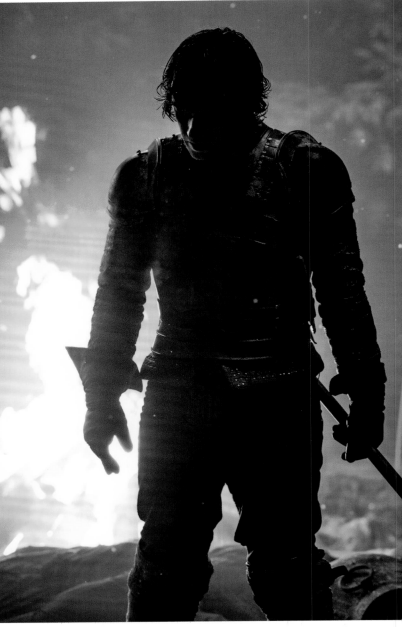

TOP LEFT: The Night King confronts Bran.

BOTTOM LEFT: Tyrion, Sansa, and the others hiding in the Winterfell crypts react at the end of the battle.

RIGHT: Theon Greyjoy finds redemption. Sloan says the Battle of Winterfell was the hardest shoot of the entire series—but the most emotional and satisfying episode to watch as a viewer. "Watching Theon die and get his redemption moment was incredibly sad."

OPPOSITE: Arya, moments before she kills the Night King.

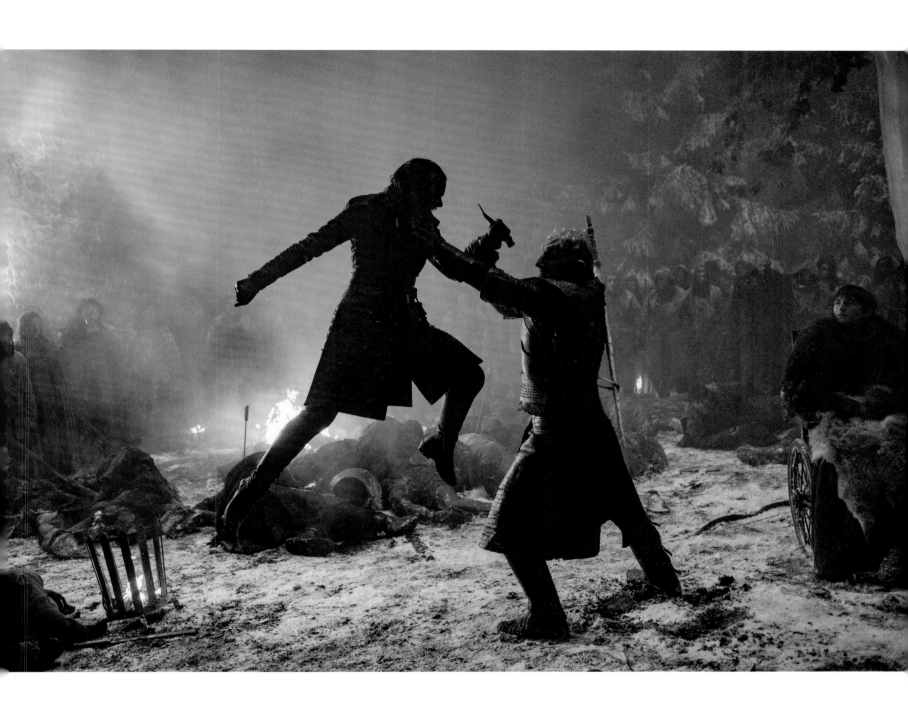

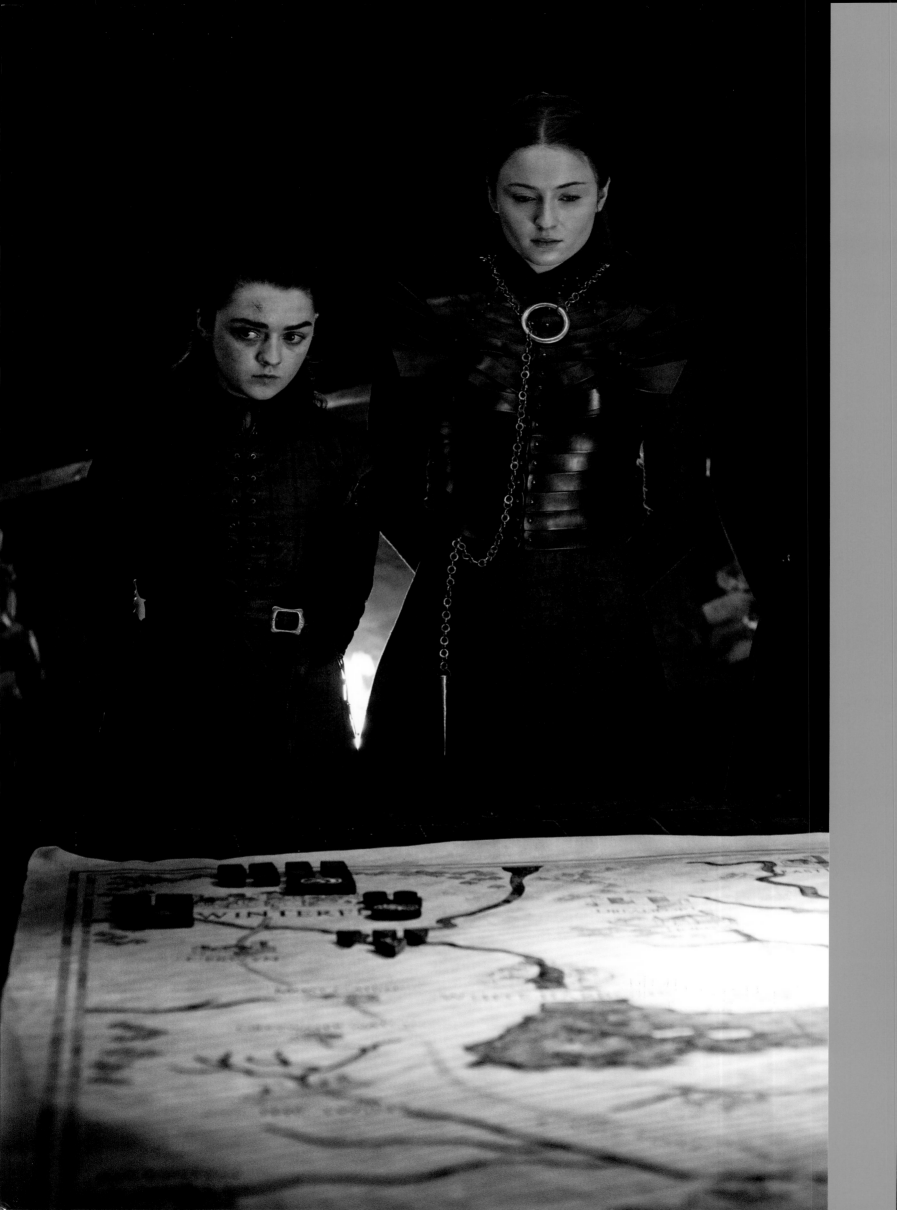

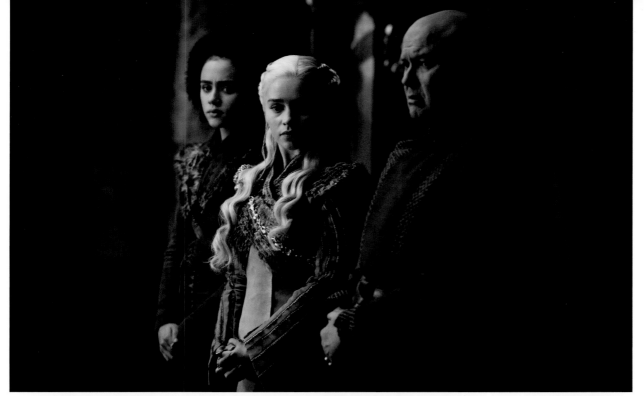

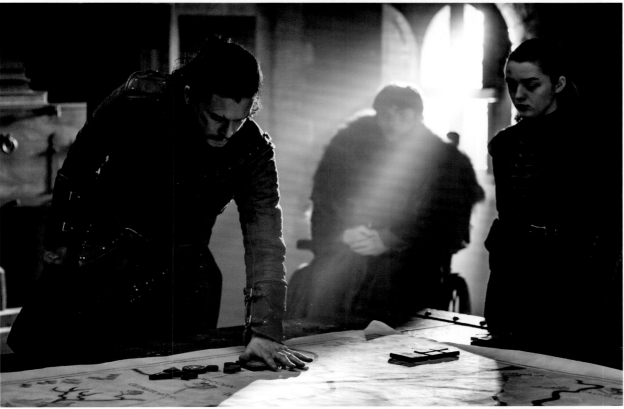

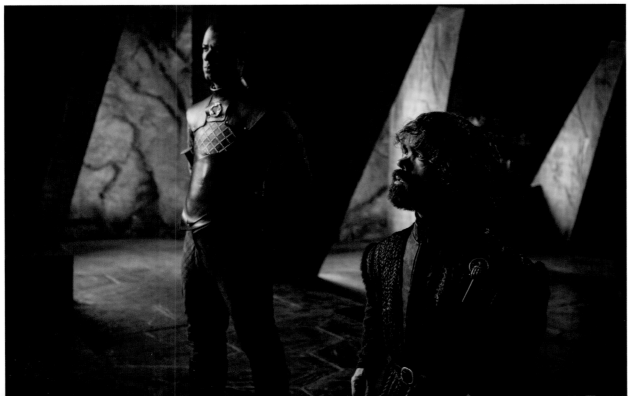

OPPOSITE: Arya and Sansa stand united for family and the North.

TOP: Daenerys flanked by Missandei and Varys as plans to invade King's Landing are devised.

CENTER: Jon discusses battle strategies with Arya and Bran.

BOTTOM AND PAGES 326–327: Daenerys's impatience with her Hand grows as Tyrion stands before his queen in the audience chamber at Dragonstone.

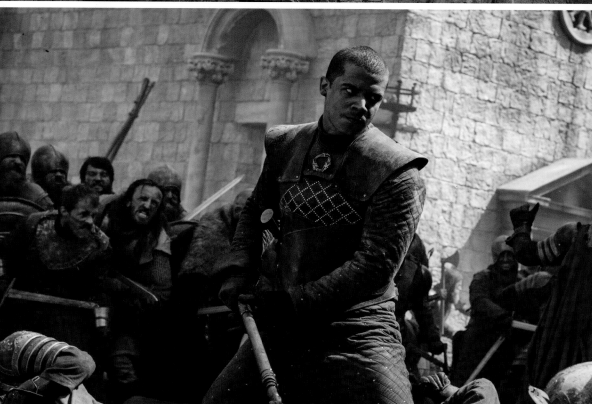

TOP: Tyrion attempts to parley with Cersei at the gates to King's Landing, at the cost of Missandei's life.
BOTTOM AND RIGHT: Grey Worm leads Daenerys's army alongside Jon Snow and Ser Davos Seaworth to lay claim to King's Landing and unseat Cersei.

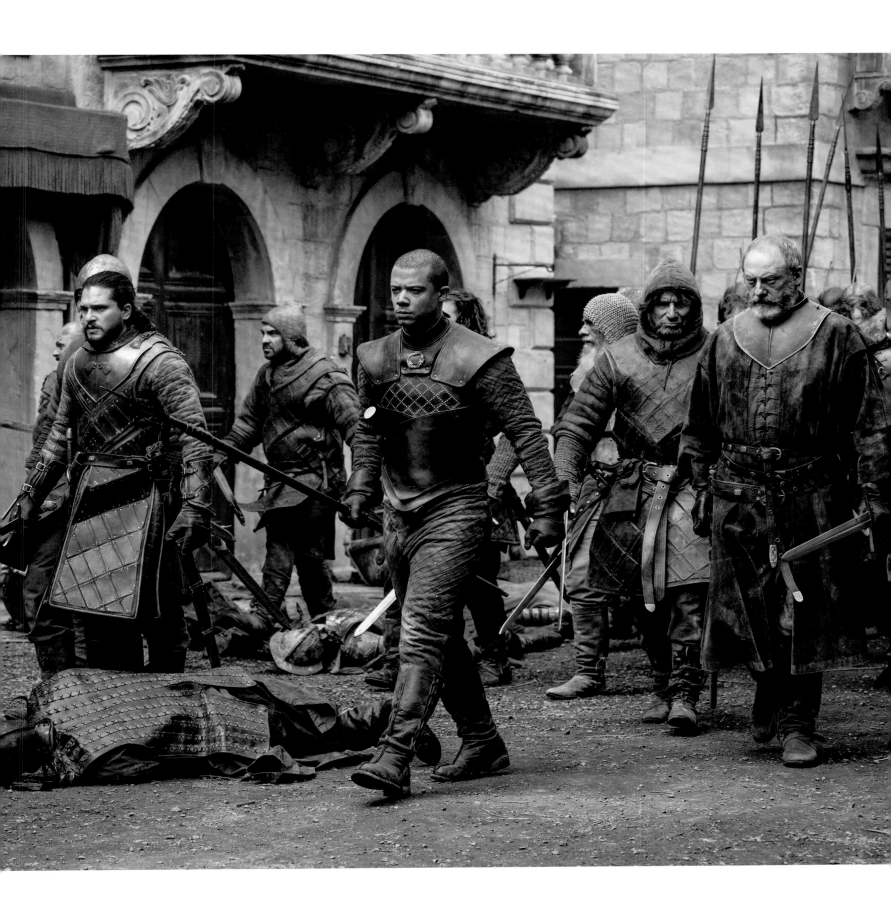

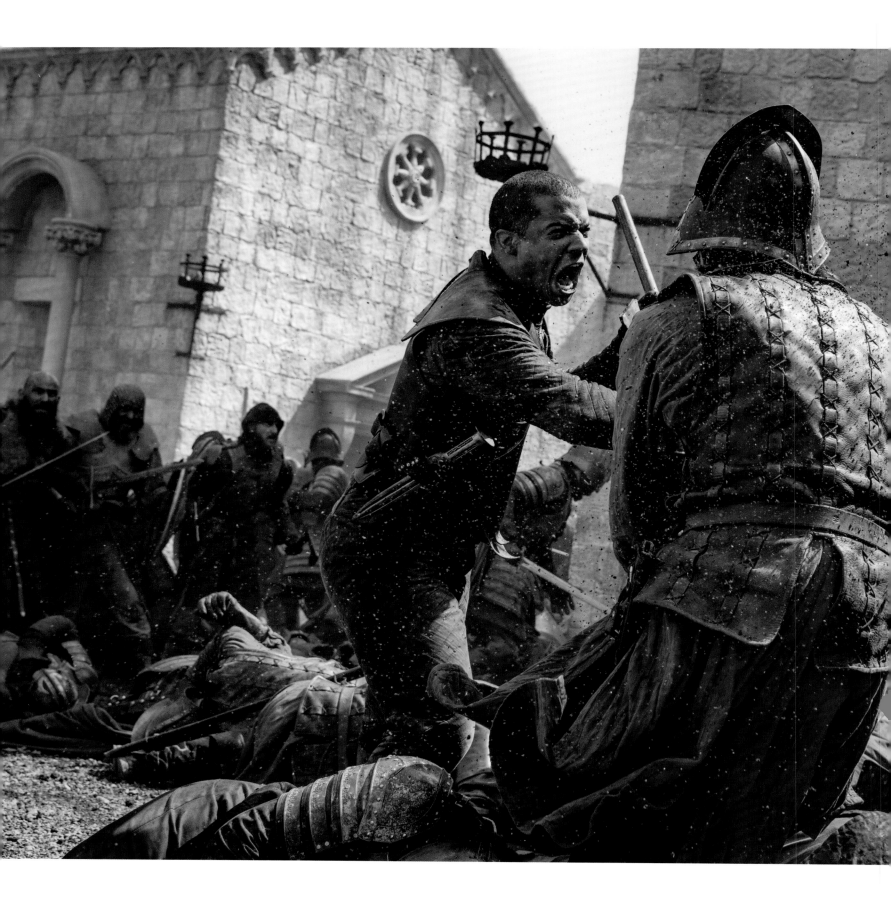

ABOVE: Grey Worm's thirst for vengeance overtakes him.

OPPOSITE: Jon and Ser Davos confront Grey Worm for executing prisoners. The King's Landing set had to be reconstructed on the studio back lot in Belfast to accommodate all of the destruction required to film Daenerys's rampage. "The fact that we had a castle—a whole city—in the car park was fascinating to me. You would walk around and you would be completely convinced you were back in Croatia (the main filming location for King's Landing) again."

PAGES 332—333: Tyrion surveys the devastation of King's Landing and realizes how wrong he was about Daenerys. The scenes in the series' penultimate episode when Daenerys destroys King's Landing involved the most smoke and fire Sloan had ever seen on any set. Warm weather in Belfast exacerbated the conditions. The Belfast King's Landing set is still standing, now overgrown with grass and wildflowers.

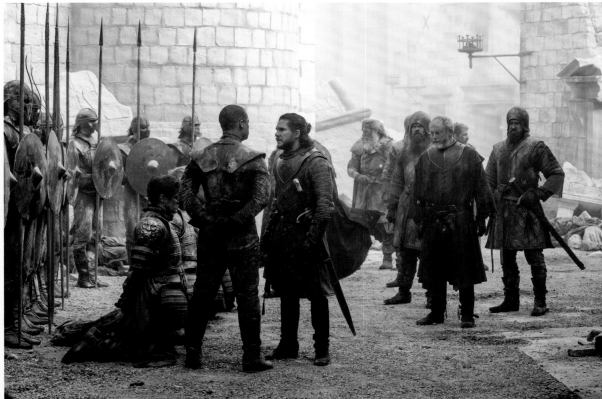
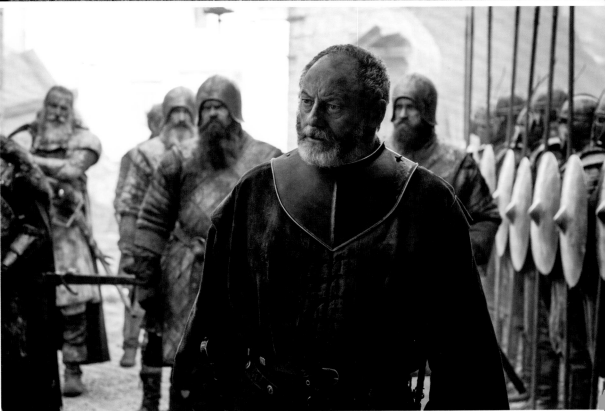

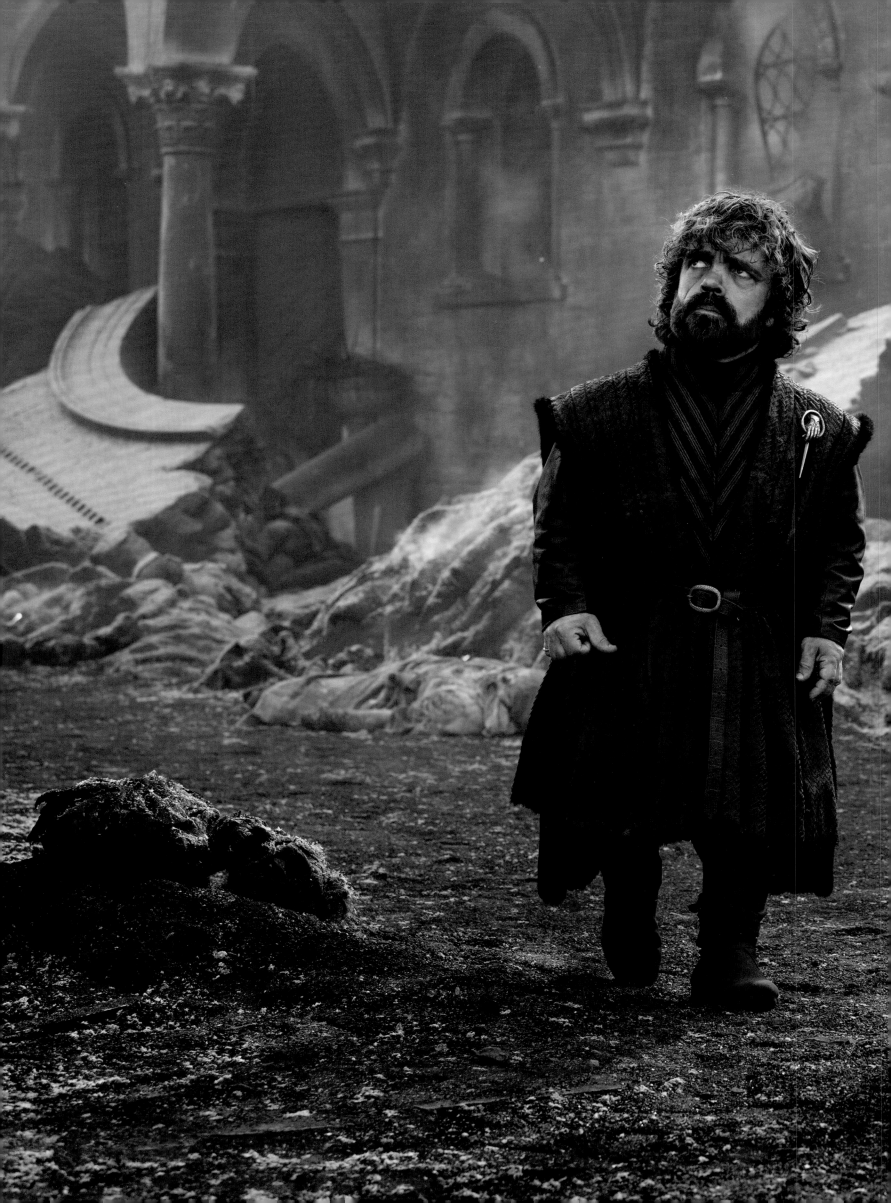

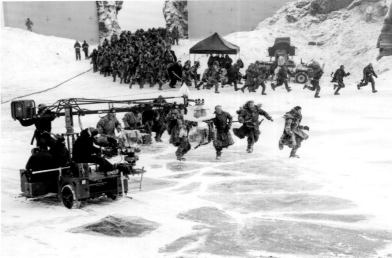

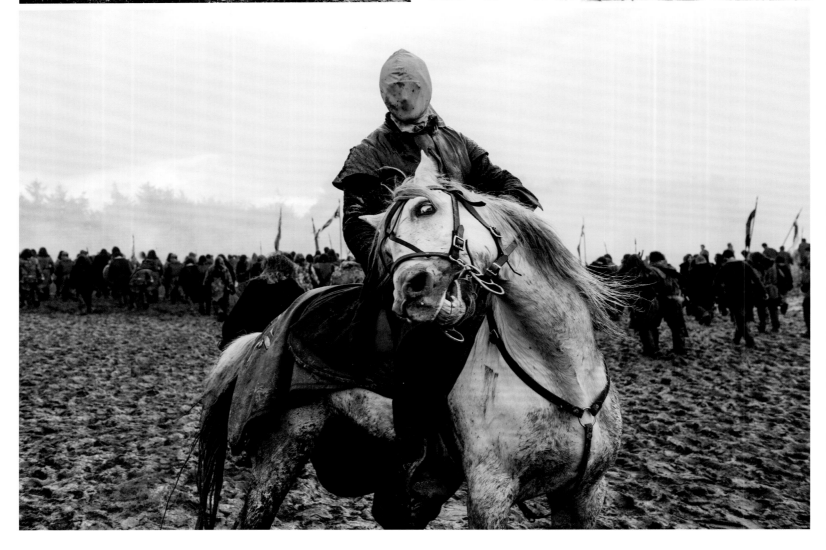

TOP LEFT: Filming during the battle at Hardhome.

TOP RIGHT: The members of the wight hunt run for their lives from a horde of extras and stunt people dressed as wights.

ABOVE: A headless horseman featured in the Battle of the Bastards.

OPPOSITE: Kit Harington lies in wait in between takes after his death in season six. Sloan says the producers tricked the crew at the end of that season, indicating that Kit Harington's time on the show was truly over. "The producers gave speeches, [writer and producer] Bryan Cogman gave a speech. I cried like a dummy and was hugging Kit Harington, saying, 'It was so nice working with you.' And then, of course, he came back."

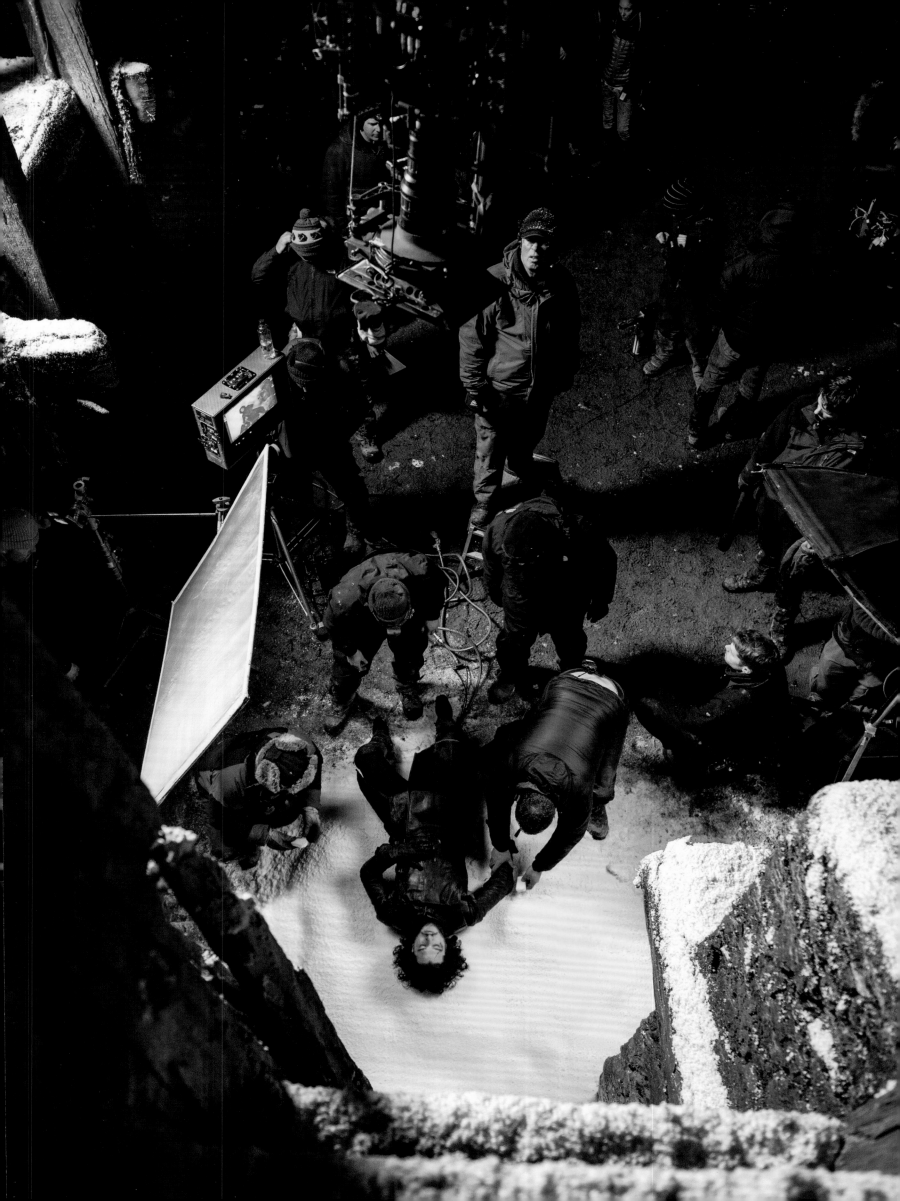

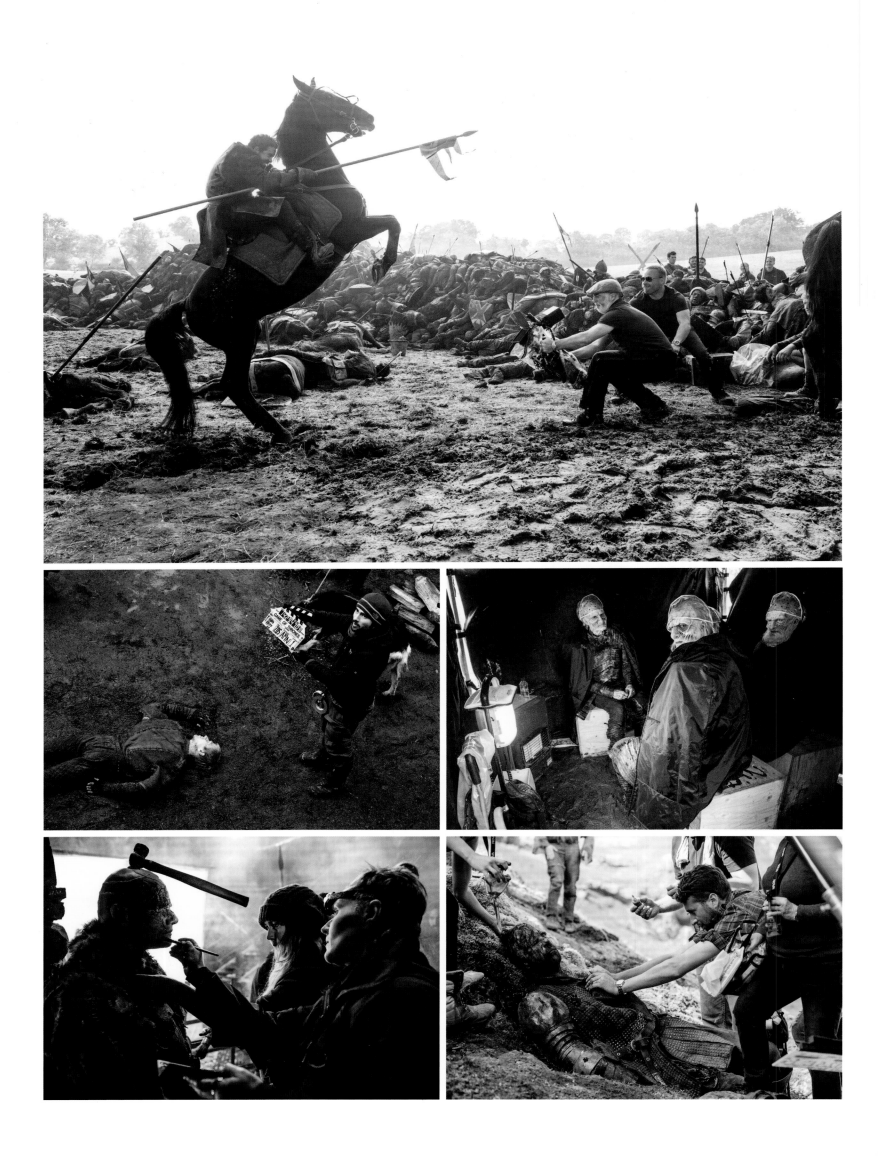

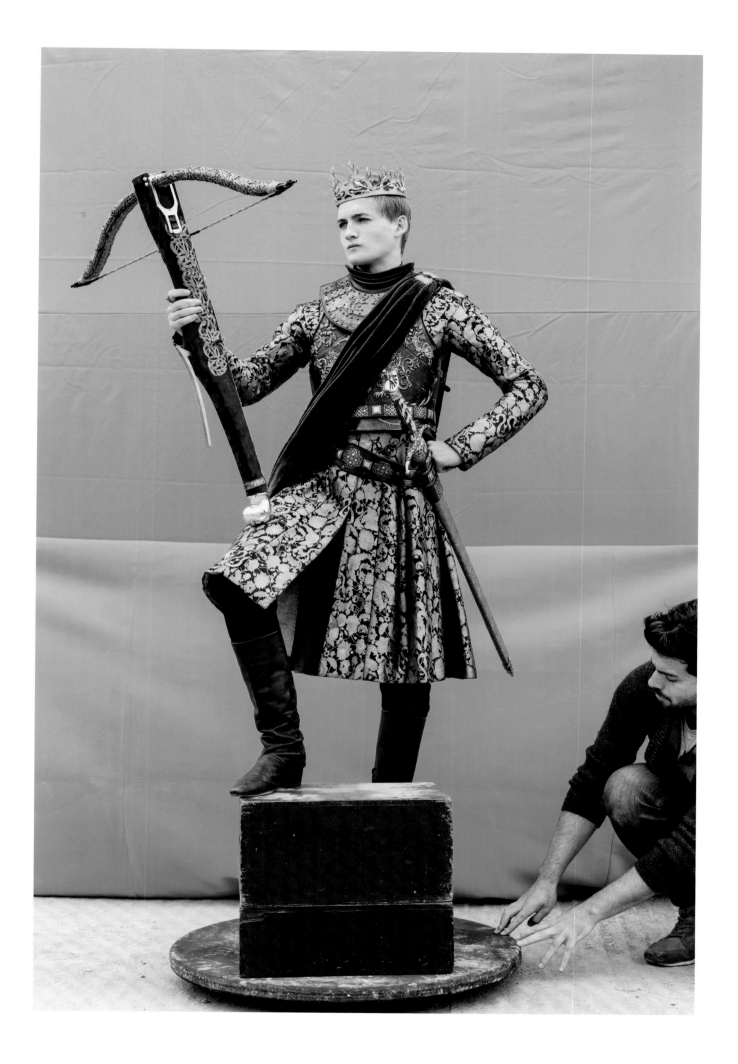

OPPOSITE: Crew members often had to get their hands dirty, as filming pivotal battle scenes saw them dealing with a lot of mud, blood, and rain.
ABOVE: Jack Gleeson as Joffrey poses for a reference image. When shooting characters for marketing or promotional images, Helen was always respectful of each actor's approach to getting into character. Helen Sloan notes, "I love it when actors can switch in and out. Particularly with Jack [Gleeson] in the studio, because he was such a chameleon. He went from this quiet, polite, mild-mannered guy into this monster in seconds, and the transformation just happened when he put on his crown. He became a total maniac."

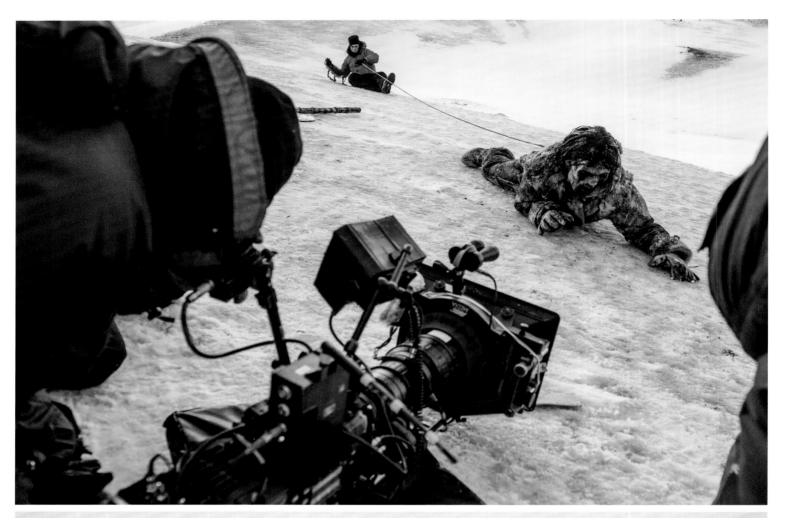

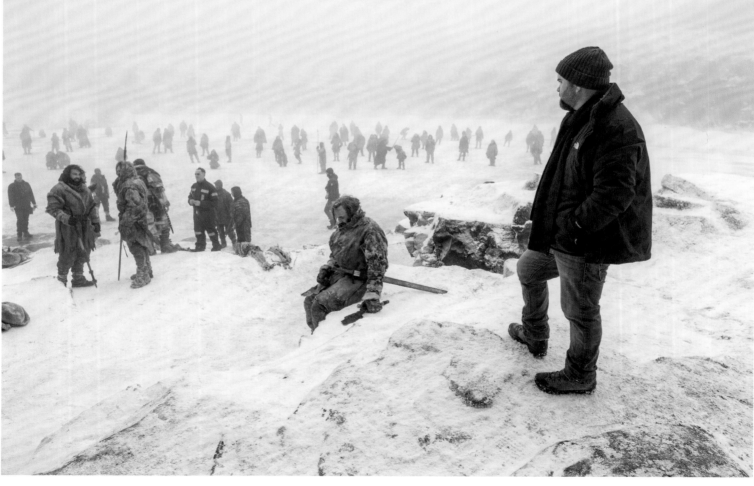

THIS PAGE: The cast and crew often endured cold and snowy conditions while filming.
OPPOSITE: Maisie Williams performing a stunt while filming.

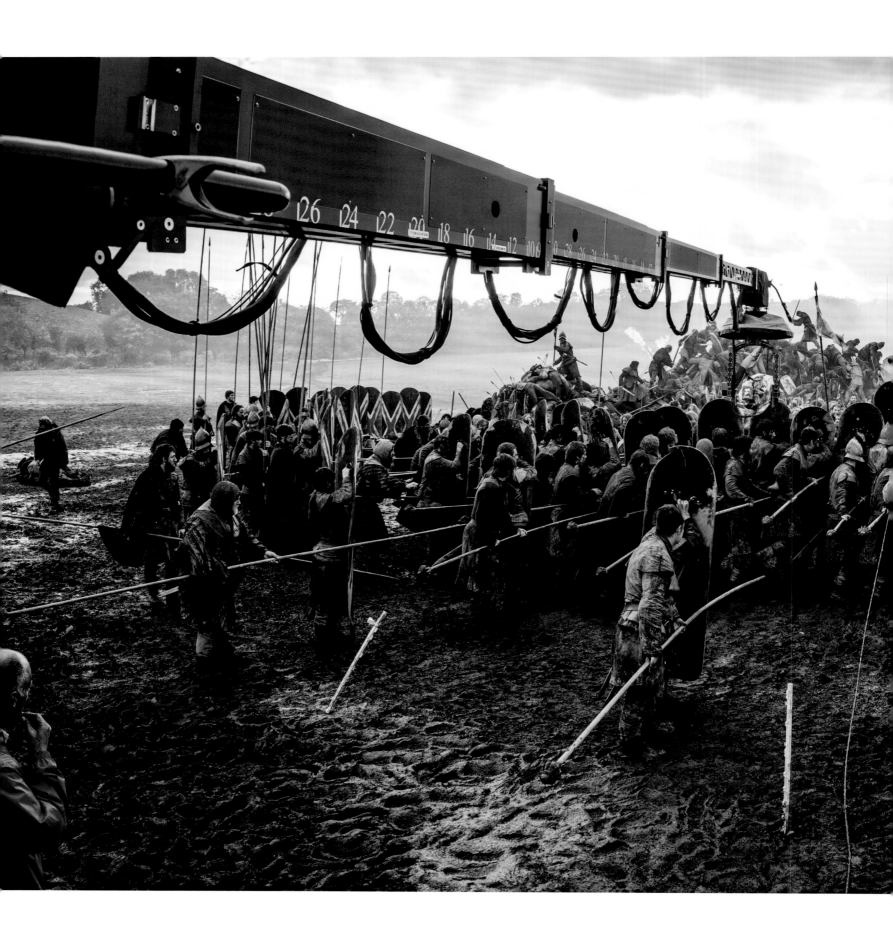

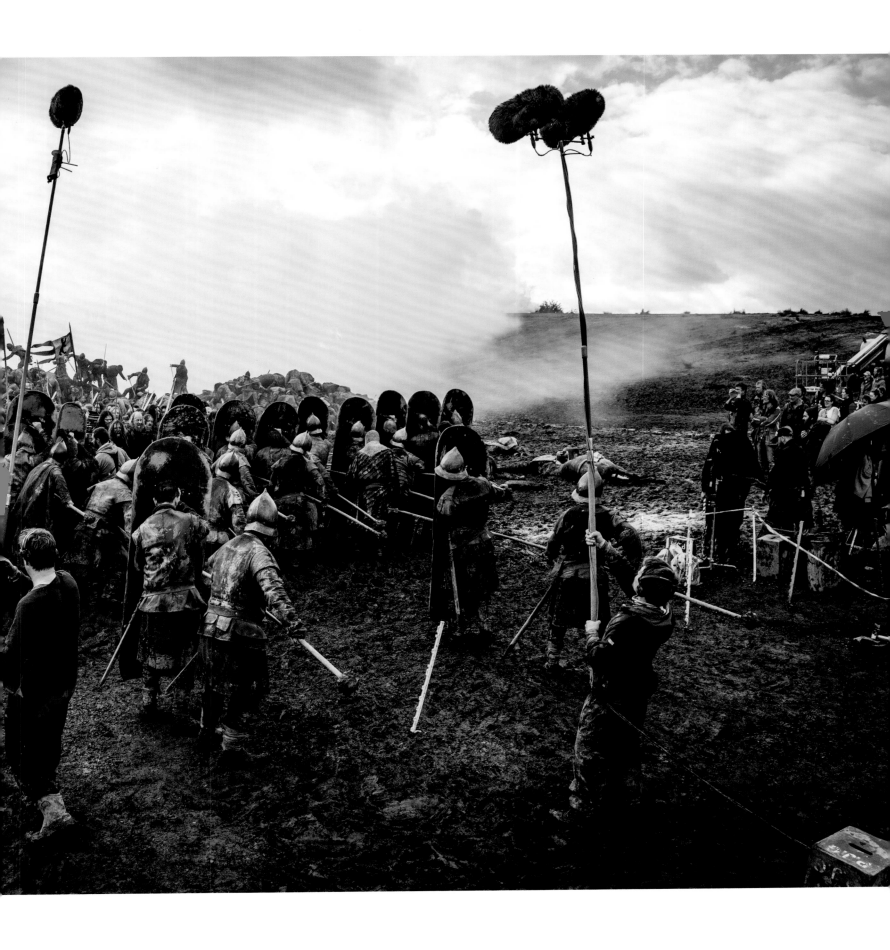

THESE PAGES: Filming the Battle of the Bastards.

341

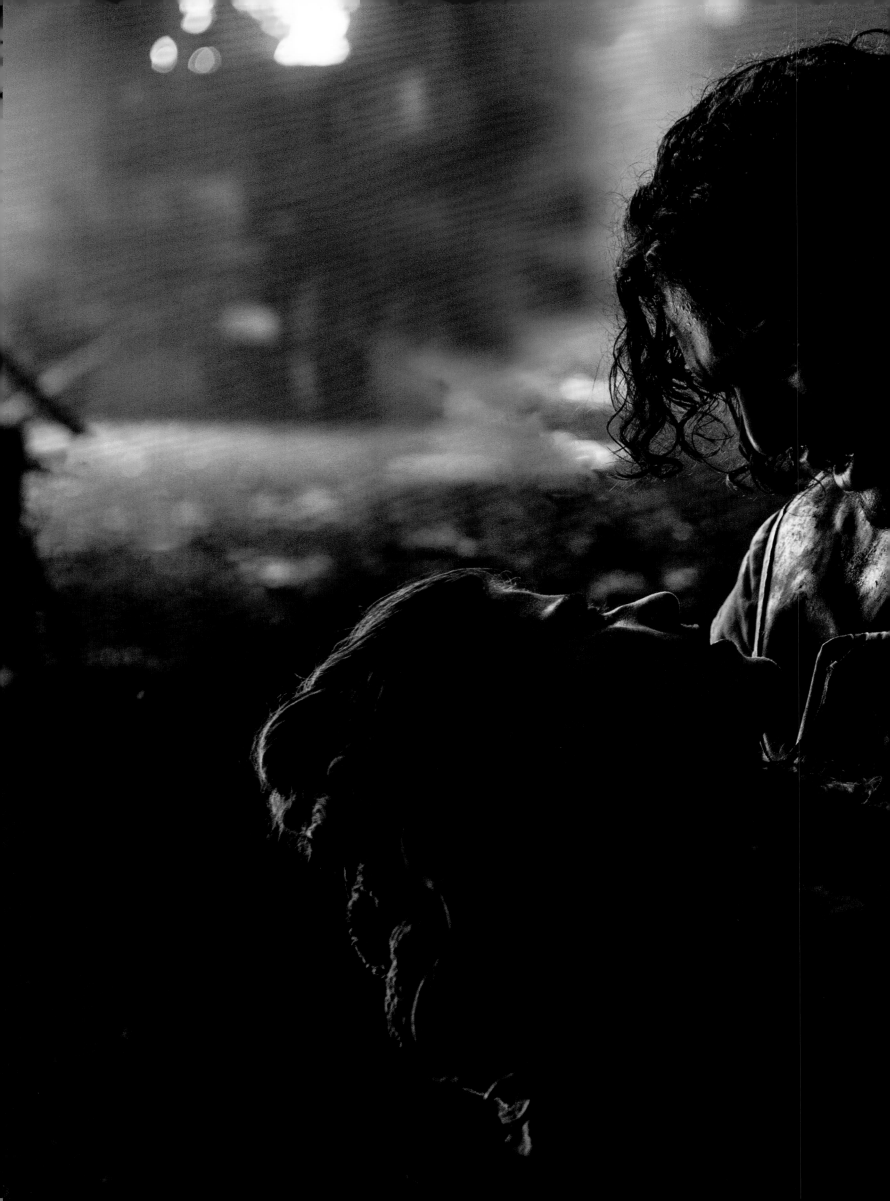

THE STRANGER

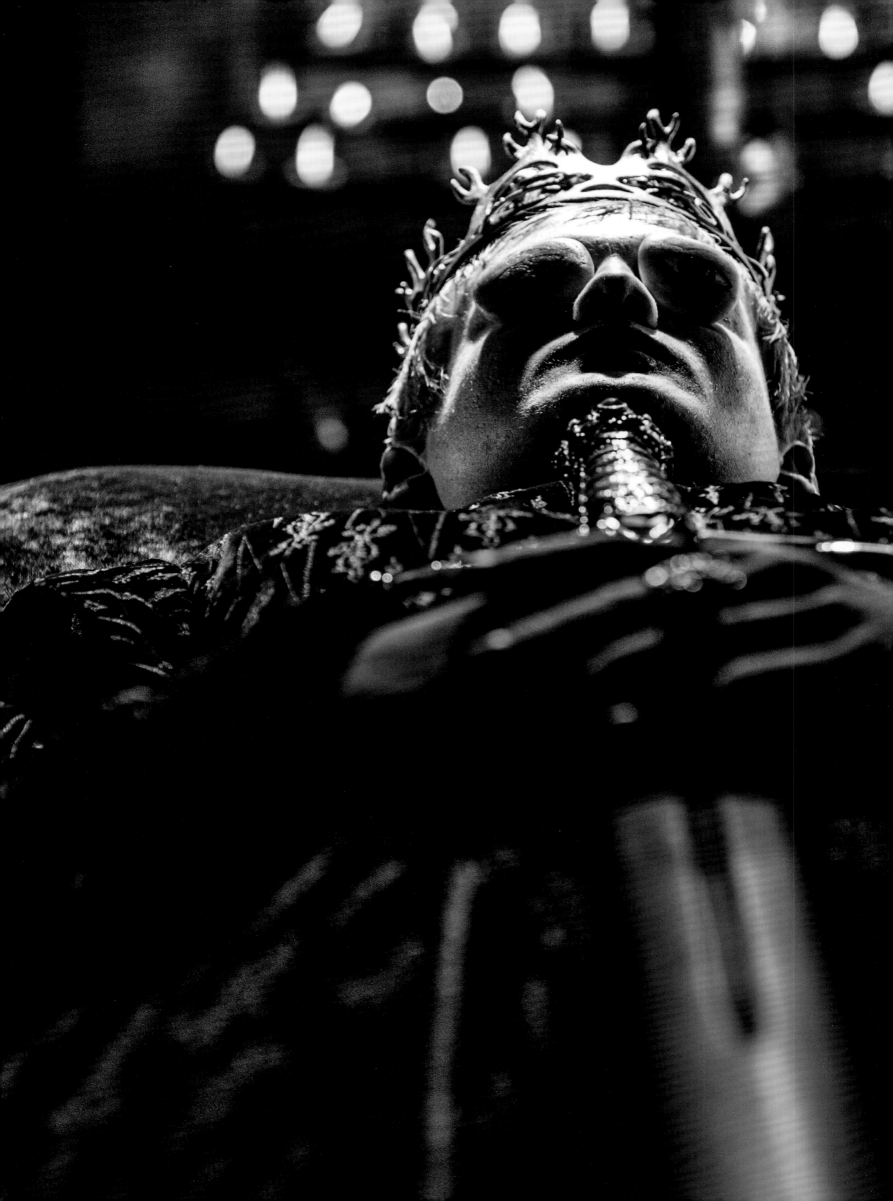

The Stranger represents the unknown and death.

Oaths may be sworn, alliances may be brokered, and promises may be made, yet such allegiances often last only as long as they are advantageous to both parties. The Stranger introduces risk and the unknown into people's lives. As soon as one party stops seeing a relationship as beneficial, they may end it abruptly—and often violently. Those betrayed are consoled only by the thought of retaliation. They may lurk in the shadows for years, whetting their appetite by devising the most meticulous and wicked of plans as they wait for the perfect moment to exact their revenge. Thus betrayal begets betrayal, spurring a cycle of distrust and violence that is passed down for generations.

Deceit is the usual means of betrayal. Accomplished liars like Petyr Baelish draw out their deceptions over an extended period of time, couching their intentions in half-truths and hiding behind seemingly altruistic acts so that their lies go unnoticed until it's too late. Baelish manipulates Sansa Stark in this fashion, professing concern for her safety and even declaring his love for her, all the while subjecting her to unspeakable evils. Though Baelish may feel real tenderness and desire for Sansa, his is a warped sort of love, distorted by his feelings for Sansa's late mother, Catelyn. Nevertheless, his deception rings true because his affections have a grain of truth, yet he never lets those affections block him from his ultimate goal: seizing power. What Baelish doesn't anticipate is that Sansa, having learned his tricks of the trade, manipulates the master manipulator in a deception of her own, which costs him both his dream and his life.

Some treacheries aren't protracted plans that beguile their victims, but rather hurried, heinous acts that shatter time-honored customs. Lord Walder Frey invites Robb Stark and his family to House Frey for his daughter's wedding, then has Roose Bolton, his sons, and his soldiers murder Robb; his mother, Catelyn; his new wife, Talisa; and their unborn baby at the celebration. Jon Snow faces the same bloody betrayal when a gang of his brothers in the Night's Watch denounce him as a traitor and stab him to death for letting their mortal enemies, the wildlings, past the Wall into the Seven Kingdoms. Even the kinship between parent and child can leave one with a sense of the unknown, as when Stannis Baratheon betrays his own daughter. These events exemplify the terrible ways some characters choose to betray their former allies, their leaders, and their children. No one can be trusted when power is at stake.

But those who dare deceive others must watch their own backs, where avenging angels are known to tread. Foremost among these avengers is Arya Stark, who has been trained in the art of assassination. She kills not for recompense but for vindication, going down a list of all who have wronged the Stark family or those she cares about. Revenge is her fuel, keeping her alive for many difficult years after she flees King's Landing.

The betrayals seen in *Game of Thrones* provide some of the most shocking and thrilling moments of the show. When asked about these pivotal sequences, Sloan notes, "People always ask me, do you read the books? I never read the books because I always wanted to be current with our season. I felt like if I knew what was going to become of Arya—how she changed from when she was a little girl—or if I knew that Sansa was going to become Dark Sansa, I would have shot them in a different way at the beginning. I want to see a character within the expression of the scene and the season, so what I shoot matches their role in the story.

"There are certain photographic techniques you can use to change the mood of a scene or the impression of a character. Cinematographers do it constantly by changing the lighting or the camera angle. Even the most simple scene of shooting a character from down below when they're standing in front of the throne, it gives them a sense of power, that they're larger than you, that you're beneath them. Those cinematic tricks can change how the viewer feels about a character and can make a character appear menacing or sweet. But I didn't want to use any of these tricks that would make you think that a character was anything other than what you were meant to think they were at that moment in the story.

"When you're a movie stills photographer, you don't only copy the cinematographer's shot. Of course, in the first instance, you use the cinematographer's frame and record the scene. But from then on, you manipulate the frame and capture additional moments and framing, then turn to documenting behind the story through your own photography."

PAGES 342–343: Ygritte dies in Jon's arms.
OPPOSITE: Joffrey lies in state in the Red Keep's sept.

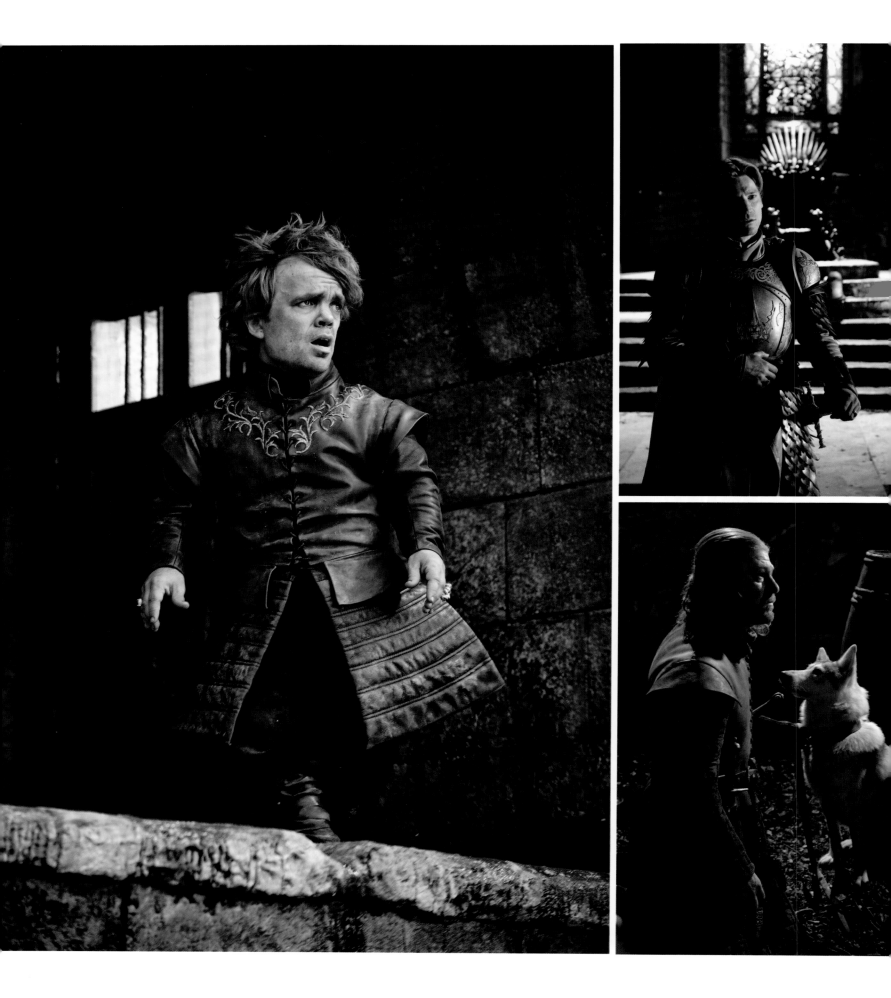

THIS PAGE: (*clockwise from left*) Peter Dinklage as Tyrion in one of the Eyrie's sky cells; Jaime Lannister of the Kingsguard; Ned Stark with Sansa's direwolf, Lady.
OPPOSITE LEFT: Yoren, the Night's Watch recruiter, protects Arya and shields her from witnessing her father's execution in King's Landing.
OPPOSITE TOP RIGHT: Arya beneath the statue of Baelor as Ned Stark is led forward.
OPPOSITE BOTTOM RIGHT: Ned Stark's execution. The scene, filmed in Malta, was one of the first that took the crew outside of Northern Ireland for a significant amount of time. "The extras were shouting their heads off. It all felt really tense and real," she says. "Maisie did that amazing performance, Francis [Magee] was protecting her. It was really moving and frantic, and the crew in Malta were wonderful. As I was capturing pictures, I was thinking to myself, 'People are going to lose their [expletive] over this. People are going to be angry about this. Because a lot happens in the first season.'"

346

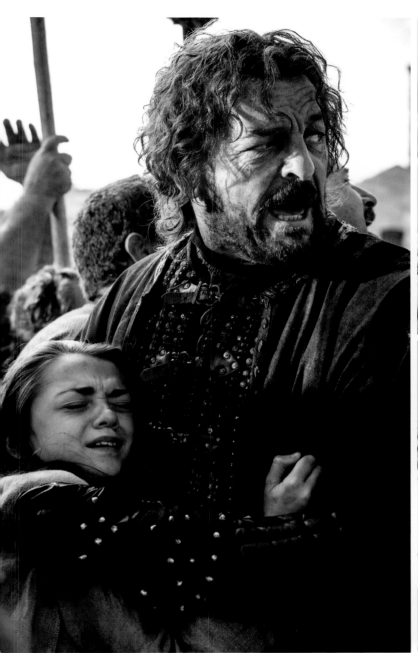

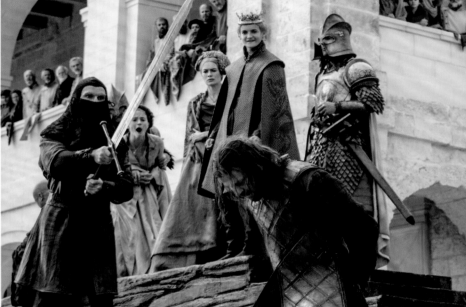

"My mother wishes me to let Lord Eddard join the Night's Watch. Stripped of all titles and powers, he would serve the realm in permanent exile. And my lady Sansa has begged mercy for her father. But they have the soft hearts of women. So long as I am your king, treason shall never go unpunished. Ser Ilyn. Bring me his head." —*Joffrey Baratheon*

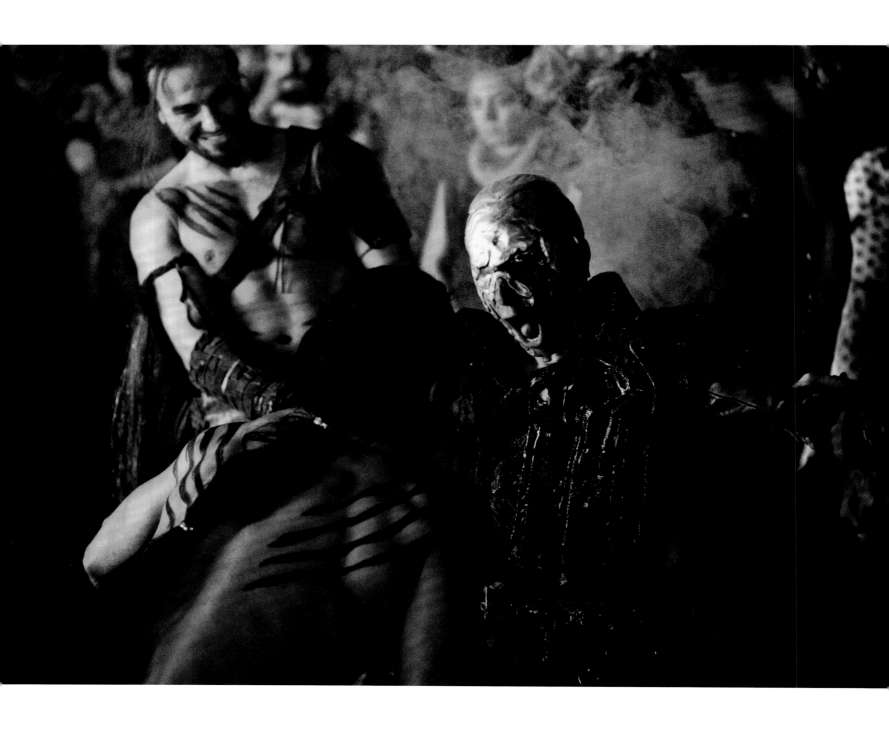

ABOVE: Viserys earns a deadly crown of melted gold.

OPPOSITE LEFT AND TOP RIGHT: Daenerys cares for a catatonic Khal Drogo.

OPPOSITE BOTTOM RIGHT: Ned Stark holds the Valyrian steel dagger used to try to kill Bran—and ultimately used to kill the Night King in the final season.

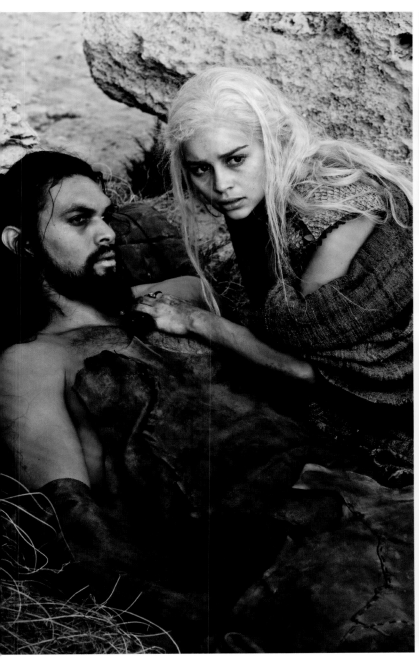
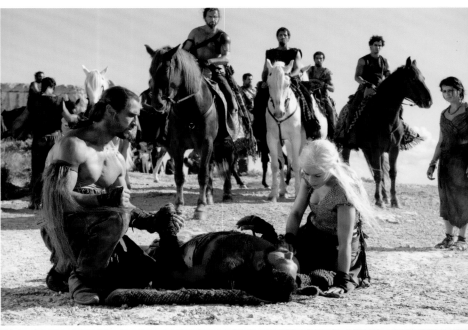
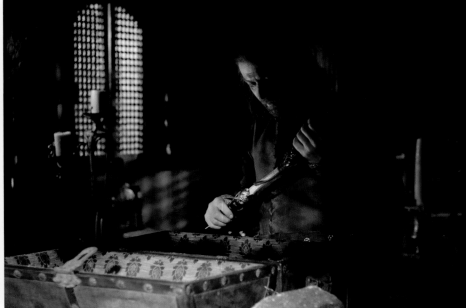

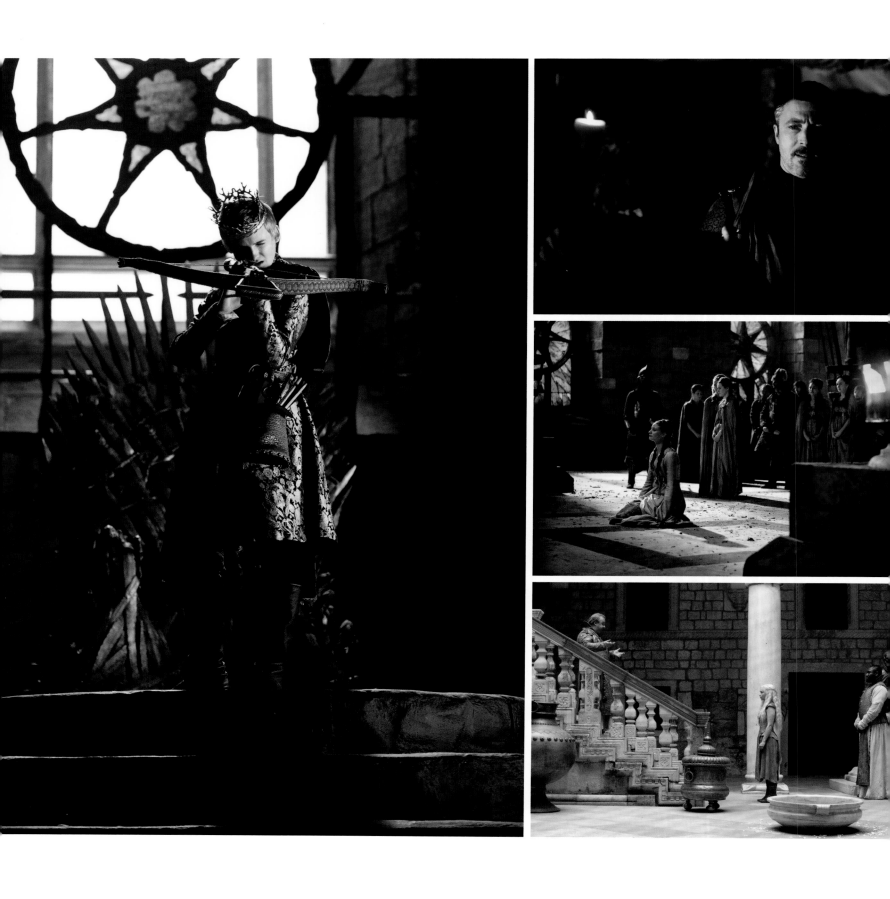

THIS PAGE: Joffrey torments Sansa (*left*); Littlefinger plots (*top right*); Sansa pleads with Joffrey (*center right*); Daenerys seeks aid in Qarth (*bottom right*).

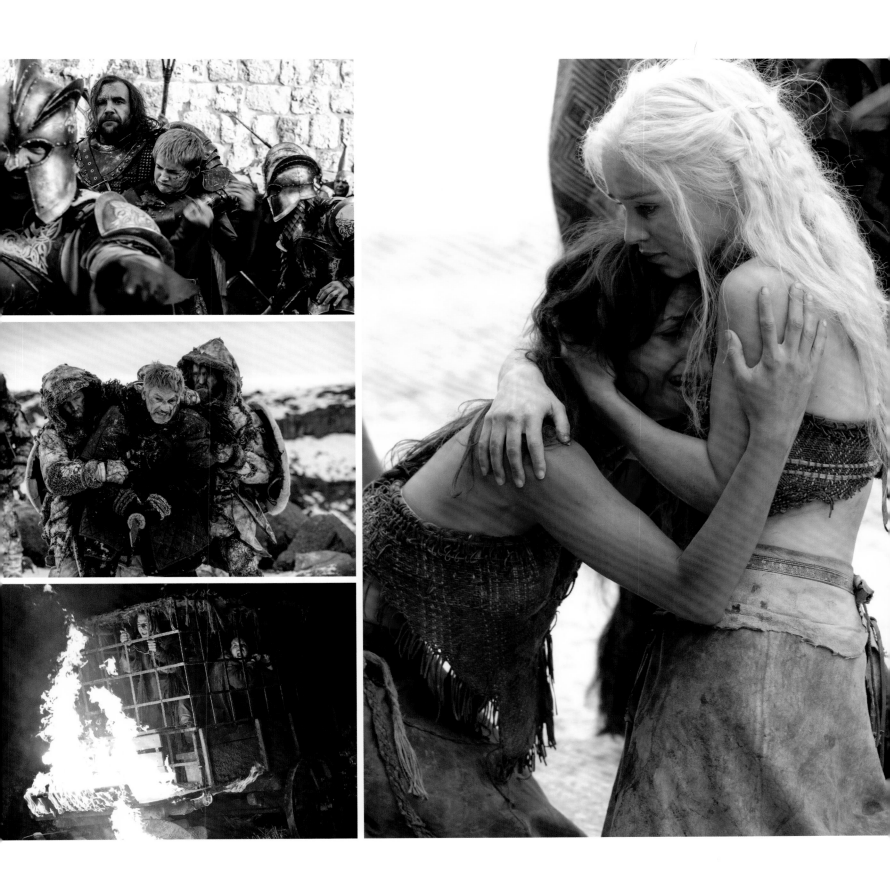

351

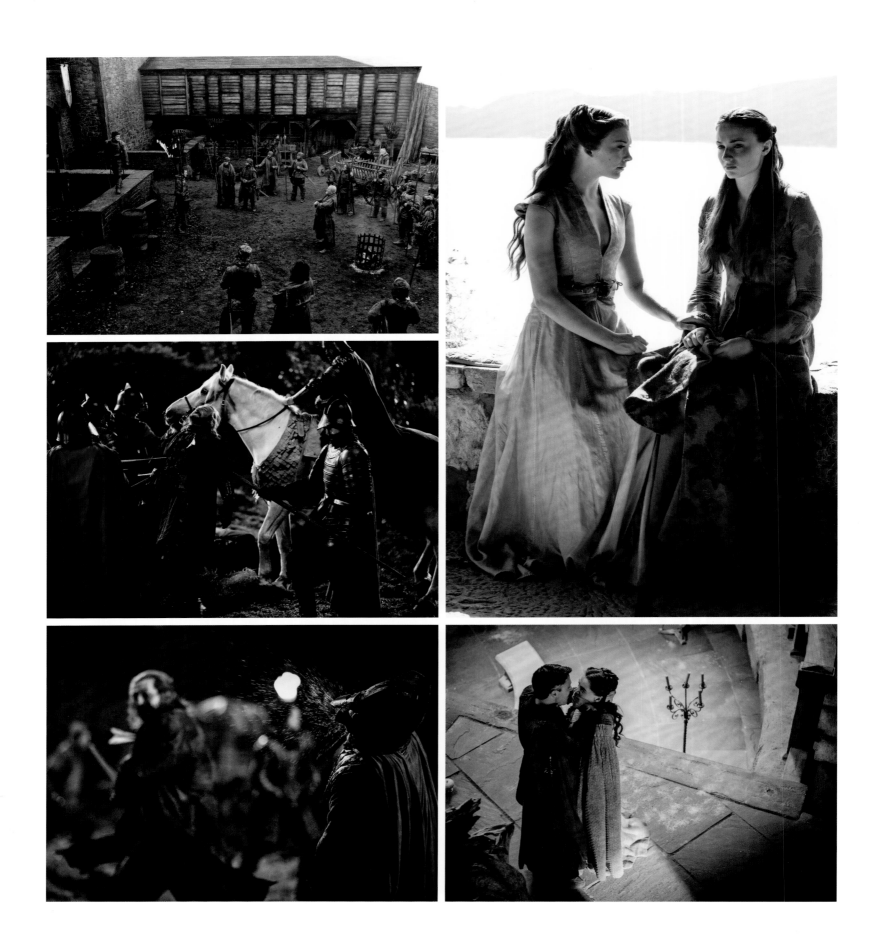

THIS PAGE: (*clockwise from top left*) Theon's speech to the ironborn falls flat; Margaery and Sansa share a moment; Littlefinger and Lysa's collusion is revealed; Yoren puts up a valiant fight against Lannister soldiers but ultimately dies. Sloan notes that on a show like *Game of Thrones* with big battles, you have to be aware of the choreography of the fighting by watching the actors and stunt people in rehearsals. There's an exact moment when the fake blood explosion happens, so Sloan is often just looking out of the corner of her eye to see a hand on a switch to know when that moment is. Stills photography requires being present and knowing the timing to get the punches and smacks. "Because if you mistime it, you could get the wrong moment and ruin the magic," she says.

OPPOSITE: Theon's torture by Ramsay begins. Sloan counts this as one of her favorite photos she's ever taken.

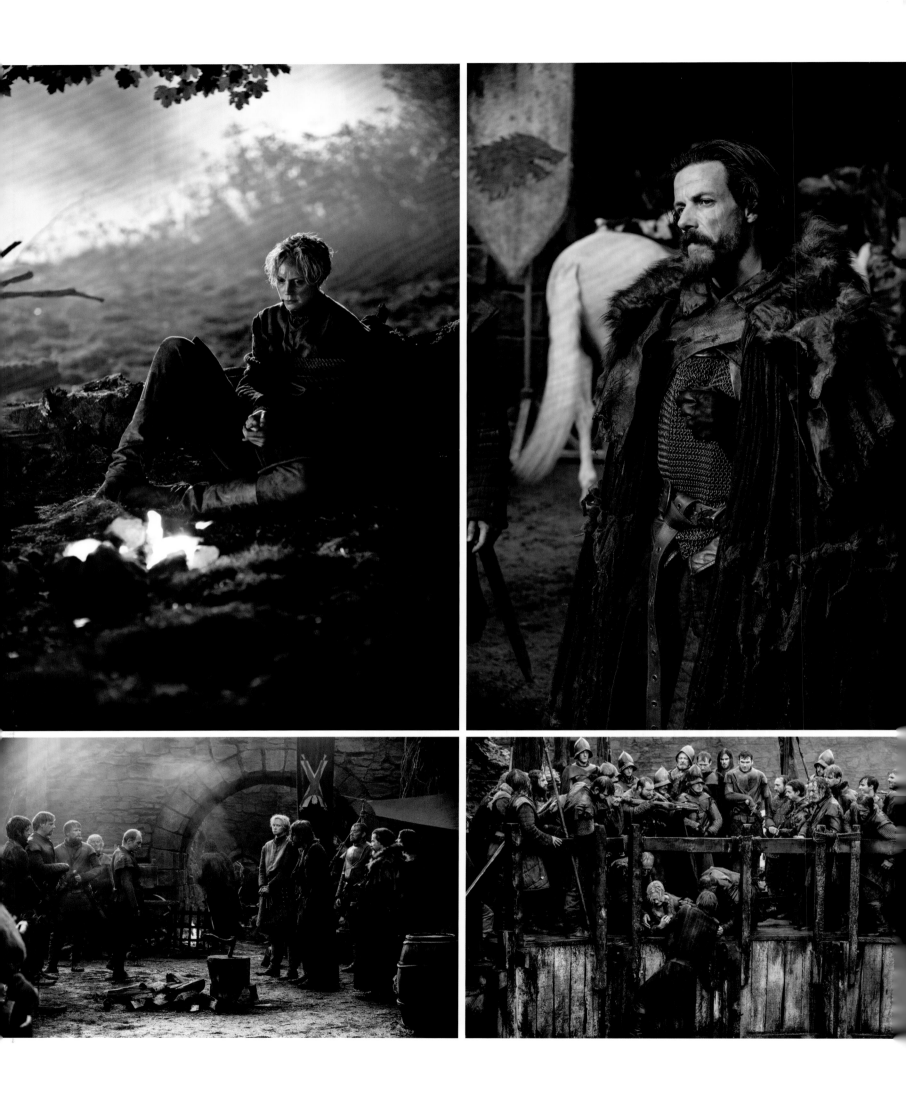

THIS PAGE: Brienne and Jaime are captured by Locke of House Bolton and brought to Harrenhal, where Jaime loses his sword hand and Brienne is made to fight a live bear.

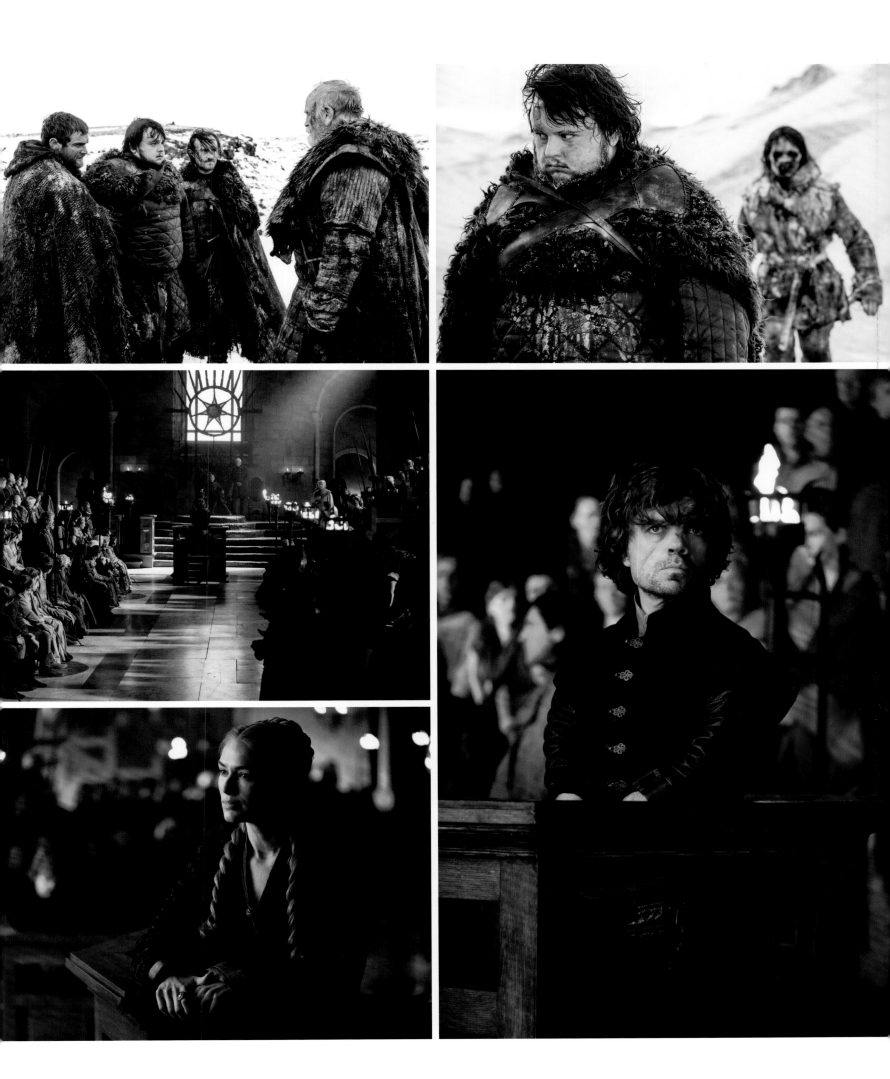

TOP ROW: Samwell Tarly of the Night's Watch.
CENTER LEFT, BOTTOM LEFT, AND RIGHT: The trial of Tyrion Lannister.

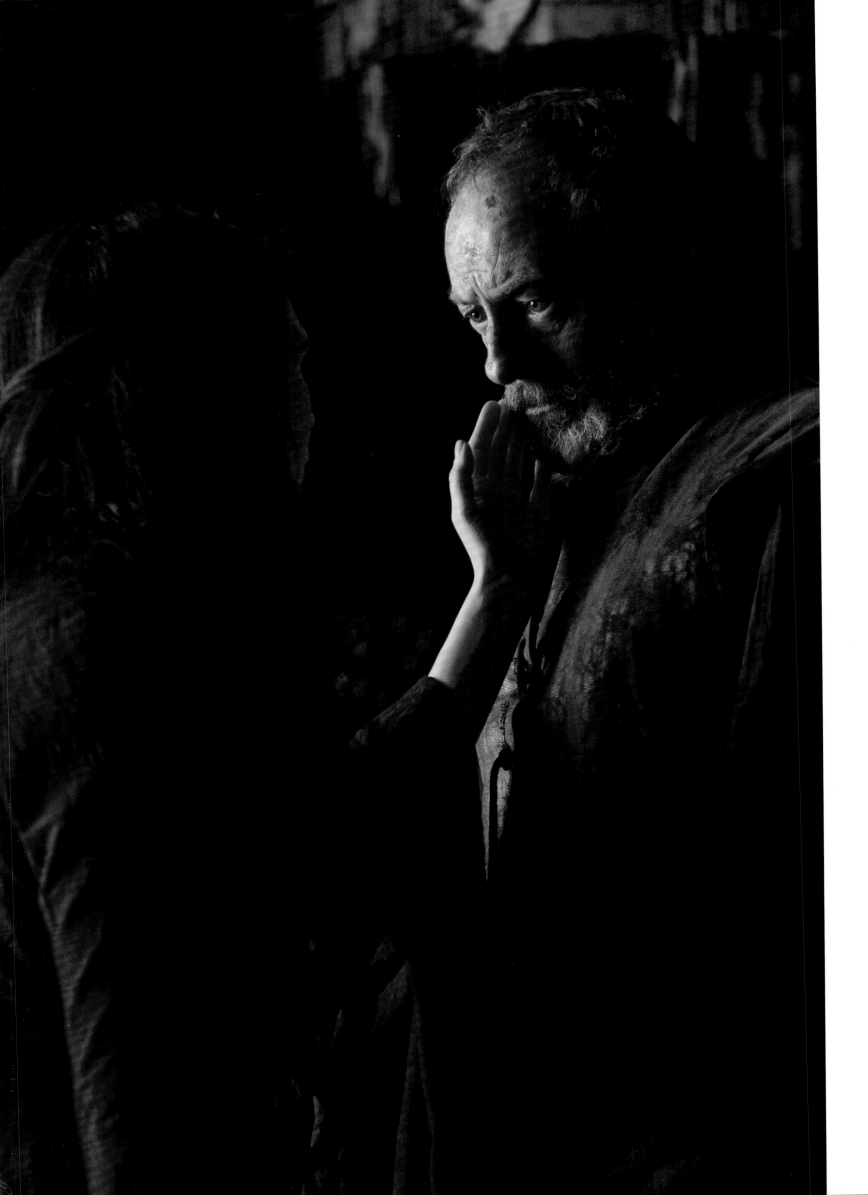

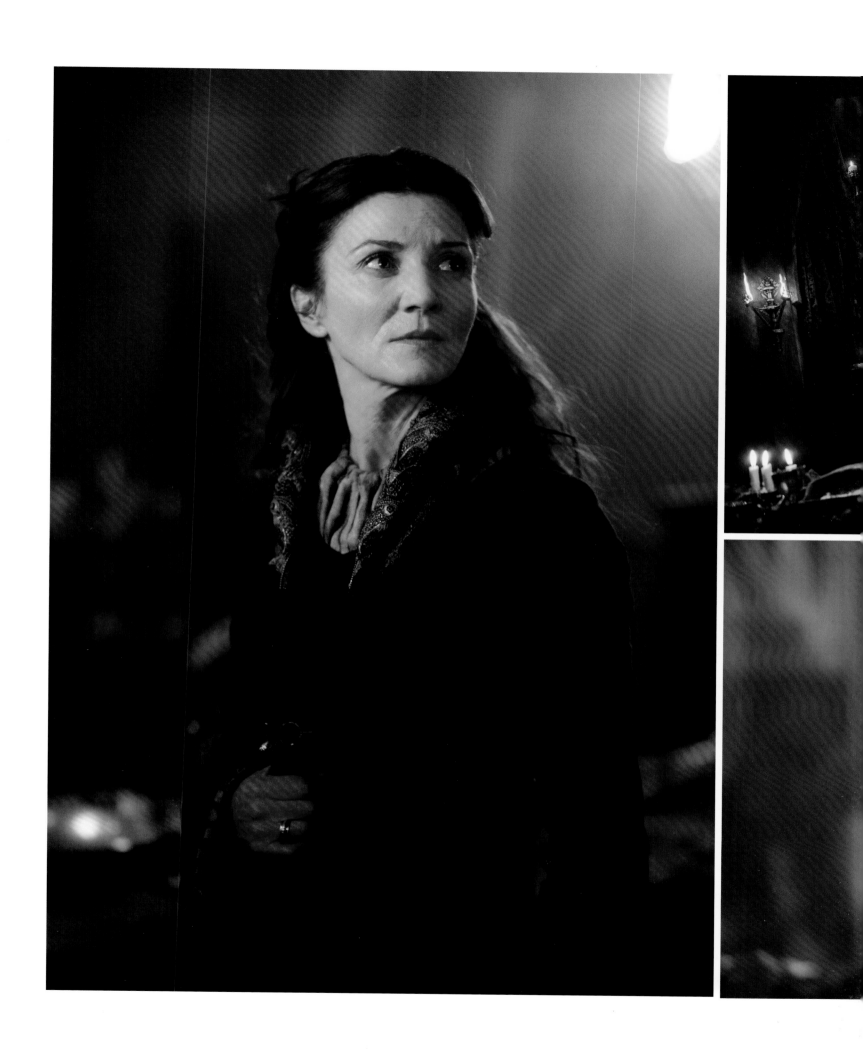

THESE PAGES: The betrayal and massacre of House Stark at the Red Wedding.

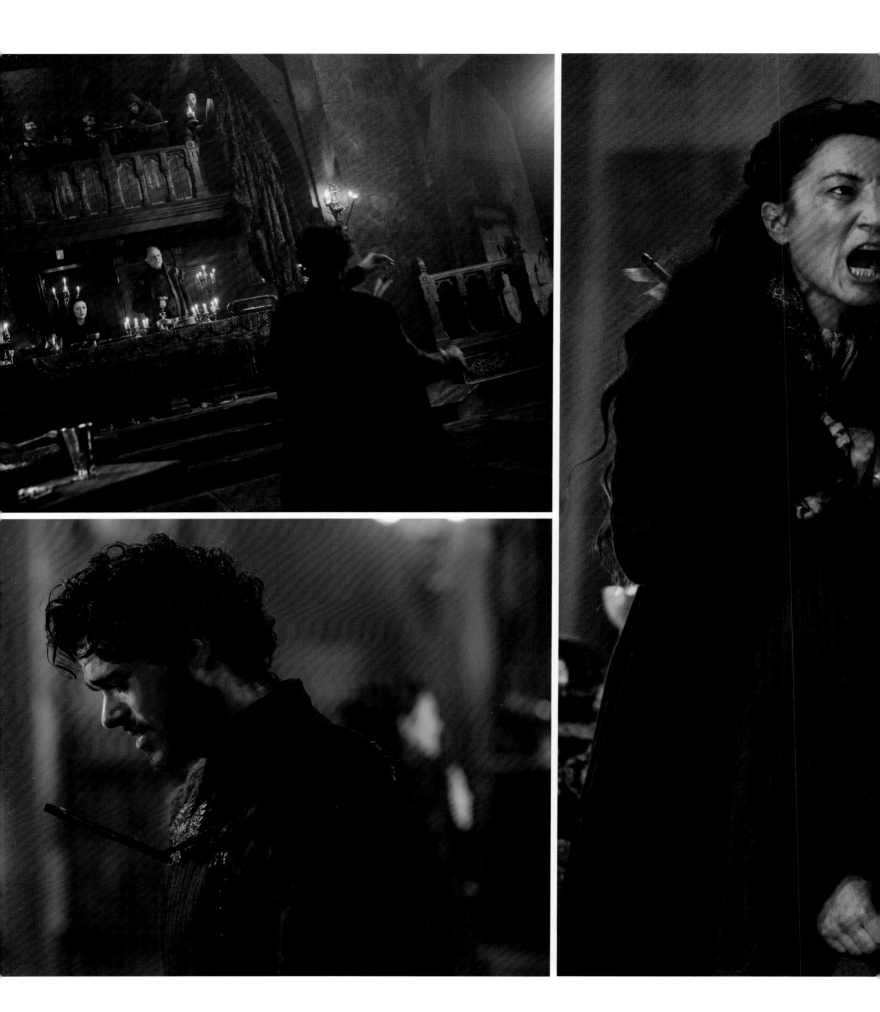

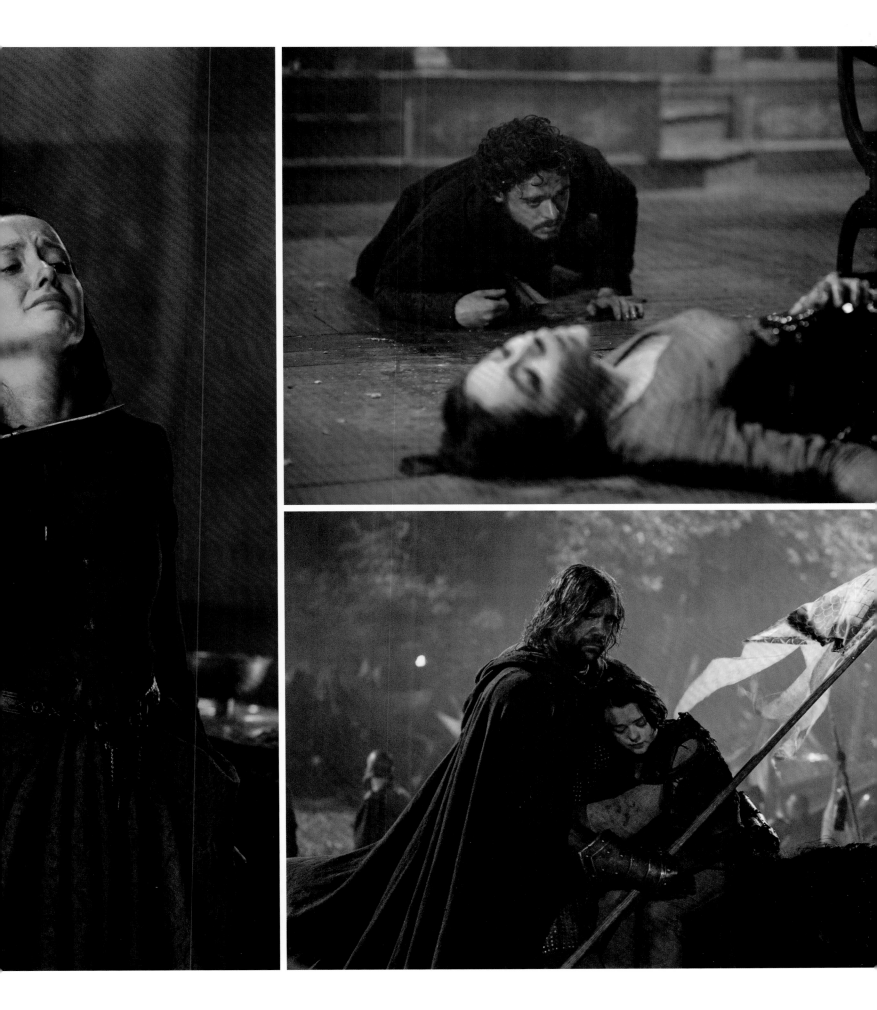

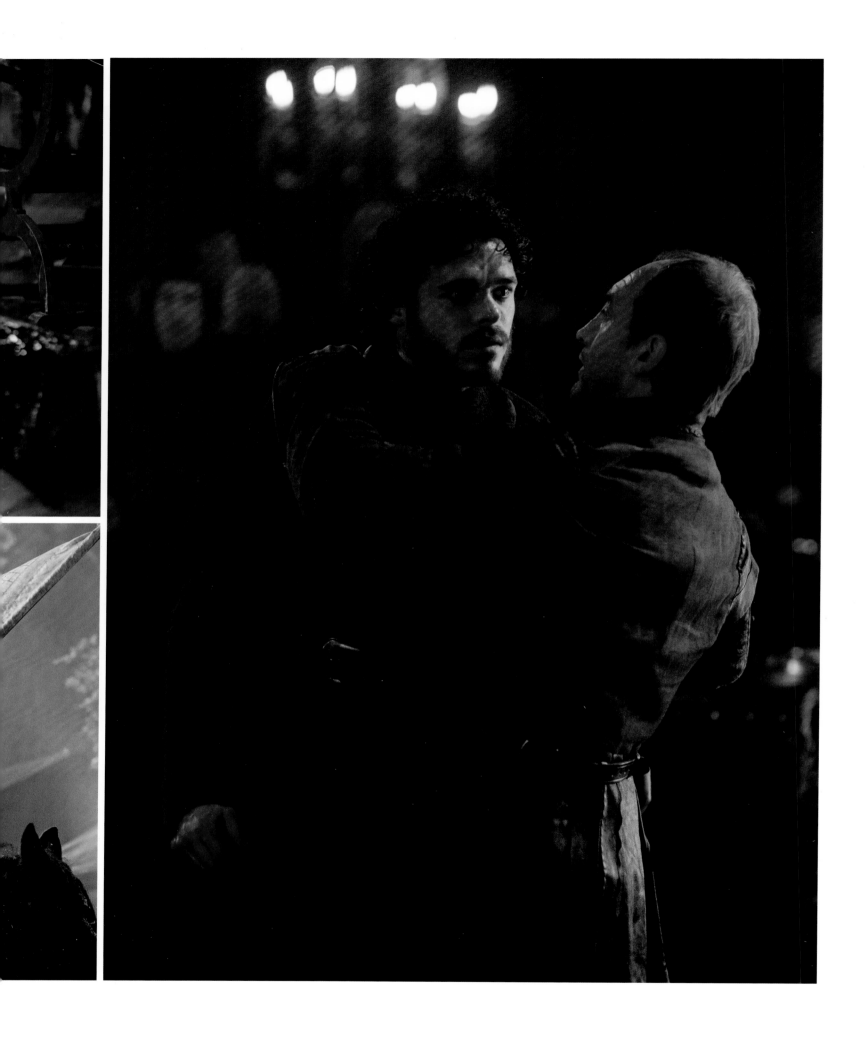

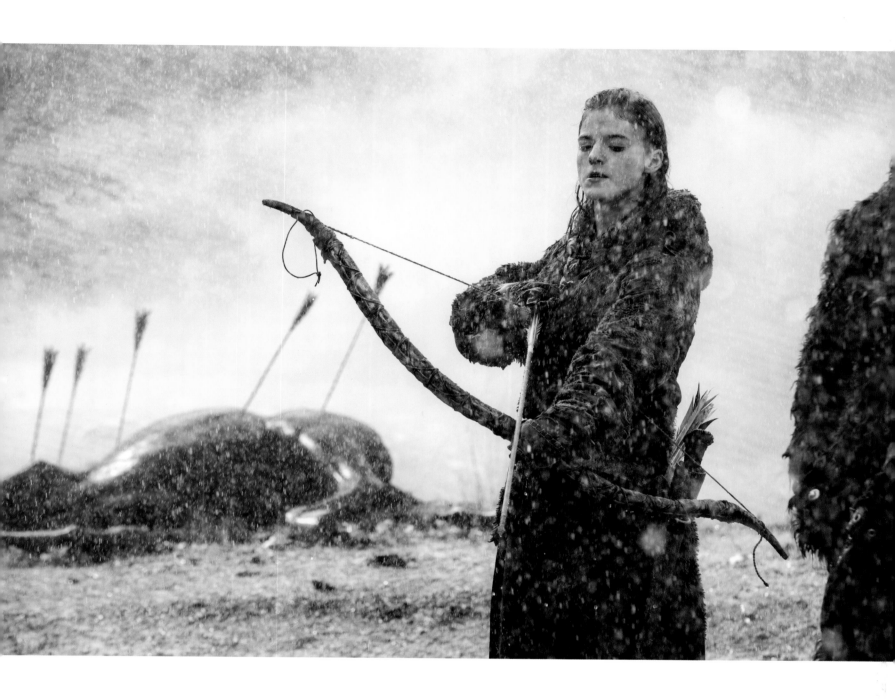

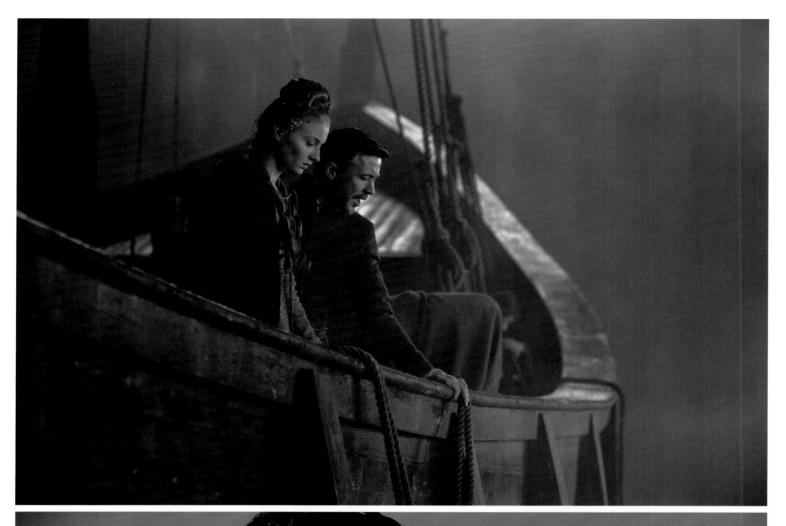

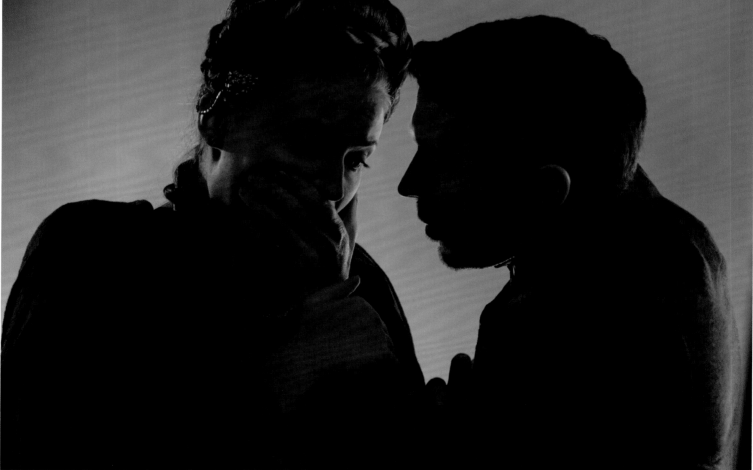

THIS PAGE: Littlefinger helps Sansa escape King's Landing.
OPPOSITE: Alfie Allen as Theon Greyjoy.

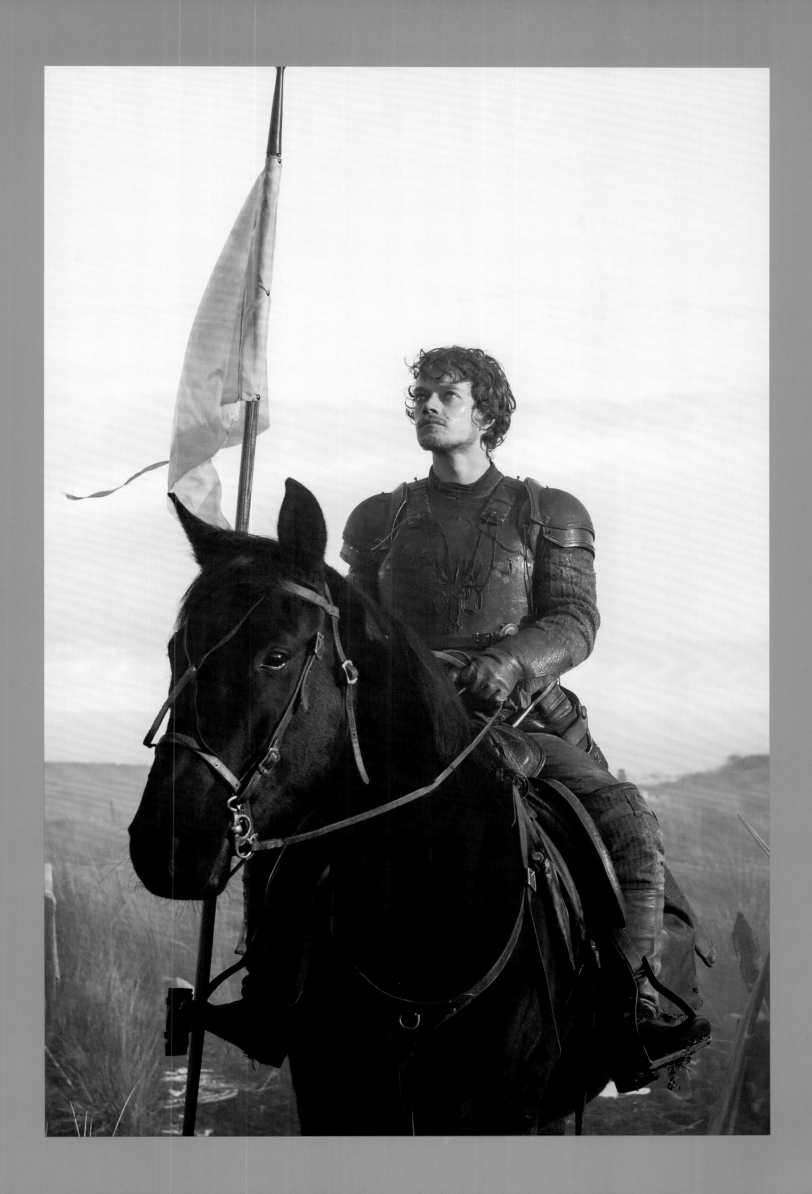

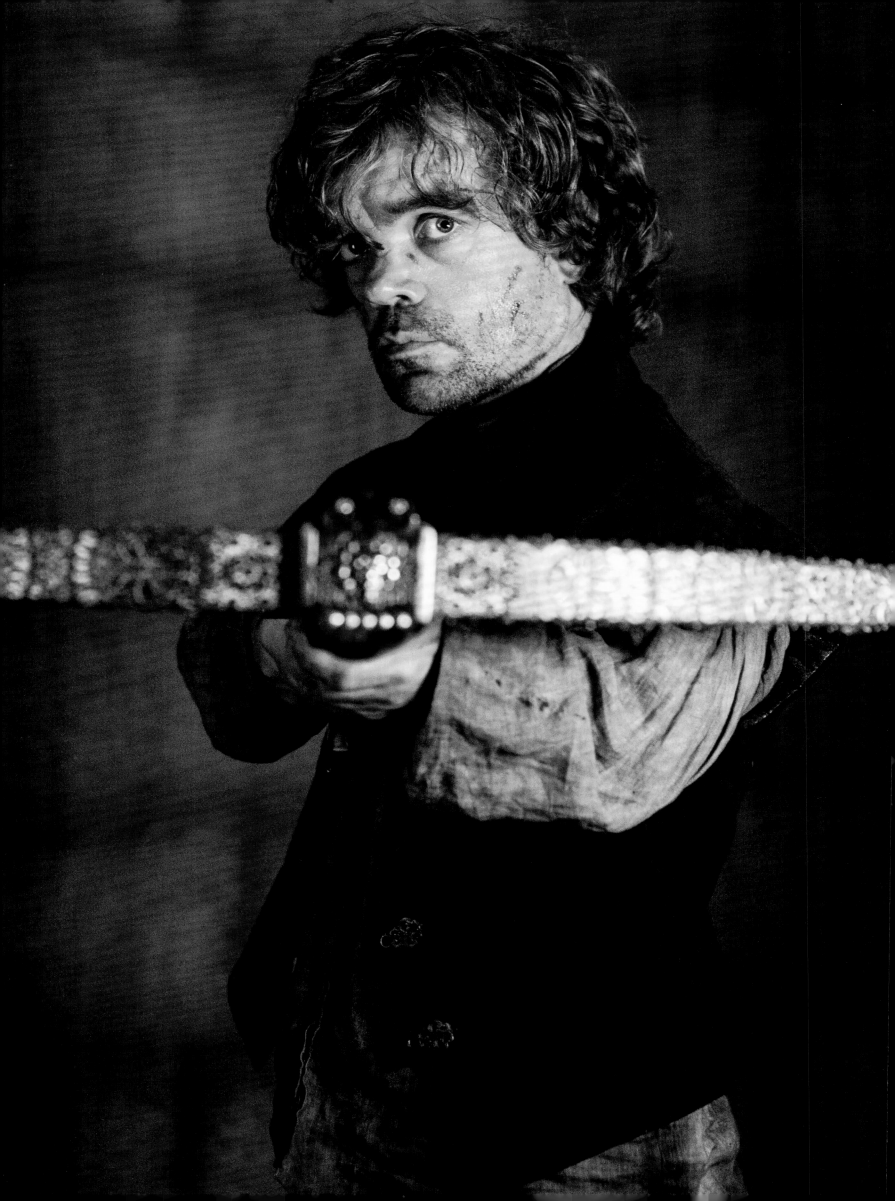

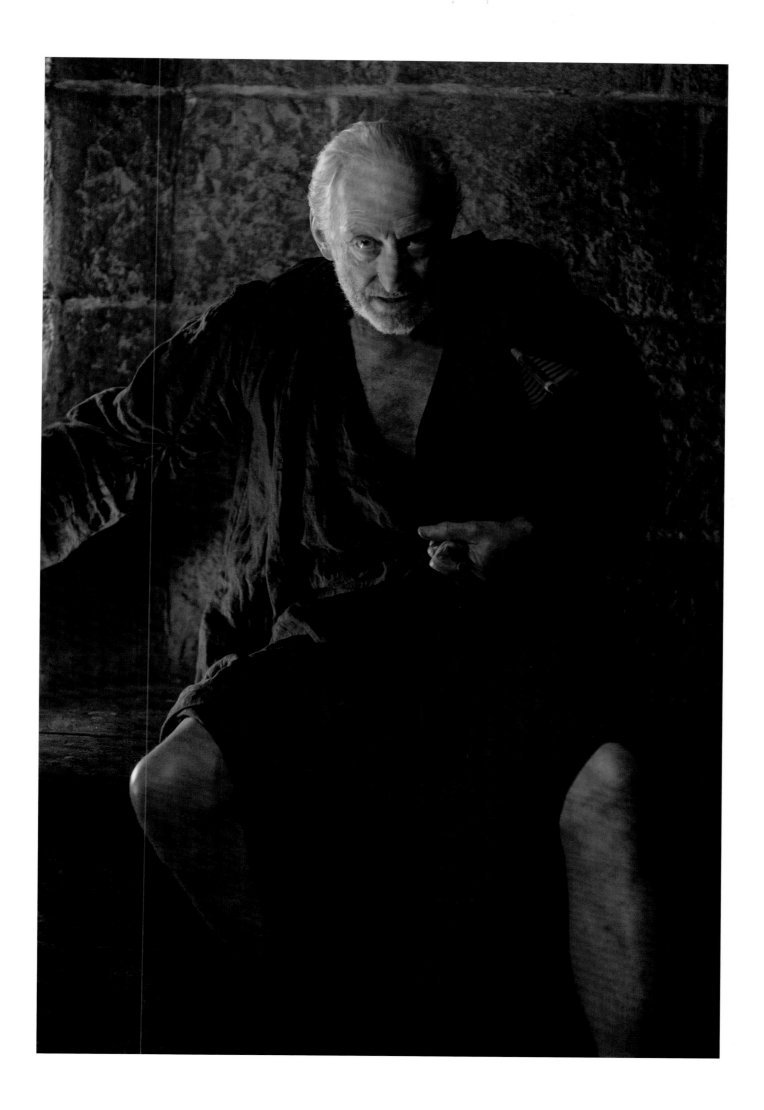

THESE PAGES: Tyrion kills his father with Joffrey's crossbow.

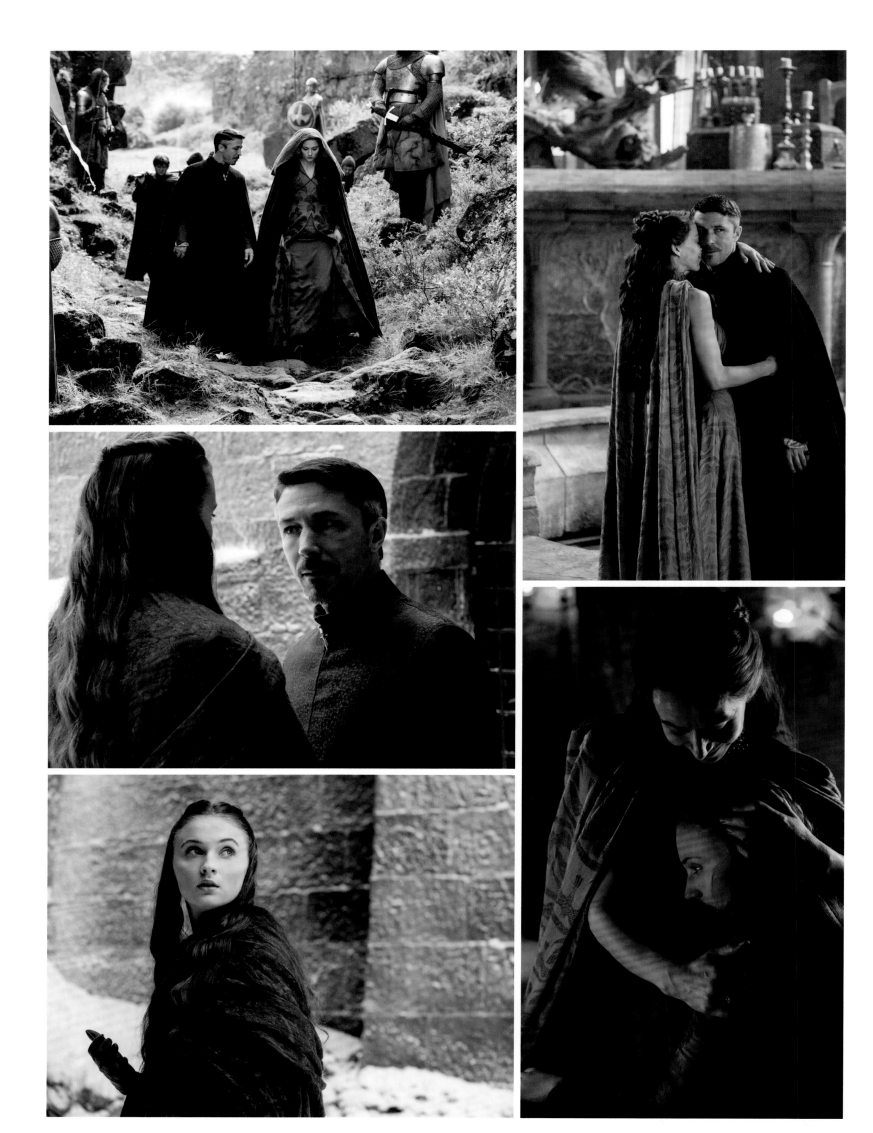

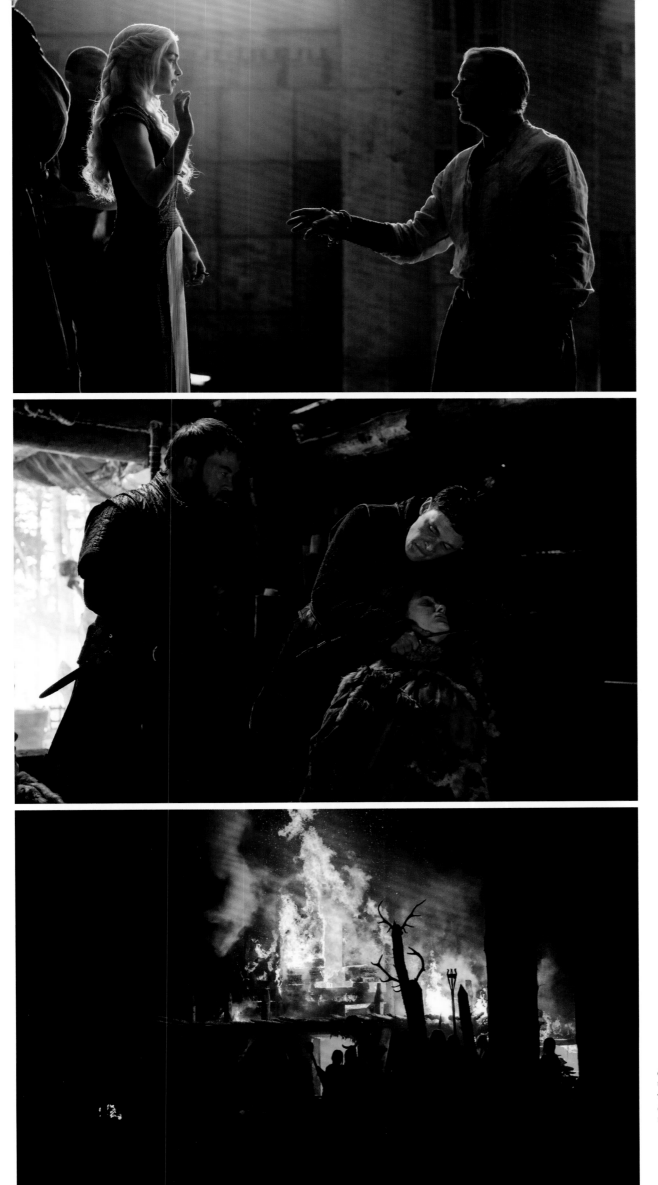

OPPOSITE: Littlefinger takes Sansa to the Vale to further his plans.
TOP: Daenerys banishes Ser Jorah.
CENTER AND BOTTOM: The mutiny at Craster's Keep.

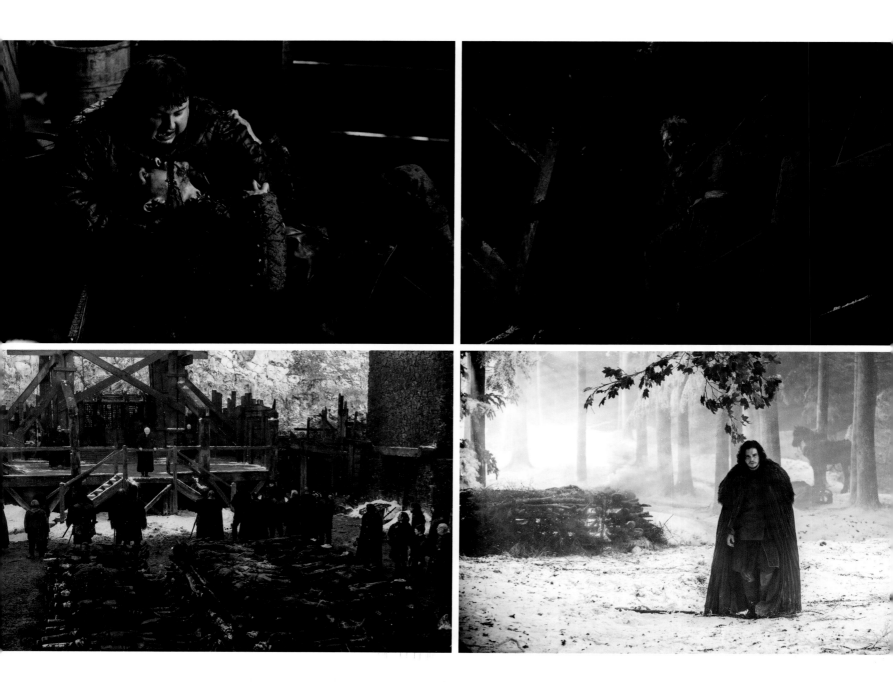

"*They came to us from White Harbor and Barrowton, from Fairmarket and King's Landing. From north and south, from east and west. They died protecting men, women, and children who will never know their names. It is for us to remember our brothers. We shall never see their like again.*" —Maester Aemon

"*And now their watch is ended.*" —Brothers of the Night's Watch

THIS PAGE: Mourning the dead at Castle Black after the battle between the wildlings and the Night's Watch.
OPPOSITE TOP LEFT: A jealous Lysa Arryn brutalizes her niece Sansa.
OPPOSITE BOTTOM LEFT: Littlefinger admits the truth to Lysa: He does not love her.
OPPOSITE RIGHT: An utterly broken Theon, now known as Reek, does Ramsay's bidding.

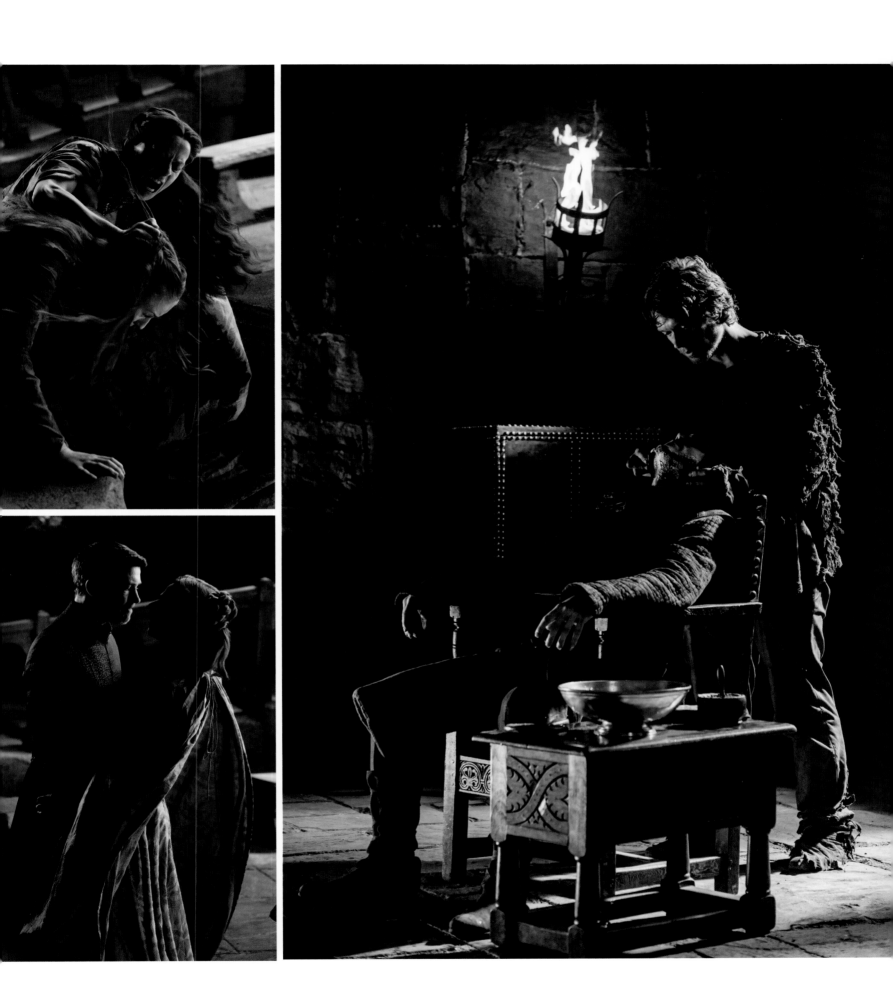

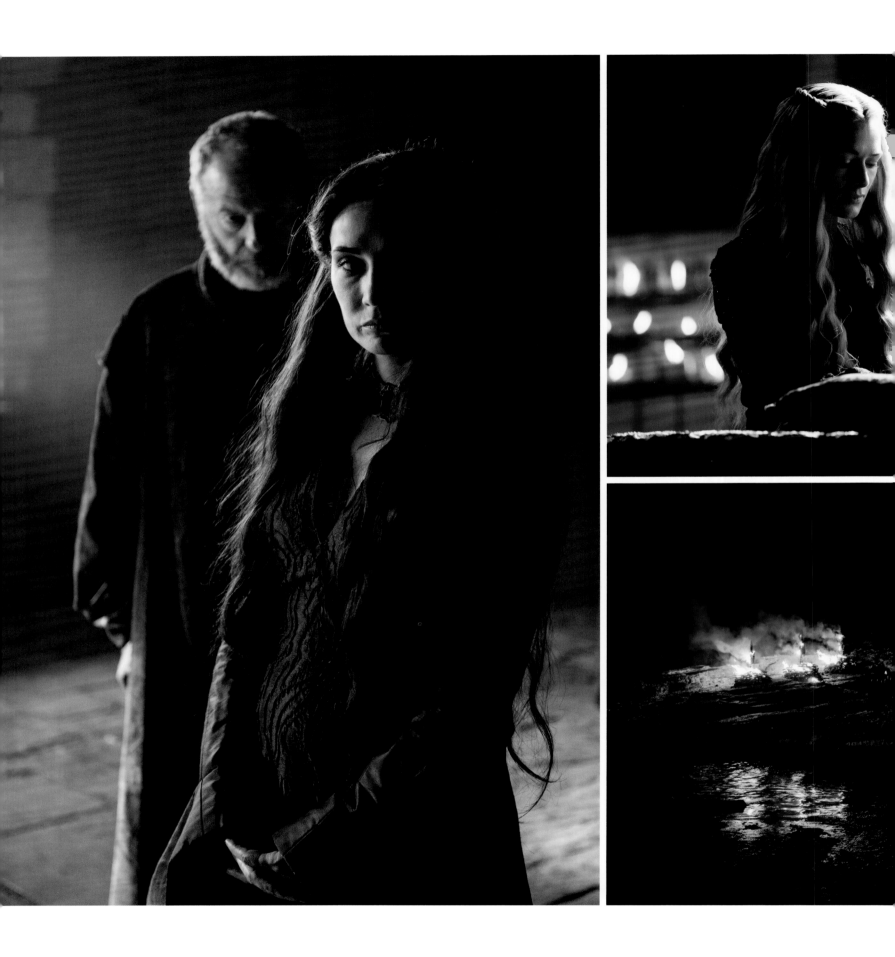

ABOVE: Ser Davos and Melisandre.
CENTER TOP: Cersei mourns Joffrey.
CENTER BOTTOM: Sacrifices made to the Lord of Light.
OPPOSITE: Selyse Baratheon watches as her brother, Axell Florent, is burned alive.

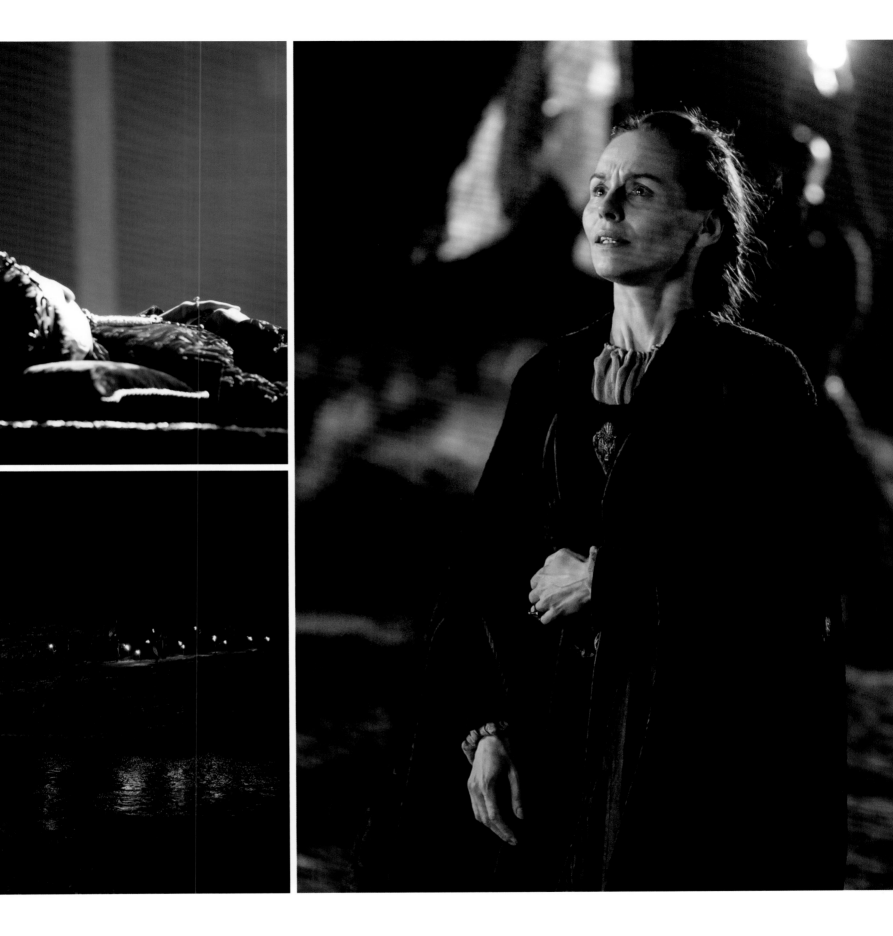

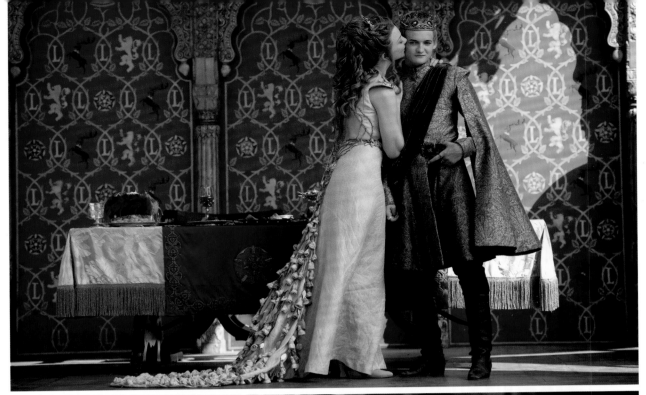

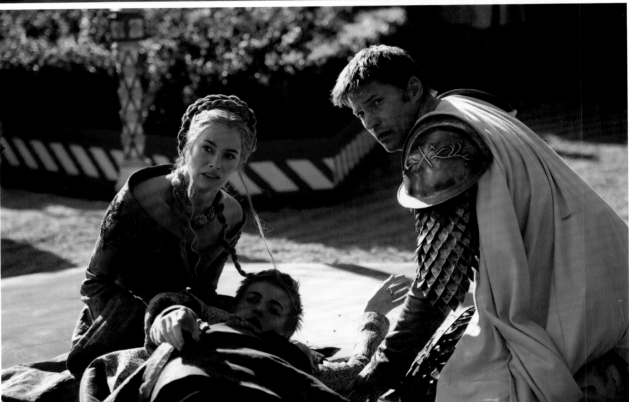

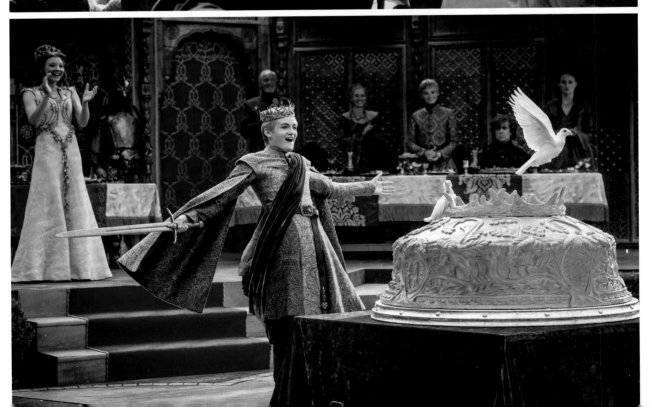

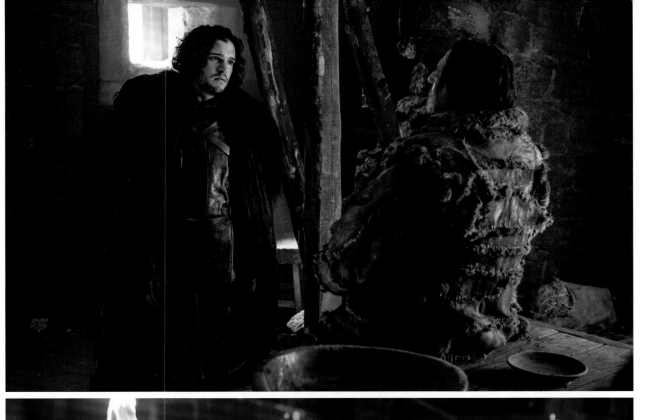

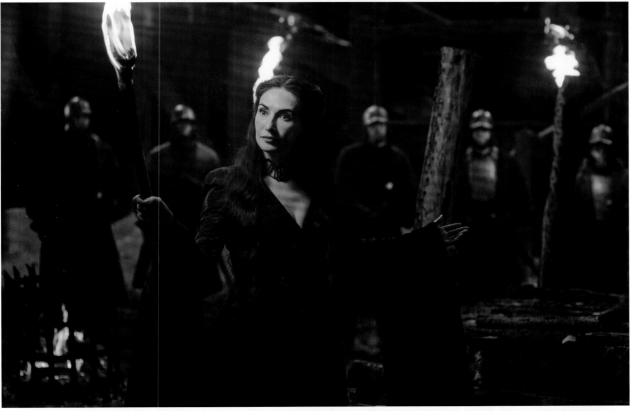

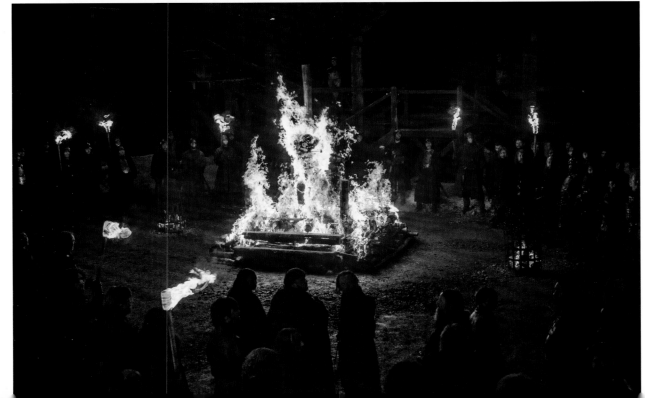

OPPOSITE: Joffrey and Margaery's tragic wedding day.

THIS PAGE: Jon Snow speaks to Mance Rayder at Castle Black. Mance is subsequently burned at the stake on Stannis's orders.

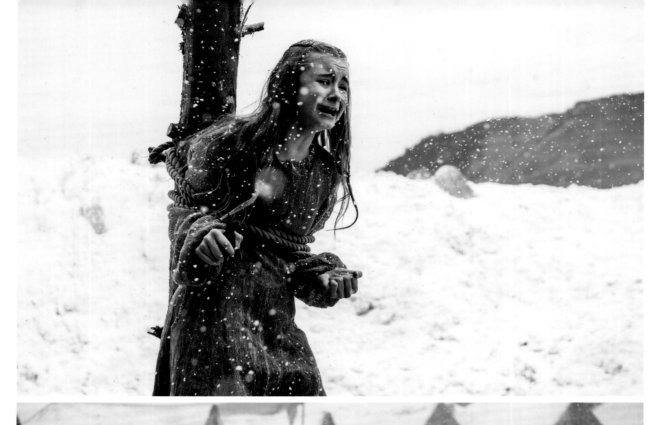

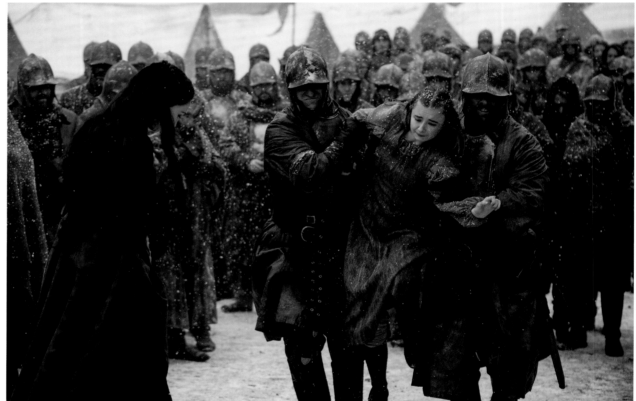

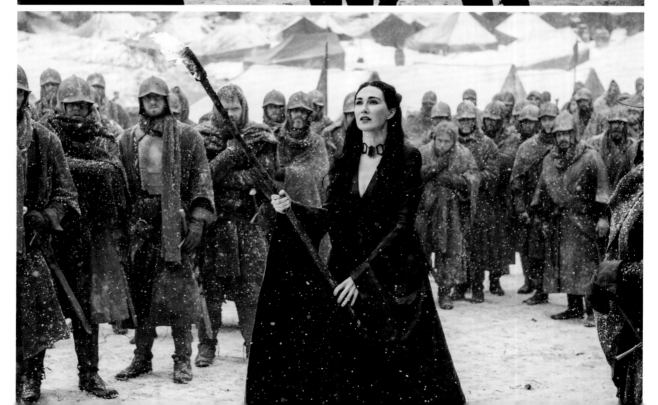

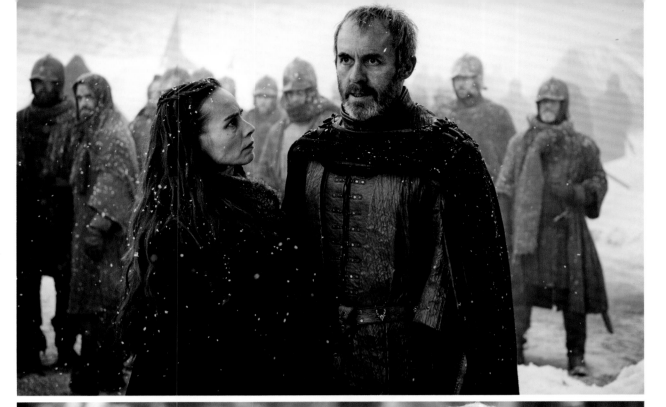

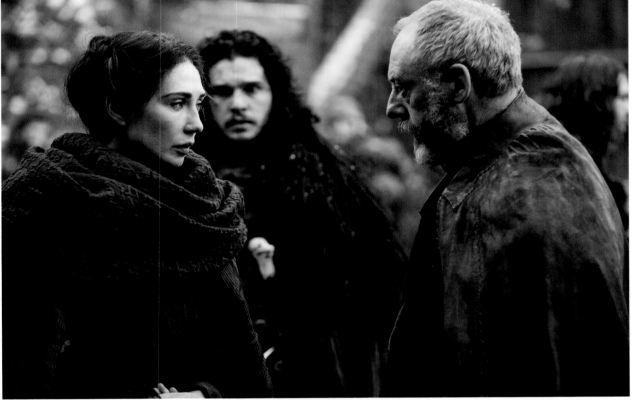

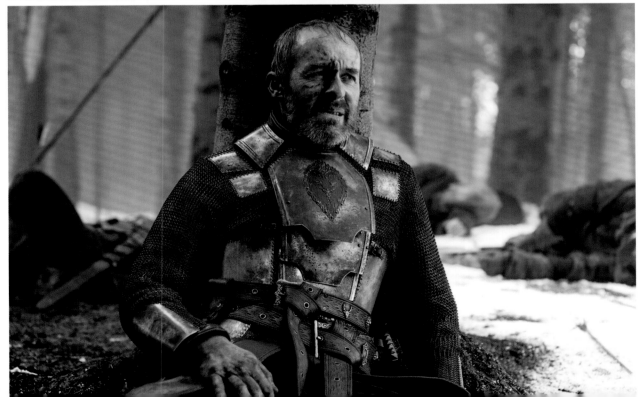

OPPOSITE: Shireen is burned alive as a sacrifice to the Lord of Light.
TOP: Stannis and Selyse Baratheon watch as their daughter dies.
CENTER: Ser Davos confronts Melisandre about Shireen's death as Jon Snow observes.
RIGHT: Stannis prepares to meet his fate, having realized he is not the Prince That Was Promised.

379

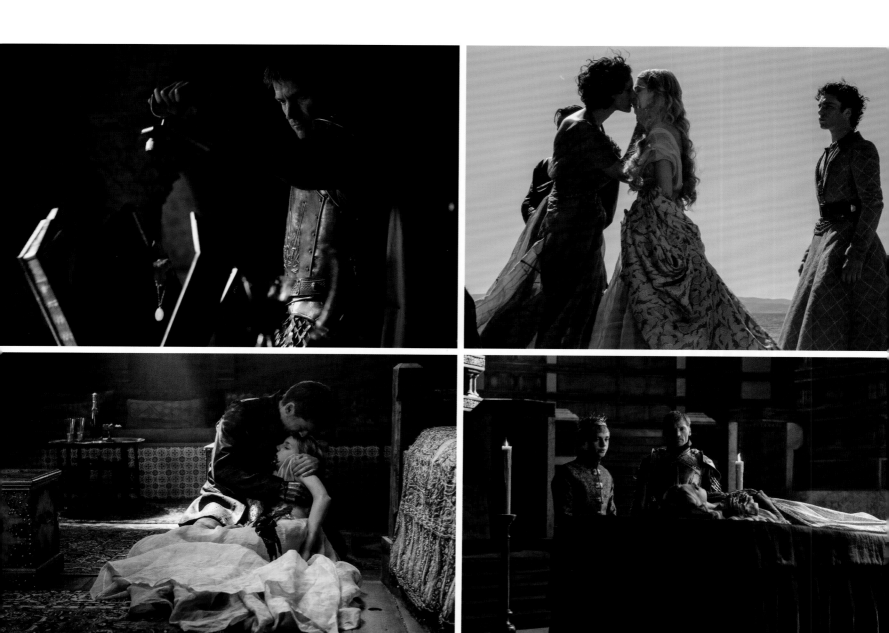

"What I'm trying and failing to say . . ." —Jaime Lannister

"I know what you're trying to say." —Myrcella Baratheon

"No, I'm afraid you don't." —Jaime Lannister

"I do. I know. About you and mother. I think a part of me always knew. And I'm glad. I'm glad that you're my father." —Myrcella Baratheon

THIS PAGE: Jaime opens a threatening message from Dorne, and Myrcella is poisoned by Ellaria Sand. She dies in Jaime's arms, just after he confirms he is her father.

OPPOSITE: Littlefinger continues to manipulate Sansa to further his plans.

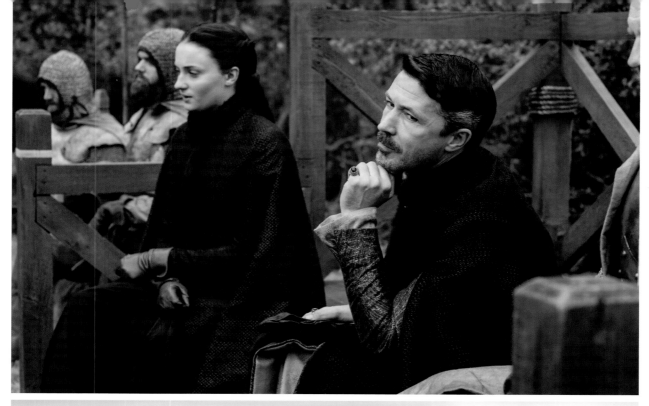

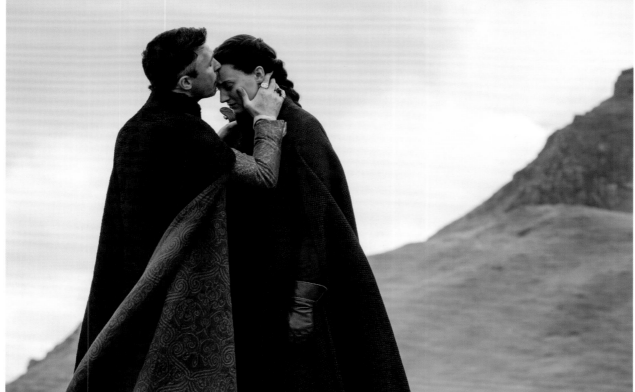

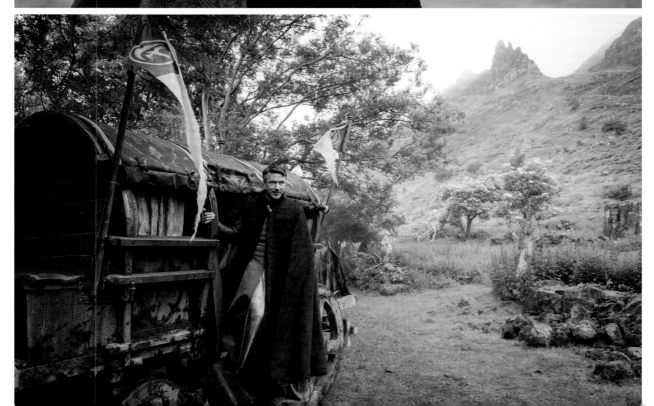

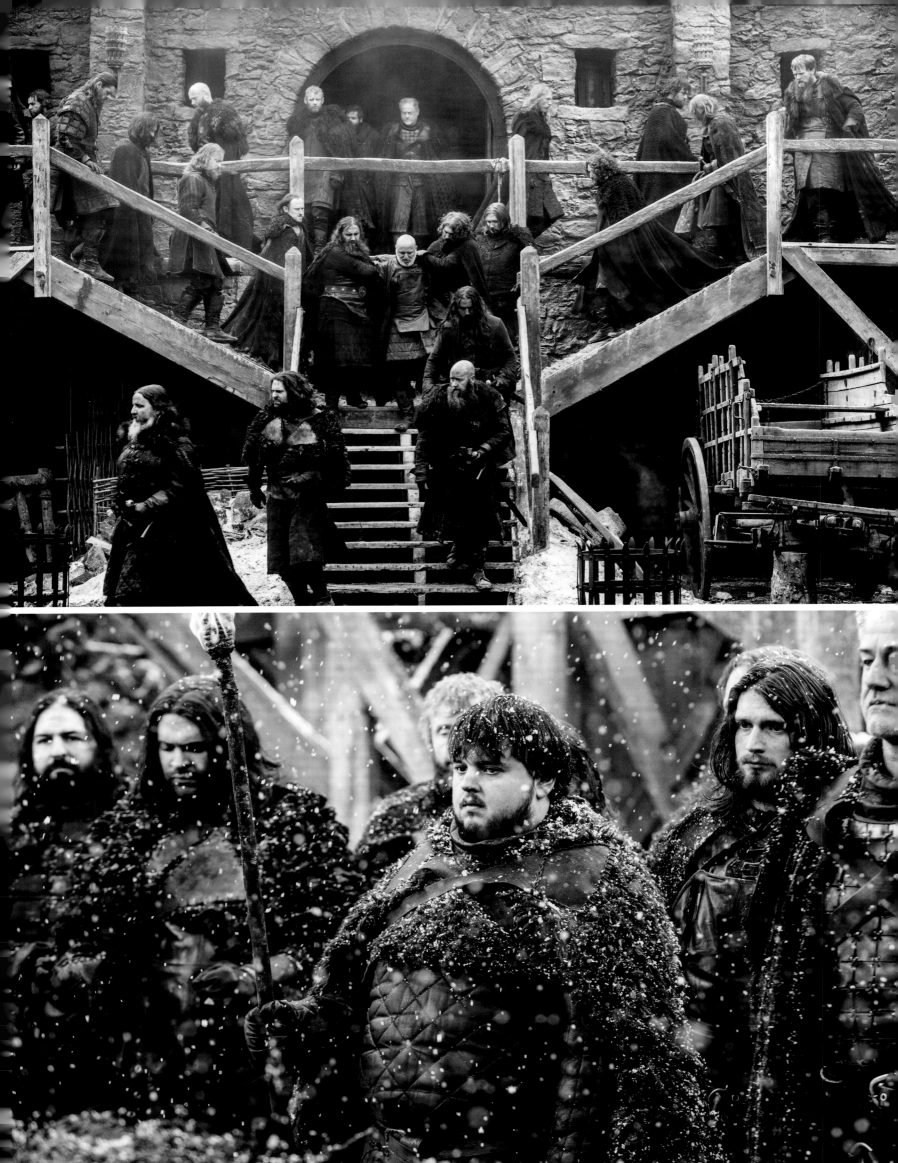

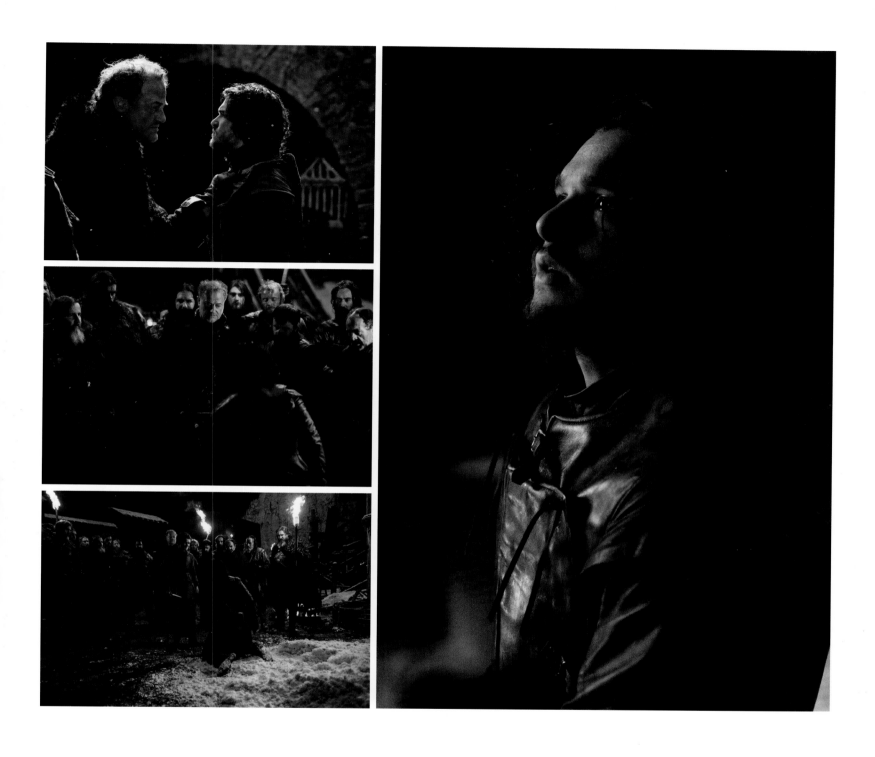

OPPOSITE: The coward Janos Slynt prepares to pay for his treachery, and the men of Castle Black watch.
THIS PAGE: Jon Snow is betrayed by the Night's Watch and murdered.

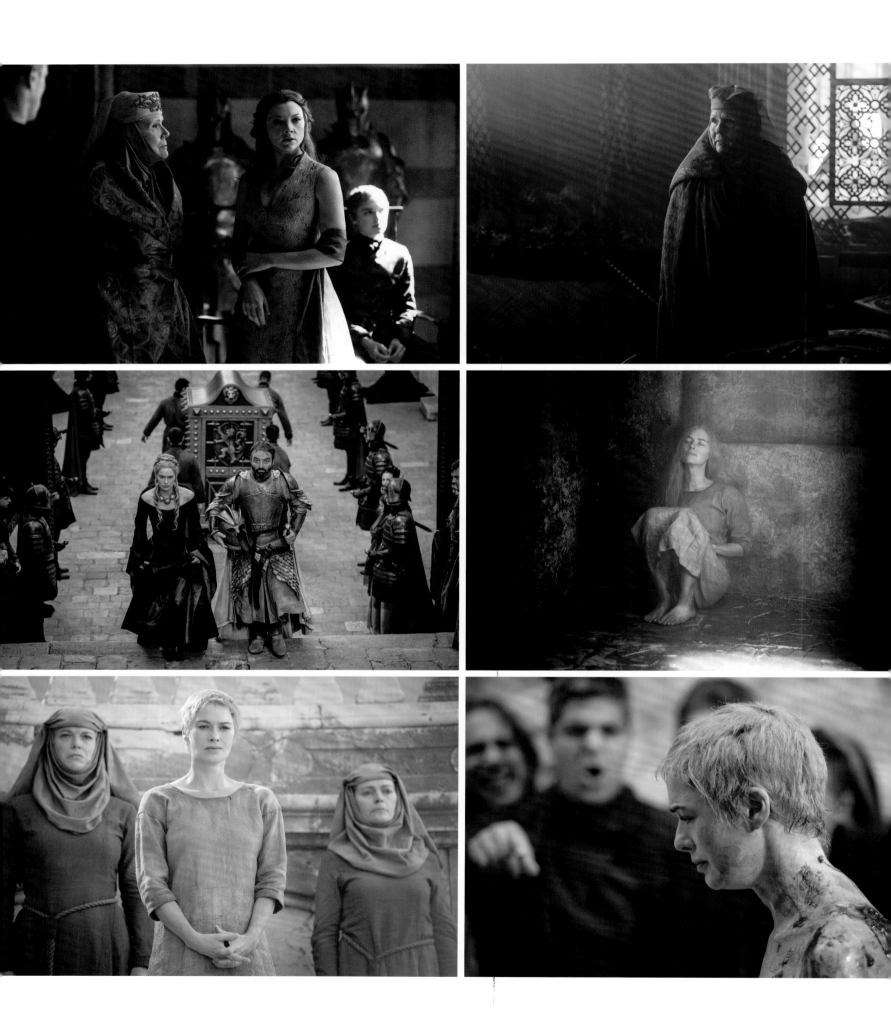

TOP ROW: Margaery Tyrell is arrested for lying at the holy inquest while her grandmother, Olenna Tyrell, protests. Olenna then meets with Baelish to exchange information.

CENTER LEFT: Ser Meryn Trant escorts Queen Cersei to the Great Sept for the funeral of Tywin Lannister.

CENTER RIGHT: Queen Cersei imprisoned.

BOTTOM ROW: Cersei takes her walk of atonement through King's Landing.

OPPOSITE: Sansa and Ramsay's wedding at the godswood.

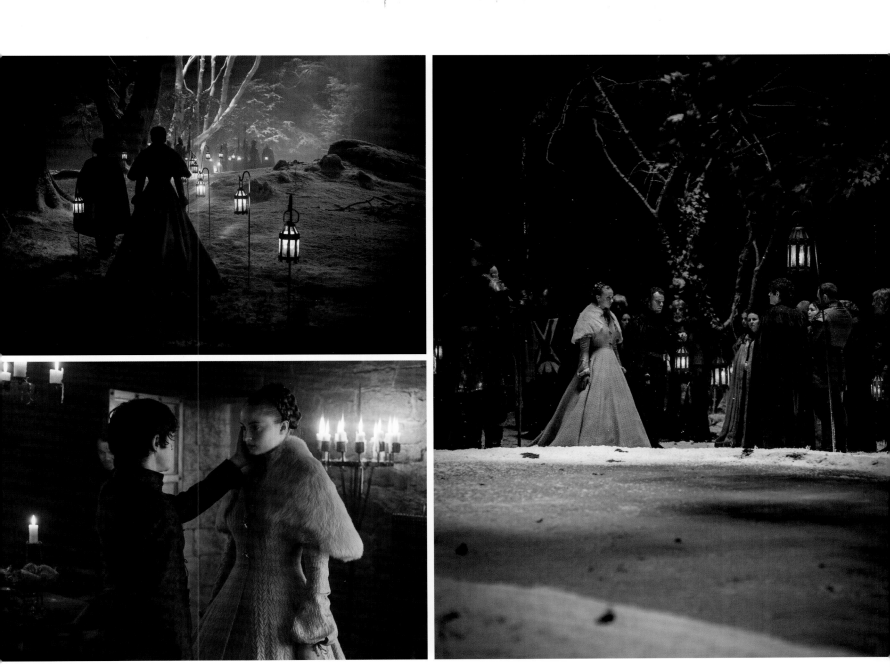

"Sansa of the House Stark comes here to be wed. A woman grown, trueborn, and noble. She comes to beg the blessings of the gods. Who comes to claim her?" —Theon Greyjoy

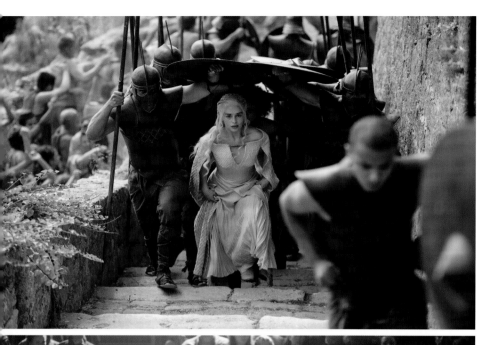

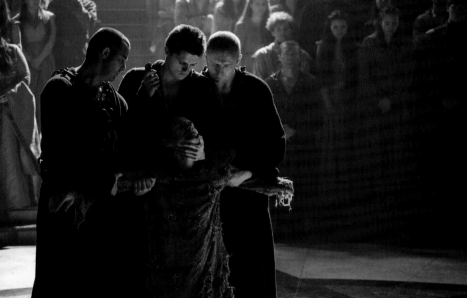

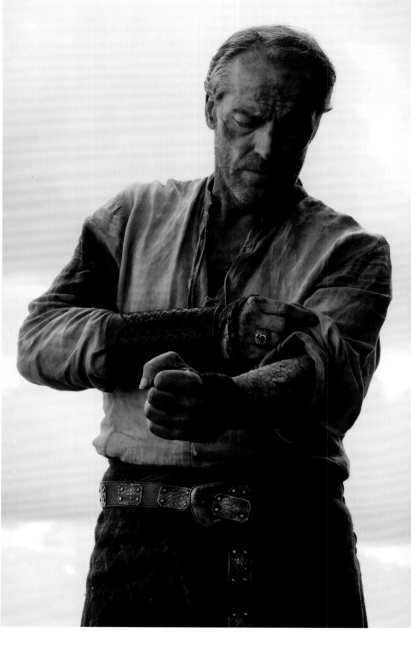

THIS PAGE: (*clockwise from top left*) The Unsullied protect their queen; Ser Jorah examines the greyscale on his wrist; Sparrows carve the seven-pointed star on Ser Loras's forehead as punishment for his crimes.
OPPOSITE: (*clockwise from left*) Aidan Gillen as Lord Petyr Baelish; Roose Bolton and his son Ramsay.

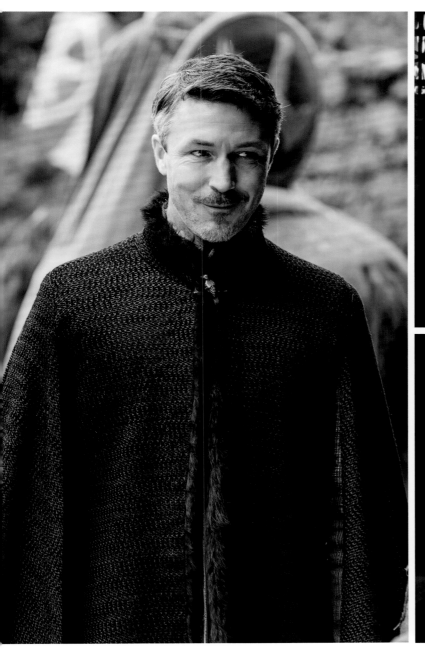

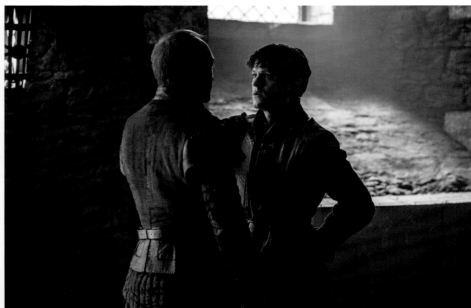

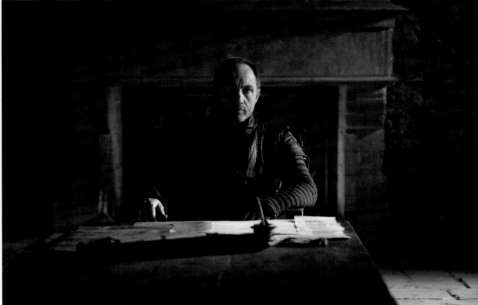

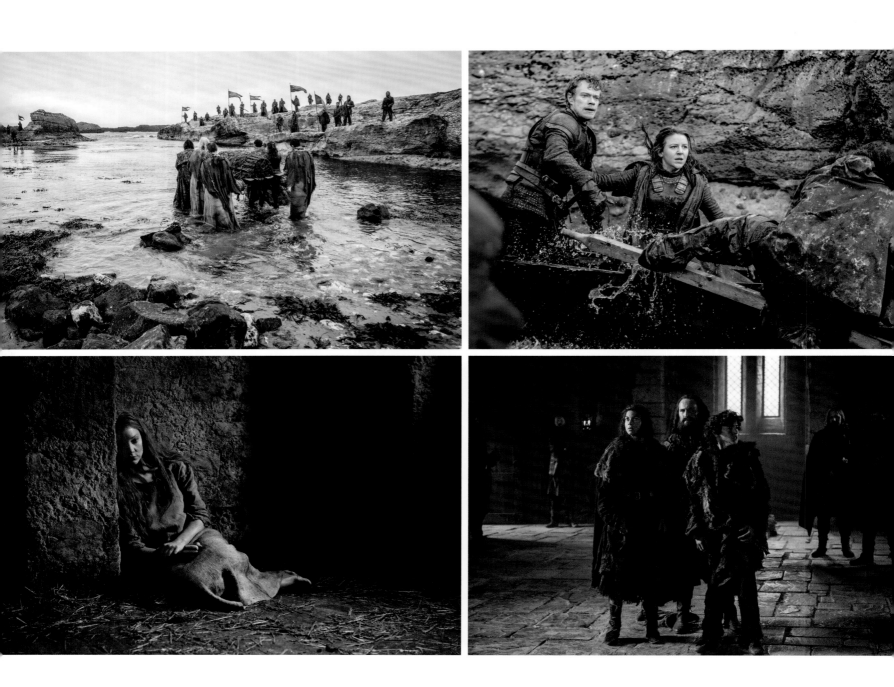

THIS PAGE: (*clockwise from top left*) The funeral of Balon Greyjoy; Yara and Theon make their escape from the Iron Islands; Osha the wildling and Rickon Stark are captured by Ramsay Bolton; Margaery Tyrell imprisoned.

OPPOSITE TOP: Littlefinger at Winterfell

OPPOSITE CENTER: Sansa argues with Jon over how to defeat Ramsay Bolton prior to the Battle of the Bastards.

OPPOSITE BOTTOM: Queen Daenerys and her council meet in the map room at Dragonstone.

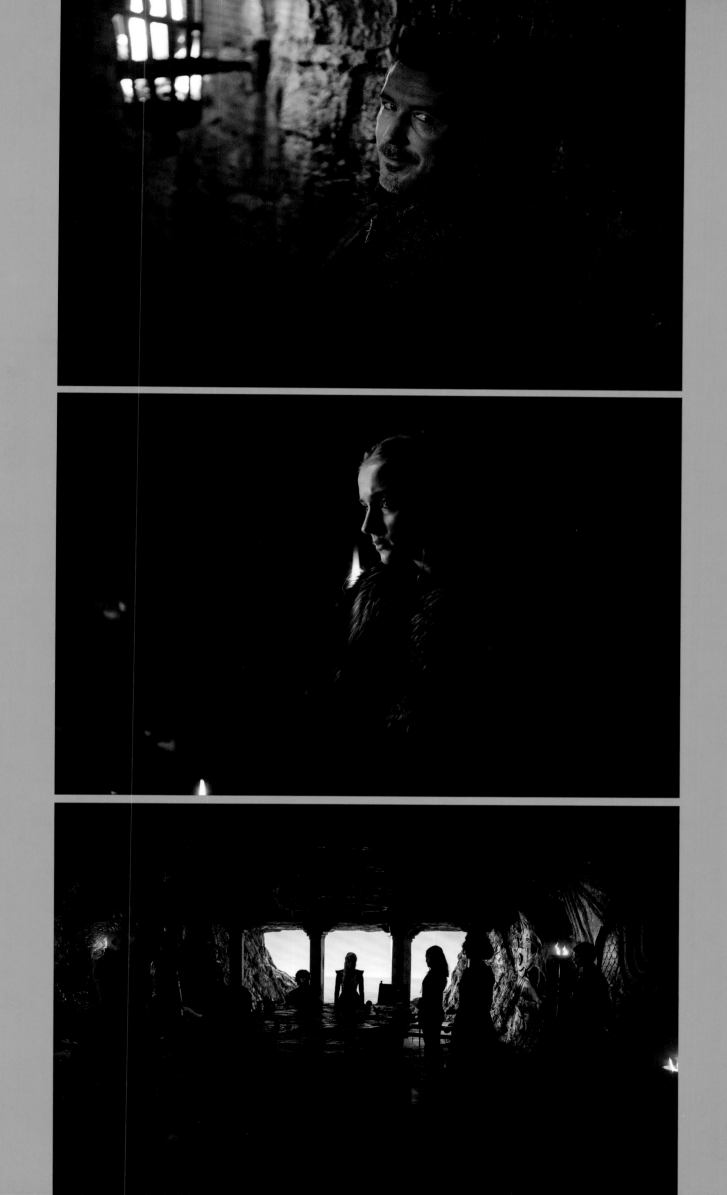

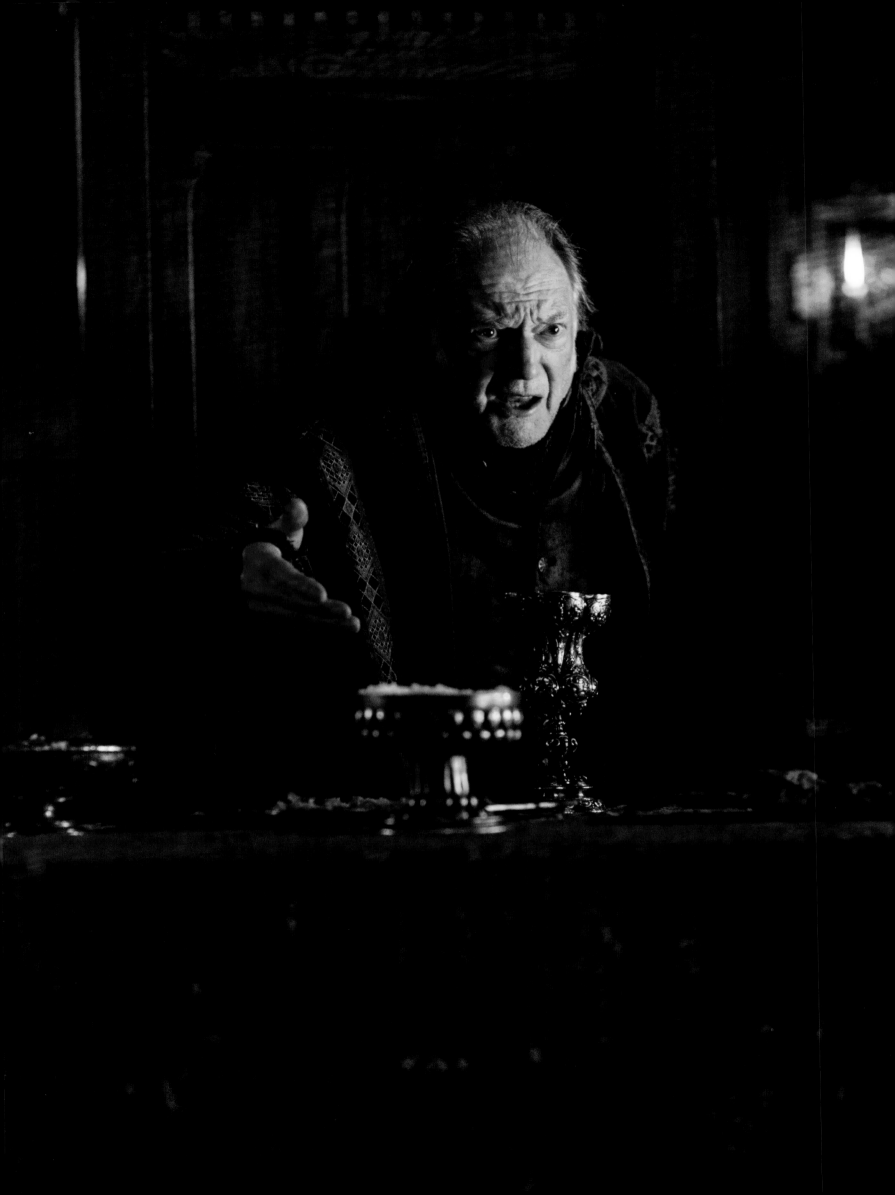

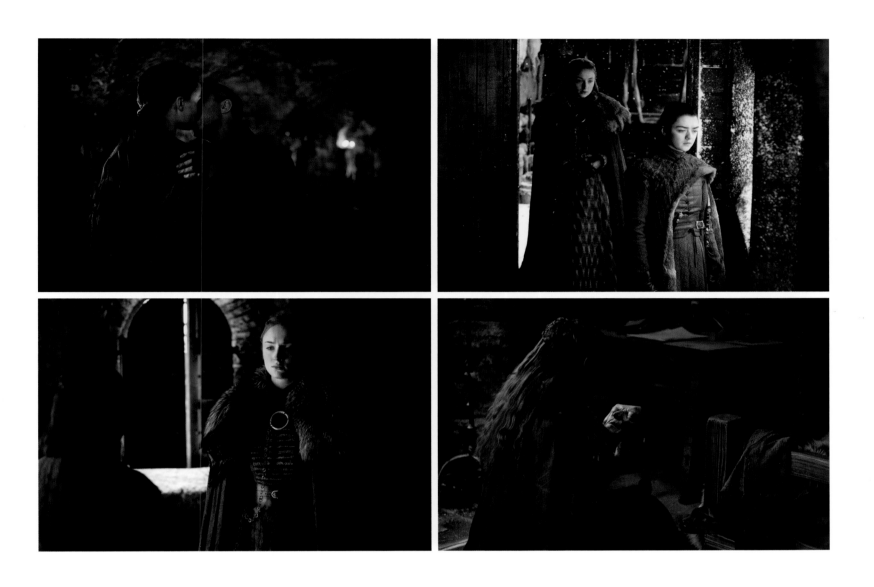

OPPOSITE: David Bradley as Lord Walder Frey.
TOP LEFT: Lord Baelish kisses Sansa in the Crypt of Winterfell.
TOP RIGHT AND BOTTOM ROW: Sansa and Arya Stark confront their pasts as they reunite in Winterfell.
PAGES 392–393: Hodor makes the ultimate sacrifice to "hold the door" so Bran and Meera can escape the wights.

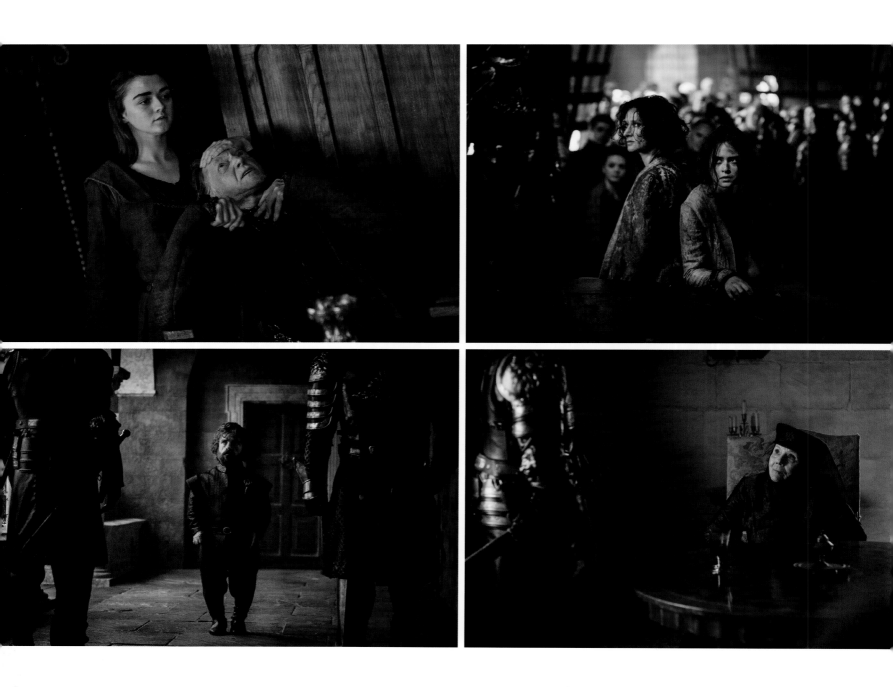

THIS PAGE: (*clockwise from top left*) Arya exacts revenge on Walder Frey for the Red Wedding; Ellaria and Tyene Sand are captured and brought before Cersei; Olenna Tyrell has a final conversation with Jaime Lannister after his forces take Highgarden; Tyrion seeks an audience with his sister.

OPPOSITE TOP: Daenerys is captured by the Dothraki.

OPPOSITE BOTTOM: Daenerys is taken to the Temple of the Dosh Khaleen.

PAGES 396—397: Cersei takes revenge for Myrcella's murder by poisoning Tyene and forcing Ellaria to watch helplessly as her daughter dies slowly in the Black Cells within the Red Keep.

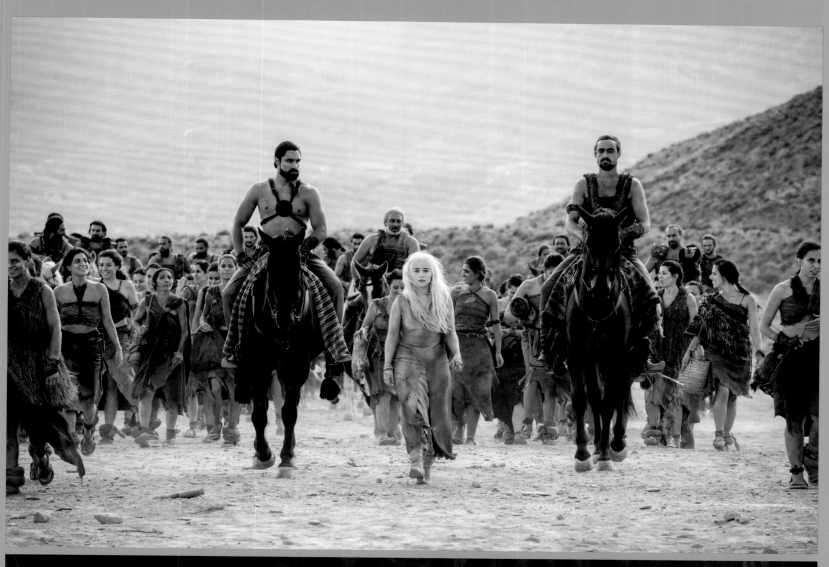

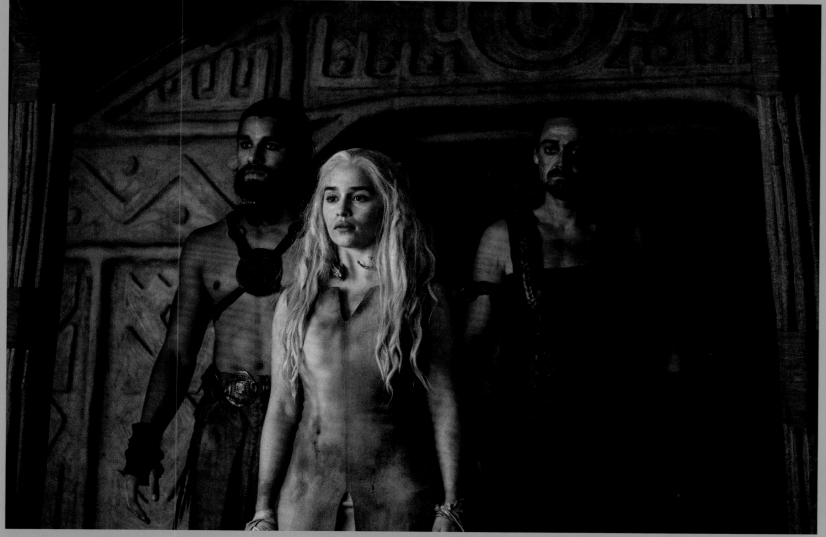

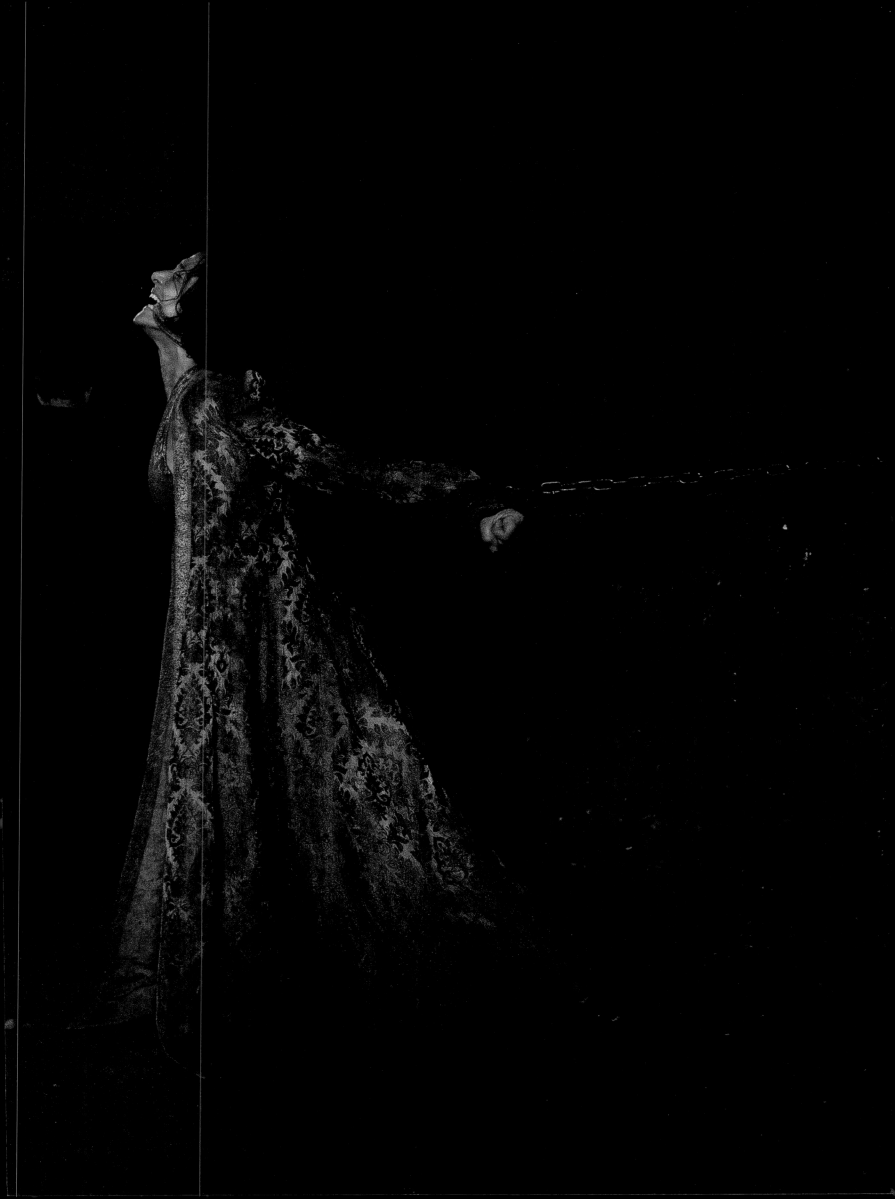

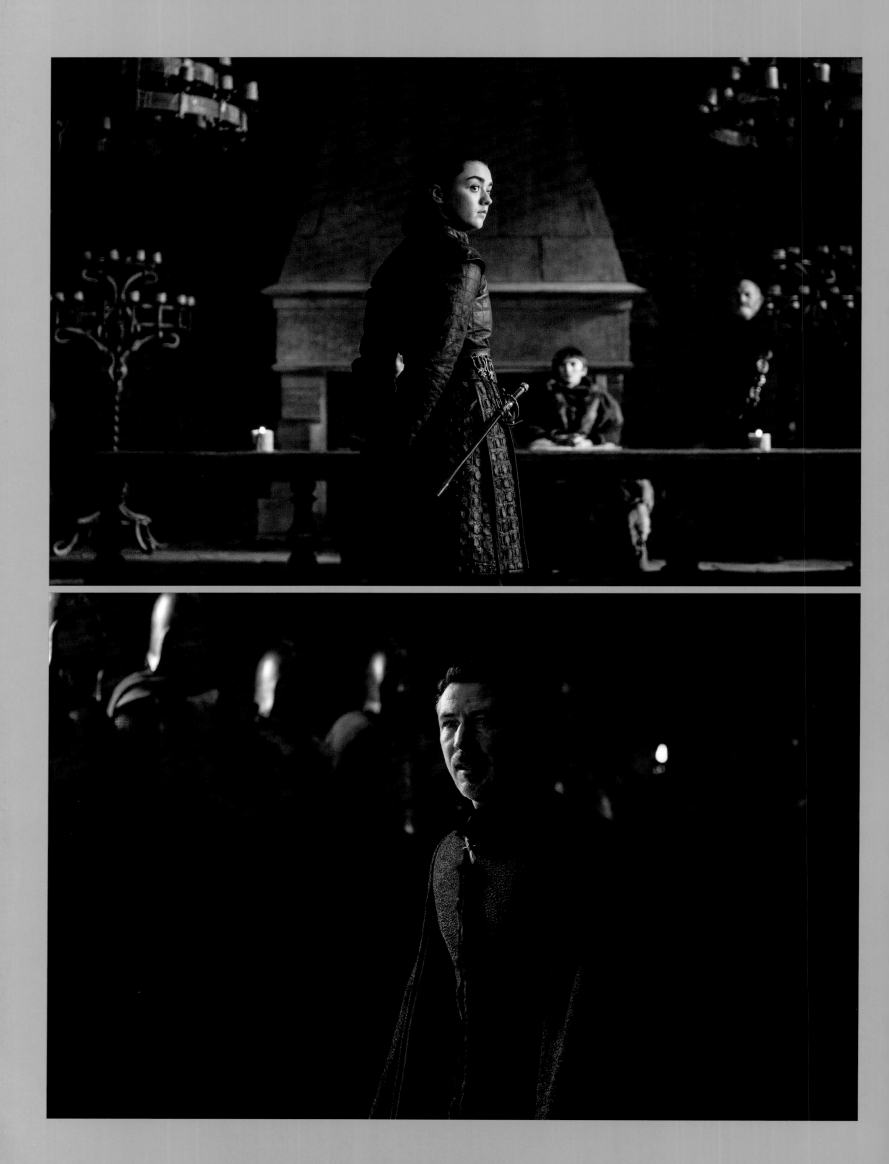

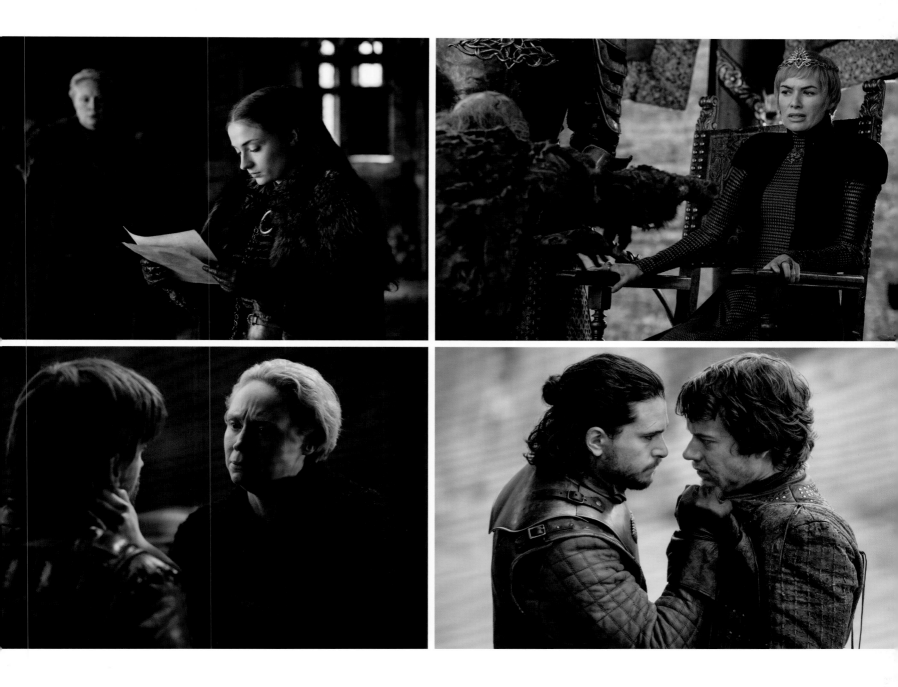

OPPOSITE TOP: Arya helps Sansa turn the tables on Littlefinger.
OPPOSITE BOTTOM: Lord Baelish realizes he has been outsmarted.
TOP LEFT: Sansa receives an invitation to a gathering at King's Landing, as Brienne stands watch.
TOP RIGHT: Cersei is terrified by the sight of the captive wight.
BOTTOM LEFT: Brienne pleads with Jaime not to return to Cersei.
BOTTOM RIGHT: Jon confronts Theon.

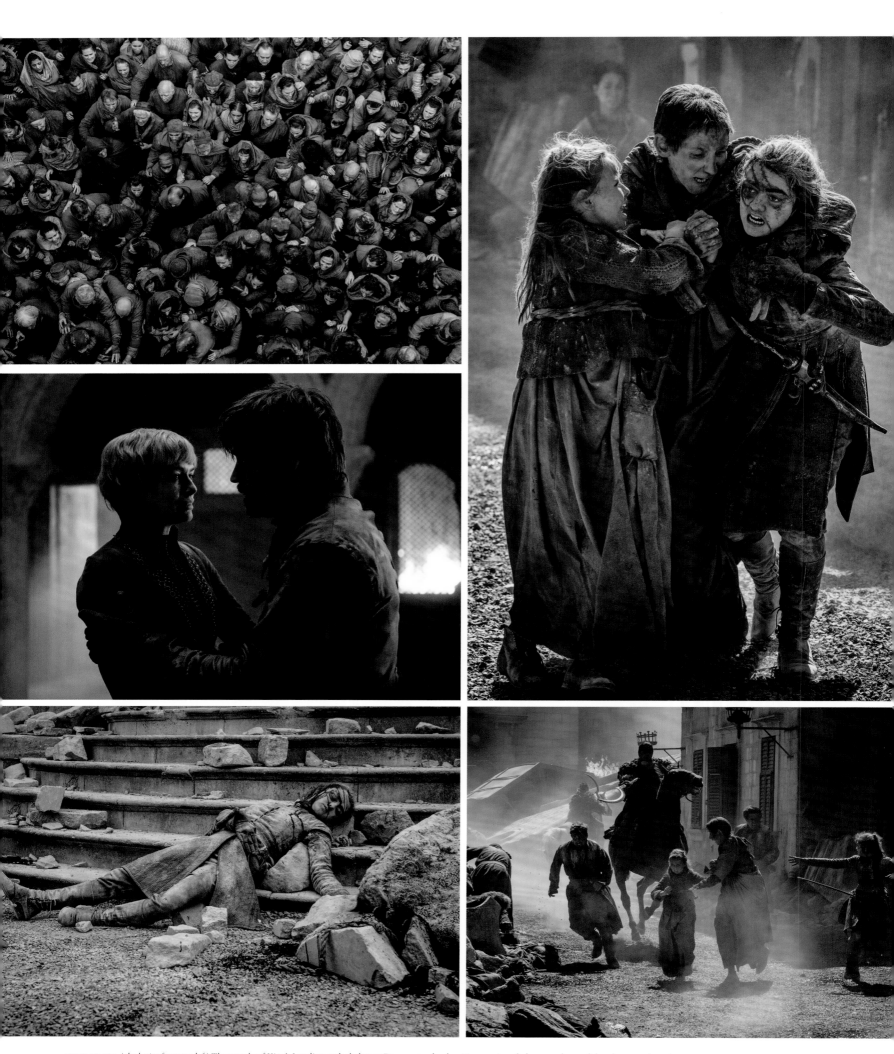

THIS PAGE: (*clockwise from top left*) The people of King's Landing seek shelter as Daenerys unleashes Drogon; Arya helps a mother and daughter to safety; the Dothraki plunder the city; Arya is badly hurt after Drogon's attack; Jaime and Cersei in their final moments.

OPPOSITE: In the aftermath of the Battle of Winterfell, Sansa and Daenerys honor the dead while preparing for the future. Director David Nutter made sure to bring everyone, from cast and crew to extras, together for moments like the funeral pyre after the Battle of Winterfell. He even played mood-appropriate music over the PA system to further punctuate important moments. "It's one of his great strengths as a director—he leads us and we would follow him anywhere," Sloan says.

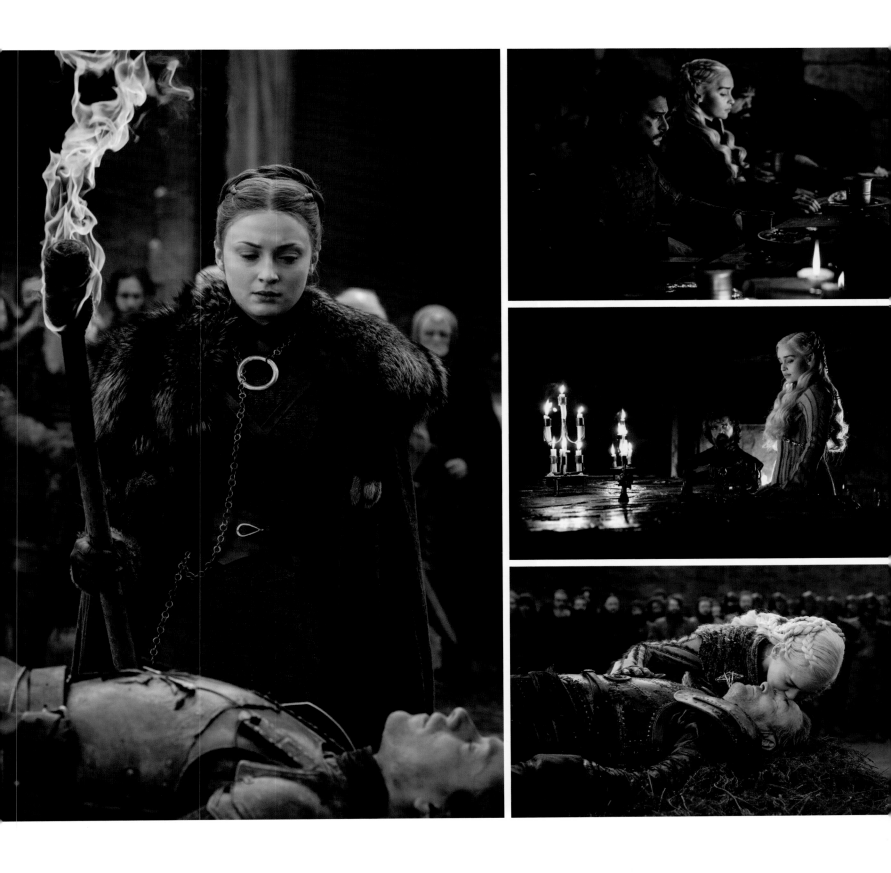

"We're here to say goodbye to our brothers and sisters. To our fathers and mothers. To our friends. Our fellow men and women who set aside their differences to fight together— and die together—so that others might live. Everyone in this world owes them a debt that can never be repaid." —Jon Snow

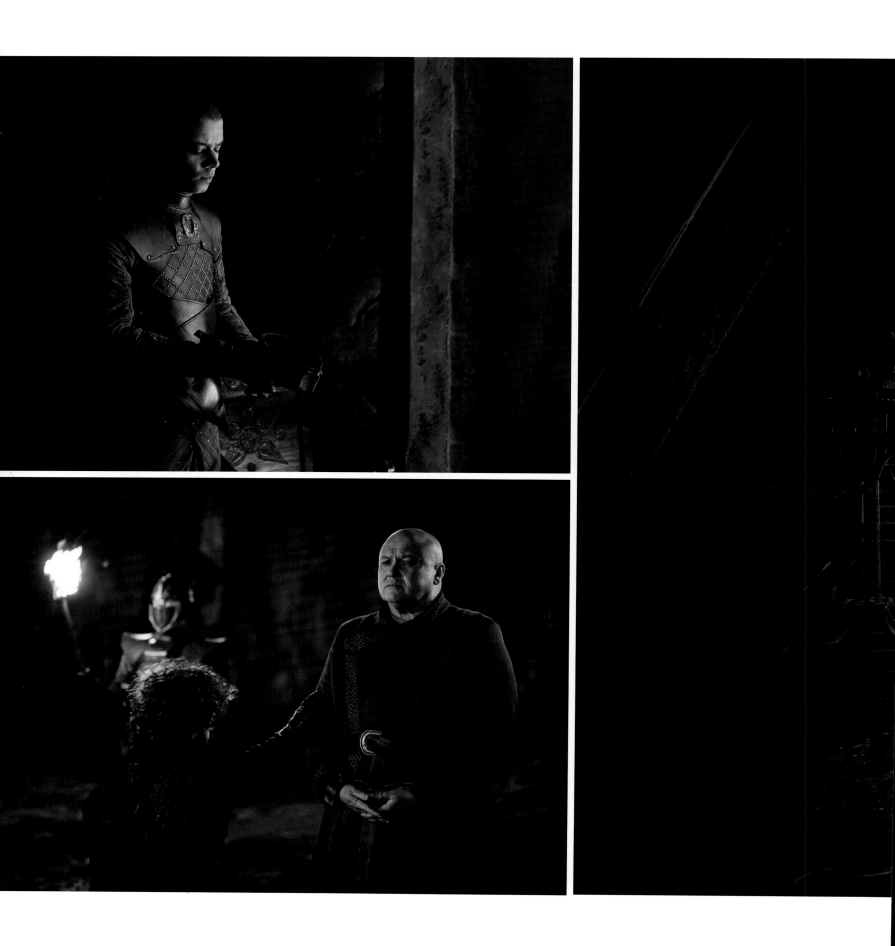

TOP: Grey Worm remembers Missandei.
BOTTOM: Tyrion says goodbye to Varys before Varys is killed by dragonfire.
RIGHT: Old friends Tyrion and Varys argue over Daenerys's fitness to rule the Seven Kingdoms.

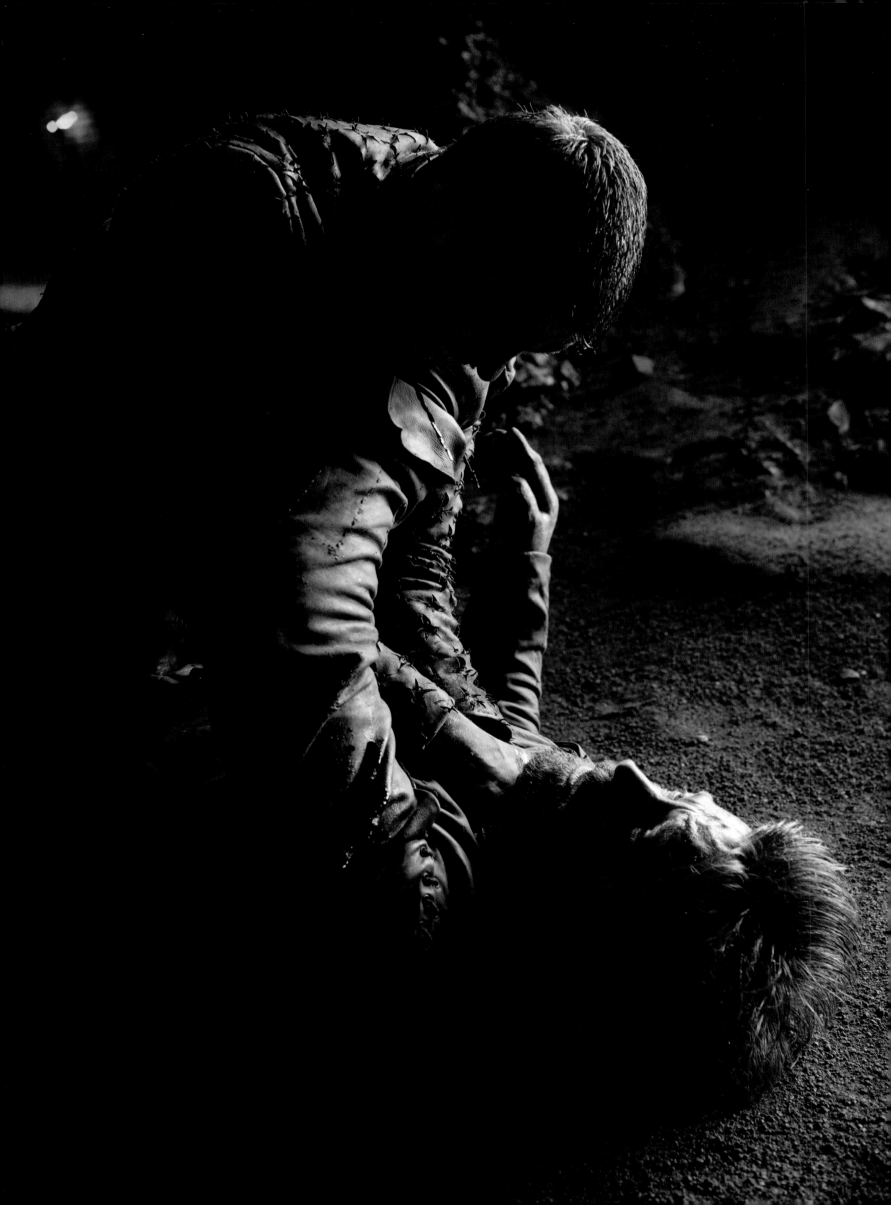

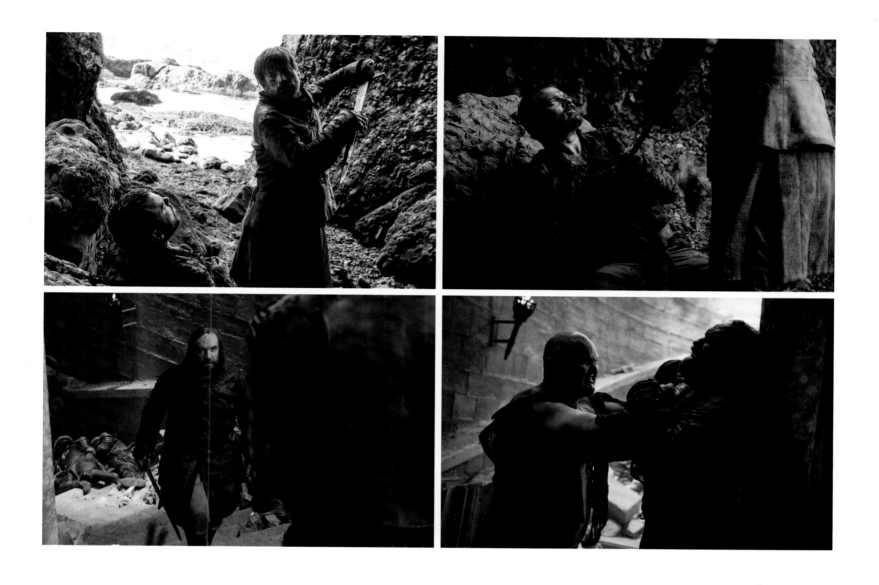

OPPOSITE: Bitter rivals Euron and Jaime engage in mortal combat.

TOP ROW: Jaime defeats and kills Euron.

BOTTOM ROW: The Clegane brothers, Sandor and Ser Gregor, in a fight to the death as the Red Keep collapses. Each hand-to-hand combat sequence in *Game of Thrones* was tightly choreographed and heavily rehearsed—but fast-paced, physical fights between such large, strong actors are always a challenge to film. For this scene, the camera crew also had to navigate the staircases to follow the action. And the moment when the brothers crash through a wall was not CGI—the actors actually ran through and landed on a crash mat below.

ABOVE: Emilia Clarke on horseback, ready to film.
OPPOSITE: Alfie Allen as Theon Greyjoy and Sophie Turner as Sansa Stark filming their desperate escape sequence from Ramsay Bolton.

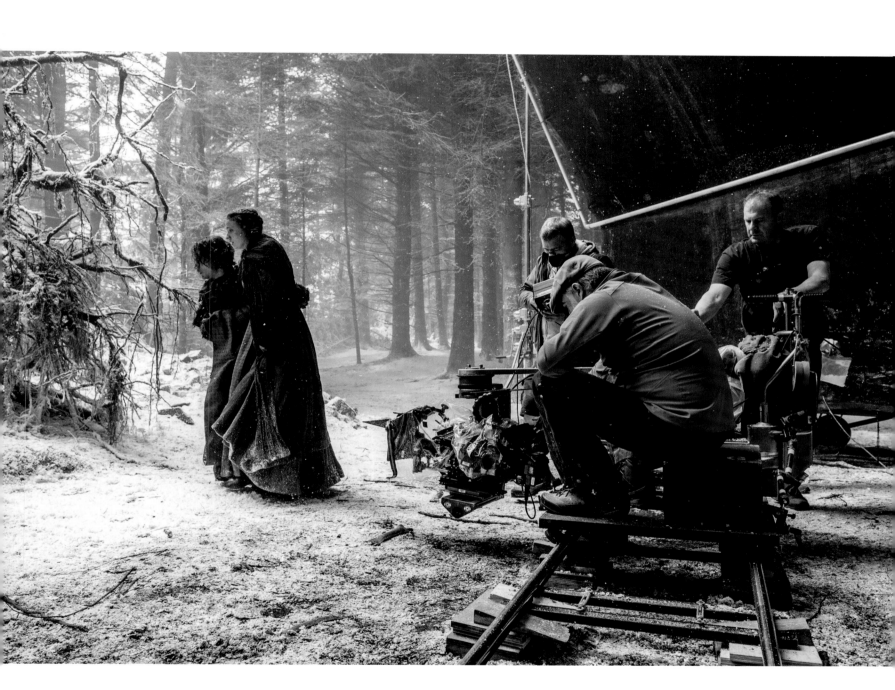

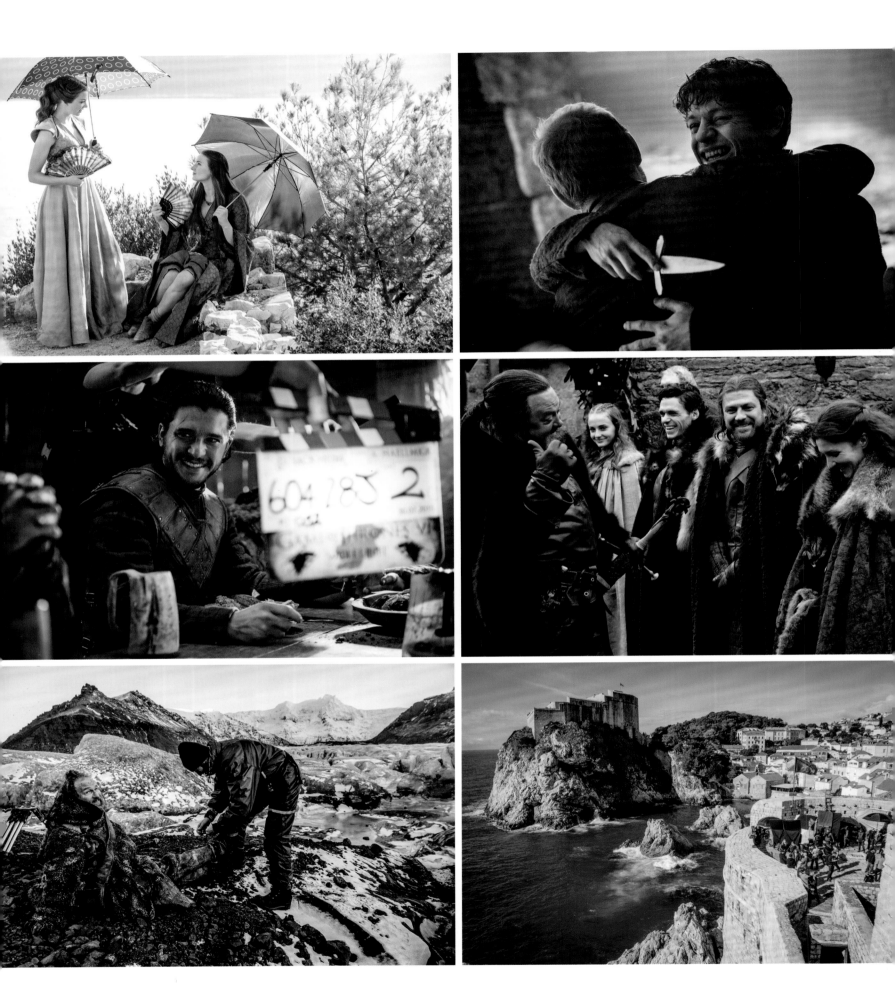

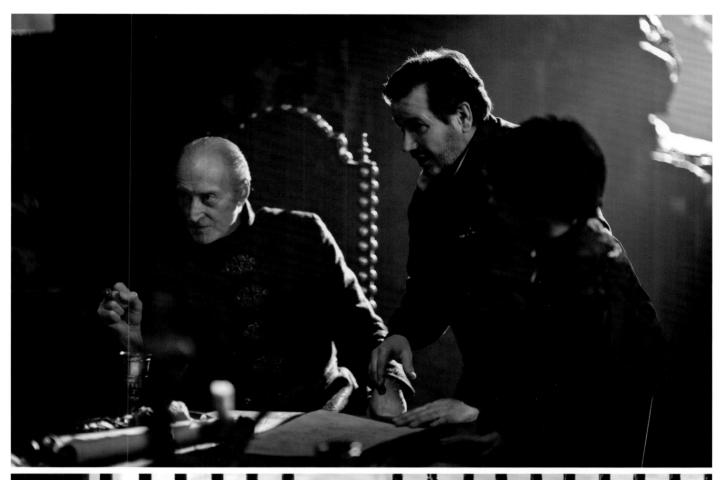

OPPOSITE: The cast and crew of *Game of Thrones*.
TOP: Charles Dance and Maisie Williams.
BOTTOM: Alfie Allen as Theon Greyjoy, who has become Reek.

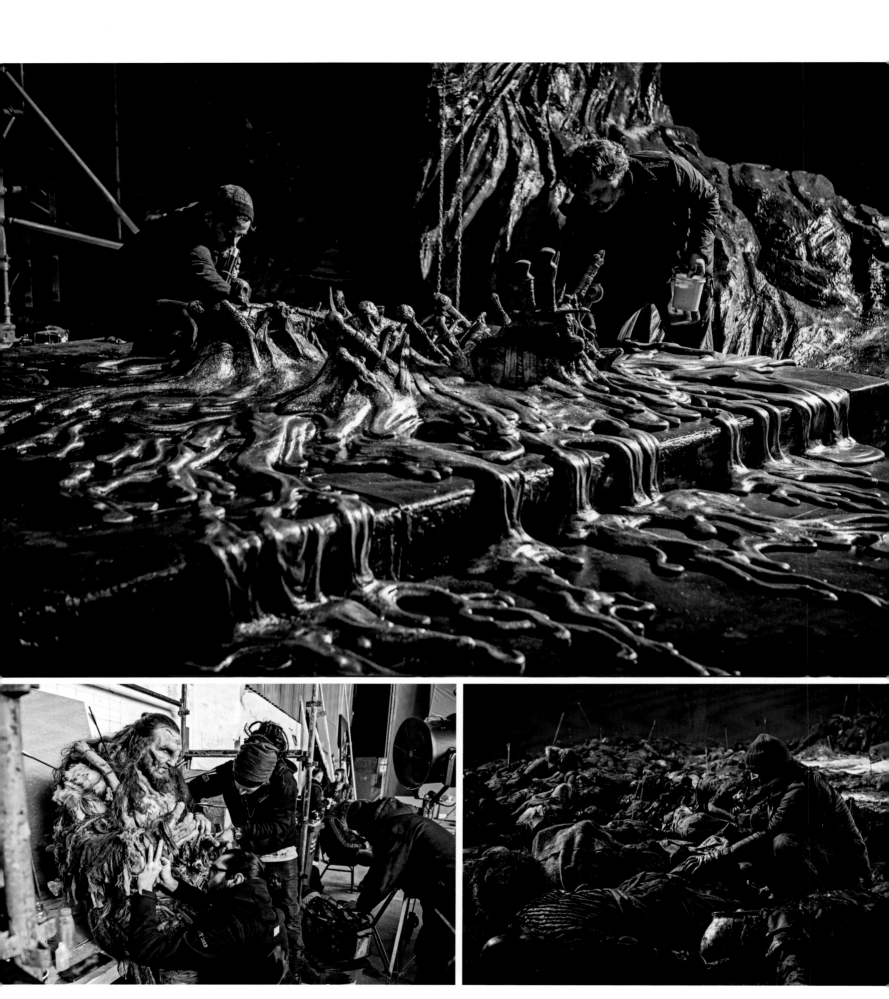

TOP: The melted Iron Throne being touched up.
BOTTOM LEFT: Checking details on the costume for the giant Wun Wun, portrayed by Ian Whyte.
BOTTOM RIGHT: The crew adjusting the placement of the numerous dummies.

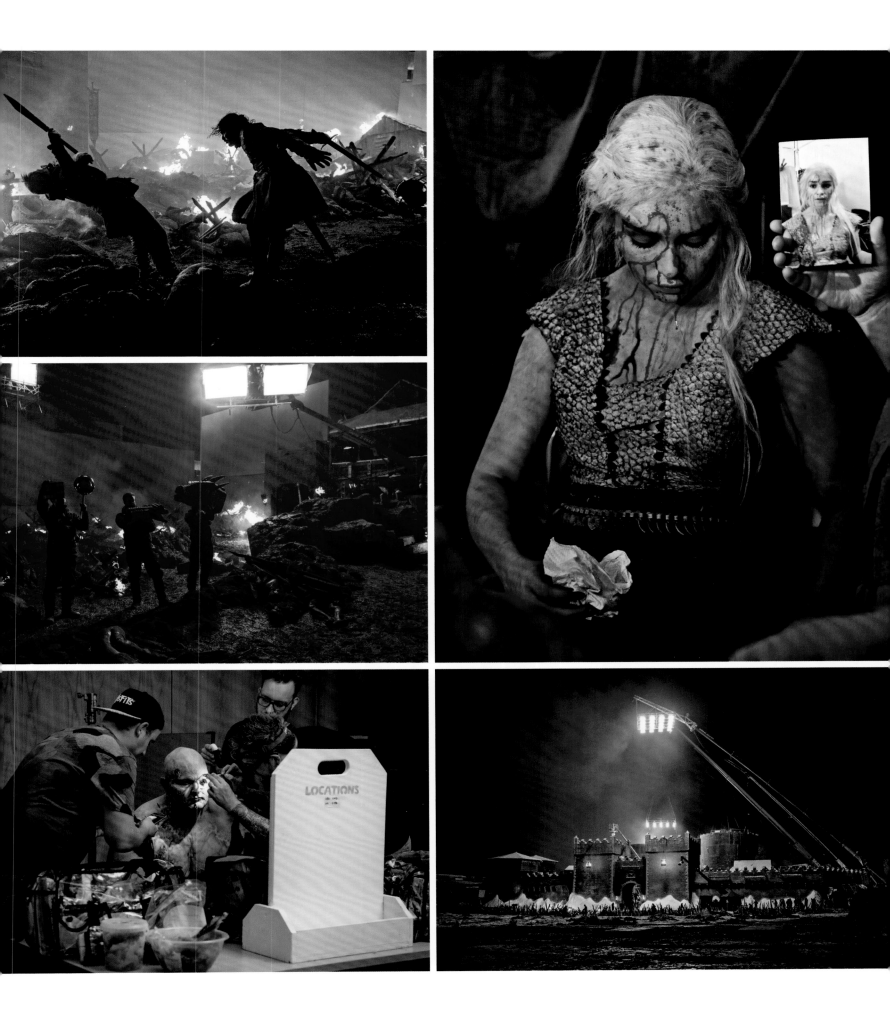

TOP LEFT: Kit Harington performing his own battle scenes and stunt work during the Battle of Winterfell.
CENTER LEFT: The VFX department taking references on the destroyed Winterfell set.
BOTTOM LEFT: Hafþór Júlíus Björnsson has extensive prosthetics placed on him to play Gregor Clegane, better known as the Mountain.
TOP RIGHT: The makeup department checks the continuity of Daenerys's makeup.
BOTTOM RIGHT: The Winterfell set is prepared for the onslaught of wights.

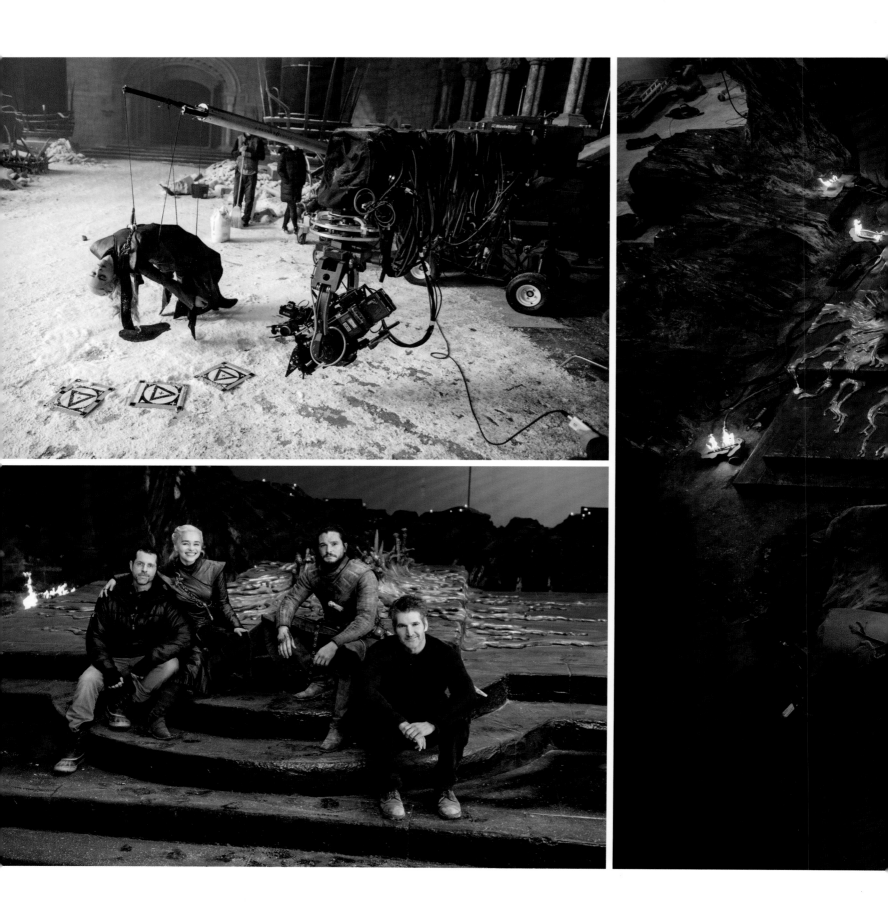

TOP: Emilia Clarke films her character's dramatic and emotional final moments.
BOTTOM: D. B. Weiss, Emilia Clarke, Kit Harington, and David Benioff sitting before the destroyed throne.
OPPOSITE: The destroyed throne room, including the melted throne and the ruined columns and braziers that once lined the expansive set.

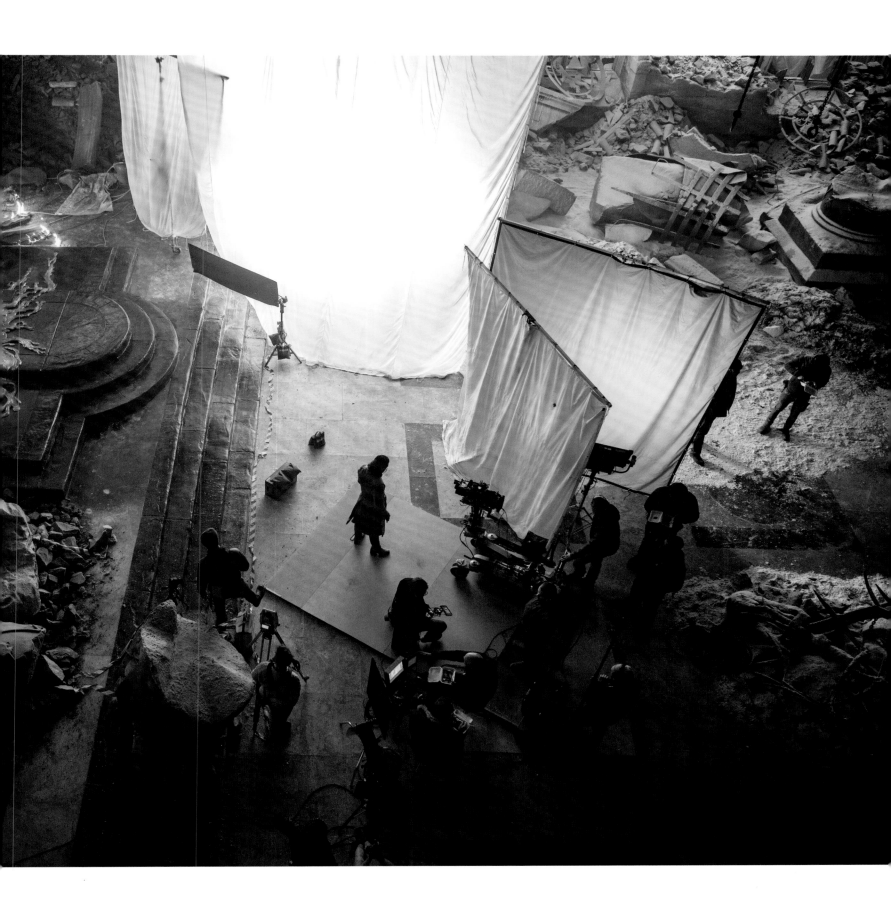

ACKNOWLEDGMENTS

First of all, thank you to all the producers and directors for your leadership and support. Especially David Benioff and Dan Weiss for giving me the incredible opportunity to make this book—it still feels like a dream.

To everyone at HBO for believing in this little Irish stranger, especially Vicky Lavergne for your friendship and Mara Mikialian for being such an inspiration.

Huge respect to all my fellow photographers included here—you have been an exceptional part of the team: Paul Schiraldi, Keith Bernstein, Olly Upton, Nick Briggs, Nick Wall, and Neil Davidson, but especially Macall Polay for your advice and camaraderie.

To Janis Fein, Cara Grabowski, Dustin Rodriguez, and Jeff Peters of HBO, and the team at Insight Editions for your understanding and experience.

To all the artisans who made *Game of Thrones* a reality, for your inspired creations, your vision, and your skill.

To our fantastic cast—you believed in me and understood what we had to achieve—thank you for your trust and love.

To everyone at Nikon, my fellow ambassadors, and the Society of Motion Picture Still Photographers for believing in my work—this would have been impossible without your technical knowledge and support over the seasons.

To the brilliant photoshoot teams and, most importantly, Trevor Wilson and Damien Elliott for your unfaltering loyalty and patience in the face of extreme stress. Og kærar þakkir fá aðstoðarmennirnir mínir á Íslandi, Guðmann Þór Bjargmundsson og Víðir Hallgrímsson.

To our beautiful crew. I hope these images jog fond memories of great days. Cups of tea in the rain, belly laughs, rants, and hugs. We really were a finely tuned machine, but more importantly, we became a family. You are the very beating heart behind these pages, and I love you so much.

To the mentors and teachers encouraging young people in the arts. You pave the path that leads us to a dream. Please know you are appreciated.

Most of us cannot function in this industry without the support of our families and friends. Mum, Steve, the As, Duncan—thank you for everything you do. And to my daughter, my everything. You are my inspiration.

—HELEN SLOAN

For Dad. I think you'd have loved all this.

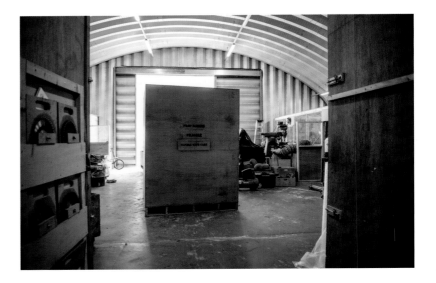

PO Box 3088
San Rafael, CA 94912
www.insighteditions.com

Find us on Facebook: www.facebook.com/insighteditions
Follow us on Twitter: @InsightEditions

Library of Congress Cataloging-in-Publication Data available.

ISBN: 978-1-68383-529-5

PUBLISHER: Raoul Goff
PRESIDENT: Kate Jerome
ASSOCIATE PUBLISHER: Vanessa Lopez
CREATIVE DIRECTOR: Chrissy Kwasnik
SENIOR DESIGNER: Ashley Quackenbush
DESIGN SUPPORT: Megan Sinead Harris
SENIOR EDITOR: Amanda Ng
ASSISTANT EDITORS: Maya Alpert and Anna Wostenberg
MANAGING EDITOR: Lauren LePera
SENIOR PRODUCTION EDITOR: Rachel Anderson
PRODUCTION DIRECTOR/SUBSIDIARY RIGHTS: Lina s Palma
SENIOR PRODUCTION MANAGER: Greg Steffen
PRODUCTION COORDINATOR: Eden Orlesky

Additional text by Mike Avila.

ROOTS of PEACE REPLANTED PAPER

Insight Editions, in association with Roots of Peace, will plant two trees for
each tree used in the manufacturing of this book. Roots of Peace is an
internationally renowned humanitarian organization dedicated to eradicating
land mines worldwide and converting war-torn lands into productive farms
and wildlife habitats. Roots of Peace will plant two million fruit and nut trees
in Afghanistan and provide farmers there with the skills and support
necessary for sustainable land use.

Manufactured in China by Insight Editions

10 9 8 7 6 5 4 3 2 1

PAGES 2–3: Kit Harington as Jon Snow.
PAGE 4: This iconic shot of Emilia Clarke as Daenerys Targaryen was captured on
Clarke's first day on set.
PAGES 6–7: An image of crew members on the set of the throne room in the Red Keep.
PAGE 8: Gwendoline Christie as Brienne of Tarth.
PAGE 415: Helen Sloan's camera and a clapper board from the final season.
ABOVE: The Iron Throne boxed up at Titanic Studios. It was the final prop to leave.

Additional photography by Macall Polay, Paul Schiraldi,
Keith Bernstein, Nick Briggs, Nick Wall, Oliver Upton,
and Neil Davidson.